ALSO BY JOHN RICHARDSON

Manet

Georges Braque

Braque

A Life of Picasso, Volume I, 1881–1906

A Life of Picasso, Volume II, 1907–1917

The Sorcerer's Apprentice:
Picasso, Provence, and Douglas Cooper

Sacred Monsters, Sacred Masters:
Beaton, Capote, Dalí, Picasso, Freud, Warhol, and More

A LIFE OF PICASSO

The Triumphant Years
1917–1932

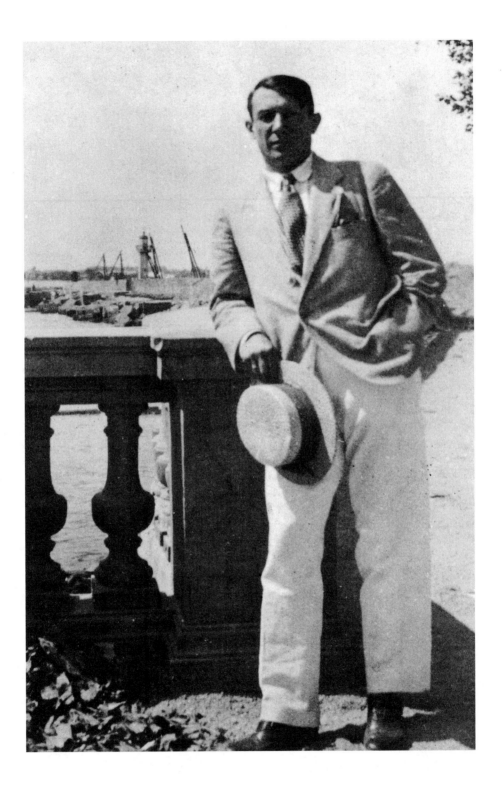

A LIFE OF
PICASSO

The Triumphant Years
1917–1932

John Richardson

with the collaboration of Marilyn McCully

Alfred A. Knopf · New York · 2007

THIS IS A BORZOI BOOK
PUBLISHED BY ALFRED A. KNOPF

Copyright © 2007 by John Richardson Fine Arts Ltd.

All rights reserved. Published in the United States by Alfred A. Knopf, a division of Random House, Inc., New York, and in Canada by Random House of Canada Limited, Toronto.

www.aaknopf.com

Knopf, Borzoi Books, and the colophon are registered trademarks of Random House, Inc.

All images by Pablo Picasso are © 2007 Estate of Pablo Picasso / Artists Rights Society (ARS), New York.

Many of the images in this book have been made available courtesy of Collection Bernard Ruiz-Picasso, Fundación Almine y Bernard Ruiz-Picasso para el Arte, and Archives Olga Ruiz-Picasso.

All images by Francis Picabia, Valentine Hugo, Louis Marcoussis, Jean Cocteau, and Fernand Leger are © 2007 Artist Rights Society (ARS) New York / ADAGP, Paris.

All images by Man Ray are © Man Ray Trust / Artists Rights Society (ARS), New York / ADAGP, Paris.

The image by Marcel Duchamp is © 2007 Artists Rights Society (ARS), New York / ADAGP, Paris / Succession Marcel Duchamp.

Library of Congress Cataloging-in-Publication Data
Richardson, John, [date]
A life of Picasso / by John Richardson.
p. cm.
Originally published: New York: Random House, c1991.
Includes bibliographical references and index.
ISBN-13: 978-0-375-71149-7
ISBN-13: 978-0-375-71150-3
ISBN-13: 978-0-307-26665-1
ISBN-13: 978-0-307-26666-8
1. Picasso, Pablo, 1881–1973. 2. Artists—France—
Biography. I. Title.
N6853.P5R56 2007
709.2—dc22
[B} 2007005714

Composed by North Market Street Graphics
Printed by R. R. Donnelley, Crawfordsville, Indiana

Manufactured in the United States of America
First Edition

Frontispiece: Picasso in Saint-Raphaël, 1919. Musée Picasso, Paris.

For Mercedes with love

ACKNOWLEDGMENTS

This book is greatly indebted to Mrs. Sid Bass, who was instrumental in setting up the John Richardson Fund for Picasso Research, without which the author's ongoing biography of the artist would have foundered for lack of financial support. Mercedes has been tireless in persuading her friends, fellow collectors, and other art world luminaries to contribute to the considerable costs of the project: four years of intensive research on both sides of the Atlantic as well as substantial copyright fees, photographic work, and other office and travel expenses.

Besides expressing his gratitude to Mrs. Bass, the author would like to thank the generous donors whose names are listed below, especially Eugene Victor Thaw, who came up with the idea for the Fund. He is likewise beholden to Jerl Surratt, for supervising the fund-raising, and the Fund's advisory board: Bernard and Almine Picasso, Annette de la Renta, John Russell, E. V. Thaw, and Nicholas Fox Weber (director of the Josef and Anni Albers Foundation, through which the Richardson Fund's assets have been funneled).

My deepest thanks to all those listed below:

Acquavella Contemporary Art, Inc.
The Annenberg Foundation
Anonymous
The late Mrs. Vincent Astor
Milton and Sally Avery Arts Foundation
Mercedes and Sid R. Bass
Leon D. Black, The Leon Black Family
 Foundation
The late Bill Blass
Robert Mnuchin, C&M Arts
Mr. and Mrs. Gustavo A. Cisneros
Douglas S. Cramer Foundation
The Nathan Cummings Foundation
Michel and Hélène David-Weill

Dame Vivien Duffield, The Clore
 Foundation
The Charles Engelhard Foundation
Mica Ertegün and the late Ahmet
 Ertegün
H.R.H. Princess Firya and Lionel I.
 Pincus
Dr. Guido Goldman
Agnes Gund and Daniel Shapiro
Drue Heinz Trust
Jorge Helft and Sylvie Robert
Dr. and Mrs. Henry A. Kissinger
Henry R. Kravis Foundation
Jan Krugier, Jan Krugier Gallery

The Lauder Foundation, Leonard &
 Evelyn Lauder Fund
Ambassador and Mrs. Ronald S. Lauder
Mr. and Mrs. George S. Livanos
Mr. and Mrs. John L. Marion
Mr. and Mrs. Donald B. Marron
The Richard Meier Foundation
Mereville Foundation
The Museum of Modern Art, Library
 Committee
James G. Niven
Phillips, de Pury & Luxembourg
Bernard Ruiz-Picasso
The late Khalil Rizk
David Rockefeller
Ambassador and Mrs. Felix Rohatyn

Mrs. Janet Ruttenberg
Mrs. Lily Safra
Mr. and Mrs. Julio Mario Santo
 Domingo
Mrs. Edouard Stern
Thaw Charitable Trust
The Ann and Erlo Van Waveren
 Foundation
Mrs. Linda Wachner
Malcolm Hewitt Wiener Foundation
Russell and Eileen Wilkinson, The
 Villore Fund
Mrs. Charles Wrightsman
Elaine and Steve Wynn
Mr. and Mrs. Ezra Zilkha

* * *

When I started on Volume I of this biography, some twenty-five years ago, Picasso's widow, Jacqueline, was kind enough to give the project her blessing. She had me stay at Notre-Dame-de-Vie and let me have the run of the studios. She also answered any questions I chose to ask. As always, I am very indebted to the artist's son Claude and daughter Paloma for their support. Their mother Françoise, Gilot, has also been generous with inside information. Salutations, too, to the artist's daughter by Marie-Thérèse Walter, Maya Widmaier Picasso, and her family—her daughter Diana, who has shared her discoveries about her grandmother with me, and her son Olivier, whose *Picasso Family Portraits* has been a useful source of facts about the family. I would also like to acknowledge the help of General Juan Picasso's family, María-Teresa and Luz Martínez de Ubago.

In writing this book, my greatest debt has been to Bernard Picasso, the only surviving son of Paulo, the artist's son. Bernard once told me that he has only one dream in life: to honor his grandfather as best he can. With the support of his wife, Almine, and his mother, Christine, Bernard has lived up to his aspirations and, among much else, has helped to create a magnificent new museum at Málaga, under the exceedingly effective directorship of Bernardo Laniado-Romero. To further his grandfather's renown, Bernard has held exhibitions of his holdings all over Europe and published an important series of catalogues and books. I would like to thank Bernard and Almine with all my heart for their constant encouragement and their generosity in providing this book with archival material vested in their foundations: Collection

Bernard Ruiz-Picasso, Fundación Almine y Bernard Ruiz-Picasso para el Arte; and Archives Olga Ruiz-Picasso. Working with Bernard has been especially pleasurable thanks to his meticulous assistants, Marta Volga Guezala and Cécile Godefroy.

As always, the Musée Picasso in Paris has proved an incomparable source of biographical material—much of it still unpublished—which the former director, Gérard Régnier, and his staff kindly made available to me. Heartfelt thanks also to the museum's former chief curator, Hélène Klein—most scrupulous of Picasso scholars. Gérard's innovative successor, Anne Baldassari, and her staff have been no less helpful—all thanks to them for being so accommodating. I also want to thank María Teresa Ocaña and the staff of the Museu Picasso in Barcelona, and to Jean Louis Andral, director of the Musée Picasso in Antibes, for many kindnesses. Isabelle Monod Fontaine and the staff of the Centre Pompidou have also been unfailingly helpful—thank you all very much.

On this side of the Atlantic, I would like to acknowledge the award of a fellowship (2001) from the John Simon Guggenheim Memorial Foundation. Coming as it did at the start of a seven-year venture, the fellowship had a most beneficial effect. As for the Museum of Modern Art, New York, the sheer scale of its Picasso holdings and the generosity of those in charge have been a constant inspiration. I am very grateful to the director, Glenn D. Lowry; the former chairman, Ronald Lauder; the former president, Agnes Gund; her successor, Marie-José Kravis. Special thanks also to Kynaston McShine and John Elderfield. At the Metropolitan Museum, my old friend the late William S. Lieberman was always ready to ransack his memory for the all-important detail. Thanks to the great director of this great museum, Philippe de Montebello, and Gary Tinterow.

Hosannas to my publisher, Sonny Mehta, the almighty head of the house of Knopf, and also to his phenomenally gifted associates. Thanks above all for taking on my Picasso project and envisioning it afresh. My editor, Shelley Wanger, treasured friend, has been heroic in keeping everything, including myself and my demons, under control in the face of incessant setbacks. For all of this, Shelley deserves canonization. As for her colleagues at Knopf, they have been wonderfully helpful, efficient, and patient: to Andy Hughes, Katherine Hourigan, Carol Devine Carson, Peter Andersen, Ken Schneider, Kevin Bourke, Erinn Hartman, Roméo Enriquez, and, especially, Robert Grover, heartfelt thanks.

All praise, too, for my agents, Andrew Wylie and Jeff Posternak, for enabling me to switch to Knopf and giving this biography a new lease on life; praise, too, for dealing with an inordinate amount of tedious problems.

As for the home front, I would like to acknowledge the crucial role played by my companion, Kosei Hara, and my assistant, JoAnn Chuba, in the birthing of this book. JoAnn's good sense, sharp wit, and warm heart have kept me going. Thanks also to

her predecessors, Rui Lopes and Priscilla Higham; also to my no less supportive helpers, Sonam Chadon and Taeko Miyamoto. I'm also greatly indebted to my dear friends Hugo and Elliott Guinness, Rachel Mauro, and Ugo Rondinone.

Before embarking on the long list of all the other people I want to thank I need to apologize for not having written them personally, but the stress of finishing this book has taken up all my time. I also want to single out three people on whom I depended for advice: the late Richard Wollheim, the philosopher who knew more about other peoples' fields than they themselves usually did, and whose death after sixty years of friendship deprived me of a crucial mentor; John Golding, eminent teacher, painter, and author of a book on cubism—written fifty years ago when I first knew him— which is still the most authoritative work on the subject; and the infinitely perceptive Lydia Gasman, whose *Mystery, Magic and Love in Picasso* (1981) penetrates further into the artist's creative process than any other study, although it has yet to be properly published. To her much love.

The following have all contributed more than they may realize to the present volume: Joan Acocella; Nuria Amerigo; Linda Ashton and staff at the Ransom Center; Dr. Gaetano Barile; the late Count Henri de Beaumont and his daughter Gaia; James Beechey; Peter Bemberg; Laura Benini; Pierre Bergé; the late Heinz Berggreun; Olivier Berggreun; Rosamund Bernier; Olivier Bernier; Marc Blondeau; Carmen Cadenas; Graydon Carter; Dr. Stanley Chang; John Clarke; Lucien Clergue; Victoria Combalía; Gerald Corcoran; Elizabeth Cowling; Pierre Daix; Brenda Danilowitz; Countess Dembinski; Christian Derouet; Simon Dickinson and associates; François Ditesheim; Grace Dudley; John Eastman; Antoine and Marianne Estène-Chauvin; Pierrot Eugène; Hector Feliciano; Evelyne Ferlay; John Field; Sylvie Fresnault; Lucian Freud; the late Vicente García-Márquez; Claude and David Gilbert; Carmen Giménez; Arne Glimcher; the late Princess Gortchakow; Gijs van Hensbergen; Roseline Hierholtz; Lord Hindlip; Waring Hopkins; Rafael Inglada; Ryan Jensen; Pepe Karmel; the late Billy Kluver; Agnes Knopf; Quentin Laurens; Wayne Lawson; Brigitte Léal; the late Alexander and Tatiana Liberman; Ralph Lerner; Laura García Lorca de los Ríos and Andres Soria Olmedo; James Lord; the late Carlos Lozano; Robert Lubar; the late Dora Maar; Laurence Madeline; Julie Martin; Earl and the late Camilla McGrath; Bernard Minoret; Charles S. Moffet; Isabelle Monod-Fontaine; S. I. and Victoria Newhouse; the late Roberto Otero; Maria Luisa Pacelli; Josep Palau i Fabre; Alexandra Parigoris; Francesc Parcerisas; Michael Peppiatt; Christine Pinault; Antoni Pixot; Peter Read; Elaine Rosenberg; Jane and the late Robert Rosenblum; Deborah Rothschild; James Roundell; Angelica Rudenstine; Kader Salouh; Peter Schell; Susan Scott; Laurence Séguin; Nicholas Serota; Richard Shone; Kenneth Silver; Robert Silvers; Werner Spies; Natasha Staller; Leo Steinberg;

Charles F. Stuckey; Juana María Suárez; Jeanne-Yvette Sudour; Lord Hugh Thomas; Gertje Utley; Kenneth Wayne; and Jeffrey Weiss.

I would like to thank Marilyn McCully, who did so much valuable work on the first two volumes, for all the research work she has done for the present book. I would also like to thank Marilyn's husband, Michael Raeburn, for working with the diligent Phyllis Stigliano in assembling the illustrations. And I am especially grateful to the brilliant, sharp-eyed young scholar Dakin Hart, who proved to be a deus ex machina with regard to the final chapters. If I have left anyone out I hope I will be forgiven.

CONTENTS

A LIFE OF PICASSO

The Triumphant Years
1917–1932

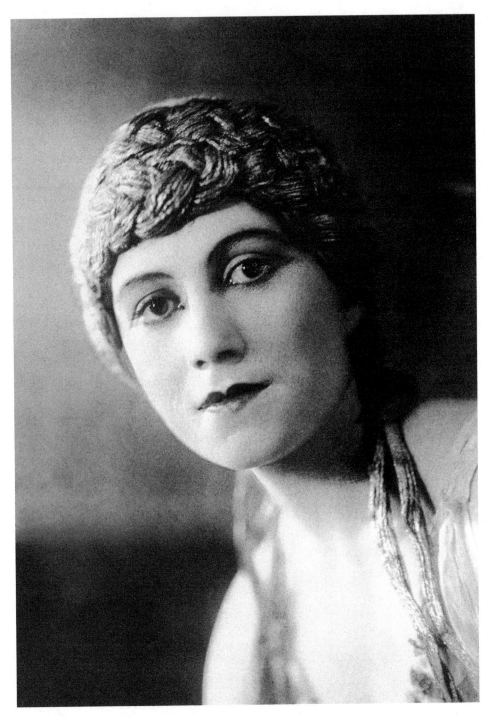

Olga Khokhlova in *L'Après-midi d'un faune*, 1913.

1

Rome and the Ballets Russes (1917)

Picasso's visit to Rome in February 1917 had originally been conceived as a wedding trip, but at the last moment his on-again off-again mistress, Irène Lagut, who had promised to marry him, changed her mind, as her predecessor, Gaby Lespinasse, had done the year before. Instead of Irène, Jean Cocteau accompanied him. In a vain attempt to set himself at the head of the avant-garde, this ambitious young poet had inveigled Picasso into collaborating with him on Parade: *a gimmicky, quasi-modernist ballet about the efforts of a couple of shills to lure the public into their vaudeville theater by tantalizing them with samples of their acts. Cocteau had desperately wanted Diaghilev to stage this ballet in Paris. The meddlesome Polish hostess Misia Sert had tried to scupper the project. However, Picasso's Chilean protector and patron, Eugenia Errázuriz, had persuaded Diaghilev to agree, provided Picasso did the décor, Erik Satie the score, and Léonide Massine the choreography. Sets, costumes, and rehearsals were to be done in Rome, where Diaghilev had his wartime headquarters. Picasso's cubist followers were horrified that their avant-garde hero should desert them for anything as frivolous and modish as the Ballets Russes, but he ignored their complaints. After two and a half years of war, with its appalling death toll, its hardships and shortages, and above all the absence of his closest friends—particularly Braque and Apollinaire at the front—Picasso was elated at the prospect of leaving the bombardments and blackouts behind to spend a couple of months in the relative peace of Rome, which he had always wanted to visit. Besides working on* Parade, *he was determined to get married.*

Picasso and Cocteau arrived in Rome on February 19, 1917, a day later than they had intended. Cocteau, who had forgotten to get a visa from the Italian embassy, had lied when telling him that no reservations were available. Diaghilev had booked

Serge Diaghilev in New York, 1916.
Bibliothèque de l'Opéra, Paris.

them into the Grand Hotel de Russie on the corner of the Via del Babuino and the Piazza del Popolo. So that Picasso could work in peace on the costumes and sets for *Parade,* he had also arranged for him to have one of the coveted Patrizi studios, tucked away in a sprawling, unkempt garden off the Via Margutta. Although most of the artists are now gone, the Patrizi studios are still as idyllic as they were in 1917.

"I cannot forget Picasso's studio in Rome," Cocteau later wrote. "A small chest contained the maquette for *Parade,* with its houses, trees and shack. It was there that Picasso did his designs for the Chinese Conjurer, the Managers, the American Girl, the Horse, which Anna de Noailles would compare to a laughing tree, and the Acrobats in blue tights, which would remind Marcel Proust of *The Dioscuri.*"[1] From his window Picasso had a magnificent view of the sixteenth-century Villa Medici, seat of the French Academy, towering above the studio garden. As he well knew, the Academy had associations with some of his favorite artists. Velázquez had painted the garden; Ingres had spent four years there as a fellow at the outset of his career and, later, six years as director; Corot had also worked there and caught the golden light of Rome and the *campagna,* as no other painter had done.

"Rome seems made by [Corot]," Cocteau reported to his mother. "Picasso talks of nothing else but this master, who touches us much more than Italians hell bent on the grandiose!"[2] That Picasso infinitely preferred the informality of Corot's radiant views to the pomp and ceremony and baroque theatricality of so much Roman painting is confirmed by his sun-filled pointillistic watercolors of the Villa Medici's ochre façade—as original as anything he did in Rome.[3]

Diaghilev insisted that Picasso and Cocteau share his passion for the city. Sightseeing was compulsory that very first evening. Since there was no blackout as there was in Paris, they were able to see the Colosseum all lit up—"that enormous reservoir of the centuries," Cocteau said, "which one would like to see come alive, crowded with people and wild beasts and peanut vendors."[4] The following morning, Diaghilev picked them up in his car for another grand tour. In the evening he took them to the circus. "Sad but beautiful arena," Cocteau wrote his mother. "Misia Sert (or rather her double) performed on the tight rope. Diaghilev slept until woken with a start by an elephant putting its feet on his knees."[5]

When he arrived in Rome, Picasso was still suffering from *chagrin d'amour.* Eager to find a replacement for Irène Lagut, he had promptly fallen in love with one of Diaghilev's Russian dancers, the twenty-five-year-old Olga Khokhlova. Although he courted her assiduously and did a drawing of her, which he signed with his name in Cyrillic, Olga proved adamantly chaste. Chastity was a challenge that Picasso had seldom had to face. Both Diaghilev and Bakst warned him that a respectable Russian woman would not sacrifice her virginity unless assured of marriage. *"Une russe on l'épouse,"* Diaghilev said. Olga personified this view. She was indeed respectable: the daughter of Stepan Vasilievich Khokhlov, who was not a general, as she claimed, but a colonel in the Corps of Engineers in charge of the railway system.[6] Olga had three brothers and a younger sister. They lived in St. Petersburg in a state-owned apartment on the Moika Canal. Around 1910, the colonel had been sent to the Kars region to oversee railroad construction, and the family had followed him there. Olga stayed behind. Egged on by a school friend's sister, Mathilda Konetskaya, who had joined the Diaghilev ballet after graduating from the Imperial Ballet School, she decided to become a dancer.

Olga had considerable talent. Despite starting late and studying briefly at a St. Petersburg ballet school,[7] she managed to get auditioned by Diaghilev. The Ballets Russes was having difficulty prying dancers loose from the state-run theaters and was desperate for recruits. A committee consisting of Nijinsky and the greatest of classical ballet masters, Enrico Cecchetti, as well as Diaghilev—a trio described by another dancer as more terrifying than any first-night audience—put Olga through her paces and accepted her. Intelligence and diligence compensated for lack of experience. Nijinsky was sufficiently impressed to pick her out of the corps de ballet.

Léonide Massine, who had taken Nijinsky's place in Diaghilev's company as well as in his heart, had chosen Olga to play the role of Dorotea in *Les Femmes de bonne humeur,* an adaptation of a comedy by the eighteenth-century playwright Goldoni, with sets by Léon Bakst and a heavily arranged score after Scarlatti. It was at a rehearsal for this ballet, which would have its premiere in Rome the following month, that Picasso spotted Olga and immediately set about courting her. To familiarize himself with the techniques of theatrical décor as well as watch his new love dance, he helped Carlo Socrate (the scene painter who would work on *Parade*) execute Bakst's scenery. So that he could join Olga backstage, Picasso even helped the stagehands at the ballet's premiere.[8] Fifteen months later he would marry her.

Compared to her predecessors—Bohemian models Picasso had lived with in Montmartre or Montparnasse—Olga was very much a lady, not, however, the noblewoman biographers have assumed her to be.[9] She came from much the same professional class as Picasso's family. Don José, Picasso's father, may have been a very unsuccessful painter, but his brothers included a diplomat, a revered prelate, and a

successful doctor, who had married the daughter of a Malagueño marquis. One of Picasso's mother's first cousins was a general—more celebrated than Olga's parent, also the real thing. Indeed, it may have been Olga's lack of blue blood that made her so anxious to become a grande dame and bring up her son like a little prince. Arthur Rubinstein, the pianist, who had met Olga in 1916 when the ballet visited San Sebastián, remembered her as "a stupid Russian who liked to brag about her father, who she pretended was a colonel in the Tsar's own regiment. The other dancers assured me that he was only a sergeant."[10] This was an exaggeration, but Olga's pretensions were resented by other members of the company.

Ten years younger than Picasso, Olga had fine regular features, dark reddish hair, green eyes, a small, lithe, dancer's body, and a look of wistful, Slavic melancholy that accorded with the romanticism of classic Russian ballet. Formal photographs reveal Olga to have been a beauty—usually an unsmiling one—although in early snapshots of her with Picasso and Cocteau in Rome, she is actually grinning. Later, she plays up to him, dances for him, takes on different personalities, which might explain the widely varying reactions to her. The celebrated ballerina Alexandra Danilova declared that Olga "was *nothing*—nice but nothing. We couldn't discover what Picasso saw in her."[11] A Soviet ballet historian, the late Genya Smakov, found references to her in an unpublished memoir by someone working for Diaghilev, where she is said to have been "neurotic."[12] On the other hand, Lydia Lopokova—the most intelligent of Diaghilev's ballerinas—was Olga's best friend in the company.

Picasso fell for Olga's vulnerability. He sensed the victim within. She would have appealed to his possessiveness and protectiveness especially when the Russian Revolution cut her off from her family. Her vulnerability would likewise have appealed to Picasso's sadistic side. (The women in his life were expected to read the Marquis de Sade.) In the past year rejection by the two women he had hoped to marry had left him uncharacteristically desperate. Picasso's residual bourgeois streak should also be taken into account. He was thirty-five and wanted to settle down with a presentable wife and have a son. None of his father's three brothers had had any issue, and there was pressure from his mother to produce an heir.

Sexual abstinence was something Picasso had seldom if ever had to face. His two previous mistresses may have shied away from marrying him, but they had been easy enough to seduce. Olga was as unbeddable as the "nice" Malagueña girls that his family had tried to foist on him. "Don't forget Olga who cares for you very much," she wrote on the back of a dramatic photograph of herself in *Firebird*. "Who neglects me, loses me."[13] (Cocteau could not resist using the phrase *qui me néglige me perd* as a caption to a caricature of Bakst he subsequently sent to Olga.)[14] Picasso must have been very much in love to put up with this ukase. Ernest Ansermet, Diaghilev's principal conductor, describes walking back to the Hotel Minerva, where he and the

dancers were staying. Olga had the room next to Ansermet's. "I heard Picasso in the passage knocking at her door and Olga on the other side of it saying 'No, no, Monsieur Picasso, I'm not going to let you in.' "[15] Clearly, marriage was his only option.

Diaghilev, who felt responsible for the genteel Russian girls in his company, advised Picasso against marrying Olga. Foreseeing problems with her parents, who were averse to their daughter marrying a mere painter, the impresario told Picasso that he had a much more suitable girl set aside for him. She was currently dancing in South America and would soon be returning to Europe. Picasso would not listen; he was obsessed by Olga. Not that this kept him away from the local brothels, to judge by an address noted down in his Roman sketchbook.[16] "In Rome of an evening," Picasso told Apollinaire, "whores ply their trade in automobiles—at walking pace— they accost their clients with smiles and gestures and stop the car to negotiate the price."[17] From Naples he would send Apollinaire a postcard: "In Naples all the women are beautiful. Everything is easy here,"[18] and, sure enough, the sketchbook he took with him records the address of a Neapolitan brothel. For an Andalusian, regular visits to a whorehouse would have been an obligatory response to a fiancée's virtuous stand. Another option was an affair with a less virtuous member of the company. Picasso did that too.[19]

Cut off by the war from Russia, Diaghilev and his company led a nomadic life. Their principal wartime base was Rome. Officially the impresario stayed in the Grand Hotel, but he spent most of his time in an apartment in the Marchese Theodoli's palazzo on the Corso that he had rented for Léonide Massine, the handsome twenty-one-year-old dancer, who had been his lover for the previous three years. So as not to compromise himself publicly, Massine had insisted that he and his employer live under separate roofs. That this hot-blooded heterosexual, who was also a cold-blooded operator, should have allowed himself to be captured and caged by the notoriously jealous and possessive Diaghilev is not surprising. In Russia it had been a standard career move for a dancer of either sex to have a rich, influential protector. To negotiate these arrangements, one of the company's dancers, Alexandrov, acted as pimp. Massine's predecessor in Diaghilev's life, the legendary Nijinsky, who was likewise heterosexual, had started off—with his mother's blessing—as the protégé of the rich, young Prince Lvov. The Prince had then handed him on to the Polish Count Tishkievitch, who gave him a piano.[20] Like Diaghilev's previous lover, Dimitri Filosofov, Nijinsky would leave the impresario for a woman; as would Massine.

Exceedingly parsimonious and very ambitious, Massine had everything to gain from this arrangement. Diaghilev had already turned him into a star dancer, a choreographer of near genius and a major collector of modern paintings, including many Picassos and Braques. Sex with Diaghilev was part of the job—"like going to bed

with a nice fat old lady,"[21] as he told one of his mistresses, when she asked how he could possibly have done it with Diaghilev.

That Massine was a passionate Hispanophile would prove to be a lasting bond with Picasso. The previous summer in Madrid, the dancer had agreed to choreograph two ballets with Spanish themes, *Las meninas,* which would be put on later in 1917, and *Tricorne,* which would not appear until 1919. A small, driven, Spanish-looking Russian with enormous eyes—in some respects a younger version of Picasso—Massine expected the artist to teach him about modern art. He proved so perceptive and imaginative and such a quick learner that over the next ten years he and Picasso would collaborate on four great ballets.

Another bond between Picasso and Massine was a passion for women—a passion that differentiated them from Diaghilev's largely homosexual entourage. Cocteau's presence in Rome made for more pique and intrigue than usual. In the face of Diaghilev's jealousy, Picasso was delighted to provide his fellow womanizer with an alibi for his amorous escapades. After failing to persuade Picasso to spy for him, Diaghilev hired a couple of detectives to take on this job.[22] At the slightest suspicion of infidelity on Massine's part, Diaghilev would have a temper tantrum, attack the furniture with his stick, tear the telephone out of the wall and smash it.

Massine's biographer, Vicente García-Márquez, has explained the dynamics of this relationship:

> Massine's reaction to such raving was to immerse himself in work. Not only were his spirit and intellect being sorely tested, but his appreciation of Diaghilev as a great man—brilliant, often magnanimous, capable of . . . self-sacrifice in the pursuit of artistic ideals—had to be set against the . . . merciless, mistrustful . . . self-centered tyrant he now faced. . . . Since Massine . . . sacrifice[d] himself to art as to a religion, any distress . . . was justified in his mind by the work that grew out of their affiliation. In the creative process he could . . . sublimate his private needs to his work. . . . the dark side of his bargain was that . . . art increasingly became for Massine a substitute for and a refuge from real intimacy.[23]

Diaghilev was too much in awe of Picasso to lose his temper with him, so everything went smoothly; but after prolonged exposure to his controlling ways, the artist said that, like Gulliver, he "felt a desperate need to travel back to the land of human beings."[24] Cocteau fared less well. If he described the impresario as "an ogre of kindness and criminality," this was because Diaghilev had made a great fuss over him in Rome, and then taken against his meddling. After returning to Paris, Cocteau made the fatal mistake of claiming that he rather than Massine was the principal begetter of *Parade.*

To promote the company's upcoming season and lure backers for new productions, Diaghilev gave frequent dinners in "Massine's apartment," which had already

filled up with balletic clutter. Michel Georges-Michel—the journalist who had recently arrived from Paris with some Picasso paintings that Diaghilev had bought for Massine[25]—described the place. Besides these newly acquired paintings, which Diaghilev planned to exhibit at the company's gala opening in April, the salon contained "lengths of muslin, fabrics, silks, sheets of cardboard, ballet shoes, costume designs on tracing paper, picture frames, musical scores, dolls."[26] Over the sofa hung an eighteenth-century portrait which intrigued Picasso. "Why are you so fascinated by that picture?" Diaghilev asked. "I am studying it carefully," Picasso replied, "in order to learn how not to paint."[27] There was a constant coming and going of friends and associates chattering away in Russian, French, English, Italian, Spanish. Diaghilev's dinners were shunned by most of the "black" aristocracy of Rome, who disapproved of his pro-Bolshevik stance, but immensely popular with cultivated diplomats and fashionable people from war-torn countries, who had settled in the city for the duration of the hostilities and were desperate for distraction.

Diaghilev had taken a liking to a young, prematurely bald, prematurely stout diplomat called Gerald Tyrwhitt (soon to be better known as Lord Berners). Berners's whimsical wit and passion for modern music made up for a lack of physical charm (he looked like nothing so much as an oyster, Lord Sackville declared). So did the considerable fortune he was about to inherit. Berners was an amateur in the eighteenth-century sense of the word: an amateurish painter and writer and a collector of everything from needlework carpets to the early Corots Picasso valued so highly, and (later) Salvador Dalís. The only thing Berners was not amateurish about was his music.

Stravinsky, whom Berners hero-worshipped, regarded his fan as the best of the young English composers—his *Valse brillante,* Stravinsky said, includes "one of the most impudent passages in modern music [a view more likely to reflect Stravinsky's poor opinion of English composers rather than his esteem for Berners's slim oeuvre]."[28] Stravinsky had introduced him to Diaghilev, who would eventually commission him to do scores for an opera and a ballet.[29] Diaghilev passed on this famously funny, ironical man to Picasso. And just as he made himself useful to Stravinsky as a go-between in the composer's complicated financial dealings with Diaghilev, Berners made himself useful to Picasso by helping to paint the set of *Parade.* He also shipped one of Picasso's portrait drawings of Stravinsky out of Italy in the diplomatic bag— probably the one of the composer seemingly wearing a monocle (in fact a broken pair of glasses).[30] More to the point, Berners took the *Parade* team to a spectacle which would inspire the ballet's famous drop curtain. As Berners wrote Stravinsky (March 13, 1917), "near my house I have discovered a tiny, dirty little theater music-hall, which I want you to see when you come. They have a variety program and an orchestra *à tout crever.* I took Picasso and Cocteau there the other night and they were thrilled."[31]

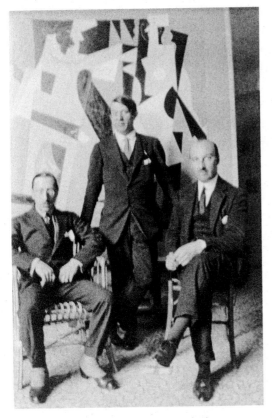

Igor Stravinsky, Picasso, and Gerald Thyrwitt (later Lord Berners) in front of Picasso's *Harlequin and Woman with a Necklace,* Rome, 1917. Musée Picasso, Paris.

They were indeed thrilled. The atmosphere of the seedy vaudeville theater that Berners had discovered corresponded exactly to what Picasso and Cocteau hoped to evoke in *Parade*—the corny Barnum and Bailey look of the drop curtain, with its vaguely Vesuvian view, stems at least in part from the décor that Picasso and Cocteau would have seen in Berners's "tiny, dirty little theater." The reference to Naples, like the references to New York in the Manager's skyscraper outfits, as well as to Spain (the torero in the drop curtain) and China (the Conjuror's mandarin costume), was supposed to reflect the ballet's cosmopolitan nature and the loosening of its ties to mother Russia. This was the message that Diaghilev hoped to project. He wanted to live down his mandarin past and be recognized as an honorary member of the avant-garde, the better to distance himself from the essentially Tsarist tradition of classical ballet founded by Marius Petipa. As that sharpest of dance critics, André Levinson, would write, *"Personne n'a servi et personne n'a trahi le ballet russe comme l'a fait Serge de Diaghilev"* (No one has supported the Russian ballet or betrayed it as Serge de Diaghilev has done).[32]

Inspiration for *Parade* came from yet another traditional form of popular entertainment: the Teatro dei Piccoli, a marionette theater that Picasso and Cocteau visited soon after their arrival, as we know from postcards of the marionettes that Picasso sent to Apollinaire ("I am writing to you from my bed having refused to go to the Forum this morning")[33] and to Juan Gris, who thanked him: "You must send me others in the same series or buy me several more which you can give me on your return."[34] Cocteau mailed one of these postcards to his mother.[35] The puppets, he said, made fairyland far more convincing than human performers ever could.[36] After the performance, Picasso, Cocteau, and Massine, and presumably Diaghilev, were invited to meet the "actresses" backstage, where the puppeteers manipulated their puppets into ceremoniously receiving their guests from the world of ballet.

Puppets had intrigued Picasso ever since 1899, when he had done a poster for a marionette show at Els Quatre Gats.[37] Now they intrigued him even more. As he had

no previous experience of the stage, he constructed a model theater out of a cardboard box in which to try out his *Parade* sets. His memories of the Teatro dei Piccoli's miniature stage would be reflected in the puppet-theater look of his décor. Cocteau raved to his mother about the spell cast by the Teatro dei Piccoli. Massine was delighted to have had another opportunity to study puppetry. Three years earlier, while on holiday with Diaghilev at Viareggio in 1914, he had been fascinated by the resort's open-air marionette theater with its commedia dell'arte characters.[38] *Les Femmes de bonne humeur*—the ballet Massine was currently rehearsing—also testifies to this obsession with marionettes.

One of the most important things a stage designer has to learn, Picasso said, was how to modify, magnify, or intensify a line or color or pattern for it to register at this or that distance from the stage. No one was better at demonstrating this than puppeteers, who needed their little figures to be identifiable and distinguishable from afar. Hence the startling boldness and brightness of Picasso's costumes, which sometimes made for confusion on the stage. By comparison, the costumes Diaghilev's former favorite, Léon Bakst, did for *Schéhérazade* looked flamboyant and démodé. Much as he deplored Bakst's taste, Picasso told Françoise Gilot that he learned a lot about stagecraft from him, for instance the way certain "colors look very nice in a maquette but amount to nothing transferred to the stage."[39] Years after the Ballets Russes period, Boris Taslitsky, a French Communist Party official, recalled how impressed he had been by Picasso's exactitude when they worked together in the 1950s on backcloths for the party's conventions.[40] To make his blacks look blacker than black, Picasso added silver powder. The *weight* of the lines had to be just so.

In Rome, Picasso's interest in puppets was shared by the young futurist painter, sculptor, and puppet maker Fortunato Depero. Diaghilev had momentarily hailed him as a genius and commissioned him to do the décor and costumes for Massine's Hans Christian Andersen ballet, *Le Chant du rossignol.* Stravinsky's score was not ready in time, so Depero's set—a fantastic futurist garden with huge plastic flowers[41]—was sold to pay his rent. A mistake, the composer said; Matisse's 1919 décor for this ballet was nothing like as good. Instead, Depero was hired to help construct the papier-mâché giants, which Picasso had contrived for the Managers and the Horse in *Parade,* and which turned out to be one of the ballet's most memorable features. Picasso enjoyed working with Depero. Although the man's style was facile and flashy—a decorative blend of futurist dynamism and synthetic cubism—Picasso could not resist helping himself to Depero-like effects in the two principal easel paintings he did in Rome. Depero had apparently assimilated enough from Picasso to pass off one of his own derivative drawings for the *Parade* Horse as an original by the master.[42]

Another of the younger futurists Picasso saw in Rome was Enrico Prampolini,

who described the visit of Picasso, Cocteau, and Bakst to his studio—a space so small that Cocteau compared it to a conjuror's box.

> Picasso remained standing by the door like a sentry; he looked about him in astonished delight, like a child at a play, his expression at once questioning and affirming as he scrutinized each object in turn with the joy of one experiencing a revelation. . . . It was an exploratory meeting rather than a mere visit. . . . Picasso asked me about Boccioni, the great friend who was no more, and the *traîtres* [whoever they were]. We all went out . . . to the Caffé Greco, where [the Florentine painter] Armando Spadini and Léonide Massine were waiting; Cocteau, who never forgot his friends, made us sign a post card to Erik Satie, on which he had drawn a heart . . . pierced by all our signatures.[43]

Prampolini went on to claim that Picasso had invited him to his hotel room to view a Raphaelesque drawing of *Three Women*, which "expressed his passionate adherence to the world of humanistic reality." No such drawing existed at the time.

The culture shock of Diaghilev's sybaritic little world, the stress of an unconsummated love affair, and the silly squabbles with Cocteau over *Parade* kept Picasso from doing what he most wanted to do—paint. As soon as he could, he embarked on two major works in which he set out to reconcile the demands of representationalism with the ongoing demands of modernism. Difficult enough in his Paris studio, this task proved to be even more daunting in the Eternal City, in the overpowering shadows of Raphael and Michelangelo. Sensitive as always to the genius loci, Picasso sought inspiration in his surroundings: not in classical monuments or Renaissance masterpieces, but in their antithesis—tourist kitsch.

A couple of gaudy chromo-colored postcards of flower sellers in traditional peasant dress[44]—a perennial feature of the Spanish Steps, which were very close to his studio—were the starting point for a large painting in the flat, decorative idiom of later synthetic cubism. *Italian Woman*[45] harks back to the great analytical cubist paintings of women holding guitars or mandolins, inspired by Corot's Italianate models, clutching musical instruments but never playing them. To establish this painting's Roman provenance, Picasso provides a glimpse through a window of the dome of Saint Peter's, behind the flower seller's head. This emphasizes the *Italian Woman*'s posterlike look—a disappointment after the large, luminous watercolor study for it, which shimmers with pointillistic light.

The considerable size and majestic counterpoint of his other big Roman painting, *Harlequin and Woman with a Necklace*,[46] indicate that Picasso was out to squeeze one more masterpiece from the residue of synthetic cubism. That he went to the trouble of photographing himself—very much *le maître*—posed formally with

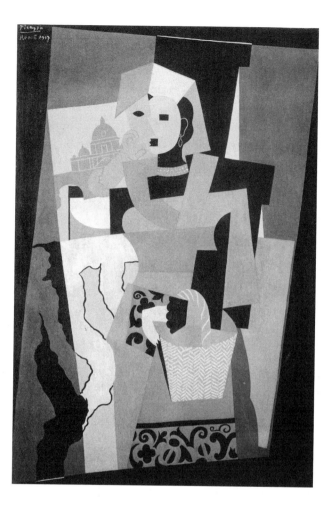

Picasso. *Italian Woman (L'Italienne),* 1917. Oil on canvas, 149.5 x 101.5 cm. Foundation E. G. Bührle, Zurich.

Stravinsky and Gerald Berners in front of this painting, suggests that Picasso regarded it as a major statement—a response to the impact of Rome.[47]

Picasso must have realized that, compared to the cubist masterpieces of the previous year, *Harlequin and Woman with a Necklace* looks flimsy. On his return to Paris a few months later, he would unroll this vast canvas for Severini—the Italian futurist who lived in Paris—and announce that it had been "inspired by Ingres's purity of form and contour."[48] He had chosen Ingres, Picasso said, as a shield against the might of Renaissance art, just as he had used this artist's sharply focused classicism in 1914–15 to wean himself off the fragmentation and illegibility of cubism. Picasso's comments on his debts to other artists are often misleading, so we have to tread carefully. The citation of Ingres in this context is at best a half-truth possibly intended to divert Severini's attention from Picasso's indebtedness to Severini as well as to Gris and Depero.

The commedia dell'arte theme and scale of the *Harlequin and Woman with a*

Necklace imply that Picasso may have envisaged it as a modernist alternative for the *Parade* drop curtain, which also features a Harlequin and a long-haired woman wearing a necklace, both of them seated. In the *Harlequin and Woman* painting, the figures are dancing their heads off, as is the homunculus (lower left) who emerges from a tiny proscenium within the huge proscenium formed by a succession of decorative frames. The disproportion makes the large dancers look even larger; at the same time it evokes recession without recourse to perspective. Dance had evidently seeped into Picasso's vision. This is the most balletic and rhythmic of all Picasso's paintings. Might Massine have helped him with the pictorial choreography? The only problem with this unwonted movement: it works against the heft that makes Picasso's work so palpable.

The eruption of pointillism in this painting, as well as in the sketch for the *Italian Woman*[49] and the watercolors of the Villa Medici, derives from the Seurat retrospective that Picasso had visited the previous summer at the Galerie Bernheim-Jeune in Paris. He had no time for Seurat's scientific theories of color, but this did not diminish his admiration for this artist's paintings or the drawings, which he would later collect. Picasso had originally resorted to pointillism as an alternative to using *faux marbre* and *faux bois* to enrich, vary, and enliven cubist paint surfaces (1913); later (1915–16) he had used it as camouflage to transform his *Seated Man* into the protagonist of Balzac's *Chef-d'œuvre inconnu*.[50]

In Rome Picasso had a different, more Seurat-like objective. By fracturing color, much as he and Braque had fractured form, he hoped to breathe new life and new light into his synthetic cubist paintings. Pointillism would have a permanent place in his arsenal of techniques, but he was apt to use it for decorative effects. The Rome paintings also include elements taken from Juan Gris, whose show at Léonce Rosenberg's had so impressed him the year before. The interlocking silhouettes and hard-edged cubist architecture of Picasso's *Harlequin and Woman with a Necklace* and *Italian Woman* derive from his one and only pupil. Ironically, Gris felt so unsure when dealing with Picasso that he concluded a letter to him "Accept, friend and master, an embrace from your old [friend] who aggravates you,"[51] and yet it was this self-effacing man who had managed to steer cubism out of an impasse that was partly of Picasso's making.

Besides introducing Picasso and Cocteau to the monuments of Rome, Diaghilev insisted on introducing them to some of the pillars of Roman society. Cocteau was eager to make use of the social clout of the impresario as well as that of Philippe Berthelot, the French ambassador and a family friend. He would also follow up on the letters of introduction he had brought from Paris to various *principessas*. Picasso,

on the other hand, tended to be antisocial when working and became even more so after his first experience of Roman high life. Diaghilev had dragged Picasso and Cocteau off to dine at an ostentatious villa on the Via Piemonte, belonging to his old friend and potential backer, the excessively rich, prodigiously extravagant, perversely exhibitionistic Marchesa Casati—a woman whose declared ambition was to be "a living work of art." She also saw herself as a Maecenas and had recently commissioned Massine to choreograph Satie's *Gymnopédies*—in the hope, one can only imagine, that Diaghilev and Massine would put it on.

Luisa Casati was the daughter of a Milanese textile tycoon of Viennese origins, who had died young, leaving Luisa and her sister to share his vast fortune.[52] To make up for being unfashionably tall and skinny, she dramatized herself by ringing her huge mesmerizing eyes with kohl and dilating the pupils with belladonna. To reinforce the Medusa look, she dressed her hair in serpentine coils dyed the color of a blood orange. The Marchesa's clothes were either of utmost fantasy—see-through dresses of gold or silver lamé sewn with diamonds, spike-heeled sandals encrusted with jewels, hats of leopard skin or peacock's tails—or conspicuously minimal. In Venice, where she lived in the palazzo that is now the Peggy Guggenheim Museum, La Casati liked to exercise her borzois or ocelots late at

night in the piazza, naked except for ropes of pearls, a sable wrap, and a mass of makeup. The Marchesa's jewelry was notoriously outré: enamel skulls, lots of "unlucky" black pearls, a tiny functioning incense burner dangling from her little finger. On occasion, *rivières* of diamonds and pearls would give way to a necklace of love bites inflicted by her lover, Gabriele D'Annunzio. A guest who admired a finely chased gold serpent around her neck was taken aback to discover that it wriggled: the Marchesa had drugged and gilded a live snake and tied it in a becoming knot. "She emerges from between the flagstones," Cocteau told Stravinsky, "like the serpent in the terrestial paradise with an apple in her big mouth."[53]

Picasso was astounded by La Casati as well as by her dinner party. Forty years later, he could still recall details: footmen tossing copper filings onto fireplaces at either end of the dining room to turn the flames blue and green; the massive gilded coil of a boa constrictor on a polar-bearskin rug; Luisa's parrot, Abracadabra, on the shoulder of a black Hercules, wearing nothing but a *cache-sexe;* the pair of borzois, one black, one white, that she trailed behind her on

The Marchesa Luisa Casati, 1912. Photograph by Baron Adolph de Meyer. First published in *Camera Work,* no. 40, 1912.

jeweled leashes. Picasso described Luisa's pearl-embroidered dress with its huge ruff as something out of an Elizabethan portrait, except that the neckline plunged below her navel. The other guests included Cocteau, Diaghilev, Massine, a couple of ballerinas, and, to Picasso's delight, the pigtailed Chinese ambassador in mandarin robes. The ambassador's colorful robes inspired the celebrated costume design for the Chinese Conjurer in *Parade,* which Diaghilev would henceforth use as a cover design for the ballet company's programs.

The Marchesa followed up the dinner with invitations to lunch on March 17 and April 2. Contessa Raggi had advised Picasso to avoid such louche company, which would have encouraged him to do the reverse, if he had not had such a prodigious amount of work to do on *Parade.* Whenever possible, he preferred to keep to his studio and have pasta and local cheeses sent in. When he dined out, it was with Olga, if she was not dancing, or musicians and painters associated with the company—Russians like Stravinsky and Bakst, Larionov and Gontcharova; Italians like Balla and Depero. "Roman grandees are art snobs and make a great fuss of Picasso," Cocteau told his mother, "but [Picasso] courteously refuses their advances and shuts himself away in the solitude to which a great master is entitled. I admire him and I despise myself. I try to be better, to destroy everything in me that's demeaning and paltry."[54] This chastened mood was the consequence of a tiff over the poet's failure to hail a cab in the rain. The artist had had enough of Cocteau's self-promotion and frivolity. A good slap from Picasso brought him to his senses.[55]

Cocteau had also infuriated Picasso by deciding that he, too, was going to have "a romance" with one of the dancers. He had picked on Maria Shabelska, who would dance the Little American Girl in *Parade,* and who looked, Cocteau wrote Misia Sert, "like Buster Brown's dog." Shabelska was not fooled—given all the makeup Cocteau wore, there was no way she could be—but "she was willing to continue the 'affair' as a game for the pleasure of her 'lover's' company. . . . The two of them made the joke rather elaborate. Discovery in 'compromising' situations, rumpled sheets, bedaubment of the 'lover's' face and shoulders with ballerina's make-up, as Picasso's were bedaubed by Olga's."[56] In a poem called "Rome" (in which Cocteau fantasizes about stealing a lemon from the Vatican garden and being pursued by the Pope), he sighs over the films—*"Cinéma la dixième muse se lève dans toutes les rues"*—that he and Maria had seen. Nevertheless, Cocteau was finally obliged to confess that the love affair with Shabelska was an act: "My dear little Marie, your hotel room is a month of Marie [the month of May] and a box at the theater."[57] Thirty years would pass before he confessed that the only person he had eyes for in Rome in 1917 was his collaborator, Picasso.[58] His passion for Picasso would last a lifetime.

Massine was delighted with Cocteau's offer to help with *Parade'*s choreography. The poet claimed that he had even learned to dance. And, indeed, Shabelska's solo

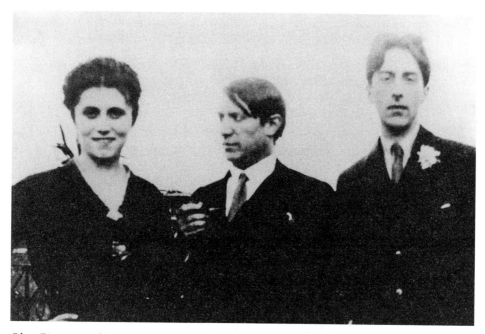

Olga, Picasso, and Jean Cocteau in Rome, 1917. Musée Picasso, Paris.

included many of his suggestions, some of them inspired by Mary Pickford and Pearl White's films. This solo had originally been called *Titanic Rag,* but, for reasons of taste, its title was changed to *Steamboat Rag,* which Satie had adapted from Irving Berlin. To believe Serge Lifar, who succeeded Massine as Diaghilev's lover, "Massine's felicitous touches in *Parade* and subsequent ballets stem directly from Cocteau, with their literary flavor and circus-like stylization. Everything that is now current in ballet was invented by Cocteau for *Parade,* which he knew by heart, and every step of which he had suggested."[59] Lifar's dismissal of Massine contains a tiny nugget of truth.

Picasso's slap had worked. Cocteau claimed that although Roman society was bombarding him with invitations, he was refusing all of them "out of self-discipline and a need to concentrate on work." "The duchesses and princes take me for a savage," he wrote.[60] He had adopted Picasso's excuse—what he called *le ruse du smoking* (the "sorry, no dinner jacket" dodge)[61]—for refusing invitations. The improvement came about too late. Diaghilev had lost patience with Cocteau's avant-garde pretensions and sent him back to Paris, where he was a press officer in the War Ministry. He was told to drum up publicity for *Parade.* Cocteau should have taken Diaghilev's dictum—"In the theater there are no friends"[62]—more seriously. By

whining, he forfeited the respect of the impresario, who would not use him for another seven years, and then for his musical contacts rather than his own mercurial flair.

The mystery as to whether Picasso visited the Sistine Chapel and Raphael's Stanze in the Vatican while he was in Rome was largely of his own making. According to Stravinsky, Cocteau, and Massine, they did, above all Picasso, who was an inveterate museumgoer. (He was particularly struck by Bernini's *Daphne* in the Villa Borghese.) And yet, on his second visit to Rome in 1949, Picasso, whose memory failed him only when he wanted it to, would deny ever having seen the Sistine Chapel.[63]

Of course Picasso had been to the Sistine Chapel.[64] Michel Georges-Michel claimed to have visited the Vatican museums with him the very day he arrived from Paris. The journalist was specific. In the Sistine Chapel they ran into Cocteau's friends, Philippe Berthelot and his wife. They then went on to Raphael's Stanze, where Picasso is supposed to have said, indicating the frescoes with the stem of his pipe, "whatever pleasure I derive from Michelangelo's tormented contours, it is with serenity that I let myself be blown away by Raphael's lines—pure, pure, sure. . . ."[65] This sententious rubbish does not sound like Picasso. Much later he told Kahnweiler: "The Sistine Chapel looks like an enormous drawing by Daumier."[66] Cocteau likewise confirms this visit to the Vatican with Picasso. The poet compared Raphael to Picasso—unfavorably, on the grounds that Raphael had not revolutionized people's perceptions as radically as Picasso had. As for Michelangelo, Cocteau dismissed him as "the futurist of his day . . . an erotomaniac architect," and, in a more Picassian mode, "a marvelous draughtsman but a bad painter."[67] Ansermet, Diaghilev's conductor, claims to have overheard Picasso and Stravinsky discussing the paintings in the Sistine Chapel very enthusiastically.[68]

Picasso's pretense that he had never seen the Sistine Chapel was probably intended to distract attention from his uncharacteristic choice of Raphael as a source—a choice that was embarrassingly academic as well as predictable. As someone who would always see himself as the rebel leader of modern art—a rebel who had overturned everything the Renaissance tradition stood for—Picasso would not have wanted to acknowledge any debt to the founders of this tradition. Two years later, he would paint a response to Raphael's *La donna velata*,[69] presumably to demonstrate that he could do a Raphael as well as Raphael. Whether or not he did so to his own satisfaction is unclear, for he never put the *Italian Woman,* as this painting is known, on the market and apparently never exhibited it.

Much later, in 1968, Picasso would execute a series of wish-fulfilling engravings in

which he depicts a lusty, young Raphael (a surrogate for his lusty, young self) having his way with La Fornarina, palette in one hand, penis in the other, while an elderly pope (a surrogate for his elderly self) gets his kicks by peeping at the lovers from his seat on a chamber pot or his hiding place behind the arras. By 1968 Picasso no longer needed to prove that he was stronger than any other artist.

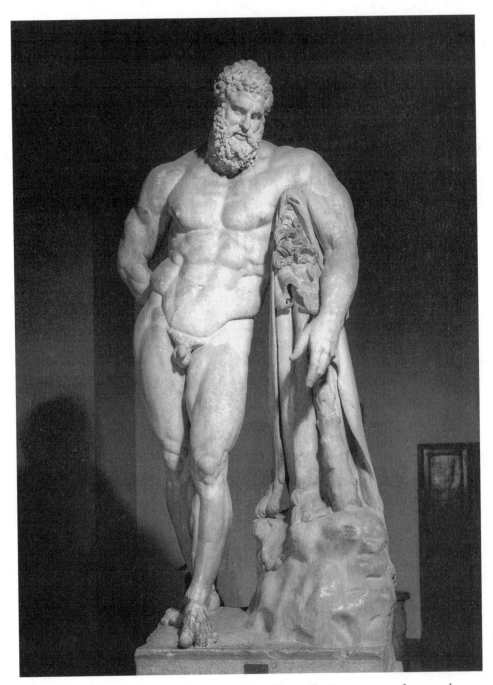

Farnese Hercules, colossal statue from the Baths of Caracalla, Roman copy of a statue by Lysippus, second half of fourth century B.C., ht. 317 cm. Museo Archeologico Nazionale, Naples.

2

Naples

Picasso was not especially interested in an audience with the Pope, but Cocteau had pulled every available string, at his pious mother's insistence, to obtain one. He was turned down. Pope Benedict XV had already blessed Diaghilev's company; also, according to Cocteau, he had better things to do: his bridge game.[1] To make up for this disappointment, Diaghilev took Cocteau, Picasso, and Massine to Naples to stay (March 9–13, 1917) at the Hotel Vesuvio on the waterfront. They spent their days sightseeing. "The Pope is in Rome, God is in Naples," Cocteau told Paul Morand, a worldly, witty writer from the same elegant background as himself.[2] And to his mother he wrote that he could not imagine any other city in the world pleasing him more than Naples. "Antiquity swarms afresh in this Arab Montmartre, this enormous chaotic fairground which never closes. God, food and fornication are the preoccupations of these fantastical people. Vesuvius manufactures the world's clouds. . . . Hyacinths push up through the paving stones. . . . Pompeii did not surprise me at all. I went straight to my house. I had waited a thousand years, before daring to return to this wretched rubble."[3] Cocteau also wrote a little ode to Vesuvius: "an eye-fooler belching smoke / the largest cloud factory in the world / Pompeii closes at four / Naples never closes / NON-STOP PERFORMANCE."[4]

Naples would have a more profound effect on Picasso than Rome. Since he had been raised in two of the Mediterranean's busiest ports, Málaga and Barcelona, he felt very much at home there—more at home than in Rome. There were also historical links to Spain. And then, like Cocteau, he was fascinated by Pompeii; he even inscribed a laurel leaf he had picked up in the ruins: "To my friend Apollinaire, Pompeii, Picasso, 1917,"[5] and mailed it to Paris. Ever the mimic, Cocteau sent his mother a laurel leaf—"from this sad little city."[6] The formal attire—stiff collars, Homburg hats, spats—expected of the men in Diaghilev's entourage did not prevent painter, poet, and dancer from scrambling over the broken columns and rubble of antiquity. Diaghilev had seen it all before and preferred to take his ease in the shade. Massine reported that Cocteau "had brought a camera and took . . . photographs of us all leaning against statues and broken blocks of marble."[7]

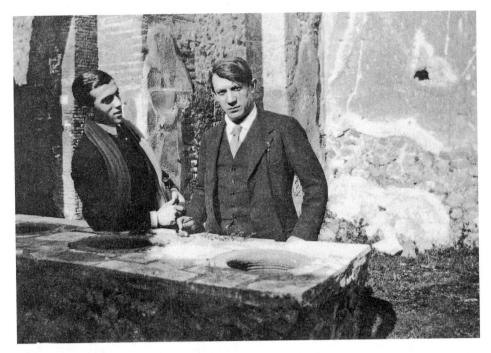

Léonide Massine and Picasso at Pompeii, 1917.

Besides Pompeii, they visited Herculaneum and, to Picasso's delight, the celebrated Naples aquarium. While the others took siestas, Massine would wander off on his own to escape Diaghilev's attentions and explore the narrow streets behind the Piazza Garibaldi. He liked to watch "craftsmen at their work or street sellers displaying their fish and fruit, [performing] their tasks with such high-spirited style . . . and bravura."[8] Previous visits had infected Massine with a passion for Neapolitan culture that would often flavor his work. After breaking with Diaghilev, he even choreographed a ballet called *Pompeii à la Massine* for the British impresario C. B. Cochran's revue *Still Dancing* (1926).

Back in Rome, Diaghilev had to leave for Monte Carlo and Paris to arrange bookings for the company—a logistical nightmare in wartime Europe. Meanwhile, Picasso pursued his courtship of Olga, a rite he had never bothered with in the past. She was busy rehearsing Massine's *Les Femmes de bonne humeur,* a ballet based on an eighteenth-century Venetian play, with a set by Bakst. Massine had looked to futurism and films for inspiration, as well as to the "jerky, flickering movements of the marionettes"[9] he had seen at the Teatro dei Piccoli. Olga had no trouble learning these unfamiliar new movements, which included ideas prompted by Massine's newfound passion for Picasso's cubism.

At the beginning of April, the company returned from a tour of South America. To celebrate this reunion, Diaghilev organized a short season at the Teatro Costanzi, including a couple of charity galas, at the first of which (April 12) *Les Femmes de bonne humeur* would have its premiere. Diaghilev, who sided with the revolutionaries in Russia, found himself in a quandary. Since the Tsar had abdicated and he and his family were under house arrest in Tsarskoe Selo, the impresario felt that the Tsarist national anthem would be inappropriate for his gala. But what to play instead? After reviewing numerous possibilities, Diaghilev and Stravinsky decided on "The Volga Boat Song,"[10] in those days little known outside Russia. Since no orchestration was available, Stravinsky agreed to do one. Time was short. Stravinsky stayed up all night and, with the help of Berners, dictated the orchestration as he composed it to Ansermet. On the title page of Stravinsky's "Volga Boat Song" arrangement, "Picasso painted a red circle as a symbol of the revolution."[11] Until the early 1930s, this seems to have been the one and only inkling of a gesture to the left.

Meeting Stravinsky, who arrived in Rome on April 5, was one of the most lasting consequences of Picasso's Italian trip. They took an instant liking to one another and would remain friends for life. Picasso told Stravinsky that he had little ear for music but an inherent sense of rhythm, and this enabled him to appreciate the achievements of "the greatest rhythmic thinker since Beethoven."[12] Since both artist and composer were recognized in their respective fields and were both in the process of using modernism to regenerate classicism, they found themselves confronting similar problems. The fact that neither Spain nor Russia had undergone a renaissance made their mutual understanding all the more instinctive. Eugenia Errázuriz, most discriminating of women, had instantly spotted these two men as twin peaks of twentieth-century culture. "What a genius," she said of Picasso, when she first met Stravinsky in 1916, "as great as you, *cher maître.*"[13]

Diaghilev's galas were an enormous success in a Rome bereft of foreign entertainment. Eleanora Duse, the most celebrated actress of the day, watched *Les Femmes de bonne humeur* from the wings and came onstage to congratulate the company. Extra performances had to be scheduled. To boost his acquisition of Picasso as a designer and promote his image as a patron of modernism, Diaghilev arranged for the contemporary art collection he was putting together for Massine—it consisted largely of Picassos—to be shown in the foyer of the Teatro Costanzi. This was the first time that Picasso's work had been exhibited in Rome, and it exerted a powerful influence—not all of it good—on local artists.

Sometime in April, Picasso wrote an undated letter to Gertrude Stein, saying that he had begun work on the two canvases (*Harlequin and Woman with a Necklace* and *Italian Woman*), in which he responded—somewhat disappointingly—to the

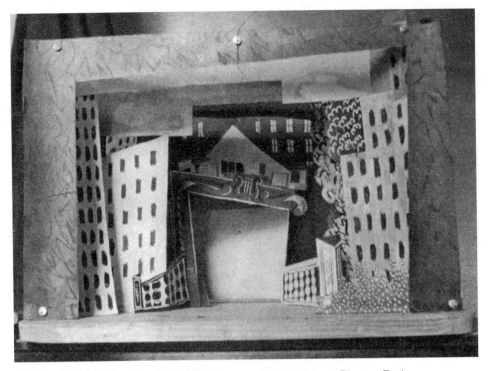

Picasso. Maquette for the set of *Parade* (destroyed), 1917. Musée Picasso, Paris.

impact of Rome. Both paintings have a high finish redolent of both Ingres and Gris, which made their execution lengthier than usual. Picasso also told Gertrude that he was working "all day at my décors and the construction of the costumes," and that the set was to be painted in Rome.[14]

In his libretto Cocteau had initially wanted the set for the little vaudeville theater to be set in Paris, but later decided that it could be any city, "where the choreography of perspectives is inspired not by what moves but by immobile objects, around which one moves, especially by the way buildings turn, combine, stoop, get up again and buckle according to one's walk down a street."[15] The only trouble was that Picasso had never shown much interest in the urban scene. So he set about checking how other artists had portrayed the city, particularly Léger, whose prewar cityscapes and *Contrastes de formes* had so impressed Apollinaire. Picasso's arrangement of diagonally raked buildings against bubble-shaped treetops recalls Léger's urban compositions as well as the text of his celebrated 1913 lecture, "Les Origines de la peinture": "I take the visual effect of trees, the curves and circles moving skyward between the houses. . . . Concentrate your curves with all possible variety but without disconnecting them. Surround them with the hard, dry surfaces of the houses."[16] Picasso also turned to his own previous work for guidance and recycled some of the skyscraperish elements from his great *Seated Man* of the year before.[17]

To prepare the set for Massine as well as the scene painters, Picasso had made a rough-and-ready model theater in which to try out variants on his original idea, some of which incorporate the façade of the Villa Medici. The effect must have been too static, for Picasso went to the opposite extreme and set off a whoosh of futurist movement. He also tried embellishing the proscenium arch with a row of decorative gas lamps borrowed from Seurat's *Parade.* Meanwhile, Cocteau, who was ever anxious to show how protean he was, came up with his own skyscraperish designs, which added nothing to Picasso's maquettes. The artist simply waited for Cocteau to go back to Paris and then had Carlo Socrate, Diaghilev's Roman scene painter, work from his final maquette.

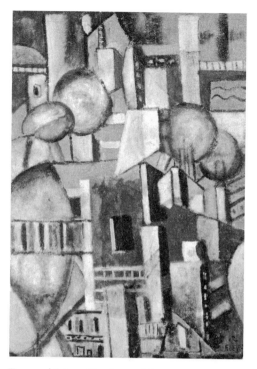

Fernand Léger. *Rooftops of Paris,* 1912. Oil on canvas, 90 x 64 cm. Musée National d'Art Moderne, Centre Georges Pompidou, Paris.

Around April 16, Diaghilev, Massine, and Picasso returned for a slightly longer trip to Naples. This time they were accompanied by Stravinsky and Ansermet instead of bothersome Cocteau. As before, they traveled by train. En route, Picasso accepted a wager: as to whether the wobbling of the train would allow him to do a portrait of Massine in under five minutes. He won the wager and gave the drawing to the sitter.[18] This time, they traveled with the company, which had been engaged for a short season (April 21–23) at Naples's great opera house, the Teatro di San Carlo. The season would be a disaster. The ballets, particularly *Les Femmes de bonne humeur,* received such terrible reviews that the last three of the five scheduled performances had to be canceled.[19]

Once again, the principals stayed at the Hotel Vesuvio. Olga was lodged at the nearby Hotel Victoria with the other dancers, but Picasso did not let that discourage him from whoring, according to notations in one of his sketchbooks: "bordello—via Tomacelli 140" and "the girls of Naples have four arms."[20] Cocteau's biographer describes the interiors of the brothels glittering with candelabras, statues of the Virgin, and gold-plated gramophones.[21] That the brothels were in the Spanish quarter and the whores mostly Spanish delighted Picasso. Ansermet, who was conducting the ballets, rhapsodized about "Napoli the insane. Yellow on a blue sea, mechanical pianos. Balconied bordellos on the street with girls taking footbaths. A cow in the

courtyard. Odor of Spain. Smoke in the sky and burning lava in the body."[22] Stravinsky recounted how he and Picasso were arrested one night for urinating in the Galleria. Stravinsky asked the policeman to take them over to the San Carlo Opera House so that they could be vouched for. When the offenders were addressed as *maestri,* they were let go.[23]

In Naples, as in Rome, the *Parade* trio delighted in popular entertainment, above all the traditional commedia dell'arte performances in the Forcella quarter of the city. These street performances have long been obsolete. However, there are still folk dancing troupes in Naples that keep the tradition alive. Anyone lucky enough to have seen them perform will be astonished by the knockabout violence of the action, the in-your-face obscenity of the clowning, the noise of the yelling, and the down-and-dirty physicality of it all. This is a far cry from the playful harlequinades that Domenico Tiepolo's charming drawings lead one to expect. Picasso and Massine would have felt as if they had been transported back, as I certainly did, to the bawdiness and maenadic mayhem of antiquity—back to the Old Comedy associated with Aristophanes, in which social, sexual, and political satire was presented in the form of farce.[24]

Stravinsky has left a vivid description of an evening "in a crowded little room reeking of garlic. The Pulcinella was a great drunken lout, whose every gesture, and probably every word if I had understood, was obscene."[25] Massine remembered these performances taking place out of doors rather than indoors, in the streets against a backdrop of blue skies and laundry-laden clotheslines hanging between the houses.[26] He persuaded one of the actors to sell him his antique leather mask, which he would always wear for his Pulcinella roles. Massine suggested that they collaborate on a real commedia dell'arte ballet, as opposed to a traditional harlequinade, something that had seldom if ever been tried in a legitimate theater. Diaghilev liked the idea, so did Picasso and Stravinsky. While they were in Naples, they worked on a scenario and did the necessary research in the San Martino Museum.

Today the San Martino Museum, handsomely situated in a seventeenth-century monastery high above the city, is celebrated for its spectacular collection of *presepios,* crèche figures, beloved by tourists. These were of very little interest to Picasso and Massine. What they had come to study was the commedia dell'arte material—Pulcinella masks, marionettes, and other such items of Neapolitan popular culture—which had been assembled by a curator obsessed by the subject. Nowadays, the San Martino Museum displays virtually none of this bygone treasure. Upstaged by the *presepios,* the more humble artifacts have been thrown into bins and left to rot in dusty storerooms. (When I visited the museum in 2000, restorers had just started work on the life-size Pulcinella figures depicted on a postcard that Picasso bought at the museum.[27] As I watched, the restorers undressed Tartaglia the Stammerer and

found that his straw shoulder had been eaten by a rat, which turned up mummified in the stuffing.)

On his visit to the San Martino Museum, Picasso bought photographs of watercolor scenes of Neapolitan life by the nineteenth-century illustrator Achille Vianelli. After Picasso's death, they were discovered tucked into an Italian sketchbook.[28] Vianelli's tavern scene with Vesuvius in the background bears such a striking resemblance to the central section of *Parade*'s *rideau rouge* that it is often cited as the inspiration of Picasso's composition. However, the artist had settled on his design months before he left for Italy. He presumably bought the photographs because one of Vianelli's watercolors was similar to his backstage scene.

Other souvenirs of Picasso's Neapolitan trip were an antique Pulcinella mask (like Massine's) and a couple of commedia dell'arte puppets, which would end up on top of Olga's piano. These items would be of help in 1920, when Picasso started work on *Pulcinella,* the commedia dell'arte ballet that Naples had inspired. According to Stravinsky, he and Picasso also bought some of the stylized gouaches of the Bay of Naples and Vesuvius, which local hacks had been churning out for tourists ever since the eighteenth century. None of them has surfaced in the artist's estate, but their formulaic style—so formulaic they look stenciled—left its mark on the crisp, stencil-like gouaches of Harlequins that Picasso would do over the next few years.

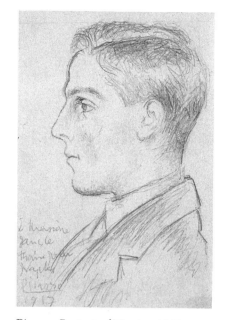

Picasso. *Portrait of Massine,* 1917. Graphite on cream wove paper, 17 x 11.4 cm. The Art Institute of Chicago. Given in memory of Charles Barnett Goodspeed by Mrs. Charles B. Goodspeed.

Phallic doodles in his Neapolitan sketchbook and a letter to Gertrude Stein about his "Pompeiian drawings, which are a bit improper,"[29] reveal that Picasso visited the Museo Nazionale's Gabinetto Segreto, where most of the erotic items from Pompeii and Herculaneum are stored. To view these items, visitors required special permission easily obtainable from venal guides. In the mid-1950s, when Picasso gave Barbara Bagenal, the British critic Clive Bell's mistress, one of these "improper" drawings for Christmas, he confirmed that the subjects had been suggested by the erotic frescoes in Naples. By comparison with the ithyphallic fantasies Picasso would do in 1927, these drawings are anything but shocking. They are inspired by wall paintings of Apollonian couplings, Bacchic revels, and the like, which were a standard feature of Roman villas, much as Tiepolo's frescoes would be in *ottocento* Venetian villas. Their purpose was primarily decorative or numinous; and their subjects, erotic or not, were mostly taken from Ovid. Besides prompting Picasso and Cocteau to come up with conceptual drawings of their friends' penises—inspired by

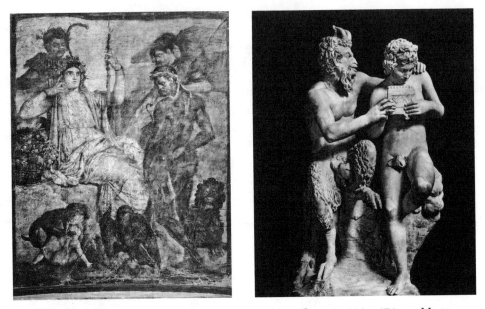

Left: *Hercules and Telephos*, c. A.D. 75. Fresco from Herculaneum, 202 x 171 cm. Museo Archeologico Nazionale, Naples.
Right: *Pan and Olympus,* second half of third century B.C. Hellenistic sculpture, ht. 158 cm. Museo Archeologico Nazionale, Naples.

a dream, Picasso attributed a curlicue *pistolet* to André Lhote[30]—the Gabinetto's phallic pendants, embellished with wings and bells and arms and legs, would have little effect on his work.[31]

For Picasso, far and away the greatest revelation of Naples was the incomparable Farnese collection of monumental Greek and Roman sculptures, which are the principal glory of the Museo Nazionale. The influence of these marbles would take three years or more to percolate fully into Picasso's work. Signs that their three-dimensional monumentality would alternate with the flatness of synthetic cubism first occur in his 1920 figure paintings. From then on the gigantism of the Farnese marbles will make itself felt in the increasingly sculptural look of his paintings as well as in his actual sculptures. Indeed, one might say that Picasso's rebirth as a great sculptor was a direct consequence of the revelation of the Farnese galleries. The marbles would give Picasso back the sense of scale that cubism had denied him by limiting the image to the size of the subject. They would classicize his work far more effectively than the antiquities he had studied in the Louvre. And they would embody the sacred fire—in this case the sacred fire of Olympus—for which he was always searching.

Of all the Farnese marbles, it was the celebrated Hercules—a Roman copy of a sculpture (second half of the fourth century B.C.) attributed to the Greek Lysippus—that left the most lasting mark on Picasso's development, above all on his sense of gigantism.[32] The sheer size of the Hercules, which looms over the other colossi in

the main Farnese gallery, overwhelmed Picasso; he was particularly fascinated by the subtle adjustments of scale—the enlargement of eyelids and fingers and the widening of the bridge of the nose—which had enabled the sculptor to endow his figure with such monumentality and yet such character and pathos. Füseli's pronouncement that "gigantism lies in the disproportion of the parts" could not be more Picassian. "Disproportion of the parts" would be a recurrent feature of even the smallest of his neoclassical images. Confirmation of his

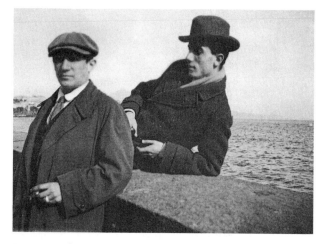

Picasso and Massine in Naples, 1917. Photograph probably taken by Cocteau.

skill at manipulating scale, Picasso said, came about when a very large truck arrived to pick up a very small bather painting.[33] The shipper knew the image but had not checked the size.

Whether or not Picasso's own shortness played a part in his obsession with the Farnese Hercules, there can be no question about his identification with the hero's pensive head, bowed down by the sheer weight of his legendary power. The self-referential figure of a bearded sculptor in Picasso's engravings of the late 1920s and early 1930s has the same preoccupied expression. In these engravings, Picasso would see himself not only as the sculptor but also, on occasion, the model, and also the resultant piece of sculpture.

Picasso would draw repeatedly on two other sculptures in the Museo Nazionale collection: one for his women, one for his men. For his women he chose the so-called Farnese Hera, a Roman copy of a fifth-century Greek Artemis. Some of the large classical heads that Picasso did in pastel at Fontainebleau (1921) have exactly the same neckline as this bust.[34] They are also similar in scale. For his ephebes he used the head of the famous Farnese Antinous. Over the years, these exemplars would be absorbed into Picasso's imagery and become generic types, just as they had done for earlier neoclassicists. Oddly enough, none of the photographs of the sculptures from which he worked has surfaced in Picasso's archive, leaving one to wonder whether this inveterate hoarder might have destroyed the evidence of his appropriations.

Picasso returned to Rome around April 22 and stayed there a week or so. Every other day, a long, comically plaintive letter would arrive from Cocteau. He was furious at being back in freezing Paris—*me voici dans mon aquarium glacial*"[35]—

furious at having his press releases and other promotional "texts" for *Parade* turned down by "that hippopotamus of the Volga," Diaghilev. To his dismay, Cocteau had discovered that Diaghilev had employed the mischief-making Michel Georges-Michel as his Roman spokesman. In this capacity, he had sent Maurice de Brunoff, who printed the Ballets' programs, a peremptory cable, "REFUSE ANY TEXTS OR DRAWINGS BY COCTEAU."[36] Besides pressuring Picasso to take his side against this treacherous underling, Cocteau's letters are full of messages to his beloved Maria Shabelska.

On April 28 or 29, Picasso left Rome to join Olga and the rest of the company in Florence, where they were to give a single evening performance on Monday, April 30, at the Teatro Massimo. Olga danced in three of the five ballets on the program. Cocteau told Paul Morand that the performance had been a failure and that the audience cried *"Basta! Basta!"* Believing that they were applauding him, Bakst had taken a curtain call; the more they jeered, the more he bowed.[37] In the entr'acte at the Teatro Massimo, Picasso was introduced to a seventeen-year-old painter, Primo Conti, whom Alberto Magnelli and the Florentine futurists were championing. Conti wanted to show Picasso a collage and was brought to his box (shared with Larionov, Magnelli, and the futurists Palazzeschi and Antonio Bruno). "So you too are a prodigy," Picasso said to him. This prodigy failed to fulfill his futurist promise.

Picasso was taken on a tour of Florence by Magnelli,[38] who had been marginally involved with Balla in the preparations for *Parade.* Together they visited museums, churches, and palaces. Magnelli does not specify what interested Picasso beyond mentioning "primitives," presumably in the Uffizi, and the Michelangelo sculptures of *Night* and *Day* in the Medici Chapel, which would later leave their mark on his work. Magnelli also took him to his studio, where he was obliged to admire this artist's latest "explosions lyriques." What, one wonders, would Picasso have felt had he known that a permanent display of this artist's bland work would one day be housed in the same complex as his Temple de la Paix at Vallauris.

The revolution had deprived Olga of a valid passport, so she had to make the trip back to Paris with the rest of the dancers on a group visa. Picasso had been away in Italy for no more than ten weeks, but in those ten weeks his social map had changed out of all recognition. Over the next year, everything else in his life, but most importantly his style, would assume a new pattern. Eighteen years would go by before he returned to his Bohemian roots.

3

Parade

Picasso arrived in Paris on May 3, 1917, and returned to his dreary villa in suburban Montrouge. Olga, whose propriety obliged her to live under a separate roof, moved into a suite at the Hôtel Lutétia. After a three-month absence, Picasso was eager to catch up with old friends, above all Apollinaire. Though still suffering from his head wound, "L'Enchanteur," as he was sometimes known, was allowed to leave the hospital during the day to help in the censor's office. The previous fall, Apollinaire had understandably been hurt by Picasso's decision to work with the pushy, would-be modernist, Cocteau, when he—the closest friend Picasso would ever have—was in hospital recovering from his trepanation.

In December 1916, Apollinaire had written to Picasso suggesting that they get together and discuss "our characters, our griefs, in a word our friendship. . . . My feelings for you are alive, but there are places where they bleed."[1] They had gotten together and by the time Picasso left for Rome, they were reconciled. Now that he was back in Paris, all was forgiven and forgotten. Far from showing any animosity, the ailing poet was now prepared to put up with Cocteau, the ambitious upstart who, as he surely knew, was out to replace him.

While in Rome, Picasso had received a letter from Apollinaire (March 22, 1917)[2] suggesting that they collaborate on a project that had first been mooted in 1910: an illustrated edition of a short story by Cervantes, "The Scholar Made of Glass." (This delightful story tells how a shy peasant scholar is given a love potion by an amorous grandee; the potion leaves the scholar convinced that he is made of glass; he allows no one to touch him and travels around on a donkey, packed in straw like a bottle.)[3]

Picasso wrote back to Apollinaire "on behalf of Diaghilev" asking him to write something for the ballet company; he also confirmed that he would do the Cervantes book. Apollinaire went on to request two engravings for a book of recent poems, *Vitam impendere amori.* Picasso agreed to both these suggestions but in the end did neither. The poet André Rouveyre did the illustrations instead. However, Apollinaire came up with the essay for the program that Diaghilev had asked him to do.[4] Picasso wanted Apollinaire's essay to promote his views rather than Cocteau's; and to the

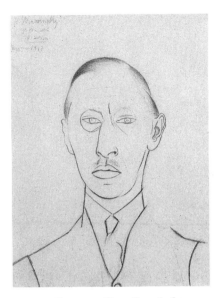

Picasso. *Portrait of Igor Stravinsky,*
1917. Pencil on paper, 27 x 21 cm.
Private collection.

extent that it included a new word, "sur-realism," it ful-
filled its role. Picasso claimed to have had a hand in invent-
ing this word, but a letter to Paul Dermée suggests that
Apollinaire had asked other friends to decide whether the
word should be "sur-realism" or "super-realism."[5]

On returning to Paris, Picasso had gotten in touch with
Gris, who reported to Léonce Rosenberg that he was find-
ing the milieu of the Ballets Russes "a little depressing for
an artist. . . . Too many beautiful women, too many jew-
els. . . . Long live the studio and clothes splashed with
paint!"[6] In his eagerness to identify with "clothes splashed
with paint," Picasso agreed to attend a dinner in his honor
after the opening of *Parade,* to be given by Max Jacob, the
Grises, the Henri Laurenses, the Lipchitzes, and other old
and new Montparnasse friends. He would come to regret
his acceptance.

Even if Picasso had envisaged returning to Bohemia,
Olga would never have fitted in. She wanted to be a glamorous ballerina married to
a charismatic celebrity fêted by the beau monde. As a descendent of a once noble
family that had come down in the world he was willing to satisfy Olga's aspirations;
and Diaghilev's backer, the manipulative Misia Edwards, was all too ready to launch
Olga in the treacherous waters of Parisian society.

Misia, who appears in Proust's great novel as Princess Yourbeletieff—"the youth-
ful sponsor of all these new great men"[7]—was Polish but had spent her early years in
St. Petersburg and spoke fluent Russian. She welcomed the Russian Revolution as
"an immense ballet," which would bring Diaghilev to power as minister of culture
and the rest of his clan, "Gorky, Argoutinsky, Benois and Bakst to top positions."[8]
Although the future Madame Picasso deplored the revolution, she took a liking to
the future Madame Sert. Misia would be a witness at the Picassos' wedding and god-
mother to their son. However, for all her panache, Misia was famously dangerous.
Known to Cocteau and others as "Tante Brutus" for her backstabbing proclivities,
she made a show of being nice to Olga but later admitted to Picasso that she was "the
most *emmerdante* and . . . boring woman" she had ever known.[9] And then, unex-
pectedly, when Picasso wanted a divorce in 1936, Misia, who had recently lost her
third husband to her closest friend, was the only one of his circle to speak up for
Olga in court.

Tante Brutus, also known as Tante Tue-Tout, had reason to befriend Olga; she was
determined to add Picasso to her pantheon: Renoir, Toulouse-Lautrec, Vuillard, Bon-
nard, Félix Vallotton, all of whom had painted major portraits of her. Now that she

was a celebrity, Misia expected Picasso to come up with another gratifying image of her and sent him photographs to work from.[10] Picasso did indeed paint Misia, but instead of the Ingresque tribute to her belle époque charms that she had hoped for, he made a cubist mockery of her prognathous jaw, mean little mouth, brioche-shaped coiffure, and pearls the size of ping-pong balls.[11] I doubt if he showed Misia the portrait. It was never published in Picasso's lifetime and is identified here for the first time.

Picasso seems not to have introduced his Russian fiancée to a couple of Russian patrons of art and literature—Serge Férat and his "sister" Baroness Hélène d'Oettingen[12]—who had formerly been a close friend. Olga is unlikely to have warmed to this raffish *grande amoureuse,* who had entertained both high and low Bohemia in her lavish apartment, or to her so-called brother—in fact an ex-lover—who had been the on-and-off keeper of Picasso's former fiancée, Irène Lagut. Picasso would not have wanted Olga to meet any of the participants in

Picasso. *Portrait of Misia Sert,* 1918. Oil on canvas, 64.5 x 46 cm. Private collection.

the farcical events, which had resulted in Irène breaking off her engagement to him and returning to Férat.[13]

As for Picasso's elderly, Chilean mother figure, Eugenia Errázuriz, she had already met Olga in Madrid and could be counted on to be supportive. However, in her love for the man as well as the artist, she would not have thought any woman good enough for him and had no intention of relinquishing her maternal hold on him. Nor had Picasso any intention of breaking with this patron, who understood him and his work better than any other woman. Also, Eugenia was exceedingly generous. By the end of the war, she was sending Picasso and Stravinsky a thousand francs a month, as well as care packages of tobacco. Eugenia would insist that Olga and Picasso spend their three-month-long honeymoon with her at Biarritz: a sojourn that would delight the husband but leave the wife wary of accepting further invitations to stay with this

benevolent tyrant. Besides presiding over the beginning of their marriage, Eugenia would preside over the end of it. When the Picassos broke up in 1935, this frail, iron-willed seventy-five-year-old grande dame, whose extravagant patronage had left her impoverished, moved into the rue la Boétie to look after him.

Encouraged by Satie, Picasso had deleted many of Cocteau's more egregious gimmicks from his original *Parade* libretto. He had also made crucial additions: three gigantic Managers—"shills" would be a more accurate term—and the famous *rideau rouge;* these additions stamped the ballet as more Picasso's than Cocteau's. Originally three Managers had been envisaged; Cocteau wanted all of them to be Negroes. Picasso insisted on diversity: a mustachioed French one with a pipe, a starched shirt front, and a walking stick (Diaghilev?) an American one with a megaphone and a papier-mâché skyscraper sprouting from his shoulders—a reprise of his skyscraper-like *Seated Man* of 1915–16—and a third one in the form of a Negro minstrel astride a canvas horse played by two dancers. According to Grigoriev: "The dancers detested these costumes, which were a torture to move about in. . . . they, too, had to do a lot of stamping, which was intended to suggest conversations between them . . . a relic of the fascination exercised over Diaghilev by pure rhythm divorced from music."[14]

The addition of a dummy Manager to the back of the "Horse" proved unwieldy; it kept falling off and had to be jettisoned. The Horse remained and brought the house down with his solo. Picasso's sketches reveal that the black Manager was originally to be a sandwich man.[15] Maybe the inspiration for this was Géry Pieret, Apollinaire's former secretary-companion and nemesis, responsible for the poet's arrest and Picasso's questioning by the Sûreté in 1911. After returning from the Wild West, Pieret had proposed to gallop around Paris with sandwich boards on his back advertising Bostock's Circus.[16] A sketch of the sandwich man mounted on a pig conveys Picasso's feelings about Pieret.[17] Another of the sandwich-man drawings makes scurrilous fun of Misia.[18]

Satie may have also had a hand in the concept of these eight-foot Managers. They are caricatures of the uncouth giants Fafner and Fasolt, the builders of Valhalla in Wagner's *Ring*—a work the composer abhorred. Satie had pilloried Wagner once before and would do so again in his and Picasso's next masterpiece, *Mercure.*[19] As he told Debussy apropos Wagner's famous motifs, "there is no need for the orchestra to grimace each time a character comes on the stage."[20] Although Picasso's giants upstaged his gimmicks, Cocteau realized that they added badly needed ballast to the concept of *Parade.* Their stamping and stomping mimicked the roar of war and reduced Cocteau's little cast to "the stature of puppets or playing cards."[21] The inter-

Picasso. Costumes for French Manager, Circus Horse, and American Manager from *Parade,* 1917. Musée Picasso, Paris.

play between these realistic performers and the unrealistic Managers set up a disorienting dynamic, for which Apollinaire's new word, "sur-realist," was a perfect match.

Picasso's other all-important contribution to *Parade* was the *rideau rouge:* something for the audience to focus on while listening to the overture, described by Satie as "very meditative, very solemn, and even a bit dull,"[22] the better to make the Managers' irruption onto the stage all the more of a shock. Cocteau wanted the curtain to mimick movie credits and be emblazoned with the stars' names.[23] Once again, Picasso would have none of it. He wanted his *rideau rouge* to portray backstage as if it were onstage and insisted on an updated allegorical version of his 1905 *Saltimbanques* painting.[24] The curtain was the first thing Picasso tackled after signing his contract. Long before leaving for Rome, he had completed a maquette[25] that corresponds in most respects to the actual curtain. He executed the final design in Rome, but it was lost or destroyed after being squared up in the scene-painting studio that Diaghilev used in Paris.

Because time was short—only two weeks between his return from Rome and the premiere—and Carlo Socrate, Diaghilev's scene painter, arrived very late, Picasso

supposedly had to begin work on the huge 10-x-17-meter curtain himself. He had to climb up and down a very tall ladder, similar to the one in the curtain, in order to gauge the general effect from a distance. Picasso is said by Massine to have taken great trouble over the curtain: "while his assistants . . . [used] large brushes, he meticulously painted in the details himself with a small toothbrush."[26] This was not corroborated by the artist. A year or two later, when Diaghilev asked Vladimir Polunin—the Russian-born, London-based scene painter who would work on *Tricorne*—to restore the delicate tempera curtain, Picasso denied any responsibility. He stated: "that the [curtain], hurriedly painted by someone in Paris, was unsatisfactory, that it required to be repainted before almost every performance. The black tones so damaged the white ones, and vice versa, that instead of clearly defined black and white surfaces, there remained only patches of nondescript colour."[27] Polunin turned down the job. In recent years the curtain has been restored, but it is only a shadow of what it must once have been. Theatrical lighting might bring some life back to it. Picasso would have taken that factor into consideration.

Like his symbolist *Saltimbanques* evocation of Bateau Lavoir Bohemianism, the *rideau rouge* situates his strolling players, painters, and poets in a whole other world of the spirit. Both works conform to Picasso's father's old-fashioned precept that a young artist should envision his career as a sequence of important compositions, which would win him fame and fortune at the Salons. Where the *rideau rouge* differs from the symbolist *Saltimbanques* with his elegaic Le Nain-like mood is in its irony and *art populaire* look. In the *Parade* curtain Picasso evokes the corniness of the little vaudeville theater in Rome he had visited with Berners. "A skillful parody of popular scene painting"[28] is how Alfred Barr characterized it.

Whereas the *Saltimbanques* had been conceived as a symbolist manifesto, *Parade*'s *rideau rouge* was intended to reassure the public that far from being pro-German or pro-Bolshevik or a *fumiste,* Picasso was not an iconoclast, as chauvinist philistines had maintained during the war. It was also intended to prepare the audience for the shock of the thundering Managers. He realized that a spectacular manifestation in a prestigious theater could win him a wider audience and promote his image more effectively than any gallery show. Picasso had another problem. Parisians were more familiar with his name than his work. And no wonder, there had not been an exhibit of his work since 1910. Fearful that the pioneer achievements of his cubist artists[29] would be contaminated by being lumped together with the work of "copycat" cubists,[30] Kahnweiler, his former dealer, had never allowed any of them to exhibit either at his gallery or at the Salons.

Cocteau always insisted that the plot of *Parade* could not have been simpler. He had merely followed Larousse's definition of the word: "a comic act, put on at the entrance of a traveling theater to attract a crowd," and then asked himself what would happen if the "parade" *failed* to attract a crowd? What if they mistook the "parade" for the actual performance and drifted away, abandoning the players to their fate? This would transform an ephemeral incident into an ironical metaphor of rejection. The simplicity of the original idea is what attracted Picasso, but Cocteau insisted on overdecorating his metaphor with flashy modernistic frills. Picasso and Satie threw out as much as they could, but that did not stop Cocteau from boasting that his libretto could be interpreted metaphysically, aesthetically, even politically. Cocteau's pretensions would earn him the undying contempt of the emerging dadaists and future surrealists, who were taking over the avant-garde and intent on keeping him out.

Just as writers like to identify Picasso's *Saltimbanques* as members of his *tertulia* (intimate group of male friends), people have tried to stick name tags onto the *rideau rouge* figures:[31] members of the ballet company, relaxing backstage in costume or rehearsal clothes. Apart from allegorical references to Massine, Olga, and himself, the only other figure who may stand for a specific person is the mustachioed sailor in blue. He resembles Carlo Socrate, the scene painter whom Picasso liked, although his late arrival put the curtain at risk. The Mallorquín woman in a conical hat is an interloper—a survivor from the *Saltimbanques* painting—which may explain why Picasso sets her against a white canvas, a picture within a picture. The turbaned Arab is also an interloper from Diaghilev's biggest hit, *Schéhérazade,* whose set décor Picasso somewhat surprisingly admired. The Arab stands for the black slave originally played by Nijinsky, and thus symbolizes the company's past glories and, possibly, Picasso's promotion over the head of the no longer fashionable Bakst.

The so-called torero is not a torero. The big hat, the beard, the guitar, above all the cross-gartering identify him as a folk dancer, possibly Massine, who was always at pains to conceal the way he padded out his disappointing legs—hence the cross-gartering. Palau sees the winged mare as what he chooses to call "Pegasso," who had "returned from Rome at full gallop, his wings outstretched and a girl on his back."[32] Pegasus is more likely to be a symbol of Picasso's lifelong pacifism. Remember he was working on the *rideau rouge* maquettes at a time when World War I had reached its nadir. Both sides were bogged down in blood and mud. Casualties numbered hundreds of thousands, mutinies were breaking out on the Western Front, and Russia was in the throes of revolution. The death toll was once again on the rise. Picasso's winged mare suckling a piebald foal on the curtain would be followed thirty-five

years later by another parable of peace. To exorcise the Korean War, what else did Picasso choose for the centerpiece of his huge paean to peace on the walls of Vallauris chapel but a very similar Pegasus, this time a male one with outspread wings, harnessed to a plow, handled by a child.

At first Picasso had seen himself as a monkey perched on the back of Pegasus,[33] while a stagehand on a ladder, hoists a cardboard sun into position. In subsequent drawings, he transforms himself into a laurel-wreathed monkey scampering up the ladder—painted red, white, and blue in the hope of appeasing belligerent chauvinists in the audience—to reach for the heavens above.[34] In the course of his climb, Picasso's simian alter ego gets a helping hand from a reddish-haired dancer in a tutu, Olga, who has taken the monkey's place on the back of the Pegasus and is poised to join the artist at the heart of his cosmology, as represented by the zodiacal sphere that lies at Pegasus's feet.[35] As well as evoking his fiancée, the figure evokes Picasso's first love, Rosita del Oro, an equestrienne who had become his mistress when he was fifteen. A star of the Tivoli Equestrian Circus, this wasp-waisted, big-bosomed bareback rider lingered in the artist's memory shortly before he died; Rosita reappeared alongside images of Picasso as a very old, very small clown in many wish-fulfilling autobiographical fantasies.[36]

The gala opening of *Parade* took place on May 18, 1917, at the celebrated Théâtre du Châtelet, the scene of many of Diaghilev's former triumphs. Due to the blackout, the performance was scheduled for three-thirty in the afternoon rather than the evening. Since the gala benefited the French Red Cross and other worthy causes,[37] the audience consisted largely of generous supporters of the charities in question rather than of modern art. To neutralize militant chauvinists and other possible troublemakers, Diaghilev had "papered" the cheaper seats of the house with wounded Allied soldiers, many of them Russian. He had also invited key members of the avant-garde: Apollinaire, Gris, Lipchitz, Miró, Laurens, Kisling, Valentine Gross, Max Jacob, Pierre Albert-Birot, Cendrars, E. E. Cummings, as well as the composers Georges Auric, Francis Poulenc, Ricardo Viñes, Germaine Tailleferre, and Louis Durey.

The older generation was represented by Misia's celebrated friends, Debussy and Renoir.[38] Debussy was dismayed. Poulenc describes him leaving the auditorium as if "at the gates of death," murmuring "Perhaps! Perhaps! But I'm already too far away from all that."[39] He had reason to be upset. Satie, who had been one of his closest associates, had recently taken a public stand against the musical impressionism that Debussy personified. Feeling betrayed, the great man did not congratulate him on *Parade,* whereupon Satie fired off one of his poisonous letters, which would

cause Debussy much sorrow in his last year of life. The cultural divide between the two composers, or rather between Debussy's romantic fin de siècle impressionism and Satie's radical twentieth-century "cool," was as nothing compared to the more brutal divide between "the left, who thought Cocteau a reactionary arriviste and imposter, and the right, who thought Satie a charlatan and Picasso a crook."[40]

Diaghilev, Misia, and Cocteau had seen to it that their friends from the *gratin* (high society) were also well represented. The Amazonian American Princess Edmond de Polignac—a Singer sewing machine heiress, celebrated as much for her generous patronage of modern music as her autocratic stinginess—was much in evidence, dressed severely in a nurse's uniform. The Countesses de Chevigné and Greffuhle (together the inspiration of Proust's Duchesse de Guermantes), the Count and Countess Etienne de Beaumont (the inspiration of Radiguet's *Bal du Comte Orgel*) were there at the behest of Cocteau. Many more of their ilk attended because it was the thing to do. Proust, ever curious, made an appearance and, as was his way, sent Cocteau an exquisite letter of congratulation, ending with the observation, *"comme Picasso est beau!"*[41]

As usual, when Diaghilev had an important opening, Misia dominated the proceedings as if, Cocteau said, she were "marrying off a daughter."[42] At the side of this woman who had done her best to sabotage *Parade*[43] was her lover, José María Sert, also her latest crush, the innovative couturière, Gabrielle Chanel. The occasion signaled Chanel's acceptance by the beau monde. Hitherto, this dressmaker of genius had been snubbed by snobs, particularly by Picasso's admirer, the far from kindly Etienne de Beaumont, whose taste for revolutionary art and music did not preclude a refusal to receive "people in trade." Chanel would become a close friend of Picasso's. In 1921, when his apartment was closed for the summer, she lodged him in her palatial apartment, and they are said to have had an affair. Chanel was already Olga's favorite couturière. "Olga . . . had many new robes from Chanel to show," Stravinsky reports.[44] Having fallen desperately in love with Chanel, he was well placed to know.

According to a drawing[45] by Michel Georges-Michel, Misia's box included Picasso, Diaghilev, Cocteau, and Marie Laurencin. In fact Marie Laurencin was in Spain; and Picasso had his own box, but was mostly backstage painting arabesques onto the costume he had had to improvise for Lopokova after Massine had made a last-minute decision to provide the male Acrobat with a partner.[46] Lopokova giggled to a friend that Picasso had tickled her nipples with his brush[47]—an act he would replicate in the early-1960s *Painter and Model* series. Olga was also backstage, preparing to go on in *Les Sylphides* later in the program. Meanwhile, Satie wandered around. When hissing broke out, he was seen to join in. He then went to Picasso's box, where Apollinaire stood out dramatically, his wounded head bandaged in

black. He and Pierre Albert-Birot (poet, painter, and founder of the new magazine *SIC*) had been asked to lead the claque. So dense was the crowd in the foyer that the artist had to shout out "Picasso, Picasso," as if the celebrity was ahead of him in order to clear the way. While doing so, he stumbled on Matisse: "Ah! How happy I am to meet a real friend in such circumstances."[48] Happy or not, the old rivalry would start up once again when Matisse was commissioned to do the décor for *The Song of the Nightingale.*

The first performance left Cocteau consumed with envy. Picasso and Satie were perceived as the stars; Cocteau had been eclipsed. Apollinaire mentioned him only in passing and reserved his plaudits for Satie's "astonishingly expressive music, so clear and simple that it [reflects] the marvelously lucid spirit of France," and for Massine's success at "adapting himself . . . to the discipline of Picasso's art."[49] "[Massine] has produced something totally new—a marvelously appealing kind of dance, so true, so lyrical, so human and so joyful."[50] So upset was Cocteau that he fired off a plaintive letter to Apollinaire: "If even a man like yourself cannot fathom my depths, no one will succeed in doing so."[51] In his quest for stardom, Cocteau had failed to make allowances for "L'Enchanteur's" concern with his own glory. Apollinaire was fearful that *Parade* might overshadow his more modest but intrinsically more sur-realist play, *Les Mamelles de Tirésias* (Tiresias's Teats), which was due to open a month later. Indeed, Apollinaire had been so worried about its reception that he had asked Satie to do a score for it; and to silence Cocteau's bitchery he had him contribute a poem, "Zèbre," to the play's text.

The theme of Apollinaire's hilarious farce—his last major work—was androgyny. Picasso greatly enjoyed it, and would draw upon the theme, ten years later, when he began work on a monument to Apollinaire. *Les Mamelles de Tirésias* is set in Zanzibar; its protagonist, Thérèse, declares herself a liberated woman, who would rather fight battles than give birth. She becomes Tiresias, grows a beard and, instead of burning her bra, as later feminists would, she unbuttons her blouse and unleashes two balloons—one red, one blue—which she pops with her cigarette lighter. "I'm virile as the devil," she announces through a megaphone. "I'm a stallion / From my head to my heels / Look at me. I'm a bull. . . . As for my husband, he is much less virile than I." While the wife becomes a macho man, the husband turns into a woman and gives birth to 40,049 babies. Eventually, the two of them resume their original genders and settle back together again as man and wife.

To describe his lyrical approach to art and literature—indeed to the whole creative field—Apollinaire had been searching for a magic word. As we have seen this word first appeared in his *Parade* essay, where it is hyphenated: *sur-réalisme.* On its second appearance, a month later, as the subtitle *(Drame surréaliste)* of *Les Mamelles de Tirésias,* it is not hyphenated. However, hyphenated or not the word, as used by

Left: Picasso. *Portrait of Guillaume Apollinaire with Head Bandaged,* 1916. Pencil on paper, 29.7 x 22.5 cm. Musée Picasso, Paris.
Right: Guillaume Apollinaire in Paul Guillaume's apartment (photograph inscribed to André Breton), and Adolph Basler on the left, 1916. Musée de l'Orangerie, Paris.

Apollinaire, would correspond to Picasso's concept of it. The meaning that Breton eventually imposed on it was a very different matter.

Back to opening night of *Parade* and Cocteau's dramatically distorted account of it: "The audience wanted to kill us, women rushed at us armed with hatpins. We were saved by Apollinaire because his head was bandaged, he was in uniform and . . . set himself in front of us like a rampart."[52] Cocteau went on to boast that "the cries of a bayonette charge in Flanders . . . were nothing compared to what happened that night at the Châtelet theater."[53] *Parade* coincided with one of the blackest episodes of the war, the horrendous carnage—the French lost 140,000 soldiers in two weeks—caused by General Nivelle's senseless advance, which had sparked a flash fire of mutinies on the Western Front. Since Cocteau had used powerful friends to have himself invalided out of the army in the face of battle, the statement that *Parade* was "the greatest battle of the war"[54] infuriated anyone who had suffered in the trenches.

Maria Shabelska as the Little American Girl in *Parade,* 1917. Musée Picasso, Paris.

The only performer to be seriously booed was Cocteau's "girlfriend," Shabelska, who played the part of the Little American Girl: a *dactylo* who had to dance a cakewalk, crank up a car, ride a bicycle, box, mimic Charlie Chaplin, fire a pistol, and other items from Cocteau's bag of tricks. Shabelska burst into tears in the wings and had to be forced back onstage by Massine. Apart from this resounding rejection of Cocteau's gimmickry, the performance was relatively uneventful compared with the violence of dadaist evenings to come. Juan Gris reported that "*Parade* had quite a lot of success, although a group was organized to boo it—boo cubism that is—but applause prevailed."[55] Paul Morand, who was very close to Cocteau and fairly close to Picasso, thought that the idea of replacing balletic clichés with the movements and noises of modern life did not work. "Some whistling, but much applause," he said.[56] Metzinger saw the event historically: "the first time cubism has had to face the crowd. Just enough whistles to add a dash of vinegar to the well-nourished thunder of applause."[57]

Nevertheless, for the rest of his life, Cocteau persisted in describing *Parade* as an epic battle between the reactionaries and the avant-garde, as if it had been Victor Hugo's *Hernani* or a replay of the first night of Stravinsky's *Sacre du printemps* in May 1913, which Cocteau had attended and his friend Valentine Gross had described as an "earthquake." "The theater seemed to shudder. People howled and whistled, drowning out the music. There was slapping and even punching."[58] The police were summoned and gentlemen challenged each other to duels. "Exactly what I wanted," Diaghilev had said.[59]

The notoriety that the impresario had wanted and duly received for *Sacre* was exactly what Cocteau wanted and failed to receive for *Parade.* Instead of acceptance by the avant-garde and a heroic martyrdom at the hands of a Philistine mob, he ended up as the dadaists' "Aunt Sally" of choice. Paul Morand even brought an Aunt Sally figure back from London for Cocteau; it had a pipe in its mouth and looked just like one of the Managers.[60] For all his *Fingerspitzengefühl,* for all his captivating eloquence, for all his genius as a *pasticheur,* Cocteau never was, and—with the exception of *Le Sang d'un poète* and one or two other films—never would be an innovator. He was too mercurial to be anything but a star, a star that still twinkles remorselessly. By trying so hard to thrust himself to the forefront of the Parisian avant-garde, all Cocteau did was mobilize an army of enemies. "Why coming from so

far and setting out so late, should [he] push ahead of everyone else?" as Pierre Reverdy asked in *Nord-Sud*.[61]

André Breton and his group of young poets—soon to be known as the surrealists—were already fomenting a campaign tinged with envy against Cocteau. Most of them were every bit as bourgeois as he was, but less affluent, less well connected, and less scintillating. Whereas the surrealists were in rebellion against their humdrum family backgrounds, Cocteau took the fullest advantage of his more fashionable milieu. Hence the fiendishness of the surrealists' denunciation of this rich, spoiled, homosexual narcissist, who had less gravitas but a lot more wit and surface brilliance than most of them.

Parade was so poorly received by the critics that Diaghilev took it off after two performances. In December 1920, Cocteau nagged the impresario into reviving the ballet in Paris with most of his egregious gimmicks restored, but the public had become so inured to the shock of the new that its modernity was taken for granted. No protests, therefore no *réclame*. André Gide describes Cocteau at the ballet's revival: "walking up and down in the wings, older, tense and uneasy. He is perfectly aware that the sets and costumes are by Picasso, and that the music is by Satie, but he wonders whether Picasso and Satie are not by him."[62]

Unlike Diaghilev's other fairground allegory, Stravinsky's *Petrouchka, Parade* never became a staple of the company's repertory. When asked about this, Diaghilev reportedly said, "[*Parade*] is my best bottle of wine. I do not like to open it too often."[63] And so, as *grands crus* do, Diaghilev's "best bottle of wine" became a legend. Over the years, the magic of Picasso's name and Cocteau's lifelong campaign to perpetuate this ballet, which very few people had ever seen, provided *Parade* with a mythic cachet. Had *Parade* been performed as much as Diaghilev's other ballets, it is unlikely to have retained its iconic status. Picasso and Satie's next collaboration, *Mercure* (1924), would have much more of a modernist edge to it, but then Cocteau was not the begetter; he was the target.

After the demise of the Ballets Russes, *Parade* would not be revived until the Béjart Company put it on in 1964. And then in 1973, with Massine's help, the Robert Joffrey Company revived *Parade* in New York.[64] At last America, to which *Parade* makes so many references, would be able to judge what the fuss had been about. It was fascinating but disappointing. Diaghilev's "finest bottle of wine" was no longer drinkable—bouquet, flavor, body, all gone. The reconstituted sets and costumes—not least the timid colors—had no Picassian impact; as for the interplay between cloudlike trees and jagged diagonal buildings, it failed to register.

I had been fortunate to see the Manager's original outfits—battered and clumsily repaired—at Richard Buckle's Diaghilev exhibit in 1955.[65] As well as being masterpieces of cubist sculpture, they left one in no doubt as to their all-important role as

the "heavies." After the exhibit, these relics disappeared, presumably thrown away. By comparison, the Joffrey replacements looked like fake Picassos, which is what they were. As for the choreography, Massine had remained faithful to the spirit of the libretto, which is perhaps why it seemed so stale compared to the "Pop" manifestations that had broken out in New York.

The only element to survive unscathed was Satie's music, a deceptively simple mix of cabaret songs, ragtime, and much else, as subtle and inventive in its way as a cubist collage. Cocteau had wanted background music; what he got, to his carefully dissembled dismay, was "the most imposing piece of musical architecture that [Satie] had ever conceived," as deft and effective as Picasso's contribution.[66] As Auric said, it captured "the nostalgia of the barrel organ, which will never play Bach fugues."[67]

Neither Satie nor Picasso emerged from the *Parade* opening unscathed. Satie had become entangled in a lawsuit with a dangerous enemy, the reactionary critic Jean Poueigh. After congratulating him on *Parade,* Poueigh had denounced the ballet in print as an outrage on French taste.[68] Satie fired back a postcard: "You are an asshole—and if I dare say so—an unmusical ass-hole. Above all, never again offer me your dirty hand. . . ." He followed this up with other fecal insults addressed to "Monsieur Fuckface Poueigh, Famous Gourd and Composer for Nitwits."[69] Poueigh sued Satie for slander on the grounds that these open postcards had been read by his concierge.

On July 12, despite testimony in his favor from Cocteau, Gris, and other friends, Satie was condemned to a week in prison, a fine of a hundred francs and a thousand francs' damages to Poueigh. This would have resulted in a seizure of Satie's royalties and scores and an embargo on his music in state-supported theaters. He appealed in November, but the verdict went against him. Jail loomed. Powerful friends intervened, including the Princesse de Polignac and Misia Sert, and in March 1918 his sentence was reduced to probationary suspension. As Satie wrote to Henry Prunières (September 14, 1917), "*Parade* separated me from a great many friends. This work is the cause of many misfortunes. I have against me a thousand unpleasant people who have more or less abused and mistreated me. Too bad!"[70]

By comparison, Picasso's problem was slight, but it would have ramifications. Diaghilev, who was punctilious about such things, had arranged a *grand dîner* for the four creators of the ballet and the stars as well as Olga, after the premiere. Picasso must have known all along—he had excellent manners as a rule—the he would have to attend this dinner, even if it meant reneging on his promise to attend the one that Max Jacob and other friends had organized in his honor. By turning his back on his Bohemian past—an act that was more symbolic than he probably realized— Picasso elicited a tart response from the hosts dictated by Paul Dermée: "We, the undersigned, who have come together at Henriette's humble Montparnasse abode

Picasso. *Portrait of Max Jacob,* 1917. Pencil on paper, 32.6 x 25.3 cm. Musée Picasso, Paris.

for the Picasso dinner regret that serious business has kept him apart from those who desire his presence and feel that they alone [these two words added in Max Jacob's hand] deserve it."[71] The letter was signed: Prince de Lipchitz, Max von Jacob, d'Hermée, Sola (the painter Léon Sola), Marthe Laurens, Duc de Laurens (Henri Laurens), Metzi (Metzinger), Madame Sola, Juan Gris, Madame Dermée, Lucie Metzinger, Grisette (Josette Gris), and Kikimora (probably Kisling, who was nicknamed Kiki).[72] It was registered and addressed (in Lipchitz's writing) to Picasso at "Grand Montrouge."

Picasso had allowed himself to be maneuvered into a trap seemingly by Max Jacob, who was not happy at his old friend's neglect of him. Whether or not Jacob had as yet been introduced to Olga, she could never stand the idea of him any more than she could the rest of the Bateau Lavoir Bohemians. Picasso should have insisted

that Diaghilev—or Misia, who probably arranged the dinner—include Max. Failing that, he should have had the courage to tell Jacob of his change of plans, instead of putting the blame on his famously reliable memory.

In all fairness to Picasso, there was a further reason for his rejection. Fond as he was of Max, the artist had not forgiven him for his outrageous behavior at the funeral of his beloved mistress, Eva, in 1915. (En route to the cemetery, Jacob had got drunk, cracked macabre jokes with the driver of the hearse, and finally made out with him.) Picasso continued to hold this against him. After promising to engrave a frontispiece for Jacob's collected poems, *Le Cornet à dés,*[73] he had kept him waiting six months. And then, on receiving a copy of the book, he told a mutual friend it was a *chef-d'œuvre*—and, indeed, it was. Thrilled at this verdict, Jacob had jumped in a cab—"a fantastic luxury for him"—to hear the words from his hero's own lips. "I haven't read it," Picasso said.[74]

And yet Picasso had great need of Max Jacob: for his poetic spirit, his wit, his vast knowledge of magic and mysticism, his historical expertise (Max would do research for Picasso's ballet costumes), and not least for the slavish, homosexual adulation— marred by petty resentment—which the artist's paradoxical psyche craved. Hence the acts of cruelty on Picasso's part and the retaliation from Max, epitomized in the aborted dinner. After Olga foolishly had him banished, Max, who had a bande-rillero's skill at getting his barbs to stick, nicknamed the next phase in Picasso's development as *l'époque des duchesses* (the Duchess period).

Diaghilev's season at the Châtelet ended on May 27. The company's next stop was Madrid, where they opened in June, and Barcelona, where Picasso looked forward to introducing Olga to his mother. Whether Olga traveled with Diaghilev or the company or separately with Picasso, we do not know.[75] Picasso had no idea he would spend the next six months in Spain.

4

The Ballet in Spain

Earlier in 1917, Picasso had obtained a visa to leave Paris for Barcelona so as to present Irène Lagut to his mother, but he had canceled the trip after Irène rejected him. Now he was back in Spain on a similar mission: to introduce his new *novia* to his mother and sister and other family members. Back, too, because Diaghilev needed to have Picasso along for the Spanish luster he would shed on his company, even though *Parade* was not as yet on the roster. When Picasso arrived in Madrid around May 30, he assumed he would stay on in Spain until early July, when the company was due to leave for South America after a short season in Barcelona. He and Olga would then return to Paris and, all being well, get married. Things would not turn out as planned.

Picasso had never liked Madrid. He had hated the bleak winter he had spent at the San Fernando Academy in 1897–98—he had been only sixteen—desperately lonely, desperately poor, and, in the end, desperately sick. After an almost fatal bout of scarlet fever, he had been thankful to return home to Barcelona. A subsequent visit in 1901 had been almost as miserable—again in the winter—when he had helped edit an ill-fated magazine, *Arte Joven*. Picasso had found the Madrileños haughty and cold. This time around, he returned as a celebrity. Everybody wanted to meet him; also, it was summer.

Picasso stayed at the Palace Hotel,[1] Diaghilev and Massine at the Ritz; Olga and the other dancers were lodged in a more modest establishment. The company, above all Diaghilev, was in a state of nervous excitement at the news of Nijinsky's return. Four years before, the dancer had left Diaghilev to marry Romola de Pulszky, daughter of a well-known Hungarian actress. After being held under virtual house arrest as an enemy alien in Budapest, Nijinsky had been released—thanks to the balletomane Spanish king's intervention—and was arriving with his wife and child to dance for him.

Nijinsky had never danced in Spain before. At first all went well. Diaghilev burst into the lobby of the Ritz to give Nijinsky a big Russian hug. He even made a point of being "a fatherly friend, protective and kind"[2] to the dancer's wife, Romola—a

woman he had every reason to loathe and would soon loathe even more. In her memoir, Romola describes Picasso in Madrid: "reticent and very Spanish looking . . . when he began to explain anything, he became full of excitement, and used to draw on the tablecloth, the menu cards and on top of Diaghilev's ivory walking stick."[3] According to Romola, Nijinsky distanced himself from Picasso because he thought *Parade* "strived after modernism for its own sake." He did not realize that this was Cocteau's fault, not Picasso's.

In honor of the Nijinskys and Picasso, Diaghilev had laid on various entertainments, notably a performance by the celebrated flamenco singer and dancer Pastora Imperio. This performer dazzled them with her famously gritty, glottal voice, the cadenzas on her castanets, and the way she moved her arms above her head, which revolutionized flamenco. "With a few gestures she offered the history and soul of Spain."[4] Picasso found her "intensely sexy." And then there were the bullfights, which Picasso had so sorely missed in France. Belmonte—possibly the greatest torero of all time—was the star of this season's corridas. Picasso was very proud that they became friends. In the evenings, he and Massine would go in search of flamenco and cante jondo in Gypsy hangouts. Nijinsky's famed proficiency at Spanish dancing made Massine the more determined to master it. He would scrutinize the flamenco dancers' every move with ravenous intentness and film the performers with his new movie camera.[5] The more flamenco they saw, the more determined Diaghilev and Massine became to do "a great Spanish ballet" with décor by Picasso. Ever the perfectionist, Massine first of all had to ensure that not only he but the company were fluent in flamenco and Spanish regional dances.

On an earlier tour of Andalusia, Massine and Diaghilev had discovered a very small (five-foot-two-inch), very shy Gypsy called Felix Fernández García dancing with a flamenco troupe in a café in Granada. Although he looked sick and undernourished, Felix had an intensity and technical mastery that dazzled Massine. "Not only had he devised a notational system for the *zapateado* . . . but he had taught himself to sing the difficult *seguidilla* and *alegría* songs while dancing."[6] After their first encounter, Massine and Diaghilev had lost touch with Felix, but they now rediscovered him in Madrid dancing in a working-class cabaret. On being taken to see *Schéhérazade* and *Thamar,* Felix became an instant balletomane; he foolhardily quit the cabaret where he was working and joined Diaghilev's company as a teacher and consultant as well as a dancer. Picasso took a great shine to him. As Lydia Sokolova recounts in her memoirs:

> The employment of Felix was the first step towards the realization of the great Spanish ballet which Massine intended to create, though at that time neither Diaghilev nor Massine can have known exactly what form it would take. The essential was that Massine and the company would learn to perform Spanish steps in a

Spanish way; and Massine in particular had to master the grammar of the Spanish dance before he could work out his choreography. At this stage Diaghilev and Massine probably saw Felix as the eventual star of their Spanish ballet . . . but, as Massine learned more of the secrets of this very special art and grew more sure of himself, and as poor Felix's unstable nature became more apparent . . . they gradually came to visualize Massine as the hero of the ballet. One thing is certain: Felix joined the company in the confident expectation that Diaghilev intended to make him a world-famous star.[7]

The "great Spanish ballet" would emerge two years later as *Tricorne*. It would be a triumph for everyone involved, except for Felix, who had been the catalyst, until Massine usurped his place.

Diaghilev opened his Madrid season on June 2 with a spectacular program, including Lopokova and Nijinsky in *Le Spectre de la rose,* and Massine and Nijinsky in *Carnaval*. The reception was ecstatic. Alfonso XIII made a point of attending every performance. The court had no choice but to follow suit. In addition, the King had Diaghilev arrange special performances in a small private theater on an upper floor of the palace, where he and Queen Ena (Victoria Eugenia) and their friends could sit around informally in armchairs. When a political crisis clashed with an important horse race, and the King was late for *L'Après-midi d'un faune,* His Majesty asked an aide to explain apologetically to Nijinsky that he had "just given birth to a new government."[8] While the monarch fell for the beautiful ballerina Tchernicheva (the cruel Queen in *Cléopâtre*) and even tried to mimic her partner's leaps, his cousin, the glamorous red-haired Duchess of Durcal, chased after Nijinsky (the Slave in *Schéhérazade*). Romola encouraged this relationship, but Nijinsky was dismayed by it. "Please, *femmka* [little wife]," he begged her, "do not leave me so much alone with [the Duchess]."[9]

After being feted for a week in Madrid, Picasso left ahead of the rest of the company for Barcelona—their next stop before sailing off to South America—as he had to prepare for Olga's arrival. He moved in with his mother, who still lived in the parental apartment on the carrer de la Mercè, the walls of which were lined with paintings by his father, as well as many of his own early works. Given the oedipal shadow that his father had cast over his early years, Picasso felt ill at ease working in the family home and went in search of an alternative space. Within a day or two he had arranged to share a studio at the top of the Ramblas with a likable hack from Málaga named Rafael Padilla. He had also arranged to share Fatma, Padilla's beautiful French-Moroccan model and mistress.

As soon as he moved into the studio, Picasso set to work painting Fatma as a *maja.*

Lola Vilató, her son Juan, Picasso, Doña María and Fin Vilató in Barcelona, 1917. Collection Doctor Vilató, Barcelona.

To show off his virtuosity, Picasso allowed the press to see this unfinished fusion of popular imagery and pointillism[10]—something he had never allowed before. Now that he was back in what had once been his hometown, he evidently wanted to follow the strategy his father had urged on him twenty years earlier: dazzle the public with a tour de force. The publicity paid off. Journalists marveled at the modernity of this anything but modernist portrait and treated the artist as a returning hero. Picasso seems never to have touched the painting again. He had carried it quite far enough, and it had served its purpose. Years later, when Douglas Cooper asked him about it, he shrugged dismissively and said he wished people would stop referring to the model as "La Salchichona" (the sausage woman).[11]

The press report that Picasso had returned to Barcelona was followed up by an account of a commemorative dinner.[12] This had originally been planned to honor two Basques, Francisco Iturrino, the painter with whom Picasso had shared his 1901

show at Vollard's, and the art critic and painter Gustavo Maetzu.[13] On hearing that Picasso was in town, the organizers made him an additional honoree. The dinner took place at the Lyon d'Or, a restaurant that had replaced Els Quatre Gats as a gathering place for writers and artists. Besides Padilla, the guests included many of Picasso's old friends: among them, Miquel Utrillo, Manuel Pallarès, Alexandre Riera, Ricard Canals, and the Junyer-Vidal and de Soto brothers. The newspaper account makes the occasion sound depressingly official: speeches in French, Catalan, and Castillian, the singing of the "La Marseillaise" and "El Segadors" (the Catalan anthem), and a group photograph. During the dinner, someone announced that the city of Barcelona was planning an international exhibition of contemporary painting later in the year, and that there would be a special gallery reserved for Picasso. Nothing would come of this project; however, most of the work executed on this Barcelona visit would be exhibited at the Palau de Belles Artes in 1919.

Instead of remaining in Barcelona until the company arrived a week later, as he had planned, Picasso received a telegram on June 13, signed by Diaghilev and Olga, summoning him back to Madrid.[14] The King had expressed a wish to see *Parade,* which "he had heard much of and was interested in because the décor was by a Spaniard whom he was anxious to meet."[15] Diaghilev had omitted this ballet from his Spanish repertoire as too advanced for such a backward country. The King felt otherwise. Picasso had to hasten back for the command performance of *Parade* on June 18. He complained that he did not have the correct clothes, nor any knowledge of court protocol: how to walk backward from the royal presence without ever looking him in the eye.

Fortunately, Eugenia Errázuriz, Picasso's Chilean mother figure and a friend of the royal family, came from Biarritz to deal with such problems as this and also meet Olga. Diaghilev, who was fussy about the way his entourage dressed, had already managed to impose a certain formality on Picasso. Instead of the mechanic's overalls and espadrilles that he had sported in Montparnasse, the artist would now wear a suit, starched collar, and tie, especially if the impresario and Olga were around, and he took an increasing pleasure in doing so. Picasso's dandyism should not come as a surprise, given the early drawings in which he depicts himself and one or two of his penniless friends as elegant boulevardiers. After Eugenia's grooming, Picasso was ready for the King; ready, too, for the beau monde, for the Durcals, Albas, and Beisteguis, to whom Eugenia and Diaghilev introduced him. The Spanish nobility took to Picasso; he took to them, but his attitude to the court was as skeptical and ironical as Goya's.

Picasso, who had seen himself as "el Rey" in an early self-portrait,[16] got on famously with the monarch. However, Alfonso XIII was notoriously cursed with the evil eye, and an audience with him must have been an ordeal for anyone as supersti-

tious as Picasso. Fortunately, the King turned out to have loved *Parade*—especially the two-man Horse, whose antics "convulsed him"[17]—far more than the public did. *La Epoca* had been especially virulent: "the product of a sick imagination . . . this cubist ballet may be seen once as a curiosity, but no more. *Parade* augurs no future for cubism on the stage."[18]

On the night before Picasso left Madrid, Ramón Gómez de la Serna, editor of an avant-garde journal, *Los Quijotes,* laid on a dinner for him at Pombo, the headquarters of the city's avant-garde. His aim was to reunite the artist with figures from his remote Madrileño past and also have him meet the new generation. According to Gómez de la Serna, the evening was a great success. "Picasso smoked an unlit pipe and took delight in being the guest of honor . . . and spoke afterwards . . . as if he were an emigrant who had been to paradise and returned to his humble surroundings."[19] The next day, Picasso and Olga, Diaghilev and Massine, and the rest of the company left for Barcelona. Olga and the more important dancers and musicians, including Ansermet the conductor, lodged at the Pensión Ranzini at 22, passeig de Colon. Diaghilev, Massine, and the Nijinskys checked into the Ritz. Picasso moved back with his mother—at first.

As soon as they arrived in Barcelona, Picasso took Olga to meet his mother, who had longed to see her son married. Many years later, Picasso told Françoise Gilot that Doña María had taken a very poor view of Olga as a daughter-in-law. They were wrong for each other, Gilot reported him as saying. Olga was not strong enough to make Picasso a good wife. "You poor girl, you don't know what you're letting yourself in for," she told Olga. "If I were a friend, I would tell you not to do it under any conditions. I don't believe any woman would be happy with my son. He's available for himself but for no one else."[20] Given Picasso's tendency to mythmaking about his past in the light of subsequent events, we should not take this story too literally. Doña María longed for a grandson and is unlikely to have admonished this presentable young woman in such a crude way. Over the years she became very fond of Olga. Perhaps the words Picasso later put in his mother's mouth were intended to convey a warning about himself to Gilot.

Whether or not Doña María approved, Olga was dead set on marriage. The Russian Revolution's descent into a bloodbath had left her with no alternative. By now she would have seen how rapturously Picasso was received in France and Spain and would have realized that he was far more of a celebrity than she could ever be. Her best hope of stardom was to sacrifice her far from stellar career as a ballerina and become Madame Picasso. And indeed, the airs Olga would give herself once the ring was on her finger would remind Cocteau of a dancer taking a curtain call. The only

problem was that Olga was as adamant as Diaghilev had said she would be about sleeping with him: apart from her gift for dancing, her virginity and her looks were her only assets.

In the thirteen years since Picasso had lived there, Barcelona had greatly changed—largely as a result of the war. Neutrality had brought prosperity. Most of the young artists who had been lured away to Paris earlier in the century had returned home. After 1914, it was Barcelona's turn to beckon. The city was also full of refugee artists, headed by Robert Delaunay and Albert Gleizes, a couple of draft-dodging Parisian modernists who lived off rich wives and shared an envious hatred of Picasso. The enormously gifted but embittered simultaneist, Delaunay, and his Russian wife, the designer Sonia Terk, had systematically tried to drive a wedge between him and Apollinaire. Braque and Derain, who were stuck in the trenches, felt far more violently about these so-called pacifists than Picasso did.

Another resentful refugee was Marie Laurencin, who had had to leave France after marrying a German painter, the handsome, bisexual (like herself) Baron Otto von Wätjen. Now that she was a baroness, this intrepid climber was out to storm the bastions of Spanish society to ensure that the ladies of the court collected her relentlessly pretty pictures and not the work of other refugee painters. Laurencin was an old friend of Picasso's—an old friend he thoroughly disliked. For dropping Apollinaire, the lover he had picked out for her, Picasso had dropped her. A letter from Laurencin to Henri-Pierre Roché confirms that his dislike was reciprocated. She had seen Picasso, she wrote, "very show-off with his décors—preoccupied with his success, having slept with every woman in sight—in short remarkably screwed-up as a painter and so Spanish and would-be flirtatious—Sentimental stroll to a church but too crass for the two of us."[21] "Flirtatious . . . sentimental . . . crass"—it sounds as if Picasso had made a pass at her.

Wives with French passports—Juliette Gleizes, Gabrielle Buffet Picabia, and Nicole Groult (Paul Poiret's art-dealing sister who had left her husband for Laurencin)—were able to make sorties across the frontier, though these were not without risk. Nicole Groult was detained as a spy when she nipped into France to ship a bundle of Picabia's diagrammatic *tableaux mécanomorphes* off to Marius de Zayas, his New York dealer.[22] Picabia's wife, Gabrielle Buffet, had a similar adventure. Questioned at the frontier by a customs official about one of her husband's mecanomorphic works, she said it was a portrait of her. "You can't fool me," the official said, "it's a propeller for a fighter plane, but you can proceed. Your thing is not going to work."[23]

Picasso's feelings for Picabia, who had left Barcelona shortly before he arrived,

would always be ambiguous. The fact that they spoke Spanish together—Picabia's paternal family hailed from Galicia[24]—made for friendliness on Picasso's part. He was amused by Picabia, but also often irritated by him, and sufficiently intrigued to filch from his works of the mid-1920s. After launching his magazine *391*[25] on January 25, 1917, Picabia had left Barcelona for New York. Picasso and Picabia, who were much freer spirits than Gleizes or Delaunay, enjoyed taking potshots at each other. In the first issue of *391,* Picabia had satirized Picasso's Ingresque portrait of Max Jacob in a crude drawing of a seated male figure with a photograph of himself superimposed on it. The drawing is inscribed "Max Goth" (nom de plume of Maximilien Gauthier), whom the photograph does not in fact portray. The accompanying text, entitled "Odors from all over: Picasso penitent" and signed "Pharamousse" (one of Picabia's pseudonyms), reads as follows: "... Pablo Picasso has decided to return to the Ecole des Beaux-Arts ... [and] is now the head of a new school which our collaborator unhesitatingly joins. The Kodak published above is the solemn sign of it."[26]

Picasso did not take Picabia's mockery seriously.[27] In issue no. 4 of *391,* Picabia wrote a spoof statement in which Picasso boasts of his position as "King of cubism."[28] If this infuriated the lesser cubists, so much the better. Picabia's numerous letters to Picasso over the next five years are mostly affectionate. When the poet Pierre de Massot asked to do a portrait of him for some publication or other, Picabia wrote begging Picasso to do it instead: "You will do it much better than I."[29] On Picabia's return to Barcelona in October, he and Picasso got together at a bullfight. Picabia's dadaist daring and devilry amused him, much as Tristan Tzara's would. Eight years later, the two artists would see each other on an almost daily basis. They do not appear to have quarreled, they simply went their separate ways.

D iaghilev's company had never danced in Barcelona, and since Nijinsky was billed to appear, the eight performances at the Liceo opera house were sold out. In her determination to get Nijinsky into bed, the Duchess of Durcal had followed the troupe to Barcelona. Romola wrote:

> Jealousy never entered my head. I was even rather pleased when Vaslav returned later than usual one night, but this escapade had quite a different effect on him than I had expected. He was mournful and told me frankly: "*Femmka,* I am sorry for what I did. It was unfair to her, as I am not in love, and the added experience that perhaps you wanted me to have, is unworthy of us."[30]

In Russia dancers were expected to have sexual relationships with royalty or the nobility, so Romola was anything but displeased by her husband's affair with La Dur-

cal. What did displease her was Diaghilev's democratic decision to publicize the entire company rather than individual stars. Romola encouraged her susceptible husband to believe that this was aimed at him.

Worse was to come. All of a sudden Nijinsky refused to go to South America. Diaghilev retaliated by invoking their contract: "I will force you to go," he said. The following morning, "as Diaghilev was crossing the entrance hall of his hotel . . . he noticed [the Nijinskys'] luggage piled up near the door."[31] Despite being billed to dance that evening, Nijinsky, egged on by his wife, had arranged to take the night express to Madrid. Citing a Spanish law that required a performer who had been billed to appear to do so, unless sick, Diaghilev's lawyer had the Nijinskys arrested as they were about to board the train. In desperation the dancer telephoned the Duke of Durcal in Madrid, who called off the authorities and arranged for a powerful lawyer, Francesc Cambò—to represent him. In the end, Nijinsky had no choice but to dance that night and the remaining five or six nights. After Diaghilev promised to stay in Europe, Nijinsky agreed to leave on the South American tour, which proved an ill-fated venture. In the course of it much of the scenery burnt up and, according to Ansermet,[32] Nijinsky showed the first symptoms of mental illness. Diaghilev had to give way on one point. Romola insisted that her husband be paid in gold after every performance.

Francis Picabia. *Max Goth,* satire on Picasso's 1915 portrait of Max Jacob. From *391,* no. 1 (January 25, 1917). Spencer Collection, The New York Public Library, Astor, Lenox and Tilden Foundations.

On July 4, the company boarded a steamship for Montevideo. To nobody's surprise, Olga stayed behind,[33] as would Diaghilev and Massine. Just as the boat was about to leave, she and Picasso arrived on the quay to say a fraught goodbye. Olga would miss Nijinsky, who had been very helpful to her. He had chosen her as one of the nymphs in the original production of *L'Après-midi d'un faune,* because she was quick to learn the rhythmically complicated steps that were unlike anything that had been done before. Olga had also been on the same transatlantic crossing as Nijinsky when Romola forced herself on him. She shared Diaghilev's distaste for this Hungarian interloper.

Farewells were strained. The dancers were sailing under a neutral flag, but, as everyone knew, U-boats sometimes made mistakes. Also, the company's coffers had been so depleted by war and revolution, and backers were so scarce that this might well be the company's last trip. For Olga, separation from her fellow dancers—her

surrogate family—was especially painful. Fortunately, Diaghilev and Massine had decided to stay on in Barcelona for the summer—much cooler than scorching Madrid—so Olga did not feel forsaken. And the charming fishing village of Sitges was nearby, where Misia's next husband, José María Sert was painting murals for a house that the Chicago millionaire Charles Deering was restoring.[34] Deering enjoyed having Diaghilev and his stars around.

Picasso was happy that he no longer had to share Olga with the company. Most days, if he was not working, he and Massine would meet at their favorite hangout and go sightseeing. Since they were both ardent womanizers, kept on a short leash by their respective lovers, sightseeing included a lot of whoring. Just as well that Massine, never the easiest or friendliest of men, and Olga liked each other. They chattered away in Russian; he also helped her practice. This was a priority. She fully intended to dance again as a guest star when the company returned from South America.

If the locals found Picasso distant, it was because they saw him in Diaghilev's reflected light. For all his avant-garde success, the impresario had coagulated into a monster of elitism, who took no interest in other people, unless they were very gifted, very grand, very powerful (Bolsheviks as well as American millionaires), or very handsome. The Catalans' pride in being Catalan would have struck Diaghilev as impossibly provincial. Why bother with them? The locals felt every bit as disdainful about him. What was their hero, Picasso, doing with this alien fop, with the white streak in his dyed black hair (hence his nickname, "Chinchilla"),[35] not to mention the redundant prop of a monocle, the Fabergé jewelry, the clouds of Guerlain's Mitsouko, and the haughty, heterosexual boyfriend on his arm? Neither Diaghilev nor any of his associates attended the dinners that fellow artists gave for Picasso in Madrid or Barcelona. There is no mention of them or Massine, for instance, at the banquet organized by friends and admirers at the Lyon d'Or on July 12. Santiago Rusiñol and Eugeni d'Ors could not make it (there was another reception for Gregorio Martínez Serra, the author of *El corregidor y la molinera,* the one-act farce that would provide the scenario for *Tricorne*); otherwise, most of his old friends attended.

The departure of the company left Diaghilev, Massine, and Picasso free to focus all their attention on the Spanish project. They were soon joined by the country's greatest composer, the exceedingly shy Andalusian, Manuel de Falla—described by Stravinsky as "even smaller than myself, and as modest and withdrawn as an oyster."[36] After hearing the exhilarating incidental music that Falla had composed for Martínez Serra's *El corregidor y la molinera,* Diaghilev and Massine decided that this could be adapted to the great Spanish ballet that would become *Tricorne*. Falla accepted the commission, but said he would have to study Spanish folk music and dances before he could successfully translate the *jota* or the *farruca* into a modern musical idiom.[37]

To help him with the flamenco dances and play the star role, Massine summoned the fantastically gifted Gypsy dancer Felix Fernández García. To perfect his technique, the remorselessly driven Massine set about squeezing every last drop of *duende,* the lifeblood of flamenco, out of Fernández. By the end of July, Diaghilev decreed that he and Massine, Falla, and Fernández should embark on an extensive tour of Spain—Saragossa, Burgos, Salamanca, Toledo, Seville, Córdoba, Granada—"to study native peasant dances"[38] and gather musical material for *Tricorne.* Picasso and Olga did not join them. Work and visa problems kept them in Barcelona.

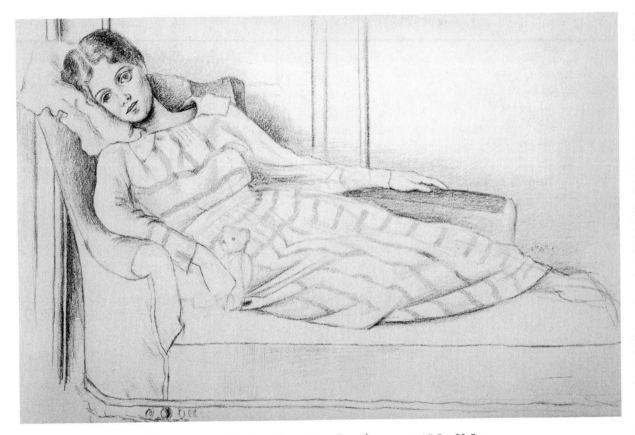

Picasso. *Olga Lying on a Sofa,* Barcelona, 1917. Pencil on paper, 15.5 x 23.5 cm.
Collection Marina Picasso.

5

With Olga in Barcelona (Fall 1917)

With Diaghilev and Massine gone, Olga found herself marooned in a country where she had yet to learn the language and where few spoke French, let alone Russian. Nor was she able to communicate with her family in Russia or her surrogate family, the dancers who were off in South America. Neither Doña María nor the family of Picasso's sister Lola took Olga to their hearts, nor did Picasso want her to consort with his raffish Bohemian friends. Fraught with worry at the news from Russia, Olga became totally reliant on Picasso, with whom she had fallen passionately in love. When he was off working in Padilla's studio, Olga stayed in the Pensión Ranzini. To keep in shape, she exercised every day at the barre in a local dance studio. Otherwise, as drawings reveal,[1] she spent her time on her sunny balcony reading, keeping her tights and tutus in good repair, and waiting for her visa to come through. So long as she was a member of the troupe, Olga had had no difficulty crossing frontiers. Now that she was stateless, jobless, and without a passport, she was stuck in Spain.

Evenings, Picasso would pay court to Olga. She liked to get herself up in the Chanel outfits she had bought in Paris, or the gauzy black dress[2] that her fiancé had picked out for her at the fashionable Grand Gérard shop on the Ramblas. This is the dress she wears in the bravura portrait of her holding a fan, *Olga in an Armchair*,[3] painted on their return to Paris. Picasso would take Olga for a paseo—as he had taken the *novias* chosen by his mother all those years before in Málaga—and they would walk ceremoniously up and down the Ramblas, arm in arm in the dusk. Picasso was exceedingly proud of Olga and enjoyed showing her off.[4] In later years, he liked to tell how a Gypsy on the Ramblas offered to read her palm. When asked her name, Olga said, "Carmen." "Mine's Olga," the Gypsy replied. Russian archness, Picasso said, was no match for Gypsy guile.

Meanwhile, Picasso had set about painting a lifelike portrait of Olga,[5] costumed *à l'espagnole* like Fatma, the girl who had sat for him a few weeks earlier. Picasso's Hispanicization of his Russian fiancée would include some of the same elements—the spit curl and the mantilla—that he had used on the Moroccan model. If Olga's man-

tilla is less convincing, it is because Picasso had improvised it out of a fringed lace tablecloth he had pinched from his hotel in Madrid.[6] These fanciful trappings are at odds with the sitter's melancholy gaze. Despite its iconic importance as the first portrait of her, it is not particularly affectionate. Olga's reproachful eyes and pursed lips look ahead to the cruel, exorcistic portraits Picasso would paint of her fifteen years later, when their marriage had soured. With hindsight, one can discern a certain inevitability.

At first, Olga would not allow Picasso to spend the night in her room at the Pensión. For someone as sex-obsessed as Picasso, the brothel would have become a daily or nightly necessity. The stress generated by Olga's adamant resistance could well explain the ambiguity and coolness of her expression in the portrait. However, the closeness that sitting for the portrait entailed seems to have melted Olga's resolve. She finally allowed Picasso to sleep in her room. He confirmed this to his sister, Lola; Miró also reported that Picasso slept at the Pensión Ranzini, going back to his mother's apartment only to shave.[7]

Charming drawings in the pages of Picasso's sketchbooks reflect their ever increasing intimacy.[8] We finally see Olga in a negligee with her mane of reddish hair loose around her shoulders or done up in a chignon. And yet, for all their love and warmth, these drawings reveal no trace of the predatory physicality that would make Picasso's images of Olga's successor, Marie-Thérèse, so insidiously sexy. One of the few drawings to evoke desire, rather than pride of ownership, is a study of a languorous-looking Olga on a chaise longue, clutching a teddy bear—Daddy's little girl, but very much a woman.[9] In another touching sketch of her on her balcony, dated July 21, Picasso portrays her feeding the caged canary that he had hung in her window. It is inscribed *"El canario y la canaria chica."*[10]

Although Picasso had intended to give the portrait of Olga to his mother, the sitter was so delighted with the likeness that she insisted on keeping it, and it has remained in the family ever since.[11] A large cubist drawing, which Palau calls *Olga as a Great Lady*[12] (Olga as a *Spanish* lady would be more accurate), includes the rest of her figure on an additional sheet of paper. This suggests that Picasso contemplated doing a full-length portrait of her wearing an authentic mantilla and holding a closed fan in her right hand. Palau mistakes the fan for the baton of authority held by most of Velázquez's equestrian sitters and illustrates one of them by way of confirmation.

Instead of following up with a portrait of Olga as a modernist *manola,* Picasso chose to do a full-length cubist painting of the celebrated music hall performer Blanquita Suárez.[13] He had seen her late in June at the Teatro Tivoli in a *zarzuela* called *La gatita blanca (The Little White Kitten)*. Picasso makes much of Blanquita's hourglass-shaped bodice, her comb, as tall and black as a witch's hat, and her fan, conspicuously open, in her left hand. Blanquita is dancing alone on the stage in a funnel-shaped

beam of gray light. In this and two other related figure paintings, Picasso is out to give cubism an appropriately austere Spanish resonance, much as his compatriot, Juan Gris, had done in his previous year's paintings. Blacks, whites, and grays are set off against dark reds and browns. Equally Gris-like is the contrast of rectilinear and scallop-edged planes—but trust Picasso to make Gris's calculated harmonies look decidedly dissonant.

A drawing for the largest of Picasso's Barcelona paintings, *Seated Man Leaning on a Table,*[14] reveals that it may have begun as a portrait of a friend: the exceedingly Spanish-looking Basque painter Francisco Iturrino. Picasso's large 1901 portrait of him had failed to sell at his first Paris show, so he had painted another composition on the back of it.[15] Picasso had also done a cubist drawing of the same man in 1914 when they were both in Avignon.[16] Iturrino's dramatic Spanish appearance had likewise inspired major portraits by the Belgian painter Henri Evenepoel and Derain.[17] And now the two of them were reunited once again: fellow honorees at the June 10 banquet. Picasso needed a model—a Spanish-looking one for preference—and Iturrino liked to sit. Picasso would later try to fix him up with a Paris dealer.

The prospect of staying on in Barcelona delighted Picasso—at least at first. The war news from France was increasingly depressing: mutinies on the Western Front, the bloodbath at Ypres, air raids on Paris, the revolution in Russia. People were beginning to despair that hostilities would never end. Everything was in short supply. In Barcelona, on the other hand, industrious Catalans were profiting from Spanish neutrality. Far from shortages, there was an abundance of meat and poultry, fruit and vegetables, even French wines, and for Picasso the greatest wartime luxury of all, unlimited tobacco. The city had expanded and, thanks to an influx of refugees, become more international. Vice—a traditional local industry—flourished as never before. Prostitution was no longer limited to the Barri Xino (the red-light district), it was everywhere; so was pornography. Drugs, too, were readily available. The major worry was not the war; it was the Spanish flu epidemic, which would soon reach Paris and the rest of the world.

To Picasso's surprise, the art world of Barcelona had become not only more active but more

Picasso. *Colón Monument,* Barcelona, 1917. Oil on canvas, 40.1 x 32 cm. Museu Picasso, Barcelona.

progressive. In April 1917, the Palau de Belles Artes had put on an enormous exhibition (1,458 works) of French art in a bid to take the place of the Paris Salon, which had been closed down by the war. To promote the show, Ambroise Vollard had given a lecture on Renoir and Cézanne.[18] When it closed in July, Picasso, who usually avoided such things, attended the closing ceremony. To capitalize on this, the Dalmau Galleries organized a show of local artists that included the leading lights of the Catalan school, Isidre Nonell, Joaquim Sunyer, and Joaquim Mir, all of them alumni like Picasso of Els Quatre Gats.

Nonell had died, Mir had gone mad, and Picasso's old enemy, Sunyer, had come to the fore. This was a far cry from 1904, when the two of them, newly settled in Paris, had fallen out over Fernande Olivier.[19] Fernande's rejection of Sunyer had left him bitterly envious of Picasso's superior skills as a seducer as well as an artist. Years later, Sunyer raised the value of one of his pastels by appending Picasso's signature to it.[20] Surprisingly, this derivative painter, who is remembered principally as a portraitist, had become leader of the Catalan art movement, noucentisme.

The term "noucentisme"—literally "twentieth-centuryism"—had been coined in 1906 by Eugeni d'Ors, a literary pundit who wanted to be the ideologue of a new movement. D'Ors had written about Picasso in the past and would write a fulsome book about him in 1930. Later, he would turn violently against him for painting *Guernica.* Despite the prominent names that d'Ors invoked—above all Picasso's—as forerunners of his movement, noucentisme was far too timid and passé to live up to its portentous name. In this respect, it was reminiscent of the preceding Catalan art movement, an offshoot of art nouveau, which had given itself an even more impossibly ambitious name, "modernisme." What d'Ors and Sunyer wanted noucentisme to evoke was a modern Arcadia: a pastoral countryside inhabited by idealized Catalan women, whose strong bodies would testify to their roots in an ancient culture. Miró diagnosed their problem—an excess of local piety—in a letter to a friend: "That business about our native carob trees performing the miracle of awakening [Sunyer] is fine when the intellectuals of the Lliga say it. . . . You have to be an *international* Catalan, a *homespun* Catalan will never be worth anything in this world."[21]

Having dabbled in Catalan Mediterraneanism many years earlier, Picasso would have found d'Ors's pretensions antiquated. However, McCully sees a hint of it in the decorative *Harlequin* that Picasso painted early on in this visit: specifically in its thin washes of color and classicistic head and hands, so typical of noucentisme.[22] This Harlequin looks back to the self-referential Harlequin in the *Parade* curtain. He allegorizes Picasso's involvement in Diaghilev's commedia dell'arte troupe and has once again become Apollinaire's Harlequin Trismegistus—a strolling player out to devise new imagery for a new audience in a new age.

It was not just for Olga's sake that Picasso distanced himself from his Catalan friends. Over the last fifteen years, few if any of the Quatre Gats group had come to much and he no longer had much in common with them. The formerly bright young Bohemians and "champagne anarchists" had mostly gotten married and settled down into bourgeois smugness. They would have found Olga a somewhat distant star. She would have found them provincial and uncouth, particularly Picasso's oldest painter friend, Manuel Pallarès,[23] who spoke only Catalan and, as Picasso said, could be counted on to bore people straight to sleep. Picasso's other very old friend, the sculptor Manolo, who had resurfaced in Barcelona with his wife, Totote, posed a different problem. He was such a devastating wit and such a ruthless practical joker that Picasso would have been wary of having him around.

Had he been on his own, Picasso would have welcomed his Catalan cronies, whom, in later years, he loved to entertain. But for Olga's sake, he fought shy of them and was accused of being standoffish for doing so. One local journalist described Picasso at this time as "condescending, friendly, jovial, ornate."[24] "His friends no longer recognized . . . [this] refined gentleman who took his splendid girlfriend to cafés on the Paralleo or strolled with her on his arm down the Ramblas."[25] Rumors of this transformation soon reached Paris: "Picasso is said to be marrying the young Russian dancer," Jacques Doucet wrote Roché; "he is still in Spain, all elegance and refinement, as to his circumstances, his best friends don't know what's become of him."[26] Doucet's information came from Max Jacob, who had reported that "for the last two months, Picasso has written me every week . . . to say that he is about to return home."[27]

Almost all the artist's output from his six months in Barcelona in 1917 hangs together in a revelatory gallery at the Museu Picasso, revelatory in that it enables us to study a six-month period of his work in its entirety. Although stylistically diffuse — pointillism alternating with Ingresque representationalism and synthetic cubism — it is unified by a pervasive Spanishness. After Diaghilev and Massine left on a tour of Spain, there was nobody around to provide Picasso with the avant-garde stimulus on which his work thrived. The longer Picasso was obliged to wait in Barcelona for

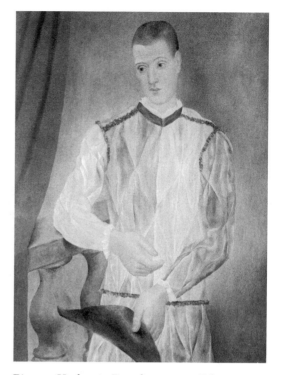

Picasso. *Harlequin,* Barcelona, 1917. Oil on canvas, 116 x 90 cm. Museu Picasso, Barcelona.

Picasso. *Disemboweled Horse,* 1917. Charcoal on canvas, 80.2 x 103.3 cm. Museu Picasso, Barcelona.

Olga's visa, the deeper he probed the darkness of his Spanish spirit. Where better to find the *duende* he was after than in his *afición*—specifically at the bullfight in honor of the Virgin of El Pilar on October 12.

To the fascination of Ernest Ansermet, who accompanied him to this corrida—Olga may have been squeamish about bullfights: she is never recorded as attending one—Picasso proceeded to do a mass of rough drawings. Sketchbook in hand,[28] he skipped back and forth between cubist and more traditional methods of representation. "Observing my astonishment, [the artist] said 'but can't you see? It's the same thing! It's the same bull seen in a different way.' "[29] Surprisingly, none of these drawings depicts the torero doing his passes or the *mise-à-mort.* Virtually all of them portray the picador on his horse, savagely jabbing the bull with his pike, while the horse—its flanks not mattressed as they are now—is being gored by the wounded bull. These drawings prepare us for a horrendously expressive image of the gored horse in its death throes—the more expressive for being executed in black chalk on canvas the color of the sand in the bullring.[30] Bowels dangle from the horse's belly

like testicles; its monstrously elongated neck and penile head rear up as if about to explode in orgasm.

A couple of observations in a Barcelona sketchbook[31] reveal how confused Picasso felt about his work at this time. The first, "One must not learn to draw," is interesting in that Picasso was forever saying the opposite. The second, "Has anyone put a prism in front of an X-ray?" confirms Picasso was still puzzling over the direction that cubism might take.

Since parting company with the ballet, Olga had persistently tried and repeatedly failed to get a French visa. As weeks and months went by and the status of Russian expatriates became ever more precarious, she and Picasso realized that a visa was never going to materialize in Barcelona. They would have to pull Parisian strings. Cocteau, who had powerful connections at the Quai d'Orsay, discovered that a visa could be granted if Olga obtained an engagement to perform in Paris. He had discussed the matter with Misia Sert, who was sure she could arrange something. Misia approached her great friend, the celebrated actress Réjane, whose husband Paul Porel was director of the Théâtre du Vaudeville. Porel had readily agreed, Misia reported, to draw up a contract guaranteed to get Olga her visa.

To check that everything was going according to plan, Picasso asked Manuel Humbert, a local noucentista painter and close friend of Manolo, to go and see Cocteau on his forthcoming trip to Paris. The news was discouraging. On August 10, Porel had dropped dead, leaving Olga's contract unsigned on his desk. Cocteau wired the news to Picasso and promised to have a new contract mailed in a week. There was a further problem. On September 1, Valentine Gross, who took over the handling of the negotiations from Misia, sent Picasso a card saying that they should wait another week or two before asking the grieving widow to amend the contract.[32] Unfortunately the grieving widow had departed on tour and nothing could be done until she returned to Paris. "Very bored. Still here. I don't know when I am getting back," Picasso wrote Apollinaire on October 18.[33] Olga's visa would not come through for a month, by which time they would both be sick to death of Barcelona.

At the end of October, the Ballets Russes returned from South America for the autumn season in Barcelona (November 5–18). Ansermet—according to Picasso, "the hardest-working member of the company"[34]—moved into the room next door to Olga's. They had adjoining balconies, from one of which Picasso painted a lively cubist view of the monument to Christopher Columbus.[35] He also did a drawing of the conductor. Meanwhile, Diaghilev and Massine had gone back to the Ritz. After touring Spain, they had spent the last few months in Madrid working on a new bal-

let, *La Boutique fantasque,* with décor by Derain—a potential crowd pleaser. *Tricorne* had been temporarily set aside.

Diaghilev's first move was to assemble the company and tell them that he had failed to arrange any future bookings. German and Austrian troops had broken through the Italian lines, so Rome was out; the third battle of Ypres was going badly, so Paris was out; Sir Thomas Beecham, the rich and powerful London conductor, wanted only British music, so London was out. Apart from a few appearances in Spain and Portugal, Diaghilev had nothing in view. To make matters worse, flu was now raging out of control in Barcelona (several of the dancers, including Sokolova, had caught it). So the Liceo was not nearly as full as it had been in the spring. Always a possibility, bankruptcy had become a probability. The Russian Revolution had wiped out Diaghilev's private means and there were only the slimmest pickings to be had from patrons like Misia, Lady Ripon, or Otto Kahn, who had lost $250,000 on the last American tour and was averse to losing more.

The impresario had insisted on the inclusion of *Parade* in the Liceo season in the hope that the pride the people of Barcelona took in Picasso (although an Andalusian, he was regarded as a native son) would guarantee the ballet's success. It did not. Most of the Catalan critics were as reactionary as the Madrileño ones: "If *Parade* is a joke, it is a joke taken to the extreme, a joke in poor taste. . . . It would be enough for the French to demand extradition for its author, who is Spanish" (Fausto in *La Vanguardia*); or "everything is cubist, even the music has been cubed" (Aladin in *El Diluvio*). To their credit, Picasso's admirers struck back: an anonymous critic in *El Poble Català* wrote that Fausto had every right to censure *Parade,* but that his call to extradite "the greatest painter Spain has produced since Goya was in abominable taste."[36] Writing in *La Revista,* Picasso's friend, the Uruguayan painter Joaquín Torres García, congratulated him on a "magnificent show. Picasso has made us—at least many of us, aware of something very new."[37] Miró was also very impressed by *Parade.* Although aged twenty-four, he was already a figure to be reckoned with; but he was much too shy to approach Picasso. The two of them did not become friends until Miró's first trip to Paris in 1920.

Delaunay had returned to Barcelona, vindictive as ever, and was once again vilifying Picasso. To Gleizes, his fellow Picassophobe, Delaunay wrote that *Parade* "is a completely crazy story—no success here, or even curiosity, when confronted with this hysterical thing—hysterical is the only word for the painting of this sick tortured mind." Besides lambasting *Parade,* Delaunay criticized Picasso's return to representationalism: "having left behind cubist incomprehensibility, he accommodates himself marvelously with his so-called classic . . . drawings which have neither father nor mother." And he warns Gleizes against "certain parties" who "want to make French

painters out to be followers of the famous genius"—that is, Picasso.[38] Obsessive resentment continued to corrode the spirit of this formerly influential pioneer.

Delaunay was especially envious of Picasso's success with the Ballets Russes. On the first night of *Parade* he had Sonia, who had met Diaghilev back in Russia in 1905, introduce him to the impresario in the hope that he, too, would be asked to do a ballet. The lobbying worked. In 1918, Massine would commission Delaunay and his wife, who had taken to calling herself Sofinka Modernuska, to replace Bakst's sets and costumes for *Cléopâtre,* which had caught fire in a South American railroad tunnel. Delaunay's draft dodging had gotten around, and he received as bad a reception in London, where the ballet opened, as he would in Paris. Nevertheless, there was talk of Delaunay doing a sports ballet: a project that Nijinska would later resurrect with Cocteau as *Le Train bleu.* Also, Delaunay executed the portraits of Massine that Picasso had not as yet got around to painting.

As Cocteau would report to Picasso a year later (September 30, 1918), Sonia had suckered Diaghilev into promoting them "as ferocious patriots who had suffered in Spain."[39] Suffered? Sonia had been ecstatic when revolution broke out in Russia— less ecstatic when the large income she received from her adoptive family ceased. To replenish her coffers, Sonia had followed her mother-in-law's example and opened a boutique in Madrid to market her simultaneist garments and bric-à-brac. With Gómez de la Serna's powerful supervision and backing, she was an enormous success and was able to launch boutiques all over the country. Sonia's mean-spirited husband, whose life had been blighted by "Picasso's eternal shadow,"[40] would soon find himself increasingly overshadowed by his wife.

As the Barcelona ballet season drew to an end, Olga heard that her papers had finally arrived in Madrid. And so, on November 19, she and Picasso took the train to the capital. Once again they traveled with the company, which had been engaged to give six performances at the Teatro Real. The performances were a disaster. The outbreak of flu had driven half the population of the city out into the countryside. However, Picasso was elated. After a week, which he and Olga spent in separate but adjoining rooms at the Madrid Palace Hotel, they finally left for Paris on the twenty-eighth: he to his villa and beloved dogs in Montrouge and Olga to the luxurious Hôtel Lutétia. Despite the food shortages, bombardments, and blackouts, they were delighted to be back in Paris. Everything in their personal and professional lives was about to change. Picasso had only one regret: he had thought it safer to leave everything he had done since June back in Barcelona,[41] everything, that is, except for his portrait of Olga and a couple of sketchbooks. Officials at the frontier still mistook cubist works for plans of fortifications, and Picasso—the most fearful of men in the face of officialdom—did not want any trouble at the frontier.

6

Return to Montrouge (Winter 1917–18)

The winter of 1917–18 was bitter, and the villa at Montrouge, to which Picasso now returned, was bleaker than ever. The place had been flooded. Several works had been damaged, and the artist's first concern was to have them dried and cleaned up. Some needed to be repainted. On a visit to welcome him back, Severini was surprised to discover that the artist had moved much of his work to his upstairs bedroom.[1] Despite the cold and the discomforts, Picasso was happy to be back home with his pet bird and his dogs and the good woman who looked after the place. A sketch dated December 9 reveals that order had been reestablished: Picasso depicts Olga and himself lunching on roast chicken at a well-set table, waited on by a comically disheveled maid.[2] Two dogs kneel on either side of their master, waiting to be fed. Hanging on the wall, beside the birdcage, is the great Grebo mask that had left such a decisive mark on Picasso's cubism.[3]

Olga settled back into the *confort moderne* of the Hôtel Lutétia where she would stay for most of the next six months. The bills, which Picasso carefully kept, confirm that she took only breakfast at the hotel.[4] Olga, who still aspired to be a prima ballerina, went off to do daily exercises at a ballet school, but there were portraits to sit for, so she spent most of her time at Montrouge. Sometimes the bombing may have obliged her to stay there overnight. A nighttime trip with shrapnel raining down could be fatal. Satie, who lived nearby at Arcueil, narrowly escaped death. "The shells were terribly close to me," he wrote Roland-Manuel, "I thought I was done for! People were killed but not me."[5]

If Picasso was out when friends called, it was because he was hiding: unwilling to interrupt his work, unwilling, too, to expose his precious fiancée to his former *tertulia*. Picasso wanted to shelter Olga from reports of his promiscuity. He would not abandon his whorehouse addiction until much later. In old age, he reminisced about the delights of such famous Parisian brothels as the Sphinx and the Chabanais, and the less luxurious establishments, which he said he preferred. In the engravings of his last years the brothel would become a microcosm of his world.

Since his involvement with the ballet had raised questions as to whether he was still a dedicated modernist, Picasso needed to reestablish himself in the forefront of the avant-garde. As Olga's hotel and dress bills were mounting up, he also needed to earn some money. Fees from Diaghilev, handouts from Eugenia, and the odd sale to Léonce Rosenberg were no substitute for a contract with a major dealer. Shortage of cash obliged him to sell a Renoir, *La Liseuse,* that he had acquired in a swap—probably with Vollard. Léonce's hugely successful brother, Paul Rosenberg, who would become his dealer later in the year, gave him 8,500 francs for it.[6] A few weeks earlier, Picasso had been asked by the up-and-coming Paul Guillaume to participate in a Picasso-Matisse show at his newly opened rue Saint-Honoré gallery. "I am going to have a sufficient number of important works by Matisse," he wrote, "and am anxious that you also should be worthily represented"[7]—Picasso unhesitatingly agreed to do so. In fact, Matisse had refused to participate. To outdo Matisse, Guillaume encouraged Picasso to persuade such

Olga on the porch at Montrouge, 1917–18. Photograph probably taken by Picasso.

patrons as Madame Errázuriz and the Steins to lend their masterpieces. And as he always did with Picasso, Guillaume titillated him with talk of the tribal treasures he had recently acquired, including "a Babylonian Negro, the most formidable in existence,"[8] in the hope of advantageous exchanges.

Guillaume had also prevailed upon Apollinaire, who had helped launch him as a dealer in tribal art, to write a preface for a catalog to be sold to benefit war veterans. Although back in hospital and near death from a pulmonary congestion—a consequence of the 1916 poison gas attack—Apollinaire promised to do so. However, he was unable to attend the vernissage. His short essays do the artists and himself little justice. Apollinaire compared Matisse's work to an "orange . . . bursting with light"; Picasso's to "a fine pearl. Don't toss it in the vinegar, Cleopatra!" Picasso's ability to surprise people reminded the poet of "a plush rabbit beating a drum in the middle of the road."[9]

A few days before the show opened on January 23, 1918, Matisse wrote his wife:

"just what I thought. Apollinaire's preface well demonstrates it. In sum, I don't know what effect it will have, but I think it was directed against me. . . . It's the peak of politics, to attract someone's works while he's away in order to try and demolish him. What must the cubists and cubifiers be saying."[10]

As it happens, we do know what they were saying. The painter Henri Hayden told an interviewer:

> They couldn't stand one another. Even their families quarreled. Picasso was the pet hate in Matisse's family. I was very close to Matisse's son Jean: it was necessary to avoid speaking about Picasso at all costs. The reason for this quarrel? Rivalry. Not material rivalry, because they were both earning a lot of money, in fact Matisse was the bigger earner of the two, but artistic rivalry. Picasso likened Matisse's painting to "vermicelli." Everyone has heard Picasso's off the cuff remark (I don't know if it's actually true): One day Picasso was dining with some friends. He ordered vermicelli soup. Picasso remarked: "Look, this soup was made using Matisse's drawings."[11]

Guillaume had more success with Picasso. The show included sixteen works by him and twelve by Matisse—mostly done in Morocco. Matisse's colors outshone Picasso's, but that did not save the former's paintings from looking less modern than the latter's cubist masterpieces.

By far the most important painting Picasso lent to Guillaume's show was *Les Demoiselles d'Avignon* (1907), which had been exhibited for the first time two years earlier, but had yet to be recognized as a revolutionary icon.[12] Louis Vauxcelles, a critic who would have been forgotten had he not coined those egregious terms "cubism" and "fauvism," published an account—under his pen name "Pinturricchio"—of this enormous painting's arrival at the gallery the day before the opening. "Pinturricchio" described a "fevered mob"[13] watching this "cubico-Picassic, or Picasso-cubic film" being made. It starred such "apostles of the new idol" as Max Jacob, Salmon, and Apollinaire. However, it turned out that Guillaume—one of the first dealers to promote his shows by leaking "news items" to the press—had put Vauxcelles up to this bogus reportage. Much later, Max Jacob explained what really happened: because of the size of the *Demoiselles,* Guillaume had difficulty getting the painting into the gallery, and passersby had gathered.[14]

Despite this mishap, the *Demoiselles* ended up on Guillaume's walls, as confirmed by the worldly, witty Abbé Mugnier—spiritual adviser to Parisian paupers as well as the nobility and the intelligentsia (Huysmans, Bergson, Proust, Mauriac, and many more). After a luncheon at Lucas-Carton on February 7, Baronne de Brimont took the Abbé to see the show. Among the paintings he noted was the "*Femme d'Avignon* [*sic*], for such is the name given to an indecipherable Cubist painting. Across from it a train wreck in a plate of spinach, as they call those gridded things that rise up."[15]

Most of Picasso's close friends had had little or no news of him since his departure for Spain at the beginning of June. Even Gertrude Stein and Alice Toklas, who were still in Nîmes doing war work, had been kept in the dark, despite an exchange of letters. In a Nîmois garage Gertrude had found some tribal sculptures which she wanted to purchase for Picasso. In his reply, he suggested that she should have her collection shipped to Nîmes—the rue de Fleurus *pavillon* was anything but solid, he said—but, surprisingly, he made no reference to his fiancée or his impending marriage. Despite telling her so little, he asked Gertrude to keep everything he told her to herself. Now that he was perceived as a celebrity, he had become secretive about his personal life as well as his work. It would take the members of the former *bande à Picasso* some time to discover that, since last seeing him, their hero had undergone a radical transformation.

One of the few people from whom Picasso had no secrets was his neighbor, Erik Satie. Picasso was anxious to provide him with moral support and financial assistance. He was still involved in a legal battle with Jean Poueigh, who was suing him for slander.[16] Although panic-stricken at the prospect of jail and bankruptcy, Satie was curious to meet his friend's fiancée. As things turned out, his elaborate mock courtesy found favor with *"la gentille Dame,"*[17] just as her demure theatricality appealed to his ironical politesses.

Max Jacob, on the other hand, was out of favor. He had usually managed to keep in with Picasso by inveigling himself into the affections of the women in his life—a strategy that Cocteau would copy—but he proved to be a flop with Olga. Knowing what she did about the homosexual ties that held Diaghilev and his company together and sometimes blew it apart, she is likely to have sensed the sexual nature of Jacob's feelings for her fiancé. Whether or not these feelings had ever been reciprocated, she would have wanted to discourage them. Worse, Olga had intercepted and destroyed a letter from Jacob in which he interceded on behalf of Picasso's unmentionable ex-mistress, Fernande Olivier.[18]

Henceforth, Olga would do her best to drive a wedge between Picasso and Jacob—the oldest and closest of his French friends and one of the finest poets of his time—by imputing all manner of misdeeds to him. As a result, the artist, who always forgave Jacob in the end, would have to sneak off and see him on the sly. The penitent Max had been out of luck on Saint Valentine's Day 1918, as he described in a heartbroken letter to Picasso: "the gate was open but the grill locked. I had brought flowers, cigars and candy. The candy has been smoked, the flowers eaten, and the cigars have faded. My heart's stalled at the locked grill and my hands . . . my hands . . . my hands!"[19]

With Max in disgrace and Apollinaire in and out of hospital during the first three months of 1918, Cocteau saw his chance for becoming Picasso's laureate. As the only one of the artist's Parisian friends to have gained Olga's approval, he was well placed to play up to her, which he assiduously did. By the end of the year, however, Cocteau decided he was tubercular: a pretext for going off to stay at Grasse in the south with his mother's friend, Marie-Thérèse de Croisset (daughter of Proust's Comtesse de Chevigné). Madame de Croisset was the mother by her first husband of a brilliant young heiress, the sixteen-year-old Marie-Laure Bischoff-sheim, who would develop a crush on Cocteau in the course of his visit. Cocteau hoped to marry her, but she opted instead to become the Vicomtesse de Noailles. After six weeks in the south, the poet was back in Paris making arrangements through Olga at the Lutétia (there was no telephone at Montrouge) to visit Picasso. Cocteau was anxious to find a publisher for the *Ode to Picasso* he had written two years earlier, and sure enough he did so. This slick pastiche of Mallarmé, which would come out in 1919, is easily dismissed, but Cocteau turns out to be the only writer to have understood the significance of Picasso's great *Seated Man*.

Cocteau's latest bid to reinvent himself necessitated a new strategy and a new field of activity. He wanted to transcend the superficial modernism of *Parade* and establish himself as an avant-garde impresario. He decided to limit his efforts to contemporary French music—a field relatively free of cubists or dadaists and bereft of leadership. To promote his chauvinistic neoclassical concepts, he published a seventy-five-page manifesto, *Le Coq et l'arlequin,* subtitled *Notes autour de la musique,* in 1919. The title was a reference to Picasso and himself.[20] It took the form of a *rappel à l'ordre:* a call to order for modern French music to be as French as it was possible to be ("French music for France"). According to Cocteau, only Erik Satie, the composer of *Parade,* satisfied this requirement.

Cocteau's choice of Satie was surprising. He still resented the composer for condemning his egregious sound effects for *Parade,* and had recently denounced him to Paul Morand as the "Alphonse Allais of music."[21] However, Cocteau was not one to allow previous convictions to stand in the way of self-promotion. He needed a figurehead and, in an abrupt change of tactics, chose Satie. Debussy was too much of an impressionist—a Wagnerian one—and Ravel too much of a Russophile—a Stravinskyite one—to be considered truly French.[22] Although half-Scottish, Satie was decreed to be quintessentially Gallic. By dismissing Stravinsky as "an octopus which you'd do well to flee or he will eat you," and declaring Satie to be the musical apostle of the new generation, Cocteau hoped to cleanse himself of the taint that *Parade* had resurrected and shine forth in French glory.[23]

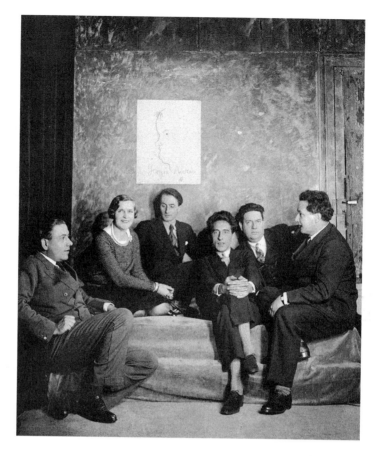

Les Six with Cocteau, 1931. From left: Francis Poulenc, Germaine Tailleferre, Louis Durey, Jean Cocteau, Darius Milhaud, and Arthur Honegger (Georges Auric, who was absent, is represented by Cocteau's portrait of him on the wall). Photo: Roger Viollet / Getty Images.

Stravinsky, to whom Cocteau had dedicated his 1919 book *Le Potomak* in return for the composer's kindness to him, was angered by the author's rejection and his favoritism of Satie over himself.[24] However, Cocteau was so adept at pulling strings that Stravinsky, who needed all the réclame he could muster, did not make an issue of it. Less than a year later, Stravinsky and Cocteau were back in contact, and by 1922 on the best of terms.

Besides promoting the patriotism that the poet wore on his sleeve, *Le Coq et l'arlequin* served as a manifesto for "Les Six," the group of young composers (Poulenc, Auric, Honegger, Milhaud, Tailleferre, Durey) whom Cocteau saw as a showcase for his own skills. That he was not a musician was beside the point. Like Diaghilev, he wanted to be an impresario, but also a star—a star whose effulgence would be generated by the composers he proposed to manage and promote. He also aspired to be a Pied Piper who would rally *le tout Paris* to his chic, gay banner. In this role he would achieve undying stardom.

Le Coq et l'arlequin begins portentously—"art is science made flesh"—and then loses itself in a polemical plea to composers, conducted mostly in aphorisms, to fol-

low Satie's example and write straightforward, down-to-earth French music that would take account of popular culture. To bolster his argument against impressionism in music, Cocteau invokes painting and quotes a comment that Picasso had copied down in one of his *Parade carnets:* "work with three colors—too many colors make for Impressionism."[25] Paradoxically, Picasso had made this comment shortly before doing exactly the opposite and embarking on pointillistic paintings that would be infinitely more multicolored than any of his previous work.

Besides adopting Picasso's anti-impressionist bias, Cocteau appropriated the artist's burgeoning neoclassicism as a platform against Wagner and Debussy. "Impressionism is a side-effect of Wagner," Cocteau fatuously claimed, "the last rumblings of a dying storm. The Impressionist School substitutes sun for light and sonority for rhythm."[26] Warming to his chauvinistic theme, he allows that "you cannot get lost in the Debussy mist as you can in the Wagner fog, but you can catch cold there."[27]

After being away from Paris for most of the previous year, Picasso was overjoyed to be back at long last in his own studio and to be reunited with the vast accumulation of his own work—his "offspring," he said. But life was not easy. There were shortages: above all, of sugar, coal, tobacco, and, even more vital for Picasso, artists' materials. Worse still, the Germans reverted to bombing Paris on January 31. French antiaircraft guns made "a shattering din night after night and all the shells they sent up returned to earth in fragments, an iron hail raining down on the city."[28] And then on March 23, "Big Bertha," the long-range, high-velocity howitzer (named after Bertha von Bohlen, the Krupp family matriarch), began shelling the French capital from the forest of Coucy, seventy-six miles away. The bombardment recommenced every third day for 140 days. Aragon's claim that Picasso took his paintings down to the cellar whenever there was a bombardment does not ring true.[29] The cellar was very damp and there were far too many paintings.

One night, unable to sleep because of Big Bertha, Picasso decided to work. Having run out of canvas, he took a Modigliani that he had recently acquired (or, more likely, swapped) and painted a still life over it—a guitar, bottle of port, sheet music, glass, and a hank of rope.[30] He also repainted several of his own flood-damaged canvases, among them some of the eleven cubist compositions—many over six feet tall and in various states of completion—which Hamilton Easter Field had commissioned for his Brooklyn library in 1911.[31] About half of them had been more or less finished. Hearing nothing from Field and receiving nothing by way of payment, Picasso concluded that the project had lapsed, so he set about turning three of the unfinished ones into post-cubist set pieces.[32] Unusually thick impasto confirms that other compositions of this period have been painted over earlier images: for

Picasso. *Montrouge in the Snow,* 1917. Oil on canvas, 27 x 35 cm. Whereabouts unknown.

instance, the crusty little still life, which Palau has arbitrarily renamed *Rococo Composition.*[33] The inclusion of a pipe and that increasingly rare commodity, a packet of tobacco, as well as a vase of flowers, newspaper, bottle, and wineglass within a decorative chocolate box garland recalls the simple pleasures of everyday life before the war, in contrast to the gloom of this freezing winter.

Besides saving his collection from the flood, Picasso was still determined to recuperate the mass of his work from Kahnweiler's impounded stock. Back in Paris, he had contacted Henri Danet, the lawyer who was handling this matter.[34] He also met with the dealer André Level, who had helped him in his attempts to reclaim the money that Kahnweiler owed him for work that had been sequestrated. In gratitude to Level, Picasso drew his portrait one quiet Sunday afternoon in January 1918.[35] Despite the sale of his Renoir, he was still short of ready money.

To celebrate his first Christmas (1917) with Olga, Picasso did two smallish paintings and a drawing of the Montrouge villa: inside, the snow is falling; outside, the sky is clear.[36] Cabanne associates their simplistic diagrammatic style with Russian folk art.[37] When in love—and he was very much in love with Olga—Picasso enjoyed contriving keepsakes of little paintings, *objets trouvés,* and homemade toys for his beloved.

After Christmas, Picasso commemorated his engagement with a portrait of Olga in all her glory.[38] She wears the black voile dress he had bought for her in Barcelona,

holds a fan, and is seated on a slipper chair that Eugenia Errázuriz had given him.[39] When she suggested that the chair be covered in tapestry, Olga offered to do the embroidery; Picasso drew a floral design on the canvas mesh as his grandson, Bernard, discovered when he had the chair repaired more than eighty years later. This might explain why the embroidery appears in the portrait as a flat decorative panel—maybe the embroidery was not yet finished or the chair upholstered— which makes for a somewhat cubist effect. The painting is Ingresque in pose, concept, and handling.[40] At the same time, it is one of the first examples of Picasso's use of a camera in preparation for a portraiture. He had Emile Délétang take photographs of Olga in the Montrouge studio[41] and followed them closely on canvas. Even the color is virtually *en grisaille,* delicately tinted as if by a retoucher. Photographs reveal a large leather-bound book on the floor to support Olga's foot. Photographs were needed because Diaghilev had summoned Olga back to Madrid in the hope of persuading her to dance once again for the company, which was preparing for a Spanish tour in April. Apart from a note to Picasso,[42] nothing is known about this brief visit, and nothing came of it. A nude study for the portrait was certainly not done from life;[43] Olga was much too modest. Around the same time, Picasso did a small painting of Olga's head and another related drawing of her in a fur-trimmed coat.[44] To save this academic image from looking remotely like a Salon portrait, Picasso has left the background unfinished. The suggestion that the sharp-edged shadow above Olga's right sleeve constitutes a hidden profile of the artist (as in MoMA's 1915 *Harlequin*) is not, to my mind, convincing.[45]

On April 26, Picasso mailed Gertrude Stein a drawing and photographs of his recent work including one of the representational portrait of Olga—"like a photographic enlargement," he said.[46] "Perhaps the best thing you have ever done,"[47] Gertrude replied—a surprise, given her modernist stance. The secretive artist did not reveal that the sitter was his prospective bride, nor that she had recently had an accident and been hospitalized.

While portraying Olga in the flattering, academic style she favored, Picasso portrayed himself as a cubist Harlequin: a Harlequin of utmost gravity (note the large, round, melancholy eyes on either side of the Picassian slab of nose). The title of the painting derives from the sheet music of a popular song called "Si tu veux," that the Harlequin holds in his hand. A comment on the forthcoming marriage?[48] It would seem so. The modesty implied by the song is an ironically courteous touch. *Si tu veux* has either been heavily reworked or probably painted over an earlier image. In its starkness it harks back to the Museum of Modern Art's equally self-referential, equally melancholy *Harlequin* of 1915. The war is present in both paintings. The violin clutched in the Harlequin's curlicue hand might suggest that the diamond-headed Harlequin is courting his sweetheart. However, the grimness of the image,

the touches of snowflake pointillism, and the frosty gray background exorcises the song's sentimentality.

Si tu veux is very much an exception to the other festive commedia dell'arte subjects that immediately precede Picasso's marriage. Most of the subjects are no longer Harlequins, therefore much less self-referential than before. Picasso seemingly wanted to shake off the mantle of the dark, demonic Harlequin Trismegistus that Jacob and Apollinaire had placed on his shoulders when he first came to live in Paris.[49] As a bridegroom, he preferred to identify with the comical Pulcinella,[50] whom he, Diaghilev, and Massine had decided to use as the subject of a ballet. With this in mind, the artist took to working from a model wearing Pulcinella's traditional wide-brimmed, conical hat, baggy white shirt and trousers, and enormous ruff. Pulcinella's *bouffon* costume is very unlike the Harlequin costume Cocteau had given him. Sometimes Picasso combines different commedia dell'arte costumes in the same image: MoMA's *Seated Pierrot*'s white costume includes shadowy hints of Harlequin's multicolored motley.[51]

Picasso. *Head of Pierrot,* Montrouge, 1917. India ink on paper, 64 x 46 cm. Whereabouts unknown.

Despite claiming that he used models only for portraits—and by no means always for them—Picasso exceptionally had recourse to models for his Harlequins and Pulcinellas: a sharp-looking, bony-faced man with a pointed chin and nose; and sometimes a younger, coarser character, endowed with a large waxed mustache.[52] Cocteau may have had the latter in mind when he told Picasso, "Your Harlequin is great looking—a charming truck-driver astonished to find himself dressed as an *apache*."[53]

A painstakingly academic drawing of a nude woman seated on a chair[54] suggests that if he was going to challenge Ingres, he needed to do academic exercises much as a concert pianist practices scales. Picasso also decreed that every artist should have an *Ecole de dessin* sign on his studio door. These assertions are less contradictory than they might seem. Picasso believed that only supreme graphic mastery could enable an artist to break every conceivable rule and, if he wanted to, draw as "badly"—that is to say as instinctively—as he liked.

While doing his prenuptial Harlequins, Picasso worked on other disparate projects: a series of minimalist cubist still lifes and, less successfuly, another stab at pointillism. The cubist still lifes are small and geometrically neat—a single glass or pipe or guitar—and often embellished with sandpaper cutouts. Hard-edged as square-cut diamonds, these gems do not always have an upside or downside.[55]

"We need a new name to designate them," Picasso wrote Gertrude Stein: Raynal suggested "crystal cubism."[56] These little gems may have constituted a response to the so-called Salon cubists who had accused Picasso of betraying cubism—the style that he and Braque had invented and the Salon cubists had dishonored and devalued—by experimenting with classicism. In fact, Picasso was keeping cubism in a constant state of renewal. That his "crystal cubist" experiments should be so fresh and so simple made his critics the more resentful. Pigheadedness blinded them to the protean range of Picasso's powers, to the ease with which he switched back and forth between cubism and classicism, irony and sentimentality, cruelty and tenderness. To envious cubist hacks this smacked of stylistic promiscuity and insincerity.

As for Picasso's attempt to exploit the possibilities of pointillism—this time to fracture light as he had formerly fractured form—it ended in failure. Given his distrust of theory and his preference for local color over *le ton juste,* this was inevitable. Picasso should have avoided pointillism. This was French (and Belgian) territory—Matisse not Picasso was the heir to it. Wisely, Picasso never allowed his garishly pointillistic still lifes and flower pieces of 1918 to be exhibited or published in his lifetime. What a letdown after the watercolors of the Villa Medici, where he handled pointillism subtly and discreetly. Picasso's sense of color was as phenomenal as Matisse's, but it functioned very differently. Whereas Matisse used color instinctively, Picasso saw color as having a separate function from form; he liked to work it out diagrammatically in drawings to eroticize, etherealize, demonize, or otherwise dramatize a specific image.

The principal vehicle for the artist's Picassification of Seurat's method was a large (162 × 118 cm) pointillistic version[57] of the seventeenth-century artist Louis Le Nain's *Happy Family* (57 × 67 cm) in the Louvre:[58] a cheerful scene of a grandmother, father and mother, two boys, and a baby at their evening meal. Back in 1905, Picasso had drawn on a painting by the recently rediscovered Le Nain Brothers for his *Saltimbanques.*[59] So fascinated was he that he would eventually acquire two "Le Nains," neither of which is now accepted as authentic.[60] Picasso told Kahnweiler that he liked the simplicity and awkwardness of their compositions. "It is perhaps their awkwardness that gives them their charm. And then it is very French. Look at all the French painters and you will see [that] basically the French painters are all peasants."[61] Alas, this leaves out of account most of Picasso's favorites: Ingres, Delacroix, Manet, Degas, Gauguin, Seurat, and many more.

A significant source of inspiration for Picasso's pointillistic Le Nain was Balzac's *Le Chef-d'œuvre inconnu.*[62] The obsessive twentieth-century artist closely identified with Balzac's fictive seventeenth-century painter, Master Frenhofer. In the vain hope of rendering light so palpably that you could drive a nail through it, Picasso has blanketed Le Nain's happy family in a blizzard of multicolored snowflakes. If only these

snowflakes did not congeal into molecular blobs—tactile but not very light-invoking! True, there are beautiful passages in this painting—notably the boy and the woman on the left, who melt into the paint, but Picasso found pointillism too laborious, time-consuming, and lacking in spontaneity to spend any more time on it. (See page 305 for the story of *Le Chef-d'oeuvre inconnu*.)

Although he had little faith in Apollinaire's eye, Picasso must have been delighted to receive a letter (March 30, 1918) of congratulation from him on this *"copie éblouissante d'après ce tableau du 17e."*[63] At the end of the summer, he would have been less delighted to receive Apollinaire's account of a conversation he had had "with Sert that isn't bad: he is in favor of the Jesuit, i.e. baroque, style as a traditional one for Catalan artists. It's an idea. They are launching Carolus Durand in Paris. I would like you to paint big pictures like Poussin, something lyrical like your copy of Le Nain."[64] Picasso would indeed go on to "paint big pictures like Poussin"—his huge *Three Women at the Spring* (1921).[65] However, Apollinaire's suggestion that José María Sert, "the Tiepolo of the Ritz," might be on the right track would have appalled him. Carolus Durand reeked of the Salon.

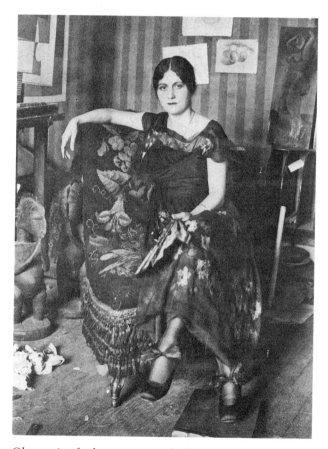

Olga posing for her portrait in the Montrouge studio, 1918. Photograph by Emile Délétang. Musée Picasso, Paris.

In April 1918, Olga's career as a ballerina came to a sudden, painful halt. She had woken up with a terrible pain in her foot. She could not bend it or move it or even get out of bed. A doctor was called.

Dancers can be reticent about their injuries, so we have to guess at the cause of Olga's: an accident in the course of her daily workout at the barre, a previous injury, or some inherent weakness. An old photograph of Olga with a stick at San Sebastián in 1916 (that is, before she met Picasso) suggests that an earlier injury might have been to blame.[66] In later years, when Cocteau needed to avenge one of Picasso's sadistic slights,

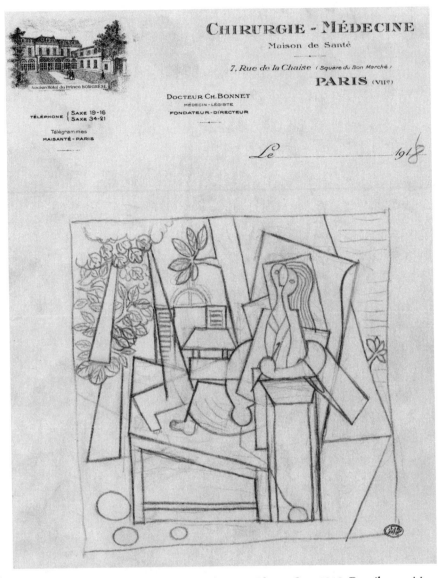

CHIRURGIE - MÉDECINE

Maison de Santé

7, Rue de la Chaise (Square du Bon Marché)

PARIS (VIIᵉ)

Docteur Ch. Bonnet
MÉDECIN-LÉGISTE
FONDATEUR-DIRECTEUR

Ancien Hôtel du Prince BORGHÈSE

TÉLÉPHONE { Saxe 19-16
 { Saxe 34-21

Télégrammes
MAISANTÉ - PARIS

Le _____ 1918

Picasso. *Olga Stretched Out Knitting with Leg in Plaster Cast,* 1918. Pencil on writing paper from Dr. Bonnet's clinic, Paris, 27.8 x 21.5 cm. Musée Picasso, Paris.

he would suggest that the artist "had struck her with a chair during an altercation," as he told James Lord.[67] Olga's papers confirm that Picasso was in Montrouge when the injury occurred.

What we do know for certain is that her condition worsened. Olga may have left the clinic too soon. A week or two later, she was back in Dr. Bonnet's *maison de santé*

on the rue de la Chaise around the corner from the Lutétia, where she underwent an operation, which left her entire right leg encased in plaster. The clinic had a large, shady garden, so she was able to convalesce on a chaise longue under a tree. Picasso did a cubistic drawing of her on the clinic's writing paper, with her leg in a cast, as well as a small painting done after it.[68] Plans for an April wedding had to be postponed.

For a dancer who had not given up on dreams of balletic glory, an injury of this nature must have been traumatic. It would take five months to mend. Cocteau, who was suffering from Spanish flu—"doubtless a virus that originated in Sert's beard," he said—wrote his mother at the end of June that Olga was "still very much an invalid. She is trying out her leg on Dr Bonnet's lugubrious lawns. I am going to be a witness at their wedding, which is imminent. They want to regularize things and get away once and for all."[69] Olga would give the clinic as her address on the marriage certificate.

During Olga's convalescence, Picasso took to using her clinic as his Parisian head-quarters. Toward the end of May, he allowed Apollinaire to hold a meeting there to promote an operetta that he was writing—"a light, gay work to celebrate the peace that was in the air"[70]—based on an incident in Casanova's memoirs. Henry Defosse, leader of Diaghilev's Ballets Russes orchestra, was composing the music; and, it was hoped, Picasso would do the décor. Nothing came of this project, except Apollinaire's treatment and some music.[71]

Apollinaire, who had very nearly died in January, continued to convalesce at the Villa Molière (annex to the overcrowded Val-de-Grâce hospital). At the end of February he went back to work—a new job at the Ministry of Colonies—but he still had to sleep at the hospital. The job left the poet enough time for his own multifarious activities. As well as finishing two novels—*Les Clowns d'Elvire* (also known as *La Femme assise*) and *La Mormonne et la danite*—he wrote several poems, some film scripts, a play, *Couleur du temps,* the Casanova operetta, assorted journalism, and countless letters. He also helped edit the magazines *SIC* and *Nord-Sud.*

That Apollinaire guessed he did not have long to live might explain this compulsion to write and write and spread himself too thin. In his determination to stay ahead of the game, he gave his blessing indiscriminately to anything that could be described as avant-garde. At the same time, the poet, who was still revered as the pope of modernism, was succumbing to the wartime wave of patriotic classicism. He had allowed friends to request the Légion d'Honneur for him, only to be informed that it would not be granted.[72] His involvement in *l'affaire des statuettes*[73] was still held against him. He had hoped to live this down by volunteering for military service, but, to his mortification, his police record was held against him.

Meanwhile, Apollinaire told André Billy that he was in search of a wife: "I need to marry a woman capable of devotion, who will bring me, if not a fortune, enough comfort to ease my anxiety—in my case very severe as with anyone of intellectual audacity. . . . Time rushes by and I am about to be 37."[74] Over the last two years, there had been two prospective candidates: Madeleine, *"la petite fiancée d'Oran,"* the young teacher he had dumped in 1916; and a mystery woman called Georgette Catalain. The wife Apollinaire ultimately chose, Amélie Kolb, better known as Jacqueline or Ruby (because of her red hair), would prove supportive and affectionate, all the same a financial burden. Henceforth he would have to work all the harder to provide for this nice, unsophisticated girl from Nancy as well as himself.

Jacqueline was ten years younger than Apollinaire and had known him before the war. He had fancied her, but she was in love with a lesser poet, Jules-Gérard Jordens. After Jordens was killed on the Western Front in 1916, she had run into Apollinaire outside a department store. He was still convalescing from his trepanation; she was a volunteer nurse. Realizing how disabled he was, she had taken him home in a cab. Her solicitude convinced him that she would make a good wife, even though she went off to Brittany to have an affair with Irène Lagut.[75] Apollinaire had insisted on joining them. Irène's stories about her scabrous past inspired him to write a book about her, *La Femme assise.*[76] Far from advancing her career as she had hoped, the book enabled Apollinaire to get his own back on Irène, whose affair with Jacqueline would linger on, as would Picasso's sporadic involvement with Irène, into the 1920s. On March 22, 1917, Jacqueline announced in a postscript to a letter written by Apollinaire to Picasso that "the first-born heir is expected." Jacqueline apparently miscarried.[77] Meanwhile, Apollinaire's health had declined even further. Jacqueline nursed him with utmost solicitude and persuaded the doctors to let her wear a nurse's cap and be with him at the hospital.[78] They decided to get married in May 1918.

The death of Jacqueline's brother in action necessitated a very simple wedding. The witnesses for Apollinaire were Picasso (without Olga, who was in the clinic) and a useful new friend, the writer Lucien Descaves, a member of the Académie Goncourt, which Apollinaire was anxious to join. He also had a brother, Eugène, who was an official at the Préfecture de Police and in that capacity would prove a help to Picasso in his bid to get married. Jacqueline's witnesses were Vollard, Picasso's first Paris dealer, and Gabrielle Buffet-Picabia. Cocteau, who longed to become a close friend, gave the bridegroom an Egyptian statuette as a wedding present, which Apollinaire wrote a poem about by way of thanks. Nevertheless, Cocteau was not invited to the ceremony.

Apollinaire had had to obtain special leave for his marriage. The civil ceremony took place on May 2 at the *mairie* of the seventh arrondisement, and the religious ceremony immediately afterward at the nearby church of Saint Thomas Aquinas.

The wedding group then repaired to Poccardi's on rue d'Amboise for lunch. That evening, Picasso dined alone with the Apollinaires. He gave them one of his latest paintings: a guitar executed in parallel lines that mimic the corrugations of cardboard. The paint may not have dried, for the poet wrote asking Picasso to fix it.[79] At night Apollinaire returned to hospital. A week later, Jacqueline went back to Brittany, this time to escape Big Bertha.

Picasso was also anxious to arrange his own wedding. He and Olga could then go and stay with Eugenia at La Mimoseraie, her *cabane* at Biarritz. As the honeymoon was to last the rest of the summer, Picasso had sent the materials he needed and also some unfinished canvases he hoped to work on to Biarritz. On June 18, Eugenia wrote Picasso that her *cabane* was not yet ready. She proposed an alternate arrangement: rooms on two floors of a nearby *pension*—"very modest but good beds and clean." She and Olga would be on the ground floor, Picasso on the floor above. "There'll be a large wicker chair for her to spend the day in the garden."[80] Eugenia was very thoughtful; she was also very manipulative. The couple decided not to leave Paris until La Mimoseraie was habitable. Meanwhile, they set about planning their marriage.

Picasso and Olga in the garden of La Mimoseraie, Biarritz, 1918.

7

Marriage (Summer 1918)

Apollinaire's marriage served as a prelude to Picasso's. By early July, Olga's leg had healed sufficiently for a date, July 9, to be set for the wedding. Her plaster cast would be off by then; also her papers would be in order, thanks to Eugène Descaves (brother of Apollinaire's witness Lucien Descaves). On June 10 Apollinaire had written Lucien, "Our friend [Picasso] is probably going to have need of [Eugène's] services for his marriage. He requires notarized papers for his fiancée, who has nothing but a passport, and the Bolsheviks won't let her obtain any documents from Russia."[1] Descaves must have done what was expected of him, for Max Jacob informed Picasso that he had recently sold Descaves a Picasso drawing for one hundred francs and that Max had asked the official what remuneration he expected for his services. Descaves had stipulated a drawing of a Pierrot in a ruff that he had seen Picasso walk over on the studio floor. True, the artist left things lying around all over the place, but he put too much of a premium on his work to trample on it.[2] Descaves failed to get his drawing.

At the last moment there was a hitch—seemingly occasioned by Olga's leg. The wedding had to be postponed until July 12. Even then the bride had to hobble around on a stick—a galling experience for a ballerina on her wedding day. The civil ceremony was held at the *mairie* of the seventh arrondissement on the rue de Grenelle.[3] The witnesses for Picasso were Apollinaire and Jacob; and for Olga, Cocteau and Valerian Svetlov, ballet critic and historian and a great friend of Diaghilev, known for his white "quiff" as "Mr. Parrot." One of the mayor's assistants, Gustave Reynier, also signed the register.[4]

Olga had insisted on a religious ceremony with all the Orthodox ritual. It took place at 10:45 a.m. in the Russian church on rue Daru. Since Eugenia had already left for Biarritz to prepare for the honeymooners, Picasso entrusted the organization of the festivities to Misia Sert. Misia claimed that Picasso had asked her to be a witness.[5] I doubt it. She was a famous liar and would not have wanted to be perceived as less important than Cocteau.

Later that day, Cocteau wrote his mother, who was on holiday in Biarritz, that the

wedding had exhausted him: "I had to hold a crown of gold over Olga's head; it made us all look as if we were performing in *Boris Godunov*. The ceremony was beautiful, a proper wedding with mysterious rituals and chanting. Luncheon afterwards at the Meurice, Misia in sky blue, Olga in white satin, tricot and tulle—very Biarritz."[6] Neither Cocteau nor anyone else provides a guest list.[7] Misia would have had a hard time rounding up friends at such short notice. The smallish group included no family members, nor any of the artists closest to Picasso: the Braques were at Sorgues; Derain in the army; the Grises at Loches; the Severinis in the mountains. Besides the witnesses, the luncheon might have included the Beaumonts; Misia's lover and future husband, José María Sert; Georges Bemberg and his Russian wife; Valentine Gross, who would marry Jean Hugo a year later; Erik Satie; Stravinsky; Ambroise Vollard, who had had the bride and groom to dinner to meet his current mistress, Etelka (identified by Picasso as a Turkish prostitute from Madrid); Eugène Descaves; and the André Levels (who had written to ask Picasso what he wanted as a wedding present).[8] No wedding photographs were taken. Photographs that appear to have been taken on the day of the wedding were actually taken at Biarritz sometime later.

The main event of Misia's wedding luncheon was Apollinaire's recital of the eight-stanza epithalamium he had written for the occasion.[9] *"Mon cher Pablo la guerre dure,"* it begins, and goes on to envision the war ironically as *"tendre de la douceur"*— each piece of shrapnel a flower. In another stanza, the poet hails "our marriages" (his and Picasso's) as "the war's triumphant offspring." The version of the poem that Apollinaire copied out in his best handwriting and had bound in morocco as a wedding present for Picasso has disappeared. The version in the Musée Picasso is a preliminary one, jotted down on the back of a sheet of Ministry of Colonies paper, with corrections and a caricatural sketch of Cleopatra's enormous nose that figures in the poem.

Olga did not move back into the Lutétia until the day after their wedding, this time with her husband, and into a rather larger room. The same day, she received a letter from Jacqueline Apollinaire, wishing her a speedy recovery but warning her not to be alarmed at the slowness of the treatment: "It's only a question of time, and I hope that I will soon be applauding you as one of the *femmes de bonne humeur.*"[10] Jacqueline was right, Olga's recovery would be agonizingly slow. For the next two weeks, the Picassos stayed on in Paris, waiting for Eugenia's rented *cabane* at Biarritz to be ready for them. Once again, Olga's condition worsened. On the same page of a sketchbook where he noted the departure time of the train to Biarritz, Picasso drafted a letter to her doctor, Pascalis, informing him that she had left the clinic the day before but needed him to come to the Lutétia as soon as possible and take a look.[11] Something had indeed gone wrong, but medical records are not available.

Above: (from left) Olga and Eugenia Errázuriz with two other women in the garden of La Mimoseraie, Biarritz, 1918. Archives Olga Ruiz-Picasso.
Right: Olga at La Mimoseraie, Biarritz, 1918. Archives Olga Ruiz-Picasso.

Meanwhile, the Picassos saw much of Misia, also of Cocteau, who had decided to accompany the Picassos to Biarritz, where his mother was already in residence. At the last moment a better option materialized. Etienne de Beaumont invited Cocteau to move into his magnificent *hôtel particulier* for a week or two while his wife was away. This was too tempting an offer to forgo. As well as going out on the town together, Beaumont and Cocteau amused themselves organizing mismatched dinner parties: one of them included Anatole France, André Citroën, and the musical-comedy star Mistinguett. In the course of Cocteau's visit, even more of Beaumont's waspishness, panache, and style rubbed off on Cocteau.

When Edith de Beaumont returned, Cocteau decided against joining the Picassos in Biarritz and went instead to Le Piquëy—a fishing village on the Bay of Arcachon with a primitive hotel he had stayed at the year before. It was just like "living in Uncle Tom's Cabin in a negro village," Cocteau told André Gide.[12] He could unwind and go native—sunbathe naked and turn as black as the American soldiers who had played jazz at the "great negro fête" Beaumont gave in his garden as soon as Cocteau left. From Le Piquëy, Cocteau wrote constantly to Picasso, thanking him and Olga for their kindness to his mother in Biarritz. Told that the Picassos were looking for a Paris apartment, Madame Cocteau, primed by her son, had urged them to move to the nice, quiet rue d'Anjou where the Cocteau family lived. Picasso failed to follow up on this suggestion.

As things turned out, La Mimoseraie would not be ready for the Picassos until

Giovanni Boldini. *Portrait of Eugenia Errázuriz*, c. 1895. Oil on canvas, 76 x 63.5 cm. Private collection.

July 29. Misia, who was good at pulling strings, had arranged for the newlyweds to have a sumptuous *coupé* (private compartment) on the night train to Biarritz. This made the journey much easier for Olga, who needed to keep her leg up, and Picasso, who had two dogs with him, Derain's Sentinel and a new Pyrenean sheepdog called Lotti (a diminutive of Charlotte). Far from being the modest *cabane* that Eugenia had described, the house was a medium-sized, late-nineteenth-century villa of indeterminate style and considerable charm. It belonged to the owner of the Hôtel d'Angleterre, next door to the casino, and its gardens had provided his hotel with flowers— mimosa all winter. Over the next few years, Eugenia would transform La Mimoseraie into a house of monastic simplicity—whitewashed walls and terracotta tiles. A minimalist fifty years ahead of her time, Eugenia had thrown out everything except a few armchairs. Her innovations would shock her hidebound neighbors, who lived in elaborate villas filled with fake *dix-huitième* furniture and ormolu bric-à-brac, as much as it delighted her progressive friends.

In Paris Eugenia's apartment was furnished with things that would harmonize with the cubist masterpieces on her walls: a stepladder from a hardware store, some metal seats pinched (though not by her) from the Bois de Boulogne, and a massive red lacquer cupboard for the concealment rather than the display of her "things." The self-denial, even mortification, in Eugenia's minimalism reflected her resolutely austere taste in art and decoration, as well as her Spanish piety. She did not see herself as a Maecenas or a muse so much as a secret sharer in her protégés' sacrosanct work. If she provided her geniuses—Picasso, Stravinsky, Blaise Cendrars (and, later, Le Corbusier)—with financial aid and tobacco, she did so in the spirit of almsgiving.

While Picasso worked away in his studio at La Mimoseraie, Eugenia would work in her garden, barefoot; for just as she liked to drink either the purest spring water or champagne, she either went without shoes or wore the highest of heels. Instead of planting flowerbeds with canna lilies, begonias, and lobelia, as the owners of other villas did, she gave over her entire garden to vegetables neatly set out in rows and rectangles. Eugenia abhorred elaborate flower displays, only liking cut flowers if they were of the simplest variety and stuck in a jar. Houseplants were aromatic ones— rose geranium, lemon verbena, lavender, jasmine—in terracotta flowerpots.

Picasso's ten-week stay in Biarritz was not so much a honeymoon as a resumption of his prewar habit of spending the summer somewhere quiet, warm, and merid-

ional—Gósol, Horta, Cadaqués, Céret, Sorgues, Avignon—where he could embark on new projects. Once again, the sea in summer worked its magic. For although the Mediterranean had given birth to Picasso, and provided him with so much of his imagery, it was on an Atlantic beach at Corunna that he had had his first, never to be forgotten glimpse of a woman's pubic hair. Nudes, conspicuously absent from his recent work, reappear, in the rough-and-ready murals he sketched on the whitewashed walls of his little studio in Eugenia's house.[13] These were among Picasso's first Biarritz paintings. Two weeks after his arrival, he informed Apollinaire that he had finished some wall decorations that included a stanza from a poem of his. "I am not too unhappy here," he added, as if in some doubt.[14] For someone as physical as Picasso, Olga's untouchable leg must have been extremely frustrating.

Wall decorations by Picasso at La Mimoseraie, Biarritz, 1918. Whereabouts unknown.

Decorating the walls of temporary studios had become a habit of Picasso's—a compulsive consecration of his place of work. He had done this to studios in Barcelona, Montmartre, and Sorgues and would do so again in Juan-les-Pins, Antibes, and Vauvenargues (the bathroom, not the studio). This time, his light-hearted Apollinairean idylls were a housewarming present for his hostess. The lines on Eugenia's walls had been taken from the opening stanza of Apollinaire's "Les Saisons"—a poem written in April 1915 and recently republished in *Calligrammes:*

> For us beachcombers it was a blissful time
> Going off at dawn barefoot, bareheaded
> Until quick as a toad's tongue
> Love would strike both the wise and the foolish in the heart.[15]

"Les Saisons" goes on to evoke the war in the same ironical spirit as Apollinaire's epithalamium. A subsequent stanza about stars in the night sky mimicking bursts of shrapnel inspired Picasso to use washes of fountain-pen ink to color the ceiling of his little room a night-sky blue.[16] After scratching a Milky Way into the blueness, he surrounded his cavorting nymphs with yet more stars. Each section, including the window, has a border resembling the brass studs on the back of the seventeenth-century chair in which he posed his sitters. "But the house is only rented," Eugenia gasped on seeing Picasso's decorations for the first time.[17] Eventually (1925), her son Max

would buy the house for her, but by that time her fortune had started to dwindle and paintings had to be sold. Picasso would help her out, just as she had helped him out. Eugenia would continue to live at Biarritz ever more austerely until she returned, in her eighties, to die in her native Chile.

Until the Côte d'Azur took over in the early 1920s, Biarritz was far and away the most elegant summer resort in France. Because of the war, many of the hotels had been commandeered by the army, but the Hôtel du Palais (formerly the Villa Eugénie that Napoleon III had built for his Empress) and the casino continued to attract old as well as new money. In their wake came the courtesans and the gigolos, the jewelers and the art dealers who catered to them. "I have seen [Paul] Rosenberg," Picasso told Apollinaire, "he has sold all his [Douanier] Rousseaus. [Jos] Hessel is here with all the Paris *antiquaires.* I have had a letter from Paul Guillaume, he's arriving any day."[18] He failed to do so.[19] Nathan Wildenstein, Paul Rosenberg's partner and father of Georges Wildenstein, had rented a villa, Les Violettes, almost next door to La Mimoseraie, for the winter and stayed on for the summer. Nathan loathed modern art, but his anything but avant-garde son saw there was a profit to be made and courted Picasso. Despite an inherent dislike of the "trade," the artist made himself available to the Wildensteins and their associates. Now that he was married to a woman with expensive tastes, he needed a dealer with sufficient resources to finance the lifestyle to which they both aspired.

Just as in 1910 Picasso had painted major cubist portraits of his three most important dealers—Kahnweiler, Vollard, and Uhde—he now embarked on a large, representational painting of Paul Rosenberg's wife, Margot, with her plump little daughter, Micheline, on her knee.[20] The delight Picasso took in painting this pouting, squirming piglet[21] redeems an otherwise lifeless portrayal of a woman who aroused little interest and no desire in him. Madame Rosenberg—a frustrated good-time girl with a taste for luxe rather than art—disliked the painting. She had wanted Boldini to paint her. Picasso realized this and did a caricature of his portrait, which he signed "Boldini."[22] The painting could indeed have done with a touch of Boldini's brio. However, Paul Rosenberg was very pleased with the portrayal, and the rapport resulting from the sittings paved the way for an advantageous contract. Picasso's drawing of

Picasso. *Mme Rosenberg and Her Daughter Micheline,* 1918. Oil on canvas, 130 x 97 cm. Private collection.

the husband—a man he would respect for his business acumen rather than his eye—is far more incisive than the painting of the wife.[23] The same can be said of the superb Ingresque drawing of Madame Georges Wildenstein, the next-door neighbor who had become a friend of Olga's.[24] Poor woman! Her husband was about to embark on a secret affair with the less pretty but much livelier Margot Rosenberg.

Since Olga was confined most of the time to an armchair or chaise longue, Picasso could draw her all he wanted. She enjoyed this ritual; it calmed her when she was upset. However, she always keeps her distance in these portrayals, and he always keeps his libido buttoned. Sometimes he depicts Olga as a noble, Ingresque beauty; sometimes less formally, as a soulful young wife; sometimes as a cubist construction. One of the Biarritz sketchbooks is filled with watercolors in which Olga is reduced to patterns of rhyming curlicues and arabesques: a form of cubist notation that could not be more antithetical to his emergent classicism.[25] However far Picasso goes in one direction, he continues to stray in the other.

In his very similar watercolors of La Mimoseraie and its environs, Picasso carries ornamentation to such an extreme that flowering shrubs and balustrades are indistinguishable.[26] Some of these watercolors depict a bizarre, machicolated building, visible from Eugenia's house. Topped by a dome and six toy-fort towers, each named after one of the owner's mistresses, the house was known locally as "Bluebeard's Tower." Picasso sent Apollinaire a drawing of it. *"Le château d'un russe,"* he wrote.[27] In fact, the "château" had been built by a local engineer who owned the Biarritz gasworks.

Picasso also executed a number of highly finished graphite drawings of the beautiful daughters of Eugenia's Spanish and South American friends who were summering at Biarritz. Of these *jeunes filles en fleur,* the one Picasso fancied and drew most frequently was the seductive Argentinian heiress Diadamia Patri. Besides three or four Ingresque likenesses of her,[28] he depicted her more intimately as a disheveled coquette,[29] and gave her a small, Renoir-like gouache of a white rose. She also inspired some lighthearted harlequinades in which an almost nude look-alike gazes at herself in a mirror held up by a child, while a Pulcinella, that is to say the artist, serenades her on a guitar.[30] In another of these harlequinades,[31] the central figure is very different—seemingly a nun holding a devotional book. A rather representational drawing of this "Spanish nun" reveals her to be Eugenia.[32] As a member of an order

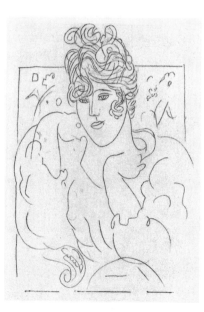

Picasso. *Portrait of Diadamia Patri,* 1918. Pencil on paper, 31 x 23 cm. Whereabouts unknown.

of lay nuns, this famously pious woman liked to appear in public wearing the habit that Paquin had made for her.

Picasso told Apollinaire that he was seeing a great deal of the beau monde; so, despite her leg, was Olga. Biarritz had always been popular with Russians, so much so that the fall season was known as *la saison russe*. From her window, Olga could glimpse the onion domes of the Russian church opposite the Hôtel du Palais. Several of the grander villas belonged to Russian noblemen or rich entrepreneurs. The star of the Russian contingent was the singer Marthe Davelli, who would arrange, a year or two later, for Chanel to become the Grand Duke Dimitri's mistress. Biarritz's leading philanthropist was a Muscovite, Lazar Poliakoff ("king of the Russian railroads"), who entertained his fellow countrymen lavishly at his Villa Oceana. Olga preferred her hostess's more cultivated circle.

Eugenia's best friends in Biarritz were the Marquesa Villa-Urrutia (wife of the Spanish ambassador to France), the Marquesa Villavieja, and one of the King's favorites, Carlos de Beistegui, the enormously rich Mexican ambassador to Spain whom Picasso had met in Madrid the previous year. Beistegui—not to be confused with his nephew and namesake, the obsessive decorator whose only client was himself—had installed part of his small, choice collection of paintings, including works by Goya and Ingres, in his Villa Zurbiac. Years later, Picasso liked to recall the steeliness of the bayonettes in a small barricade scene by the meticulous Salon painter, Ernest Meissonnier. Apprised by his mother of Picasso's success with the beau monde, Cocteau could not resist denouncing his lionization. "He hates that and will take against Biarritz. . . . There will be dramas," he wrote, and underlined the words.[33] There would be no dramas. Cocteau was envious; the beau monde was *his* preserve. Picasso was beginning to derive a certain cynical amusement from his social success. What he most liked about Biarritz was that almost everyone spoke Spanish.

One person Picasso was happy to see was his admirer since the first night of *Parade,* Chanel, who had chosen Biarritz as the venue for her avant-garde summer fashions. She had followed up her triumph in Paris by buying the Villa Larralde and converting the stables into a bustling workshop. The provocative Chanel bathing suits—sleeveless, skirtless, clinging—would catch Picasso's eye. Fascinated by this revolutionary garment's effect on the way women looked and behaved, Picasso did a fine, small painting of three bathing-suited girls—each fiddling with her hair—on the beach below the Palace Hotel.[34] This is the first of countless bather compositions in Picasso's work. Besides using the beach as a setting for classical idylls, he would envision it as a sexual arena, later still as a cosmological limbo outside time and space.

The Biarritz *Bathers* harks back to Puvis de Chavannes's celebrated *Young Girls*

by the Seashore,[35] however, Picasso has been careful to exorcise Puvis's wan blend of romanticism and neoclassicism with up-to-the-minute allusions to the fashion plates of Braque's old friend, the illustrator Georges Lepape. This summer, Lepape's svelte, flat-chested, long-waisted flappers are the sisters of Picasso's. By next summer, these flappers will have grown into hefty goddesses. Picasso's also drew on his own past: specifically his melon-buttocked *Bather* of 1908,[36] whose elongated arms and legs anticipate the skinny articulation of the Biarritz girls.

Another of this summer's *chefs-d'œuvre* is a fine pencil drawing of fifteen naked nymphs at play on the beach.[37] Its sheen recalls Ingres's *Bain turc,* which had dazzled Picasso when he first saw it at the 1905 Salon d'Automne after a century of conceal-ment.[38] The recumbent figure at the center is a direct quotation from Ingres. The lin-ear purity of the drawing also recalls the Etruscan mirror backs Picasso had studied in the Louvre. The intricacy and complexity of the composition, with its three central figures—one standing, one sitting, one reclining—interspersed with playful couples wrestling, running, and caressing each other, suggests that he may have envisaged an ambitious painting along the lines of the large neoclassical *Bathers* Renoir had painted thirty years earlier.[39] However, Picasso's drawing turns out to have been an end in itself, a manifesto of his neoclassical mastery. To have executed it in paint would have been superfluous—*pompier* and time-consuming. Most of the single figures and small groups to be found in Picasso's subsequent neoclassical works derive from this little masterpiece.

In the course of this honeymoon summer, Picasso painted a couple of still lifes of a basket of fruit, which are remarkable for their banality. One of them is painted directly onto a tray,[40] which suggests that it was intended as a present; it would have been too kitschy for his exigent hostess, but perfect for his incapacitated wife. The other still life is signed and dated, "Juan de Luz, 1918,"[41] and is the only evidence we have that the artist worked at Saint-Jean-de-Luz, a charming, as yet unspoiled Basque resort some eight miles south of Biarritz.

That summer, Saint-Jean-de-Luz had been turned into a hive of cultural activity by Princesse Edmond de Polignac, the Amazonian patron who had presided with Misia over the *Parade* opening. A disciple of Debussy, Winnaretta had been shat-tered by the composer's death in March 1918. Instead of spending the season in her Venetian palazzo, she had chosen to grieve at Saint-Jean-de-Luz in the cottage where Debussy had passed his last summer. Indignant that this illustrious man had been insufficiently eulogized, Winnaretta devoted herself to memorializing his work. With the help of Picasso's old friend, the Spanish pianist Ricardo Viñes, as well as Saint-Jean-de-Luz's cherished composer, Ravel, she had arranged a festival in Debussy's

Olga at La Mimoseraie with paintings by Picasso, 1918.

honor, which was attracting throngs of modern musicians. The proximity of Spain prompted Winnaretta to commission (through Viñes) a work from Manuel de Falla, *El retablo de Maese Pedro,* based on an episode from *Don Quixote.*[42] Picasso would have had every reason to visit Saint-Jean-de-Luz to find out from Viñes (and possibly Falla) whether or not Diaghilev's "great Spanish ballet," soon to be called *Tricorne,* had been shelved.

There was no mention of *Tricorne* when the impresario had cabled Picasso in August asking him and Olga to join the company in London for the reprise of *Parade* in November 1918. The artist had not bothered to reply. Diaghilev would try again in October to reassure his *"cher Pica"* that visas for England would be no problem[43]— again to no avail. Picasso knew that Diaghilev's principal reason for enticing him to London was to paint a full-length portrait of Massine as a commedia dell'arte figure—a project that had been mooted the previous summer. Diaghilev said he had set aside ten thousand francs for this commission. Coincidentally or not, Picasso had already begun just such a painting (as well as an identical, very worked-up drawing),[44] but it turned out to be a generic image of a Pulcinella rather than an actual portrait of Massine. Picasso would never paint Massine, but the following year he would do a bravura drawing of him.[45]

Diaghilev said he was very worried about Olga. "Has she abandoned the art of dancing for good? It would be a great shame. As a choreographer, Massine misses her, so, as a loving old friend, do I."[46] In fact, Olga's leg was much better. Around August 20, she wrote Jacqueline Apollinaire that she was still *couchée*.[47] Ten days later, she wrote that she was finally beginning "to walk a bit."[48] However, it was not until late September that she finally appeared to be *"tout à fait remise."*[49] Normally, she would have had to undergo months of agonizing rehabilitation before being allowed to dance. Whether or not she did so, one thing is certain: Olga never danced again in public. This would prove to be an intolerable test for Picasso's ambivalent tenderness. The shadow of Olga's injury would darken his future relationships with women. "Women's illnesses are women's fault," he said to me many years later, as if to shift the guilt and the blame from his shoulders onto theirs.

Olga with a cane, with works from the series *Woman in an Armchair,* Biarritz, 1918.

Picasso's work was going so well and he felt so at ease at La Mimoseraie that he would have stayed on another month had he not received news that burglars had broken into the Montrouge house. He immediately (September 28) cabled Apollinaire: "Unable to leave just yet. Would you do the necessary?" He signed it *"ton Pablo"* rather than Picasso for fear of wartime censorship. This did not prevent the telegram's being held up for two days.[50] On arriving in Paris a few days later, Picasso sent Apollinaire a note: "My old pard . . . need to see you, if you have a moment . . . *Je t'embrasse."*[51]

A photograph taken shortly before Picasso left La Mimoseraie shows Olga, crouched with her stick on the floor of the living room, surrounded by paintings he had done in the course of his visit, as well as the great *Seated Man* belonging to Eugenia. It is an impressive, stylistically varied group: MoMA's *Pierrot;* the Washington National Gallery's cubist *Still Life on a Table* (the one with the realistic table leg jutting out at us), which he would rework in Paris; the Musée Picasso's *Bathers;* the *Portrait of Madame Rosenberg;* and a large cubist composition, which was either painted over or destroyed.[52] Given the paintings and drawings Picasso had done and the sketchbooks he had filled, his two-month honeymoon had been extraordinarily productive.

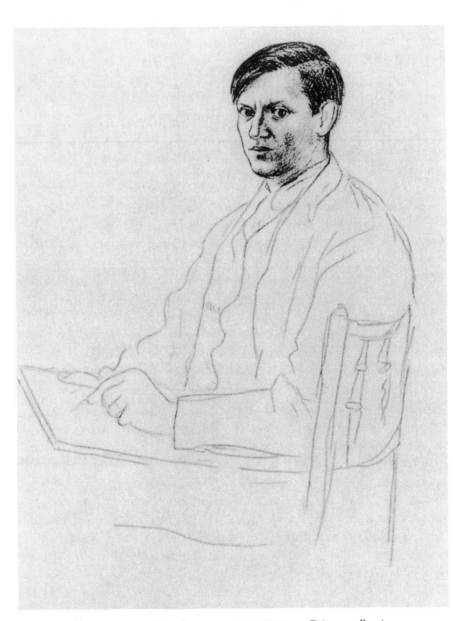

Picasso. *Self-Portrait,* 1918. Pencil on paper, 34 x 23.5 cm. Private collection.

8

Death of Apollinaire

No art, only linen turned out to have been stolen from Montrouge. In her book on Picasso, Gertrude Stein wrote that this burglary

> made me think of the days when all of them were unknown and when Picasso said that it would be marvelous if a real thief came and stole his pictures or his drawings. Friends, to be sure, took some of them, stole them if you like from time to time, pilfered if you like, but a real professional burglar, a burglar by profession, when Picasso was not completely unknown, came and preferred to take the linen.[1]

A few weeks later, Picasso visited Léonce Rosenberg's Galerie de l'Effort Moderne. Someone commiserated with him for being robbed.[2] "Ransacked," Picasso replied, gesturing at Rosenberg's walls, which were lined with paintings by cubist copycats. He had a point, although some of these works were doubtless by Juan Gris, who was under contract to Léonce at the time and could have leveled a similar complaint at some of Picasso's recent appropriations.

The honeymooners returned home to Montrouge at the beginning of October and set about searching for a suitable apartment in central Paris, the farther away from Picasso's old haunts the better. Paul Rosenberg saw to it that they did not have far to look. To keep his valuable new artist under surveillance, he arranged for him to rent an apartment at 23, rue la Boétie, the building next door to his, and on the corresponding floor. Rosenberg had a lease drawn up, and by October 16 Picasso was able to show the apartment to Apollinaire.[3] Two days earlier, they moved from Montrouge to the Hôtel Lutétia, the better to supervise the decoration. Meanwhile, for his work Picasso continued to use the Montrouge studio.

Before leaving for Biarritz, Picasso had embarked on a colorful still life on a gueridon.[4] The image did not live up to its considerable size (147 × 113 cm), which is probably why, when he returned to Montrouge,[5] he transformed it into a Harlequin. A few strokes of his metamorphic brush turned a rudimentary fruit dish into a rudimentary moon face; he then added three pudgy fingers to the neck of the guitar to imply arms; two shadows cast by the table to suggest legs—and the Harlequin comes

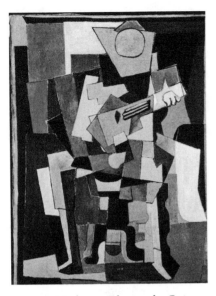

Picasso. *Harlequin Playing the Guitar,*
1918. Oil on canvas, 147 x 113 cm.
Private collection.

to life. The resultant hybrid helped trigger a masterpiece, the Smith College Museum of Art's *Table, Guitar and Bottle* (see insert);[6] it also showed Picasso how to make his still lifes come alive, as we will see in the countless anthropomorphic gueridons of the next two years.

Exactly how long Picasso continued to work at Montrouge is unclear, but he seems to have made use of the studio well into the spring. That he worked in two very different environments during the winter of 1918–19 is reflected in his astonishing ability to work in two seemingly opposite styles as well. The extent of this dichotomy became evident only after Cowling discovered that the two key paintings of the period—the Ingresque *Olga in an Armchair* and the cubist *Table, Guitar and Bottle*—had been wrongly dated 1917 and 1919 and that Picasso had actually begun them both in 1918.[7] Picasso saw himself as a paradox, and he enjoyed playing volumetric representationalism against synthetic cubist flatness, much as he enjoyed playing Olga's conventionality against his own instinctive iconoclasm.

"A condensed representation of [Picasso's] studio"[8] is how Cowling describes Smith College's *Table, Guitar and Bottle.* I would go even further and see it as a metaphorical self-portrait. The bottle suggests a head in double profile set on what might be a neck. The L-shaped form below implies an upper arm and elbow; and the stacked forms on the floor set up a rhythmic rapport between a variety of legs—easel legs, table legs, human legs and one that resembles a carpenter's square. In the course of studying the image upside down, Cowling established that Picasso had done the same while working on it, and an anthropomorphic presence continues to make itself felt. The Smith College gueridon is another *chef-d'œuvre inconnu* in that the subject is concealed, as it is in its great predecessor, the *Seated Man,* another bid to rethink and revitalize cubism.

Shortly after his visit to the rue la Boétie, Apollinaire's precarious health took a turn for the worse. He could not stop coughing. To Vollard, who saw him in the street clutching a bottle of rum, early in November, he said, "with this I can laugh at the epidemic,"[9] referring to the Spanish flu that was decimating Europe. With his lungs already weakened by emphysema, Apollinaire stood little chance against it. Cocteau used his friendship with Picasso to stay close to the sickbed, the better to lay the foundation for what Steegmuller describes as "a posthumous friendship."[10] His

assiduous courting of Apollinaire had not been very successful, as an embarrassingly plaintive letter (June 9, 1917) reveals:

> Dear Apollinaire, I am sad because I had hoped we would see each other and that would bring us closer. Each time we meet, I feel I am an object of suspicion [*je vous suis "suspect"*]—watertight compartments—solitude—and the realization that if a man like you cannot perceive my profundities, it will be impossible for anyone else to discover them.[11]

Unable to keep Cocteau at bay, Apollinaire reluctantly accepted the services and the gifts that he proferred, including an expensive pipe—an odd present for someone dying of lung disease. However, a much more formidable young poet was also determined to step into Apollinaire's illustrious shoes: a youngish (twenty-two-year-old) man in a blue uniform, whom Picasso remembered meeting for the first time in the hallway of Apollinaire's apartment a day or two before his death—"a military orderly, I think, [who] had been extremely courteous and did not hide his grief at Apollinaire's state of health."[12] This was André Breton: the future leader of the surrealists and Cocteau's nemesis. Breton and his friends were already planning a brutal campaign against this pampered, high-society homosexual, who was trying to gate-crash the avant-garde. Cocteau did not stand a chance against Breton.

The morning of Apollinaire's death, Cocteau summoned Picasso and Max Jacob to his apartment and asked them to let him bring his doctor, the fashionable quack Capmas, to see the invalid. Apollinaire turned out to be terrified of dying. "I want to live. I want to live," he told Capmas, who thought there was a chance of saving him. Late that afternoon, Picasso happened to be walking "along the wind-swept arcades of the rue de Rivoli," as he told Penrose,[13] when a war widow's black veil blew across his face, momentarily blinding him. To anyone as superstitious as Picasso this could mean only one thing, death. Back at the Lutétia, the artist sat down in front of the bathroom mirror and started to draw. He depicted himself twice over as a no longer young man about to embark on a new life without the support of the one human being in whom he had total faith—Apollinaire. Self-portraitists usually look lonely, but few as lonely as Picasso does in these drawings.[14]

In the midst of drawing himself, Picasso received a telephone call from Jacqueline, or someone acting for her, confirming that Apollinaire had indeed died. The artist, who was doubtless familiar with the superstition that to learn of a death while looking at oneself in a mirror is to foresee one's own death,[15] would always treasure these haunted drawings. Shortly before he died, he would give one of them to his second wife, Jacqueline.

On hearing of Apollinaire's demise, Picasso and Olga hurried off on foot. From the Lutétia it was no distance to the poet's apartment at 202, boulevard Saint-

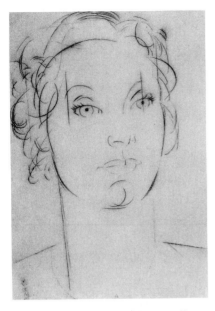

Louis Marcoussis. *Jacqueline Apolli-naire.* Drypoint, 33 x 23 cm. Biblio-thèque Nationale de France, Paris.

Germain-des-Prés. Apollinaire had died at 5 p.m. He was thirty-eight, a year older than Picasso, and had expired to jubilant yells of *"A bas Guillaume"* (Down with Kaiser Wil-helm)[16] from the boulevard below. This story has been dis-missed as a legend—wrongly. The war would not be over for another two days, but the Kaiser had abdicated on November 9, the day of Apollinaire's death. Already, the crowd had reason to howl for Guillaume's blood.

Besides a terror of death, Picasso had a terror of infec-tious diseases. He was so fearful of Spanish flu that, accord-ing to Cocteau, he held his hand over his mouth when anyone addressed him.[17] It must have taken all Picasso's courage to visit Apollinaire on his deathbed. When Cocteau arrived, Picasso took him over to view the body. Shining a lamp on the dead man, the artist said, "Look— he's as he was when we first met," and showed him Apolli-naire's "admirable face, in profile, lean and very young."[18]

Later that evening, midnight to be precise, Cocteau wrote a letter to André Salmon: "Poor Apollinaire is dead. Picasso is too sad to write. He asks me to do it, and to attend to notices in the newspapers. I have no experience of such things—would you be so kind as to take over? Apollinaire did not know he was dying...but both his lungs were affected.... His miraculous energy had enabled him to stay alive."[19]

Salmon, who worked for a newspaper, announced the news to the press. The fol-lowing day, the surviving members of the prewar *bande à Picasso* flocked to Apolli-naire's apartment to pay their respects. Max Jacob promised to spend the next nights watching and praying over the corpse until the funeral on November 13: "We have spent enough hours laughing together for me to spend a few hours weeping by his side."[20] Another visitor was Irène Lagut, Picasso's former fiancée and Jacqueline Apollinaire's sometime girlfriend. In an interview in 1969, Irène described how

a man from the funeral parlor arrived to measure Guillaume for the coffin. "I don't know," he said, "there is a dearth of coffins. I don't know whether we have one for someone that size." Off he went and came back sometime later to announce, "Yes, it is going to fit him like a glove!"...And then...they had to go to Père Lachaise and pick out a plot for him. The man returned to announce that [Apollinaire] "is going to be fine up there, just as if he were at home."[21]

On the morning of Monday the eleventh, the day the Armistice was signed, Paul Léautaud, the writer and editor who had published Apollinaire's breakthrough

poem, *La Chanson du mal-aimé,* went to take leave of his friend. In his journal he describes the streets around Saint-Germain-des-Prés as filled with joyous crowds still shouting *"A bas Guillaume"*; also how inside the apartment, the corpse, under a mass of flowers, was beginning to decompose: "I couldn't look at him," Léautaud writes.[22] The funeral took place two days later at the church of Saint Thomas Aquinas, where the Apollinaires had been married the previous May. The funeral cortège was accorded full military honors; a company of territorials accompanied the hearse to the grave. The church overflowed with admirers and followers from Apollinaire's multifaceted, multitiered life—everyone from Brancusi to Misia to Léger.[23] Picasso, who had Olga on his arm, must have dreaded seeing so many figures from his past. For their part, they would have welcomed a glimpse of Olga.

For once, Apollinaire's flamboyantly awful Polish mother attracted pity rather than ridicule, as she left the cemetery all by herself clutching the recently awarded lieutenant's kepi that her son had never worn. She would die of the Spanish flu a few months later (March 1919), as would her lover of many years, Jules Weill. Later in the year, her other son, Albert, would be killed in an automobile accident in Mexico, where he worked in a bank. There was talk of a curse on the family. Another odd fact: the day Apollinaire died, his old friend, Eugène Montfort, received a letter from Géry Pieret, the psychopathic con man who had landed Apollinaire and, very nearly, Picasso in jail after involving them in his theft of the Louvre's Iberian sculptures.[24] In his letter to Montfort, Pieret, who claimed, truthfully or not, to be an officer in the Belgian army stationed on the Western Front, said that a raven had suddenly flown into his room through an open window. "I felt I was getting a message from Guillaume Apollinaire. I'm very worried about him and beg you to tell me whether he's still alive."[25]

On Armistice night, Cocteau and a great many others drowned their sorrow at Apollinaire's death and their joy at the war's end in champagne at an enormous victory party given by the couturier Paul Poiret. Picasso was too stricken to go. Except for the death of his sister Conchita, the death of Apollinaire would haunt him more than any other. To commemorate his friend, he let it be known that he was going to design a monument, which would capture the polymorphous spirit of this charismatic genius. As we will see, the revolutionary maquettes that Picasso presented would be turned down, year after year, by the widow and the reactionaries on the Comité Apollinaire. This would be a blessing in disguise. The Comité's refusals would challenge Picasso to come up with a succession of the most imaginative and influential sculpture of the twentieth century. Despite his reservations about Apollinaire's understanding of modern art, Picasso revered him as a catalyst—he had a hand in making a lot of great art happen. His genius "lit up the darkness and showed us the way" is how he put it.

In the fight for Apollinaire's throne, Breton had considerable advantages. He had an intimidating intellect and an intimidating sense of authority to match. He could be charming but also tyrannical and mean-spirited. Despite his passion for Freud and the Marquis de Sade, he encouraged his followers to be as homophobic as himself. Because of its didacticism, Breton's prose is admired more than it is read, but his essay on Picasso in *Minotaure* (1933) is as perceptive as anything written about the artist in his middle years. By comparison Cocteau was a featherweight, done in, as Misia Sert said, by his desire "to please everyone at the same time, Picasso, Madame de Chevigné and the sharpshooters in the Marines. Instead of wasting his best years trying to please, he should seek to displease."[26] It is tragic that Cocteau's mercurial imagination, his scintillating style, his incomparable wit, his early novels and his later diaries, his modish films and plays, which reflect the life and style of his times so sharply and wittily, are so lacking in ballast that they tend to evaporate like his magical conversation.

In the face of Breton's campaign against him Cocteau embarked on a literary public relations campaign. To establish that he was no longer the precious poetaster of *Le Prince frivole,* he published a long "modern" poem, *Le Cap de Bonne Espérance (Cape of Good Hope).* This takes the form of a tribute to the heroic fighter pilot Roland Garros, on whom Cocteau had a crush. Garros had been shot down by the Germans, taken prisoner, and had escaped and resumed flying against the enemy, only to be shot down again, this time fatally. Cocteau claimed that the proofs of his as yet unpublished poem were found in the wreckage of Garros's plane. The "modernity" of this epitaph rested in the effects he had borrowed from his predecessors— Mallarmé, Apollinaire, and Pierre Albert-Birot (the *lettriste* passage).[27] To launch this accomplished pastiche on literary Paris Cocteau exploited his magnetism as a performance artist. The readings that he gave in fashionable drawing rooms—Paul Morand's, the Etienne de Beaumonts', Jean Hugo's—were "stunning." This was partly the consequence of the metallic megaphone voice Cocteau had affected for these occasions. However, Cocteau's salesmanship could not hide the fact that *Le Cap de Bonne Espérance* is too thin, too long, and too self-aggrandizing. Instead of taking root on the page, as Mallarmé's *Un Coup de dés* triumphantly succeeds in doing, Cocteau's fragments of words and phrases vanish as rapidly as slogans on billboards seen from a passing car.

Jean Hugo has described the reading that his fiancée, Valentine Gross, organized in her apartment in the Palais Royal on September 3, 1918. Besides Picasso and, presumably, Olga, the carefully picked guests included Proust, Misia, André Lhôte, the actor Pierre Bertin, and André Breton, whom Cocteau had deluded himself into

believing that he could transform into a potential fan. After waiting an hour for Proust to arrive, Cocteau decided to start his reading. When Proust finally turned up with two friends, Cocteau rounded on him and petulantly told him to go away: *"va-t-en, Marcel!"*[28] Proust left. Cocteau proceeded, as Hugo later recalled,

> [to] read marvelously well and it was difficult not to admire a work read by him. When the evening was over and each of the guests had enthusiastically congratulated him, he went over to Breton, who tried to avoid him. I happened to be nearby. Cocteau explained [to him] in an undertone: "It's very good, isn't it?, but it's not what's needed, it's too sublime and (with a glance in my direction) too Victor Hugo. . . ." Dumbfounded, Breton froze. Cocteau went white and let [Breton] slip away towards the door.[29]

Cocteau held his next public reading in certifiably intellectual surroundings: the back room of Adrienne Monnier's celebrated bookshop. Monnier has described the Madame Verdurin–like preparations for this modest event. Cocteau had told André Gide that Monnier wanted him to give a reading in the bookshop. " 'You will come, won't you?' We saw almost immediately, Gide and I had been hoodwinked."[30] Cocteau had also tried to entrap Paul Valéry into attending, but his intrigues failed. Interestingly, Cocteau had asked Monnier "above all not to invite society women." He also "insisted that I have all the young people possible come." Apart from Gide and his lover Marc Allégret, whom Cocteau had lured away from Gide and earned his enmity, only Breton and Soupault were to be seen, both of them still wearing their horizon-blue uniforms. "They held themselves very straight, radiating hostility."[31]

On June 10, 1919, Breton would have further cause to excoriate his victim. As Cocteau informed Picasso, who was in London, there was about to be a tribute to Apollinaire at Léonce Rosenberg's L'Effort Moderne gallery. "Your paintings are arranged . . . nicely set out like desks in a classroom equidistant from each other. When Léonce is not looking, they stick their tongues out at him. I am going to read in front of my Harlequin painting [MoMA's great 1915 Picasso] and strike a modest pose so that people will recognize me."[32] Cocteau's eulogy at this event would confirm his opponents in their contempt. He envisioned Apollinaire in heaven, as if it were a chic resort where he could make interesting new friends and invent a new ism, "eternism." In the early 1920s the surrealists' attacks on Cocteau would start in earnest. Picasso was loyal to Cocteau insofar as he needed a Rigoletto. He also foresaw that Breton's support might be more useful. And so beyond allowing Cocteau to shelter in his shadow, he stayed above the fray.

9

Rue la Boétie

Former friends and associates in the art world denounced Picasso's new address, 23, rue la Boétie, as all too redolent of bourgeois affluence and commerce—bereft of distinction and charm. Rosenberg's cousin and business associate, Jos Hessel, had been the first to move there, and so many of his associates had followed suit that the rue la Boétie had replaced the rue Laffitte as the center of the Paris art trade. It was lined with galleries and expensive *antiquaires*. Jacques-Emile Blanche described Rosenberg's premises as especially vulgar: a marble-fronted "Ritz Palace . . . with a façade [and] vestibule of marble; a staircase of onyx . . . vast rooms hung with watered silk" and elaborately lit by clusters of light bulbs "like grapes on the vine."[1] One might wonder why, in view of his denunciations of "dealers [as] the enemy," Picasso wanted to live on the Right Bank in their very midst instead of on the Left Bank—Saint-Germain-des-Prés or Montparnasse—where he had previously resided. It was because he would have encountered disgruntled cubists and former girlfriends at every turn. Also Olga wanted him to shed his Bohemian associations.

The Picassos moved into their new apartment a week before Christmas 1918. It consisted of a single, spacious floor. Georges Martin, who interviewed the artist for *L'Intransigeant* a year later,[2] recalled small cubist paintings in conventional frames on the dining room walls and a cage with a parrot in one corner ("as in an elderly spinster's house"). To receive the journalist, Picasso made a movie-star entry, "young-looking, shaved, in white silk pajamas," accompanied by Lotti, his large Pyrenean sheepdog. He showed Martin into two other spacious, light-filled rooms, "where total disorder reigned"—stacks of canvases, an array of tribal and Oceanic sculpture, a large seventeenth-century Spanish carving of Christ on the cross "with its dry and knotted arms outstretched" (a gift from the pious Eugenia), which had inspired a recent Crucifixion drawing.[3]

The apartment was divided into his and her realms. Picasso had taken over the rooms looking onto the street for his studios; the rooms at the back were his wife's domain. To judge by drawings of the salon and dining room,[4] Olga did up the rooms

Picasso. *The Dining Room at rue la Boétie,* 1918–19. Pencil on paper, 20 x 27 cm. Musée Picasso, Paris.

in a conventional but relaxed way. Apart from the paintings and drawings on the walls, the only Picassian touches were the upholstery of the armchairs in the salon, each in a different bright color, and the screen that he painted for Olga's sitting room. Eugenia would have had a hand in this (a good upholsterer, she decreed, was every bit as important to a woman as a good couturier). Olga turned out to be an exemplary *maîtresse de maison:* "not the slightest disorder, not a grain of dust," according to Brassaï.[5] Picasso, on the other hand, was a compulsive hoarder with an idiosyncratic relish of dust: it enabled him to tell whether anybody had disturbed his piles of old journals, letters, and smokers' debris. The bedroom smacked of Olga: twin brass bedsteads, just like the Hôtel Lutétia.

To keep her domain just so, Olga assembled an impeccable staff: a white-gloved butler, cook, and maid. She was exacting, Clive Bell said, and took her role as hostess very seriously. With the social guidance of Cocteau and Misia, she was soon giving suitable little dinners and suppers after first nights at the ballet or theater. The Picassos attended similar occasions: for instance, the party Cocteau threw (late 1918) in his mother's apartment. As Jean Hugo relates in his memoirs, "The dawn of Les Six was about to break: Auric and Poulenc played Couperin, Scarlatti and Satie."[6] Fond

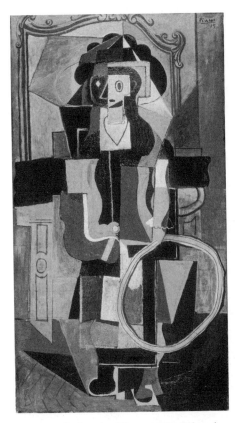

Picasso. *Girl with a Hoop,* 1919. Oil and sand on canvas, 142.5 x 79 cm. Musée National d'Art Moderne, Centre Georges Pompidou, Paris.

as he was of Satie and Stravinsky, Picasso confessed that he had a terrible problem staying awake while their compositions were being performed.

Besides their address, the Picassos' genteel existence would come under fire. The more the artist protested that life in the studio had nothing to do with life in the salon—which was entirely true—the more his erstwhile associates, exemplified by Max Jacob, sneered. Cocteau and Diaghilev, Jacob said, had tainted the artist with their worldliness, which appealed to an inherent bourgeois streak in Picasso—a streak that no previous woman in his life had invoked. The artist's sardonic nature and penchant for self-mockery should also be taken into account. The *comme il faut* impersonation was in part an elaborate joke.

Whenever Picasso embarked on a new relationship there would sooner or later be a new studio, apartment, or house; and since he became very attached to his various homes, he kept records of them—the look, the space, the atmosphere, the view—in drawings, paintings, and later photographs. The earliest of the rue la Boétie images are of the dining room: frontal views of the lace-curtained windows at the back,[7] with a gueridon—presumably the one we know from Montrouge. Picasso was becoming ever more intrigued by this piece of furniture, intrigued by its silhouette, by the way it supported and enhanced still lifes, much as a plinth supports and enhances a sculpture. The gueridon was about to become an infinitely adaptable motif—a personage in Picasso's work.

Drawings and one or two paintings show that Picasso had left his conventionally paneled studio walls the way they were. Cornices, chair rails, and chimneypieces play an ironical background role in many a still life. Look how the *trumeau*—the mirror set into the wall above the fireplace—provides his large, parodic *Girl with a Hoop* with a frame in such a way that it puts a subject as it were into quotes.[8] To mock a conventional genre scene, Picasso uses cubist notation to give the painting's inane subject—a dolled-up, loopy-looking child in a big hat standing with her wonky hoop in front of a living room fireplace—an edge that is both comical and modernist.

He does the same with an even larger painting (185 × 140 cm) entitled *The Lovers:*[9] a spoof not only of Manet, but of Picasso's bourgeois lifestyle. Note the

man's starched evening shirt, the sort that Olga obliged him to wear; the fringed chaise longue; the paneling and the "abstractions" hanging on the wall. The better to mock himself, he has assumed the role of Manet. Roberto Otero was present when Picasso decided to include this painting (which he referred to as *Hommage à Manet*) in Malraux's 1966 retrospective. He mimicked the artist standing in front of the canvas, his brow furrowed with concern: " '*Caramba,*' he said. 'The little cat has been erased. I'll draw it in again with charcoal. Besides, it has to have fixative and the word "Manet" has to be written in at the top. What do you think? Malraux wants to give me an homage show? Well, I want to do the same for Manet! To each his own.' "[10]

There is no mockery in Picasso's images of Olga. In the 1919 *Woman Wearing a Wristwatch,*[11] Picasso comes up with an idiom that is Ingresque and cubistic in its gamut of grays and ochres, which anticipates many melancholy portraits of her to come. Painted at the rue la Boétie, seven months after the Montrouge portrait, this painting is to my mind the finest of all Picasso's representational images of Olga. The wristwatch — until recently an accessory considered outré on women and effeminate on men — exorcises the

Olga reading, rue la Boétie, in front of the folding screen and works painted by Picasso, 1921.

taint of Ingres, a taint that had left his cubist followers in a state of resentful confusion. Picasso must have given Olga a wristwatch, just as, years later, he would give one to Marie-Thérèse Walter. Lydia Gasman believes that wristwatches had a special significance for Picasso. Marie-Thérèse developed a superstitious reverence for her watch; it appears on her arm in a particularly demonic painting — dating from 1936, the year Picasso finally broke with Olga and began to fall out of love with Marie-Thérèse. According to Gasman the ominousness of wristwatches in Picasso's imagery has to do with "time corroding love."[12]

P icasso's choice of Paul Rosenberg as his representative was a sensible one, even though he had none of the qualities that distinguished his prewar dealer, D.-H. Kahnweiler. Kahnweiler was unquestionably the most intelligent, farsighted, and scrupulous dealer of his generation. He had an intuitive eye and an instinctive under-

standing of modernism: by 1914 he had Braque, Léger, Gris, as well as Picasso under contract. He also had the courage to support his artists in the face of attacks by chauvinists and cubist hacks and devise strategies to counter them. Unfortunately, Kahnweiler's decision to spend the war in Switzerland and leave his vast stock to be appropriated by the French state as enemy property had so infuriated Picasso that he refused to have anything to do with him when he returned to Paris. This fight with Kahnweiler is what necessitated the alliance with Rosenberg.

Rosenberg was an enormously successful dealer—totally focused on the art market, immensely hardworking, rapacious, and deeply committed to his artists, so long as their work sold. Rosenberg's expertise was limited to French nineteenth-century masters—it included Delacroix, Ingres, and Corot, as well as the post-impressionists—and he traded in them more assiduously than any of his rivals. However, the prospect of invading a promising new field transformed Rosenberg into a canny appraiser of modern art. Picasso would have preferred to sign up with the dealer who had given him his first Paris show, Ambroise Vollard. But this formidable supporter of Cézanne and Gauguin as well as the impressionists had closed his Right Bank gallery in 1914, and was now ensconced in an *hôtel particulier* on the Left Bank as a private dealer and the publisher of *éditions de luxe* illustrated by modern artists. Vollard would later commission some of Picasso's finest engravings.

The "contract" that Picasso and Rosenberg negotiated never existed on paper; it would be a matter of mutual trust. Picasso granted the dealer a *droit de première vue:* a right to first refusal on all current work. The arrangement would be backed by Wildenstein and Hessel,[13] who had entered into partnership with Rosenberg. According to FitzGerald, the dealers agreed to

> split the Picasso market between them. They bought from him in equal shares, Wildenstein representing his work in America and Rosenberg in Europe. The only living artist handled by Wildenstein, Picasso joined a stable that held a vast inventory, with many acknowledged masterpieces. Yet, from the beginning, Wildenstein remained discreetly in the background. Rosenberg was the dealer publicly associated with Picasso.[14]

Although Picasso said that he always dealt with Paul Rosenberg and never his partner, Georges Wildenstein, Georges's son, Daniel, claims in his memoir that his father had "a red telephone with two separate lines, one line connected to Paul's gallery, the other to Picasso's studio."[15] In fact, Picasso had a far more effective means of communicating with his dealer than Wildenstein's quasi-presidential hotline. He would call Rosenberg and ask him to step out onto his next door balcony and take a look at whatever he needed to show him.[16]

By the end of 1918, Paul Rosenberg had paid Picasso 55,000 francs for the portrait of his wife and a group of lesser recent works. At first sales were slow, largely

because the prices Rosenberg asked were much higher than those that his preceding dealers had asked. Over the next few years, these prices would soar. So would Picasso's earnings, thanks to his wisdom in not tying himself down, as standard contracts did, to a fixed rate per canvas point for a fixed period of time.[17] (The contract permitted Picasso to raise the price that Rosenberg paid per canvas point as the value of his work on the market increased.) Picasso had a limited understanding of business, so this strategy was probably masterminded by his astute banker, Max Pellequer. In the course of his twenty years with Rosenberg, the artist repeatedly raised his prices as the value of his work went up and the value of the French franc went down. At first cordial and neighborly, personal relations between the cold-blooded dealer and the hot-blooded artist would inexorably cease to be either. On a business level, it worked until the outbreak of World War II.

Léonce Rosenberg, Paul's elder brother, who had kidded himself that *he* was Picasso's dealer, was most displeased with this arrangement. He felt he had a far greater understanding of modern art than his brother. He had acquired his first Picasso in 1906 and, shortly before the war, had bought fifteen cubist paintings from Kahnweiler (indeed, he still owed 12,000 francs on them). He was also proud of having helped Picasso out, in November 1915, by agreeing to pay 8,500 francs for his two most powerful wartime paintings—the great *Harlequin* and the even greater *Seated Man*.

Thanks to a cushy job in the army, Léonce was able to keep his gallery functioning throughout the war and was convinced that he alone was qualified to replace the fugitive Kahnweiler, and that "the destiny of the cubist movement was in [his] hands." Léonce had even boasted to Picasso that he was about to "undertake an *extremely energetic and vast* action in all of Europe and America" to promote cubism. *"Together,* we will be *invincible*. You will be the *creator,* I will be the *action"*—far more effective than "the *boche* dealer" (Kahnweiler). Even more offensive coming from a German Jew with a background similar to his own was Léonce's accusation that Kahnweiler had contaminated Picasso's work "with a vague odor of sausage and sauerkraut."[18]

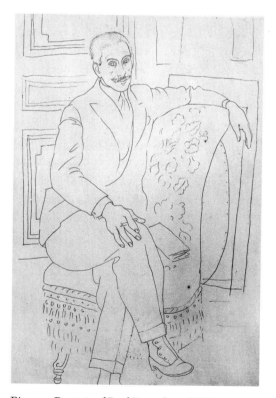

Picasso. *Portrait of Paul Rosenberg,* 1918–19. Pencil on paper, 35.6 x 25.4 cm. Private collection.

Since Léonce was perpetually on the verge of bankruptcy, his claim to have subsidized the entire cubist movement with continuous purchases did not make for credence.[19]

Léonce further irritated Picasso by railing against the insidious influence that the Ballets Russes and the reactionary Cocteau were supposedly exerting on him and other modernist artists.[20] In fact, Picasso enjoyed working for the ballet and no longer wanted to be perceived primarily as a cubist. And he was damned if he was going to be criticized by an uppity dealer whom Apollinaire had denounced as someone who reduced *"chefs-d'œuvre . . .* to the level of *hors d'œuvres."*[21] Despite fine works by Gris and Léger, Léonce's stock was a mixed bag of "puzzles," as the dealer Réné Gimpel said: "cubes of canvases, canvases of cubes, marble cubes, cubic marbles, cubes of color, cubic colorings, incomprehensible cubes and the incomprehensible divided cubically."[22] Despite a passionate belief in modernism and a goodish eye for it, Léonce would never have the intellectual or financial acumen to replace Kahnweiler, or be much more than a costly embarrassment to his brother Paul.

The Rosenbergs' most feared rival was the new boy on the block, Paul Guillaume. By 1919, Guillaume, who started life as a *garagiste,* had become a major dealer—an achievement that his show of Picasso and Matisse in 1918 had done much to establish. Like many another short, self-made man with an overblown ego and a murderously ambitious wife,[23] Guillaume had contracted a severe case of *folie de grandeur.* He had taken to driving around with an entourage of assistants in two Hispano-Suizas, the chauffeurs "dressed up like generals in the Tsar's imperial guard."[24] Picasso, who had once thought well of Guillaume, had no further time for this pretentious poseur, who boasted of having a better eye than any museum director in France. Picasso preferred dealers who made no bones about being in trade. He approved of Rosenberg's claim to find no beauty in a canvas unless it sold.[25]

By the last months of the war, the Ballets Russes was on the verge of bankruptcy; "Our small savings [had] dwindled to nothing," Grigoriev, the company's regisseur, relates.[26] But once again, Diaghilev managed to save the day. He arranged a booking in London—not at the prestigious Drury Lane Theatre, where they had appeared in 1914, but at a music hall, the Coliseum—where they were expected to give "two performances daily, with a weekly change of programme."[27] Despite their reduced circumstances, the company opened their London season on September 5, 1918, with *Cléopâtre,* and new sets by Delaunay. Its success persuaded Diaghilev to make London his base—at least for a year or so—and he settled into the Savoy Hotel with Massine, his valet Beppe, and Beppe's wife, who was in charge of the company's costumes. Diaghilev and his company endeared themselves to the British

by recruiting local girls, who were given Russian names—Isomina, Grantzieva, Muravieva[28]—the better to replace defecting Russian dancers. At last Massine could set to work with Felix Fernández on *Tricorne.*

Toward the end of March 1919, Diaghilev dispatched Massine to Paris to discuss the décor for another new ballet, *Boutique fantasque,* with the recently demobilized Derain, and also talk to Picasso about *Tricorne.* Two weeks later, Diaghilev himself came over from London to negotiate terms. On April 15, he sent Picasso a *pneumatique:* "I will come and see you tonight and spend the evening with you."[29] They came to the following arrangement:

> I want you to be responsible for the décor of the *Tricorne* ballet . . . for my Ballets Russes production. You will do the designs for the drop-curtain, sets, and costumes and accessories that the said ballet requires and also supervise the execution of these curtains and costumes, and you yourself will paint sections of the décor if you think this necessary. For these services I will pay you ten thousand francs. You will make yourself available in London from May 20, 1919, until the ballet's first night. . . . It is understood that the sketches will remain your property, and the curtain, set, and costumes will become my property. Your devoted, Serge de Diaghilev[30]

Despite detailed discussions with Diaghilev and Massine in Spain in 1917, Picasso did not start work on *Tricorne* until the contract was signed. He began with the set, as Diaghilev informed Falla on May 10: *"Picasso fait une merveille de mise-en-scène."*[31] At one point Picasso suggested having the dancers wear modern dress,[32] but Diaghilev stipulated eighteenth-century Andalusian style. Knowing nothing about historical costume, Picasso asked Max Jacob to do the research.[33]

The Picassos' departure for London was delayed by visa problems, which Diaghilev took up with the British authorities.[34] On May 15[35] the impresario sent a telegram confirming that their visas had come through, but it would be another ten days before they arrived in London—the first time for Picasso, though not for Olga.

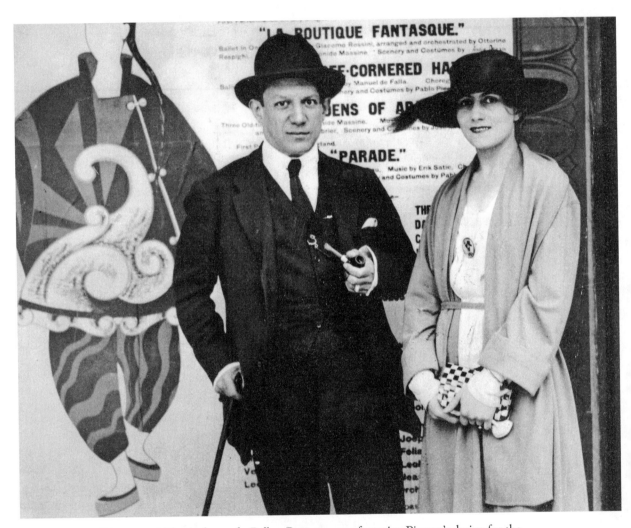

Picasso and Olga in front of a Ballets Russes poster featuring Picasso's design for the Chinese Conjuror's *Parade* costume, Alhambra Theatre, London, 1919. Popperfoto.

10

London and *Tricorne* (1919)

Shortly before the Picassos arrived in London, tragedy struck at the heart of *Tricorne:* tragedy all too reminiscent of Nijinsky's collapse a year before. The victim was Felix Fernández García, the acutely nervous little Gypsy whose flamenco virtuosity had so thrilled Picasso, Diaghilev, and Massine two years before. Early in May, Felix (known by his friends back in Spain as *el loco*) had suffered an attack of dementia, brought on, it was said, by Massine's callous exploitation of his phenomenal skills.[1]

To understand how this came about, let us return to Barcelona in the summer of 1917, when Diaghilev, Massine, Falla, and Felix took leave of Picasso and Olga and embarked on an extensive tour of Spain in search of raw material for *Tricorne.* The tour was a triumph. After a visit to the Generalife in Granada, Falla—who believed that a composer should "draw sounds and rhythm from natural, living sources," as opposed to "folkloristic documents"—had stopped to listen to a blind man playing a guitar.[2] The composer had asked him to "repeat the mournful little tune. . . . [He] stood with his eyes closed humming it through and then methodically writing it down in his notebook."[3] The melody would provide the theme for the *sevillana* in the second part of *Tricorne,* just as a tune to which Felix had danced in Madrid would inspire the famous *farruca.* Since he was well known in the Gypsy world, Felix had no problem bringing Diaghilev and his associates together with performers of flamenco and cante jondo, so that Falla and Massine could gather material for their *jotas,* fandangos, and boleros. "Even the cripples danced," Massine said.[4]

Massine, who was almost as relentless as Picasso in his pursuit of the sacred fire, watched these performances with manic attention, jotting everything down in a notebook that he kept in his pocket. A slight defect in the shape of Massine's legs ruled out a career as a *danseur noble,* so it was all the more important for him to perfect himself as a character dancer and wear trousers instead of having to pad out the calves of his white silk tights with strips of ermine.[5] All the more need for him to master the dynamics and minutest details of Felix's technique, from the arch of an eyebrow to the clickety-clack of the heel beats.[6]

In the summer of 1918, the entire company had embarked on an even more ambitious tour of Spain than the last one. Felix continued to teach the dancers, but "he had a quick temper and screamed at [them] when they could not do a step."[7] Sokolova describes Diaghilev taking a chosen few of them in carriages to a café in an orange grove outside Seville, where Gypsies performed in "pavilions strangely built between [the] trees." After a number of ever more dazzling performances, a spectacular-looking youth proceeded to stun them—Diaghilev especially—with his bravura. Whereupon, challenged by the applause for this young man, Felix

> leaped into the middle of the room and danced as he had never done before. He tapped his heels faster and faster in amazing rhythm, and played on his fingers as though they were castanets. He danced on his knees and leaped into the air and crashed his body down on the side of his thighs, turned over and jumped up with such speed that it was unbelievable that the human body could stand such a strain without injury. The gipsies were themselves amazed and encouraged him with all they had to give. [Felix] . . . was exhausted, but would not stop. We called "Basta, basta" but it was not until the gipsies surrounded him that he would give in. After that evening, Diaghilev [realized] he would never find a dancer who could do better than Felix.[8]

A few months later, when the company finally made it to London, Felix continued to train Massine as well as other leading dancers for *Tricorne.* Since Falla was slow to finish the score, Diaghilev decided to put the Spanish ballet on hold. Massine switched to another project, his *Nutcracker*-like ballet, *Boutique fantasque,* with music by Rossini, arranged by Respighi. Diaghilev brought in Derain to replace Bakst and to do the décor. Ironically, Bakst's supposedly démodé décors would have a triumphant comeback while Derain's have been forgotten.

As soon as he finished with *Boutique,* Massine switched to *Tricorne,* whereupon Felix's worst fears were confirmed. The star role of the Miller—the reward, Felix had naively assumed, for sharing the secrets of his métier with a "treacherous Russian interloper"—was to be Massine's, not his. As Felix's technique was entirely a matter of improvisation, he was unable to follow the dictates of a choreographer, so there were no other roles for him in the company's repertory.[9] As a sop, Massine tried him out for the tarantella in *Boutique fantasque.* When he proved incapable of performing it, Massine bought him a metronome, but this made matters much worse. In despair at being done out of the Miller's role, Felix went mad. He took to timing his actions to the ticking of Massine's metronome. Walking down the street, he would adjust his pace to different speeds; he would even masticate his food to the gadget's relentless tick-tock tempo. At a rehearsal of *Boutique,* Diaghilev, who had dismissed Felix's behavior "as a pose to keep himself in the limelight,"[10] was appalled when the

dancer suddenly put on a hat, made faces at him, and refused to be separated from a gigantic sandwich.

After Tamara Karsavina, the company's greatest star, who had difficulty escaping from Russia, joined them in London, Diaghilev insisted that she assume the role of the Miller's Wife. So that she, too, could give her performance an authentic Spanish edge, he took over the Savoy's ballroom late one night and had Felix demonstrate his powers. "I followed [Felix] with open-mouthed admiration," Karsavina wrote,

> breathless at his outward reserve when I could feel the impetuous, half-savage instincts within him. He needed no begging, and gave us dance after dance. In between, he sang the guttural songs of his country accompanying himself on the guitar. I was completely carried away, forgetful that I was sitting in an ornate ballroom 'til I noticed a whispering group of waiters. It was late, very late. The performance must cease or they would be compelled to put the lights out. They went over to Felix too, but he took not the slightest notice. He was far away. . . . A warning flicker and the lights went out. Felix continued like one possessed. The rhythm of his steps—now staccato, now languorous, now almost a whisper, and then again seeming to fill the large room with thunder—made this unseen performance all the more dramatic. We listened to the dancing enthralled.[11]

This turned out to be Felix's last performance. The next night (May 13), when he should have been onstage as an extra, "he was discovered in his dressing room, his face spotted with a weird mixture of greasepaints, grimacing at himself in the mirror. . . . By the time the ballet was over Felix was nowhere to be found."[12] Later that night, the police caught up with him: he was dancing as if possessed on the altar steps of Saint-Martin's-in-the-Fields, James Gibbs's great theater of a church in Trafalgar Square. Felix was certified insane and admitted to an asylum, Long Grove Hospital at Epsom. He was twenty-two. Sokolova, the original choice for the Miller's Wife, said that "those of us who had known him best visited him at various times. . . . he remembered me and talked to me a little. [Sokolova spoke Spanish.] But he had become like a small child in mentality, and never stopped shaking his head."[13] As she wrote in her memoir: "Felix's reason was the price fate demanded for the creation of a masterpiece—a masterpiece for which Massine would take total credit."[14]

A few months later, when Matisse came to London to work on *Le Chant du rossignol,* Massine and Diaghilev took him to visit Felix at Epsom.[15] They would surely have arranged a similar outing for Picasso when he arrived; unless his superstitious fear of insanity might have decided him against seeing a fellow Andalusian—in his own way a genius—in an alien madhouse. While Picasso was in London, he did a fine drawing of a doleful Felix dancing with Vera Nemchinova.[16] He must have worked from a photograph: by the time he arrived, the poor man was incarcerated.

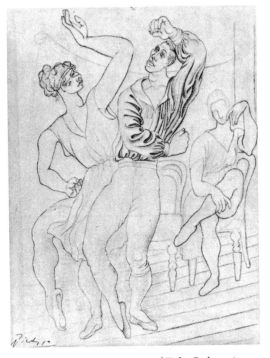

Picasso. *Vera Nemchinova and Felix Rehearsing "Tricorne,"* 1919. Pencil on paper, 31.5 x 24.5 cm. Whereabouts unknown.

When *Tricorne* was eventually performed in Madrid—with Leon Woizikowsky replacing Massine, who had by then broken with Diaghilev—the impresario was terrified that the story of Massine's treatment of Felix might leak out and cause a scandal that would antagonize the Gypsy community. And so he summoned the company to a meeting on the stage and, brandishing a telegram, announced that Felix had died. Sokolova did not discover that this was a lie until she went backstage, some seventeen years later, to congratulate Massine on his new ballet to Beethoven's Seventh Symphony. He told her that a few days earlier he had visited Felix in his suburban madhouse. Felix was physically as fit as ever, but much fatter and still insane. Sokolova could "only think that Diaghilev must have had private reasons for having made that announcement."[17] Felix died at Epsom in 1941.[18]

There are two postscripts to this story. In 1947, when Massine was in London, performing what else but *Tricorne,* he agreed to star in Michael Powell and Emerich Pressburger's film *The Red Shoes,* based on Hans Christian Andersen's story about a dancer possessed by an urge to dance herself to death. Massine plays the choreographer, as it were himself, as well as the Carabosse-like cobbler in *The Red Shoes* ballet, whose scenario mirrors the plot of the film. Anton Walbrook is the jealous impresario, a role clearly based on Diaghilev, while Moira Shearer, who had starred with Massine in *Tricorne,* plays the doomed dancer, a surrogate for Felix. So striking are the parallels between the film and the macabre events of May 1919, it is difficult to decide whether Massine intended to exploit or exorcise his Svengali-like treatment of Felix. During the filming, Shearer confessed to being "tantalized" by Massine's air of mystery—tantalized by the sense that there was a "hint of a deeper, more cryptic, and quite unreachable level to him."[19] Margot Fonteyn, who also danced the Miller's Wife opposite Massine, said that his "marvelous eyes . . . fascinated yet also had the effect of a closed door. . . . I felt at a great distance from him."[20]

The second postscript: *The Red Shoes* was so successful that Sir Arthur Rank, the British mogul who produced it, summoned Nijinsky, who was supposedly recovering a measure of sanity, to work on a film based on his own life. To stimulate Nijinsky's

interest in the project, Rank arranged a special viewing of *The Red Shoes.* Nijinsky was so revolted by the film that he lapsed back into insanity. When Eric Wollheim, who had been Diaghilev's London agent, took his son, the philosopher Richard Wollheim, to visit Nijinsky in the suburban house Rank had rented for him, they found the dancer pacing the garden in impenetrable silence. However, as Joan Acocella points out, as well as being a romantic cliché, the theme of the possessed dancer has its roots in the essentially Dionysiac nature of the dance.[21]

The news that Picasso was coming to work in London gladdened the heart of Eugenia Errázuriz. She had given up her apartment in Paris and rented a house in Chelsea at 27 Saint Leonard's Terrace, where she insisted the artist and his wife should stay. She sent Picasso a checkered overcoat—she would also have a suit made for him—and arranged for Diaghilev and Massine, who were off to Paris with Lord Berners, to take Olga the largest possible bottle of her favorite eau de toilette, Penhaligon's Hammam. Far from wanting to move in with her elderly rival, Olga insisted on staying close to the dancers—in particular Lopokova, who had taken the place of her no longer accessible family.

Although Olga had continued to take lessons in Paris with Sonia Derloff, she would never dance again. This raises a number of questions whose answers we can only guess at. Had her injury not healed well enough? Or did the excessively possessive Picasso not want to relinquish control of her career to Diaghilev, or see her in the embraces of male partners? Or did it have to do with Picasso's desperate desire for an heir? Since the artist had to wait until 1921 for a son, Olga may have postponed this event in the hope of resuming her career. The fact that she wrote in November of 1919 asking Clive Bell to send her the scores of *Boutique fantasque* and *Les Femmes de bonne humeur* suggests that she may not have given up this hope and needed to study an old role as well as a new one.[22]

As for Picasso, he, too, preferred the anonymity of a hotel in the center of London to confinement chez Eugenia. Besides working on *Tricorne,* he was anxious to see the Elgin marbles and the tribal art in the British Museum, as well as the masterpieces in the National Gallery—all the more of a pleasure since the Louvre had not reopened since the war. He also looked forward to buying elegant new clothes in line with his elegant new image.

Picasso and Olga arrived on May 25 and checked into Room 574 (now 536), one of several rooms that Diaghilev had booked at the Savoy Hotel.[23] The impresario loved this grand hotel; it was close to the Alhambra Theatre and the Covent Garden Opera House; it also had a famously fashionable grill room, where patrons and performers gathered after the opera or the ballet, and where Diaghilev would give daily

luncheons—occasions that delighted Olga and bored Picasso, who preferred to lunch at Gennaro's trattoria in Soho. Diaghilev was too broke to treat himself or his stars to the Savoy's more expensive suites, so far from having a view of the Thames, the Picasso's room looked into an inner courtyard. Not that he was tempted, but he would never have been able to fulfill Rosenberg's fatuous request of June 10, 1919: "There are some beautiful Thames-side subjects. You should do what Monet did, forty views of London, but no foggy ones. They would be a great success."[24] Given Picasso's implacable stand against impressionism and Monet in particular—*"trop flou,"* he used to say—Rosenberg of all people should have known better.[25] However, his idea of portraying the same subject in different lights would bear fruit later in the year.

Besides the sets for *Tricorne,* Diaghilev had another commission for Picasso: a drawing of Derain for the "souvenir" program of *Boutique fantasque,*[26] which was due to open on June 4, so the drawing had to be done in a hurry. Though formerly the closest of friends, the two artists had grown apart. The war had left the recently demobilized Derain very resentful of artists who had done well for themselves during the war while he and Braque had been stuck in the trenches. Rivalry and strained relations put Picasso on his mettle and resulted in a portrait of exceptional strength. Carefully modulated contours and partly erased pentiments convey a wonderfully weighty experience of the sitter's massive frame.[27] Inspiration for the Derain drawing did not come from Ingres—as it did in the drawings of Olga and Lopokova that date from this trip—but from Picasso's own 1906 *Portrait of Gertrude Stein,*[28] a painting that, ironically, Derain had borrowed from in the past.

The promotional efforts of Paul Guillaume and the Paris-based Swedish dealer Walter Halvorsen resulted in Derain being regarded as not only more of a money-spinner than Picasso but, in the opinion of André Lhote and others *"le plus grand peintre vivant."*[29] (Two years later, Picasso would complain to Roger Fry of the prices—30,000 francs for a still life—that Derain's work was fetching.)[30] However, given Derain's fluent English and his familiarity with London, the subject of some of his finest Fauve paintings, he would prove a useful companion to Picasso. Derain, who prided himself on his knowledge of the British Museum's classical and ethnographical galleries, is likely to have accompanied Picasso on his visits there as well as to the National Gallery. And since Olga insisted on attending every ballet performance—a chore for Picasso, who pre-

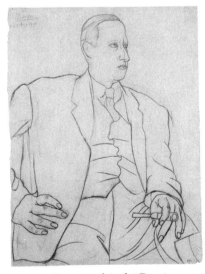

Picasso. *Portrait of André Derain,* 1919. Black pencil on paper, 39.9 x 30.8 cm. Musée Picasso, Paris.

ferred rehearsals—and Derain was on his own, the two of them were free to go out on the town together. Clive Bell, the art critic, had arranged for Derain to take over the flat that his wife, Vanessa, had recently rented and not yet moved into, and he spent as much time as he could with the two artists, reporting that *le gros*—that is, Derain (Picasso was *le petit*)—"each night fell in love with a new English girl [but] consoles himself playing the organ [that is to say, masturbating]."[31] After the first night of *Boutique,* Derain returned to Paris but came back to London for the first night of *Tricorne.* His future wife,[32] Alice, who had formerly been Picasso's mistress, stayed away. She had taken against him.

Diaghilev had yet another commission for Picasso: a portrait of Massine that the impresario had been nagging him to do ever since they first met. Since he had no studio in London and the room he shared with Olga was out of the question, Picasso was unable to paint the full-length canvas of Massine that Diaghilev had set his heart on. The dancer had to settle instead for a drawing—a flashy image contrived to please the narcissistic sitter and his besotted boss. Unlike Derain's portrait, Massine's is a tour de force rather than a masterwork.[33] The dancer would not have had to sit for it. Picasso worked from a publicity photograph as he did in the drawing he made around the same time of Diaghilev.[34] This drawing is also flattering in that the impresario looks all the more debonair in his top hat and white tie, mischievously contrasted with the potbellied, bowler-hatted, black-tied moneyman, Alfred Seligsberg, who worked for the company's principal backer, Otto Kahn. When the drawing was reproduced in the first number of Léonce Rosenberg's magazine, *L'Esprit Nouveau,* its academicism and "show biz" subject caused as much controversy as Picasso's Ingresque drawing of Max Jacob had caused four years earlier.

In Rome, Picasso had had a studio, which enabled him to execute major paintings as well as work for the ballet. In London he was able to do little beyond Diaghilev's commissions. However, his day-to-day involvement with the dancers inspired a series of masterly drawings done for his own pleasure, after publicity photographs of the ballerinas, including Olga, costumed for *Les Papillons* (1914) and *Les Sylphides* (1916).[35] Their greatness resides in their affectionate mockery. Picasso singles out hands and other details for magnification, which gives us a new take on the styliza-

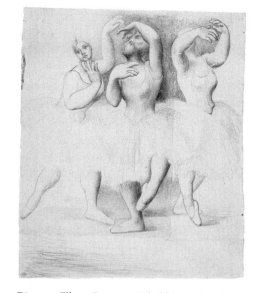

Picasso. *Three Dancers (Khokhlova, Lopokova, Chernicheva),* 1919–20. Pencil on three sheets of paper pasted together, after a publicity photograph. 37.5 x 32 cm. Musée Picasso, Paris.

tion of classical ballet positions. He suggests that, for all the grace and beauty of romantic ballet, there is a flesh-and-blood physicality to these gossamer wraiths. These drawings pave the way for next year's galumphing giantesses.

To accommodate his scene painters, Vladimir and Elizabeth Violet Polunin,[36] Diaghilev had rented an enormous studio on Floral Street opposite the stage door of the Covent Garden Opera House. The studio's most prominent feature was a very tall ladder, which the Polunins and the set designer had to climb up and down whenever they needed to gauge the effect of their handiwork from a distance. And it was there, one day late in May, that Vladimir Polunin recalled how:

> Diaghilev came into the studio accompanied by a gentleman of medium height, southern complexion and wonderful eyes, whom he introduced to me as Pablo Picasso. . . . Picasso showed me the booklet-*maquette* of his scene for . . . *Le Tricorne,* and we all began discussing the construction of the future setting. . . . [After] Bakst's complicated and ostentatious scenery, the austere simplicity of Picasso's drawing, with its total absence of unnecessary detail, the composition and unity of the colouring . . . was astounding. It was just as if one had spent a long time in a hot room and then passed into the fresh air.
>
> . . . Picasso came to the studio daily . . . gave his instructions regarding the drawing and requested us to preserve its individuality and pay special attention to the colouring. The drawing, despite its deviation from the usual perspective, was set down with mathematical precision.
>
> . . . All this care was of the utmost importance, for the entire scene was based on the very clever combination of the four fundamental tones. . . . The colours appeared remarkably quiet and required the addition of zinc white, a proceeding which, in scenes of the Bakst type, would have been considered a crime; but Picasso maintained that this led to a general unity of tone.
>
> . . . Pure white was dulled by the addition of light chrome, which resulted in a tone having the beauty of old ivory. Picasso was invariably present at these experiments and though often accepting our advice, never departed in the slightest degree from the colour-key and construction he had evolved. His presence during the execution of the work gave a special charm to the joint solution of all questions.
>
> With him, there were never any of the doubts, alterations and variations so characteristic of "designers" of inferior calibre. . . . Different proposals and variations were discussed while deciding on the colours, but, once everything had been settled, the given tone was not altered on the canvas by a hair's breadth.[37]

The scene painting was finished within three weeks.[38] In gratitude to Polunin, Picasso executed a particularly sympathetic portrait of him.[39] Sacheverell Sitwell describes going to watch Picasso working on the central corrida section of the *rideau de scène*—an introductory curtain that is the pictoral equivalent of an overture. For

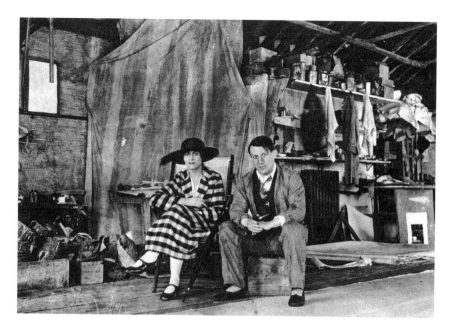

Olga and Picasso in the scene painting studio, Floral Street, London, 1919. Musée Picasso, Paris.

broad effects he used a brush attached to a broom handle; for more detailed work, he used a toothbrush.

> Diaghilev and Massine were there, and Picasso, in carpet slippers and with a bottle of wine standing near him, was at work. The canvas lay stretched upon the floor, and Picasso was moving around at great speed over its surface (he wore carpet slippers for this purpose) walking with something of a skating motion.... I recall ... thinking that this was the nearest that modern eyes would ever get to the spectacle of Tiepolo ... at work.[40]

Sitwell reports that Picasso intended the *rideau de scène* to evoke Goya's tapestries. And it is true, the format resembles one of those eighteenth-century tapestries with an allegorical or historical scene set at the center of an area given over to swags, arabesques, and ornate borders.

The maquette Polunin worked from has been lost; however, successive drawings for the central section indicate Picasso's original intentions.[41] Although the plot of *Tricorne* has nothing to do with bullfighting, Massine and Diaghilev decided that the subject of the curtain should be ultra-Spanish therefore tauromachic:[42] the image of a picador being charged by a bull, framed at the sides by tiers of balconies occupied by Goyesque *majas*. At the bottom, serried rows of spectators are seated by the arena's stylized steps. By enabling the people in the audience to identify with the figures on the stage and, in imagination, become part of the action, Picasso hoped to blur the frontier between stage and auditorium.

Picasso's most imaginative design for the curtain proved too polemical and un-Spanish for Diaghilev and Massine. On a gigantic trompe l'oeil easel, flanked by

trompe l'oeil theater curtains, he proposed to set a cubist still life with a guitar against a representational view of the bullring.[43] Once again, he was to demonstrate that cubism and classicism were two sides of the same coin. This version was predictably turned down. The final version was a compromise: as stylistically harmonious and unchallenging as a travel poster.[44] Diaghilev loved it. Since no photograph of this curtain in its entirety has survived, little is known about the decorative border panels. All we have is a rough watercolor sketch,[45] which indicates that each of the vertical areas to the right and left of the central scene consisted of a cubist guitar enclosed in a tall diamond-shaped border.[46] The inspiration for these guitars was a seven-foot-tall papier collé, or rather *papier épinglé,* in the Museum of Modern Art that Picasso had executed a few months earlier, to judge by the date, February 11, 1919, on one of the bits of newspaper.

Given all the research that Falla and Massine devoted to the folk music and dances for their "great Spanish ballet," it is surprising that Picasso should have allowed himself to be talked into doing what Palau calls an *espagnolade.*[47] A ballet critic who has misidentified the figures in the *Parade* curtain claims that the swaggering *majo* in the cloak—a stock Spanish image reminiscent of advertisements for Tío Pepe—is a self-portrait; that the Goyesque *majas* represent Diaghilev in drag talking to Karsavina; and that the frisky boy selling pomegranates—a figure that Picasso had borrowed before from El Greco—was Idzikowski.[48] The artist's jokes are never that inane.

The choice of Iberian pastiche over the original violent image of the bull charging the picador involved replacing the first act of the tauromachic drama with the last, anticlimactic moment—the *arrastre,* when horses drag the dead bull out of the ring. To counteract the left-to-right movement of the *arrastre,* Picasso introduced a right-to-left flight of the swallows; it looks contrived.

After working on the curtain for over two weeks, Picasso asked Polunin to let him know when he "had achieved the most suitable result":[49] an unexpected request that confirms Picasso's fear of overworking an idea. Alas, Polunin did not stop him in time. The corniness may have pleased the public, but it played into the hands of his artist's modernist detractors.

In desperate need of money in 1928, Diaghilev announced to Grigoriev, his regisseur, that he had decided to sell the central section of the curtain:[50]

"I've already got a buyer in Germany; and the money will enable me to do some new productions." [Diaghilev] looked at me questioningly. I was sad at the idea of parting with the curtain for *Le Tricorne,* which I love, and said I feared we might be criticized for presenting the ballet without it. Diaghilev laughed. "Oh, in that case we'd say we were afraid it might get spoilt, if we went on using it," he said, "and so we'd put it away. No, I must sell it. So will you please produce it . . . tomorrow? I'll

do the cutting out myself." The "cutting out" he referred to was what made the sale of the *Tricorne* picture possible; for it had been painted as a comparatively small panel in the center of a huge cloth. Diaghilev would have liked also to sell Picasso's curtain for *Parade.* . . . But the design in that case covered the whole expanse of [the cloth]; and no-one could be found to buy anything so vast.[51]

Paul Rosenberg sold what was left of the curtain to one of his biggest clients, G. F. Reber, the German speculator who had invested much of his fortune in cubism.[52] Twenty-five years later, Philip Johnson, Mies van der Rohe's collaborator on the Seagram Building in New York, would acquire the curtain on behalf of the Bronfman family for installation in the foyer of their building's Four Seasons restaurant, where it remains to this day.[53]

Polunin's statement that work on *Tricorne* "proceeded in a spirit of exultation" was especially true of the sublime drop curtain for the ballet itself.[54] Its overarching bridge and mountainous backdrop were inspired by the hallowed months in 1898 and 1909 that Picasso had spent in Horta.[55] The restraint of Picasso's palette— ivory, gray, terracotta, and a faded blue for the sky—has been said to derive from Goya's tapestries.[56] Nonsense. These tapestries—above all the cartoons for them in the Prado, with which Picasso was more familiar—tend to be decorative and colorful, like the *rideau de scène.* Picasso's colors for the drop curtain correspond exactly to the tonality of the sun-parched Aragonese highlands. Note the absence of anything green. Even the millstream and waterwheel, which are features of early sketches, have vanished; the bridge in the background is the only indication of the river, which is crucial to the ballet's plot. For Picasso, *Tricorne* was a useful vitrine for his emergent stylistic synthesis. By blending cubist and representational elements so subtly and easily, Picasso was able to demonstrate to a wider audience than ever before how alternative modes of notation could harmonize as well as set each other off.

Picasso's other major contribution to *Tricorne,* the costumes, have come to be seen, like the set, as the artist's supreme theatrical achievement. Indeed, Rosenberg was so delighted with them that when he came over to London for the opening, he decided to have pochoirs (stencils) made of them, which he would publish in a portfolio the following year. Unfortunately, designs of individual beauty do not necessarily make for viable ensembles. So long as the Miller and his Wife were alone onstage, everything looked fine; but, as W. A. Propert, author of an early book (1921) about Diaghilev's ballet company, pointed out,

> With the entry of the other characters one began to feel less at ease. The beauty began to fade with the insistence of those noisy dresses that never seemed to move with the wearers or assume the changing curves of their bodies that looked as if they were art in cardboard, harshly striped and rayed, with all their contours heav-

ily outlined in black. One or two . . . might have been forgiven, but multiplied to ten or twenty, they became merely ugly.[57]

Propert was not alone in taking exception to the surfeit of stripes that recall the puppets' costumes Picasso had seen in Rome. In the tiny Teatro dei Piccoli these stripes, which accentuate a costume's folds and draperies, helped spectators to differentiate between the characters when seen from afar, but en masse and in constant movement on a crowded stage they made for confusion.

Massine continued to perform the role of the Miller in front of Picasso's backdrops until he was well into his sixties. As a junior ballet critic, circa 1950, I saw him dance *Tricorne* several times—with Margot Fonteyn and Moira Shearer, among others. Although he could no longer do Felix's famous crash to the floor and leap to a sudden stop, which brought the *farruca* to a sensational finale and the audience to its feet, Massine still had a mesmerizing stage presence as well as an amazing ability to simulate Felix's flamenco. But it is hard not to agree with that formidable classical ballet critic, André Levinson, that Massine used gesture and step to "translate the score note by note; movement was no longer significant or expressive, but purely dynamic and decorative."[58] In this respect, at least, Massine's dancing was the antithesis of flamenco in that it was almost totally lacking in what Spaniards call "*duende*" and blues singers call "soul."

The more Picasso worked with Diaghilev, the more convinced he became that the impresario's cult of the new was a showman's gimmick rather than a matter of modernist conviction. This emerges in a very hurt letter—from Diaghilev written a day or two before the first night of *Boutique* on June 5—that he had sent to Picasso's room. "*Cher, cher Pica,* You know how fond of you I am. . . . I am writing to you in all frankness. Massine has given me a distressing lecture on the decadence of my taste and activities, based on a reflection you and Derain made to the effect that Diaghilev serves up the same stuff as the Folies Bergère, except that they do it better."[59] This critique had apparently been made in Massine's presence during an argument over a controversial prop for *Boutique.* Diaghilev, who had reservations about Derain's set (the toy shop reminded him of "a restaurant overlooking the Lake of Geneva"),[60] had wanted to add "some wretched green lamps."[61] He would not have minded, Diaghilev wrote, if Picasso and Derain had told him of their reservations in person, but it was galling to hear them from someone he regarded as his pupil. Massine, it appears, was beginning to question his mentor's precepts and resent his yoke— much as Nijinsky had done. Diaghilev ended by saying that he would not attend any more rehearsals. Massine would take over: he "will execute your orders and have a better understanding of what Derain desires. . . . I would be happy to lunch with you and Massine, as always, at the Savoy at 1:30."[62] Whether Picasso went we do not

know. Massine, who was stumped for a finale to *Boutique,* had every reason to be delighted with Derain: he had come up with an extremely apt solution: "the dolls should rebel and attack the shopkeeper and his customers"[63]—an ingenious way of expressing his and Picasso's annoyance with Diaghilev.

On July 10, the company would once again become the focus of a scandal. This time the spotlight was on Lopokova: a great favorite with the British public on account of her mischievous wit as well as her dazzling virtuosity. Since Picasso fancied Lopokova, he was careful not to have Olga around whenever he did a drawing of this enchanting dancer.[64] The newspaper headlines—*FAMOUS BALLERINA VANISHES*—overplayed the story. Lopokova had simply left her nice, intelligent, but not especially alluring husband, Randolfo Barocchi, Diaghilev's business manager, and

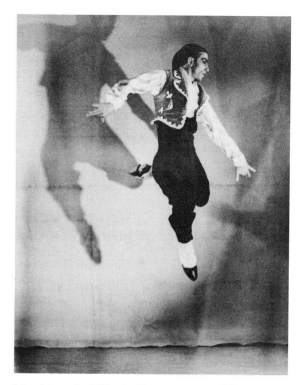

Massine as the Miller in *Tricorne,* 1919. Bibliothèque de l'Opéra, Paris.

eloped with a Russian officer, albeit no farther than St. John's Wood. The affair did not last long and she rejoined the company, only to leave it once again when Massine quit. In 1923 Lopokova would surprise her friends by going to live with Duncan Grant's former lover, Maynard Keynes, the brilliant young economist who had recently walked out of the Paris peace conference. She would marry him two years later. When Picasso and Lopokova met in London in 1950, he promised to send her a drawing of her dancing the cancan with Massine in *Boutique fantasque.* Instead he sent her a photograph inscribed *"en attendant l'original."* Apparently she never received the drawing.[65]

In the past, Picasso's contacts with the English had been limited to the coterie known as Bloomsbury. Before the war, Clive Bell, his wife, the painter, Vanessa Bell (Virginia Woolf's sister), and Duncan Grant had visited Picasso's studio on rue Schoelcher. Grant had given him some wallpaper samples for his papiers collés; and Vanessa had bought a small cubist painting from Kahnweiler for twenty dollars. Picasso had already met Bloomsbury's guru, Roger Fry, on his trip to Paris in 1910 to organize his breakthrough exhibit of modern art in London. However, he had never

really warmed to Fry—for all his harum-scarum charm, he was too earnest a prose-lytizer for Picasso's taste. Bloomsbury's leading aesthete came from a prominent Quaker family and had been raised in the bosom of William Morris's arts and crafts movement—a movement that had inspired him to set up in 1911 a modern equivalent of it. Fry's Omega workshop was at the very heart of Bloomsbury, but for all its worthy intentions, Omega never prospered. The more gifted adherents broke away and founded a more progressive movement, vorticism. Fry and his cohorts, Duncan Grant and Vanessa Bell, battled bravely on, but their artifacts were painfully artsy-craftsy and all too evidently homemade. By 1919 the workshop was on its last legs, but Fry insisted on taking Picasso to the showroom, where everything was on sale. Fry's biographer attributes Picasso's evident distaste for Omega's wares to his belief that "all English art was either pretty or sentimental [and he] was only moved to praise by the pottery."[66]

The dinner Fry gave for Picasso and Derain, early in June, at his new house on Dalmeny Avenue in North London, was no less of an ordeal. "The three men relaxed in the conservatory after dinner and Picasso told amusing stories about tortoises and cacti. Afterwards they accompanied Fry upstairs to his studio, but what Picasso said about his paintings has not been recorded."[67] Fry's dry pastiches of Cézanne and Derain would have been of far less interest to Picasso than a glimpse of his own painting of an almost abstract cubist head, which Fry had had the courage to buy virtually off the easel in 1913.[68]

Another old acquaintance who was intent on inveigling Picasso into her clutches, as she had formerly inveigled Nijinsky, was Lady Ottoline Morrell. This ramshackle grandee (daughter of the Duke of Portland) had recently cut her hair short and dyed it bright orange. It made for an eye-catching effect combined with her preposter-ously plumed hats and strings of Marie Antoinette's pearls that she habitually wore. Lady Ottoline—"Ott," to her Bohemian friends—was not really a "Bloomsberry," as members of the coterie were known. However, she had bedded and otherwise entertained several of them and had bought their work—not that this had earned her their gratitude or affection. On the contrary, most of them enjoyed castigating her: Virginia Woolf referred to her as Lady Omega Muddle. Bell was the beastliest. Before the war, Ott had been taken by Gertrude Stein to Picasso's studio, where she bought some engravings and drawings. To Bell's dismay, Ott was now hell bent on returning the favor by giving a dinner for the Picassos in London and having them for a weekend in her seventeenth-century manor house, Garsington, near Oxford—a house so magical that it served as an irresistible target for Bell's envious sneers.[69]

Bell set out to foil Ott's plans. Weeks before Picasso arrived in London, he and Fry and Harry Norton—a Cambridge mathematician who owned a cubist Picasso[70]—had organized a supper party for him and the ballet, but had given up when the artist

postponed his visit. When Ott discovered that neither she nor her entourage of painters and writers had been on Bell's guest list, she lashed out at him, and he lashed back. "Apparently one can neither give a dinner-party nor not give a dinner-party, without inviting the old whore and her *trembillage*."[71] "Picasso loathes parties," Bell added, but this did not deter him and his roommate, Maynard Keynes, from rescheduling the Picasso supper party. It would now take place on July 29. Once again, Bell failed to invite Ott. Worse, he dissuaded the Picassos from attending the weekend party she had arranged in their honor. It was a shame because Lady Ottoline had invited Mark Gertler,[72] a rather more interesting painter than any of the Bloomsbury Group. The poor woman had to settle for having the Picassos as well as Diaghilev and Massine down to lunch at Garsington, a house mordantly commemorated in Aldous Huxley's *Chrome Yellow.* At another dinner for Picasso given by Flora Wertheimer, the wife of Sargent's art dealer, she got along famously with him. What, one wonders, did Picasso make of the twelve full-length Sargent portraits of the family members that covered the Wertheimers' walls.

Like Ott, Bell had met Picasso through Gertrude Stein, shortly before publishing *Art* (1914), the book that launched his theory of "significant form." *Art,* which purported to explain modernism to a "public bewildered by competing notions of the avant-garde," was a best seller and would continue, for the next twenty years or so, to give its readers the illusion that they knew what modern art was all about.[73] As Bell admitted in his preface, many of his ideas, such as the supremacy of Cézanne, had been culled from his mentor, Roger Fry. However, Bell was a more eloquent popularizer. On the strength of this book and some nicely phrased articles, Bell had come to be perceived as England's most eloquent supporter of modern art, as personified by Matisse, Derain, and Picasso, but only so long as their work was easy for him to understand.

A measure of Bell's limitations is his obsessive promotion of Duncan Grant as "the long looked-for British genius."[74] Grant was famously lovable, but his skills were no match for his modernist aspirations. D. H. Lawrence made this brutally clear when he asked Ott to stop Grant making "silly experiments in the futurist line."[75] Though a lifelong lover of men, Grant lived mostly with Bell's wife, Vanessa, a marginally more interesting painter, who had recently borne him a child, Angelica.[76] As a result of these involvements, Bell's sponsorship of Grant was much resented by other British artists. They felt that Bell was denying them access to Picasso and Derain, who were supposedly bringing modernism, courtesy of Diaghilev, to their shores. Picasso was aware of their feelings. "Why," he asked Wyndham Lewis, "when I ask about modern artists in England, am I always told about Duncan Grant?"[77] Picasso was being disingenuous; he knew the reason.

Picasso's adoption of Bell as his London cicerone had nothing to do with Bell's

theory of "significant form," and everything to do with his promotional skills and the fact that he corresponded to Picasso's somewhat Pickwickian notion of an English gentleman—affable, rubicund, merry. It also helped that Bell was a bit of a toady, as his letters to Picasso bear out. The son of a rich colliery owner turned country gentleman, Bell was better off than most of Bloomsbury. At Cambridge he had "seemed to live, half with the rich sporting set and half with the intellectuals."[78] By the time he came into Picasso's life, Bell was perceived—approvingly by the smart set, disapprovingly by Bloomsbury—as worldly and unserious, a bon vivant with a taste for wine and women, who spoke excellent French and enjoyed modern art and literature, so long as it was not *too* modern (dada and surrealism shocked him). Bell's readiness to please may have been a major flaw in the eyes of his sister-in-law, Virginia Woolf, but it commended him to Picasso and reassured Olga as to his suitability as a friend, just as, forty years later, it would commend him all over again to the artist and his second wife, Jacqueline.

After an evening that, as Bell wrote, left Picasso and Derain "very much inclined to like me,"[79] he gave a lunch for the two artists at the house in Bloomsbury he shared with Keynes. He hired a large Daimler and arranged outings for the Picassos: a tour of East End pubs (without Olga); an expedition to West End shops (with Olga); visits to Bloomsbury's livelier parties. At one of these David Garnett noticed Picasso talking to Douglas Fairbanks Sr. He also enjoyed the spectacle of Lytton Strachey and Mary Pickford introducing themselves to each other.[80] Bell was seldom if ever accompanied by Vanessa, who was busy nursing Grant's baby. He was more often in the company of his principal mistress, Mary Saint-John Hutchinson, the wife of a popular literary barrister who was a distant cousin of two quintessential Bloomsbury families, the Stracheys and the Grants. Vanessa had recently painted an unflattering portrait of her husband's mistress, in which she evokes a look of calculation rather than Mary's celebrated warmth and wit and charm. Ten years later, Vanessa's sister Virginia would publish a rather more incisive portrait of Mary as "the febrile socialite Jinny" in *The Waves*.[81] Since both of them were married, and therefore not always available to each other, Bell wrote Mary a great many gossipy letters chronicling his meetings with Picasso and other Parisian celebrities. There was much talk of Picasso doing a drawing of Mary, whom he found *"sympathique."* This never materialized, but no matter: Mary persuaded her next lover, the handsome French Byzantinist, Georges Duthuit, to persuade his father-in-law, Matisse, to draw her. Matisse took to Mary. According to her grandson, Lord Rothschild, every year on her birthday, Matisse would send her a carefully packed lily, its petals enhanced with dabs of color.[82]

Picasso's social life in London was by no means confined to Bloomsbury. He saw a lot of Eugenia, who had stayed on in London to help her much loved relative, Tony

Gandarillas, a more or less permanent attaché at the Chilean embassy, to sort out the mess of his marriage to her *richissime* niece, Juana Edwards. Besides being homosexual, Gandarillas was a confirmed opium addict. Such was his charm that no one seemed to mind. From time to time, he would slip away to Paris to hang out with his opiomane friends Prince Yusupoff (Rasputin's killer) and, later, Cocteau. Picasso, who had met Gandarillas through Eugenia, was relieved to find someone in London who spoke Spanish and knew a bit about modern painting (Eugenia would give Gandarillas the *Ma Jolie* still life that the artist had painted on the wall of his house at Sorgues in 1913).[83] This diverting little dandy would take Picasso, some time in June, to see Augustus John, the flamboyant Bohemian painter whom Picasso had known in his Montmartre days. In 1907 John had declared Picasso to be "a wonder," and they had visited each other's studios.[84] However, John's inability to stomach cubism had curtailed their friendship. Picasso was intrigued by the Welshman's obsession with Gypsies: *"Auguste est noble comme les animaux,"* he told Bell, and to someone else he described him as "the best bad painter in Britain."[85]

Gandarillas made the mistake of introducing Bell to his unfortunate wife, Juana. She would fall for him and he would use her as his mistress when Mary was off with someone else (Aldoux Huxley's wife, Maria, for one). Although Bell complained that Juana was too silly to converse with, their affair dragged on until 1927. Meanwhile her husband had embarked on an affair with Christopher Wood: the only young English artist of any real merit to have gone to Paris and become a friend of Cocteau, Picasso, and Braque. Gandarillas got "Kit" Wood hooked on drugs, and would be blamed when Wood threw himself under a train in 1930. Five years later, Gandarillas would again be blamed—unjustly—when his next lover, the surrealist poet Réné Crevel, committed suicide.

A social rather than an intellectual snob, Diaghilev felt ill at ease in the dauntingly high-minded milieu of Bloomsbury. At one of the few Bloomsbury parties he did attend, the hosts had been at pains to rustle up a "princess" in the unlikely form of Dorothy Brett (the artistic sister-in-law of the "White Rajah of Sarawak") to make him feel at home. Ever since the Ballets Russes' first appearance in London in 1911, Diaghilev had courted the more affluent and cultivated members of London society for their social cachet as well as their potential as backers. Now that the war was over, he saw to it that powerful hostesses such as Lady Ripon, Lady Cunard, Baroness d'Erlanger, and the sharp-tongued Daisy Fellowes vied with each other, as they had before the war, in giving parties for the stars of his company. Night after night, Picasso had to don his brand new dinner jacket and escort Olga, now described by her husband as *"ma femme légitime,"* to supper parties, which he claimed truthfully or not bored him as much as they stimulated her. As Bell reported, "Madame Picasso has no notion of joining in the rough and tumble of even upper Bohemia."[86] Olga

may not even have attended the jolly party to celebrate the completion of *Tricorne* that the Polunins gave for Picasso in a rope makers' loft. "Upper Bohemia" was well represented at this event—among them the society portraitist Oswald Birley, his beautiful wife Rhoda, and young Florrie Grenfell, later Lady Saint-Just, a passionate balletomane whose lover, Leon Woizikowsky, one of Diaghilev's stars, would father the next Lord Saint-Just. Picasso later joked that in one respect Olga's disdain was a godsend. It allowed for assignations on the side.[87]

Belated peace celebrations (the Treaty of Versailles had been signed on July 1) postponed the first night of *Tricorne,* from July 18 to July 22, only eight days before the company's season ended. Cyril W. Beaumont, the learned British ballet critic, described the scene backstage at the Alhambra: the low-ceilinged storage room for props, which served as a green room (with bouquets for the ballerinas laid out on a large table). This was Diaghilev's "headquarters in the field."[88] It was here that the impresario would discuss such forthcoming productions as *Pulcinella* with Picasso, or go over scores with his conductors, Ansermet and Defosse, or confer with his troubleshooter, Edwin Evans. Diaghilev had taken on this popular and perceptive music critic, who described himself as the company's "buffer state," on his first visit to London and would use him for press relations and such problems as keeping disgruntled dancers from disturbing him. Picasso liked Evans enough to do a little drawing of him.

On the opening night of *Tricorne,* Beaumont watched the stage being set and Picasso strolling "into view, accompanied by a stage-hand carrying a tray of grease-paints":

> One of the dancers, dressed as an Alguacil, came on the stage, walked towards Picasso, bowed and waited. Picasso made a selection of grease-paints and decorated the dancer's chin with a mass of blue, green and yellow dots, which certainly gave him an appropriately sinister appearance. As he went off, another Alguacil appeared, and I well remember his startled look on seeing his fellow artiste.[89]

Just as he had painted arabesques onto Lopokova's Acrobat costume before the curtain went up on *Parade,* Picasso used the faces of the *Tricorne* dancers as his canvases. In preliminary studies for the makeup, he tried out tribal markings as well as the pointillism he had been using in his recent paintings. Unlike Derain, who gave each of the dancers a diagram indicating how to apply their makeup, Picasso preferred a more hands-on approach.

And then, as Beaumont describes, the ballet began, "with a fanfare of trumpets followed by the slow thunderous beats of a big drum. But, before the curtain rose,

there was a volley of enthusiastically shouted olés, immediately followed by a burst of heel-tapping and the dry rhythmic clicking of lustily shaken castanets."[90] These sounds, which had been added at Picasso's insistence, displeased Margot Asquith, the outspoken wife of the ex–prime minister. She took it upon herself to send a note to Diaghilev the following morning: "... the cries were *feeble* and not at all *spontaneous* they [should] be *sharp & all together*. The castagnettes [*sic*] were not quite *in time*.... Can you Déjeuner today 1:30? Or tomorrow jeudi 24th and bring Mme. Bruce [Karsavina]. Please do."[91]

Another of Picasso's imaginative touches occurred toward the end of the ballet, after the lecherous old Corregidor has the Miller arrested, the better to seduce his flirtatious but faithful Wife, danced by Karsavina. When the Corregidor returns by night to take advantage of her, she shoves him off the bridge into the river. Picasso had Woizikowsky, who played the Corregidor, do a quick change into a second coat, sewn with stripes of shiny black American cloth and sequins to suggest the sparkle of water. The ballet then ends with a joyous Goyesque scene: the villagers toss an effigy of the Corregidor in a blanket to celebrate the end of the despotism that his gold-braided tricorne symbolized. Although *Tricorne* lends itself to political interpretation, Picasso claimed that he took no interest whatsoever in the plot.[92] What interested him above all was the ballet's Spanishness—the Spanishness of his décor, of Falla's music, and the dances that Felix had devised.

Like *Boutique fantasque, Tricorne* "took the audience by storm."[93] Unlike *Boutique,* which cashed in on the fashion for nineteenth-century frou-frou that was erupting in postwar Europe, *Tricorne* was incontrovertibly modern and it would leave a far more progressive mark on taste than that left by Bakst's décors. These had proved a fertile source of baddish, modish style as exemplified by the tasseled bolsters and poufs in purple, peacock blue, and orange to be found in many a balletomane's rooms. *Tricorne* too would launch a fashion—a fashion for things Iberian: a fringed shawl on the piano, a beribboned guitar on the wall, kiss curls and fans and Gypsy earrings would take the place of Bakst's barbaric orientalism. As Buckle writes, "London would soon be full of Spanish dancing schools."[94]

After the first night, July 22, Diaghilev had arranged a party for the stars and his army of grandees and distinguished fans: among them Osbert and Sacheverell Sitwell and the T. S. Eliots, who would return the following evening with Mary Hutchinson and her husband Jack. Picasso claimed to loathe being lionized or put on exhibit, especially by people with whom he had no common language. Fortunately most of Diaghilev's friends spoke French.[95] However, his ordeal was coming to an end. On July 28, Picasso and Olga, accompanied by Diaghilev and Massine, motored down to Garsington for the visit that Bell had done his best to sabotage. Vanessa and her sister Virginia had both declined; the Aldous Huxleys and a woman

friend of the Morrells were the only other guests.[96] Picasso remembered the beauty of the house with its great Italianate garden but not half as well as he remembered the bizarrely dressed, six-foot-tall hostess with her prognathous jaw, often to be seen crunching gob-stoppers with her equine teeth.[97]

The following day, July 29, Bell and Keynes gave their farewell party for Picasso. They had "some forty young or youngish painters, writers and students"[98] to sit at "a couple of long tables. At the end of one we put Ansermet, at the end of the other Lytton Strachey (who found Picasso's work: 'Futuristic and incomprehensible') so that their beards might wag in unison. I remember that Aldous Huxley brought with him a youth called Pierre Drieu la Rochelle—that ill-starred and gifted writer."[99] Diaghilev was not invited: too grand. Falla's father had died, so he had had to return to Spain before the opening night of *Tricorne,* which he had been scheduled to conduct. Picasso told Duncan Grant that this was "the party he had been looking for ever since he had been in England."[100] This was not mere politesse. Bell was intent on pandering to Picasso.

The company's last performance of the season took place on July 30. London society was present en masse, so was Bloomsbury. To thank Bell, whose enthusiastic article on the ballet had just appeared in the *New Republic,* Picasso gave him a farewell lunch at the Savoy the following day. Bell described them watching Eddie Marsh, Winston Churchill's former secretary, who was famously susceptible to male beauty, "hanging around the foyer in the hope of getting a final glimpse of Massine."[101] Afterward they went to the Mansard Gallery in Heal's furniture store, where Osbert Sitwell and his brother Sacheverell (who had once considered becoming an art dealer) were having an opening of their exhibition of modern French art. This had been organized by Leopold Zborowski, a Parisian Pole, who derived far more profit from being Modigliani's friend and dealer than from writing poetry. A very mixed bunch of works culled from Paris dealers, this show included a large wicker basket full of sheaves of Modigliani drawings priced at a shilling each.[102] Arnold Bennett, the popular novelist who fancied himself a connoisseur, wrote the preface to the catalog and bought a Modigliani and an Utrillo for seventy pounds. Herbert Read, who would replace Roger Fry as Britain's art guru, served as the Sitwells' salesman. Picasso seems to have kept tactfully quiet about the merits of the artists represented in this show.

After the opening, Bell took the Picassos for a last day's shopping. He wrote to Mary Hutchinson that he had "rigged him out as a perfect English gentleman, so far, at any rate, that an English gentleman is a matter of shoes, hats and ties."[103] Since Eugenia had instituted this process two years earlier and had supplied Picasso with suits from the Saville Row tailor Poole and shirts from Jermyn Street haberdashers, this was not altogether true. The same with another of Bell's claims: Picasso's final

injunction to him—"Write from time to time, and keep me in your thoughts"[104]—sounds more like Olga.

This letter included one startling piece of news: Picasso had bragged to Bell that Renoir had sent him a letter "in which this *vieillard* says he will be in Paris on August 3, and that he is coming chiefly to see Picasso and his works. Picasso hopes to make a portrait."[105] In fact, what Picasso *had* received was a letter dated July 29 from Paul Rosenberg, not Renoir. The dealer said that Renoir was coming to Paris on August 3; and they had talked about Picasso. "It's too long to write about, but [Renoir] wants to see you. He was impressed by some [of your] things, and all the more shocked by others."[106] Whether the meeting with Renoir materialized, we do not know. Later in the year, Picasso did indeed execute a large, very *travaillé* drawing of him,[107] but from a photograph, not from life. A letter from Rosenberg to Picasso dated August 20 suggests that the meeting may not have taken place: "If you had stayed with us at Vaucres-

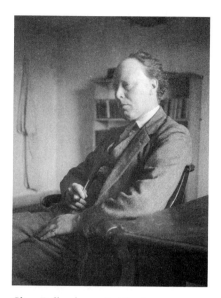

Clive Bell at home in Charleston, Sussex, 1923. Tate, London.

son, you would have lunched tomorrow with Renoir, who is doing me the great honor and great pleasure of being my guest."[108] When an artist he especially admired died, as Renoir did in December, Picasso tended to see himself as an heir to the dead man's vision. In the next year or two, Renoir would become something of a father figure like Ingres.

Picasso told Penrose he liked London "because of an old romantic dream of an atmosphere, the contrary to Spain and the beggars in top hats,"[109] but he had mixed feelings about this trip. As he expected, he found the art scene bereft of energy, but he was enormously stimulated by the rapturous reception of *Tricorne*. Picasso would have enjoyed it more, he said, if there had been less "Russian despotism" on Diaghilev's part as well as Olga's. He needed to escape the atmosphere of intrigue and high drama that was endemic to the Ballets Russes. In Paris he could slip the leash. In London this was more difficult. Picasso would tell Françoise Gilot that he and Olga had failed to get along "almost from the start."[110] However, deny it though he might years later, he would continue to take great pride in his trophy bride. What paled was the primitive Russianness. When Picasso went to have his hair cut, the barber assumed he was Russian. Too much of the ballet had rubbed off on him. That did it, he said.

11

Summer at Saint-Raphaël (The Gueridon)

After more than two months with the ballet in London, Picasso was raring to get back to painting major works that would reestablish him at the forefront of the avant-garde. While he was off with the ballet, his leading rivals—Léger, Braque, Gris, and Matisse—had each had a major show of recent work, and, except for Matisse, each had been perceived as furthering the cause of modernism. Now it was Picasso's turn. Realizing the need for a riposte, Rosenberg arranged for him to have a sizable exhibition at his gallery in October. To outshine his rivals, the thirty-eight-year-old Picasso needed to come up with a cohesive group of new work. However, Diaghilev's demands had left him little time to produce enough for a large show. And so Rosenberg decided to limit the exhibition to works on paper and whatever else the artist came up with over the summer.

Picasso longed to get away to the sea and recover from the turmoil of the London season, but business kept him in the city. Bankers, publishers, and dealers all needed to see him. He also had to arrange for his old friend the Catalan collector Alexandre Riera (a witness to Carles Casagemas's suicide) to take money to his mother in Barcelona. As Picasso could not stand having a secretary around, he had Olga balance the household books and keep track of sales to dealers.[1]

Meanwhile, Picasso had every reason to worry that the thing he feared most was a fait accompli: the sale by the French authorities of the stock of his former dealer, Kahnweiler. This would mean that hundreds of the artist's cubist paintings, papiers collés, drawings, and prints would be thrown on the market and would devalue not only cubism but also his current work. Picasso had consulted lawyers and André Level, one of the few dealers he liked and trusted, only to discover there was nothing he could do.[2] His outrage at the prospect of a series of sales surpassed that of Kahnweiler's other artists—Braque, Léger, Gris, Derain, Vlaminck, Van Dongen—because the dealer had acquired far more of Picasso's output than anyone else's. Also he was obsessively protective of his work and felt that the very heart of it was at risk.

On August 6, shortly after returning to Paris, Picasso had a visit from Jean Hugo and his fiancée Valentine Gross—portraitist, balletomane, bluestocking, muse—

who had kept the peace when Picasso and Satie were working on *Parade* and having problems with Cocteau's pop gimmicks.[3] Valentine was famously *à la page.* She knew everything that was going on in contemporary art, literature, music, and ballet as well as society. She kept Picasso, who relished gossip, abreast of Cocteau's capers, Satie's witticisms, and the sayings of the "new Rimbaud," the barely sixteen-year-old writer Raymond Radiguet, nicknamed "Monsieur Bébé." Radiguet had been discovered by the writer André Salmon, passed on to Max Jacob, seduced by Picasso's former fiancée, Irène Lagut, and served up to Cocteau, who would fall obsessively in love with him. Picasso would soon take him under his powerful wing.

Valentine, who would always adore Picasso—eventually to distraction—had her own reason for visiting the rue la Boétie. She and Jean Hugo were to be married the following day in the teeth of his family's opposition. Satie and Cocteau had agreed to be witnesses, but Valentine wanted Picasso to give their marriage his seal of approval and, maybe, a wedding present. The artist turned out to be in a foul mood, as Jean Hugo, who was on special leave from the army, has described in his memoirs: "[Picasso] opened the door himself. He did not look as if he had been painting; nevertheless one felt one was disturbing him."[4] Hugo remembered the two great Douanier Rousseaus: the *Standing Woman* in the hall and the *Fête populaire* in the dining room, which looked out onto a tree-shaded garden. He also remembered being surprised at Picasso's references to Olga as *il;* and her references to him as *lui.* "After a short time, Picasso pulled a key out of his pocket and unlocked a door to the enfilade of studios. . . . [They] were piled with the usual mixture of treasure and trash, but there was no sign of paint, palette or easel. Where, how and with what did he paint? He showed us some canvases, among them the *Three Musicians*[5] [he misremembered] and then he accompanied us to the door and brusquely said 'good day.' "[6] Everything had been packed up, as the Picassos were about to leave for the south.

While the Picassos were in London, Eugenia had urged them to return to Biarritz for what was left of the summer, but they wanted to be on their own and finally have a less social honeymoon. Picasso preferred the Mediterranean over the blustery Bay of Biscay. Accommodation was hard to find. The Riviera was still primarily a winter resort. Most attractive hotels in attractive places closed for the summer. They finally found rooms in Saint-Raphaël at the Hôtel Continental et des Bains, a hotel popular with the British, who were famously unafraid of the midday sun. Picasso enjoyed visiting the nearby harbor of Fréjus, where there was a Roman aqueduct and an arena, which served as a setting for Comédie Française productions of classical drama. Later, it was used for bullfights, which Picasso would regularly attend.[7] This and other classical remains in the neighborhood evoked the ancient Mediterranean world, whose aura would help to classicize his style.

Eugenia continued to press Picasso to come and stay ("Tell Olga the apartment will be ready in ten days. . . . there won't be any Americans nor so many people," she wrote him on August 20),[8] but they refused to budge from Saint-Raphaël. To their surprise, the Picassos had landed in a resort that boasted an Anglican church, a twelve-hole golf course, and an English tea shop. The pattern of this summer would conform pretty much to the pattern of Picasso's pre-1914 summers. He would head for the south, work intensively in relative seclusion, come up with some new concept, and return to Paris recharged by the sun with a harvest of fresh work and fresh ideas that he would explore and develop in the months to come. The resultant paintings, whether figures or still lifes, would usually be redolent of the woman who had accompanied him.

This summer was different. Except for a few affectionate sketches, Olga makes no overt appearances in her husband's work. Picasso loved her as a proud Spanish husband would, which was radically different from the way he loved his mistress. Portraying her emerging from her own vagina (Eva's fate) or in the guise of his own erect penis (his next love, Marie-Thérèse's fate) would have been unthinkable. For the first five years of their marriage Olga never appears in any of his innovative masterpieces but only in representational portraits, from which the affection gradually seeps—which is why there is never any mention of an *époque* Olga. It was only later when her physical and psychological problems took their toll on the marriage that she would play a dominant role in Picasso's revolutionary imagery. These problems called for exorcism. This would take the form of images seething with ridicule and rage, cruelty and resentment.[9]

Picasso's traditional attitude toward the bride who loved to sit for him made it very difficult to portray her in any but a traditionally representative way. To reconcile conventional love for Olga with his pursuit of modernity, he turned to the subject of the anthropomorphic gueridon, which had preoccupied him the previous winter, and applied it to Olga instead of himself. While the Smith College gueridon had been about the artist and his work, the ones done at Saint-Raphaël are about Olga and are intrinsically feminine, honeymoon images that radiate with love and sunny freshness and no hints of Picassian darkness.

This second honeymoon was more of a success than the first, despite or maybe because the newlyweds were cooped up together in a smallish room,[10] which seems also to have served as a studio. Their room looked out over decorative balcony railings and the pagodalike top of the town's bandstand to the beach, in those days relatively free of bathers, and "the sea of blue ink" which Level had promised when he recommended the place.[11] Sketches of the room done soon after their arrival depict its contents: an *armoire à glace,* a coat rack, a fringed chaise longue, a radiator, a pair of *portes-fenêtres* framing the view, and, to Picasso's delight, a little dressing table

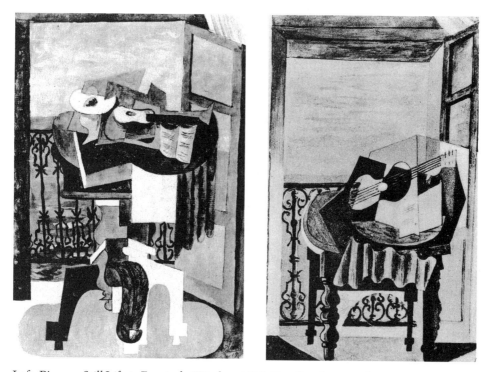

Left: Picasso. *Still Life in Front of a Window,* 1919. Pencil and watercolor on paper, 32 x 22 cm. Private collection. Right: Picasso. *Musical Instruments and Score in Front of an Open Window,* 1919. Pencil and watercolor on paper. Private collection.

with a mirror on top, its shelves carved like daisies. Its kitschiness inspired a detailed drawing.[12]

In fact, as sketches reveal, there was no gueridon in front of the Picassos' balcony window, only a four-legged table elsewhere in the room, which rings an occasional change on the gueridon theme. Only the open window with its curtains sometimes looped back to form a proscenium arch framing the backcloth of sea, sky, and railings are for real.[13] The wasp-waisted gueridon with its splayed legs and humanoid array of familiar objects—fruit dish, guitar, sheet music, and tablecloth—is entirely conceptual. It is also strikingly theatrical. Picasso, the stage designer, has set the scene to perfection. His gueridon has the air of a spotlit star alone on a stage. One feels that music from the bandstand below might set the gueridon in motion.

When he was in London, Picasso had turned a deaf ear to Rosenberg's suggestion that he follow Monet's example and paint successive views of the same motif in different lights. In Saint-Raphaël, he did something of the sort with his gueridons. Sometimes it is seen against the sunlit sky; sometimes the source of light seems to

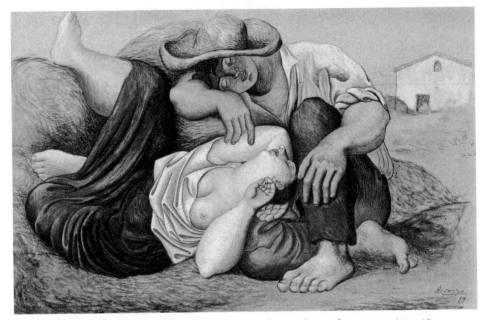

Picasso. *Sleeping Peasants,* 1919. Gouache, watercolor, and pencil on paper, 31 x 48 cm. The Museum of Modern Art, New York.

come from within the room; and sometimes cubist flanges of the still life rear up like a spinnaker, as if to waft the outdoors indoors.[14] Six months later, Rosenberg would send Picasso a postcard, apropos the gueridons, prophesying that "1919–1920 will turn out to be the year of the windows! Windows by Picasso, a window by Matisse."[15] "The year of the gueridon" would have been more to the point.

By the end of the summer, Picasso had executed some twenty-five *Gueridons* in watercolor, gouache, and pencil. He had also experimented in a more traditional style. Among the summer's more surprising images are some highly finished and highly colored fête champêtre scenes of amorous haymakers enjoying an alfresco nap.[16] These appear to have been inspired by Boucher's and Fragonard's genre scenes that he knew from Rosenberg's stock. One of Picasso's drawings depicts a voluptuous young woman, rapturously offering her breast to a baby as if to a lover— a wish-fulfilling *maternité.*[17] Picasso also returned to landscape—farm buildings in a hayfield—something he had not done for ten years or so. Designing for the ballet had left a theatrical stamp on his perception of nature. To the right, farm buildings constitute "wings" (as in *Tricorne*); to the left, two trees cry out to be scaled up, hung on gauze, and used as a *repoussoir* to imply recession without recourse to perspective. Zervos's claim that this painting was executed, or at least finished, after Picasso's

return to Paris,[18] would explain its look of contrivance. By comparison the paintings of the very same Esterel mountains that he executed forty years later have a van Gogh–like ferocity.

That this stylized landscape was done at Rosenberg's behest would explain the dealer's ecstatic outburst a year later: "the most unbelievable, the most extraordinary, the most inconceivable news, which is going to surprise you and fill you with joy and put your worries at rest. Yes, my friend, I have sold a Picasso...the one you thought was unsaleable, *le paysage rousseauiste*."[19] The Saint-Raphaël painting is the only one that fits the bill. Rosenberg's hyper-

Picasso. *Landscape at Saint-Raphaël,* 1919. Oil on canvas, 49.4 x 64.4 cm. Bridgestone Museum of Art, Ishibashi Foundation, Tokyo.

bole was presumedly supposed to encourage his artist to do more landscapes, because they appealed to collectors weaned on impressionism. Rosenberg failed to realize that Picasso was not a *paysagiste* at heart. Nature fascinated him, but only insofar as he could bring it within reach and have his metamorphic way with it.

Picasso and Olga returned to Paris on September 17.[20] Diaghilev had written from Venice saying that he and Massine had been working on *Pulcinella,* the commedia dell'arte ballet engendered by their trip to Naples and needed to get together with him in Paris,[21] where Stravinsky was due to arrive. Diaghilev had decreed that the music for this *ottocento* Neapolitan ballet had to be by an *ottocento* Neapolitan composer—which is why he and Massine had been studying scores by Pergolesi in libraries in Naples and London.[22] Diaghilev originally wanted Falla to transform these orchestral pieces into ballet music, but he declined, and so the impresario turned to Stravinsky, a wild idea that would inspire a new concept of musical neoclassicism.

In his memoir, Stravinsky describes Diaghilev asking him, as they were crossing the Place de la Concorde together, "to look at some delightful eighteenth-century music with the idea of orchestrating it for a ballet. When Diaghilev said the composer was Pergolesi, I thought he must be deranged. . . . Diaghilev knew I wasn't the least excited about it. I did promise to look, however, and to give him my opinion. I looked, and I fell in love."[23] Within a week Stravinsky had started work on the taran-

tella, and by the time he returned home to Switzerland, "the ballet had been agreed on in principle and Picasso had made the little promissory drawing of Pierrot and Harlequin," which Stravinsky reproduced in his autobiography.[24]

On this trip, Stravinsky stayed with the Jean Hugos in their Palais Royal apartment, where they gave a small party in honor of Editions de la Sirène's publication of his *Ragtime*.[25] The score, with a calligraphic cover by Picasso,[26] was dedicated to Eugenia Errázuriz, but the printers had misspelled her name, and the original edition had had to be scrapped. The guests included Picasso, Diaghilev, and Massine, as well as two of Cocteau's "Les Six," Poulenc and Auric (for once, Cocteau was not present). At the party, Stravinsky drank "without restraint" and sat down and played the brief (five-minute) *Ragtime*. The group went on to dine at La Roseraie, a restaurant with red plush walls lit by lamps with shades like little orange bells. "Now that's what one should paint," Picasso said.[27]

Another musical celebrity, the peripatetic Polish pianist Arthur Rubinstein, who frequently passed through Paris, would later write a far from reliable account of *his* meetings with Picasso. "Come and see me in my nasty apartment," Picasso supposedly told him when they met at a tea party of Eugenia's. "It was a nasty apartment all right," Rubinstein misremembers, "I could well imagine that he would still prefer to live in the shabby, dirty Bateau Lavoir. . . . What he called his atelier was a typical kind of salon, like the waiting room of a dentist."[28] Nor does Rubinstein's claim that he paid Picasso "practically daily visits" and watched him paint the same subject (presumably the gueridon) carry much conviction. "Is there a great demand for [this subject]?" Rubinstein asked. "What a stupid question," Picasso said. "Every minute there is another light, every day is different too, so whatever I paint becomes always a new subject."[29] "A great lesson," Rubinstein thought. Picasso liked Rubinstein well enough to do a drawing of him. When told that this portrait had been destroyed during World War II, the artist would do several more and give the great pianist four of them.[30]

Picasso did not miss "the shabby, dirty" Bateau Lavoir. That world no longer existed. Montmartre's Lapin Agile had become a tourist trap; so had Montparnasse's cafés the Rotonde and the Coupole. Dadaists and surrealists would soon have their own haunts and hideaways, but Picasso would avoid them—too sectarian, too conspiratorial. Also, Olga would not have fitted in any more than she would have fitted into a *tertulia*. Much as he *said* he missed the good old days in Montmartre, he was happy, for the time being at least, with the bourgeois routine of dinners that Olga had created for him served by a white-gloved butler. Complaints to Rubinstein and others were a cover-up. Had he wanted to, Picasso could perfectly well have led a Bohemian *vie de luxe*, as Derain did.

In her campaign to "de-Bohemianize" her husband Olga made the mistake of

having Picasso banish Max Jacob, his oldest French friend and godson. She should have befriended this saintly, incorrigibly disreputable poet, as Cocteau did. En route to the second night of *Tricorne* (January 30, 1920), Jacob was knocked down by a cab and so badly injured that he had to spend a month in hospital. Picasso rushed round to see him. He was in a public ward with an enormous bunch of violets from Eugenia at his bedside. Picasso teasingly reminded Jacob that when he was received into the Catholic Church, he had told him to take the name of Saint Fiacre. "You see I'm a prophet," Picasso said. Much offended, Jacob replied that he had been run over by a private automobile, not a *fiacre*.[31]

Of all Picasso's friends, the one Olga was fondest of was Cocteau. He was elegant, *mondain,* witty, and had been born into the haute bourgeoisie. Also he was always at pains to charm her, as he would most of Picasso's women. Cocteau, who would always be masochistically in love with Picasso, had made himself indispensable—a mercurial manipulator—but he was no kindred spirit. For all his brilliance, there was little ballast or depth to this jester. And Picasso needed someone less flamboyantly homosexual than this egomaniacal star. He thought he had found the right qualities in a rich, young Argentinian painter named Georges Bemberg. Unfortunately, Bemberg would turn out to be a paranoid schizophrenic, who wanted to *be* Picasso.

Georges Bemberg has never figured in the Picasso literature because his manipulative tycoon of a father wrote him out of history. Rather than admit that Georges had gone mad, which happened in 1922, Bemberg's father told everyone, including his family, that his son had died. Bemberg's friendship with Picasso began with a letter dated February 13, 1914, requesting a meeting. *"Monsieur, je voudrais vous connaître,"* it began, *"je suis tout jeune peintre."*[32] The writer went on to proclaim his admiration for Picasso's work: "wherever I put my feet," it is always in Picasso's tracks. The letter was signed "Jorge Bemberg." Subsequent letters would be signed "Georges." Their mutual friend Max Jacob had presumably told Bemberg that Picasso favored people who spoke Spanish, and he would also have informed Picasso that Bemberg came of an exceedingly rich and powerful family.

Originally brewers from Hamburg, the Bembergs had made a prodigious fortune in Argentina and then settled in Paris, where Georges's sister, Rosita—a daunting, difficult woman—had been married off to the Marquis de Ganay. *Alliances de fric* were becoming a tradition in the Ganay family. The previous marquis had made just such a marriage to the granddaughter of another Jewish tycoon, Baron Haber of Vienna. Haber had endowed the Ganays with two of the most beautiful châteaux in the Ile-de-France, Courances and Fleury-en-Bière. And then Otto Bemberg had set-

Picasso. *Portrait of Georges Bemberg,*
1917. Conté crayon on paper,
49 x 30 cm. Private collection.

tled a second fortune on them. Instead of marrying into the
gratin, Georges had disappointed his dynastically minded
father by marrying a Russian dancer and taking up paint-
ing. God forbid that the Bemberg millions should turn out
to be tainted with insanity.

The friendship with Bemberg would not have flourished
if so many of Picasso's friends had not gone to war. I also
suspect that Bemberg's psychic need of him as a men-
tor might have reminded Picasso of his earliest disciple,
the suicidal Casagemas. Bemberg was very anxious that
Picasso should do his portrait; this wish was granted early
in 1917: a large pencil sketch of him was followed up a year
later by an Ingresque portrait drawing[33] in which the artist
has caught the fine cut of Georges's jacket and the fit of his
shoes; he has also caught his look of alienation. Further
portraits are rumored to have existed, but none has sur-
vived.

Besides aspiring to be a great modern painter—another
Picasso, no less—the deluded Bemberg aspired to be a
great composer; in this respect, like another family disap-
pointment, his musical Uncle Hermann, a friend of
Proust's, who had become involved in a homosexual scan-
dal. To further his musical aspirations, Bemberg employed
an elderly teacher—a magnificent King Lear–like figure, whose looks inspired a cou-
ple of drawings by Picasso, one of them among the most worked up of his pencil por-
traits.[34] In a letter dated November 19, 1918, Bemberg tells Picasso that his old
teacher had returned from a trip and was upset that Picasso was not around to paint
him.[35] This letter establishes the hitherto unidentifiable sitter's identity; no painting
of him exists.

That both Picasso and Bemberg married Russian dancers constituted a further
bond. Nothing is known about Bemberg's first wife, beyond the fact that she and
their baby died in childbirth in 1920, and that she is said to have been friends with
Olga. Some thirty-five letters from Bemberg to Picasso survive. Most of them con-
cern everyday arrangements, but occasionally Bemberg obsessed about silly, minor
things. In a long letter dated May 15, 1919, he takes issue with a woman who had
supposedly asked Picasso whether he saw people the way he painted them. "Of
course not, that would be terrifying," the artist replied.[36] Bemberg argued that
Picasso was doing what poets had been doing for centuries: fashioning *une femme
vivante* out of poetic metaphors (ebony hair, rosy cheeks, coral lips, pearly teeth, and

so forth). Bemberg went on to complain how difficult it was to follow in his master's footsteps: "You know where you are going, I don't."

Since Bemberg's paintings were said to resemble his, I asked Picasso whether they had been copies. "Worse," the artist said, "Bemberg was mad, thought he was me, and wanted to paint his own Picassos." The mere thought of identity theft so terrified Picasso that he refused to discuss the matter further. Members of the Bemberg family turned out to be no more prepared to talk about Georges than Picasso. The discovery that Bemberg had lent Picasso a studio in his country house at Yerres made the matter all the more intriguing. In the end Bemberg's loyal stepdaughter, the late Princess

Picasso. *Portrait of Georges Bemberg's Music Teacher,* 1919. Pencil on paper, 60 x 50 cm. Private collection.

Marie Gortchakow, was good enough to explain why the Bembergs had written her stepfather out of history. He had saved her family after their escape from Russia, she said, and she was determined to set the record straight.

12

Pulcinella (1919–20)

Picasso's exhibition of drawings and watercolors opened at Paul Rosenberg's gallery on October 20 and closed on November 15, 1919. The catalog had a bombastic preface ("Picasso is all alone between heaven and earth. . . . Picasso has invented everything") by André Salmon, an old friend he no longer liked. Since individual works are not identified,[1] people have concluded that Picasso followed the example of Braque, Léger, and Gris and exhibited only recent work.[2] However, as the artist told the journalist Georges Martin, *"voilà toute ma vie."*[3] This remark is confirmed by J. G. Lemoine, the critic of the influential *L'Intransigeant,* who reported that Picasso "agilely pirouettes over cubism which now bores him. He jumps over impressionism. He jostles Courbet in passing and falls on his knees before Monsieur Ingres."[4] Roger Allard went further. In *Le Nouveau Spectateur,* he complained that the show included a bit of everything: "Leonardo, Dürer, Le Nain, Ingres, Van Gogh, Cézanne, yes, everything . . . except Picasso."[5]

Juan Gris may have had Allard's article in mind when he declared, two years later, in a letter to Kahnweiler, that he had been

> thinking about what is meant by "quality" in an artist. . . . Well, now I believe that the "quality" of an artist derives from the quality of the past that he carries in himself—from his artistic atavism. The more of this heritage he has, the more quality he has. This has nothing to do with his natural gifts or talent, that is to say his accomplishments or even his style. . . . One's resemblance to one's parents is always strong enough without putting on their clothes.[6]

Ingres had put this differently: "He who will not look to any other mind than his own will soon find himself reduced to the most miserable of all imitations, that is to say his own works."[7]

Despite the postwar slump, Picasso's show sold well enough for Rosenberg to raise his prices. The success was due to a growing perception on the part of the press of Picasso as a celebrity, a perception that obliged him to subscribe to a press-cutting service (June 1919).[8] André Warnod described the artist at the Rosenberg vernissage

"surrounded by snobs and dealers bleating *'maître, maître'* "[9]—a word Picasso abhorred.

On November 1, Clive Bell arrived in Paris for six weeks or so to see the Rosenberg show, consolidate his friendships with Picasso and Derain, and possibly forge additional ones. In the course of this visit Bell was accepted into Derain's coterie of mostly minor painters and friendly models, whose rowdy evenings were apt to end in song. Picasso kept aloof from this old-time *vie de bohème.* He and Olga would have Bell to lunch at home or dinner at the restaurants de luxe—Lapérouse or Voisin—which she preferred to the bistros her husband favored. Bell's letters to Mary Hutchinson, whom he was forever prodding Picasso to draw, provide sycophantic accounts of their meetings. On the afternoon of November 2, Bell went to the rue la Boétie where Picasso showed him "all the pictures in the house" and mischievously told him he had recently caught Mary Hutchinson's husband in the streets of Paris with a lady on his arm. "Come and lunch or dine whenever you like," Picasso told him. "Olga is a nice pretty little thing," Bell wrote, a touch condescendingly, but "I'm in love with him,"[10] though not so much with the work—little of which he understood—as with Picasso's ever-growing fame.

On the fourth, Bell visited the show at Rosenberg's ("the virtuosity of that man is almost alarming"); on the eighth, he spent all the afternoon "jabbering with le petit [Picasso]" in his studio. On the ninth, he boasts that "no one but the Prince of Wales has so many engagements": dinner with the Picassos the night before ("Olga very smart in a new gown, [he] brushed up with a smart bow-tie") as well as the night after. The artist had inveighed against Epstein's monument to Oscar Wilde in Père-Lachaise, as well as against the Epsteins themselves: "two of the most disgusting people he had ever met."[11]

Two days later, Picasso took Bell to dine in "a little Italian restaurant in Montmartre—on the way we visited the fête de Montmartre, which we found in full swing, though sadly fallen . . . from its ancient glory. Still the galloping pigs and lady wrestlers were there."[12] They went on to the Cirque Medrano—a visit that inspired some equestrienne drawings—and ended up at an English bar (probably Fox's, where Picasso had first met Apollinaire), which Bell described as "sorry." There was another outing with the Picassos to a typical Montmartre restaurant ("masses of whores, bad champagne . . . very few American officers . . . a raucous band . . . and couples dancing everywhere. . . . La belle Olga . . . attracted a good deal of attention and before long several handsome young gentlemen were pelting her with balls and feathers. . . . We went on to the Bal Tabarin, where they still dance their 'quadrilles réalistes' ").[13]

The day after the Rosenberg show closed in Paris—the same day *Parade* opened

Picasso. *Jean Cocteau, Olga, Erik Satie, and Clive Bell at rue la Boétie,* November 21, 1919. Pencil on paper, 49 x 61 cm. Musée Picasso, Paris.

in London—the Picassos gave a luncheon in their apartment for Bell, Cocteau, and Satie.[14] Afterward, with Courbet's great *Atelier* in mind, Bell suggested that "the time had come for an Atelier de Picasso."[15] "We were set in a row, for all the world as though we were posing for the village photographer, and Picasso took our likenesses."[16] The alienation of the sitters is a touch comical.[17] The lady of the house, very elegant in her cocoon of sables, sits between a prissy-looking Cocteau and a quizzical Satie, with Bell on the right in a wing collar and meticulously drawn spats. To animate this static scene, Picasso has played tricks with the perspective of the parquet floor: the four of them seem unaware that they appear to be posed on the brink of very steep steps. There's a stiffness to the scene as if the sitters are waiting for "the village photographer's" exposure to end so that they can look themselves again.

The following day, Bell called on Gertrude Stein and "her red Indian companion, Miss Jockness [*sic*]." "Old Gertrude," he reported to Mary Hutchinson, "has a certain horse sense and humanity that are comfortable."[18] A few days later, he went back there with the Irish painter Roderick O'Conor—a friend once upon a time of Gauguin's. After admiring Gertrude's Picassos, Bell allowed that this was "where a

good bit of Derain comes from, not that Derain is a bit the smaller artist for that." It was not until Picasso dropped him later in the 1920s that Bell solved the problem of reconciling his worship of Picasso with his affection for Derain: "of all the French painters . . . the one I know best . . . the only one whom I *tutoyéd*."[19]

Like the Picassos, the Derains took Bell to the Cirque Medrano, where they had a drink with Gustave Coquiot, the impresario who had commissioned Picasso to do a portrait drawing of Jane Avril and other music hall stars, in 1901.[20] "It was a fine star-lit night, and they decided to walk home across Paris. Suddenly Derain burst out with terrific abuse—Picasso was a 'mauvais camarade,' a mean arriviste."[21] Then his wife, Alice, took up the cudgels and went on about how badly Picasso had treated Fernande Olivier and his other women. He was nothing but "un petit syphilitique sans talent."[22] When, at Bell's urging, Derain admitted that Picasso was a great draftsman, he could not resist adding that he was "unable to paint . . . only the French can do that." "I begin to take against [Alice]," Bell wrote, "though I begin to recognize more clearly than ever that she is terrifically handsome and passionately in love with Derain . . . I suspect there is a good deal—a great deal even—in what they say of Picasso's character, but all the French are so jealous of his art and his influence that one hardly knows how far they may not go in the way of exaggeration."[23] Picasso seems to have surmised what the Derains were up to. Once again he asked Bell to dinner at the rue la Boétie and once again "showed him everything in his studio." The strategy worked. "I now have not the slightest doubt," Bell wrote, "that Picasso is a greater artist than Derain."[24]

One day when Derain failed to turn up for lunch, Bell looked in on Rosenberg, who showed him "extraordinary things," "amazing Picassos, Courbets, Corots, Renoirs," as he told Mary Hutchinson.

> In the middle of it all came a telephone message and news of Renoir's death. [Rosenberg] wept; I offered to go; he insisted that I should stay . . . ; he embraced me and poured out a torrent of tolerably insincere sentimentality, ending up with "In any case, I was the one who paid him the homage: I offered him 250,000 francs for a painting" . . . It [was] unforgettable. This black jew, with the smutty tears on his cheeks, a lump of half-real emotion in the heart, and in his head a very clear idea of the probable rise in the price of Renoirs of which he has a sizable collection.[25]

Two days before returning to London, December 10, Bell gave the Picassos dinner at Lapérouse. The only guest mentioned by Bell was a charming and "so good-looking" designer called Fauconnet, who had flattered the very heterosexual Bell by making a pass at him. Picasso liked him, so did Cocteau, who had asked him to do the décor for his *Le Bœuf sur le toit* revue. Bell needed an extra man who was "tolerably mondain."[26] To his mistress Bell described Olga as "vastly improved—gay and ladylike, two qualities, as you know, that please me. She is extremely pretty and

dresses charmingly. She is also small and slim and fond of pleasure and likes par-tridges and Grand Marnier."[27] Picasso surprised Bell by asking him "whether it was true that Roger Fry had once tried to rape Lady Ottoline and that it is one of the grand scandals of Angleterre. I gave them the true story as I believe it to be."[28] Bell surprised Olga by coyly asking her to pick out two pairs of garters for him to give a lady friend for Christmas. "For Lady Ottoline?"[29] Picasso joked; but they were, of course, for Mary Hutchinson. According to Bell, the Picassos "entreated [him] to stay in Paris till the New Year."[30]

Once the war was over, it took the Louvre over a year to bring its contents back to Paris, which had been removed to the country for safety. By the end of 1919, the museum was ready to reopen. That summer, André Lhote wrote an article urging painters to visit the museum to check their bearings and see how far off course they had drifted. Lhote saw salvation for modern French art in classicism—as exemplified by Le Nain's *Peasants* and David's *Rape of the Sabines,* two paintings that Picasso par-ticularly revered. J. E. Blanche declared Lhote's article "intelligent, yet utterly incom-prehensible";[31] Picasso is likely to have agreed with it. As someone who saw himself reworking the masters of the past in his own idiom, he was all too ready to return to the Louvre eager to convert, as Lhote put it "the classic theme into the furniture of our pictures"; he needed to study how the masters of French classicism had reacted to the classicism of the ancient world, the better to reinvent the style in his own work.

The Salle Française du XIXème Siècle was the principal focus of Picasso's inter-est. Here were many of the masterpieces he would wrestle with in years to come—Delacroix's *Femmes d'Alger* and Manet's *Déjeuner sur l'herbe*—as well as a number of other works which he would borrow from less overtly: Courbet's *Atelier;* Géri-cault's *Radeau de la Méduse,* and both Poussin's and David's *Rape of the Sabines.* Picasso would have also wanted to take a good look at Ingres, whose influence on his work had got him into trouble with modernists. Much as he admired this artist, he needed to move away from the shadow of someone whose name had become too closely associated with his own. Well-intentioned friends were deluging him with postcards of Ingres's work; and enemies, such as the hypocritical Delaunay, had taken to using Ingres against him—"Picasso . . . imitates Bouguereau, being unable to attain the purity of Ingres," Delaunay wrote, while feebly following in Picasso's neoclassical footsteps.[32]

Many of Picasso's portrait drawings do derive from Ingres, but that does not mean that all his representational works of this period can be lumped together as "Ingresque." On the contrary, many of his less representational works—especially the pristine little "crystal"[33] cubist still lifes—turn out to be strikingly Ingresque

in their immaculate finish and clarity; at least one major painting, notably *Italian Woman,*[34] Picasso's most worked-up image of the winter of 1919–20, owes more to Corot than to Ingres.

Confirmation of Picasso's renewed interest in Corot's figures is to be found in Paul Rosenberg's catalog preface to Thannhauser's 1922 show in Munich—the first major Picasso show in Germany since before the war. Unaware of how much Picasso's cubist guitar players owe to the Corots he saw at the 1909 Salon d'Automne, Rosenberg announced that "chance" in the form of a Corot *Portrait of a Woman* had prompted Picasso to "create a Corot in the same style." The portrait is almost certain to have been the one of Mademoiselle de Foudras that was in Rosenberg's stock at this time.[35] However, when he came to paint his *Italian Woman,* he is more likely to have had the Louvre's famous *Femme à la perle* in mind.

Derain, too, was trumpeting Corot as "one of the greatest geniuses of the Western world"; and

Picasso. *Italian Woman,* 1919. Oil on canvas, 98.5 x 70.5 cm. Whereabouts unknown.

then to demonstrate how independent of cubism he had become, he went on to say, "By comparison [Cézanne] hangs by a thread. . . . His painting is as pleasing as face powder."[36] As a modernist influence, Cézanne was indeed going out of fashion: but Derain was not a modernist. If anybody's paintings are "as pleasing as face powder," it is Derain's. Compare his overblown *Italian Woman*[37] of 1921–22 to Picasso's magisterial painting of the same subject and the insipidness becomes all too evident.

Picasso next addressed himself to Chardin. In the winter of 1919–20, Picasso did a Chardinesque painting, *Still Life with Pitcher and Apples,*[38] of the jug on the chimneypiece in the drawing of Bell, Olga, and friends in November 1918. Gris, too, had developed a taste for Chardin: "I believe you can borrow the means of a Chardin," he wrote Kahnweiler, "without accepting either his style or his notion of reality."[39] Picasso would have agreed. He has seemingly taken a detail from a Chardin—a painting, which Paul Rosenberg may well have handled—with its "absolute equilibrium and perfect construction"[40] and eroticized it. By hinting that the pairs of russet apples in this painting might stand for breasts, buttocks, or testicles, and the jug's lip for an oral, anal, or vaginal orifice, Picasso conjures up a flesh-and-blood presence, suggestive of a vessel in need of filling. The jug might also stand for the artist himself.

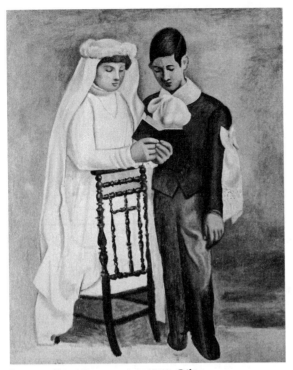

Picasso. *First Communion,* 1919. Oil on canvas,
100 x 81 cm. Musée Picasso, Paris.

Picasso often animates the inanimate with a shot of anthropomorphic sex, but seldom as subtly, mysteriously, and subliminally as here. Note the disconcerting arrangement of the apples on top of the jug.

Robert Rosenblum interprets this timeless painting differently. He sees its *camaïeu* tonality as "dust over layers of history"[41]—a reference to the pots covered with volcanic ash from Pompeii, which Picasso had seen in Naples in 1917. He was certainly intrigued by these poignant relics. Another possible reference to Naples is the use of a dusty, muted palette to simulate stone and give this smallish painting the heft of sculpture that characterizes so much of Picasso's classical imagery.

In his reaction against the "Rosewater Hellenism" of Puvis de Chavannes[42] that had faintly tainted the Blue period, Picasso saw eye-to-eye with Stravinsky, who believed that "the only critical exercise of value must take place in art, i.e., in pastiche or parody."[43] Picasso chose parody. This involved seeing the old in terms of the new, the déjà vu in terms of the dernier cri. He tried out his volumetric classicism in variations on a subject of utmost banality: a photograph of an unknown boy and girl, presumably brother and sister, dressed for their First Communion.[44] The subject harks back to the painting Picasso had done at the age of fourteen of his sister Lola's First Communion.[45] By mocking the sentimentality of one of his earliest works, he seemingly hoped to exorcise the trauma of his own adolescent piety: his teenage vow to God that he would never paint again if his sister Conchita's life was spared.

These First Communion paintings can also be seen as stylistic exercises. Four out of the five look ahead to the pneumatic stylizations of the following year, while one of them looks back at the flat, jagged planes of synthetic cubist drawings of the dead or dying Eva in 1915.[46] The artist would always be in search of ways of playing style and content off against each other. Paradox is intrinsic to Picasso's vision. He had an instinctive understanding of something pop artists would discover fifty years later: namely that banality, even inanity, used ironically can provoke people into seeing familiar things anew.

Work on *Pulcinella* started at the very beginning of 1920, possibly even earlier. Diaghilev had moved his troupe to Paris, and to make life easier for Picasso and Sert (the designer for another eighteenth-century ballet, *L'Astuce feminine*), he had arranged to bring the Polunins over from London. Even so, *Pulcinella* got off to a terrible start. Since he had first discussed the idea for a commedia dell'arte ballet in Naples in 1917, Picasso had had a change of heart. As he told Douglas Cooper, he no longer wanted to do the traditional commedia dell'arte spectacle that Diaghilev had envisioned; he wanted to do something more modern in period as well as in style.[47] What Diaghilev wanted from Picasso was the same as he wanted from Stravinsky: something traditional with a modernist gloss. Picasso's first proposal for the décor was ornate and fin de siècle, like Derain's *Boutique.* It involved a stage within a stage: the interior of a theater with tiers of boxes on either side as well as a chandelier and a proscenium arch, giving on to an arcaded Neapolitan street scene with a baroque fountain in the foreground and a view over the bay to Vesuvius in the background. Picasso modified this in two similar but simpler designs, one of them with couples in the boxes in the manner of Renoir's *La Loge.*[48]

The stage-within-a-stage device was supposed to give the ballet the look of the puppet shows that had so impressed Picasso, Diaghilev, and Massine in 1917. In the course of a previous summer, Massine had returned to Naples to do further research. While there, he had bought an antique hooked-nose Pulcinella mask—one side laughing, one side crying. This had originally belonged to Antonio Petito, a celebrated commedia dell'arte actor of the eighteenth century. Massine wore the mask and then began trying out Pulcinella's gestures and movements. Later, he would have a copy made for the actual performance. Meanwhile, he searched the libraries of Naples for a suitable scenario for his ballet and found one entitled *The Four Little Pulcinellas;* he also searched the streets for puppet shows featuring Pulcinella. To judge by his memoirs, Massine came to identify with Pulcinella, much as Picasso had identified with Harlequin. Massine's Pulcinella was "a local hero in Naples . . . witty, eccentric, a composite creature—magistrate, poet, schoolmaster, spy, philosopher."[49]

Massine and Diaghilev's failure to make their revised concept of *Pulcinella* clear to Picasso led to the "lack of liaison between the choreographer and the artist" reported by Cocteau.[50] When Diaghilev rejected his Second Empire–style maquette of a theater within a theater, Picasso exploded in rage. Stravinsky has described the scene.

> Diaghilev was very brusque: "Oh, this isn't it at all," and proceeded to tell Picasso how to do it. The evening concluded with Diaghilev actually throwing the drawings on the floor, stamping on them and slamming the door as he left. The next day abject apologies on the part of Diaghilev and a great deal of diplomacy on the part

Picasso. Design for *Pulcinella* costume, 1920.
Gouache and graphite on paper, 34 x 23.5 cm.
Musée Picasso, Paris.

of Misia helped to mollify the deeply insulted artist. Diaghilev did succeed in getting him to do a commedia dell'arte *Pulcinella*,[51]

one that, according to Massine, was more "abstract."[52] Both sides, it seems, had had changes of heart. Picasso, who had originally wanted simplicity, had tried to give Diaghilev what he mistakenly thought he wanted. It all ended happily. Picasso's simple, cubistic set was perfect.

Stravinsky had similar difficulties. There had been a misunderstanding about the orchestration. According to Cooper, "before Stravinsky delivered the orchestral score—towards the end of February—Diaghilev had told Massine that it would be for a 'large orchestra with harps,' whereas Stravinsky had scored the ballet for a small string orchestra, a wind quartet and three voices."[53] Stravinsky was obliged to make repeated trips to Paris before this matter was sorted out. According to the composer:

there were often disputes which ended up in pretty stormy scenes. Sometimes the costumes were not as Diaghilev had anticipated them, sometimes my orchestration proved a disappointment. . . . when I was shown certain steps and movements which had already been decided on I realized with horror that the meagre sound of my little chamber orchestra did not match them in character and importance. Wishful thinking and their own taste had unfortunately led Diaghilev and Massine to expect something quite different from what they found in my score. So they had to change the choreography and adapt it to the volume of my music, which did not please them at all.[54]

By the time Diaghilev and the company left on a tour of Rome, Milan, and Monte Carlo in early February, everyone was more or less in agreement. Picasso still had one outstanding task to perform: a *rideau de scène,* such as he had done for *Parade* and *Tricorne.* He did three pencil sketches of a group of Harlequins romping around a nude on a bed and a small painting of Harlequin, Columbine, and a clown on a horse in a circus arena.[55] In the end, none of these was ever used, despite a peremptory telegram from Diaghilev in Monte Carlo to Polunin asking whether the *"rideau Picasso"* was finished.[56] It seems never to have been started.

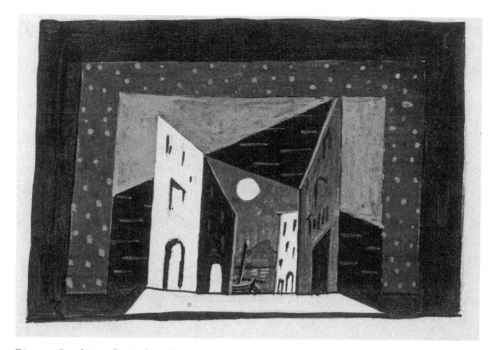

Picasso. Set design for *Pulcinella,* 1920. India ink, gouache, and pencil, 23.4 x 33.6 cm. Musée Picasso, Paris.

Pulcinella's problems were still not over. Sloppy scheduling, compounded by a railroad strike, very nearly resulted in the company being stranded in Monte Carlo four days before the first night at the Paris Opéra. Diaghilev was in despair. At the last minute, sleepers were found on a night train to Paris for Diaghilev, Massine, Karsavina, and Matisse, who had joined them to arrive in time for the first night of his ballet, *Le Chant du rossignol.* The rest of the company managed to squeeze into the very crowded compartments. Massine has described being awakened by a violent jolting, a heavy ashtray hitting him on the nose, and an Englishman in the other bunk, who had been doused in mineral water, asking, "I say, could there be a leak?" The line had been cut by strikers and the engine lay on its side. No one in the company was hurt; Diaghilev and his group continued their journey by car.

The first night went off without a hitch. To Diaghilev's delight, Picasso had whittled down his décor to a simple configuration of two houses built up cubistically out of flat planes.[57] According to Sokolova, the set suggested the improvised screens of a troupe of strolling players:

> an irregular quadrilateral of white was the moonstruck wall of a house, a triangle of grey conveyed the shadow and mystery of a narrow street, a few marks on the back cloth—moon, boat and volcano—placed the action geographically and expressed Naples. This décor showed triumphantly what cubism could be and could do. One

innovation was the omission of footlights. The chalk-white floor-cloth provided an arena for the action, and it was no doubt thought that all the lighting should come from above to suggest moonlight. . . . The absence of footlights revealed the faces of the audience and the dancers realised, to their distress, that they were under observation.[58]

Although the puppet theater concept, favored by Picasso and Massine, did not survive Diaghilev's suggestions, Picasso told Cooper that he "liked *Pulcinella* the best of all the ballets he designed because the sets 'corresponded so closely to my personal taste.' "[59] This time around, Picasso decided against elaborate, highly finished designs for impractical costumes, as he had for *Tricorne.* Instead, he based them on the historical research that Max Jacob had done for him and came up with costumes that did not impede the dancers or boggle the eye. *Pulcinella* inspired a series of dazzling commedia dell'arte gouaches, which Rosenberg had no trouble selling.[60]

Like Picasso, Stravinsky regarded *Pulcinella* as a milestone in his classical development. As his biographer, Stephen Walsh, has written, "Stravinsky had at a stroke re-established himself as the most chic and brilliant modernist—the supreme genius of the unexpected in that age of the artist as an illusionist and magician."[61] Stravinsky's words could have been expressed by Picasso:

Pulcinella was my discovery of the past, the epiphany through which the whole of my late work became possible. It was a backward look, of course—the first of many love affairs in that direction—but it was a look in the mirror, too. No critic understood this at the time, and I was therefore attacked for being a *pasticheur,* chided for composing "simple" music, blamed for deserting "modernism," accused of renouncing my "true Russian heritage." People who had never heard of, or cared about, the originals cried "sacrilege": "The classics are ours. Leave the classics alone." To them all, my answer was and is the same. "You 'respect,' but I love."[62]

Modernist mockery of Picasso's classicism recalls Arnold Schoenberg's sarcastic attack on Stravinsky's classicism: "Why, who could be drumming away there? If it isn't little Modernsky! He's had his pigtails cut. Looks pretty good! What authentic false hair! Like a peruke! Quite (as little Modernsky conceives of him), quite the Papa Bach!"[63] Christian Martin Schmidt puts Schoenberg's malice in an interesting perspective: "it was not the going back to the past as such that incited this protest, but rather the way in which this found artistic expression."[64] Schoenberg was concerned "with the 'correct' relationship to the musical past, which represented one of the pillars of his musical thought. . . . [He] proposed an 'internal' classicism, in contrast to the 'external' one, which he thought he observed in Stravinsky and many others."[65]

Cocteau and his group of Six were all too evidently "external" classicists. Picasso, on the other hand, conformed to Schoenberg's qualifications for a young composer: "Of course you cannot imitate . . . directly; you have to take the essence and amalgamate your ideas with them, and create something new."[66] By these lights, Picasso was a quintessentially "internal" classicist. To understand what the artist would do over the next four years, we need to keep this in mind.

The beau monde turned out in force for the opening of *Pulcinella* at the Paris Opéra on May 15. Sacheverell Sitwell told Richard Buckle that he was a guest in Misia's box, as was the celebrated dandy and fortune hunter Boni de Castellane. Sitwell overheard Castellane telling Picasso, "*I'm* not an anarchist."[67] After the performance there was a party, which would be central to Raymond Radiguet's *Bal du Comte Orgel,* a roman à clef about Etienne and Edith de Beaumont that this wunderkind would finish shortly before his death in December 1923. The extravagant young Persian Prince Firouz (*firouz* is Persian for turquoise), who had chosen a fashionably louche dance hall for his ball: a gimcrack suburban "château," run by an ex-convict friend of Cocteau's, called René de Amouretti. To help the procession of cars find their way through the Parisian suburbs, men with flashlights were stationed at every crossroad. Besides Amouretti and the Prince, the Picassos, the Serts, Diaghilev, Stravinsky, and Massine greeted the guests, who included Cocteau, Poulenc, Auric, the Hugos, Violette Murat, Radiguet, and a great many more. A vast quantity of champagne was consumed. Very drunk, Stravinsky raided the rooms upstairs and tossed pillows, bolsters, and mattresses onto the heads of the guests below. The ensuing pillow fight kept the party going until three in the morning.

Olga with a bird, Hôtel de Paris, Monte Carlo, 1920.

13

Summer at Juan-les-Pins (1920)

On May 17, 1920, two days after the first night of *Pulcinella,* Vanessa Bell and Duncan Grant, who had come over from London for the occasion, visited Picasso's studio. Vanessa gave Roger Fry an account:

> Duncan and I went to see Picasso . . . He . . . showed us an astonishing painting of 2 nudes, most elaborately finished and rounder and more definite than any Ingres, fearfully good, I thought. Also a very interesting beginning of a portrait of the Emperor and Empress Eugenie and Prince Imperial done from a minute photograph.[1]

The painting in question, the magnificent life-sized *Two Nudes,* which Picasso seemingly conceived as a manifesto for his increasingly volumetric classicism—much as he had conceived his more subversive *Demoiselles d'Avignon* as a manifesto of a far more revolutionary form of modernism—has always been thought to date from the end rather than the beginning of 1920. Vanessa Bell's letter settles that point.

Picasso's preoccupation with hefty nudes goes back to 1905, when he spent a month in Holland doing nude studies of "schoolgirls like guardsmen."[2] Rosenberg, included one of these works in a show in the spring of 1920, at the same time that the celebrated portrait of Gertrude Stein was on exhibit at another gallery. Stein's stout frame—"sturdy as a turnip," to quote Elizabeth Hardwick[3]—had inspired Picasso's 1906 paintings and drawings of corpulent nudes, couples often arm in arm. Whether or not Picasso had Stein and Toklas in mind, he wanted to hint at sapphic sex and give a hallowed classic subject a modern gloss, as Courbet had done with his lesbian *Sleepers.*[4]

The hints of sexuality in Picasso's *Two Nudes* are minimal. True, one of the women has her hand on the other's knee, but she appears to be making a conversational point rather than a pass. The two women stand for womanhood and, conceivably, earth-motherhood. Their setting might be a dressing room or boudoir or Turkish bath: a place where women get together, undress, and relax.

The way Picasso combines figures and draperies into a single configuration—a feature of the *Two Nudes* as well as the countless small paintings, drawings, and pastels that derive from it—has to do with his ever growing urge to become a sculptor. John Quinn, the American collector who purchased *Two Nudes* and *Three Women at the Spring* and several other classical paintings, referred to them as his "bronze figures."[5] Lack of suitable premises condemned the painter to being a sculptor *manqué* until he took to welding with González and later he bought a country house with space for a sculpture studio. In the *Two Nudes* it looks as if they are carved out of a single block of stone. By cramming them into a space that is too narrow and shallow for them, Picasso makes them appear to be bursting, not just out of their frame, but out of their spatial element.

The magnification in these paintings afflicts those parts of the body—hands, feet, and noses—which protrude and are closest to the viewer. In his quest for gigantism Picasso has looked back at the devices that enabled classic sculptors to monumentalize their figures—devices that he had learned from studying the Farnese Marbles in Naples. However, he did not make off with the sacred fire of classicism for mere stylistic considerations. He did so because he wanted to bend classicism to his will, Picassify it, question its sacrosanct proportions and the time-honored notions of ideal beauty on which they were supposedly based. In parodying classicism, he subverts it. Had he tried his hand at architecture, Picasso would have made good use of entasis—"a lie that tells the truth."

The only models that Picasso is likely to have used for *Two Nudes* and other related paintings are the postcards and photographs he had brought back from Italy. When asked about this, he usually claimed never to have needed models. This was not entirely true: portraits were mostly done from life; and some drawings (November 1920) of a woman, clothed and unclothed, seated in Picasso's favorite studio chair, were evidently done from a model—someone who is clearly not Olga.[6] Remember, too, that some of his images of the women in his life are a mélange—a mélange, he told me, of as many as three or four different women. Picasso was also a master at flouting physiognomical facts and would have relished using a corpulent colossus to stand for his skinny, fine-featured wife.

While working on the monumental *Two Nudes,* Picasso resumed doing portrait drawings: the three composers Satie, Falla, and Stravinsky with whom he had recently collaborated; two dealers, Yvon Helft and Berthe Weill;[7] and the art patron Etienne de Beaumont.[8] The choice of subjects seems to have been strategic; friends were always asking Picasso to do their portraits, but he seldom obliged. In reaction against the Ingresque delicacy and virtuosity of the Madame Wildenstein and Lopokova drawings of 1918,[9] Picasso adopted a style that has a van Gogh–like intensity and rigor. The three great composers that Picasso chose to portray were almost

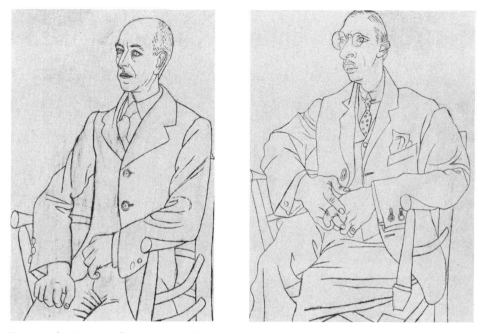

Portraits by Picasso of Manuel de Falla and Igor Stravinsky in Ballets Russes program (Théâtre de la Gaité-Lyrique, May 1921). Musée Picasso, Paris.

as short as he was, and nothing like as handsome. To remedy this, he gave them stature. He sat all three of them down in the same chair with their huge hands—only really true of Stravinsky—folded in front of them. At the same time he suggests their gigantism, mental as well as physical. Instead of pencil or silverpoint, Picasso uses black chalk outlines to delineate his subjects—outlines he can work over with an eraser and use smudged pentiments to suggest volume.

The atavistic pull of the Mediterranean, which had revitalized Picasso's work in the summer of 1919, manifested itself even more strongly in the summer of 1920. Such was the artist's anticipation that two weeks before his departure on June 24 he had started on seaside subjects.[10] Palau thinks these drawings attest to an earlier trip to the south.[11] However, a letter, dated June 23, from Level to Picasso, refutes this.[12] And a remark made years later to his biographer Antonina Vallentin confirms that these evocations of the Côte d'Azur were premonitory. "I don't mean to sound psychic, but it was truly amazing. Everything turned out to be exactly the way I painted it in Paris. Then I understood that this scene [the Riviera] was really mine."[13]

Shortly before departing for the south Olga discovered that she was pregnant.

Picasso and Olga at Villa des Sables, Juan-les-Pins (postcard sent to Stravinsky), July 20, 1920. Igor Stravinsky Collection. Paul Sacher Foundation, Basel.

After playing a secondary role in her husband's imagery the year before, she reappeared, this summer, as a central figure. Olga's pregnancy seems also to have revived Picasso's habit of visiting whorehouses, to judge by two drawings. In one of them, dated May 28, a man takes a postcoital nap on a bed, while a naked girl primps in a mirror and an elderly Celestina cleans up after them. In the other, the same girl fondles her breast while a voyeur looks on.[14]

This summer, the Picassos broke their journey south at Marseilles for a few days before returning to the Hôtel Continental et des Bains at Saint-Raphaël. By June 29, they had found a villa on a hillside above the yet to be developed resort of Juan-les-Pins next to Antibes. The Villa des Sables on the chemin des Sables, which no longer exists, was a modest house with a good view of the Mediterranean and a small garden—overgrown with the vines and creepers that figure in the outdoor still lifes of this summer. Picasso chose the place because it was quiet and out of the way—down the road from the Pension Butterfly—and it offered adequate studio space. This summer would prove very productive.

Picasso had brought his camera and took a great many photographs, which he would show to Clive Bell back in Paris in October. According to Bell, "They were mostly of himself and la belle Olga at Antibes, generally more or less naked, Picasso black as an Indian and très beau. He learnt to swim. Imagine his pride and satisfaction."[15] In fact, Picasso never learned to swim. Jacqueline told me he mimicked the strokes, while keeping his feet on the bottom. The photographs and the affectionate sketches that Picasso did of his pregnant wife writing letters, reading, sewing baby clothes, and, in one case, filing away at her calloused heels suggest that they were wrapped up in each other, more in love[16]—perhaps than they would ever be in the future. A snapshot of Olga at a window of the Blue Train, a birdcage at her side, prepares us for a poignant photograph taken of her at the Hôtel de Paris, in Monte Carlo, holding the bird as she looks at herself in the wardrobe mirror, the birdcage at her feet. Although there is no other record of such a trip, the Picassos had presum-

ably joined Diaghilev, Massine, and Stravinsky in Monte Carlo in mid-April to put the finishing touches on *Pulcinella.*

Picasso had few if any friends in the neighborhood. There were, however, occasional visitors from Paris, among them the man who had been his biggest prewar collector, Sergei Shchukin. The former tycoon was spending a week at the nearby Hôtel Graziella. After the confiscation of his collection, the Troubetzkoy Palace where it hung, and his commercial empire, Shchukin was a broken man. In August 1918 he had escaped from Soviet Russia to Germany. The following year he made his way to Paris, where he had sought out Picasso, the artist for whose work this intensely spiritual man had developed a mystical passion.

Although Shchukin had once bought his work at the rate of ten major paintings a year, Picasso no longer felt especially well disposed toward him. This was supposedly Kahnweiler's fault. When war broke out in 1914, Shchukin owed Kahnweiler a very considerable sum of money for his recent purchases. Because of the sequestration, this debt had never been settled; and because he had not been paid either, Picasso felt, with some justice, that Shchukin should pay *him* for these paintings, especially after discovering that, "contrary to widespread belief, [Shchukin] was not poor."[17] The funds he had deposited in France and Germany before the war to cover his acquisitions "enabled him to live modestly and comfortably" as a refugee. Shchukin turned out to have yet another source of money. On the eve of the revolution, he had sent his wife and three-year-old daughter, Irina, off to Germany and had stuffed the child's favorite doll with the family's jewels.[18]

Nevertheless, when Shchukin had called at the rue la Boétie, he was well received. Picasso took a liking to the collector's beautiful young sister-in-law, Nadezhda, and did a drawing of her, which he gave to this former benefactor. "These days it's worth money," Picasso said. Shchukin duly sold it.[19] Olga would also have had reason to welcome Shchukin. His Paris apartment had become a meeting place for White Russian refugees as well as visiting Soviet officials who dispensed news from home. (Shchukin was the man Diaghilev would consult when he contemplated putting on a Soviet ballet in collaboration with Vsevolod Meyerhold.) Shchukin also kept in touch with refugees who had settled on the Riviera. Since Olga's contacts with her compatriots were mostly limited to her fellow dancers, she needed others to bring her news from home.

The year before, Shchukin had a rather more fraught reconciliation with Matisse in Nice. In his infinite pride, the Russian did not want Matisse to see how the revolution had diminished him. At first he avoided meeting the artist. Matisse persisted. Anxious for Shchukin to see his new work, he went to call on him at his hotel. "I am no longer in a position to buy," Shchukin stammered out.[20] Matisse was understand-

ably upset that his kindly concern should have been misconstrued. A meeting the following day at a crowded gathering of Russian exiles went no better. Matisse had one last try at reestablishing a relationship; he arranged to take his former patron by train to see the ailing Renoir at Cagnes. He looked vainly for Shchukin in first class and finally found him in second class. "One must keep in the good graces of the masses," Shchukin said.[21] Their old friendship does not seem to have survived these misunderstandings.

Early in September Picasso was diverted by the arrival, at Juan-les-Pins's anything but elegant Hôtel de la Gare, of two of Cocteau's closest friends, Paul Morand and Darius Milhaud. Morand was a diplomat and man-about-town, who would soon marry the hugely rich Romanian Princess Soutzos and make his name as a novelist, a caustic social chronicler, and, much later, a World War II collaborator who would be obliged to live in exile. Milhaud had recently returned from a trip to London with Cocteau to promote their combined effort—a farcical revue with musical interludes called *Le Bœuf sur le toit*.[22] After a successful run earlier in the year in Paris, it had opened in London on July 12 under a new name, *The Nothing-Doing Bar*, sandwiched between turns by Grock, the great clown, and Ruth Draper, the witty American monologist. They had been royally entertained by Prince Firouz, the host at the *Pulcinella* party, who had since moved to London. He had been heavily bribed by the British, as Persia's foreign secretary, to agree to an unacceptable Anglo-Persian treaty. This character, who greatly intrigued Picasso, would die mysteriously—probably assassinated—the following year.[23]

Picasso. *Olga in Ballet Costume,* July 26, 1920. Black pencil and turpentine on canvas, 129 x 96 cm. Whereabouts unknown.

When he installed himself in a new place, Picasso usually did drawings of the area to get his bearings and map out a kind of cosmology for himself.[24] A turning in the road, a stretch of railway track, a view of the sea, telegraph poles: such are the subjects of his sketchbook notations. He also did colorful oil sketches of local villas in which he has fun with their distinctive towers and balustrades.[25] Playful views culminate in a larger, sunnier, tougher painting,[26] which looks ahead to Picasso's convulsive visions of the mid-twenties: a vast van Gogh–ish sun shaped like a vagina beats down on a tight little group of tree-shaded, seaside villas and charges the scene with energy that is more sexual than

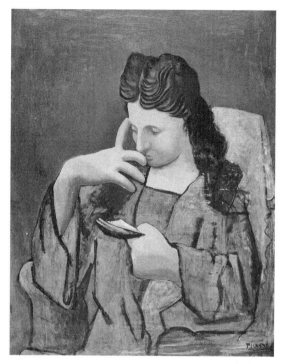

Above: Jean-Auguste-Dominique Ingres. *Madame Moitessier,* 1856. Oil on canvas, 120 x 92.1 cm. The National Gallery, London.
Right: Picasso. *Woman Reading,* 1920. Oil on canvas, 100 x 81.2 cm. Musée de Grenoble.

solar. For the next fifty years, this combination of sun, sea, sand, and sex would provide Picasso with the "Dionysiac intoxication" that Nietzsche saw as the classical counterpart of Apollonian tranquillity. Cowling sees these "two modes" as "antithetical but complementary, and great art resulted only from their reconciliation."[27] In theory, Picasso, who admired Nietzsche, may have agreed with this analysis; in practice he kept Apollo off his beach. It would always be sacred to Dionysos.

Pregnancy and the blazing southern sun melted Olga's northern formality. Snapshots reveal her barefoot in loose-fitting dresses, reddish hair falling to her waist. This new relaxed mood is reflected in Picasso's affectionate drawings of her holding a tennis racket or in the shade of a straw hat wreathed in flowers.[28] Olga's pregnancy had reawakened her husband's solicitude. Besides a large canvas (which he later painted over) and some fine drawings of her (one in black pencil on canvas) in the ballet costume she never traveled without, Picasso did two major paintings in which he transforms a relatively representational drawing of her (Musée Picasso) into a giantess in an armchair, reading a book.[29] The monstrous octopus-shaped hand Olga holds up to her face is a mocking reference to Ingres's *Madame Moitessier,* which had also been inspired by a fresco from Herculaneum in the Naples Museum.[30] The full-

length version of the painting is in the Centre Georges Pompidou; Picasso gave the more massive-looking head-and-shoulders version to the Musée de Grenoble. This was the first of Picasso's countless gifts to public collections. Significantly, he chose a museum, where the director Andry-Farcy was a fervent admirer of Matisse, who had already given his museum an important work.[31]

As Kenneth Clark wrote, "the nude remains our chief link with the classic disciplines."[32] And sure enough, the nudes that had made a tentative reappearance in the previous year's work return in force over the next three and a half months: Picasso's longest Mediterranean sojourn since childhood. As the temperature soared at the end of July, the flimsy nymphs of the first sketches solidify into a posse of hefty sunbathers chatting, reading, sleeping, and swimming. Pen and ink give way to pastel, the better to evoke the matte sheen of skin. Little by little, the women sort themselves out into threesomes: a squatting and standing figure to left and right presiding over a figure lying on the sand in the foreground. Way out to sea, a disproportionate

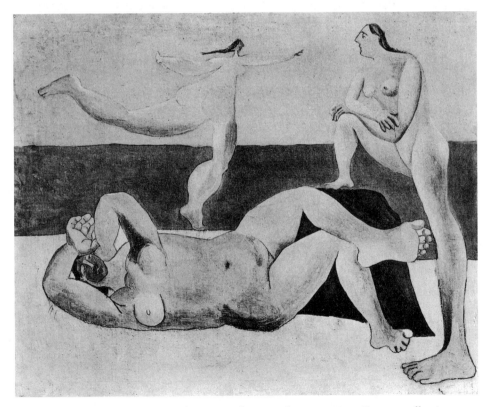

Picasso. *Three Bathers on the Beach,* 1920. Oil on panel, 81 x 100 cm. Former collection, Stephen Hahn, New York.

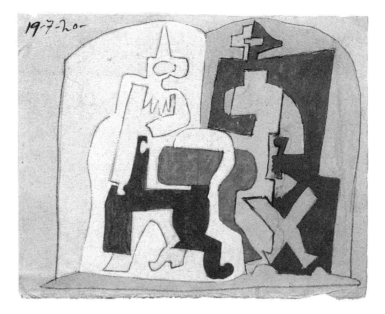

Picasso. *Pierrot and Harlequin,* July 19, 1920. Pencil and gouache on paper, 21.5 x 27 cm. Musée Picasso, Paris.

and disembodied head pops out of the water as if the swimmer were as close as nearby figures on the beach.[33] In his most daringly experimental painting of this summer, *Three Bathers on the Beach,*[34] Picasso stretches the limbs and shrinks the heads. And then by situating a bather's foot at the water's edge and her pinhead at a vanishing point in the sky, he establishes both a nearness as well as a farness between beach and horizon, also an eerie feeling of disquiet, which stems from a childhood dream Picasso recounted to Françoise Gilot:

> I like nature, but I want her proportions to be subtle and free, not fixed. When I was a child, I often had a dream that used to frighten me greatly. I dreamed that my legs and arms grew to an enormous size and then shrank back just as much in the other direction. And all around me, in my dream, I saw other people going through the same transformations, getting huge or very tiny. I felt terribly anguished every time I dreamed about that.[35]

This amazing painting is also unusual in being painted on wood, possibly one of the *contre-plaqué* panels he had asked Rosenberg to ship to him at Juan-les-Pins.[36] Juan Gris, who had switched to *contre-plaqué* when canvas was in short supply during the war, had recommended this alternative form of support to Picasso.[37] It made for a harder, sharper, flatter finish.

Picasso continued to produce colorful gueridons in gouache and tempera along the lines of the ones he had done the previous summer. However, there is a notable difference. Whereas the focal point of the Saint-Raphaël gueridons of the previous summer is a cubist construction, as three-dimensional as a house of cards, the Juan-

les-Pins gueridons are two-dimensional and tightly integrated into the composition. A diagram in a sketchbook[38] reveals the intricate layering of the planes, each one a fraction behind the other. The way these planes interlock like pieces of a puzzle[39] suggests that Olga may have brought a jigsaw with her to while away the time when her husband was working. Dotted lines are another new development in still lifes done later in the year.[40] Palau claims incomprehensibly that "the objects represented by dotted lines apparently tell us that they are not really what they seem, although they could be."[41] Surely Picasso is playing a conceptual game. The dotted lines imply the words "Cut here" and they invite us to envision the effect that compliance with his instructions might precipitate.

This summer, Rosenberg, who now referred to Olga as "La Marquise," kept up the pressure on Picasso to produce "a large number of canvases" for his next show. Originally scheduled for fall 1920, this would be put off until the spring. To nudge Picasso into taking a more traditional path and attract a more conservative clientele, the dealer told him he was also organizing a show of Picasso's "cubist and non-cubist work in one of the most beautiful museums in one of the biggest cities of America . . . his work would be hung next to Verrocchio and Pollaiuolo and great masterpieces of the past."[42] This show would indeed materialize, but not until 1923. The Arts Club of Chicago, where it took place, rented space in the Art Institute, but not in the museum section, so there was no question of Picasso's work being hung next to any old masters.[43]

Picasso paid little attention to the dealer's deceptive suggestion. In his last two weeks at Juan-les-Pins, he did eight drawings of a centaur carrying off a woman.[44] These are usually assumed to represent the rape of Hercules' wife Dejanira by the centaur Nessus,[45] but the absence of the usual iconographic details suggests that Picasso did not necessarily have Dejanira in mind. (He would provide a far more definitive portrayal of this legend in one of his 1930 illustrations for Ovid's *Metamorphoses*.)[46] The inspiration for this baroque subject has a surprising source: Rubens's great bravura set piece, *The Rape of the Daughters of Leucippus*.[47] Rubens was an artist he always claimed to dislike.

Back in Paris, Picasso turned to a very different seventeenth-century master for inspiration, Nicolas Poussin. Once again he settled on a rape scene; it is based on *Tancred and Hermione* in the Hermitage. Picasso uses much the same three figures as Poussin with the addition of a white horse to evoke a very different story. Whereas Poussin portrays Hermione saving Tancred's life by binding his wounds with the tresses she has chopped off her head, Picasso portrays his heroine being dragged away, like Dejanira, before she can attend to her supine lover. A year later, Picasso would paraphrase another Poussin: the magnificent *Echo and Narcissus* in the Louvre. The artist kept these little panel pictures back for himself. Given his irrita-

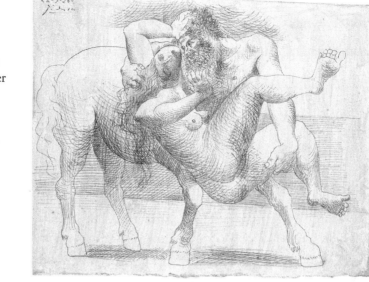

Picasso. *Nessus and Dejanira,* 1920. Metalpoint on tan wove paper prepared with white ground, 21.5 x 27 cm. The Art Institute of Chicago.

tion at being described as Ingresque, he would not have wanted to lay himself open to a charge of Poussinism.

The idyllic life that the Picassos had led at Juan-les-Pins did little to prepare the pregnant Olga for her husband's neglect back in Paris. The artist spent most of his time in his studio and left her to her own devices. On October 30, Clive Bell, who had returned to Paris to check out Picasso's summer harvest, described Olga to Mary Hutchinson as feeling so lonely, so miserable, so neglected that she found a visit from Lady Colefax, a relentlessly pushy London hostess, as "something like a treat."[48] The day before writing this letter, Bell said more or less the same thing about Picasso: "[he] talked to me about art and his art with a seriousness, a bitterness, and a lack of reticence, which he has never shown to me before: and when we parted he embraced me—I don't mean kissed but hugged. He is conscious of being horribly alone."[49] Bell went on to describe

> the *aquarelles* [Picasso] did during the summer and the big pastels on which he is at present working . . . [as] marvelous and full of *trouvailles* [but] he has something like a mania for hiding them and is always on the lookout for spies. Twice during the morning we were interrupted, and both times intricate precautions had to be taken before the stranger was admitted. The first visitor was [Frank Burty] Haviland, who didn't stay long and seemed nice, the second was Leónce Rosenberg, who dragged on infinitely talking politics and dealerism.[50]

Bell writes as if he were still on the friendliest terms with Picasso, but a letter that Roger Fry sent Vanessa Bell, a few months later, suggests otherwise:

> I've been to see Picasso, [Fry wrote on March 15, 1921] . . . [who] is rather furious with Clive. You'd better not tell Clive; it'll pass over (I think very unfairly) because

he said something about Ingres. It's merely what everyone does when they see some of Picasso's later work. Fortunately I didn't; on the contrary. I murmured about Fra Bartolomeo, and, in fact, that is nearer the mark. It's curious how near all his late work is in its aim to the things Fra Bartolomeo and Raphael worked out. (Plastic balance within a strictly limited space.)[51]

We can only guess at the nature of Bell's gaffe. Given his obsessive desire to please Picasso, whatever he said would have been intended as a fulsome compliment. It probably included the word "Ingresque": a word the artist was tired of hearing. "As if Ingres were the only artist I ever looked at in the Louvre," I recall Picasso moaning. When Bell returned in May 1921 to see the show at Rosenberg's, he seems to have been forgiven—but was he? Arthur Rubinstein had infuriated Picasso by bringing a group of chic friends, who had been having tea with hiim at the Ritz, on an impromptu visit to the rue la Boétie. Regarding this incident, Picasso told Bell, over lunch a day or two later, how much he admired intellectuals and how much he detested "the bourgeoisie ci-inclus, Lady Colefax and Marie Beerbohm and Arthur Rubinstein and Madame Gandarillas."[52] Since Bell had brought Lady Colefax and Marie Beerbohm into Picasso's life, and was also having a sporadic affair with Madame Gandarillas, Picasso might have wanted to hint that Bell belonged with the detestable bourgeoisie rather than the intelligentsia.

On this visit Bell also saw Cocteau: "I told him about Picasso—you know they have been at odds for some time—and he appeared to be a good deal upset."[53] This coolness stemmed from *Parade.* Cocteau had never entirely forgiven Picasso, Satie, and Diaghilev for suppressing his "noises off"—revolver shots, sirens, foghorns, and other would-be modernist effects—in the ballet's original production. When Diaghilev proposed to revive the ballet in the spring of 1920, Cocteau lobbied to have his gimmicks restored, and was none too happy when Diaghilev put off the revival for another six months. Undeterred, the poet made such a fuss—"he's worn Picasso and myself to a pulp,"[54] Satie wrote Valentine Hugo—that Diaghilev finally gave way and agreed to the inclusion of the least bothersome of "Jean's noises."

"Diaghilev is sweet as sugar," Cocteau wrote the Hugos: "[he] is letting me stage *Parade* as it always should have been staged."[55] The revival took place at the Théâtre des Champs-Elysées on December 21. Diaghilev persuaded Picasso and Satie to overcome their irritation and take a bow with Cocteau from a box. Once again, Cocteau insisted that *Parade* was a triumph—a triumph in that, this time round, there was more of him and less of Picasso. "There were twelve curtain calls,"[56] he later boasted, though as he well knew, these were for Picasso and not for him. "The same people who wanted to murder us in 1917 stood up and applauded in 1920. What had intervened? What made those conceited theatergoers do a *volte-face* and admit their mistake so humbly? A lady gave me the explanation, in the way she con-

gratulated my mother: 'Ah, madame,' she cried. 'How right they were to change it all!' "[57] The words of Cocteau's mother's lady friend carry as much conviction as the imaginary harridans with hat pins in 1917.

The success of *Parade* seems only to have fueled Cocteau's resentment toward Picasso. Unwittingly, Rolf de Maré, Diaghilev's avant-garde rival, enabled Cocteau to jab his hero in the back. Maré had been very impressed by a reading of Cocteau's "Nietzschean farce," *Les Mariés de la Tour Eiffel,* and had decided that his Ballets Suédois should stage it. Maré had wanted Auric to do the music, but Cocteau insisted that five out of his Les Six (besides Auric, Poulenc, Milhaud, Tailleferre, and Honegger) should each compose a separate section. This would be the only time Les Six worked together.

Cocteau took a great deal of care over the seating at the *répétition générale* of *Les Mariés de la Tour Eiffel.*[58] In the absence of Olga, who was pregnant, he arranged for Picasso to join Misia Sert's box with Chanel as his date. Whether or not he realized that he was being set up, Picasso went ahead and had a sporadic affair with her. This time round, it was not a gang of phantom hags who disrupted the second opening night of *Parade,* it was an all too real gang of belligerent dadaists out to demonstrate against the hated Cocteau. Somehow or other they had infiltrated the invited audience and "kept standing up and sitting down . . . shouting Vive Dada!"[59] As a result, the critics were unable to hear enough of the words or music to write proper reviews. Although *Les Mariés* began as a succès de scandale, it ended up having a certain succès d'estime. The dadaists had good reason to loathe Cocteau. He had taken their iconoclastic shtick and defused it into sophisticated, meretricious entertainment.

Successive honeymoons with Radiguet kept Cocteau away from Paris. Picasso missed his treacherous Rigoletto. He missed his shamelessly insincere *connaissance du monde,* the fizz of his wit and his spite. He also missed having him around to mock, outwit, and torment.[60]

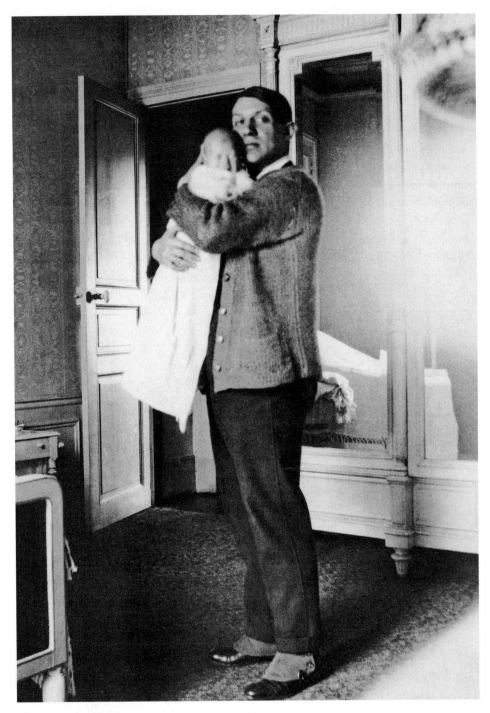

Picasso holding Paulo, 1921.

14

L'Epoque des Duchesses (1921)

At 9 p.m. on Friday, February 4, 1921, Olga gave birth to a son weighing "6 pounds 3 ounces," according to a diary of Olga's in the Archives Picasso. On March 14, Mlle. Arnauld, the wet nurse, left. Picasso did some drawings of her breast-feeding the baby;[1] later he would draw Olga giving him his bottle. On April 2 at 11 a.m. the baby was christened Paul Joseph (after his father Pablo and grandfather, Don José) at the neighboring church of Saint-Augustin.[2] The godparents were Misia Sert and Georges Bemberg, who was supposed to bring a Spanish archbishop to preside over the ceremony. Gertrude Stein—Picasso's "pard" of prewar days—was not asked to be a godparent. They had quarreled: "they neither of them never knew about what," wrote Gertrude in her *Autobiography of Alice B. Toklas:*

> Anyway, they did not see each other for a year and then they met by accident at a party at Adrienne Monnier's. Picasso said how do you do to her and said something about her coming to see him. No I will not, she answered gloomily. . . . They did not see each other for another year and in the meantime Picasso's little boy was born. . . . A very little while after this we were somewhere . . . and Picasso came up and put his hand on Gertrude Stein's shoulder and said, oh hell, let's be friends. Sure, said Gertrude Stein and they embraced. When can I come to see you, said Picasso, let's see, said Gertrude Stein, I am afraid we are busy but come to dinner the end of the week. Nonsense, said Picasso, we are coming to dinner to-morrow, and they came.[3]

After this reconciliation, "the friendship between Gertrude Stein and Picasso had become if possible closer than before (it was for his little boy, born February fourth to her February third, that she wrote her birthday book with a line for each day in the year)."[4] Gertrude exaggerates. In fact, they saw rather less of each other.

Gertrude also records that Max Jacob "was complaining that he had not been named godfather."[5] Nor had he received a formal announcement. When finally allowed to see little Paulo, Jacob claimed that "even the baby turned his back on me."[6] Successive rejections prompted the heartbroken Max to leave Paris, the following June, for a quasi-monastic life in a presbytery attached to the secularized

monastery of Saint-Benoît-sur-Loire. For Max, Picasso had become a surrogate for Christ (and, on occasion, for the devil). Now that his messiah had effectively abandoned him, he decided to settle for the real thing. Shortly before taking this step, Max published another book of poetry, *Le Laboratoire central*. This includes two nostalgic poems about the past he had shared with Picasso: a long, intensely felt evocation of his visit to the artist at Céret in 1913, entitled "Honneur de la sardane et la tenora"; and a shorter, no less fine prose poem about the Bateau Lavoir. Max evidently felt compelled—and not for the first or the last time either—to recall the highlights of his years as the artist's disciple. He wanted to exorcise his obsession with Picasso—an obsession compounded of love that was both spiritual and physical and a lot of self-lacerating resentment. Poor Max, no amount of nostalgic verse or penitential prayer would ever banish these feelings.

Max had another cross to bear: the young poet Louis Aragon. Aragon, who was supposedly his friend, indeed his protégé, and was about to abandon his medical studies to become a dadaist, published a roman à clef entitled *Anicet ou le Panorama*. Anicet was Aragon; the other characters included Bleu (Picasso), Jean Chipre (Jacob), Baptiste Ajamais (Breton), Harry James (Jacques Vaché, who had recently committed suicide), Ange Miracle (Cocteau), Le Bolonais (a crass American art critic), and the ghosts of Lautréamont and Rimbaud. In a passage of icy cruelty, Aragon describes the rich, celebrated artist, Bleu, jeering at his old friend, the anything but rich and celebrated Chipre:

> "I have been thinking about our life of suffering, dear pauper, savoring my pity for the past we shared and from which only I have been able to escape. In my astrakhan-collared overcoat, I want you, wretched Jean, companion of my freezing youth, to recall our winters without coal in studios without furniture. . . . oh the sweetness of being able to enjoy a little of the cold in which you still live. Look at me in my glory. I have accomplished all our dreams. You appear to me as if from the depths of a mirror, my exemplary friend, you have not betrayed my very first notion of myself. To me your eyes reflect more than the usual mirror images: your eyes are dazzled by my grandeur and riches. . . . Admire the costly cigar I am about to light, only three of us in the world smoke such as this: a millionaire, a convict and myself."[7]

In years to come, Picasso and Aragon would frequently meet, but, according to Jacqueline Picasso, the artist never liked the poet, neither in the heyday of surrealism nor later when the two of them became stars of the French Communist Party. After *Anicet,* it is hardly surprising. As for Jacob, he was deeply humiliated by the exposure and the mockery. Hysterical letters to Picasso reveal the extent of his hurt: "if you find this letter ridiculous, bear in mind that it is only natural for me to want to defend myself yet again—poor me, silent as a battered lamb."[8] Picasso took pity on

Jacob. He did an engraving of him[9] for yet another collection of poems, *Visions infernals,* which never in the end appeared. He gave Jacob a jacket (which was too small for him) and almost certainly some money.[10] Olga was relieved that the poet was no longer around, but Picasso missed him, as witness the two versions of the *Three Musicians,* the great *tertulia* paintings that date from the summer of Max's departure.

Olga and Paulo, 1921. Musée Picasso, Paris.

At first Picasso was delighted to have a son, the only male heir born to his branch of the family. Paintings and drawings of the baby in his mother's arms testify to paternal pride and love. But there was a downside to all of this. Olga would henceforth behave as if the birth of a son and heir entitled her to the prerogatives, not to mention the deference, due to the wife of the world's foremost painter. From now on, she would play the role of Madame Picasso as if it were indeed a starring role. The artist, who was never anything but a Bohemian at heart, would try to adjust to her notion of how a celebrated artist should live. He was proud of Olga and enjoyed the ambiance she provided. This enjoyment came under increasing attack from some old friends. Gertrude Stein reported that when shown a Man Ray photograph of Picasso dressed as a *torero* at one of the Beaumont parties, Braque said, "I ought to recognize that gentleman."[11] This did not stop Picasso from attending these functions and then blaming Olga. "You see, Olga likes tea, caviar, pastries, and so on," he told Jacint Salvadó, the Catalan painter who modeled for him in 1923, "me, I like sausage and beans."[12] Cabanne gives us a wonderfully revealing glimpse of Picasso in this same costume looking at himself in a mirror and murmuring, "comedia."[13]

Françoise Gilot points out the principal danger of Picasso's involvement in Parisian society:

> Olga's social ambitions made increasingly greater demands on his time. In 1921 their son Paulo was born and then began his period of what the French call *le high-life,* with nurse, chambermaid, cook, chauffeur and all the rest, expensive and at the same time distracting. In spring and summer they went to Juan-les-Pins, Cap d'Antibes, and Monte Carlo, where—as in Paris—Pablo found himself more and more involved with fancy dress balls, masquerades, and all the other high jinks of the 1920s, often in company with Scott and Zelda Fitzgerald, the Gerald Murphys,

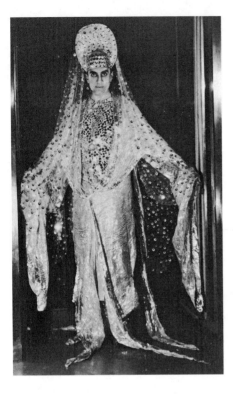

Above: Cocteau. Caricature of Marie-Laure de Noailles and Etienne de Beaumont, 1931. Collection PFB / Rue des Archives.
Left: Etienne de Beaumont in costume, probably for his *Bal de la Mer,* 1928. Photograph by Man Ray / Telimage.

the Count and Countess Etienne de Beaumont, and other international birds of paradise.[14]

Picasso had met the Charlus-like Maecenas, Etienne de Beaumont, through Cocteau in 1916. He had become a close friend of this fiendish social tyrant. Beaumont's patronage of avant-garde art (Picasso and Braque), music (Satie), and ballet (Massine) would culminate in 1924 in a ballet season, *Les Soirées de Paris,* which would include Picasso and Satie's *Mercure.* As Gilot confirms, Picasso and Olga made regular appearances at the fancy-dress balls that Beaumont (who had trained as a dancer) and his wife Edith gave in their magnificent *hôtel particulier* on the rue Masseran. Since the manipulative Beaumont liked to keep his friends wondering whether or not they would be invited, he would always exclude two or three especially vulnerable people, as well as anyone "in trade." When Misia found to her chagrin that Chanel, who had helped Beaumont with the costumes for his 1920 ball, had not been invited, she refused to attend. Instead, she and Chanel "with Picasso and Sert as our escorts . . . mingled with the chauffeurs crowded in front of the house to watch the costumed guests make their entrance. Rarely have I been so amused."[15] To *épater* his more straitlaced guests, Beaumont also encouraged exhibitionism and transvestitism. Jean Hugo, a great lover of women, was once made to dress in drag as

Herodias in one of the endless *entrées* that were the pretext and focus of the balls. Lucien Daudet's *Spectre de la rose* costume was so provocative that it was ripped off him, as he had doubtless intended.

The earliest of these entertainments—the Tower of Babel Ball (*Soirée Babel),* which Picasso had attended—took place in 1916,[16] but they did not become a Parisian institution until after the war. In 1919, the Beaumonts chose a theme that was risqué but impractical: guests were expected to leave "exposed that part of one's body that one considered the most interesting."[17] Later, there would be *Le Bal des jeux* (1922); *L'Antiquité sous Louis XIV* (1923); *Le Bal des entrées de l'opéra* (1925); *Le Bal de la mer* (1928); *Le Bal colonial* (1930); *Le Bal des tableaux célèbres* (1935); and *Le Bal du tricentenaire de Racine* (1939). The final one took place after World War II in 1949.

Once the *entrées*—group after group of guests, directed as a rule by Massine, personifying such subjects as the Awakening of Ariadne, Little Red Riding Hood, or Sodom and Gomorrah—were over, there was little to drink (Beaumont was famously stingy) and nothing much to do except stand around and admire or disparage the guests' costumes, or take people up on the invitations that certain outfits implied. For although these balls were a throwback to the court of Louis XIV, there were Saturnalian undercurrents.

Jean Hugo said the dressing-up phase was more fun than the actual ball. The Beaumonts' bedrooms would be a-shriek with camp followers doing their best to make fools of one another and themselves. Whatever the theme, Satie resented it; Cocteau usually came as Mercury. As for Beaumont, he always managed to upstage his guests by appearing in one spectacularly androgynous costume after another, designed by himself. Picasso claimed to be bored by these events, but he went on attending them until 1925. They remained friends until the Germans came between them in World War II.

The entertainments devised by the Vicomte de Noailles and his wife, Marie-Laure—dear friends and bitter rivals of the Beaumonts—were far more relaxed and far more lavishly catered (at one of their balls the buffet included a *pièce montée* of oysters in shells filled with caviar). Picasso, who had met Marie-Laure through Cocteau, did two uncharacteristically staid drawings of her in 1921. In 1923 the twenty-one-year-old Marie-Laure—descended on one side from a family of plutocratic Belgian bankers (the Bischoffsheims) and on the other from Laure de Chevigné (Proust's Duchesse de Guermantes and a granddaughter of the Marquis de Sade)—chose to marry into the *gratin.* Charles de Noailles, the twenty-second of his line, claimed that his family had lost more members to the guillotine in the Revolution than almost any other in France. Like Beaumont, he liked men; unlike Beaumont, he was very discreet about it.

Marie-Laure had been an only child. Her father had died when she was two, leaving her an immense *hôtel particulier* on the Place des Etats Unis, filled with fine French furniture and old master paintings, including two superb Goya portraits. Over the years she would replace the lesser heirlooms with major works by Picasso, Braque, Gris, Léger, Mondrian, as well as an extensive collection of surrealist paintings, especially Dalís and Ernsts. In addition, she organized concerts of modern music in her rococo ballroom. Besides a frescoed ceiling by Solimena, the ballroom was equipped with a movie projector in a hidden cabinet and a white grand piano stacked with scores inscribed by such as Poulenc, Auric, Sauguet, Britten, Rieti, and Weill. To their credit, the Noailles were prepared to take far greater risks than their rivals in their patronage of avant-garde films: *Les Mystères du Château du Dé* (Man Ray), *L'Age d'or* (Luis Buñuel),[18] *Le Sang d'un poète* (Jean Cocteau), and a 1928 thriller called *Biceps et bijoux* (Manuel Jacques).

Left: Picasso. *Portrait of Marie-Laure de Noailles,* 1921. Charcoal on canvas, 130 x 97 cm. Private collection. Right: The Noailles' ballroom, Place des Etats-Unis, Paris, paneling from a palazzo in Palermo; ceiling painting by Francesco Solimena. Photograph from *Connaissance,* 1964. akg-images.

Max Jacob's description of this period as Picasso's *époque des duchesses* smacks of envy: Jacob was a regular guest of Prince and Princess Georges Ghika and took far more interest in balls and masquerades than Picasso did. Actually, there was only one duchess Picasso remembered liking, as well as fancying: the unconventional Italian beauty Maria de Grammont, who subsequently married Jean Hugo's brother François.[19] Otherwise, he took no more interest in the *gratin* than the *gratin* took in him.

Despite his oath never to work for Diaghilev again, Picasso allowed himself to be lured back into the ballet. He found the company in turmoil. Although credited by Alexandra Danilova with requiring "three girls and a boy to satisfy his daily needs," Massine told Picasso he had finally fallen in love with an English dancer, Vera Savina (real name, Vera Clark). Diaghilev's jealous rages were causing havoc at a time when Massine was working on his version of *Sacre du printemps:* colder and more abstract than Nijinsky's, which the company had forgotten how to dance.[20] Trust Misia to make a bad situation worse. One evening, Savina naively asked Misia, "Have you seen Mr. Massine? I have an appointment with him." "Where?" Misia demanded. "At the Arc de Triomphe, but it's such a big place I don't know exactly where to meet him." "I should stand right in the middle of the arch if I were you," Misia replied, and hurried off to inform Diaghilev.[21]

This much was published by Sokolova. In 1960, apropos of a mutual friend, whose jealous tantrums reminded him of Diaghilev's, Picasso told me the rest of the story. On receiving Misia's news, Diaghilev had telephoned Picasso and insisted that they go together in his car to the Arc de Triomphe. The two of them circled the Etoile again and again until Diaghilev decided that the guilty pair must have returned to the Continental. Back they rushed. "It was like a Feydeau farce," Picasso said, "Diaghilev going up in an elevator, Massine racing down a flight of stairs, people popping in and out of bedrooms, Vera trying to escape." A few days later (December 15), Diaghilev gave a *grand dîner* to celebrate the opening of the ballet's winter season. Guests included the principal stars as well as the Picassos, Misia, Chanel, and Stravinsky. Massine got very drunk and, according to Stravinsky, burned "Picasso's hand with a cigarette (Picasso never moved)."[22] Might this have been in return for Picasso spying on him?

The company's next engagement was Rome; and it was there that Diaghilev finally broke with Massine. The impresario was heartbroken and very bitter. "Hadn't [I] . . . done everything for [him]," he said to Grigoriev. "Hadn't [I] *made* him? What had Massine . . . been? Nothing but a good-looking face and poor legs!"[23]

Diaghilev had every reason to be furious. Massine's departure left the company without a star dancer or a choreographer and the impresario without a lover—all this at a time when he was more than usually broke.

A month later, a nice-looking, seventeen-year-old refugee from Moscow arrived unannounced in Diaghilev's suite at the Continental. He turned out to be a precocious balletomane called Boris Kochno, who was immediately taken on—much to his disappointment—as a secretary rather than a lover. (Diaghilev had supposedly asked Kochno to undress. "Put your clothes back on," the impresario said—"too hairy.")[24] Nevertheless, their relationship worked extremely well. For the remaining eight years of Diaghilev's life, Kochno would be an indispensable right-hand man, scenarist, and artistic collaborator. Picasso liked him enough to do a couple of drawings of him[25] but claimed that he was an amusing rogue, one you had to keep an eye on; drawings had a way of walking out of the door with him.[26]

On March 16, Kochno left Paris with Diaghilev and Stravinsky for Madrid, where the King had invited the company back for a two-week season. Since he no longer had a choreographer, Diaghilev thought up a balletic entertainment that did not need one. And he set about recruiting the most accomplished Gypsy dancers he could find for *Cuadro flamenco*—an evening of flamenco—to include in his forthcoming engagements in Paris and London. Diaghilev wanted Stravinsky to arrange the music, but the composer felt that traditional music needed no arranging and declined to do it. Nevertheless, the two of them plus Kochno went to Seville for the Semana Santa and the Feria:

> Night after night [Kochno recalled] the Gypsies poured in to dance for Diaghilev in a private room in a cabaret. Diaghilev's task was complicated by the fact that most of these artists had not the slightest intention of signing a contract or of leaving Spain; they came for the pleasure of being applauded. . . . One day several of them . . . [presented] a protest. [Diaghilev] had concealed from them the fact that to reach Paris they would have to cross the ocean. Who had told them this? The barber in the corner shop.[27]

Getting the flamenco performers to agree to terms proved so daunting a task that after signing up the beautiful Gypsy dancer María d'Albaicín,[28] Diaghilev, Kochno, and Stravinsky returned to Paris, leaving the negotiations to underlings. Daily telegrams would arrive: May 1, "Ramírez has lost wits. Refuses contract unless we engage Rosario who will not come without aunt or Macarona or Malena who now asking six thousand with husband performer"; May 10, "Absolutely indispensable you meet me station Thursday with address cheap pension and bus transportation for entire flock for they are all repeat all dotty."[29]

As for the décor, this, too, posed a problem. Only a month was left before the first night. Picasso was the obvious choice, but he flatly refused to do it. Diaghilev knew

how to win him round: play on the artist's ticklish vanity by letting him know that he had commissioned Picasso's "pupil," Juan Gris, to do the sets. The unsuspecting Gris had even informed Kahnweiler of the good news. A week later came the bad news: Gris's response had arrived too late; Diaghilev "had made other arrangements."[30] Six days after cabling Gris, Diaghilev had apparently cabled Picasso from Madrid to confirm that he had the job and that Gris had been demoted to doing portrait drawings for the program.[31] Diaghilev's strategy had evidently worked.

"Picasso got away with it," Gris wrote to Kahnweiler on April 29, "by producing a set of designs already made, saying that I would never be able to do it in so short a time. He seems also to have rattled the skeleton of cubism and dwelt on the difficulties of executing any conception of mine. However, I never thought of making a lot of poor creatures dance around with buildings on their backs."[32] Picasso did indeed have "a set of designs already made." Ironically, these were the *Pulcinella* ones—a stage within a stage with trompe l'oeil boxes to left and right[33]—that Diaghilev had originally rejected and enraged Picasso by stamping on. And, all too true, Gris was inexperienced and unable to come up with anything as ambitious and original as Picasso's designs in a matter of weeks.

Diaghilev duly returned to Paris, and he and Picasso set about adapting the *Pulcinella* set to the requirements of *Cuadro flamenco* and the small, ill-equipped stage of the Gaîté Lyrique. The shabby theater on the boulevard de Sebastopol, which catered to a working-class public with a taste for operetta was all that Diaghilev could afford.[34] As it turned out, the Gaieté Lyrique proved to be the perfect foil for Picasso's parodic décor and the perfect setting for a troupe of Gypsies, who, when not performing, perched on a row of chairs, clapping their hands and shouting *olé*. Kochno told Buckle that the locals, who had whistled and booed the fashionable first-nighters as they arrived (May 17, 1921), soon became fans of the ballet, so much so that "one night Misia, in her box, raised a lorgnette to survey the packed house and, recognizing no familiar face, exclaimed 'There's no one here.' "[35]

To give *Cuadro flamenco* a macabre Goyesque edge, Diaghilev had included a performer called Maté el Sín Pies. His legs had been cut off at the knees so he had to dance on "stout leather sheaths" fixed to his stumps.[36] Picasso was so fascinated by him and his partner, a dwarf dancer called Gabrielita del Garrotín, that he arranged for them to perform a mock bullfight late one night in the courtyard outside Chanel's magnificent Faubourg Saint-Honoré apartment, to the horror of the landlord, Count Pillet-Will, who lived above.[37]

Despite their popularity in Paris, these "freaks" caused so many protests in London that their dance had to be eliminated. There were no such protests at the Gypsy women's unorthodox way of accepting applause: "they would lean over the footlights, push up their breasts, and then [jerk] their bodies so that their breasts shook

violently."[38] D'Albaicín was so dazzling that Diaghilev decided to keep her in the company. He arranged for Sokolova to teach her the role of the Miller's Wife in *Tricorne.* After one performance, it became clear that she would never manage to reconcile the demands of Massine's choreography with flamenco spontaneity. Nevertheless, she remained with the company and appeared in the revival of the *Sleeping Princess* in 1921. The scenery for *Cuadro flamenco* was never used again. Only the bits that Picasso had actually painted—the four stage boxes and a basket of flowers—were preserved.[39] Diaghilev was relieved at the departure of his flamenco troupe. Fear of backstage violence had prompted him to hurry nervously past them.

If *Cuadro flamenco* was the last major décor that Picasso did for the Ballets Russes, it was not for lack of offers from Diaghilev. On accepting an invitation from the Prince de Monaco in 1922 to base his company at the Monte Carlo opera house, Diaghilev asked Picasso to do the sets for two operettas: Gounod's *Philémon et Baucis* and Chabrier's *L'Education manquée.* The artist was not the least interested, so the impresario had Benois do the Gounod and Juan Gris the Chabrier. For his part, Picasso came up with his own conceptual projects—*bonnes blagues,* he called them—as Cooper relates:

> One of these projects, described to me by Kochno and confirmed by Picasso, called for a still-life décor of assorted meats and vegetables in and around which the dancers, dressed as flies, would weave while progressively devouring the delights of the table. Another such project, described to me by Picasso himself, was a ballet about the life of Diaghilew, showing him in a succession of scenes from the day he cut his first tooth to the toothless Diaghilew of old age. These projects were, of course, imaginative flights on the part of Picasso. . . . Yet there was behind them the serious purpose of trying to spur Diaghilew on to recapture the mood in which *Parade* had been created and produce ballets which were more challenging and lively.[40]

It was in this mocking spirit that Picasso agreed to replace Bakst's ornate, outdated scenery for *L'Après-midi d'un faune,* which had perished during the war. Diaghilev wanted something more modern, something that would work with Bronislava Nijinska's new production of her brother's masterpiece. Picasso came up with a minimalist set: a backcloth with horizontal strips of yellowish beach, bluish sea, and bluish-gray sky. The impresario was horrified—"I wanted Egypt and you've given me Dieppe"—all the same he used it.[41] Forty years later Picasso would have a similar problem with the Paris Opéra when Lifar, the maître de ballet, commissioned him to do another minimal *Après-midi d'un faune.* Auric, an old but no longer close friend of Picasso's, first accepted it[42] and then, according to Cooper, "refused to allow it to be carried out."[43] Undeterred, Lifar used the curtain in the summer of 1965 at the Théâtre du Capitole in Toulouse at a special evening of ballets by Picasso

that he had arranged. After Lifar showed me the paltry design, I thoroughly agreed with Auric.

As he had done with *Tricorne* and *Pulcinella,* Rosenberg organized a major Picasso exhibition (May 13–June 11) to coincide with *Cuadro flamenco.* To create a context for the recent classical works, Picasso decided to add important examples from earlier periods. Unlike the 1920 show, the exhibits were mostly on canvas and not paper. There were thirty-nine paintings, but more works may have been added at the last moment. The loans included Gertrude Stein's *Woman with a Fan,* Eugenia Errázuriz's *Seated Man,* Etienne de Beaumont's 1914 cubist still life, Gompel's 1905 Rose period gouache of two young *Saltimbanques,* and Léonce Rosenberg's 1915 *Harlequin.*[44] This painting would exert a powerful influence—as Picasso's earlier works so often did on his later works—on this summer's greatest achievement, the two versions of the *Three Musicians.*[45] The dealer also brought the large portrait of his wife and daughter down from his apartment above the gallery. Picasso added the 1918 portrait of Olga and the 1918 Biarritz *Bathers* from his own collection.

The cynosure of Rosenberg's show was *Two Nudes.* Its overwhelming presence and monumental scale did more than any of his previous works to establish Picasso as a preeminent modern painter. Not that most gallerygoers understood what they were looking at. For all its representationalism, *Two Nudes* was sometimes mistaken, according to Pierre Reverdy, for Adam and Eve.[46]

There is little to be learned from the reviews of Rosenberg's show. Fresh from publishing a mawkish roman à clef, *La Négresse du Sacré Cœur,* about Picasso (portrayed as a painter called Sorgue) and the orphan that he and Fernande had adopted in 1907,[47] André Salman wrote an embarrassing, would-be "brilliant" preface to the catalog in the manner of Cocteau. Maurice Raynal, who had written perceptively about cubism and recently published the first monograph on Picasso (interestingly, in German as well as French), provided loyal but half-hearted support. Bissière, an enlightened critic who would become a well-known abstract painter, made much of a supposed dichotomy between Picasso's "Spanish" cubism and his "French" classicism,[48] but he was too much of a chauvinist to perceive that Picasso's classicism was rooted in his atavistic Mediterraneanism rather than *la grande tradition française;* and that, despite his plundering of Gauguin and Cézanne, Ingres and Corot, his art would always be inherently Spanish in its darkness and intensity, its savagery, paradox, and irony. Picasso was closer, in spirit if not in style, to Goya than to most of the French masters.

On the subject of criticism, Picasso shared Braque's view that "if a critic's expla-

nations make things less rather than more explicit, that's all to the good." "French poets are particularly helpful in this respect," Braque said. "Few of them have understood the first thing about modern painting, yet they are always writing about it. . . . Almost the only exception is Reverdy."[49] Indeed, Pierre Reverdy's text on Picasso[50] was one of the few publications about him that he admired. Reverdy, who only liked the company of artists—"They lie less," he used to say[51]—had come to love painting, above all cubism, through Braque. He had helped the artist polish the *pensées* on art, which Braque had jotted down while convalescing from his wound. Reverdy would publish these maxims in his short-lived magazine, *Nord-Sud.* Such sayings as "A vase gives form to the void as music does to silence" would not so much explain cubism as familiarize readers with the ideas behind it.

Reverdy is particularly good on Picasso's portrait drawings:

> Nobody has wanted to say or see that the line in these drawings is cleaner, stronger, more precise and also more incisive than anyone else's; and that [Picasso] achieves a likeness through a process of *reconstitution,* whereas others confine themselves to copying. . . . He avoids the picturesque and never *idealizes . . .* [and] he never has recourse to the literary, evocative or extraneous devices, which no other artist in recent years has been able to forgo.[52]

Picasso. *Portrait of Pierre Reverdy Reading at rue la Boétie,* 1921. Etching, 11.8 x 8.8 cm. Musée Picasso, Paris.

Throughout his text Reverdy stresses the importance of *poésie*—"*poésie* is to literature what cubism is to painting."[53] This was a concept that Braque would make his own; insofar as it involved metamorphosis, so would Picasso. "*Poésie,*" Braque once explained, is "the quality I value above all else in art. . . . It is to painting what life is to man. . . . It is something that each artist has to discover for himself through his intuition. For me it is a matter of harmony of rapports, of rhythm . . . of metamorphosis. . . . Everything changes according to circumstances: that's metamorphosis."[54] Picasso's preoccupation with metamorphosis would owe a great deal to ideas formulated by Braque.

Braque and his wife, Marcelle, had been infuriated by Picasso's much repeated quips. He used to refer to Braque as "my ex-wife," and claimed that, after seeing Braque and Derain off to war at Avignon station in 1914, he had never seen them

again. Their pre-1914 competitiveness still prevailed, but it had soured into disapproval of Picasso's worldliness. In 1922, Reverdy, who had a mysterious bustup with Braque, would write Picasso a letter about the two large classical figures, *Les Canéphores*,[55] that Braque had recently painted, "Here we have the integral cubist on a new path doing [classical] women which he will not hesitate to say he was the first to come up with. I believe these women have been done for the house that Doucet is building. Braque is a pure and disinterested artist, but he has lost no time in summoning Doucet to see them. Do you agree with me that he will probably sell them at a reduced price? *Hein!*"[56] Reverdy seems to be egging Picasso on to envision Braque laying claim to a prior role in the neoclassical revival, just as he had come out in 1912 with the all-important first papier collé behind Picasso's back.

The two artists may have grown apart, but when it came to painting, Picasso still subscribed to many of the precepts, not only the notion of metamorphosis but the notion of tactile space, that Braque had instilled in him. Braque would always occupy a central place in Picasso's cosmology. The reverse did not apply. The fact that *La Lecture* (1921)—Picasso's painting of two men reading a letter,[57] which commemorates his heroic association with Braque—was never exhibited or published in his lifetime suggests that Picasso did not want anyone to detect the nature of their psychic codependence or their rivalry. Might the letter they are both reading stand for the papier collé that was central to their relationship?[58] As Gertrude Stein reported, "Picasso never wished Braque away."[59] If Braque wished Picasso away, it was much more than a matter of a wounded war hero's resentment. It was his realization that he had to break with Picasso if he were to survive as a great artist.

Olga in Picasso's studio at Fontainebleau; on the wall, a group of large pastels; in the foreground, a pastel landscape, 1921. The Pushkin State Museum of Fine Arts, Moscow.

15

Summer at Fontainebleau

Before leaving for the summer, Picasso suffered an ordeal that he had been dreading for the previous seven years: the first of four sales of Kahnweiler's confiscated stock.[1] The collections of two private dealers, Wilhelm Uhde and Richard Goetz, would also be auctioned.[2] Since over half his cubist output was at stake, Picasso had fought to have the sequestration set aside. He had expected to recover at least the items for which Kahnweiler had never paid, but now he had lost hope. Braque, Derain, Léger, and Vlaminck, whose work had also been sequestered, were more optimistic than Picasso. As French citizens who had served their country, they felt entitled to preferential treatment; however, the world situation worked against them. The Germans were so slow in paying the reparations stipulated by the Treaty of Versailles that the French government decided to convert all the assets they had been able to confiscate into cash. There would be no exceptions.

After being turned down once and for all by the authorities, the artists directed their rage at Léonce Rosenberg, who was doing his best to usurp Kahnweiler's place as the impresario of cubism. Léonce had managed to get himself appointed expert adviser for the auctions. This, he said, would guarantee the success of the sales and put cubism back on the map as an ongoing movement. Léonce claimed to be doing this for ideological reasons; in fact, his motives were anything but ideological. This unscrupulous man wanted to prevent Kahnweiler from recovering his prewar stock, so that he could crown himself king of cubism.

Paul Rosenberg tacitly supported his brother. The dismemberment of cubism would be to his advantage. However, he was far too canny to appear to have had a hand in things and be tarred with the same brush as Léonce. By flooding the market with the cream of cubism, he effectively devalued it and earned the contempt and distrust of the painters he claimed to be promoting. As Kahnweiler foresaw, the auctions would be a disaster; the prices for paintings by the major cubists would not appreciate for another twenty years.[3] Far from garnering any profit or prestige from his auctions, Léonce also did himself in as a dealer and, despite a flair for modernism—a flair devoid of discrimination—he found himself regarded as a men-

ace to the art trade. Léonce would not redeem himself until World War II, when he took conspicuous pride in flaunting his yellow star in the streets of German-occupied Paris and behaving as if nothing were amiss. For once luck was with him. He survived.

Before dealing with Kahnweiler's stock, the authorities held a sale of Uhde's collection at the Hôtel Drouôt on May 30, 1921. The seventy-three items included works by Picasso, Braque, Léger, Laurencin, and the Douanier Rousseau. The Braques, all seventeen of them—did badly, but the Picassos did relatively well. His *Portrait of Uhde* sold for 1,650 francs and his great 1910 painting of *Fanny Tellier (Girl with the Mandolin)* for 18,000 francs,[4] but the highest price of all, 26,000 francs, was paid for the best of Uhde's many Douanier Rousseaus, *Woman in Red in a Forest.*[5] Considering all the controversy in the press, the Vente Uhde went off without incident.

The first of the four Kahnweiler sales (June 13–14) was enlivened by a fight, triggered surprisingly by Braque—who was memorably described by his literary friend, Jean Paulhan, as "reflective but violent."[6] In his rage at Léonce's attempt to pass himself off as cubism's spokesman, Braque seized the dealer and shook him like an old rag. Despite his victim's shouts and screams, Braque went on kicking away at him. When Amédée Ozenfant tried to separate them, he got kicked in the stomach and sent flying into the arms of André Level. After Léonce called him a "Norman pig," Braque, who prided himself on his Norman upbringing, as well as his prowess as a boxer, pounded the dealer with his fists until the victim shrieked for rescue from "this madman."[7]

All of a sudden, Matisse materialized. Gertrude Stein told him what the brawl was about, and he, too, started shouting. "Braque is right, this man has robbed France, and we all know about those who have robbed France."[8] In the end, the police were summoned and the participants were taken off to the police station where Rosenberg made a scene at being *tutoyéd* by Braque only to be reprimanded for insulting a war hero with a Croix de Guerre. No charges were brought. Braque did not reappear in the saleroom. Instead, he returned in disgust to his house at Sorgues. Léonce set about learning to box.

Kahnweiler did not attend the sales. It would have been too painful, and the terms of the sequestration order prohibited him from bidding on his own property. No matter, friends and family members—his brother Gustav, the Berlin dealer Alfred Flechtheim, and Hermann Rupf, who had looked after him during his wartime exile in Switzerland—formed a syndicate under the name "Grassat" and purchased as many lots as they could afford. Kahnweiler's millionaire uncle, Sir Sigmund Neumann, to whom he had once been apprenticed,[9] had advanced him a 100,000-franc line of credit in April 1920, but most of this had been earmarked for his new Paris gallery.

On November 17, 1921, Kahnweiler had to undergo the torture of a second sale. Once again, the atmosphere in Room 6 of the Hôtel Drouôt was highly charged. Potential bidders drummed their feet on the floor, impatient for the boxing to start. They would not be disappointed. This time, Léonce's attacker was Adolphe Basler, a Polish critic and "collector," a euphemism used by private dealers. "Poor Basler," as he was known to Picasso in the Bateau Lavoir days, was supposedly a supporter of modern art, but, like many other nervous émigrés, he had become more chauvinistic than the French. In an attack at the time of the third sale the following year, this xenophobe had deplored the "Gypsy tricks" with which foreign artists like Picasso "easily fascinate the public."[10] Whereupon Léonce called Basler a "dirty half-breed," and now, in front of Kahnweiler's ill-fated stock, ethnic slurs flew.[11] "Filthy Pole!" Léonce yelled. "Austrian swine!" Basler yelled back, and brought his cane crashing down on Léonce's head, as the latter was about to hit him on the nose. Egregious critic Louis Vauxcelles deplored their behavior as "the art world's new manner"—for once at a loss for a demeaning term.[12]

This second sale included forty-six Picassos, thirty-five Braques, fifteen Grises, ten Légers, sixty Vlamincks, twenty-seven Van Dongens, as well as a number of gouaches, drawings, and papiers collés, which were sold several at a time in bundles. At today's rates, the sale could fetch over a billion dollars. As a result of Léonce's mismanagement, they made the ludicrously small figure of 175,215 francs. Even so, Kahnweiler's syndicate could not afford more than twenty-five lots. Given the international slump in the fall of 1921, this sale was even more of a disaster than the previous one. Only Léonce maintained otherwise. "All this is good publicity for the cubists . . . compensation for your losses," he had the gall to tell Kahnweiler, who replied that he was too cast down by misfortune "to see it in such an objective manner."[13] In a letter written to Derain a month before the second sale, Kahnweiler had deplored Léonce's cheeky request to collaborate with him "out of courtesy to a fellow defender of cubism . . . the Rosenbergs are bastards. To think that Léonce is now making grotesque proposals. I am convinced that had they not meddled, an agreement with the government could have been reached."[14]

Kahnweiler was right. Both Rosenberg brothers were at fault. While appearing to hover above the fray, Paul slyly pursued his own agenda. If Léonce's irresponsible behavior ruined the market for cubism, so much the better for him. Paul was ready to speculate in cubism if there was money to be made (his Picasso show in June had included as many as twenty cubist works); however, Paul never really understood or liked the movement. He wanted Picasso once and for all to finish with it, stick to classicism, and remain within the bounds of traditional representationalism. Unlike Léonce, Paul seems never to have imagined that cubism might come to be perceived

as the most significant movement of the twentieth century, which is why, despite derisory prices, he did not buy any Picassos at the Kahnweiler sales. Rosenberg seems also to have dissuaded Picasso from buying back any of his own art—an inexplicable lapse, given the value the artist put on his cubist work and the regret he would feel at owning so little of it. Rosenberg's hands-off attitude may cast light on another mystery: why, given his former, desperate efforts to retrieve his sequestered works, Picasso took so little interest in their fate.

Just as Picasso had let Kahnweiler decide how best to market his work before World War I, he accorded the same power to Rosenberg after it. It was all a matter of strategy. Kahnweiler had cleverly concentrated on promoting and disseminating his cubist artists' work in Germany, where there were fewer local hacks and plagiarists to contend with. However, the war had turned this highly successful *Ostpolitik* into a fatal liability. Cubist painters, who were foreigners, had been singled out for chauvinistic attack.[15] Far from looking eastward, dealers in modern art now looked westward to America for a new market. For Paul Rosenberg—a steely operator who cared far more for the business of art than for art itself—the bargain sales that his brother, Léonce, was promoting were a blessing in disguise in that they made it easier for Paul to manipulate the public into accepting Picasso as a new artist, cleansed of his revolutionary cubist past. *Realpolitik* would take the place of *Ostpolitik*.

To transform Picasso into a best seller, Rosenberg had recourse to a time-honored trick of his trade: encouraging the husband to indulge the wife. The more Picasso pandered to his wife's taste for Chanel and Cartier, the more he would need to paint. Sure enough, Picasso came up with a number of small, saleable paintings: classical figures on the beach or formulaic still lifes in a decorative cubistic style. These lesser works abound in ingenious combinations of texture and color and are more energized than comparable paintings by the Salon cubists. They sold extremely well. As for the more important paintings, Rosenberg's ploy was to tell an interested client that the work he liked was "not for sale," except to him and the Louvre.[16] He also promoted the artist as a protean modern master rather than a "difficult" cubist. Picasso's prices accordingly doubled or even trebled in 1920–21 and would continue to rise until the Wall Street crash of 1929. Although it was short-lived and unsuccessful, Rosenberg's attempt to manipulate the artist would cast a long shadow. Critics still cite the early works that Picasso did for his dealer to disparage the masterpieces in which he challenged the canons of classicism.

The results of the Kahnweiler sales did not deter Léonce Rosenberg from going ahead with a series of no less ill-advised sales of his own stock in Amsterdam. These would prove to be as much of a disaster for him as for everyone else. By October 1922, he was virtually bankrupt and consigned 381 canvases from his Galerie de l'Effort Moderne, including a great many Picassos, to an Amsterdam auction house

called A. MAK. Paris dealers were amazed at his folly. Kahnweiler's biographer dismisses these sales as a fiasco.[17] And so they may have been, above all for the artists involved; nevertheless, they included important works by Picasso and Braque—the best of which were bought by Helene Kröller-Müller and are now in the Kröller-Müller Museum in Otterlo.[18] The sales also included hundreds of paintings and drawings, many of them by Léger, Duchamp, and Picabia. These Amsterdam sales did little to save Léonce from ruin. His brother Paul, who usually came to his rescue, refused to do so on this occasion. "Penniless and crazed," Léonce turned for advice to the one person he had done the most to wrong: Kahnweiler. "You are to blame for everything that is occurring now, the eclipse of cubism and the rest of it," the valiant, albeit bitter Kahnweiler told Léonce; however, he characteristically extended a helping hand, "not out of compassion

Olga holding Paulo, with Doña María and Picasso at Fontainebleau, September 1, 1921.

for the man but because one liquidation is enough."[19] Cubism would have suffered even more if Léonce's gallery had closed; "that would be too many in one year."[20] Kahnweiler advised his nemesis to apply for a moratorium available to veterans whose businesses had failed in the postwar slump; this would keep this tragically flawed bungler solvent.

Toward the end of June 1921, the Picassos, a nurse, and other retainers moved for the summer to a rented house at 33, boulevard Gambetta, in Fontainebleau.[21] Picasso had wanted to return to the Midi, but Olga felt that she and her baby needed to be within reach of Paris; also Fontainebleau had a famously healthy microclimate. The house they found was a larger version of the house at Montrouge, and it was likewise protected by railings. There was a pleasant garden with a pond, where Olga liked to nurse Paulo, and Picasso would sit doing drawings of her.[22] He also did drawings of the house's conventionally pleasant rooms, one of which had a piano for Olga to play.[23] By way of a studio, he took over the adjacent coach house, which had

a cobblestone floor and plastered walls. Its considerable scale and height allowed the artist to work on very large canvases.[24]

In this makeshift studio Picasso spent the next three months, turning out a succession of masterpieces—far more than he had done in the previous six months in Paris. Now that the baby had eclipsed him as the main focus of the household, he preferred to shut himself away in the garage and wrestle with classicism. As Penrose says, "Picasso was not entirely happy with his role of paterfamilias."[25] Also he missed Paris: "he remarked to friends who visited him that he was thinking of ordering a Parisian street lamp and a *pissotière* to relieve the neat respectability of the lawn."[26] As the rue la Boétie had been packed up for the summer, Picasso preferred not to go there.

Coco Chanel, 1932. *Evening Standard /* Hulton Archive / Getty Images.

"Fear of loneliness—a dominant trait in Picasso—gave him a sovereign horror of spending the night alone in his apartment ... of finding the bedroom with the two brass bedsteads empty."[27] He had a tempting alternative: Chanel had put a room in her Faubourg Saint-Honoré apartment at his disposal. She was not entirely *désintéressée.* Years later, she confessed to Paul Morand that she had fancied Picasso: "He was the only one in that milieu who really turned me on, but he was not free."[28] Nor, for that matter, were Chanel's other two principal lovers: Stravinsky and Reverdy were both married, but that had not deterred her. The reluctance is more likely to have been on Picasso's side. Chanel was too much of a celebrity—and not submissive enough.

Misia had dried Chanel's tears after the death of her lover "Boy" Capel in a motor accident two years earlier; she had encouraged Chanel to give Diaghilev massive financial support. But she was outraged when Chanel dared to give *her* protégé, Stravinsky, money for a concert at the Salle Gaveau. In a spasm of vindictive rage, Misia had fired off a telegram to Stravinsky, who was in Madrid with Diaghilev, informing him that Chanel was having an affair with the Grand Duke Dimitri: "Coco is a midinette who prefers Grand Dukes to artists." Stay away, Diaghilev wired Chanel, "Stravinsky wants to kill you."[29]

"Tante Brutus," the name that Cocteau and Satie had invented for Misia, proceeded to make trouble between Picasso and Chanel. Misia had apparently boasted of having saved Chanel from the artist, Chanel told Morand: "The only person I needed

to be saved from was Misia. Grass never grows back where Misia bestows her affections. Picasso did a great job hoovering up anyone in his path, but his vacuum cleaner never came my way. The man pleased me. In fact, it was his painting I admired, although I did not understand it. I found it convincing, and that is what I like. For me it's a logarithm table."[30] Chanel went on to say that she had "always had the friendliest feelings for Picasso. I believe them to be reciprocated. Despite upheavals, we have not changed."[31] As for Misia, Chanel had the last word: "We love people only for their faults. Misia has given me abundant reasons for loving her."[32] Despite the bitchery, these daunting women remained friends for life, bound ever more closely together by a fondness for morphine.

As well as her affairs with Stravinsky and Grand Duke Dimitri and the occasional night with Picasso, Chanel carried on a more serious and long-lasting relationship with Picasso's old friend Reverdy. She chose well. This remarkable poet would mean more to her than anyone since "Boy" Capel. Reverdy had come into Chanel's life through Misia, who had helped him launch *Nord-Sud* (1916–18). *Nord-Sud* and Pierre Albert-Birot's *SIC* were the two most progressive magazines of art and literature of their day. Chanel would try to take over this ascetic and truculent recluse, but never succeeded. She financed Reverdy's first major book of poems, *Cravates de chanvre,* a reference to the hempen rope used in hangings. Picasso engraved a *portrait charge* for it.[33] He also did a watercolor on every page of a special copy printed for Chanel.[34]

In her early days, Chanel had preferred the company of artists and poets to that of her fashionable customers and so had no problem with Reverdy's solitary ways or humble origins—hers were even humbler. Besides, they both loved food and wine. Nor did she mind his slovenly Napoleonic looks—physical qualities meant less to her than intelligence, character, and charm. However, Chanel was never able to undermine Reverdy's loyalty to his wife Henriette, a former seamstress who had given up her work to live with him in poverty in Montmartre. Inspired by Max Jacob, he rejected his socialist father's atheism and became a Catholic (he was baptized on May 2, 1921).[35] Chanel would be further shattered in 1926, when Reverdy decided to abandon worldly things to go and live with his wife at the monastery of Solesmes, as an oblate—a lay monk. And there he stayed until his death in 1960. Reverdy and Chanel remained closely in touch; to her dying day she would be a fanatical champion of his work.

Among the numerous friends and collectors who visited Picasso at Fontainebleau, one of the most useful was Henri-Pierre Roché, the art adviser and writer *(Jules et Jim)* who had introduced the artist to Gertrude and Leo Stein in

1905. On July 9, Roché motored out from Paris with yet another important modern art collector, the American lawyer John Quinn, and his mistress, a poet called Jeanne Robert Foster, to have tea, including foie gras, with the Picassos in the garden. Quinn was already negotiating with Rosenberg to buy *Two Nudes;* next spring, he would acquire *Three Women at the Spring* directly from Picasso.[36] Roché was such an old friend that Picasso let him go through his "private collection"—a cache of paintings from all periods, which he kept locked away in the rue la Boétie and had never allowed Rosenberg to see. Roché managed to persuade Picasso to sell Quinn his last two Blue period paintings, but the artist reneged on the deal.

Since Picasso had never signed a contract with Rosenberg, he was in a position to do deals on the side, but this sometimes made for complications. "[Picasso] changes his mind . . . without seeming to know why—and remaining so friendly and sweet," Roché informed Quinn.[37] This useful go-between arranged for the collector to buy "the small giant women"[38] as well as some other works from Picasso. The artist was so scrupulous that he refused to accept a check from Quinn's agent until the paintings had been delivered. Roché cited this as an example of Picasso's paradoxical way of doing business. "[He] is at the same time very simple, very sweet and very difficult with money—absolutely to be trusted as you know."[39]

Another visitor who had come to play an important role in Picasso's life was Paulo's godfather, Georges Bemberg. In September 1920, Bemberg had sent Picasso a heartbroken letter announcing the death of his wife and baby. Since then, Bemberg had staunched his grief by taking on a new wife, Marie Vrubova.[40] Like her predecessor, she was Russian. Her husband had lost his life fighting the Bolsheviks. Countess Vrubova had managed to escape to France with her three daughters, Marie, Irène, and Olga, to whom Bemberg would become, all too briefly, a devoted stepfather.

As well as an apartment in Paris, Bemberg had rented a charming house, Le Manoir Charmilles, at Yerres, a small attractive town twenty-two kilometers southeast of Paris, where Gustave Caillebotte, the painter and pioneer impressionist collector, had lived across the Yerres River from Bemberg. Caillebotte's views of the town would be a feature of his retrospective at the 1921 Salon d'Automne. The manor house that Bemberg had rented no longer exists, nor do the stables with rooms above, which he transformed into studios—one for Picasso and one for himself. This neurotic young man had always hoped to have the artist as a mentor, and it now seemed as if his wish would come true. Picasso liked the idea of a studio outside Paris, where he could work in seclusion and escape his dealer as well as his wife and baby. After leaving Fontainebleau in the fall, Picasso took Bemberg up on his offer and, according to one of his host's stepdaughters, for the next two years would frequently make use of the hideaway studio at Yerres.

Picasso was always sensitive to changes in his surroundings; and the proximity of

François I's château with its decorations by Primaticcio and Rosso and their French followers, as well as the sculptures of Jean Goujon, were crucial to his initial essays in the grand manner. A back entrance, only five minutes from his rented house, provided Picasso with easy access to the eponymous fountains and network of springs in the great royal park, where he liked to exercise his dog Lotti. A shortish walk would bring him to the famous four-hundred-year-old vine or to the Napoleon Fountain, a semicircular stone parapet enclosing a grottolike rock with a spring gushing out of it.[41] This would be the setting for this summer's classical set pieces, the two versions of *Three Women at the Spring:* the first, a monumental sanguine on canvas; the second, a no less monumental painting, nothing like as lively as the sanguine, which would have pride of place on the walls of the château that Picasso would acquire in 1930.[42]

Another source of inspiration would have been the exhibition of School of Fontainebleau drawings that lasted all summer long in the château's Jeu de Paume. It had been organized by La Société des Amis de Fontainebleau, under the auspices of Bemberg's sister, the Marquise (Rosita) de Ganay, whose magnificent château, Courances, abuts the Forest of Fontainebleau. Bemberg would certainly have taken Picasso to see this exhibition of the ninety-two works on paper. Several of them were sanguines, which might explain his lavish use of this medium in what is surely the artist's largest drawing. The drawings in the Fontainebleau show belonged mostly to a collector called Jean Masson, who specialized in the Italians Primaticcio, Niccolò dell'Abbate, and Luca Penni and the French Du Cerceau, Caron, and Dubreuil. They seem to have constituted something of a challenge to Picasso. The slender, long-necked water nymphs emblematic of the château's genius loci are the antithesis of Picasso's portly naiads, although every bit as mannerist.[43] The indulgence in distortion and exaggeration, in the morbid and the bizarre, are as much a feature of the sixteenth-century School of Fontainebleau allegory as they are of Picasso's prodigious perversions of the Apollonian ideal.

Mannerist sculpture—above all the great reliefs (1550–62) that Goujon and his workshop executed for the Cour Carré at the Louvre—left no less of a mark on Picasso's Fontainebleau paintings, *Three Women at the Spring* especially, as well as, later, on his sculpture. The works that most fascinated Picasso were the four Michelan-

Jean Goujon workshop. *Roman Charity,* c. 1550–62. Stone relief, 269.5 x 133 x 40 cm. Musée du Louvre, Paris.

Picasso. *La Source,* July 8, 1921. Pencil on paper, 49.4 x 64 cm. The Museum of Modern Art, New York.

gelesque reliefs that had been taken down early in the nineteenth century by Napoleon's decorators, Percier and Fontaine, and installed in the garden of the Ecole des Beaux-Arts.[44] These did not return to the Louvre until 1980, and they now embellish the underground rotunda in the Cour Napoléon. Their enormously enlarged arms and legs, hands and feet, and the way these massive bodies have been crammed into smallish spaces out of which they seem to be bursting endow them with the heft and monumentality that Picasso was always after. Interestingly, "archaic Greece and Jean Goujon"[45] is how, some twenty-five years later, he would define the difference between his mistress, Françoise Gilot, and one of her girlfriends.

Picasso also helped himself to "one of the most famous images in all Fontainebleau iconography,"[46] a sixteenth-century engraving after a drawing by Rosso, traditionally entitled *The Nymph of Fontainebleau.* This engraving, which corresponds to a decoration in the king's gallery, inspired a number of drawings of a similar nymph emptying an amphora into a rock pool from which a dog sometimes drinks.[47] In the earlier versions of this subject, dated July 11 and 12—that is to say soon after his arrival—the nymph with the amphora reclines on a beach,[48] as if sunbathing at Juan-les-Pins. Picasso's Fontainebleau imagery is permeated with the atmosphere of these history-haunted woods and watercourses and the fountain, where he sets his hefty women stretching out their hands to the splashing water as they fill jugs that mirror the scale and amplitude of their owners.

Quasi-Pompeian sketches done around the same time testify to the pull of classi-

The Nymph of Fontainebleau (detail), c. 1545–54. Engraved by Pierre Milan and René Boyvin after a design by Rosso Fiorentino. Intaglio sheet, 31.8 x 52.7 cm. The Metropolitan Museum of Art. Gift of Junius S. Morgan.

cal antiquity[49] and his mastery of the classical vernacular. At the same time, Picasso delved back into his own past and found inspiration in a critically important early cubist painting, *Three Women* of 1908,[50] which is almost exactly the same size as the Fontainebleau painting. He may also have been reaching back into his childhood memories of crouching under a table at the feet of his thunder-thighed aunts who helped his dumpy mother at the washtub or kitchen sink, while the father hung out in the local cafés with his *tertulia.*

After he returned to Paris, Picasso envisaged an urban, modern-dress version of *Three Women at the Spring:* a group of women and children—conceivably Bemberg's stepdaughters, who complained of having to sit for Picasso—gathered around a very different source of water: a Wallace fountain.[51] Nothing came of this composition, but some of the figures reappear later in the fall in some spectacular pastels.[52]

I n a report to Vanessa Bell about his springtime visit to Picasso, Roger Fry declared that "he now needs a vast hall to decorate."[53] Presumably, Fry had heard that a major commission was in the air. An eccentric English baronet, Sir George Sitwell, owner of a large castle in Tuscany called Montegufoni, had allowed his literary sons, Osbert and Sacheverell, to commission Picasso to fresco one of the castle's staterooms. Unfortunately, these would-be patrons had set their hearts on Renaissance pastiche. Picasso welcomed the prospect of working on a huge scale, but not the Sitwells' proposal that he reinterpret Benozzo Gozzoli's frescoes in the Medici chapel.[54] Since Osbert Sitwell owned a fine albeit very faint Picasso drawing of mischievous Harlequins teasing a girl, there was also talk of a commedia dell'arte subject.

After meeting with the younger Sitwell in Paris, Picasso agreed to do the work for a fee of one thousand pounds. He told them he wanted his then pregnant wife to go somewhere restful, whereupon Sacheverell suggested that the Picassos spend the winter of 1920–21 in their uncomfortable—underheated and understaffed—castle. In the end, Sir George, who enjoyed agreeing to his offspring's schemes, and then sabotaging them, refused to provide the money. Instead, the Sitwells had Severini do a decorative Tiepolo-like harlequinade. Undeterred, Sacheverell Sitwell,

Picasso. *Head of a Woman,* 1921. Pastel on paper, 65.1 x 50.2 cm. The Metropolitan Museum of Art. Bequest of Scofield Thayer.

who was still at Oxford but saw himself as a budding patron of arts and letters, came up with another fanciful Picasso project: to illustrate an edition of Sir Thomas Urquhart's seventeenth-century translation of Rabelais with a foreword by D'Annunzio. Nothing came of that, either.

Although he had as little luck with the Sitwells as he had had with the cubist murals for Hamilton Easter Field's Brooklyn library,[55] Picasso was still very eager to work on a heroic scale and challenge Matisse's magnificent murals for Shchukin. The experience of designing theater décors had taught him, among other tricks of the trade, how to gauge effects of scale at varying distances; so had the experience of seeing François I's decorations in situ as well as up close. Some had been taken off the wall and were on exhibit in Fontainebleau's Jeu de Paume. Picasso now felt ready to tackle subjects far larger than himself. The lure of sculpture or, rather, the lure of *becoming* a sculptor should also be taken into account. Since Picasso lacked the requisite facilities—space, equipment, and above all, time—that monumental sculpture requires, he set about doing paintings in a classical vein that would double as conceptual sculptures. To simulate the matte look of stone, he executed his nudes and heroic-sized heads in pastel or sanguine, sometimes on canvas.

The most modernist of the large paintings done at Fontainebleau are the two very similar versions of *Three Musicians,*[56] in which the artist switches from the classical recto to the cubist verso of the Picassian coin. Reff, as I do, identifies the three musicians as Picasso, Apollinaire, and Max Jacob,[57] though, as always with Picasso, we should leave the door open to other interpretations. Reff also interprets *Three Musicians* in the context of symbolist poetry and the romantic, medieval legend of Harlequin as Herlequin—a being escaped from hell.

In Chapter 12, we saw Picasso Italianizing his Harlequins and turning them into commedia dell'arte Pulcinellas—bawdy and comical. By 1921, however, their picturesque charm was beginning to pall. The Harlequins in *Three Musicians* are neither Italian nor French; they are Catalan. And far from being palpable human beings, like the figures in *Three Women at the Spring,* they are effigies, such as a shaman might fashion out of bits and pieces—effigies of the artist himself and the two laureates of his prewar *tertulia,* who look back in time to Picasso's breakthrough

into the synthetic cubist style, which they personify and celebrate.

Although colorful as most of his later synthetic cubist works, both *Three Musicians* are spiritually dark but not as troubling as his great 1915 *Harlequin,*[58] which the artist would surely have seen in a recent show at Léonce Rosenberg's. Like this masterpiece, done at one of the lowest periods of World War I, the two versions of *Three Musicians* are steeped in nostalgia as well as guilt for caving in to his wife and banishing Jacob and other members of his *tertulia.* They are also steeped in the loneliness that he had complained of to Clive Bell and Arthur Rubinstein.[59] *Three Musicians* has also been interpreted as an apotheosis of the three composers—Satie, Stravinsky, and Falla—with whom Picasso had collaborated.[60] However, I prefer to see the subject in a larger context: as a requiem for Picasso's prelapsarian past, before satanic Diaghilev and snaky Cocteau had tempted him away from the path of modernism with the lure of worldly success.

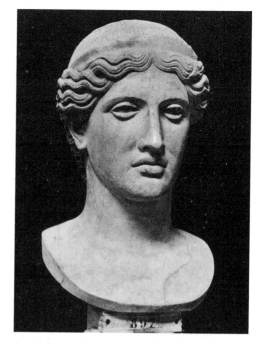

Bust of Juno (Roman copy of an original by Alkamenes, fifth century B.C.). Marble, ht. 60 cm. Museo Archeologico Nazionale, Naples.

Just as Apollinaire's poem hailing Picasso as Harlequin Trismegistus had triggered his self-referential *Saltimbanques* of 1905, a nostalgic poem dedicated to Picasso that Jacob had recently published, "Honneur de la sardane et de la tenora," triggered *Three Musicians.* This poem is a loving yet reproachful adieu, which Jacob fired across the abyss of his resentment, knowing that it would lodge deep in Picasso's far from guilt-proof psyche. Ostensibly, the poem commemorates an outing that Jacob, Picasso, and his adored mistress, Eva, made to Figueres in Catalonia in 1913.[61] Jacob evokes a serene summer evening with circles of local inhabitants performing the sardana on a town square ablaze with the red and yellow bunting of Catalonia. Max had been fascinated by the band, known as a *cobla,* that accompanies the dancers. *Coblas* consist of six men seated in a neat row on a crude bandstand raised above the dancers.[62] The *cobla* musicians have been traditionally limited to wind instruments: little flutes called *flabiols,* rustic oboes called *tibles,* and a larger, rougher version of a clarinet called a *tenora,*[63] whose dry nasal tones Jacob celebrates in his poem. The *tenora* makes an appearance in a number of Picasso's cubist compositions as well as in the first (Philadelphia) version of *Three Musicians.*

Although Picasso would do a lively cover for the sheet music of Stravinsky's *Ragtime,*[64] he had taken little interest in jazz until 1923–24, when Gerald and Sara Mur-

phy lent him records from their extensive collection, so I tend to doubt Reff's claim that the *Three Musicians* reflects Picasso's interest in jazz. Otherwise, Picasso's ear for music was extremely limited. "Tipperary" was one of the few tunes he could hum. He admired Falla because his music was based on cante jondo, flamenco, and Spanish folk music, which he loved as much as he loved the music for the sardana[65]—"a communion of souls," he said.[66] Indeed back in 1913, he had planned to devote one of the larger panels for Hamilton Easter Field's commission to this subject.[67]

Jacob's rhapsodic poem about his Catalan evening ends with a farewell to Picasso:

> Adieu sardana and *tenora*! Adieu *tenores* and sardana
> Tomorrow since fate hounds me
> Tomorrow since the Tsar commands
> Tomorrow I'll be far away
> Tomorrow in a monastery garden
> Folk will smile and hide their praying
> As for me, I'll just say thanks![68]

Three Musicians is a response to Max's valediction. After commemorating his friend's departure for the monastery in a large charcoal drawing (July 1921) of him wearing the cowl and habit of a Benedictine[69] (on the right of the Philadelphia version), Picasso envisions the poet as a masked monk playing an accordion. In the MoMA version, he is singing plainchant from a sheet of music—something he is likely to have been doing at Saint-Benoît. The ominousness of *Three Musicians* evokes the ominousness of the summer of 1913, when Eva Gouel, the mistress Picasso lured away from Marcoussis, suffered the first symptoms of the cancer that would kill her; when the father he had once loved and later rejected died; and the beloved dog Frika (half German shepherd, half Breton spaniel), which had to be put down.[70] The perceptive Reff sees the dog underneath the chair of the Picasso figure in the MoMA version as "a ghost of a dog."[71] The image does indeed suggest the ghost of the dog that had been so closely associated with his original *tertulia,* whose death he would never forget. As for the Harlequin's red-and-yellow outfit, this is a reference to the *quatre barres,* the four red and yellow stripes of the Catalan flag that decorated the square where the sardana was danced.

The grotesque commedia dell'arte masks with huge phallic noses, which Picasso had designed for Massine in *Pulcinella,* are a far cry from the synthetic cubist masks that Picasso devised for the self-referential Harlequin and Jacob-like monk in the MoMA version. These resemble Spanish carnival masks, which traditionally reflect the characters of the people who not only wear them but make them. As the anthropologist David Gilmore explains, at Carnival time, the men in Andalusian villages raid their wives' or mothers' closets for rags and bedcovers so that they can race

around the streets shrieking, dressed as women.[72] The use of rags (as opposed to shop-bought costumes) "is a conscious expression of working-class solidarity as well as a symbolic demonstration of the triumph of wit over poverty."[73] Gilmore's photographs of *mascarones,* comical transvestites who cover their faces in veils of fishnet, fringe, raffia, or lace, the better to conceal their identity as well as their sex, are astonishingly close to the otherwise baffling masks that Picasso has devised for the figures representing himself (fishnet) and Max Jacob (fringe).

So productive was Picasso's summer at Fontainebleau that, as he told Roché, he contemplated building a house in the country, where, like "Adam on the first day out of the garden," he would create "from the whole cloth a total domestic fabric." Everything was "to be thought out anew by him, with new simplicity and new proportions, even the steps of the stairs, the windows—every piece of furniture: tables, chairs, jugs, glasses, etc., created as for the first time, forgetting all [that] exists already. . . . [Picasso] says it is the work he feels in his head [that] he would most love to do."[74] This utopian dream sounds more like that apostle of the *Gesamtkunstwerk,* Henry van de Velde, in whose house everything from the dinner plates to the wall treatment and his wife's dress had to harmonize and "dissolve into each other"[75] like forms in a cubist still life. Nothing ever came of Picasso's dream house. When he finally bought a house in the country—the Château de Boisgeloup—he made minimal changes.

The studio at Yerres proved a godsend. For the next two years Picasso would drive out there to escape the bourgeois domesticity of the rue la Boétie and work alongside his admirer, rather as he had done in his youth with the no less neurasthenic Casagemas. To judge by the very few works by him that have survived, Bemberg appears to have been moderately gifted. Two largish, linear portraits of his wife and her Russian nanny are impressive in their economy.[76] So are his still-life drawings: they recall Picasso's exercises in the same representational genre, but their resemblance could never be mistaken for mimesis. It is only in Bemberg's drawings of nudes that his schizophrenia manifests itself in the clawlike convolutions of fingers and toes. One can see why Picasso bothered with Bemberg: he must have reminded him of the other lost souls—Wiegels and Casagemas—who had used him as a beanpole of magical power up which to climb and cling. Picasso needed lost souls to satisfy his cannibalistic appetite for other people's energy.

The close rapport between Picasso and Bemberg did not extend to their wives. That she, too, was a victim of the Russian Revolution failed to endear Olga to the new Madame Bemberg. "I don't think Olga ever came to Yerres," Bemberg's eldest stepdaughter, Princess Gortchakow, said, "my mother would never have received her."[77] Noble families like the Vrubovs, who had lost everything in the revolution, not least family members, and had been reduced to all manner of humiliating expe-

dients to stay alive, would have been put off by the fact that her railroad engineer father went on working for the Soviets, just as he had for the tsars. People like Madame Bemberg, who prided themselves on their stoic conduct in the face of calamity and terror, would have found Olga's airs and graces irritating. Neither did Madame Bemberg and her daughters take to Picasso. They found him uncouth in the way he put down their troubled stepfather; they also loathed having to pose for him.[78] The two men argued a lot—seemingly about the public's perception of Picasso's work. Besides worrying about her husband's pathological identification with Picasso, Madame Bemberg worried about his manic obsession with Christian Science. In his fight to alleviate his own mental problems, Bemberg had convinced himself that he was a powerful healer of others.

Although Madame Bemberg had no faith whatsoever in Christian Science, she allowed her husband to treat her daughter, Marie, when she was sick. To the surprise of everyone except Bemberg, the treatment proved effective. Bemberg was also anxious to treat Nijinsky, who had been diagnosed as suffering from a psychosis similar to his own. Knowing that Picasso was working with the dancer's sister, Nijinska, on the new production of *L'Après-midi d'un faune,* Bemberg asked him to forward a letter to her requesting that Nijinsky be brought to him for therapy. He had already devoted two or three days to giving the dancer long-distance treatment. "But," as he wrote Picasso on April 14, 1922, "receiving no answer to the letter, which you passed on to [Nijinska], I've done nothing more. I believe her brother to be absolutely curable, and if he is brought here, there is a very good chance of my being able to do so. . . . But to treat him from afar with so little collaboration on the part of his family would seem to be a waste of my time."[79]

In his last dated letter to Picasso, Bemberg complains that he himself is "far from being cured. Depression often takes over and leaves me searching for solitude. . . . You know how much I love you and how the thought that a man like you exists is a consolation to me."[80] Sometime in 1923, schizophrenia finally got the better of this gentle, well-intentioned man. To put an end to his aspirations as a painter, and possibly an end, too, to his dependence on Picasso, he set fire to their studios in the stables at Yerres. The blaze destroyed most of Bemberg's own work. Princess Gortchakow thought that "quite a few of Picasso's things might also have perished in the fire."[81] Bemberg's papers include a battered old photograph of a fascinating drawing in an Ingresque manner, which looks like a collaboration between Bemberg and his master. The original cannot be traced.

Georges's ruthless father, Otto, insisted that nobody—neither his ailing mother nor his sister, the Marquise, who was pregnant, let alone any of their friends—be told of his son's psychotic attack. After treatment in Paris, Georges was packed off to an *asile de luxe* at Prangins in Switzerland, where he improved sufficiently to be

allowed to spend the rest of his long life in a house off the premises. He sketched away—mostly breasts—in his *carnets*. His wife moved to Lausanne with her daughters and remained close to him until she died in 1936. Meanwhile, the Bembergs continued to deny Georges's very existence.[82] For all the father's generosity, neither he nor any of Georges's brothers and sisters ever went to see him. Nor, except for Proust's friend, the musical uncle, did any of them dare to communicate with him. For a dynasty whose upward mobility was geared to alliances with the *gratin,* any hint of congenital problems had to be kept very, very dark.

Georges Bemberg did not die until 1969. After his death, one of his stepdaughters asked the French auctioneer Maurice Rheims to take some unsigned drawings, supposedly Picassos, to be signed by the artist. In one of his television interviews Rheims gave a vivid account of what had transpired.[83] The almost-ninety-year-old Picasso had been terrified by the mere sight of the drawings. "Don't touch them, don't touch them," he cried. "They are not by me. They are a madman's drawings. No Spaniard would dare to touch them." Such was Picasso's superstitious fear of his powers rubbing off on others that he would never allow Françoise Gilot to pass on his old clothes to the gardener—some of his genius might rub off on the wearer. No wonder the old shaman could not bear to be contaminated by the work of this madman, who had tried to make off with his sacred fire. That had always been and always would be Picasso's prerogative.

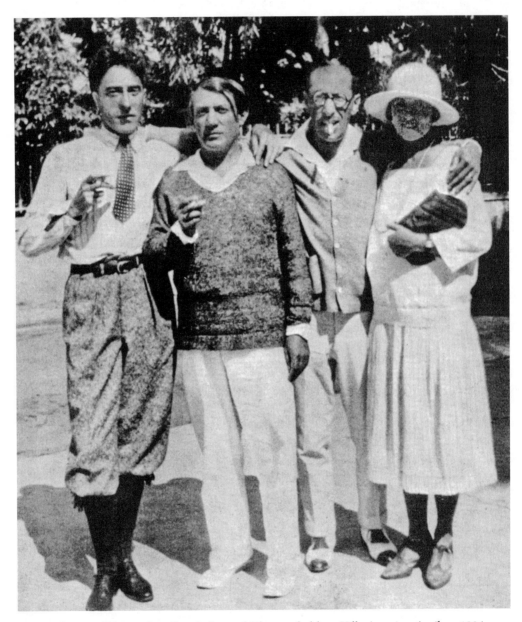

Jean Cocteau, Picasso, Igor Stravinsky, and Olga, probably at Villa America, Antibes, 1926.

16

Beau Monde (1921–22)

After his return to Paris on September 23 or 24, 1921, Picasso continued to work as triumphantly as he had at Fontainebleau. The momentum generated in the course of the summer carried him through into the following year. Back in the rue la Boétie apartment, he did his best to fill the role of a dutiful husband and father, but sometimes the tedium of these responsibilities and the Russian chitchat of Olga's ballet associates became intolerable, and he would go off to work in the studio at Yerres or call on one of his older women friends—Gertrude Stein, Eugenia Errázuriz, or, at a pinch, Misia—for more inspirational company. And then in October, an attractive American couple, Gerald and Sara Murphy, entered his life and, for the next three or four years, they would be fixtures in it.

The Murphys were young and well off. Gerald's father was the proprietor of Mark Cross, a fashionable Fifth Avenue store that sold leather goods: an American version of Vuitton. Sara's no less upwardly mobile family, the Wiborgs of Cincinnati, manufactured high-quality lithographer's ink: a world-famous product which Toulouse-Lautrec promoted in a poster featuring a printing press with a fashionable young woman—Misia Sert, no less—standing beside it.[1] Like other rich, idealistic American expatriates of the postwar period, they had reacted against the mundane values of their parents and decided to settle in Paris, the better to reinvent themselves socially as well as artistically. And reinvent themselves the Murphys did. Thanks to their charms, including a considerable repertoire of American folk songs and jazz, and their fresh, guileless, American mindset, they were an instant success in Paris. On the surface, Gerald was handsome, cultivated, and genial—so long as his mood was good. He and his adored wife aspired to lead a life that would be a work of art; however, he suffered from "a sexual deficiency": Gerald's euphemism for his homosexuality, which he tried, not altogether successfully, to control. (Donald Ogden Stewart is said to have glimpsed Gerald in the bedroom of his Paris apartment dancing rapturously in front of a mirror in a dress.)[2] Sara was a life enhancer: beautiful, intelligent, creative, and a beguiling mother to her three children, but her fidelity

made her husband's "sexual deficiency" the harder to bear: "It must make you feel rotten," he said.[3]

After the intrigue and bitchiness of Cocteau's entourage, the apparent straightforwardness of "these useful and precious Americans," as Satie described the Murphys,[4] came as a refreshing change—especially to Picasso. Their introduction into his life was anything but social. Shortly after arriving in Paris (October 1921), Gerald experienced an epiphany on seeing a painting by Picasso in the window of Rosenberg's gallery. Inside, he was overwhelmed by the Picassos, Braques, and Grises he was seeing for the first time. "There was," he wrote later, "a shock of recognition which put me into an entirely new orbit. . . . I was astonished that there were paintings of that kind."[5] "If that's painting," he told Sara, "that's the kind of painting I would like to do."[6] Sara, likewise, saw the light, and the two of them went in search of a modern artist, who would accept them and a woman friend as students. Their choice of Natalia Gontcharova, the Russian painter who had designed Diaghilev's *Le Coq d'or,* was most opportune. Gontcharova and her lover Michel Larionov, who took part in the teaching, were confirmed modernists, ruthless in forbidding students to paint anything representational—"no apple on a dish," Sara remembered.[7]

Gerald showed such talent that Gontcharova recommended him to Diaghilev, who was looking for someone to restore the company's tour-damaged backcloths and ready them for the spring season. The impresario was unable to pay much for these services. No problem, the Murphys were delighted to help out for free and have access to rehearsals and to mingle with Diaghilev's artists and stars. The work, carried out in the company's Belleville studio, was arduous. The Murphys had to spread the canvas curtains and muslin flats on the floor and work with soft brushes at the end of broom handles, then climb thirty-foot-high ladders to judge the effect. Once the repainting was done, the artists—Braque and Derain as well as Picasso— would come and check. On one of these occasions Picasso's roving eye fell on Sara. They soon became friends. As their biographer, Calvin Tomkins, has described:

> Americans seemed to fascinate Picasso. Once, in Paris, he invited the Murphys to his apartment, on the rue la Boétie, for an *apéritif,* and, after showing them through the place, in every room of which were pictures in various stages of completion, he led Gerald rather ceremoniously to an alcove that contained a tall cardboard box. It was full of illustrations, photographs, engravings, and reproductions clipped from newspapers. All of them dealt with a single person—Abraham Lincoln. "I've been collecting them since I was a child," Picasso said. "I have thousands, thousands!" He held up one of Brady's photographs of Lincoln and said with great feeling, "there is the real American elegance!"[8]

There are no traces of Picasso's cache of Lincolniana in his archive, and such a cache would have been out of character. Gerald's memory was unreliable.

Sara's life in Paris was complicated by the presence of her louche but intensely snobbish sister, Hoytie, who had volunteered for ambulance work during the war and been awarded a lifetime tenancy of an attractive apartment on the quai de Conti. In his roman à clef *Le Bal du Comte Orgel,*[9] Radiguet would pillory Hoytie as Hester Wayne, the drunken, intellectually pretentious American heiress. Hoytie had recently come out as a lesbian and developed an unreciprocated passion for Misia Sert.[10]

Unable to understand what her sister was up to in working-class Belleville, Hoytie descended on the atelier and told Sara and Gerald they were wasting their time. Years later, when Hoytie's name came up in conversation, Picasso shuddered—besides being a fearsome drunk, she became a shrill anti-Semite—but, as he admitted, she had briefly been a much more important collector of his work than the Murphys. Her collection included the National Gallery's *The Lovers* (1923), MoMA's great *Seated Woman* (1926), and the National Gallery of Ireland's 1924 *Still Life with Mandolin.*

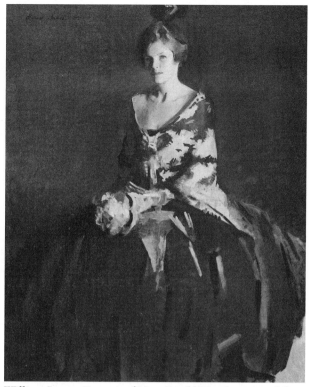

William James. *Portrait of Mrs. Gerald Murphy,* 1921. Oil on canvas, 127 x 152.4 cm. Museum of Art, Rhode Island School of Design.

Scene painting brought the Murphys together with Picasso and enabled Gerald to blossom in an extraordinarily short time from an unfocused dilettante—he had briefly studied landscape architecture at Harvard—into an accomplished artist with an eye-catching, hard-edged style that owed as much to poster artists like Cassandre as to Léger. Working for the theater inspired Gerald to monumentalize things: "paint small objects on a scale considerably larger than life-size."[11] Gontcharova had likewise left her mark on Gerald's vision, so had a new mentor, Léger, whose machine aesthetic became a principal guiding light. A token of this new passion was the huge industrial ball bearing that Gerald kept on the lid of his piano. People took it for a piece of abstract sculpture. To accommodate ever larger canvases, Gerald rented a studio in Montmartre with a thirty-foot ceiling. And within less than a year of apprenticeship, he had painted a still life of a razor the size of a mallet (1924), which would cause a stir at the L'Art d'Aujourd'hui exhibition in Paris (December

1924). It would also prompt Léger to hail him as "the only *American* painter in Paris."[12] After an extraordinarily successful series of vast, hard-edged compositions (1922–30), Gerald lost his self-confidence and packed away his brushes for good. He felt that his work was second-rate, and "the world was full of second-rate painting."[13] Gerald's oeuvre consists of a mere thirteen paintings, of which the largest, *Boatdeck, Cunarder* (18 × 12 ft.), and two others cannot be traced.

The presence in Paris of Diaghilev and his company delighted Olga, and also Picasso: it gave him a pretext to shut himself up in his studio. Clive Bell, back in Paris, reported on May 14, Olga's "sole topic of conversation is the ballet—which must be unlucky for Picasso as he is sick to death of the whole thing," not least of having to comply with Diaghilev's incessant requests[14]—such as a portrait of Bakst for a book of his *Sleeping Princess* designs.[15] A boil on the end of Bakst's large nose postponed the sitting until April 1. Bakst gave Picasso one of his designs for *Les Femmes du bonne humeur,* the ballet in which he had first seen Olga rehearse, but for once Picasso did not reciprocate. He liked Bakst well enough—he was the source of much of Picasso's stagecraft—but apart from *Schéhérazade* he disliked his work and failed to give him the portrait.

Nineteen twenty-one ended with a New Year's Eve party given by the Beaumonts.[16] Etienne had arranged for Djemil Amik, an exotic dancer described by Jean Hugo as "the black pearl of Caryathis" to dance the New Year in.[17] The main concern of the guests was whether Proust, who was mortally ill with asthma, would or would not appear. "I'm the most troublesome of guests," Proust had written in answer to Beaumont's invitation,

> [but] I very much hope to come. I'm feeling rather sprightly at the moment. But in my fear of not being able to come, I've been swallowing drugs with such abandon that you'll have a man who is semi-aphasic . . . through giddiness. . . . it will make me a lot of enemies among those I've refused, but that's a consideration only in so far as it makes me all the keener to bring you my good wishes. . . . I might ask you for a cup of boiling-hot tea on arrival (lime tea, anything), hot enough to burn the throat, not simply very hot. And also not to introduce me to too many intellectual and fatiguing ladies.[18]

Proust was a famously demanding guest. According to Edith de Beaumont, the writer's maid, Céleste, called ten times to make sure that there were no drafts and that the tisane had been prepared to her specifications. "Finally at midnight," as Jean Hugo described, "there was a tremor in the crowd, and one knew that Proust had arrived. He had made his entrance at the same moment as the incoming year—the

year of his death . . . his face was pale and puffy, he had put on weight. He spoke only to dukes. 'Look at him,' Picasso said to me, 'he's on the job' (*sur le motif*)."[19] Besides the dukes, Proust found time to converse with the artist he had described as "the great and admirable Picasso." Proust stayed on most of the night, as Picasso said, "on the job"—collecting material for his last volume. However, as Proust wrote Princess Soutzo, "I thought I was making a particular gesture of friendship to the Beaumonts (matched by theirs) by staying up all night at their New Year's Eve ball. They seem to have thought otherwise, for I wasn't invited to [their next] party"[20]— the *Bal des jeux*.

Proust was fascinated by Picasso. His maid, Céleste, recalled Prince Antoine Bibesco arriving to take the great novelist to a dinner at the Crillon, "with the object of introducing him to Picasso." On the stroke of two in the morning, all three of them went to Picasso's studio to see his paintings. When Proust described them to Céleste, she commented that "the Picasso faces must be a funny sort." He laughed and said, "I must admit I didn't understand it much."[21] Picasso met Proust again on May 18 at a supper party at the Hotel Majestic,[22] given by a rich Englishman, Sydney Schiff (aka the novelist Stephen Hudson, who would translate Proust's last volume, *Time Regained*), and his wife Violet. The occasion was the first night of Stravinsky's *Renard* with choreography by Nijinska.[23] Besides honoring Diaghilev and his company, the party brought together the Schiffs' four favorite geniuses: Proust, Picasso, Stravinsky, and James Joyce. Schiff, whom Clive Bell accused of being intellectually and socially on the make,[24] was determined that Picasso should help him in his quest for memorabilia. To this end, Schiff wrote Proust an unctuous letter (July 21), informing him that the British Picasso, Wyndham Lewis—"has a stronger intellect than Picasso but [he] doesn't paint as well"[25]—was doing portraits of himself and his wife. The latter was to be given to Proust, in return for which Schiff hoped that Proust would sit for a portrait drawing by Picasso. "It would only take an hour or so." Encouraged by Bell, the artist had taken a dislike to Schiff, whom he described as *le monsieur qui est trop gentil*. Nothing came of this project.[26] A day or two after the dinner, Picasso received a nosy letter from Cocteau, who was not at the Schiffs' supper: "I heard all about your dialogues with Proust."[27]

Except for Picasso, the Schiffs' geniuses failed to shine. When asked by Proust whether he liked Beethoven, Stravinsky—exhausted from conducting *Renard*—said he detested his music. "But surely the late quartets?" "Worst things he ever wrote," Stravinsky snapped.[28] Proust fared no better with Joyce, who arrived late, drunk, and inappropriately dressed. "Joyce complained of his eyes, Proust of his stomach. Did M. Joyce like truffles? He did. Had he met the Duchesse de X? He had not. 'I regret that I do not know M. Joyce's work,' remarked Proust. 'I have never read M.

Proust,' Joyce [lied]. . . . Thus the two greatest novelists of the twentieth century met and parted. 'If only we'd been allowed to meet and have a talk somewhere,' remarked Joyce sadly afterwards."[29] Picasso's only recorded opinion of Joyce is suspect, coming as it does from Gertrude Stein, who regarded him as a dangerous rival. Stein quoted Picasso as saying that "Joyce and Braque are the incomprehensibles whom anybody can understand."[30] Picasso had no more read Joyce than he had read Stein. His opinion had apparently been formed by Bell, who told Mary Hutchinson, "When I told Picasso that Joyce's book was not really pornographic—only *conscieusement indécent*—he remarked that it was 'regrettable,' and we both deplored the modern passion for the dull."[31]

T he roaring twenties" had got off to an exhilarating start in Paris on January 10, 1922, when Le Boeuf sur le Toit opened its inconspicuous black door on the rue Boissy d'Anglas. The "Boeuf," as it soon became known, had its origins in Cocteau's Mutual Admiration Society, his Parisian *tertulia*. The regulars included Morand and Milhaud, Radiguet, the Hugos, Pierre Bertins, and Picabias, and the rest of Les Six. Although Picasso shunned this "Society," he enjoyed hearing about their weekly dinners at Le Gaya, a bar on the rue Duphot, where a pianist friend of Milhaud's, Jean Wiener, played to a room that was usually empty. In desperation, Wiener and the proprietor, Louis Moysès, had asked Milhaud to ask Cocteau to use their premises for his dinners: fashionable gatherings that guaranteed the bar's popularity. Cocteau would recycle the conversation generated by these occasions in his short-lived magazine, *Le Coq*. As the founder of Les Six, the poet felt he had to qualify as a musician by accompanying Auric and Poulenc on a drum that Stravinsky had lent him ("I play it as often as I can," he wrote to his mother).[32] Given half a chance, Cocteau would also perform on "the castanets, drinking glasses, the mirliton and a klaxon."[33]

Spawned by Le Gaya the Boeuf was an immediate success. The walls were lined with drawings by Cocteau and other of the bar's famous clients. Picasso, too, lent some large drawings but removed them a few years later. They left conspicuous gaps. The most celebrated of the bar's artworks was Picabia's *Cacodylic Eye* (1921); the artist had asked fifty of the visitors to his studio to do whatever they wanted to a canvas.[34] The result is a collage of random elements: signatures, graffiti, newspaper clippings, aphorisms, and the like. "The canvas was finished when there was no longer space on it. I find this painting very beautiful," Picabia said.[35]

The Boeuf was soon thronged with the beau monde. Men were expected to wear dinner jackets, women to dress up in Chanel, Lanvin, or Vionnet. Overnight it became the headquarters of what would soon be known as café society: a place

Interior of Le Boeuf sur le Toit, Paris, with Moysès at the left, and Doucet, the house pianist, on the right, 1924. Photographer unknown (inscribed in 1960 to Moysès's son by Cocteau). Archive Louis Henrion.

where high and low, *gens chic* and *gens louche,* could mingle with the leading lights of the avant-garde. Celebrities included Josephine Baker, Charlie Chaplin, the Prince of Wales, Chanel, Ernest Hemingway, the Aga Khan, and Barbette, the American trapeze artist whom Cocteau had discovered and who performed in drag. The French were often outnumbered by Americans—refugees from Prohibition and puritanism. At the Boeuf you could dine and drink and dance and make out with gorgeous young men and women who did not always come free. You could also discreetly score drugs.

Within a year or so, the Boeuf was being hailed by Jean Hugo as "the navel of Paris,"[36] the most energized and energizing establishment of its kind in all of Europe. Although he had no more than a few months to live, Proust, eager as always to investigate social phenomena, insisted that his friend Paul Brach take him to dine there. Proust wore a white tie and tails for what turned out to be a disastrous evening. "Some unbelievable pimps and queers" got into a drunken argument with Brach, which resulted in Proust challenging one of them to a duel.[37] Proust was disappointed when an abject letter of apology from the culprit put an end to his farcical show of gallantry. A few months later Proust would be dead, but many of the originals of his characters continued to haunt the Boeuf.

For Cocteau, the opening night of the Boeuf was marred by the temporary defection of Radiguet. Both Jean Hugo and a jolly pub-crawling painter from London called Nina Hamnett recorded this episode.[38] Arriving around eleven o'clock, Hamnett found the Picassos with Cocteau, Marie Laurencin, Marie Beerbohm, and Moysès, the Boeuf's proprietor. Already a confirmed alcoholic, Radiguet had gone to

the bar to join Brancusi, one of the very few guests not wearing a dinner jacket. They had both had enough of Cocteau's shenanigans. "Let's leave," Brancusi said. Off they went, with Nina Hamnett, to Montparnasse. The Dôme was about to close—just time to buy cigarettes. Brancusi suggested they go to the Gare de Lyon for a bouillabaisse. It was no good, so they decided to take a train to Marseille as they were, without luggage and without Nina. The Marseille bouillabaisse turned out to be no better. Radiguet exchanged his dinner jacket for a sailor suit, and after a night of debauchery in the *vieux port,* they boarded a boat for Corsica. The men of Ajaccio seldom let their women out of the house, so Radiguet and Brancusi departed for the mountains, where all they found were hags in black herding goats.[39] They ended up in a vast, unheated hotel, where they stayed warm by consuming quantities of Corsican brandy. Heaven knows what else they got up to. Ten icy days later, they returned to Paris and an icy welcome from Cocteau. After dropping Radiguet off at the Boeuf, Brancusi left—never to return to the Boeuf and never to be mentioned in print by Cocteau. Picasso, who loathed Brancusi but not as much as Brancusi loathed him, was much amused by this story and would tease Cocteau about it in later years. Cocteau may have had cause for jealousy. Although Brancusi enjoyed telling friends how in his youth he had attended a country dance dressed as a girl and been invited out to dinner by a young officer, he was famously heterosexual. So, up to a point, was Radiguet despite his relationship with Cocteau.

Radiguet would not have time to develop into the genius that Cocteau cracked him up to be. Although his farouche adolescent manner, surly shyness, and belief in a poet's obligation to experience the *dérèglement de tous les sens* evoked Rimbaud, Radiguet was determined to distance himself from that dangerous exemplar. He had chosen a very different one: the sobriety, coolness, and classicism of Madame de La Fayette's seventeenth-century masterpiece, *La Princesse de Clèves.* Picasso made fun of Radiguet for allowing himself to be seduced by Cocteau, but he sympathized with the priapic young writer, much as he had with the priapic young Massine. If Picasso agreed to do a *portrait charge*[40] for Radiguet's first book of poems, *Les Joues en feu* (published in 1925), it was not so much a favor to Cocteau as it was to a young author whose work carried much more conviction. There was a further link between the painter and the poet. Radiguet was having an affair with Picasso's former fiancée, Irène Lagut. Indeed, the title poem in *Les Joues en feu* is an acrostical ode to her. Irène now belonged principally to Georges Auric, but she had tried to steal so many husbands away from their wives—Braque and Derain, among others—as well as a wife or two away from their husbands, that she was now known by Satie as "Poison."[41] With Radiguet's connivance, Picasso would start seeing "Poison" again.

On January 21, 1922, Cocteau arranged for Radiguet to give a reading of his almost completed novel, *Le Diable au corps,* to the Picassos, Beaumonts, Serts, and

Pierre de Lacretelle at the Hugos' apartment. Surveying the listeners balefully through the monocle he used to camouflage his youth, the myopic young prodigy noticed that Edith de Beaumont had fallen asleep. This was unfortunate,[42] given that Radiguet was already working on his roman à clef about the Beaumonts. After the reading, Radiguet shrugged off compliments, saying that "the *Comte d'Orgel* will be much better." Little knowing that he might be playing into Radiguet's hands, Beaumont then announced his plans for a Mardi Gras *bal des jeux,* that is to say a fancy-dress ball on the theme of games. Here was the climax that the writer needed for his novel. Beaumont immediately started work on the *entrées.* Picasso enjoyed designing some of the costumes, among them a merry-go-round complete with an organ for Valentine Hugo. She would finish this outfit only just in time for an *entrée,* which would include her husband as a game of billiards, Misia's

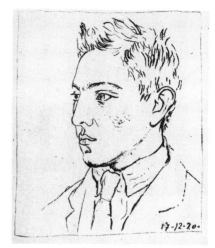

Picasso. *Portrait of Raymond Radiguet,* December 17, 1920. Drawing on transfer paper reproduced in collotype (frontispiece of Radiguet's *Les Joues en feu,* 1925). Private collection.

nephew, Jean Godebski, as a house of cards, and—most appropriately in the context of this ball—Radiguet as a shooting gallery. In addition Picasso painted a large decorative panel for the music room where Beaumont gave his parties: a stick figure made of tridents holding a fish next to another figure representing the sun holding a sign saying *BAL.*

The day before Radiguet's reading, the Picassos had shared a box with the Hugos and Auric at the first night of *Skating Rink,* the groundbreaking new work put on by Rolf de Maré's Ballets Suèdois. De Maré, an aristocratic landowner whose millions came from family forests in Sweden and coffee plantations in Brazil, was a tremendous admirer and collector of Picasso and wanted him to design ballets for him. Cocteau, who still resented Picasso for tampering with *Parade,* would not hear of this; he persuaded de Maré that Picasso's décors did not enhance the ballets so much as they upstaged them. All a ballet needed, Cocteau told the impresario, was "a single creator, who would combine the tasks of choreographer, librettist, composer, scenographer and dancer"—that is, himself.[43] Since de Maré was far more radical than Diaghilev or for that matter Cocteau and his considerable fortune absolved him from mundane conventions and box office considerations, Cocteau's sabotage of Picasso was particularly regrettable. And so the avant-garde ballets that made the reputations of de Maré and Jean Borlin (de Maré's principal dancer, choreographer, and lover) included nothing by Picasso. De Maré turned to Léger and Picabia instead.

Skating Rink was an experimental "dance poem" that had been thought up by

Picasso's Italian friend, Ricciotto Canudo, Honegger wrote the music. Léger did a brilliant abstract set that extended into the auditorium and enveloped the audience in a blaze of color. It was the most original, startling, and modernist décor since *Parade.* The dancers' jazzy costumes and stylized movements were based on the couples whom Léger, de Maré, and Borlin had watched in working-class dance halls and roller-skating rinks. What Picasso felt about Léger's brilliant harnessing of synthetic cubism to the stage design in *Skating Rink,* as well as in his next ballet, *La Création du monde,* we do not know. Rather than commit himself to an opinion on Léger's undeniably great work of this period, Picasso would say, "his cubism is not my cubism." At the first night of *Skating Rink,* the public made the usual philistine din. Léger did not exploit this as a historic battle between the establishment and the avant-garde, as Cocteau had done with *Parade;* he played things down: "no need for an orchestra," nor for rehearsals—"rehearsals are money down the drain."[44]

The third Kahnweiler sale took place on July 4, 1922. The timing was anything but propitious: the art market was at its lowest ebb in years and many potential buyers had already left Paris for the summer.[45] Kahnweiler tried to persuade Léonce to postpone the auction until everyone returned in the fall. He would not listen. The press was contemptuous, especially the flippant Vauxcelles, who was reasonably fair about the sale under his own name but catty under one or other of his pen names. Léonce should show up in armor, he suggested; Basler in tin hat and gas mask, Braque in boxing gloves, and so forth.[46] At the sale people jeered as porters held pictures upside down. No one seemed to care. Kahnweiler was very hurt when the one item he was anxious to buy for himself—Derain's portrait of his wife, Lucie—went to his enemy, Paul Rosenberg, for a price he could not match. On the other hand, Roger Dutilleul, most discreet and perceptive of cubist collectors, bought the gallery's archives and presented them to Kahnweiler.

This time, the sale included ten Picassos, fifteen Braques, twelve Derains, and thirty Vlamincks. Although the prices for cubist works were as low as before, Kahnweiler's syndicate could not afford to buy much. Indeed, the success of the Derains and Vlamincks in this sale convinced Kahnweiler and his Berlin confrere, Flechtheim, that they should specialize, insofar as they could, in Derain rather than Picasso. A new type of collector had entered the ring: young dadaist poets, who made virtually nothing from their writings, but profited from their "collections," consisting of bargains bought at sales or minor works cadged off artist friends. Picasso was particularly generous in this respect; André Breton and Elvard particularly greedy. At this third Kahnweiler sale, Breton bought three Braques and a Léger for Jacques Doucet, the collector and bibliophile whom he was advising. Meanwhile,

he was pressing Picasso to sell Doucet *Les Demoiselles d'Avignon*—the painting that Breton would be one of the first to hail as a masterpiece. This transaction would come to pass, but not until 1924. Thanks to Breton, Doucet would keep many of the poorer surrealist writers going by acquiring their manuscripts for the ever-growing library he would leave to the Sorbonne. Under the aegis of François Chapon, the Bibliothèque Littéraire Jacques Doucet would become one of the greatest sources of documentation available to historians of twentieth-century French art and literature.

As they had the previous year, the Picassos chose to spend the summer in the supposedly salubrious north, this time at Dinard. This "family," rather than fashionable, resort had been recommended by Yvon Helft, a dealer in fine French silver, who was Paul Rosenberg's brother-in-law and sometime partner. Helft had chosen Dinard for the same reasons that Rosenberg and Wildenstein chose Biarritz: prosperous clients were to be found there. In the course of this summer, the Helft and Picasso families saw much of each other. Whether the Picassos got together with the Murphys, who were spending their summer at a nearby resort, Houlgate (one of the stops on Proust's *petit train* to Balbec); or whether they accepted the Beaumonts' invitation to visit them in Normandy; or whether they attended the *soirée mémorable* provided by Miss Jane Day and her all-girl band at Dinard's High Life Casino, we do not know. We can, however, assume that Picasso is unlikely to have missed seeing *Monsieur Podrecca et le Théâtre des Piccoli,* the puppet show that had captivated him and Cocteau and Massine in Rome in 1917.

Picasso, Olga, and Paulo, plus a nanny, checked into the Hôtel des Terrasses on July 15. They stayed there for a week while Madame Grosvalet, the local real estate agent, found them a house. The Villa Beauregard, which they moved into on July 22, was a sizable Second Empire house with a mansard roof on the Grande rue, now avenue Georges V. It was perched above the sea, close to the Grand Hotel and opposite the Port de Plaisance, where the ferry docked, and it had an attractive view across the water to Saint-

Picasso. *Estuary from Villa Beauregard, Dinard,* 1922. Oil on canvas, 46 x 55 cm. Private collection.

Malo. There was a nice, messy garden but nothing much by way of a studio, as there had been at Fontainebleau. This summer there would be no big paintings.

At Dinard, as at Fontainebleau, Picasso filled a sketchbook with sharply observed drawings of his summer abode: its rustic paneling, shuttered windows, an Empire desk, ormolu candlesticks, and that staple of Breton and Norman interiors, a large oak screw from a cider press.[47] Drawings of the garden include details of wrought-iron chairs, wobbly urns, and chestnut trees. Other crisp sketches depict the estuary, with its bustling ferry, lopsided yachts, pleasure craft aflutter with bunting, and, in the distance, Saint-Malo's seventeenth-century ramparts.

The paintings Picasso did at Dinard are nothing like as ambitious or powerful as the ones he had done at Fontainebleau the year before. One has the feeling that the artist had "emptied himself," to use Gertrude Stein's phrase,[48] and resigned himself to doing his dealer's bidding. In the course of the summer he worked on a series of small, sharp still lifes formed out of horizontal black lines superimposed on flat planes of color. Penrose compares their effect to "light filtered by slatted shutters,"[49] but Picasso must have taken a good look at the very similar vignettes that Braque had done three years earlier for Reverdy's magazine, *Nord-Sud*, using an identical linear technique. The larger, more colorful of the Dinard still lifes transcend their formulaic imagery, but the lesser ones conform to Rosenberg's request for modernistic images that are easy on the eye.

Picasso. *Mother and Child*, 1922. Oil on canvas, 100 x 81 cm. The Baltimore Museum of Art. The Cone Collection.

The mother-and-child paintings engendered by the atmosphere of this family resort must also have pleased Rosenberg. To this day they are extremely popular with the general public. By the same token, they are extremely unpopular with modernists, who have used them to impugn Picasso's classicism. And it is true, these *Maternités* are unashamed pastiches of Renoir's late work—much in the news, given the recent auction of the contents of his studio[50]—but the sheer scale (130 × 90 cm) of the magnificent culminating *Mother and Child* and its slash of vermilion leave the other versions in its shadow. One of the finest of Picasso's Renoiresque nudes is the exquisite pastiche of a *Seated Bather*[51] that he made the previous summer, based on Renoir's

Left: Auguste Renoir. *Seated Bather in a Landscape,* called *Eurydice*, 1895–1900.
Oil on canvas, 116 x 89 cm. Musée Picasso, Paris.
Right: Picasso. *Seated Bather Drying Her Feet,* 1921. Pastel on paper, 66 x 50.8 cm.
Museum Berggruen, Staatliche Museen zu Berlin.

painting of the lone subject (known as *Eurydice*), which he had acquired from Rosenberg.[52] Picasso was out to claim a place in the great French classical tradition. The saccharine Dinard *Maternité*s do little to justify this ambition.

These allegories of motherhood are also indebted to one of Picasso's Andalusian forebears, Esteban Murillo, tenderest of the masters of Spain's Golden Age. The nuns who had given the sixteen-year-old Picasso his first commission—two altarpieces for their convent—had insisted that he take Murillo's Madonnas as a model. Since Picasso's paintings were destroyed in the "troubles" of 1909, we can only hazard a guess at the role they may have played in his subsequent development. My feeling is that the Andalusian sweetness that manifests itself in Picasso's work counterbalances the no less Andalusian machismo that fueled the dark side of Picasso's *alma española.*

Sporadic flashes of genius would reassure his faithful followers that for Picasso,

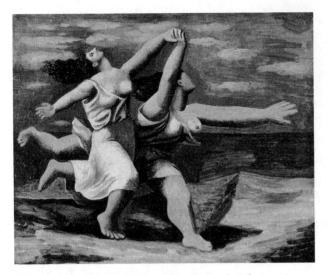

Picasso. *Two Women Running on the Beach (The Race)*,
1922. Gouache on plywood, 32.5 x 41.1 cm. Musée
Picasso, Paris.

the classicist pastiche was no more than a temporary lapse. One of these flashes took place shortly before he left Dinard. In a sudden flare-up of his Dionysiac spirit—an explosive reaction perhaps to the ennui of domestic life in this genteel resort—Picasso painted a small power-ful panel of two muscular maenads tear-ing along the beach, their hair streaming out behind them in joyous abandon. In *Two Women Running on the Beach,*[53] Picasso looks back at his Juan-les-Pins drawings of two naked men jogging on the beach, playing with what appear to be beach balls, but turn out to be rocks that they are hurling at targets outside our field of vision.[54] There were similar sights on the Dinard beach. Rather than spend all day with Olga, Paulo, and the nanny, Picasso wandered off in search of girls, to watch and maybe befriend, as he would when he returned in 1928 with a young mistress, and portrayed these same beaches with their rows of cabanas as erotic arenas. The maenads in the 1922 panel, who seem to inflate as we look at them, are the forerunners of the pneumatic ball-playing girls of 1928. Picasso, who had recently done a beachlike backdrop for *L'Après-midi d'un faune,* may well have wanted to give Massine's nymphs more sub-stance. The balletic echoes that resonate in this little masterpiece appealed to Diaghilev. In 1924 he would use a blown-up version of it as a backcloth for Nijinska's diverting and influential ballet *Le Train bleu.*

In mid-September, Olga suddenly fell seriously ill. The nature of her illness has never been divulged. All we know is that she had to be rushed to Paris for an emer-gency operation. Picasso had a difficult drive back to Paris, coping with Paulo's car sickness while applying ice packs to Olga's temples.[55] Had she had a miscarriage—Picasso is likely to have wanted more than one child—or, had Paulo's birth left her prone to problems? A sanguine drawing of Olga, done around the middle of Sep-tember, shows her looking haggard and sick.[56] This drawing evidently had a malign significance for Picasso: he gave it to his son Paulo shortly before Christmas 1963—seemingly the only work that he ever inscribed to him. There would be many more representational portrayals of Olga, but none of them manifest the anguish and com-passion that make this drawing memorable.

After Olga's operation, Picasso returned to Dinard to collect the work he had done in the course of the summer.[57] His return attracted attention: while in Paris he had bought a costly new car and hired a driver. The car was a Panhard, not the famous Hispano-Suiza that he would acquire in 1930, and it was impressive enough to be written up in the Dinard newspaper. From now on, everything Picasso did would be news.

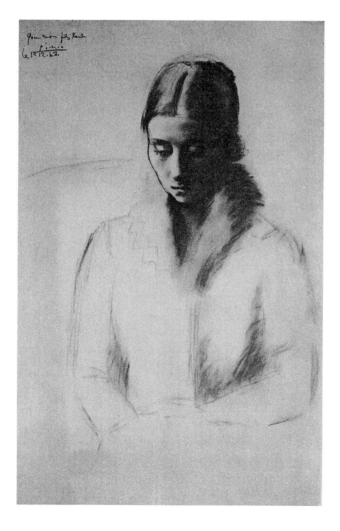

Picasso. *Olga,* 1922. Sanguine on paper, 100 x 90 cm. Inscribed "Pour mon fils Paul/ Picasso/le 1er 12-63." Work stolen from Christine Ruiz-Picasso's country home.

17

Paris (1923)

The acquisition of a chauffeur-driven automobile put a final touch to Olga's *embourgeoisement* of Picasso. It caused a lot of talk. Many of his fellow artists and writer friends had acquired expensive cars, roadsters or racing cars for the most part, but they were always their own drivers. In the 1920s, Picabia had some fifteen of the finest makes; Derain owned a Renault and a racing Bugatti; Braque had an Alfa-Romeo, which he sold to the one-armed Cendrars. So dangerous was Cendrars's driving that Eugenia Errázuriz supposedly put a hex on the car stop it from starting. Unlike most of his artist friends, Picasso refused to learn to drive. He told Françoise Gilot that he was frightened "of spoiling the suppleness of his hands and wrists."[1] If a painter was rich enough to buy a car, Picasso thought, he should be rich enough to afford a chauffeur, and he was always berating Braque for driving fast cars himself. People interpreted Picasso's pleasure in driving around in a chauffeured limousine as showing-off—all Olga's fault. And it is true she had succeeded to some extent in gentrifying her husband. She was even trying, unsuccessfully, to stop him smoking, barging into his studio to catch him out.[2] Visitors would be asked to take the incriminating cigarette or pipe and pretend it was theirs. No wonder Picasso was becoming resentful, especially now that Olga was often *souffrante.*

The change in Picasso's attitude to Olga is reflected in the portraits he did after her recovery. There is a remoteness to them, which bears out something Picasso told Gilot: that "he tried to placate his wife by having her sit for him."[3] Olga figures in her husband's work as a trophy wife rather than a desirable woman. The three largish portraits of her in a blue dress with a fur collar he did in 1923 are not so much likenesses as idealizations. Though still unashamedly Ingresque, their sharp focus and silken sheen suggest that Picasso had also been studying eighteenth-century pastel portraits in Rosenberg and Wildenstein's stock. A painting of Olga gazing demurely down at the letter she is writing recalls Greuze in its artifice and sentimentality,[4] while a large, exceptionally fine pastel of her in a similar pose[5] suggests that he was pitting himself against such virtuoso pastelists as Jean-Baptiste Perronneau and Quentin de La Tour. There is not a glimmer of the devouring sexual passion that would super-

charge the images of Olga's successor, Marie-Thérèse Walter. The chill in these academic tours de force indicates that Picasso's feelings for his wife were cooling.

The numerous portraits—paintings, drawings, pastels—that Picasso did of his son are more affectionate than those of his mother. The surrealist poet Jacques Baron, who visited Picasso around this time, reported that the artist had allowed Paulo to take over the dining room floor for his model train track. After demonstrating the train's possibilities, "like a child and like a king," Picasso got up from the carpet and told Baron:

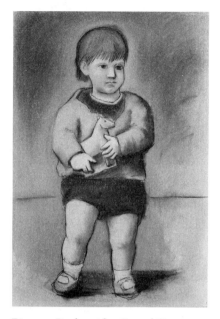

> "There's a painting by Ingres you probably know of, Henry IV on all fours with a child on his back. He is the horse and the child is the cavalier. The Spanish Ambassador arrives and raises his arms to heaven at the sight of this genial family scene. I am going to do a picture like that: President Poincaré (or Deschanel) with a little boy of ten on his shoulders, and the Spanish Ambassador, Mr. Quinones de León, arriving unexpectedly. *Hein,* that's what one should paint today!"[6]

Picasso never painted such a scene, but he portrayed Paulo in many different styles and poses: on a donkey, with a toy lamb or a horse[7] or a motorcar, drawing at his desk, or, a little later, dressed up as a Harlequin, bullfighter, or Pulcinello.[8] On one occasion, Picasso took away his sleeping son's model motorcar and repainted it in bright colors with trompe l'oeil cushions and a checkered carpet on the floor.[9] When he awoke, Paulo was furious. Paternal doting

Picasso. *Paulo with a Carved Horse,* 1923. Charcoal, pastel, and gouache on paper, 103.5 x 73.5 cm. Collection Bernard Ruiz-Picasso.

did not last long. The father was not happy at the way the boy was pampered and overprotected by his mother. His upbringing at the hands of music teachers, dancing instructors, and such like became a bone of contention between them. Like the father, the son would come to resent Olga.

A principal task that confronted Picasso on his return to Paris from Dinard was the décor for Cocteau's adaptation of Sophocles' tragedy *Antigone.* Although he claimed to be through with the theater as well as Cocteau, Picasso welcomed the prospect of working with Charles Dullin, whom he had first known at the Lapin Agile, reciting poetry for the pennies people threw into his hat. Now, twenty years later, Dullin was revolutionizing French drama at the Théâtre de l'Atelier. Besides directing *Antigone,* Dullin played the part of King Creon. Cocteau described his ver-

sion of this seminal drama as a "pen and ink drawing after a painting by an old mas-
ter" and "an aerial photo of the Acropolis."[10] He claimed that the idea of "putting
new dress on old Greek tragedy" came to him during his summer idyll with Radiguet
at Pramousquier, as he wandered the beach brandishing a Greek shepherd's crook
topped with a goat's horn "curved like Minerva's eyebrow." In fact Cocteau had
already discussed the project with Honegger, who would compose the musical
accompaniment ("a little score for oboe and harp"). Emboldened by the success of
Les Mariés de la Tour Eiffel, Cocteau had realized the need for another theatrical
advertisement for himself—this time in a more solemn vein.

Dullin's assistant, Lucien Arnaud, claims that Picasso left his set design for
Antigone until the very last moment. A day or two before the play opened, the artist
calmly produced from his pocket "a scrap of white paper, deliberately crumpled, and
with his inimitable accent and ironic expression said: 'Here's the maquette.' "[11] A
charming story, but it leaves out of account some twenty pages of sketchbook cro-
quis and some worked-up drawings for a three-dimensional structure on the stage—
all of them projects for *Antigone.*[12] I can only imagine that Cocteau or Dullin, or
more likely Picasso himself, was not happy with the maquettes, so he decided to
wing it. Cocteau has described Picasso's modus operandi:

> The day before the dress rehearsal . . . I was sitting in the Atelier [theater] with
> Dullin and the actors. On stage was a back-cloth painted a sort of laundresses
> blue . . . like the rocky background of a crib. This had openings on the left and
> right: and in the middle . . . a hole for the voice of the chorus to come, amplified by
> a megaphone. Around this hole I had hung the masks of women, boys, and old men
> which I had made from Picasso's models and which he and others had painted.
> Under the mask a white panel was suspended. The problem was to indicate on this
> surface the meaning of a fortuitous setting, which sacrificed precision and impreci-
> sion . . . to the representation of a warm day.
> Picasso walked up and down.
> He began by rubbing red chalk over the panel, which turned the unevenness of
> the wood into marble. Then he took a bottle of ink and traced some majestic-
> looking lines. Abruptly he blackened a few hollow spots and three columns
> appeared. The apparition of these columns was so sudden and so unexpected that
> we began clapping.
> When we were in the street, I asked Picasso if he had calculated [the apparition
> of the columns]. . . . He answered that the artist is always calculating without
> knowing, that the Doric column came forth, as a hexameter does, from an opera-
> tion of the senses, and that he had perhaps just invented that column in the same
> way the Greeks had discovered it.[13]

Unable, as he said, to "imagine Oedipus's daughters patronizing a 'little' dress-
maker," Cocteau had asked his Chanel to make their costumes out of heavy Scotch

wool. Antigone was played by a young Greek dancer, whose strong accent delighted Cocteau. He put her in a white plaster mask, through which she enunciated his harsh, pseudo-archaic lines in a harsh, pseudo-archaic manner. For the first few performances, Cocteau declaimed the lines of the chorus through a grill in the scenery. On the third night, he was heckled by a familiar voice from the balcony: his nemesis, André Breton. Through a hole in the backcloth, the "chorus" snapped back at Breton that the performance would not proceed until the interruption ended. The combination of Picasso, Cocteau, Honegger, Dullin, and Chanel ensured a succès d'estime. *Antigone* ran for a hundred performances.

Toward the end of 1922, a fresh male presence manifests itself in Picasso's work: a handsome young man with a prominent Roman nose and helmet of dark hair. The young man bears a striking resemblance to the Farnese Antinous in the Naples Museum. To judge by his earliest appearances in Picasso's work,[14] wearing a romantic ballet costume (silken jerkin and breeches, a ruff, and frilled cuffs), the new model was a dancer. In later appearances, he is portrayed in practice clothes—a leotard and ballet slippers. Like Olga, this dancer seems to have suffered an injury to his foot or leg, since he is almost always seated; and in one of the most familiar paintings of him, *The Sigh*[15] (*Le Soupir:* a sentimental title dreamed up by Cocteau), there is an otherwise inexplicable walking stick leaning against the back of his chair. After going through photographs of dancers in the Diaghilev company, McCully thinks the model may have been Nicolas Zverev. He was known to the company as "Percy Greensocks" for his green practice clothes; also as "Rasputin" for having filled Nijinsky's head with the Tolstoyan ideology that had caused much dissension in the company.[16] Since Zverev had danced the Acrobat in the original production of *Parade* and was also one of the leads in *Pulcinella,* he was known to Picasso and, of course, to Olga, who loved having Russians around and would have felt a special sympathy for an injured dancer.

This dancer also stars in two large (130 × 97 cm) paintings, both in the National Gallery, Washington. In the so-called *Saltimbanque with Arms Crossed,*[17] he sits with a towel around his neck, as if fresh from exercising at the barre. In the other painting, *The Lovers,*[18] Picasso pairs him with Irène Lagut: the only real likeness of her in the artist's work, she later maintained.[19] Irène had come back into Picasso's life and, according to her, would resume her affair with him.[20] The fact that she was also sleeping with Radiguet would no longer have bothered the once possessive Picasso. On the contrary, by putting any suspicions Olga might have had to rest, it was an advantage. The handsome dancer could be said to stand for the artist, but I think Radiguet is a more likely candidate. Picasso seldom gave titles to his paintings, but in this case he presumably did. Visualizing his ex-fiancée in the arms of a stand-in

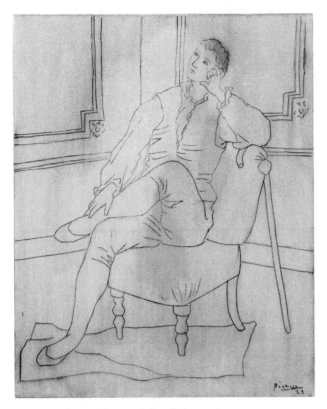

Picasso. *The Sigh,* 1923. Oil and charcoal on canvas,
61 x 50 cm. The Museum of Modern Art, New York.

for the writer she shared with Cocteau would have been an irresistible private joke—a joke on Picasso's part at the expense of all those other lovers of Irène's like Serge Férat and Jacqueline Apollinaire who had once made him so jealous. The painting's resemblance to kitschy French postcards of simpering lovebirds sharpens the irony.[21]

The dancer's interlude as a model coincided with Picasso's bid to do yet another classical set piece. In the winter of 1922–23, he tried out various possibilities. His choice of the *Toilet of Venus*[22] may have had to do with Renoir's choice of the Judgment of Paris for two of his late classical compositions. Like *The Lovers,* the *Toilet of Venus* lent itself to pastiche and parody. Picasso took advantage of both. Studies for this work show that he originally envisioned a *Coiffure* subject: a classically robed or naked deity with a cupid-like child at her feet and an attendant dressing her hair or holding up a mirror to her. However, in the course of working from a male model, Picasso decided to switch from the mostly female *Coiffure* to a traditional *Mars and Venus* subject. He relegated the figure holding a mirror up to Venus—traditionally the goddess's son Cupid—to the very top of the composition. The dancer appears to have been the model for both Venus's lover, Mars, on the left and the pipe player on the right, inspired by a similar figure in a famous marble group in the Naples museum.[23] Mars blurs into the legendarily handsome Adonis, whom the goddess fell for after a chance scratch from one of Cupid's arrows. The pipe player, who gave a musical dimension to this stilted work, is all that would remain of the *Toilet of Venus* after Picasso came back and painted out this pretty pastiche and all that it stood for.

In 1994, William Rubin, then chief curator of the Museum of Modern Art, announced that he had made a major discovery regarding the original *Toilet of Venus* composition. After studying the X-rays and preparatory sketches,[24] Rubin had concluded that the Venus figure stood for none other than Sara Murphy, with whom, he went on to argue, Picasso had fallen very much in love.[25] Rubin maintained that

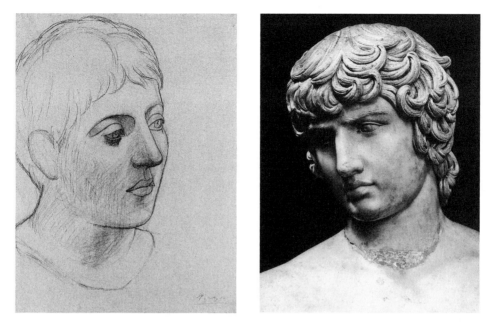

Left: Picasso. *Head of a Young Man*, February 11–12, 1923. Conté crayon on paper, 63 x 47 cm. Collection Jan Krugier and Marie-Anne Krugier-Poniatowski.
Right: Farnese Antinous (detail). Roman copy, second century A.D., from Greek original, first half of fifth century B.C. Marble. Museo Archeologico Nazionale, Naples.

Picasso had taken the huge *Toilet of Venus* down to Antibes, where it played a key role in a passionate summer romance that lasted only a few days but left a lasting effect on Picasso's imagery. In despair that his love was not reciprocated, Picasso had painted over the *Toilet of Venus* with the masterpiece known as the *Pipes of Pan*.[26] This attempt to canonize Sara as one of Picasso's major loves has caused nothing but confusion. Rubin's contention that there are "almost 40 paintings and more than 200 drawings of Sara that we can now identify . . . [and that] in 1923, pictures of Sara far outnumber those of Picasso's wife Olga" is sheer fantasy, as is his contention that "by 1922 . . . Picasso's infatuation was well under way [and] by 1923 . . . he was clearly in love with [Sara]."[27] The artist once said that sometimes as many as three or four women figure in one of his portraits. This might well have been the case in 1923 with such masterly paintings as the Metropolitan Museum's popular *Woman in White* and the Tate Gallery's bolder, less academic *Woman in a Chemise.* Picasso apparently wanted to give his women a classical look that is idealized and generic and that draws upon Olga and Sara as well as the Farnese Juno and the Farnese Antinous and, who knows, a maid or model or a mistress.

Sara was beautiful, intelligent, warm, and motherly, and Picasso, like many of her men friends, was attracted to her, but she was impervious to sexual advances. She figures in some of Picasso's sketches of bathers on the beach, wearing pearls down their

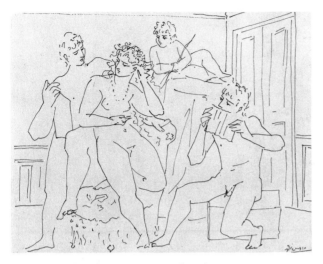

Picasso. *Toilet of Venus,* 1923. India ink on paper, 24.7 x 32.3 cm. Private collection.

backs as Sara did.[28] He also executed two likenesses of her in oil paint and sand at La Garoupe.[29] On the occasion of Rubin's marriage, Picasso's widow gave one of these paintings to him as a gift. This apparently sparked his interest in Sara Murphy, but not enough to keep him from selling the Rubin painting to Heinz Berggruen (now in the Museum Berggruen, Berlin).

Central to Rubin's case for seeing the original *Toilet of Venus* composition as a celebration of Picasso's feelings for Sara as "a kind of pagan mystic marriage" by the Mediterranean is his assumption that the artist had this painting with him at Antibes; and that when the romance went awry, he painted out Sara/Venus and her attendants, leaving only the pipe player to be recycled in the subject that replaced it. Alas for Rubin, instead of rolling up this vast canvas and roping it onto the roof of his car, Picasso had left it behind, sensibly enough, in Paris. And on his return in September, it was still there on the easel, still very much the *Toilet of Venus,* as Jacint Salvadó, the artist's next model, confirmed in his 1924 article on modeling for Picasso.[30]

Far from confirming a relationship, Sara's letters to Picasso are friendly rather than affectionate and signed S. W. Murphy or Sara W. Murphy. Until Jacqueline Roque entered his life in 1953, Picasso was averse to affairs with women who had had children, preferring to play Adam to unencumbered Eves. Since Olga was exceedingly jealous, he would have been especially wary of an involvement with someone she knew and liked. Lastly, Sara adored her adoring, albeit far-from-heterosexual husband and was famously faithful to him.

On May 7 and 8, 1923, the fourth and last of the Kahnweiler sales took place at the Hôtel Drouôt. It fetched 227,662 francs and included fifty Picassos, forty-six Braques (among them fourteen papiers collés), thirty-six Derains, twenty-six Grises, eighteen Légers, ninety-two Vlamincks, in addition to a number of the illustrated books Kahnweiler had published. If anything, this sale was even more shabbily conducted than its predecessors, as Robert Desnos, the surrealist poet who worked as a reporter for *Paris-Journal,* describes:

The preview was a scandal. Paintings were stacked any old way; drawings were rolled up or folded in boxes, some were sealed in cardboard tubes so that it was impossible to see them, others had been stuck in hampers or concealed behind the rostrum. Everything was in an indescribably filthy mess, which would justify the direst retaliations on the part of the artists in question.[31]

Desnos singles out the hanging as particularly egregious: designed to attract war profiteers and vulgarians. The least interesting but most saleable of the paintings in the auction—that is to say, the Vlamincks—had a whole wall to themselves; likewise the Derains. The cubist Picassos, Braques, Légers, and Grises were crammed together onto a single wall.

The sale itself was no less of a scandal. The auctioneer, Alphonse Bellier, who should have known better, made silly jokes about the cubist gems he was selling—"silly jokes that drew attention to his lack of intellect."[32] His crassness encouraged the porters to outdo him. More often than not they showed paintings upside down, crumpled the drawings, trashed the papiers collés and sand paintings, and failed to display things to the buyers. Lot numbers were struck onto the surfaces of paintings, many of them with signs of recent splattering and in one case the unmistakable imprint of a shoe.

Desnos ends by describing how he had asked his friend Eluard to bid on a charcoal drawing, cataloged as a Braque but closer in style to Picasso. He got it for thirty-seven francs; and, sure enough, when he took it out of its frame, the sheet turned out to be signed "Picasso"; it was also much smaller than the listing in the catalog. So much, Desnos says, for the integrity of the expert, the high and mighty Monsieur Durand-Ruel, who seems to have replaced Léonce Rosenberg.

There were further blows in store for Kahnweiler. As the dealer's biographer puts it, "Derain and Vlaminck let their success at [Kahnweiler's] auctions go to their heads.... Braque and Léger signed up with Paul Rosenberg, Vlaminck with Bernheim-Jeune, Derain with Paul Guillaume.... [The sale] was the end...in every sense of the word."[33] The only one of Kahnweiler's original cubists to stay with him was Juan Gris, who moved to the Paris suburb of Boulogne so as to be his neighbor. Until Gris's early death four years later, he and the dealer who had made his reputation would remain the closest of friends.

Once the sales were over, Kahnweiler was able to patch things up with Picasso. After Kahnweiler paid back the twenty thousand francs he had owed him since 1914, the artist agreed to do an edition of prints for him. Later there would be other deals—at first relatively minor. Picasso would always have infinitely more respect for Kahnweiler's eye and judgment than he would ever have for Rosenberg's. Henceforth, his relationship with his principal dealer would be restricted to business.

Rosenberg's ability to keep Picasso's prices higher than those of Matisse—higher indeed than those of any other living artist—ensured Picasso's loyalty.

Now that they were pillars of the beau monde, the Picassos were condemned to a constant round of fashionable functions. On the last night of 1922, they had been guests at a New Year's Eve party given by Rosenberg's in-laws, the Jacques Helfts. Everyone wore fancy dress, except Picasso, who enjoyed dressing up so long as it was not mandatory. Olga put on a tutu; Paul Rosenberg came as a chauffeur. Picasso was so impressed by the antique French silver on the Helfts' dining table that he asked whether he could buy a set of eighteenth-century knives, forks, and spoons. Helft took him down to the vault, and the deal was done. Picasso would give Helft a watercolor of a knife, fork, and spoon to commemorate this purchase. The artist had also admired a magnificent pair of *chenets* by Gouthière in the dealer's stock. "Everything in your place is hideous," Picasso told Helft, "but these [firedogs] are works of art."[34] On hearing that the Louvre was interested, Picasso was determined to acquire them. The Louvre won out.

On May 30, Olga was back again in costume—one designed by her husband—for yet another Beaumont ball.[35] This time the theme was baroque as well as classical: *L'Antiquité sous Louis XIV.* Beaumont had been at pains over the entertainments, especially *La Statue retrouvée:* a divertissement conceived by Cocteau, costumed by Picasso, choreographed by Massine, to music by Satie. The host gave Picasso detailed specifications:

> The fête takes place in the world of the imagination, that of fairy stories and allegories of the sixteenth, seventeenth, and eighteenth centuries.
> The theme is that of a magnificently served supper party with set pieces made of cardboard, during which divertissements will be performed. The first *entrée* will consist of guests at the [imaginary] supper . . . women in shades of gold with white wigs and masks . . . men in shades of brown with golden wigs, and draperies over their formal costumes. . . .
> The fête will culminate in a firework display before the real supper is served. Needless to say the costumes should be of utmost fantasy made from stuffs of utmost simplicity.[36]

Besides Olga—for whom this must have been a last public performance[37]—the Marquise de Médicis and Daisy Fellowes were the stars of *La Statue retrouvée.* Satie, who treated grandees with even more irony than Picasso did, confided to his "Chère Délicieuse Comtesse" (Edith de Beaumont) that the mercilessly chic Daisy Fellowes (daughter of the Duc Decazes and one of "Winnie" de Polignac's Singer Sewing Machine sisters) "had flabbergasted [him] . . . if I dare say so myself. Yes.

Absolutely. Yes . . . Yes."[38] That same evening Satie informed his "Chère, Délicieuse Princesse" (de Polignac) that he was writing some special music for her niece, "the utterly charming Madame Fellowes."[39] As for the rest of the *entrées,* one of them had been inspired by Molière's *Malade imaginaire.* In his memoir, Hugo describes Marie Laurencin being carried in on an armchair with an entourage of bewigged doctors and apothecaries carrying clysters, and Radiguet painted with red spots—measles![40] Seven months later, typhoid would kill him.

To embellish the grandiose Louis XVI music room where the ball took place, Beaumont had commissioned Picasso to paint four large decorative panels. "Nothing would please me more than your idea," he told the artist.[41] Picasso's "idea" turned out to be an ensemble of classical scenes *en grisaille.* The artist began with an elegant *Three Graces,*[42] which the sculptor Apel-les Fenosa recalled seeing in the rue la Boétie studio in late May. The size of the canvas is close enough to the size stipulated by Beaumont for us to assume that it probably started life as a decoration for the music room. However, in the course of painting it, Picasso apparently got carried away by the subject—so central to the sculpture of antiquity—that he decided to transform the composition into an altogether more significant feat: a major contribution to neoclassicism that would carry on from Canova's famous version of the subject. *Three Graces* differs from Picasso's other monumental figure composition of the period by respecting classicism rather than parodying it.

The only other painting that might relate to the Beaumont decorations is *La Grecque:*[43] a gawky woman leaning against a draped column. It is such a cliché that Picasso must have been poking fun at corny neoclassical decoration. How else to explain this lapse into banality? In the end nothing came of this project. Picasso was coming under pressure from Rosenberg to turn down commissions that entailed a lot of work, little compensation for the artist, and no profit whatsoever for the dealer.[44] Rosenberg was particularly anxious that Picasso should devote himself to completing as many canvases as he could for the first exhibition of his paintings at Wildenstein's New York gallery in November. Once on board a transatlantic liner with the paintings in the hold, the dealer changed his strategy. He sent Picasso a letter urging him to accept Diaghilev's request and do the décor for yet another ballet, *Trepak.*[45] It would be good publicity for his next show. Picasso turned the proposal down.

Twelve days after the Beaumont ball, in the "Sert-ified" music room of her palatial *hôtel particulier,* Winnie de Polignac gave a private performance of a new work by Stravinsky. *Les Noces* turned out to be one of this composer's most profoundly moving scores: "a Russian peasant wedding with its primitive pathos and awkward solemnity,"[46] which Diaghilev would present the following evening as a ballet.[47] Stravinsky had begun *Les Noces* as long ago as 1913, shortly after finishing *Sacre du printemps.* Nijinsky and Massine had quarreled as to who should have the honor of choreograph-

ing it. Neither, Stravinsky had decreed, but it was not until 1921 when he was luxuriously ensconced in Chanel's apartment that Stravinsky had been able to whittle the score down to a cantata for four pianos, percussion, solo voices, and a Russian choir.

Les Noces was rumored to be a masterpiece; and the princess had selected her guests very carefully. Among them were the Picassos, the Serts, the Murphys, and the more musical members of the *gratin*. Only Stravinsky's former lover and generous patron, Chanel, was not invited. The daughter of the man who had invented the sewing machine was not prepared to have "that sewing-woman" to her house, although this particular sewing woman had put Mr. Singer's lucrative gadget to more imaginative use than anyone else on earth. The same group, with the addition of Chanel, was in attendance the following evening when *Les Noces* had its gala premiere at the Opéra.

Besides a libretto by the Swiss writer C. F. Ramuz, *Les Noces* was choreographed by Nijinska and had décor by Gontcharova. The latter's garish, folkloric sets and costumes had horrified Stravinsky when he finally saw them shortly before the opening. They were all wrong for the darkness and primeval earthiness of a Russian peasant wedding, and he insisted that minimalist brown-and-white flats be used instead. Gontcharova needed someone to help her repaint the set and Gerald Murphy was an obvious choice. The rush job was too much for one man, so he called in his friend, the writer John Dos Passos, who was eager to experience backstage life at the Ballets Russes. After redoing the sets and attending all ten rehearsals, the Murphys decided to give a party for everyone connected with *Les Noces*. They invited old friends from America, as well as the new friends they had made in Paris—Picassos, Beaumonts, Stravinskys, Serts, Cendrars, Tzara, Cocteau, Radiguet, all of Les Six, the stars of the Ballets Russes, and many more.[48]

Originally, the Murphys wanted to hold the party at the Cirque Medrano, where the big draw was the Fratellini brothers—a celebrated trio of clowns whom Picasso was rumored to be painting[49]—but the manager told them that his circus "was not yet an American colony."[50] Instead, they settled on a large barge moored opposite the Chambre des Députés, which served as the chamber's restaurant. Since the party was to take place on a Sunday, when the florists were closed, Sara decorated the tables with pyramids of toys—"fire engines, cars, animals, dolls, clowns"[51]—that she had found in a Montparnasse bazaar. Picasso was enchanted and rearranged the toys into a "fantastic accident topped by a cow perched on a fireman's ladder."[52] Could he have had this game in mind thirty years later, when he constructed a monkey's head out of two of his son's toy motorcars?

In the annals of social history, the Murphys' party rates almost as high as the Rousseau banquet in 1908. Stravinsky switched the place cards; Gontcharova read palms; Marcelle Meyer played Scarlatti; and, as usual, Cocteau tried to steal the show—

at first refusing to go on board for fear of seasickness, and then rushing around with a lantern, dressed up as the captain, proclaiming, *"On coule"* (We're sinking). As dawn broke, Kochno and Ansermet (the conductor of *Les Noces*) took down the gigantic laurel wreath, inscribed *"Les Noces—Hommages,"* which Sara had put up in the main saloon, and held it like a hoop for Stravinsky to take a running jump through. Picasso found American high jinks a relief after the protocol and intrigue that were de rigueur at the Beaumonts' amateur theatricals.

Tristan Tzara, 1921. Photograph by Man Ray. Telimage.

On July 6, Picasso attended an infinitely more subversive event, Tzara's disastrous *Evening of the Bearded Heart (Soirée du coeur à barbe)* at the Théâtre Michel. Picasso, Satie, and others in the know realized that this soirée, with which Tzara hoped to revitalize his dying dada movement and stop Breton and his surrealist followers in their tracks, would end in a pitched battle. Satie, who was pro-Tzara and anti-Breton, dismissed the breakaway surrealists as "false dadas." To Marcel Raval, who was to be his guest,[53] he wrote, "We are going to laugh our heads off. The Tzara 'thing' should be quite comical. Breton's gang has been spotted in the distance; Hum!"[54]

Compared to most dada spectacles, the first (musical) section of the program was relatively tame: Stravinsky's *Pièces faciles à quatre mains,* Auric's *Fox-trot;* Milhaud's *"Shimmy" caramel mou,* and Satie's *Trois morceaux en forme de poire,* all of which received polite applause. In the second section, the actor Pierre Bertin gave a reading of poems, including some by Tzara's friend and Breton's bête noire, Cocteau. And then, unexpectedly, a popular, minor dadaist called Pierre de Massot appeared on the stage and embarked on a monotonous litany:

> André Gide dead on the field of battle
> Pablo Picasso dead on the field of battle
> Francis Picabia dead on the field of battle
> Marcel Duchamp . . .

Partisan yells drowned out the rest.[55]

Massot's nihilistic text set Breton's gang—Aragon, Desnos, Eluard, Péret—at the

Tzara gang's throats. On hearing Picasso's name, Breton had leaped onto the stage, ostensibly in support of the artist he venerated, but, in reality, to act as an agent provocateur. When Massot refused to obey Breton's command to leave the theater, two of the latter's henchmen, Desnos and Péret, held the little poet while Breton whacked away at him so violently that he broke his left arm. Picasso, who was in a dinner jacket, jumped from his box and shouted at Tzara, "No police here," but the police were already massing in the aisles, and Breton assumed, rightly or wrongly, that it was Tzara who had summoned them. To boos from the audience and opposing cries from Picasso—*"Non, pas à la porte! Pas à la porte!"*—Breton and his henchmen were expelled from the theater.[56] Meanwhile, Massot returned to the stage and, despite his broken arm, finished intoning his subversive litany. Things calmed down when the lights were lowered so that films could be projected: Hans Richter's abstract *Rhythme 21;* Man Ray's *Le Retour de la raison* (slow abstract oscillations enlivened with images of Kiki of Montparnasse); and *Les Fumées de New York,* "an impressionistic documentary" by Paul Strand and Charles Sheeler that had little in common with the other more avant-garde films.[57]

The last spectacle on the program was Tzara's *Le Cœur à gaz,* a dada farce in three short acts. At its first performance, two years earlier, members of the audience had been so infuriated by its utter pointlessness that they had attacked the dadaist actors—among them Tzara and Aragon—who, when someone struck up the *Marseillaise* on a trumpet, had stormed out singing. This time round, the cast included professional actors—Jacqueline Chaumont of the Odéon as "Mouth," Marcel Herrand as "Eyebrow," and Saint-Jean of the Odéon as "Ear"—as well as Tzara's associates, Jacques Baron as "Neck," René Crevel as "Eye," and Pierre de Massot as "Nose." Tzara's characters would come to mind twenty years later when Picasso wrote his own dadaist farce, *Le Désir attrapé par le queue;* the dramatis personae would include "Big Foot," "Onion," "Fat and Thin," "Anxiety," "Silence," and "The Curtains." In 1923, Tzara had put the actors playing body parts into cubistic costumes made of stiff tubing by Sonia Delaunay. This reduced their ability to walk to a geriatric shuffle. To enliven the third act of the spectacle, Ilia Zdanévich (subsequently known as Iliazd) recited one of his linguistically experimental "Zaoum" poems to the accompaniment of an absurdist dance by a woman called Lizica Codréano. Thin stuff, but worse was to come.

Never one to miss a vindictive opportunity, Eluard, who loathed Cocteau every bit as much as Breton did, could not resist avenging himself on Tzara for including his poems in the same reading as Cocteau's. Throughout the performance of *Le Cœur à gaz,* he heckled so noisily that Tzara finally called for order. In doing so, he unleashed a further riot. Eluard clambered onto the stage and hit Tzara and Crevel in the face. Terrified, Crevel tried to flee, but the rigidity of his costume hampered

him, and he was grabbed by the stagehands and not only roughed up but shoved into the orchestra pit along with the shattered footlights. The stagehands then turned their attention to other disruptive elements. Aragon—"splendid and diabolical in his dinner jacket and black shirt"—tried to rescue Eluard, who had been badly beaten and frog-marched back to his seat.[58] So violent were the fights between the dadaists, including their allies in the audience, and the future surrealists, that once again the police had to intervene. The damage to the theater was considerable. Confronted with rows of smashed seats, the owner gave way to imprecations: *"Ma bonbonnière! Ma bonbonnière!"* he wailed. Outside on the street, the battle started up again with renewed violence. Yvan Goll used an uppercut to settle his score with Breton. Whereupon the police arrested the lot of them and took them off to the precinct house.

When the dust settled, Breton was perceived as having triumphed over Tzara. Dada had self-destructed—consumed in a bonfire of egos and vicious sectarian spite. Breton's surrealism would replace dada. Convinced that Eluard had been out for personal vengeance, Tzara brought a suit for damages against him. Eluard countersued. These suits petered out, but seven years of infighting followed, during which the surrealists repeatedly denounced Tzara as a police informer who had handed Breton and his cohorts over to the cops. And then, in 1930, Breton, the original provocateur, did a sudden turnabout: in his second *Manifeste du surréalisme* he attributed the discreditable behavior of everyone, not least himself, at the *Coeur à barbe* evening to a misunderstanding.

Misunderstanding or not, Picasso *"était ravi,"* to believe Satie:[59] he had enjoyed himself no end at this disastrous evening. Nevertheless, he refrained from taking sides. He liked Tzara well enough for his anarchic Jarry-like spirit and would remain a faithful friend. Although he was adamant in his refusal to become a surrealist, Picasso thought it wiser to keep in with the increasingly magisterial Breton, to the mortification of Cocteau.

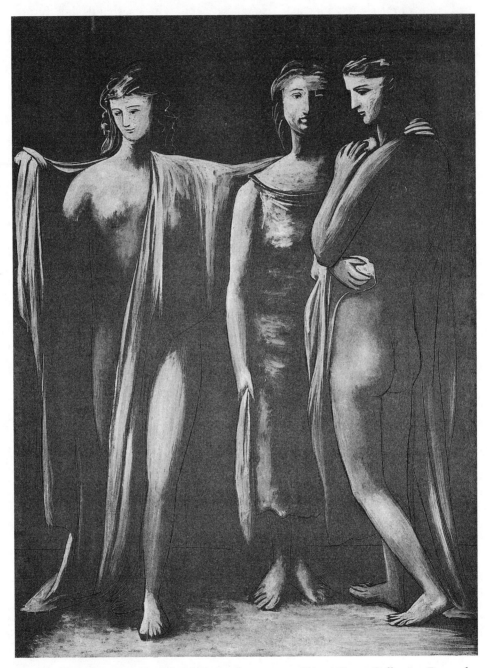

Picasso. *Three Graces,* 1923. Oil and charcoal on canvas, 200 x 150 cm. Collection Bernard Ruiz-Picasso.

18

Summer at Cap d'Antibes

On July 23, a week or so after the *Coeur à barbe* riot, the Picassos left for the summer. Their first choice was Royan on the Atlantic coast, where Picasso would spend the first months of World War II. This choice is more likely to have been hers rather than his. After a week at Royan's Grand Hôtel du Parc, they failed to find a suitable house for the summer and set off for the Riviera.[1] En route they spent a night in Toulouse where they stayed at the Hôtel Tivolier—a block away from the museum, with its great collection of Ingres drawings. Why the switch from the Atlantic to the Mediterranean? In Toulouse, they had received a message from the Murphys suggesting that they join them at Antibes. The previous summer, the Murphys had spent a week there with the Cole Porters, who had rented the Château de la Garoupe, next door to the Hôtel du Cap at the promontory's beautiful tip. The Murphys had liked the hotel so much that they had persuaded Antoine Sella, the proprietor, who usually closed the place from May to September, to keep a few rooms open on a trial basis the following (1923) summer. To the Murphys' delight, the Picassos decided to join them there at the beginning of August. Their visit launched a fashion which would enrich not only Monsieur Sella but all the other hoteliers on the Riviera, and, for better or worse, bring about the transformation of the Côte d'Azur into a summer rather than a winter resort. As Picasso once said, looking out over the throng of sunbathers at Eden Roc, he and the Murphys had a lot to answer for.

The only other people in the hotel were a Chinese diplomat and his family. However, a painter friend of Picasso's from Montmartre days, who had been spending his summers at Antibes since 1913, was staying next door. This was the popular Glasgow artist J. D. Fergusson (known as Fergus) and his wife, a performer and teacher of modern dance, called Margaret Morris. Fergus had persuaded his rich English patron, George Davidson,[2] to buy the property adjacent to the Hôtel du Cap. Davidson renamed it Château des Enfants, and provided the Fergussons with accommodation in exchange for help with the "unwanted children" he spent his life adopting and educating.[3] Fergus's wife had talked Sella into lending her three empty

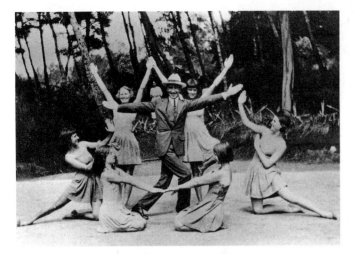

Margaret Morris's dancers with André Sella (son of the owner of the Hôtel du Cap, Antibes), c. 1923. Pierre Joannon Collection.

cottages for her assistants and pupils as well as providing her with "raised seating and very good lighting" for dance recitals in the hotel's garden. "Sella . . . asked me," Margaret Morris writes in her memoir, "to bring my girls to bathe at Eden Roc [the dramatic bathing place carved out of the rocks at the end of the Cap] and he would get photographers and would start a *Summer Season* in the South of France."[4] Margaret's troupe of some twenty dancers inspired Picasso's drawings of girls on the beach: "All of them swam divinely," Picasso told Clive Bell, "but couldn't dance at all."[5]

Fergus never joined the avant-garde, but his modified fauvism carried rather more conviction than the Bloomsbury artists' genteel attempts to be modern. He had great charm, great muscles, and a body burnt black by the sun. Picasso was delighted to see him, as Margaret Morris has written:

> He greeted us saying, *"Ah mon vieux copain Fergusson,"* and embraced him warmly. Fergus expressed surprise at finding Picasso in this conventional hotel, to which he replied that his wife liked it, but he hated it. . . . "But why are you here?" [Picasso] asked. Fergus explained that we were at the Château des Enfants, next door.
>
> Picasso had rented a motor launch and wanted us to go with him to the islands. Fergus firmly refused, but said I would be delighted to go. So I had to. Picasso's first wife . . . was only interested in the pearls and diamonds Picasso had given her, so my main occupation on these trips to the islands was to *hold her jewels* while she bathed. I felt like throwing them into the sea.
>
> One day we met Picasso at Eden Roc and we walked back to the hotel together. He said, "You do not fit into this place," and he picked a sprig of bog-myrtle from a bush and handed it to Fergus saying, "This is you."[6]

Picasso had arranged for his mother, Doña María, to join him at Antibes. Apart from a visit to see her grandson at Fontainebleau in 1921, plans for her to stay with them in Paris had always fallen through.[7] Antibes out of season proved to be the perfect place for a family vacation. Doña María enjoyed beach life and loved looking after Paulo, the grandson she had yearned for. Picasso's feelings for his mother are a

mystery and likely to remain one until his sister Lola Vilató's family make family papers available. According to Brigitte Baer, "[Picasso's] mother . . . wrote to him nearly every other day, or at least once a week, and . . . when he first settled in Paris, reminded him, in one of her letters, of those nights in Barcelona when, after he had stopped roaming around the streets and came back home, he would always go into her bedroom to say good night (or good morning) as if to efface by that last kiss all the goings-on of the previous night."[8] It was from her that he got his energy, ambition, and feistiness, but also his lack of stature, something of which he was less than proud, although it has rather too often been seen as a spur to greatness. Françoise Gilot may not have come into Picasso's life until well after his mother's death, but her assessment of Doña María is valuable in that it reveals how negative his feelings for her were. He described her as:

Picasso. *Doña María,* 1923. Oil on canvas, 73 x 60 cm. Private collection.

> willful and stubborn [and] limited intellectually. She insisted on a ritualistic discipline based on a code of behavior that was altogether conventional; she was constricted and constricting, fearful of poverty, of change, of social intercourse. Pablo was her firstborn; she had high ambitions for him and soon proclaimed him to be a future genius, but . . . there was no understanding of what that entailed. . . . When her son went through puberty she pitted him against his father and the father against the son to chastise his precocious sexual awakening. She loved him, of course, and he loved her, but their love was accompanied by hatred and suppressed violence.[9]

Picasso told his second wife, Jacqueline Roque, a similar story. The only detail she added to Gilot's account was the characterization of both his father and mother as "bourgeois, bourgeois, bourgeois"—as if to exorcise a taint he shared with most of his friends, not least the surrealists who were in violent reaction against their bourgeois origins. Breton was the only major surrealist to come from working-class stock.

Xavier Vilató, a son of Picasso's sister Lola, with whom Doña María went to live, characterized his grandmother differently: typically Andalusian: strong, simple, bossy, warm but no fool.[10] She had considerable humor and in old age prided herself on "keeping up": one of those old women in black still to be seen reading newspapers—liberal ones, in her case—under a black umbrella on Spanish beaches. Just as she had played with little Pablo on the Playa de Riazor at Corunna, she enjoyed playing with little Paulo on the Plage de la Garoupe. This shy, uneducated Andalusian widow, who did not give a damn for appearances, endeared herself to the Murphys and their friends rather more than Olga did. ("Olga is so prosaic," Sara said.)[11] To facilitate conversation, Doña María tried to teach the Murphys Spanish—to no avail.

Picasso was especially anxious that his mother—whose fanatical faith in him included no understanding of any but his earliest work—see how celebrated he had become. And so there were outings to restaurants and friends' houses. Although he loathed gambling, he took Doña María to Monte Carlo, where Diaghilev was staying; and for the one and only time in his life, he went to the casino and played roulette. To show off to his mother, he gambled simultaneously at different tables and lost a bundle of money.[12]

Despite having told Olga that she was the wrong woman for Picasso, Doña María got on so well with Olga that Picasso insisted she return with them to Paris. Now that the marriage was beginning to run out of love, Olga needed allies. Clive Bell reported coming across Doña María in the street—"a dumpy old body, shorter than Olga, comic looking and very shy"—shopping with her daughter-in-law, who was "as exquisite as ever."[13] Before his mother went back to Barcelona, Picasso had her sit for an affectionate yet dignified portrait[14]—only the second one he had done in twenty-five years—in the same graphic style that he had used in recent paintings of his wife, and of his son on a donkey.[15] The conventional charm of these paintings reveals the pride Picasso sometimes took in showing off his prowess as a painter of family portraits.

In August or September, Gertrude Stein and Alice Toklas, who had been house hunting in the Midi, came to stay at Antibes. Their visit had been preceded by a letter from Gertrude, which Picasso had brought down to the beach in fits of laughter to show the Murphys. Gertrude had seen a painting by Picasso at Rosenberg's and wanted to exchange his famous portrait of her for it. Would he mind? The Murphys were scandalized. "Yes," Picasso said, "but I love her so much." "[Gertrude] and Picasso were phenomenal together," Gerald said, "each stimulated the other to such an extent that everyone felt recharged witnessing it."[16]

In her *Autobiography of Alice B. Toklas,* Gertrude describes this visit:

It was there I first saw Picasso's mother. Picasso looks extraordinarily like her. Gertrude Stein and Madame Picasso had difficulty in talking not having a common language but they talked enough to amuse themselves. They were talking about Picasso when Gertrude Stein first knew him. He was remarkably beautiful then, said Gertrude Stein, he was illuminated as if he wore a halo. Oh, said Madame Picasso, if you thought him beautiful then I assure you it was nothing compared to his looks when he was a boy. He was an angel and a devil in beauty, no one could cease looking at him. And now, said Picasso a little resentfully. Ah now, said they together, ah now there is no beauty left. But, added his mother, you are very sweet and as a son very perfect. So he had to be satisfied with that.[17]

Visits such as these as well as picnics, alfresco parties, boat trips, even a spoof beauty pageant in bathing suits organized by the Murphys and the Beaumonts, may

Above: Sara Murphy with her children, Honoria, Patrick, and Baoth, on the beach at La Garoupe, 1923.
Left: Gerald Murphy and Picasso on the beach at La Garoupe, 1923. Musée Picasso, Paris.
Below: Picasso and Doña María in the right foreground with a group of friends on the beach at La Garoupe, 1923.

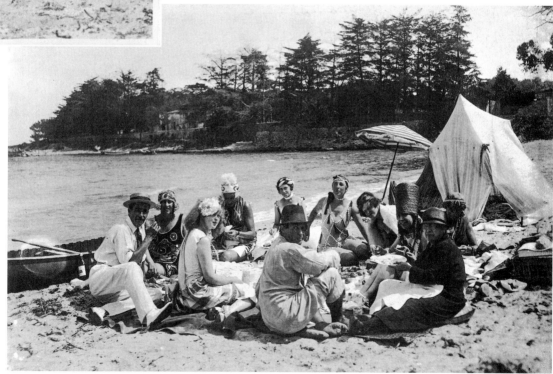

be the reason why this celebrated summer engendered no major works and little progress. The lack of a studio may have contributed to this meagerness.

Early in August, the Murphys spent two weeks in Venice staying with the Cole Porters, who had taken the Palazzo Barbaro on the Grand Canal for the summer. Gerald had work to do. On Léger's recommendation, Rolf de Maré had commissioned him to do the scenario and décor for an "American" ballet. Asked to find a young American to do the music, Gerald had suggested Porter, a friend from their days in the Yale Glee Club. Porter's alimony-rich, socially ambitious wife, Linda, was opposed to the idea. She wanted her husband to become a serious composer, had even tried to lure Stravinsky down to La Garoupe the year before to bring this about. Porter stood firm. He was determined to make his name on Broadway and insisted on accepting de Maré's commission. The ballet, to be called *Within the Quota,* was about the impact of America—New York, the Wild West, jazz, Hollywood, and so forth—on a young Swedish immigrant, played by Jean Borlin, who ends up a movie star. Porter's score would parody "the music played in silent-movie theaters, with the orchestra ... [taking] over but the piano always winning out."[18] Gerald's backcloth—an eye-catching collage of newspaper headlines—would impress Picasso when he and his wife accompanied the Murphys to the opening night, which happened to fall on his forty-second birthday.

Gerald spent three weeks in Venice working on the ballet. Linda Porter's addiction to what Gerald called "sheer society" imposed a constant strain on her guests; so did her well-founded fears that Gerald, like many other men in their group, shared her husband's homosexual tastes. Nor did Linda take to Sara, who returned to Antibes after two weeks of nonstop partygoing, relieved to be back with her three young children. And it is there at the Hôtel du Cap, a week before Gerald's return, that Sara and Picasso are said by Rubin to have experienced the ill-fated "pagan mystic marriage," which supposedly ended with the heartbroken artist painting over the *Toilet of Venus.* Sheer novelettish fantasy.

Picasso returned with his family to Paris in late September. Since he had done so little work at Antibes, he would have to devote his energy to providing Rosenberg with paintings for the upcoming New York show. The *Toilet of Venus* was still on the easel, but he is unlikely to have transformed it into the *Pipes of Pan* until November or December. Far from signifying a change in Picasso's feelings for Sara, the eclipse of the *Toilet of Venus* signifies a change in his feelings for conventional classicism. "The beauties of the Parthenon, Venuses, nymphs, Narcissuses are so many lies," as he told Zervos in 1935.[19] When Picasso scrapes down a painting and does another one in place of it, the new image will often turn out to comment on the previous one.

In the course of his quest for the sacred fire of classicism—a quest that was by no means over—he had sometimes allowed himself to get snared in classicist pastiche. The pastiche had to go, and a few months later Picasso saw that it did—buried under the *Pipes of Pan*.[20] In repainting the canvas, Picasso wanted to play off the New World confusion, as personified by Gerald, against the sensuality of the ancient world, as personified by the Dionysiac pipes player. Picasso also wanted to hint at sexual ambiguity. And where better than at Antipolis, as the Greeks once called Antibes?

For Picasso, spending the summer months with an American family and their mostly American friends proved an enjoyable experience—also a puzzling one, especially with regard to the paradoxical Gerald: so accomplished and yet so lost. As holiday snapshots confirm, Picasso had Murphy in mind for the standing figure in the *Pipes of Pan:* same height, build, stance, and bathing suit; the same self-conscious awkwardness and ambiguity. Once again the artist found inspiration in his own earlier work: specifically the *Two Youths* of 1906[21]—one standing, one seated, as in the present composition, only the other way around. Over the years, the elegiac tenderness of Picasso's 1906 Mediterraneanism has given way to a feeling of alienation. Like Cézanne at L'Estaque the artist has painted the sea as a blue wall—a device that reinforces the sensation of being shut in. Rubin was right in seeing a Murphy as central to Picasso's change of subject, but wrong with regard to which one.

Picasso. *Portrait of Sara Murphy,* summer 1923. Oil, sand, and glue on canvas, 55 x 45.7 cm. Museum Berggruen, Staatliche Museen zu Berlin.

19

Cocteau and Radiguet

Back in Paris in the fall of 1923, Picasso did his best to accommodate Rosenberg and produce paintings that were naturalistic and easy enough on the eye to appeal to the conservative clients of Wildenstein's New York branch, where the artist's first major U.S. show was to open in November. Rosenberg was convinced that Americans had not as yet developed a taste for modernism. Insofar as this applied to Wildenstein's clients, he was probably right; there had been renewed requests for Harlequins. Fortunately for Rosenberg, Picasso had found a suitable new model. Jacint Salvadó was a twenty-two-year-old Catalan painter who hailed from the village of Montroig—the site of Miró's family farm—and had recently settled in Paris.[1] Picasso liked Salvadó for his Catalan look and also for having the same Barcelona art school background as himself. The model would serve as a surrogate for the artist's Harlequin persona. The paintings might thus be seen as self-portraits in the guise of someone else.

Salvadó had revered Picasso ever since his first glimpse of him, protesting the expulsion of André Breton from the theater at the *Coeur à barbe* evening. Shortly after arriving in Paris, he had tried to call on his hero but made the mistake of presenting a letter of introduction from the artist's old enemy: the Catalan entrepreneur Pere Manyac, who had acted as Picasso's agent in 1901 and later abandoned him. Salvadó had been turned away from Picasso's door but would soon be summoned back.[2]

Salvadó later described what had ensued. For helping with the decorations for the art students Carnival rout, Salvadó had been given a free ticket. Off he went and rented a Harlequin's outfit. At the ball, one of the few people he recognized was Derain, even though he was wearing a heavy mask. They talked. "I like the way you are dressed," Derain said. "Come to my studio with that Harlequin costume. I want to paint you."[3] Salvadó did so and spent the next month working as Derain's studio assistant and modeling for the artist's *Harlequin and Pierrot* set piece—his swan song as a painter of any stature.[4] Salvadó painted much of the sky.

All had gone well until Braque visited Derain's studio and saw the painting of *Harlequin and Pierrot* and met the model. Braque had a manipulative streak and could

not resist telling the competitive Picasso about Derain's ambitious Harlequin composition and the "Spanish painter who works for him [and] is serving as his model."[5] On hearing this, Picasso wrote Salvadó a letter inviting him to his studio.

"I understand that Derain has done a portrait of you dressed as a Harlequin," Picasso said.

"Yes."

"Well come tomorrow with the costume because I, too, want to paint you."

I told him I didn't have the costume since I had rented it. At that moment Olga, then Picasso's wife, who was there, said:

"Remember Picasso that you have a Harlequin costume put away."

"Well, get it and we'll see if it fits him."

I put it on and it fitted me fine.

"Come tomorrow and I'll paint you."[6]

Salvadó sat for four portraits dressed in Cocteau's old costume.[7] The most carefully worked (though never finished) was the first. In this painting, Picasso used the same graphic technique he had used in the portraits of his mother and his son on a donkey. Very fine brushes enabled him to mimic the cross-hatching of a pen. The first portrait "took only a day," Salvadó claimed, "The painting . . . lacked back-

Left: Picasso. *Paulo on a Donkey*, April 15, 1923. Oil on canvas, 100 x 81 cm. Collection Bernard Ruiz-Picasso.
Right: Picasso. *Olga,* 1923. Oil on canvas, 130 x 97 cm. Private collection.

ground, but [Rosenberg] arrived and made off with it."[8] Since the rapacious John Quinn was in Paris, intent on buying directly from Picasso, Rosenberg was determined that nothing should be available in the studio. "He grabbed it off the easel" for the New York show, just as he would the next two Salvadó portraits, which are identical in pose and scale (approximately 130 × 90 cm). There is a depth of feeling in these paintings that is missing from recent portraits of Olga. However, by the time he came to paint what appears to be the last of the four—the posterlike image in the Ludwig Collection, Cologne—Picasso appears to have lost interest in the self-referential possibilities of his model.

Making off with Derain's assistant and dressing him up as a Harlequin was not a matter of one-upmanship; Picasso was simply paying his former friend back for pinching the commedia dell'arte subject from him. Salvadó found himself in dire trouble. "Derain didn't want anything more to do with me," he said, "but Picasso helped me."[9] Asked what payment he expected, Salvadó jokingly suggested one of the versions of the *Three Musicians*. Picasso responded by asking Salvadó to give him three of his own canvases to sell for him. And it is typical of Picasso's generosity, above all to Spaniards, that he not only sold the three paintings for his model but also found him a dealer. The dealer bought the contents of Salvadó's studio and gave him a contract that enabled him to purchase two studios in Paris and another in the Midi. No one knew better than Picasso the misery of being a penniless Spanish painter in Paris; and no one was more secretly generous with his help.

For all his loathing of the man, Breton was not above aping Cocteau's self-promotional strategies, the better to usurp his place in Picasso's pantheon. Just as Cocteau had wormed his way into this pantheon by insisting that Picasso do his portrait, Breton pressured Picasso to do the same for him: a *portrait charge* for the book of poems *Clair de terre,* which he was about to publish.

> I would do anything for you if you would permit a portrait of me by you to preface [my] book—a long-standing dream that I have never had the audacity to propose to you. . . . If this is not possible, maybe you could lay your hands on something that might pass for a portrait of me, without eyes, without nose, without mouth or without ears . . . or, failing that, perhaps you could allow me to reproduce two or three of your unpublished drawings. . . . But a portrait is what would give me boundless joy. . . . I gather that you never write. All I ask for by way of reply to this letter is one word, as follows: Yes—portrait; No—nothing.[10]

Picasso agreed to do a drypoint, but that did not stop Breton from asking whether additional items might be available and, if so, whether they should be part

of the book or *hors texte*.[11] There would be no additional items, the artist decreed, only the drypoint portrait. In mid-October Picasso came up with a surprisingly tentative likeness (only one proof exists),[12] which pleased neither artist nor sitter. And so, on October 29, Breton brought around a second plate for Picasso to engrave.[13] This time, the portrait turned out brilliantly. By focusing upward, Picasso was able to make the most of Breton's leonine presence and the disdainful *de haut en bas* regard that struck fear into friend and foe alike. Breton, who was eager to project a charismatic image, relished being portrayed as *le maître*. For his part, Picasso relished having gained a useful ally: a possible successor to Apollinaire though never as close. Polizzotti, Breton's biographer, claims that this magisterial likeness "added a new element of friendship to what had previously been a mutually respectful, professional relationship." But he is mistaken when he goes on to state that "Breton's discourses on automation fascinated Picasso, who shortly afterward began incorporating automatist techniques into his art."[14] Picasso had no time for automatism; he held it against the surrealists and never incorporated it into his work. The nearest he came to it was his exploitation of accidents that occurred in the course of painting.

Polizzotti goes on to claim:

[Picasso] was also impressed by Breton's prophetic aura, and the portrait he drew is unmistakably that of a leader: formally dressed, torso rigid, "eye somewhat fearsome," as a pleased Breton described his likeness. Breton himself began stepping up his contact as of that fall, and made a point on several occasions of publicly and privately stressing their friendship. "My admiration for you is so great that I can't always find the words to express it"; he told the painter in October.[15]

While sitting for Picasso, Breton again approached him about selling the *Demoiselles d'Avignon* to Jacques Doucet, whom he served as librarian and art adviser. Breton had first made this suggestion in a letter to Doucet in 1921, soon after starting to work for him. "I somewhat regret . . . your failure to acquire one of Picasso's major works (by this I mean something whose historical importance is absolutely undeniable, such as, for example, the *Demoiselles d'Avignon,* which marks the origin of cubism and which should not be allowed to end up abroad)."[16] In the spring or early summer of 1922, Breton had had another go at Doucet: he had accompanied him to Picasso's studio where the *Demoiselles* was kept rolled up in a corner. On this occasion, the artist did not unroll it for Doucet—maybe he dreaded being badgered into selling it—but he did show it to another visitor, the German critic Albert Dreyfus, who wanted to write an article and a book about Picasso. Dreyfus, who had visited Picasso before the war, describes him spreading the great painting out on the floor:

I was more or less speaking to myself when I asked [Picasso]: "Didn't this lead to Cubism?" Many a painter would have [launched into] a lengthy excursion about himself and against his colleagues. Instead of answering, Picasso pulled a small brass top from his vest pocket, gave it a twist with two fingers and—with his Arabian smile—let it dance on the floor.[17]

Sensing that Picasso might be prevailed upon to part with the *Demoiselles,* Breton sent Doucet an artfully phrased letter (November 6, 1923), pressing for its acquisition: "through it one penetrates right into the core of Picasso's laboratory and because it is the crux of the drama, the center of all the conflicts that Picasso has given rise to and that will last forever. . . . It is a work which to my mind transcends painting; it is the theater of everything that has happened in the last fifty years."[18] A month or so later, Breton's diplomacy was rewarded.

"I remember the day," Breton later wrote when Doucet "bought the painting from Picasso, who, strange as it may seem, appeared to be intimidated by him and offered no resistance when the price was set at 25,000 francs. 'Well, then, it's agreed, M. Picasso,' Doucet said. 'You shall receive 2,000 francs per month, beginning next month, until the sum of 25,000 is reached.' "[19] The price entered into Picasso's sales book in Olga's writing is 30,000 francs.[20] This might be an error; it might mean that Picasso did not want Olga to know how drastically Doucet, a famously hard bargainer, had beaten him down. Olga would not have minded. She had been horrified at her first glimpse of the *Demoiselles* and wanted to get this whorish masterpiece out of the house at any price.

Surprising as it is that Picasso sold the *Demoiselles,* it is even more surprising that he sold it for so little. In 1916, when his work was nothing like as valuable, he had refused an offer of 20,000 francs. A few months after the sale to Doucet, Roché would appraise the painting at 200,000–300,000 francs. The explanation: Doucet had deceived Picasso with a false promise: "After my death, the whole collection shall go to the Louvre and I shall be the only collector whose authority compels the Louvre to accept avant-garde paint-

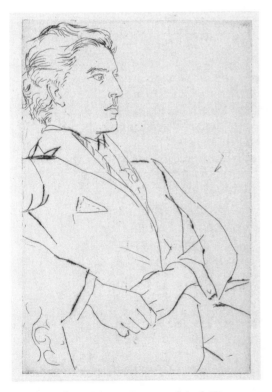

Picasso. *Three-Quarter Portrait of André Breton,* 1923 (frontispiece for Breton's *Clair de Terre*). Drypoint, 28 x 19 cm. Musée Picasso, Paris.

ing."[21] Doucet made similar declarations to most of the painters whose work he bought, but did not live up to these vows in his will. The only paintings he left to the Musées nationaux were Douanier Rousseau's *Snake Charmer* and Seurat's large sketch for *Le Cirque*.[22] After his death, the rest of his paintings, including the *Demoiselles,* were sold one at a time over the years—mostly through César de Hauke, a dandyfied dealer of Polish origins, who worked for Jacques Seligman.

For Picasso, the prospect of his revolutionary masterpiece hanging in the Luxembourg, and thence the Louvre, alongside his favorite Manets, Courbets, and Ingres, took precedence over other considerations. Doucet not only cheated the artist over the price of *Demoiselles;* but he did so on the spurious grounds that he could not hang a painting of whores in his wife's drawing

Les Demoiselles d'Avignon in the stairwell of Jacques Doucet's studio in Neuilly, c. 1929. Courtesy Daniel Wolf, Inc.

room.[23] Why ever not, someone said, given that Madame Doucet supposedly started life as an equestrienne in a circus?[24] Picasso would turn down Doucet's invitations to see the *Demoiselles* in situ and would flatly refuse to sell him *La Danse,* another masterpiece the collector yearned to own: a decision that the terms of Doucet's will would fully justify.

Need for money may have necessitated the sale of the *Demoiselles.* In 1923, Picasso contemplated leaving the rue la Boétie. He required a much larger space with a separate working area, preferably an *hôtel particulier.* To raise the money, he would have had to make some major sales, hence that of the *Demoiselles.* Picasso had alerted friends to his requirements, among them Roché, who went looking for a house, "maximum price 600,000 francs, to include an atelier, preference for an old house in the 16th, 17th, 18th, 6th, or 4th arrondisements."[25] Roché's diary confirms that he took the Picassos in search of suitable premises on January 17 and 31, 1924 ("driving around in a car, house-hunting, nothing pleases them"); and again on February 10 ("the Picassos: still in search of a house. He dragged along his wife and son").[26] Meanwhile, Edith de Beaumont had come up with two small *pavillons* at

Neuilly, *"avec jardin, chaque pavillon séparé"*; and José María Sert had written to say that "if you are interested in my studio, you know that you have priority over everyone else."[27] Sert's huge ornate studio—which had inspired Degas's comment: "How very Spanish—and on such a quiet street"—did not tempt him.

Why not have a modern architect build a house to your specifications? Gertrude Stein suggested. (Braque would soon acquire a plot of land near the Lion de Belfort, where Auguste Perrin would design a modernist house for him.) "Imagine, if Michael Angelo would have been pleased" Picasso said, "if some one had given him a fine piece of Renaissance furniture. Not at all. He would have been pleased if he had been given a beautiful Greek intaglio."[28]

In the end, Picasso found nothing that pleased him. Instead, he settled for an additional floor in the rue la Boétie building, which he could use as a studio. Negotiations would take another three years. At last he would be able to lead an independent life. Picasso's marriage would never be the same, nor would his work.

The first American exhibition of Picasso's paintings opened at Wildenstein's in New York on November 17, 1923. Of the sixteen works, three were biggish pastels; the thirteen oils included three of the Salvadó portraits, a couple of the Dinard *Maternités,* and some bravura portraits of Olga. All had been chosen for their "easiness on the eye," in other words their sales potential. Cubism was excluded. This was a mistake. Insofar as Picasso had a following in America, it was a modernist one—young artists, writers, and intellectuals, mostly without the means to collect. Well-informed critics like Henry McBride felt that Rosenberg had underestimated American avant-gardism in limiting the show to establishment taste.[29] Also, Rosenberg had not allowed for the fact that the two biggest collectors of modern art in America—Dr. Barnes, who preferred Matisse to Picasso, and John Quinn, who preferred Picasso to Matisse—made most of their acquisitions through their Paris agents.

Rosenberg had only himself to blame for the failure of the Wildenstein show. He was so dazzled by the riches of the New World and so greedy to share in them that he asked prices nobody was prepared to pay. Works of minor importance were all that sold. Picasso was dismayed that Rosenberg had misjudged the U.S. market, just as he and Thannhauser had misjudged the German market on the occasion of their large show at Munich the year before. "I am sorry for Picasso's sake," John Quinn had written Roché, "that the Munich . . . exhibition was not a financial success, but Mr. Paul Rosenberg was too cocky about it. When he very cockily and most impudently wrote me about the exhibition . . . I could not help . . . pointing out that I doubted whether it would be a financial success."[30] In March 1924, Quinn reported to Roché

that Marius de Zayas had seen Picasso, "who was very much disappointed at no sales having been made in America [and] realized that [Rosenberg's] prices had hurt him very much . . . and that he [Picasso] would have been willing to sell the clowns (Harlequins) for forty to forty-five or fifty-thousand francs, but that it was Rosenberg who made them seventy-five or eighty-thousand francs."[31]

Rosenberg wrote to reassure Picasso. The opening had gone off "without tambourines or trumpets," he said, but it "has had a great *succès d'estime et moral.* Everybody finds it marvelous . . . even if there are only sixty visitors a day, which is apparently a lot!"[32] On November 26, Rosenberg wrote that *"les Montparnassiens"*—presumably New York's modernists—found that "a change has come over their Picasso. . . . The painting that should have pleased the most, the Harlequin in profile [Salvadó], pleased the least, the most popular [paintings] are the woman with the blue veil and [*La Réponse*]. It's just as we thought."[33] On December 11, the day after the paintings were shipped to Chicago, Rosenberg reported that New York "had been a success on every level except that of sales."[34]

The Chicago show differed from the New York one in that it was held under the auspices of the Arts Club of Chicago, an organization of moneyed, art-loving ladies (much like the founders of New York's MoMA), who rented gallery space in the Art Institute complex. This was not quite the same thing as the great museum show Rosenberg had promised Picasso. The Arts Club was a nonprofit organization, but it was entitled to make sales. Paul Rosenberg had counted on helping the good women of Chicago do this, except there were no sales. Hence his conclusion that the new country was not conducive to the new painting; America was fine for contacts, but Paris was the place for sales. This conclusion would be confirmed when the paintings that failed to sell in America were shown at his gallery. The most resolved of the Salvadó Harlequins promptly sold for 100,000 francs to the Swiss collector Rudolf Staechelin. In his review of the show, Picasso's old friend, Maurice Raynal, took Rosenberg to task for failing "to hang a group of works that presents the current different tendencies."[35] The artist would see that Rosenberg never made that mistake again.

In his letters to Roché, his Paris agent, John Quinn—the ruthless Irish-American lawyer who was already one of the two or three greatest collectors of Picasso in the world—provides a cold-blooded analysis of the situation. Listen to the brute gloating over Rosenberg's failure:

> That will be a setback to Picasso in Paris. Picasso will want to make sales to you or me in the course of the next three or four or six months. And he will not do so. The stand-off attitude can be played by both sides. Picasso stood you off after you saw him this autumn. Now when he comes to you about selling things to me, you can stand him off. When he does that I think you may frankly say: "Mr. Quinn thought

we had a friendly understanding, honorable to both sides. Mr. Quinn did not wish to jew you down and did not make any condition[s]. . . . Mr. Quinn was very much interested in the Harlequin and would have been glad to trade with you . . . if you had not taken the attitude that you . . . could do nothing until Rosenberg saw [it]."[36]

For all his dislike of dealers, Picasso treated Rosenberg honorably. He was indeed entitled to make sales behind Rosenberg's back, but he was certainly not going to allow Quinn or anyone else to have first pick of the paintings that he was preparing for Rosenberg's New York show. Nor was he going to allow Quinn or his cat's-paw, Roché, to drive a wedge between him and his dealer. Quinn saw himself becoming the greatest of all Picasso collectors, but he died unexpectedly the following year. The only other U.S. collector who surpassed him in ruthlessness and rapaciousness was that other egomaniacal Irishman, Dr. Albert Barnes of Philadelphia.

Quinn's dislike of Rosenberg was fueled by anti-Semitism, given his description of the dinner he unwillingly gave for him in New York:

[Rosenberg] was very anxious to come to see my things. Finally I had to agree. . . . [Felix] Wildenstein and he accepted my invitation to dinner. . . . Wildenstein is a perfect gentleman whereas Rosenberg showed himself to be a cheap little Jew. He disgusted everybody by constantly turning to me and asking me to come in . . . so I can show you a wonderful portrait of Madame Cézanne, etc., etc. . . . Rosenberg talked shop nearly all the time and nothing but shop. Wildenstein did not talk shop and showed himself to be a sympathetic and gentle man.[37]

In his last letter to Roché (June 25, 1924), written shortly before his death from cirrhosis, Quinn once again castigates Rosenberg: "I don't like that kind of Jew jobbery. That is too much of Paul Rosenberg's trickiness for me."[38] "Despite their combative relationship," Michael FitzGerald, who has done so much to clarify Picasso's relationships with his dealers, would have us believe that "Quinn and Rosenberg clearly understood each other very well."[39]

Rosenberg had the last laugh. On hearing the announcement after Quinn's death, in July 1924, that his entire collection was to be sold at auction, Rosenberg immediately contacted his executors and made an offer for all fifty-two paintings and sculptures by Picasso. The disappointing results of the Kahnweiler sales played into his hands.[40] To the dismay of collectors and dealers poised to fight over Quinn's treasures, Rosenberg's offer was accepted. It would prove a very profitable deal.

Meanwhile, the souring of the relationship between Cocteau and Radiguet was becoming the subject of much malicious speculation, especially on the part of Picasso, who found Cocteau's jealousy of Radiguet as absorbing as Diaghilev's jeal-

ousy of Massine. Just as he had encouraged Massine to dump Diaghilev, he encouraged Radiguet to dump Cocteau. Jean and Valentine Hugo unwittingly amplified the anxiety that had settled on their group by conducting table-turning séances at which death manifested itself. Jean got this idea from his great-grandfather, Victor Hugo, who communed with spirits during his exile in Guernsey. However, as Jean certainly knew, his surrealist friends were also delving into the supernatural. The table-turning took place in the Hugos' new apartment in a small anteroom hung in pink velvet. Jean transcribed the messages that a little black gueridon tapped out. As well as the Hugos, the participants included Auric, Cocteau, Radiguet, and, on occasion, Paul Morand.[41] Radiguet appeared to be the spirit's target. On April 21 it announced that "malaise increases with genius." "What malaise?" "Uncertainty." On April 25, Cocteau asked the table to tell them its name. "No," it answered. "Because it is forbidden?" "I am death." "Is it death that speaks?" "Think of me." On April 30, the table rapped out a request for Radiguet's youth *("Je veux sa jeunesse")*. At this, the Hugos and their guests found themselves suffering from collective nervous depression and stopped the séances. It was too late. Fear had been unleashed.

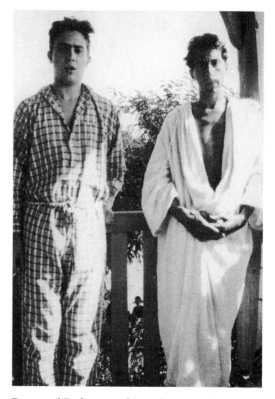

Raymond Radiguet and Jean Cocteau at Le Piquëy, September 1923. Collection Serge Tamagnot, Paris.

Twenty-year-old Radiguet had never accepted the role of Rimbaud redivivus that Cocteau tried to thrust on him, except in one respect: the derangement of the senses through excessive indulgence in alcohol, drugs, sex, and self-destructiveness in quest of the artistic martyrdom advocated by Rimbaud. Radiguet did not go as far as Rimbaud in his quest; although, according to Cocteau, he was drinking "a bottle of whisky and a bottle of gin a day."[42] He was also smoking opium. He had been involved with numerous women—among them Irène Lagut, Beatrice Hastings, and Thora Dardel (the beautiful Swedish wife of Nils de Dardel, Rolf de Maré's former boyfriend)—before falling under the spell of two sexy young Polish models he had picked up in Montparnasse. *"Mes chinoises,"* he called them. Bronia and Tylia Perlmutter were the daughters of a Polish rabbi who had settled in Holland. To extricate himself from the embarrassment of Cocteau's infatuation and

Valentine Hugo. *Raymond Radiguet,*
1921 (frontispiece for Radiguet's
Le Diable au corps). Lithograph.

egged on by Picasso, Radiguet asked the eighteen-year-old Bronia to marry him. Bronia—later the wife of the film director René Clair—has stated that Cocteau became so jealous of her that he threatened to have her and her sister deported.[43]

In July, Radiguet gave in to Cocteau and agreed to spend the rest of the summer recovering his health on the Mediterranean. For this rest cure, Cocteau chose Le Piquëy, an isolated fishing village where the sunset had a way of turning the sky, water, and sand a nacreous pink. Jean Hugo said it was like being inside a pearl. *La bande à Cocteau* took over the one and only Hôtel Dhourte. Besides the Hugos and Auric, the group included Bolette Natanson, Misia's manic-depressive niece, who was much loved by everyone except her aunt. Bolette had fallen suicidally in love with Cocteau. Chewing on lightbulbs had failed to work, but she eventually found a more effective method. There were also a couple of alcoholic aesthetes, the half-French, half-English Count François de Gouy d'Arcy and his rich American boyfriend, Russell Greeley, art patron friends of the Hugos.[44]

During this troubled summer, Cocteau would finish his booklet on Picasso, Jean Hugo would do evocative little watercolors, and Radiguet would dictate his *Bal du Comte d'Orgel* to Auric, who traveled with a typewriter. He also traveled with a rented piano, which had to be ferried to Le Piquëy on one of the gondola-like boats that plied the Bassin. While Greeley encouraged Radiguet to drink, Gouy d'Arcy, who loathed Etienne de Beaumont, urged him to darken and sharpen his subtly cruel portrait of him.

Valentine Hugo, writing thirty years later, remembered their stay as eerily idyllic, with "an underlying malaise both physical and moral."[45] The weather was ominous—torrential rain and thunderstorms—and on July 30, Radiguet, who was a strong swimmer, would have drowned in the current had not some fishermen gone to his rescue. At first the prodigy suffered attacks of irrational rage, then pulled himself together, drank less, worked hard, rose early, and went early to bed. The improvement did not last. At the beginning of September, he and Valentine complained of food poisoning. They blamed it on the local oysters. Jean Hugo took Valentine home to his *mas,* an hour or so away at Lunel, but her condition deteriorated. On December 10, she had to be rushed to hospital for a peritonitis operation. It saved her life.

A different illness would soon kill Radiguet.[46] After returning to Paris on October 4,

he distanced himself, insofar as he could, from Cocteau and his jealous scenes. Threatened with military service in December, Radiguet embarked on a downward spiral of "debts, alcohol, insomnia, heaps of dirty linen, moving from hotel to hotel, from crime scene to crime scene" with Bronia Perlmutter.[47] One night when he and Bronia were out with Cocteau and Auric, Radiguet took Auric aside and told him he was going to marry Bronia. She was no more in love with him than he was with her, but he liked women and had no intention, as he said, of becoming "a forty-year-old man called Madame Jean Cocteau." Meanwhile, his health was deteriorating; also his morale. He had been shattered by the successive suicides, a month apart, of two of his close friends, Emmanuel Faÿ and Philippe Daudet, the dysfunctional fourteen-year-old son of the founder of the fascist Action Française, Léon Daudet. Philippe had blown his brains out in a taxi as he drove past the Saint-Lazare prison where a girlfriend was incarcerated.[48]

By the beginning of December, Radiguet was running a high fever. Cocteau's fashionable quack, Dr. Capmas, who had failed to save Apollinaire, failed to save Radiguet. The patient had *une grippe* (flu), Capmas said, and should drink a lot of grog. Sensible as ever, Chanel sent over her own doctor, who diagnosed typhoid. Ever since his sister's death from diphtheria almost thirty years earlier, Picasso had had a mortal terror of disease and stayed away. Misia rushed Radiguet to a clinic, but it was too late. Abuse of alcohol and drugs had weakened a system that had never been very strong. There was no saving him. When his mother was sent for, she, too, turned out to have caught typhoid and ended up in isolation at the clinic. Poor, forlorn Bronia—"that very tiresome Dutch woman," as the Abbé Mugnier described her[49]—was glared at by Cocteau's disapproving mother for cuckolding her son. On the eleventh, Radiguet began to hallucinate, but he still had moments of lucidity. "Tomorrow, I'll be dead," he told Cocteau. When Cocteau protested, he repeated, "Yes, yes, I know I'll be dead . . . executed by God's firing squad."[50]

On the night of December 12, Monsieur Bébé, as Radiguet was still sometimes known, died alone. To some, Misia described his face in death as a mask of terror; to others, a mask of serenity.[51] Cocteau later claimed to have been at his lover's deathbed. He was not. Shocked to find that the dying Radiguet had no one at his side, Chanel told Cocteau to "spend the night with him," but he was too terrified of typhoid to do so, let alone view the body or attend the funeral.[52] He fled. Henceforth, some of Cocteau's closest friends, headed by Valentine Hugo, would keep their distance. To the bitchy boys at the Boeuf, Cocteau would now be known as *Le Veuf sur le toit* (the widower on the roof).

For Picasso, Radiguet's demise reopened the scars of Apollinaire's premature death five years earlier. Although he usually avoided funerals, Picasso and Olga joined the mourners at the funeral at Saint-Honoré d'Eylau. The ceremony was the

more affecting for being a *service en blanc:* white altar cloths, white flowers, a white coffin, and two great white horses to pull the hearse through the wet foggy streets. Those who complained that white was reserved for children's funerals were told that anyone under the age of twenty-one was a child in the eyes of God. Chanel and Misia, who had known Radiguet through Max Jacob, since he was fourteen, had paid the medical bills and the costs of the elaborate funeral; Gouy and Greeley took care of the dead man's hotel debts; and Moysès his vast bar bills at the Boeuf sur le Toit. The funeral was very well attended: Radiguet's distraught mother and father and six sobbing siblings and an army of the dead poet's sorrowing fans and friends from *le tout Paris,* most of whom braved the freezing rain and followed the white horses and Vance Lowry's black band from the Boeuf to Père Lachaise.

I suffered a great loss, and I ran away,"[53] is how Cocteau explained his flight from the deathbed. He ran away to join Poulenc and Auric in Monte Carlo, where the ballets—which they had written music for—*Les Biches* and *Les Fâcheux,* were in rehearsal. Satie, who was also there doing arrangements for Diaghilev, was anything but welcoming. He was horrified to find that Cocteau had struck up a friendship with his archenemy, Louis Laloy, a powerful music critic who had hitherto despised Les Six. In his paper, *Comoedia,* Leloy had inveighed against Satie for *Parade,* against Cocteau for *Le Coq et l'arlequin,* and against Poulenc and Auric for their lack of gravitas. The latter were so fearful of what Laloy might write about their ballet music that they had gone ahead and made peace with him. After a blazing row with them for their faint-heartedness and treachery, Satie returned to Paris and denounced them in an article entitled "Souvenirs de Voyage."[54] He inveighed against the sugariness of Poulenc's and Auric's "lemonade" or "lollipop" music—"a mixture of the sexual, the unsexual, and the emetic"—and then went on to lambast "the loathsome Laloy": "So they [Cocteau, Auric, and Poulenc] won him over, did they?" Satie asked rhetorically, "What was the price?"[55] No less than the dissolution of Les Six. Cocteau proved all too ready to abandon the musical power base that his group had represented. He no longer needed them. Thanks to Laloy, he had found a whole new world of the senses to explore—opium. Satie would not speak to any of Les Six ever again. He would avenge himself on them when he and Picasso collaborated on their ballet *Mercure.*

Besides being an eloquent critic and a leading supporter of Debussy, Laloy was secretary general of the Paris Opéra, as well as a man of considerable charm and intellectual curiosity. He was also a celebrated opiomane, thanks to his best-selling *Le Livre de la fumée,* which promoted opium as a mood enhancer for a new generation in search of *paradis artificiels.*[56] The pipe of peace that Laloy handed Cocteau,

Auric, and Poulenc was laced with opium. Cocteau had already smoked the stuff—with the flamboyantly decadent actor, de Max, as well as with Radiguet—so seemingly had Auric. But it was above all Laloy who, despite preaching moderation, set them on the road to addiction: a road that Picasso had renounced fifteen years earlier and Cocteau and Auric would follow for the rest of their lives.

Cocteau would attribute his opium addiction to the death of Radiguet, "whom I thought of as a son. My nervous suffering became so unbearable, so overwhelming, that Louis Laloy . . . suggested that I relieve it this way."[57] As well as smoking every day, Cocteau would join Laloy most Sundays for opium parties at his house. Opium turned out to be a perfect palliative for Cocteau's grief, also for his dysfunctional nervous system, which would never recover from his father's suicide and his mother's tyrannical love.[58] Despite opium's side effects—hot flushes, chills, nonstop yawning, nausea, constipation, and diminished libido, not to mention the countless useless cures—Cocteau's astonishing ability to function as a poet, playwright, movie director, and social superstar depended on its tranquilizing balm.

The drug was also an advantage in that it enhanced the image of glamorous decadence that Cocteau cultivated. As Princess Soutzo observed, "From 1914 onwards, Cocteau, society's darling, had always wanted to appear as a *poète maudit,*" to which Paul Morand, soon to be her husband, added, "hence the air of insincerity emitted by his work."[59] Stravinsky thought that opium facilitated Cocteau's writing; enemies claimed that his addiction was a "drama queen's" affectation. Successive efforts to cure himself of the habit never lasted for long, except during World War II, when the drug was difficult and dangerous to procure. His protective movie-star lover, Jean Marais, helped Cocteau through a painful rehabilitation, but once the war was over, he resumed the habit.

Invited to lunch with the Picassos at the rue la Boétie in July 1924, Cocteau would have an epiphany. Going up in the antiquated hand-operated elevator, Cocteau lapsed into a narcoleptic state: "I imagined that I was growing larger alongside something terrible—I don't know what. . . . A voice was calling to me: 'My name is on the [door] plate!' A jolt woke me, and I read . . . Ascenseur Heurtebise. During lunch the conversation touched on miracles with Picasso characteristically remarking that 'everything is a miracle: it's a miracle not to melt in the bathtub like a piece of sugar.' "[60] Cocteau's miracle would take the exhilarating form of demonic possession: an evil angel—*"d'une violence acceptée et même souhaitée"*—who would take up residence within Cocteau and torment him until he managed to expel it from his body as if he were giving birth. Cocteau spelled this out in a masochistic cri de coeur of a poem—"as important for my work as the *Demoiselles d'Avignon* is for Picasso's"—entitled "L'Ange Heurtebise."[61] The angel was of course a fantasy version of Radiguet. In the poem, he proceeds to torture and rape Cocteau with his

"*sceptre male,*" as if he were Rimbaud beating up on that most *maudit* of *poètes maudits,* Paul Verlaine.

> *L'Ange Heurtebise, d'une brutalité*
> *Incroyable saute sur moi. De grâce*
> *Ne saute pas si fort*
> *Garçon bestial, fleur de haute,*
> *Stature.*[62]

> (Angel Heurtebise with incredible
> Brutality jumps on me. Have mercy,
> Don't jump so hard
> Beastly boy, flower of great stature.)

In claiming that his masterpiece had come to him "against his will, automatically" in an opium-induced vision, Cocteau may have hoped to curry favor with the surrealists, for whom automatic writing was a key to the subconscious. Actually "L'Ange Heurtebise" was anything but automatic. Cocteau had devoted some nine months to the poem, which was not finished until March 1925—a few days before he went back into a clinic for a cure. The poem is not at all spontaneous: it is full of other poets' music—echoes of Rimbaud, Anna de Noailles, Rilke, and Mallarmé.[63] And yet, for all its straining for effect, "L'Ange Heurtebise" is probably Cocteau's finest poem. Besides commemorating the loss of Radiguet, it resonates with the fear of being dropped by Picasso. This on top of being blackballed by the avant-garde must have been unbearably humiliating for Cocteau. Hence the vision in the elevator. It is surely no coincidence that Heurtebise, manifested as Cocteau, was on the way up to visit Picasso, the god who was failing him and who would fail him again and again and derive a certain sadistic satisfaction from doing so. Cocteau later discovered there was no such thing as a Heurtebise elevator. Picasso's was an Otis.

In his quest for a new god, Cocteau asked Auric to take him to Meudon to see Jacques and Raïssa Maritain, eloquent Catholic proselytizers who were celebrated as much for their understanding of philosophy, the arts, and literature as for their contagious piety. Max Jacob, who had also turned to God for solace after being rejected by Picasso, had been urging Cocteau, a lapsed Catholic, to return to the sacraments, "the way one goes to a doctor." "You mean swallow the host like an aspirin?" Cocteau said aghast. "The host should be taken like an aspirin," Jacob replied.[64]

On the road to redemption, Cocteau was joined by two of his *gosses,* as he called the fawning homosexuals in his fan club. The nice one, Jean Bourgoint—the model with his sister for Cocteau's *Enfants terribles*—would eventually abandon the Boeuf sur le Toit and Jean Hugo's hospitable roof for a Trappist monastery; the nasty one, Maurice Sachs, would start off as a chic seminarian and end as a spy for the Gestapo,

trading allegations about his fellow Jews for drugs and other privileges before being killed on a death march from Hamburg to Kiel in 1944.

To steer Cocteau back to the sacraments, the Maritains recruited a charismatic missionary, a tall, tanned priest, fresh from the Sahara, called Father Charles Henrion. Father Henrion was given to wearing a white burnous emblazoned with a crimson cross above a blood-red heart. He "gave me the same shock as Stravinsky and Picasso," Cocteau said.[65] On Friday, June 19, 1925, the feast of the Sacred Heart, the born-again poet took communion from Father Henrion in the Maritains' private chapel. The sacraments provided balm for his ongoing grief at Radiguet's death and Picasso's defection. For Cocteau, the opium of the people would all too soon prove no match for the real thing.

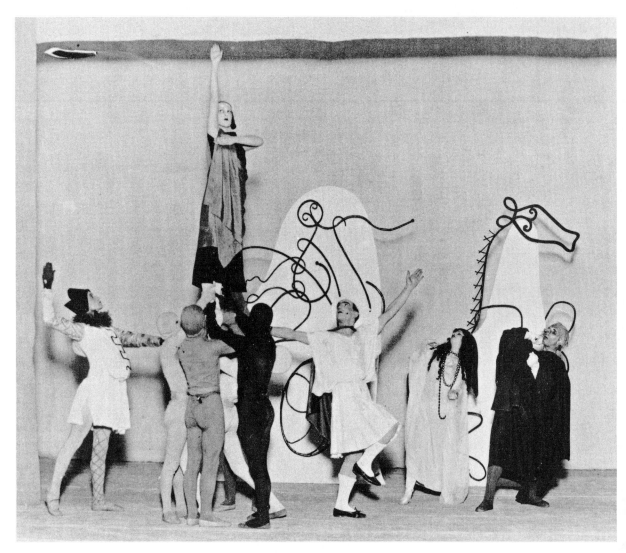

Bacchanal scene, *Mercure,* with sets by Picasso, 1924. Musée Picasso, Paris.

20

Mercure (1924)

The success of the divertissement *La Statue retrouvée,* which Cocteau had thought up and Picasso designed for the Beaumonts' ball in June 1923, had inspired Beaumont to become an impresario like Diaghilev. He went ahead and rented a large Montmartre music hall (currently a pornographic cinema) called the Théâtre de la Cigale, and set about organizing a season of mostly balletic entertainments.[1] He named his venture *Les Soirées de Paris,* after Apollinaire's pre-1914 magazine of art and literature. For the occasion, Beaumont persuaded Moysès of the Boeuf sur le Toit to transform one of the theater's galleries into a Boeuf-like bar, where patrons could drink, eat, and dance, but it lost money and had to be closed. He also installed Massine, whose marriage and attempt to form his own company had both failed, in an apartment in the courtyard of his *hôtel particulier.* He appointed him consultant and choreographer. As always, Cocteau was eager to collaborate. He just happened to have a short adaptation of *Romeo and Juliet* up his sleeve and was ready to direct it and play the role of Mercutio. To his subsequent regret, Beaumont agreed to take on this project: Cocteau's text was thin and he kept throwing tantrums. Nevertheless, Jean Hugo's stylish décor and costumes ensured that the production was well received. Beaumont would soon come to regret the expense of being an impresario. Having drawn on an unexpected windfall to launch his venture, he blamed an unexpected loss in the stock market to terminate it.

By far the most original and significant of the *Soirées de Paris* productions was the short (thirteen scenes in less than ten minutes) ballet *Mercure,* which Beaumont commissioned from Picasso, Satie, and Massine. The lighting for this and his other productions was entrusted to the American dancer Loie Fuller, whose performances in swirling veils and beams of colored light had made her an expert in the field. Everyone involved was very secretive about this project. On February 20, Beaumont wrote asking Satie to compose the music for a ballet to be called *Les Aventures de Mercure* for a fee of eight thousand francs.[2] The next day he wrote Picasso in greater detail, outlining his plan for a new form of balletic entertainment—part ballet, part mime, part *poses plastiques,* part sculpture, part drawing:

My point of departure for our mythic dance has been your drawings. I don't want to drag literature into it, nor do I want the composer or the choreographer to do so. What I want from you are *TABLEAUX VIVANTS*. I have drawn on mythology to the extent that it is a universal alphabet and not by virtue of any ties to a specific period or place. . . . This old alphabet is the only means we have of explaining the totality of human nature in simple terms that everyone can understand. Let us therefore make use of the assets we have at hand . . . [and] take Mercury rather than Jupiter or Saturn; nevertheless do whatever you want and do not regard the little story we already have as anything more than a collection of letters that a child has at its disposal for word making.

So it's a series of drawings that I am asking you to do. Just as you transformed the horrible nudes of the Folies Bergère into admirable drawings, you will certainly find a way to adapt the admirable nudes in your incomparable drawings to music-hall requirements.[3]

The instructions that Picasso and Satie took most to heart were "do whatever you want" and "respect the music hall requirements." The two of them decided to avenge the would-be with-it tricks that Cocteau had tried to impose on *Parade* by making him their butt. Since Cocteau liked to don a Mercury outfit—winged helmet, winged shoes, silver tights—whenever fancy dress was called for and flit about at high speed among the assembled guests, who better? Work on the ballet proceeded in tightest secrecy. Picasso did drawings for thirteen successive tableaux—most of them less than a minute long—as Beaumont had suggested; Satie then "furnished" them with *musique d'ammeublement*. Satie insisted on a similar arrangement with Massine. Like a composer of a film score, he fitted his music to the choreography instead of the other way around. This was the only way he could protect himself from being misinterpreted.[4] The sole function of the music, Satie told Pierre de Massot, was to provide a sonic backdrop to Picasso's plastic poses.[5] Actually, this was not quite true. As the composer's biographer, Steven Whiting, has described, Satie used his music mischievously to define and ridicule the character of Cocteau/Mercure (danced by Massine). For instance, the pratfall music at the end of the first tableau:

a slapstick final cadence that might have accompanied a clown tripping on his way offstage. In this configuration of glib melodic surface and devious accompaniment, one may already hear a musical characterization of Mercury, hence

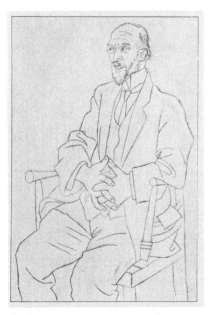

Portrait by Picasso of Erik Satie in Ballets Russes program (Théâtre de la Gaité-Lyrique, May 1921). Musée Picasso, Paris.

of Cocteau. This association is corroborated at the end of the first tableau, the god enters to the syncopated tune, now reharmonized . . . that emphasizes the jerky rhythms. Given Cocteau's taste for jazz, the deliberate Americanism of the music assumes its own sarcastic point.[6]

In the night scene after the overture, dancers bearing placards printed with ETOILE in block letters jolted audiences into a fresh awareness by confronting them with the unexpected word in place of the expected image. A set of zodiac signs that Polunin, who painted the scenery, had in his studio inspired Picasso to introduce constellations into the décor.[7]

Mercure's most memorable tableau was the sixth one: a bathing scene in which the Three Graces, played by men in drag and long black wigs—supposedly Auric, Poulenc, and Laloy—poke their bewigged heads and bright red cardboard breasts through a large hole in the backcloth representing a bathtub.[8] In the following scenes, Mercure bursts in and steals the "girls'" pearls—a swipe at Satie's bête noire, Wagner, and his Rhine maidens—and is then chased away by a cutout of the dog Cerberus. Meanwhile, the Graces have turned into basketwork constructions, manipulated like puppets by wires. The final tableau opens with a party given by Bacchus, in which Picasso and Satie get in digs at Poiret, Diaghilev, and Beaumont. The polka—based on Vincent Youmans's *Tea for Two*—was intended to "capture the mood of forced gaiety at a high-society get-together."[9] As if to bring his so-called classical period to a suitably farcical conclusion, Picasso ends the ballet on a note of what else but Chaos, portrayed by male dancers in multicolored tights—pink, blue, yellow, green[10]—surrealists!

These in-jokes were lost on most of *Mercure*'s audience. People tended to be baffled or offended, and the ballet was an instant flop. Cocteau was angry and hurt; Diaghilev worried, with good reason, that in losing Picasso, Satie, and Massine to Beaumont he had forfeited his avant-garde credentials. Misia was upset because Diaghilev was upset. As for Breton's newly conscripted surrealists, they used the first night of *Mercure* as a pretext for yet another divisive demonstration. Under pressure from Satie's disloyal former pupil, Auric, Breton—who took little interest in

Dance of the Three Graces with Cerberus scene, *Mercure,* with sets by Picasso, 1924. Musée Picasso, Paris.

Picasso. Study for *Mercure* curtain with Harlequin playing guitar and Pierrot playing violin, 1924. Pastel on gray paper, 25 x 32 cm. Musée Picasso, Paris.

music—disrupted the performance by instructing his gang, including Aragon, to yell "Bravo Picasso, down with Satie" at the box where the Picassos and General Mangin presided.[11] When the police intervened, Aragon broke away, jumped onto the stage and went on inveighing against Satie. Breton wanted to settle a score with Tzara by attacking his ally; Auric was out to bite the hand that had fostered him. Undeterred by the fracas, Beaumont went ahead with the ball he had arranged to follow the ballet. For once, there was no specific theme. By contrast with the shambles of the performance, the composure of the guests at the ball seemed stately. Picasso and Eugenia Errázuriz went *à l'espagnole,* and Olga more traditionally in couture, as we know from Man Ray's famously stylish photograph of the Picassos at the height of their *époque des duchesses,* together with Eugenia, who had unwittingly made it all possible.

At the time, *Mercure* appeared to be a failure, but it left Diaghilev, as described by Serge Lifar on opening night, "pale, agitated, nervous."[12] A dangerous "threat to Russian ballet," he said, "the only thing missing is my name."[13] The impresario would put that to rights in 1927 when he arranged for his company to give two performances of *Mercure* in London. Once again, it was not a success. After that, this

ballet, the most provocative of all Picasso's works for the theater, including *Parade,* was never danced again in its original form.[14] Except for pastel studies for the curtain—a left-handed Pierrot about to play a violin and a right-handed Harlequin playing a guitar—and a few sketches and photographs, which hung for many years in Beaumont's bathroom, little has survived.[15] However, if *Mercure* is studied in the light of statements by Picasso and Satie and contemporary accounts, the ballet emerges as a major milestone of avantgarde theater. No less important, the constructions that were such a novel feature of *Mercure* paved the way for the open work sculptures that Picasso would embark on four years later. Nobody saw this more clearly than Aragon who wrote in *Le Journal Littéraire* (June 1924) that "*Mercure* caught me unaware. Nothing stronger has ever been brought to the stage. . . . It is also the revelation of an entirely new style for Picasso, one that owes nothing to either cubism or realism, and which transcends cubism just as cubism transcended realism."[16]

Man Ray. Photograph of Eugenia Errázuriz, Picasso, and Olga at the Beaumont ball after the premiere of *Mercure,* 1924. Musée Picasso, Paris.

Breton had been too busy jeering to realize how innovative and adventurous *Mercure* was, let alone how Picasso and Satie had worked together as one. There could be no question of praising the one at the expense of the other, but this did not stop Breton from publishing a letter of passionate support of Picasso, signed by him and several other surrealists.

> It is . . . our duty to put on record our deep and wholehearted admiration for Picasso, who . . . goes on creating a troubling modernity at the highest level of expression. Once again, in *Mercure,* he has shown a full measure of his daring and his genius, and has met with a total lack of understanding. This event . . . proves that Picasso, far more than any of those around him, is today the eternal personification of youth and the absolute master of the situation.[17]

Satie derided Breton's unctuous letter as *"assez curieux et un peu 'con' "*—a laughing matter. As for Picasso, he welcomed Breton's gesture as an act of fealty. It came at a tricky time for him. *Littérature,* the avant-garde magazine that had been a vehicle

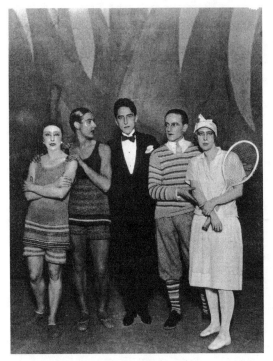

Cocteau with (from left) Lydia Sokolova (as the Perlouse), Anton Dolin (as the Beau Gosse), Léon Woïdzikovsky (as the Golfer), and Bronislava Nijinska (as the Tennis Champion), in *Le Train bleu*, 1924. Getty Images.

for modernist principles since 1919, closed down with a *numéro démordisant* (June 22, 1924), the day after Breton's letter appeared. Breton was about to correct the galleys of his first surrealist manifesto, which would be published on October 15. It would be replaced in December by a new review, *La Révolution Surréaliste,* to be edited by Benjamin Péret and Pierre Naville. For Picasso, Breton's backing was all-important in the face of the possible but unlikely event of his leadership of the avantgarde being challenged by the iconoclastic Marcel Duchamp or that even wilder card, Picabia. In return, Picasso was always ready to do portraits and frontispieces for books by surrealist poets; to allow his work to appear in surrealist publications and provide those he liked with handouts when they were broke. At the same time Picasso took care to hold himself aloof from the movement. He never attended their meetings, never signed their manifestos, and never subscribed to the views expressed in Breton's *Le Surréalisme et la peinture* in 1925.

The same day that Breton's "Hommage à Picasso" letter appeared in the press, Diaghilev unveiled his new ballet, *Le Train bleu:* scenario by Cocteau, décor by Henri Laurens, costumes by Chanel, choreography by Nijinska, and a magnificent drop curtain by Picasso after the gouache of two maenads racing along the beach at Dinard in 1922.[18] This curtain had been so sensitively executed by Prince Schervachidze—a generous patron of the arts under the Tsar, a scene painter in exile—that the artist signed it and dedicated it to Diaghilev, who took to using it as a logo for the Ballets Russes.[19] *Le Train bleu* had a scenario by Cocteau that featured Diaghilev's new Irish dancer and favorite, Patrick Ray (Russianized to Anton Dolin), to his best advantage. The impresario had decreed that Dolin play the acrobatic Beau Gosse ("gorgeous guy") in this ballet named after the glamorous new express train that took Parisians to sea and sun and *la vie sportive* on the Côte d'Azur.

Apart from supervising the drop curtain, Picasso had nothing much to do with *Le Train bleu.* Nevertheless, he attended a number of rehearsals, which by this time usually bored him. Was he, one wonders, interested in one of the dancers? He was also

obliged to be in attendance when Diaghilev invited his patrons to watch the company practice. On one occasion, the Picasso family joined the hereditary Princess Charlotte of Monaco, her husband, Prince Pierre de Polignac, the latter's American sister-in-law, Winnie de Polignac, as well as the Duchesse d'Ayen, the Marquise de Ganay (Georges Bemberg's sister), Lord Berners, Auric, Milhaud, and Poulenc to watch the company rehearse *Le Train bleu.* Little Paulo was so excited by the jumps Nijinska was teaching the dancers that he asked his father if she was "ever going to descend."[20] When Dolin appeared onstage, "Diaghilev adjusted his monocle and watched him closely, beating time with his foot. . . . Nijinska lit another cigarette."[21]

Le Train bleu narrowly missed being a flop. Cocteau made Nijinska cry with his nagging. When doing lifts, partners had difficulty getting a grip on the knitted bathing suits that Chanel had designed for them. Also, the large pearl earrings— soon to become a popular fashion accessory—that the couturière had devised for Sokolova made it as difficult for her to hear the music as her special rubber slippers made it difficult to dance. Worst of all, the pas de deux that Nijinska had choreographed for Dolin and herself did not work. At the very last moment, as the stage was being readied for the first performance, Nijinska took Dolin off and rechoreographed their dance, capitalizing on the craze for the body beautiful. The pas de deux was a triumph and made Dolin an instant star. With its Prince of Wales–like golfer in plus-fours, its bathing belle in pink georgette, its gorgeous *poules* (tarts) in Chanel "flapper" dresses, and its sexy gigolos in swimsuits, *Le Train bleu* epitomized the period and the Côte d'Azur and spawned a series of ballets which were essentially about little else but fashion.[22]

The *Train bleu* curtain was Picasso's last contribution to Diaghilev's company. He had had enough. His feelings for the ballet and the beau monde were much the same as the ones Stravinsky expressed in a letter to his friend C. F. Ramuz:

> I go sometimes to the Ballets Russes, sometimes to the Cigale . . . and everywhere one sees nothing but the snobbery and nastiness of horrible people who flutter about, and who (happily) play no part in your life, princesses who do nothing but ask you to lunch, honest bourgeois who listen to [Chabrier's] *L'Education Manquée* as if it were *The Rite of Spring*. . . . In the long run one is seized with disgust and could easily become a pessimist, which is what I most fear in the world.[23]

Olga, c. 1924. Photograph probably taken by Picasso.

21

Still Lifes at La Vigie (Summer 1924)

On or around July 20, 1924, the Picassos, with Paulo and his nanny, and the Murphys with their three children, left Paris for the Riviera. The Murphys' daughter, Honoria, says that when the train stopped at Marseilles for half an hour, they got off to stretch their legs. Picasso had a way of becoming attached to a place, any place, in no time at all, and he said, "Let's stay here."[1] In obedience to the master's whim, they spent a night or two at the Hôtel de Noailles. Honoria assumed that the Picassos spent the summer at Marseilles. She misremembers. They all went on to Antibes.

After a day or two at the Hôtel du Cap, looking for somewhere to spend the rest of the summer, the Picassos found a villa not far from the one they had taken in 1920, but grander and architecturally more fanciful. A mini-château rather than a villa, it was called La Vigie (the lookout house) and its garden overlooked the beach. Picasso did the usual drawings of his summer abode:[2] its Gothic windows and turrets; its ornate striped awning over the balustraded entrance giving onto the beach; its machicolated watchtower sticking out of the Aleppo pines that gave the resort its name. The house—now greatly transformed—was spacious. It had several guest rooms and a garage across the road that Picasso, who had left his car in Paris, took over as a studio,[3] much as he had done at Fontainebleau in 1921. The bare walls of the garage proved all too tempting. To the annoyance of the owner, the artist could not resist painting them. Unswayed by Picasso's argument that his "fresco" was worth a lot of money, the owner insisted that the artist pay to have the wall restored to its original state.[4] It was not photographed.

Now that most Riviera hotels stayed open in the summer, the *jeunesse dorée* was abandoning northern resorts like Deauville and Le Touquet for the Midi. Antibes and Juan-les-Pins had become very "in," though not as yet touristy. Some of Picasso's friends had followed his example. New arrivals included the Stravinskys. They had taken a house at Nice, but since all four of their children had caught diphtheria, Picasso kept away; he insisted the composer visit him. Another musical couple in the neighborhood, who had become close friends, were the Pierre Bertins: the attractive

Olga in front of the beach entrance to La Vigie, Juan-les-Pins, 1924.

husband was an avant-garde actor, singer, and theatrical director; the attractive wife was the well-known avant-garde pianist Marcelle Meyer. The first person to play the four-hand version of *Parade* with Satie in 1917, Meyer would later try to teach Paulo to play the piano.[5]

As expected, the Beaumonts materialized. After promising to join them at the Hôtel du Cap, they had chosen Cannes instead, but paid frequent visits to Juan-les-Pins and Antibes.[6] To judge by two sketches that look much like Valentine,[7] the Hugos may have driven over from their *mas* in the Languedoc. Diaghilev was installed at Monte Carlo with his company, which kept Olga happy. Cocteau was spending the summer with Auric and other opium smokers at Villefranche in a villa called Le Calme. The Picassos kept away from this louche group. Gertrude Stein and Alice declined Olga's invitation to join them.[8]

Once again the Murphys made the Hôtel du Cap their headquarters. No longer under the same roof, as they had been the year before, the two families saw less of each other. Many of the Murphys' American friends from previous summers had returned. Picasso was pleased to see the Dos Passoses, the Archibald MacLeishes (who had taken a villa nearby), Donald Ogden Stewart, and Gilbert Seldes—critic and editor of *The Dial*—with his new wife, Amanda. Picasso liked the Seldeses and gave them one of his *Nessus and Dejanira* drawings as a wedding present.[9] The artist told me he was beginning to tire of them en masse—too rowdy, no common language, too many cocktails.

The Scott Fitzgeralds were a recurrent problem. They had taken a villa at Valescure, but spent much of their time at the Hôtel du Cap, where Picasso remembered seeing rather too much of them.[10] Zelda—"intensely private and publicly outrageous"[11]—was in a bad way. A blatant affair with a trainee pilot at a local air base was the cause. Alcoholic animosity fed the flames. To sober up after late night parties, Zelda would go to Eden Roc, slip out of her evening dress and dive into the darkness of the sea from thirty-five-foot-high rocks. *Bella figura* obliged Fitzgerald to follow suit; he hated that. One night, Zelda overdosed on sleeping pills. Sara tried to administer an olive oil emetic, but Zelda recoiled: "Don't make me drink that, please. If you drink too much oil you turn into a Jew."[12] Picasso found Zelda strange.

Meanwhile, Fitzgerald had become fascinated by Sara and spent hours trying to draw her out. He constantly cross-examined her about her relationship with Gerald, whose homosexuality he could not resist putting to the test—mischievously intro-

Picasso. *La Vigie,* 1924. Oil on canvas, 22 x 27 cm. Private collection.

ducing him to young men. Ten years later, when the author's masterpiece *Tender Is the Night* came out, Sara would be mortified to discover the motive for his interrogation. Fitzgerald had recast the Murphys in his and Zelda's image. To be perceived as spoiled expatriates at the nadir of the Depression would be a source of sorrow for Sara: retribution, perhaps, for having lived too well. "You can't hide from a hurricane under a beach umbrella" was the *Daily Worker*'s verdict on this great roman à clef.[13]

Eventually, the gregarious Murphys tired of hotel life and bought a small tumbledown "chalet" a short walk from La Garoupe. Besides a panoramic view of the coast, it had outbuildings (including a donkey stable which became a studio), a small farm, and a vast idyllic terraced garden, which the former owner—a colonial official—had planted with exotic trees and shrubs. Over the next year or so, Gerald, who had trained as a landscape architect, would enhance the garden and enlarge and remodel the house, which they would call Villa America.

Thanks to Calvin Tomkins's perceptive and deservedly popular book about the Murphys, *Living Well Is the Best Revenge,* the Villa America has come to occupy a uniquely glamorous place in transatlantic cultural history. For Picasso, it was the novelty and camaraderie of that first summer at the Hôtel du Cap that counted; it would never be repeated.

Picasso started work the day he moved into La Vigie: a difficult-to-decipher drawing in purple ink is dated July 23, 1924.[14] Cowling sees three sunbathers.[15] She may well be right. The artist has done his best to bamboozle us; there do not

Picasso. *Three Bathers,* July 23, 1924. Violet ink on paper, 15.6 x 20.1 cm. Musée Picasso, Paris.

seem to be enough hands, feet, eyes, mouths, breasts, armpit hair, and sexual organs to go around. Body parts are strewn over what looks like a beach towel, so randomly that one is hard put to conjure them back into figures. Top right, Picasso portrays the blazing sun; top left, he uses wavy lines for the sea and dots below for the sand.[16] The following day, he did another drawing[17]— a still life with guitar and fruit dish— and again scrupulously dated it. Since he dated little else this summer, he apparently wanted to establish these two images as starting points for his next phase of work. The haphazard rearrangement of body parts in the July 23 drawing would not become a fixation with Picasso for another year. The July 24 croquis of a guitar and fruit dish, on the other hand, sets the pattern for this summer's still lifes.

Preliminary sketches for three of the great still lifes[18] that make this summer so memorable recall the Saint-Raphaël *Guéridons* of 1919, except that the theatrical setting—open windows, looped-back curtains, ornate railings—has been omitted. Instead Picasso evokes the Mediterranean by incorporating shorthand signs for sea, sky, sand, and stars into the fabric of his still lifes: as, for instance, when he gives a guitar a fishy look by extending its neck into a tail and repositioning the sound hole to suggest the fish's gills. In the first major work to emerge from these studies, the Stedelijk Museum's hieroglyphic *Still Life with Mandolin,*[19] Picasso renders the mandolin as if it were a fish caught in a net, and sets it off against a tablecloth with a wavy pattern and panels of shorthand pictorial notation, dotted with stars and divided into areas of night blue and day blue to give the painting a night-and-day resonance.

The second of these large still lifes (the one with the mandolin in the National Gallery of Ireland)[20] is shrill and assertive—a bit like its first owner, Sara's impossible sister, Hoytie Wiborg, who had recently returned from America with a present of neckties made of *"mouchoirs de négresses"* for Picasso.[21] The star-studded fruit dish and the wonky bottle look as if they have been fighting each other. The electrical brightness of these objects against the darkness of the foliage establishes this as a night painting, set out of doors. To steady this unsteady still life, Picasso plants it on an ornate base that matches the striped and scallop-edged canopy over the front entrance to La Vigie.

The third and most complex of these still lifes—the Guggenheim Museum's *Mandolin and Guitar*—is one of the largest (180.9 × 220.8 cm) he ever did.[22] This *grand coup de théâtre* exemplifies a new, more supple and expressive form of late cubism. Cowling sees the painting as a response—above all in its scale—to Matisse's even larger pseudo-cubist version (1915) of the Louvre's sizable *Still Life, "La Desserte,"* by the seventeenth-century Dutch master Jan Davidsz de Heem.[23] She is certainly right. Picasso regarded Matisse's *Still*

Picasso. *Still Life with Mandolin*, 1924. Oil on canvas, 97.5 x 130 cm. Stedelijk Museum, Amsterdam.

Life after de Heem[24] as a travesty of cubism and would have wanted to correct his rival's misunderstanding of his and Braque's language and demonstrate how he would have done it.

Cowling sees the Guggenheim still life in a sexual light. She likens the strings of the mandolin and guitar to "a woman's hairy genitals [and/or] her anus" and "the bottle as a man's genitals and its eye-like base as his anus."[25] Picasso's still lifes of this period are indeed anthropomorphic, but they do not as yet abound in genitalian puns and other encoded references as she suggests, though they soon will. The guitar strings, to my mind, are guitar strings. *Mandolin and Guitar* is not about sex; it is about the farcical nature of the commedia dell'arte.

Picasso told us to regard his still lifes as "parables."[26] So let us apply his words to the Guggenheim still life, starting with the three puzzling fruits at the very heart of it—usually said to be apples, although they look like oranges.[27] Over the next two years these three fruit will manifest themselves again and again in various forms in still life after still life. So far as I know, nobody has been able to decode them. I believe them to be a reference to *Love for Three Oranges,* Prokofiev's revolutionary commedia dell'arte opera, which was first performed in December 1921 at the Chicago Auditorium and was still much in the news. This opera's international success sparked enormous controversy in the musical circles frequented by Picasso. Prokofiev's rival, Stravinsky, inveighed against it but failed to persuade Diaghilev to share his view. *Love for Three Oranges* enjoyed tremendous popularity. F. Scott Fitzgerald even used a passage from it as background music for the nightmare of the Gerald Murphy character, Dick Diver, in *Tender Is the Night*.[28]

Prokofiev's plot would have been much to Picasso's taste. The composer had adapted it from a play by Vsevolod Meyerhold, the modernist Russian dramaturge,

who had adapted it from a farcical satire by the eighteenth-century Venetian dramatist Carlo Gozzi. Gozzi had set out to ridicule his two leading rivals: Carlo Goldoni for Frenchifying the bawdy old commedia dell'arte vernacular, and Pietro Chiari for turning classic drama into fustian melodrama. To mock them both, Gozzi dramatized "the most ridiculous story in the world," *Love for Three Oranges.* Its success in 1761 was soon forgotten. Its rediscovery, 150 years later, had so impressed Meyerhold that he named his theater magazine as well as his experimental theater company after it, as Picasso probably knew. He is likely to have met Meyerhold when the latter visited Paris in 1914 and became a friend of Apollinaire's.[29] *Les Mamelles de Tirésias* reflects many of Meyerhold's ideas, including ones inspired by the iconoclastic Gozzi.

What had intrigued Meyerhold and Prokofiev, and would certainly have intrigued Apollinaire, was Gozzi's use of absurdist farce—could anything be more absurd than three princesses imprisoned inside three oranges—to satirize the aesthetic issues of his time. The participation of rival factions of clowns and commedia dell'arte characters, like Truffaldino the jester and Pantalone the courtier, would have delighted Picasso. He would have seen how they applied to the dadaist clowns and commedia dell'arte surrealists in their attempts to take over the avant-garde in the early 1920s. Diaghilev, who admired Prokofiev and commissioned ballets from him, may have contemplated putting on a production of the opera. Matisse's most recent biographer says the impresario asked Matisse to do a drawing of Prokofiev for the program of *Love for Three Oranges.*[30] This was in fact for the program of Prokofiev's ballet *Chout,* but it does not rule out the possibility that Diaghilev contemplated putting on the opera with décor by Picasso, who would have been an obvious choice for a commedia dell'arte spoof. This is only a hypothesis, but the way the tablecloth is diapered like a Harlequin's costume, and the way the baggy white shapes of the instruments resemble the baggy white shapes of Picasso's Pulcinellas, confirm that this is a commedia dell'arte still life.

Also, the more one scrutinizes *Mandolin and Guitar,* the more one realizes that it is booby-trapped with visual jokes—including perspectival ones, like those to be found in the eye-teasing engravings of M. C. Escher. Take the seemingly matter-of-fact railings: in a row outside the window, which are echoed in a second row between the legs of the table. Are they fencing us in or fencing us out? Same with the window on the left. At first sight, it seems quite normal. Look again and you will see that the top pane faces away from you, while the bottom one faces directly at you. Picasso plays similar games elsewhere in the painting, not least in the crisscross triangles above the window.[31] Just as he had used perspective against itself in cubist works to bring things back within reach, Picasso uses perspective against itself to perplex us—anything to hold our attention. As Apollinaire observed, "Surprise is the great new source of energy."[32]

Musical Instruments on a Table (Museo Nacional Centro de Arte Reina Sofía, Madrid) and *Musical Instruments on a Table* (Fondation Beyeler, Riehen/Basel) in Picasso's La Vigie studio, 1924.

As well as painting these complex still lifes, Picasso embarked on two no less sizable but much more minimalist ones. These appear in the photographs of works in various stages of completion on the walls of the La Vigie garage. Hitherto, these breakthrough paintings have been dated 1925, 1926, even 1927. The photographs now enable us to assign them definitively to the summer of 1924. The painting on the right is now in the Beyeler Foundation.[33] Its rust browns and blacks evoke an earthy, autumnal look, and the darkness at the bottom exerts a heavy earthward pull. The bluish-greenish painting on the left—now in the Reina Sofía Museum[34]—has a skyward pull. The all-important patch of blue below the table legs gives this still life the air of an altar floating in the empyrean. It is serene and meditative. There is also a secretive, one might say confessional, aspect to the painting: an almost invisible image of the head and upper body of a girl is buried just below the surface of the guitar on the right. Daix, who discovered this secret, maintains that it is a likeness of Marie-Thérèse Walter,[35] whom Picasso would not meet for another three years. This image therefore refers to someone else—a mistress on the side—conceivably a dancer. Nobody in the artist's entourage comes to mind, and so the identity of this unknown woman whom Picasso wanted to commemorate and, at the same time, conceal in art as well as in life remains a mystery.

As well as these monumental still lifes Picasso did some full-face portraits of Olga

at La Vigie:[36] a black-and-white, night-and-day image split down the middle and another, which can be seen on the studio wall, with sand added to the paint as in the previous summer's sandy portrait of Sara Murphy. Snapshots of the family visiting friends reflect Picasso's pleasure at being back on the Riviera, playing on the sand with his son, while the cicadas drowned out the wash of the sea. He even did a fine, old-masterish drawing[37] of the local fisherwoman making her way up the beach with the morning's catch in a basket. Just as he had done daytime and nighttime versions of his still lifes, Picasso did daytime and nighttime versions of the watchtower amid the pine trees. To differentiate yet again between day and night, he added a vaginal sun sign to a patch of red paint for daytime and a moon and the usual stars to a patch of pitch-black paint for nighttime.[38]

The usual stars! These had originated in the "Night" scene in *Mercure*. After bringing stars in one form or another out of the sky onto the set of *Mercure,* Picasso sets them back in the firmament in a sequence of sketchbook drawings known as "Constellations."[39] The splendor of the meridional sky—Braque said that "the sky always looked so much higher" than the sky in the north[40]—inspired Picasso to create his own constellations: ink dots connected by fine pen lines that turn the zodiac into guitars and mandolins and the crotchet-dotted staves of musical scores.

There was also a philosophical side to these constellations. The association of stars in the night sky and music suggests that Picasso was aware of the "music of the spheres"—a notion that had its roots in Pythagorean teaching. Pythagoreans believed that the disposition of the heavenly bodies was ordained by mathematical laws of musical harmony. The music of the spheres concept crops up in Shakespeare as well as in the ideas of modernist composers[41]—among them Picasso's friend Edgard Varèse. The Bateau Lavoir's mathematician, Maurice Princet—all too briefly Alice Derain's first husband—would also have been aware of these Pythagorean beliefs. The number of night-and-day references in his Juan-les-Pins imagery suggests that Picasso knew about the Pythagorean discovery that the earth revolved on its own axis—a discovery that made it possible to comprehend the alternation of night and day.

I would also like to cite Gombrich's assertion about the zodiac: "the hold that these images in the sky still have on the imagination of western man [suggests] that projection was one of the roots of art."[42] This notion of projection—that is, the viewer's active involvement in a visual experience—had been taken up by the surrealists. As soon as Breton saw these constellations, he grabbed them for the first number of his new journal, *La Révolution Surréaliste.* Later (1931), Picasso would use "constellations" to illustrate Vollard's *édition de luxe* of Balzac's *Chef-d'œuvre inconnu.* They too would play a role in his first open work sculptures of 1928.

The summer of 1924 proved to be almost as productive and innovative as the summer at Fontainebleau. The previous year, he had been too distracted by the Murphys' alfresco beach life at Eden Roc and La Garoupe to focus on serious work. This year, Picasso had sufficient space, privacy, and peace of mind to make a prodigious forward leap.

Picasso. *Constellations,* summer 1924. Pen and India ink on sketchbook page, 31.5 x 23.5 cm. Musée Picasso, Paris.

22

La Danse (1925)

At the very end of September, the Picassos returned to Paris. Instead of moving out of the rue la Boétie, he had made up his mind to take the floor above. This arrangement, which would triple his rent, was anything but a fait accompli. Another year's haggling would pass before Rosenberg managed to nail the deal: 25,000 francs a year for the two apartments.

A month later, Clive Bell arrived on his customary fall visit. When he called on the artist, he was shown "three enormous more or less abstract works" (three of the Juan-les-Pins still lifes).[1] In Bell's vocabulary, "abstract" was not a compliment; he no longer had any understanding of Picasso's work. His letters to Mary Hutchinson are filled with bitchy Parisian gossip: a visit to Marie Laurencin, whose malice "astonished and ravished" him. "Such snapping and biting . . . how Jeanne Salmon had once been on the *trottoir* . . . and the link between her and André was opium . . . the duchesses never pay artists. One fine lady came up for judgment after another . . . then on to Olga Picasso's snobbishness, her bad effect on Picasso."[2] On previous visits, Alice Derain's fiendishness about the Picassos had disgusted Bell. Now he enjoyed it, but he continued to court the artist as assiduously as ever.

The Murphys had asked Bell to a dinner for "the great Bolshevik poet," Vladimir Mayakovski, which included the Fernand Légers, though not the Picassos. Olga would not have liked it, nor did Bell. On a visit to Picasso's studio in 1922, Mayakovski had apparently urged Picasso "to go along with a pot of paint one night and decorate the walls [of the Chambre des Députés] while they aren't looking. . . . I saw a glint of alarm in Madame Picasso's eye."[3] Bell told Mary Hutchinson that Mayakovski "can't speak a word of French and seems a lout and has to be approached through his mistress, a pretty yellow round-headed Frenchified little thing. . . . After dinner . . . the poet danced a *pas seul* and went through some parlour evolutions all of which seemed supremely ridiculous."[4] And then the Murphys sang the folk songs and Negro spirituals that Gerald had learned at the Yale Glee Club.

On December 4 Picasso attended the opening of *Relâche* with scenario and décor

by Picabia, music by Satie, choreography by Borlin.[5] Having worked closely and happily with Satie, he was eager to see how the composer had fared with the dadaist *Relâche.* It turned out to be as iconoclastic as *Mercure,* though not quite as sardonic or brilliant. Once again, Satie served up a subtly subversive, deceptively simplistic score, which he categorized as "obscene" on the grounds that it derived from two famously bawdy ditties, "Cadette Rousselle" and "Le Père Dupanloup." There were quotes, too, from Chopin's "Marche Funèbre." The collaborators had roles in the actual performance. Satie and Picabia drove around "the stage in Borlin's five-horsepower motor-scooter chair, gleefully waving to the jeering . . . cheering crowd they had so magnificently ridiculed."[6] De Maré had thoughtfully provided the audience with whistles, the better to jeer with.

After only twelve performances, a strip of paper printed with the word *relâche,* meaning "closure" (no performance), was pasted across ballet posters, emblazoned ironically with the very same word. *Relâche* had been almost universally panned, as de Maré and his collaborators had intended—at least so they said. To celebrate this flop, whose considerable costs would contribute to the end of the Ballets Suédois, de Maré gave a New Year's Eve dinner at the Boeuf sur le Toit.

Satie's cirrhosis had reached a terminal phase. At first, he continued to commute from Arcueil to see Braque or Derain or Milhaud, but this became too taxing and he moved back to central Paris: first to a hotel, later to the Hôpital Saint-Joseph, where Beaumont had endowed a ward. Satie's friends vied with each other in their support. Milhaud and the woman he was about to marry paid daily visits; Brancusi, a devoted admirer, brought yogurt and chicken soup that he made in his studio; Valentine Hugo arrived with suitable handkerchiefs; Maritain with a suitable priest, described by the invalid as "looking like a Modigliani, black on a blue background."[7] When pleurisy caused Satie's temperature to soar, Picasso and the painter Survage would change his sweat-soaked sheets. It is a measure of his regard for Satie that Picasso was able to overcome his fear of illness.

Satie died on July 1, 1925; his last words were "Ah! The cows . . ." The funeral took place five days later. Like several other friends, Picasso had already left Paris for the summer. He chose not to return to Arcueil for the funeral; it would have been too painful. He had come to trust and love Satie, not least for the intricacy and perversity of his wit, more than anyone since Apollinaire. One of Satie's friends described the congregation: "only the smart, leisured, homosexual set was well represented. But the . . . good people of Arcueil, café companions and others, followed the cortège."[8] As for the former associates whom Satie had denounced for betraying him, Poulenc stayed away; Auric appeared "stricken [with] the same hangdog expression he wore at the première of *Les Matelots . . .* very close to tears [and] Cocteau sobbed rather noisily."[9] Brancusi was devastated. He promised to do a

sculpture for the grave and Beaumont promised to pay for it, but nothing would ever come of this. Later in the summer, Picasso would commemorate Satie's death covertly in a dark, ambiguous still life.[10]

The wretched apartment at Arcueil, which Satie would never allow his friends to visit, turned out to be filthy: a weird combination of meticulous order and quirkish mess. Dozens of umbrellas still in their wrappings lurked in corners. If Satie ever took one out in the rain, he was careful to keep it dry under his overcoat. "The piano pedals had been repaired with string and behind the instrument long lost manuscripts were found. . . . Milhaud tells us that the wall of the house opposite was emblazoned with the words, 'this house is haunted by the devil.' "[11]

Death was much in the air that spring and summer of 1925, leaving Picasso with a lot to exorcise. Some months before Satie's end, the death of someone Picasso had known much longer, but avoided in recent years, Ramon Pichot, cast an even darker shadow on his life and work. The guilt and grief that this loss entailed inspired that allegorical masterpiece *La Danse*.[12] Shortly before Christmas 1924, Picasso had been summoned to Montmartre to the sickbed of this Catalan painter turned rare-book dealer, who had been his most supportive friend in early years.[13]

Picasso. *La Danse* (1925) shown in 1960 with Lee Miller, Picasso's wife Jacqueline, Roland Penrose, and the artist at Notre-Dame-de-Vie. Photograph by Lee Miller. Lee Miller Archives, England.

Pichot had lent Picasso his Barcelona studio in 1900. With his sister, the Wagnerian singer Maria Gay, Pichot had also arranged for Picasso and Fernande Olivier to spend the summer of 1910—a period of crisis for cubism—with them at Cadaqués, where the Pichots had a house. Unfortunately, when Picasso broke up with Fernande in 1912, Pichot had loyally sided with the old love against the new one, Eva Gouel, and was instantly dropped from the artist's *tertulia*.

But now Pichot was dying from the combined effects of syphilis, tuberculosis, and a weak heart—dying, what is more, in La Maison Rose, the Montmartre house that Pichot's mother had bought for him when he married Germaine Gargallo: Picasso's former mis-

tress and the unwitting cause of Casagemas's suicide.[14] Pichot had gone through most of his money and Germaine had been running La Maison Rose as a bistro. Always ready to forgive his Catalan friends anything they did, short of faking his work, Picasso hurried over to provide whatever help he could. Pichot rallied and then there was a relapse. He died on March 1, 1925. Germaine lived on until 1948, sporadically provided for by Picasso. The demons unleashed by this deathbed reconciliation could only be exorcised in paint, as they had been after Casagemas's suicide in the greatest of Blue period paintings, *La Vie.*

La Danse had started life as a balletic Three Graces: a subject Picasso had addressed in 1923 at the height of his classical phase for the decorative panels commissioned by Beaumont.[15] Since then, Picasso's attitude toward classicism had turned increasingly to parody, as in *Mercure*'s campy Bath of the Graces. Over the next three months, he would transform his Three Graces into what is now known as *La Danse*—a title that Picasso disowned,[16] since "the painting is above all connected with his misery on hearing of the death of his old friend."[17] "It should be called *The Death of Pichot*," he said.[18]

Before reworking this vast canvas (215 × 142 cm), Picasso accepted an invitation from Diaghilev to take his family to Monte Carlo to celebrate Russian Easter. Kochno was sent to Paris to escort them onto the Blue Train and install them. Diaghilev, who was frantically trying to raise money for his more than usually penniless company, wanted Picasso to collaborate on another sellout ballet like *Tricorne.* However, Picasso had turned against the ballet; it was too distracting and time-wasting. Nevertheless, he agreed to draw some of the dancers for the commemorative program. He also did an Ingresque portrait of Enrico Cecchetti,[19] the venerable *maître de ballet* whom Diaghilev had lured to Monte Carlo to shape up his torpid dancers. The new young star Danilova was so heavy her partner, Dolin, said he felt like "a piano mover."

As usual, Diaghilev had other favors to ask, among them a bookplate for the library of Russian books that Kochno was assembling for him. Picasso promised to design one that would be a "quatrain in a universal language . . . objects rhyme, as words do, in painting melon rhymes with mandolin."[20] A lyrical still life, the *Red Tablecloth*,[21] done

Picasso. *Portrait of Enrico Cecchetti,* 1925. Pencil on paper, 34 x 26 cm. Collection Jan Krugier and Marie-Anne Krugier-Poniatowski.

the previous December, makes it clear that melon is a perfect rhyme for mandolin. Picasso never did the bookplate, nor did he grant Diaghilev another request: a portrait of his handsome new protégé, Serge Lifar. Picasso had no desire to draw this starstruck narcissist and sent him away.[22] Lifar's mendacious memoir omits this humiliation. Told that Diaghilev had arranged for an unnamed artist to draw him, he had thrown a tantrum at being asked to waste precious rehearsal time. Only later did he discover that the unnamed artist was Picasso. Although Lifar subsequently said he sat for the artist at Monte Carlo, no such portrait has come to light, nor have the twenty-five drawings that Picasso supposedly did of him in *Zéphire et Flore.*[23] The only reference to Lifar in Picasso's Monte Carlo drawings is a forgettable sketch with the young dancer Khoer, who had escaped with him from Kiev two years before.[24] Without the *dédicace,* nobody recognized one of them was Lifar.[25]

A painting, originally entitled *Odalisque,* that Picasso would execute back in Paris may or may not have been commissioned by Diaghilev. It is a large (97 x 130 cm) horizontal canvas[26] after a publicity photograph of the fiery flamenco dancer María d'Albaicín[27] (see page 309), whom Picasso had first met when she was starring in *Cuadro flamenco.* Diaghilev kept her in the company, although she was unable to adapt to classic choreography. Eventually, a suitable role was found for her as Scheherazade in a divertissement for Diaghilev's ill-fated revival of the *Sleeping Princess.* Albaicín "was carried in on an exquisite white sedan-chair, and although she had little to do but sway her body and make exotic gestures with her hands, she created a sensation."[28] Although Diaghilev had commissioned Gris to do a drawing of d'Albaicín for the program—as compensation for having lost *Cuadro flamenco* to Picasso—he may have suggested that Picasso also do a painting of her. Picasso may have had an affair with her. Albaicín had an inane Argentinian lover in tow, but that would not have discouraged Picasso or her. Like him, d'Albaicín was Andalusian and famous for her sinuous sexuality and the staccato of her castanets. She might even have been the reason why Picasso stayed longer than he had intended in Monte Carlo.

In his 1998 Matisse and Picasso essay, Yve Alain-Bois sees this painting as a prime example of Picasso infringing "explicitly on Matisse's terrain," as typified by Matisse's *Odalisque, with a Tambourine.*[29] Bois is right to say Picasso "infringes," but, given this odalisque's origins in a photograph and the fact that it is likely to have been painted first, I do not see it infringing "explicitly," except in the teasing, playful use of Matisse's generic title.

That so many Russian grandees had taken refuge in Monte Carlo pleased Olga. One of the most prominent was Matilda Kchessinskaya, who owned a villa on Cap d'Ail. This chubby, once ravishing star of the old Imperial Ballet had been the mistress of the Tsarevich (later Tsar Nicholas). On his marriage, she had been passed on

to Grand Duke Andrei and was now married to Grand Duke Michael. He and other members of the imperial family were living, most improvidently, off whatever they had been able to smuggle out of Russia, notably Kchessinskaya's million rubles' worth of jewels. Picasso remembered visiting one or two of the grand-ducal villas, among them the imposing Villa Kasbek at Cannes. Picasso had been amazed, he said, by the profligacy of these exiles: the gambling and boozing, the childish games of hide-and-seek in closets full of ball dresses and uniforms, and the hangers-on (these included Kchessinskaya's "faithful jester" the female impersonator Baron Gotch).[30] Their frivolity did them in. Her jewels sold, Kchessinskaya ended up running a ballet school.

Serge Lifar in *Zéphire et Flore,* 1925. Bibliothèque de l'Opéra, Paris.

In gratitude to the Princess of Monaco and her consort, Prince Pierre, for letting his company use the principality as their base, Diaghilev expected his stars to pander to them—do whatever they could to keep the Grimaldi family happy. When Princess Charlotte needed to regain her figure after Prince Rainier's birth, Tchernicheva gave her exercises to do. When Prince Pierre's glamorous cousin, Daisy Fellowes, wanted ballet lessons, Sokolova was dispatched to her villa. The lessons were abruptly discontinued when Diaghilev discovered that Mrs. Fellowes had given the innocent Sokolova cocaine to cure a headache.

Rather than attend social occasions Picasso preferred to hang out with the dancers and draw them rehearsing Massine's new ballets. One was *Les Matelots,* with music by Auric and décor by the Catalan Pedro Pruna. According to Paul Morand, Pruna was "Picasso's latest discovery,"[31] He and another Catalan, the sculptor Apel-les Fenosa, had visited Picasso's studio in 1923. Originally mistrustful, they both became passionate devotees of the man and his work. Among other kindnesses, Picasso had arranged for Level to give them a combined show at his Galerie Percier in January 1924, with a catalog text by Max Jacob, who would later encourage Pruna to follow his example and become an oblate like him, though in a Spanish monastery. Urged, presumably by Picasso, who would act as best man at his marriage later in the year, Diaghilev was sufficiently impressed to commission Pruna to do the décor for *Les Matelots.*

Massine's other ballet, *Zéphire et Flore,* had décor by Braque, a scenario by Kochno, and music by Diaghilev's new prodigy, Vladimir Dukelsky: a prodigiously gifted twenty-year-old friend of Kochno's, described by the impresario as his "third son,"[32] Stravinsky and Prokofiev being the other two. Vernon Duke, as he renamed

himself, would soon win fame as a composer of jazz in America. Kochno's scenario for *Zéphire et Flore*—a mythological masque, such as an eighteenth-century nobleman might have had his serfs perform in his private theater—turned out to be too precious, Dukelsky's score too characterless,[33] and Braque's sets too painterly to find favor with the public.

Braque, who had arrived in Monte Carlo two days after the Picassos, had none of his old friend's stagecraft to draw on and was averse to acquiring any. Picasso's all too evident absorption into Diaghilev's effete world left Braque worried about the state of his old friend's integrity. He felt out of place in Monte Carlo and when not working would sit "in his bowler hat and bow-tie in the exotic gardens of the casino."[34] Whereas Picasso, elegantly turned out in a navy blue jacket and white trousers, would dart about posing for snapshots on the beach with Olga looking sublimely happy and the ballet boys showing off their muscles. In one of the snapshots Picasso has pulled down the shoulder strap of his bathing suit like the dancers'; in another he has hoisted Paulo up on his shoulders.

A harmonious stage picture into which the dancers would blend is what Braque was out to create. In this respect his costumes for *Les Fâcheux* the year before had functioned too well: like camouflage, in that dancers tended to vanish into the scenery. The same with *Zéphire et Flore:* the dancers did not appreciate the artistry of this effect. Prince Schervachidze, the scene painter who had done wonders with Picasso's *Train bleu,* interpreted Braque's backcloth so sensitively that it was acclaimed as if it were the original. Braque's costumes were as beautiful and unsuitable as the ones for *Les Fâcheux:* invisible when they blended in; oddly eye-catching (Lifar's gold lamé shorts and Dolin's flower-petal tunic) when they did not. Poulenc wrote Picasso that "They simply killed the choreography."[35] Although Braque's inherent painterliness was unsuited to romantic ballet, Diaghilev made the mistake of asking him to design a set for *Les Sylphides.* He then compounded the mistake by disregarding Braque's explicit injunction not to work from his designs until they were finished. Braque promptly applied for a restraining order against the ballet company. He won and would not return to stage design for another twenty years.[36] To back up his claim that collaboration was not his forte, the composer Francis Poulenc quotes Braque as saying it was "bad enough taking three people into account—choreographer, painter, and musician—if you have to include a writer as well, all unity is sacrificed."[37]

Dukelsky fared little better than Braque. Like his god, George Gershwin, his real forte was jazz. Diaghilev detested jazz and would be furious to arrive at a rehearsal to find Dukelsky playing "Lady Be Good" or some other popular song, with Lifar, Kochno, and Dolin clustered around the piano.[38] Out of Diaghilev's sight, the boys and girls of the corps de ballet could jive away while Dukelsky strummed and

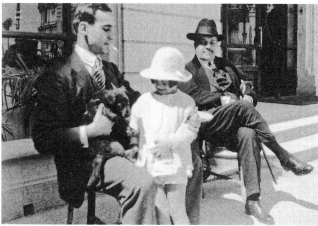

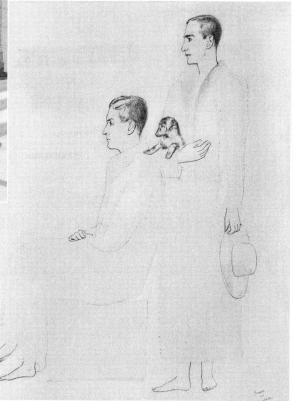

Top: Picasso and Olga with dancers on the beach at Monte Carlo, c. 1925.

Above: Boris Kochno, Paulo Picasso, and Diaghilev in Monte Carlo, 1925.

Right: Pere Pruna. *Vernon Duke and Boris Kochno,* 1925. Colored crayons on paper, 61 x 48 cm. Bibliothèque de l'Opera, Paris.

Picasso drew. The frenzied syncopation of the Charleston would continue to reverberate in the artist's memory. The day after the disappointing premiere of *Zéphire et Flore,* Diaghilev and the company left for Barcelona. The Picassos, who were looking for a summer rental, stayed on in Monte Carlo so long that Rosenberg wrote asking whether he had become Monégasque.[39] This early in the season, they were able to find exactly what they wanted at Juan-les-Pins, and would return a month later.

Back in Paris in early May, Picasso got down to reworking *La Danse.* He put everything into it—above all, his "blood and guts," as he said a year later when asked what his art was about.[40] Most radical were the changes to the left-hand side of the composition. Memories of the dancers shimmying away to Dukelsky's ragtime enabled him to galvanize this figure to the point of menace. To sharpen the focus and tonal contrasts, Picasso has set his figures against a bright, malevolent Monégasque sky. The crucificial dancer at the center is usually said to stand for Olga: her terse little dash of a mouth; her right leg as stiff and straight as if still in plaster; and—a surprise from someone as genitally focused as Picasso—nothing, but nothing, between her thighs.

The Dionysiac dancer on the left is the antithesis of the central figure. Picasso has punched a hole in her pelvis and reassembled her face as a vagina dentata. She is a maenad all right, a maenad fresh from slaying Orpheus, but she also has a dash of Nina Payne, the American tap dancer, who was "the rage of the Riviera" and the girlfriend of Dukelsky at the time.[41] There may also be a dash of Zelda Fitzgerald, who still aspired to be a dancer. This maenad may be the worse for cocktails or cocaine, but she is not, to my mind, convulsed in *une grande attaque hysterique,* as scholars who envisage her in the Bretonian gaslight of Dr. Charcot's clinical photographs like to think.[42] She is dancing a demonic Charleston. The notion of a Charleston tallies with a fantasy Picasso had described to Diaghilev: "a chorus of music-hall girls [coming] on stage to the music intended for a procession of bacchantes"—and then performing "a French can-can number."[43]

Several decades ago, my Jazz Age interpretation of *La Danse* resulted in Lawrence Gowing—a distinguished British painter and critic of the time—accusing me of defiling a masterpiece. But the girl *is* dancing the Charleston. Gowing's failure to face up to the contemporary nature of Picasso's vision typifies his generational failure to understand the enormous historical and cultural resonance and relevance—of the way Picasso has plugged the modernity of *La Danse* into the savagery of antiquity.

As for Pichot, the pretext for *La Danse,* he manifests himself in the form of a dark, sinister silhouette at the back. This effigy of death merges with the right-hand dancer, who extends an apparently co-owned hand in a white glove, behind the cen-

tral figure's back, to the dancer on the left. The portrayal of Pichot as a dancer might also refer to the Rousseau banquet in 1908, when he "danced a wonderful religious Spanish dance ending in making of himself a crucified Christ upon the floor."[44] It would be very typical of Picasso to invoke the crucifixion in order to conjure up intimations of darkness and death. *La Danse* is one of Picasso's most profound and mysterious paintings.

As soon as he completed the masterpiece, Picasso showed it to Breton, who instantly saw its potential as a surrealist icon. Breton arranged to have it photographed by Man Ray. On June 9 he sent Picasso a letter on paper headed *La Révolution Surréaliste,* abjectly apologizing for the poor quality of Man Ray's photographs. He was desperate that his journal should be the first to publish this painting and hoped that Picasso would overlook *"cette imperfection de détail."*[45] Were Picasso to have second thoughts, he should telephone the following day. Breton could not wait to exploit *La Danse.* Asked in later years about the surrealists' adoption of it, Picasso would cite the Pichot connection. My own feeling is that *La Danse* is convulsive, which does not necessarily mean that it is surrealist. It is sur-realist in the original meaning of the term Apollinaire invented.

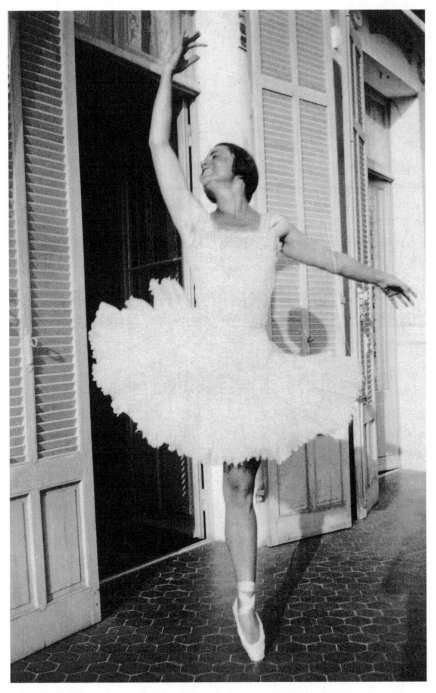

Olga posing in a tutu at Villa Belle Rose, Juan-les-Pins, 1925. Photograph probably taken by Picasso

23

The Villa Belle Rose (Summer 1925)

Around June 10–11 the Picassos returned to the Midi, once again to Juan-les-Pins, which had become *the* place for the Boeuf sur le Toit crowd to spend the summer working on the now obligatory tan. They settled into the Villa Belle Rose, a large house in a large garden, situated in the town rather than by the sea. This summer Picasso made no drawings of the house; however, a great many snapshots were taken, so we have a good idea of this long-gone villa, which was the setting for this summer's series of large, powerful paintings, stemming from *La Danse*. In these works, Picasso delved ever deeper into his labyrinthine psyche. The surrealists have taken credit for the psychic power of this summer's achievements—unjustifiably, as Picasso made clear to Penrose: "We [cubists] wanted to go deep into things. What was wrong with [the] Surrealists was that they did not go inside, they took the surface effects of the subconscious. They did not understand the inside of the object or themselves."[1]

Now that he had extricated himself from overt neoclassicism, Picasso set about extricating himself from the mandarin atmosphere of the Ballets Russes: no easy task, given his and his wife's involvement with Diaghilev. Breton's canonization of him had certainly helped Picasso to reestablish himself as the spearhead of the avant-garde, but there was a price to pay. Breton was determined that Picasso should come out in support of his recent manifesto, *Le Surréalisme et la peinture.*[2] The artist was determined to keep his distance. Breton was relentless in this game of quid pro quo, so relentless that he spent July at Nice, trying to get Picasso to lend important recent works to his inaugural exhibit of surrealist painting at the Galerie Pierre in November. Picasso refused to commit himself; in the end Breton got very little. Breton would have far more success with Miró, Ernst, and Masson, and later Dalí, so much so that the poets who had founded the movement would find themselves eclipsed by the painters. However, the painters would end up supporting their impecunious brother poets with a constant supply of saleable drawings, which enabled some of them—Eluard in particular—to become virtual art dealers.

Other visitors to Juan-Les-Pins included the ambitious André Masson and his

Olga curtsying in the garden at Villa Belle Rose, Juan-les-Pins, 1925.

wife Rose. On money borrowed from Doucet they had rented the ground floor of a villa, as well as a beach cabana. They were anxious to get to know Picasso and counted on Breton, whose portrait Masson had recently painted,[3] to bring this about. The two artists would meet but never become close friends. Picasso felt that Masson was destabilizing and softening cubism—*his* cubism—and turning it into an art nouveau meltdown. He accused Masson to his face of "setting cubism up on a pedestal, the better to knock it off."[4] Another possible reason for Picasso's coolness toward Masson was that he was the first artist Kahnweiler had signed up since 1914. Masson had effectively stepped into Picasso's old shoes as the gallery's leading light.

Kahnweiler arrived at Antibes on August 1 and spent two weeks at the Hôtel Josse. He had driven down with his wife Lucie, her elder sister Berthe, known as Béro, with her painter husband Elie Lascaux, as well as Lucie's younger "sister,"[5] Louise Godon, known as Zette, who was in fact Lucie Kahnweiler's illegitimate daughter. Zette was accompanied by her fiancé, Michel Leiris, soon to become celebrated as a poet and ethnographer and, later, the author of one of the finest and most self-lacerating of modern memoirs, *L'Age d'homme.* Hitherto, Zette had refused Leiris's marriage proposal. This strange, brilliant young suitor would have qualified a generation earlier as a *poète maudit*. It was not until they drove down together from Paris that he was able to persuade Zette to marry him. Despite bouts of manic drinking and attempted suicides, the marriage would work out well. Over the next few years, Leiris would become one of Picasso's closest, most trusted, and enlightening friends—an antidote to both Cocteau and Breton. Zette, too, would come to play a major part in the artist's life. She would eventually run the gallery of her stepfather, Kahnweiler, which he would have the foresight to Aryanize as the Galerie Louise Leiris shortly before World War II.[6]

Leiris was tortured by guilt, dread, and self-deprecating shame as he confesses to feeling in his autobiographical writings. To conceal the effects of the "barber's rash" he had suffered from in his twenties, he had covered "his entire face with powder as white as talcum."[7] On one occasion he asked Juan Gris to take a razor blade and carve a parting from the nape of his neck to the center of his forehead "to give himself a geometric air or a *'sorte d'Adam divin ou de constellation.'* "[8] Surprisingly,

Leiris is the only one of Picasso's close poet friends whom he never portrayed; the artist did, however, give Leiris a drawing of Verlaine that looks like him. In the 1960s, Leiris would develop a passion for another painter, Francis Bacon, who would repair this omission. Bacon's flayed-looking portraits of him are anguish made palpable.

Besides an obsession with primitive art, Picasso and Leiris shared a deep interest in shamanism and the concept of Eros and Thanatos, which, in Leiris's case, manifested itself in an obsession with suicide and castration. Decades later Picasso was upset but not in the least surprised when, in May 1957, Leiris swallowed enough phenobarbital to put him in a coma for three days and necessitate a tracheotomy.[9] Thanks to Zette, he would survive this and other near-fatal incidents and live to be eighty-nine.

Michel Leiris, c. 1925, from Leiris's *Miroir de l'Afrique,* edited by Jean Jamin.

T his summer, Picasso was too focused on his work to waste much time with the Murphys, but Olga and Paulo often spent the morning and afternoon with them. Sara and Gerald had just about finished rebuilding and redecorating the house they had bought two years before and renamed Villa America. The décor of this house was 1920s minimal: black tiled floors, white walls, black satin sofas, stainless steel furniture, as well as café chairs and tables that had been silvered. With a number of helpers, Gerald replanned the superb garden, which had a panoramic view of the coast.[10] Picasso shared Gerald's taste for ragtime and would frequently borrow his records—Jelly Roll Morton and later Louis Armstrong—and recalled Zelda Fitzgerald doing a solitary, self-absorbed dance to them. Gerald would be very irritated when the records were not returned.

There was a large staff at the Villa America: a cook and maid or two, a nanny, a Mam'zelle, a chauffeur, a farmer (the Murphys had their own cows and chickens), and a young cousin of Diaghilev's, who served as a studio assistant, tutor, court jester, chef, and skipper of Gerald's various boats. There were guest cottages, one of which, La Ferme des Orangers, was renamed "la Ferme Dérangée" by Robert Benchley.[11] John Dos Passos complained that the Villa America was too much. "Fond as I was of [the Murphys]," Dos Passos wrote, "I could stand it for about four days. It was like trying to live in heaven. I had to get back down to earth."[12] Except for the reference to heaven, Picasso would have agreed.

Many a morning, Sara would send a car for Paulo and his nanny to join her three children on the Plage de la Garoupe. Later, the Murphys and their guests would

The Murphys' Villa America, c. 1925.
Beinecke Rare Book and Manuscript
Library, Yale University, © Estate of
Honoria Murphy Donnelly, VAGA.

come down to the beach and swim and sunbathe before being served an excellent American-style lunch under a linden tree. Picasso enjoyed the sweet corn they grew; hitherto he had regarded it as cattle fodder. After lunch, the children would take a siesta in the garden. On one of these occasions,

> little Paulo enlivened the children's siesta hour by gravely instructing them on the different parts of the anatomy, with particular attention to the ways boys are different from girls. After their naps there would be . . . a treasure hunt or a costume party. Or there might be a children's art show, which the Murphys called the Salon de la Jeunesse, for which Picasso served as organizer and judge.[13]

Antibes had become so fashionable that, as Scott Fitzgerald joked, there was no one there except for himself and Zelda, the Rudolf Valentinos, the Murphys, Mistinguett, ex-premier Orlando of Italy, and Etienne de Beaumont. In addition, there were the Murphys' bright young American friends—Donald Ogden Stewart, the Dos Passoses, MacLeishes, Benchleys, Philip Barrys, and, after 1926, Hemingway, who was changing wives. With Picasso as a magnet, "interesting" people gravitated to the Murphys—not that this calculation would have entered their hospitable heads.

At one of the Murphys' alfresco dinners—one that the Picassos are likely to have attended—Fitzgerald behaved so churlishly that he was banned from the house. Enraged at Robert McAlmon's suggestion that he was a closet homosexual, Fitzgerald sought to refute this by subjecting the gifted young pianist, painter, and writer Eugene McCown to a barrage of homophobic taunts. He then retired to the vegetable garden and threw ripe figs at the bare back of the Princesse de Caraman-Chimay until Archie MacLeish "knocked him cold."[14]

The razzmatazz of life at the Villa America amused Picasso—up to a point. When his work was going full blast, as it was this summer, he became fiercely self-absorbed and easily angered, especially in the company of strangers and people who did not

speak his languages. In this respect his fellow countrymen, especially painters, were all the more welcome. This summer, several of the so-called School of Paris Spaniards—Manuel Ángeles Ortiz, Francisco Bores, and Joaquín Peinado—came to pay their respects to Picasso, as a photograph of them all with Olga and Paulo outside Villa Belle Rose reveals.[15]

Ortiz had been introduced to Picasso by Falla. This fascinating but not especially gifted Andalusian had grown up in Granada and been a childhood friend of the great Spanish poet, Federico García Lorca (his child's godfather). Ortiz had been so shattered by the death of his wife in childbirth that he had taken to sleeping with his arms wrapped around her death mask. To console Ortiz, Lorca took him on expeditions throughout Andalusia in quest of cante jondo—sounds that Lorca described as "naked and blood curdling."[16] They became so proficient that they could even communicate in cante jondo. This would make for a close bond with Picasso, who shared this passion. The rumor that he sometimes used Ortiz as an assistant is likely to be true.[17] Given the scale of his work this summer he would have needed help. At the time that the photograph with the Picassos was taken, Ortiz would arrange, at the behest of Lorca—who never came to France and therefore never met the artist—an introduction for Salvador Dalí to meet Picasso. After fleeing Spain, Ortiz was interned by the French in a concentration camp, Picasso rescued him, as he did many other refugees from fascism.

The most successful of the "School of Paris Spaniards" was Francisco Bores, who had moved to Paris in 1925. After flirting with the surrealists, he adopted his fellow countryman, Juan Gris, as his guide. By 1927 Bores had forged a sensitive cubistic style which appealed to collectors who preferred subjects to be, as it were, hummable. Picasso liked Bores but was never particularly close to him. He had more in common with the less successful Peinado, whose passionate *afición* was a match for his own. At the Salon d'Automne (1923), Picasso had "stopped suddenly before a painting and said to a friend: 'That must be by a Spaniard.' It turned out to be by Peinado, recently arrived from his native Ronda; [Picasso] asked that he come to see him and made him a member of his intimate circle."[18]

At the outset of this triumphant summer, Picasso reestablished, if only temporarily, his on-again, off-again friendship with the immensely gifted, infinitely erratic Picabia. This French-Cuban-Spanish jack-of-all-styles turned dadaist pioneer had recently inherited a fortune from an uncle and built himself a large, ugly Mauresque villa at Mougins, just west of Cannes. He painted it ochre and vermilion and filled it with some good cubist and dadaist art (Picabia's wife, Gabrielle Buffet-Picabia, was a *marchand amateur*) as well as a vast stash of junk model sailboats,

tourist trinkets, gaudy bibelots, and Spanish *bondieuseries.* He also filled his garages with a collection of expensive cars, Rolls-Royces for preference. Picabia called his house the Château de Mai; it was soon throbbing with guests, among them Picasso.

Their enjoyment of black humor and of women ensured that the two men got on extremely well. They were about the same height and build and, more to the point, widely perceived as the principal perpetrators of whatever was new and shocking in art. Since their names started with the same four letters, they were often confused with one another. Picasso used this coincidence to his advantage. He told friends that if involved in an embarrassing incident, he gave his name as Picabia. Léonce Rosenberg dubbed them *les deux Picas.* Picabia would simultaneously mock Picasso's cubist paintings as *"cathédrales de merde"*[19] and praise him (Paris, 1922) as "the only painter I like";[20] or find fault with his neoclassicism as he did in 1923—"his work is now more antique than Cormon's; it is painting for antiques dealers";[21] or, as he did this summer, work in tandem with him.

Picabia's anarchic fervor, his reckless disregard for loyalties or commitments or considerations of personal or artistic integrity, amused Picasso. When, as sometimes happened, expenditure on women, cars, yachts, houses, not to mention baccarat, left Picabia temporarily broke, he would churn out whatever schlock the market called for. His first wife says that when his fortune evaporated in the 1930s, Picabia contracted through a North African dealer to supply the king of Morocco's palaces with soft-porn paintings—a devaluation of his own powers, one might have thought amounting to iconoclastic suicide. However, according to Gabrielle, even his schlock had *une aura mystérieuse.*[22]

That Picasso and Picabia's sons, Paulo and Lorenzo, were about the same age had helped to trigger this new camaraderie. The families would go swimming together—in Picabia's pool or off one of his boats, and as snapshots reveal, end up picnicking on the beach. According to Picabia's second "wife,"[23] Germaine Everling, the two men shared "the same mordant wit and were attracted to the same outlandish curiosities"; quite independently, they would appear wearing almost identical clothes and shoes fitted with identical heels designed to add an extra inch of height.[24] Away from the dada-surrealist war zone, they turned out to have more in common than either might have thought.

The outrageous, multivaginal *Kiss*[25] that launched Picasso's work this summer owes a very great deal to Picabia. Before determining what this magnificent obscenity is about, we need to figure out what it represents. A woman in a lattice-patterned dress is sitting on the beach with her back to the sea, her arms folded in front of her. Behind her a jug-eared man clutches her in his hairy, reddish arms, one around her shoulder, the other around her waist. His legs extend on either side of her and terminate on the right in the hob-nailed sole of a shoe, and on the left in a striped trouser

Above: Picabia, Olga, Picasso, and Germaine Everling at Château de Mai, 1925. Photograph by Poupard-Lieussou.
Left: Picabia. *Mardi Gras (The Kiss),* 1925. Ripolin on canvas, 92 x 73 cm. Private collection.

leg and the other shoe. The man's huge face and the woman's smaller one look out at us fused in a kiss, phallic noses almost touching, vaginal eyes and mouths agape in an organic free-for-all. Yet another vagina—oculata rather than dentata—is set like a target between her huge feet. Others see this image differently. Cowling argues that it represents a mother clutching and kissing a child.[26] And, indeed, the man's left arm (upper right), with its tattoo of what may be a snake, looks a bit like a baby. This confusion is likely to have been intentional. Picasso loved to deceive his viewers— "Cubism was full of deception," he told Penrose[27]—so as to keep people looking and guessing and looking again.

Picabia had painted his *Kiss*[28] a few months earlier than Picasso. It is one of a series of works, dubbed "Monster paintings" by Duchamp, that were inspired by the Mi-Carême Bacchanalia at Nice. "I am doing a lot of work [Picabia wrote his friend, Pierre de Massot in March] in a whirlwind of baccarat, a whirlwind of legs, a whirlwind of jazz. I am doing mid-Lenten paintings [i.e. Carnival ones] of lovers, confetti paintings in which the sheen of cheap silk is duplicated by Ripolin."[29] Fifty years before the advent of pop, Picabia has used the energy and tawdriness of the Carnival scene—tarnished finery, caked makeup, candy floss hair—to administer a succession of painful shocks to conventional art lovers. In *La Lecture,* another of his Monster paintings (later owned by Tzara),[30] Picabia used large mouths slathered in Ripolin lipstick in place of the woman's eyes and matching vaginas in place of earrings. These relocations left an all too evident mark on Picasso's *Kiss,* as well as on some of the other genital faces of his it would spawn.

According to Gabrielle, Picabia thought that he had gone too far in these Monster

paintings. Much as he loved to shock, he may have feared that modernists would look askance at a style and technique so perfectly attuned to the sleazy underbelly of the Riviera. Gabrielle blamed her former husband's "disapproving entourage"—a euphemism for her successor, Germaine Everling—for persuading him to stash these paintings away. "He was going to destroy them," Gabrielle said, "but I begged him to do nothing of the sort since they manifested some of the most astonishing aspects of his personality."[31] Picasso likewise hid his *Kiss* away from prying eyes.[32] Dreading as he did accusations of plagiarism—usually from the very people who had plagiarized him—he would not have wanted to reveal his indebtedness to Picabia. We should also allow for the residual streak of bourgeois propriety that Olga had evoked in her husband's persona. He would have wanted to spare his wife and child and Spanish family the embarrassment of this wonderfully visceral image.

The colossal strides made by Picasso in one masterpiece after another between June 10 and the end of September 1925 can be followed in two successive sketchbooks. The earlier of these,[33] dated June 28–August 1, opens with drawings of a bather on a beach towel, which relate to *The Kiss*. Next come studies of an Empire clock that probably adorned a *cheminée* at the Villa Belle Rose. Picasso was attracted to the figure of Jupiter on top of it, poised to hurl a thunderbolt at anyone checking the time. This figure's tiny arm brandishing his celestial weapon inspired the huge plaster arm clutching a thunderbolt that dominates one of this summer's most celebrated paintings, MoMA's allegorical still life, *Studio with Plaster Head*.[34] Musical instruments have given way to a whole new dramatis personae of still-life objects, including plaster limbs, such as Picasso had drawn from as an adolescent art student.

Asked about the cluster of little buildings interspersed with bits of sky at the back of this painting, Picasso said it was a toy theater he had made for his son.[35] In fact, it was a model for the set he had done, four years earlier, for *Pulcinella*. Paulo is unlikely to have been allowed to play with this so-called toy; the dolls that his father would later make for his half-sister Paloma were considered too fragile for the rough-and-tumble of the nursery.[36] As we will see, the flight of steps that Picasso has added to this model has a symbolic significance.

Picasso. Study (detail) of the figure of Jupiter Tonans on top of a clock at Villa Belle Rose, Juan-les-Pins, June 1925. Pen and India ink on sketchbook page. Musée Picasso, Paris.

"What are we to make of the lone yellow and orange apple at the very heart of the composition?" William Rubin gives a surprising answer to his own question: "[Its] shape and scale suggests a breast."[37] A giant breast on the steps of a toy theater? It is not, of course, a breast; it is an orange: a reprise of the three oranges in the great Guggenheim still life of the previous year. The other two oranges take the rhyming form of concavities: one the plaster arm, the other inside the plaster leg, which are linked together by an olive branch. The concavities might refer to the fact that only one of the three oranges in Prokofiev's opera gives birth to a living princess. The other two are stillborn.

As for the batonlike thunderbolt brandished by the clock figure, this is traditionally an emblem of divine love and power; however, like many of Picasso's symbols, it can also stand for the reverse: vengefulness and cataclysmic violence. The carpenter's square introduces a new element into the artist's work: Freemasonry. Besides being a standard component of allegories of the arts, this tool is a principal attribute of the Masonic Master, "the great Architect of the Temple."[38] Freemasonry had fascinated Max Jacob and Apollinaire, and would later fascinate the surrealists. The carpenter's square symbolizes the Masons' cosmological belief that God is "the Light of the World," "the Divine Architect of the Universe," honorifics that Picasso would have identified with. We should also remember that Picasso and Braque had used the carpenter's square as the cornerstone of many of their cubist compositions; and that later Malevich had stripped the carpenter's square of its representational significance. In this *Studio with Plaster Head,* Picasso has given the tool back its meaning, enhanced with a mystical, masonic aura.

Gasman, who was the first to perceive the Masonic connection, thinks that in adding an arch and a flight of steps to the model theater Picasso sought to transform it into a Masonic temple.[39] She thinks that he regarded Masonry as a source of mystery and sacred power. What fascinated him was not the dogma but the hidden agenda of Freemasonry: that it had always been a secret society, also that the simple utensils used in Masonic rituals had a magical significance, like many of the utensils in his still lifes.

Lastly, what does the bust at the center of this ornate composition signify? Unlike other busts in Picasso's recent still lifes, it is not generically classical; nor is it a specific incarnation of evil—Nero, Caligula, Cagliostro, the Marquis de Sade—as has been suggested. Once again, Picasso comes up with an image that means different things to different people: it could refer to his own miraculous *mirada fuerte* power, Breton's arrogant glare, or Pichot's ominous silhouette in *La Danse.* Picasso likened his complex still lifes to parables. The more layers of meanings a parable has, the better.

ack to the Juan-les-Pins sketchbook. Halfway through, Picasso, who had been schooled to portray martyrdoms, switched to doing horrendous drawings of a beheading. The guillotine conjures up the abattoir, which is the source for the main motif of the next "still life of cruelty,"[40] *Ram's Head on a Table*. As Meyer Schapiro, who has coined that phrase, has pointed out, rams' heads figure in processions celebrating the execution of Louis XVI, a monarch who, as Gasman says, Picasso always associated with decapitation.[41] The painting was done around the *quatorze juillet* celebrations, so it might well constitute an allusive link between the ram's head and the monarch's fate.[42] Picasso used allusions—historical, personal, metaphysical, sexual—much as he used a hint of color or a pictorial pun to reinforce or, as he once said, "perfume" an image.

The *Ram's Head* conforms to the Spanish convention of *bodegón* painting: a kitchen array of fruit, vegetables, as well as fur, feather, and fin. Spanish masters—principally Zurbarán and Sánchez Cotán—would give these humble subjects a quasi-sacrificial dimension by arranging them as if on an altar. Picasso had already followed their example—notably in the early cubist *Bread and Fruit Dish on a Table*.[43] This time, however, his intentions are anything but sacred. We seem to be in a hellish kitchen. The artist likens the menacing mouth of the scorpion fish and the spiky sea urchin to a vagina dentata. Everything looks ready to bite, cut, sting, or poison. Like the shamanic fetishes Picasso would do the following March, this is an exorcistic painting, a protection against Olga's demons, which had been acting up earlier in the year. Although he gives no source for his information, Cabanne claims that Olga "was getting more and more difficult. The little ballerina had now become a violent, tyrannical woman, hating everyone, accusing her husband of unfaithfulness, Kahnweiler of shortchanging them, seeing enemies everywhere. There were more and more frequent painful family scenes; sometimes he actually thought she was losing her mind."[44] Jacqueline Picasso told me her husband had recounted similar stories.

So much for allegory. The definition and disposition of the objects owe much to Miró—specifically to his festive 1920 still life with a rabbit, rooster, and fish on a platter on a square tabletop tilted temptingly out at us.[45] This was the painting that "really got Picasso interested in my work," Miró said.[46] Picasso did not stay on in Paris for his compatriot's first show at the Galerie Pierre, June 12–27, 1925, but he had already seen everything in his studio. Miró's fusion of cubism with Catalan representationalism was very much to the taste of Picasso, who would soon help himself to the artist's new pictorial language. And although he would often belittle Miró's childlike, petit-bourgeois side—*"toujours la trotinette"* (always the scooter), he used

Still Life with Guitar and Oranges (private collection) at Villa Belle Rose, Juan-les-Pins, 1925.

to say[47]—Picasso never belittled his work, until it lost its edge and began ominously to bloat, twenty years later, after a prolonged visit to America.

The *Ram's Head* painting was originally conceived in stark contrasts of black and white, to which a few patches of color were added. It displays many of the same features as its predecessor, *Studio with Plaster Head.* The ram's dead eyes stare out at us as balefully as the similarly placed eye of the bust. Likewise, the hard-edged head of the scorpion fish harks back to the carpenter's square; and the scallop shells recall the clenched fingers of the plaster arms. Back in Paris, Picasso would do a much larger, emptier version of the *Still Life with Ram's Head* in grisaille.[48] The mournful colors evoke a seventeenth-century Spanish *Vanitas,* possibly a reference to Satie's recent death: the ram's head is likened to a lyre.[49]

A second Juan-les-Pins sketchbook[50] (dated August 20–September 13) charts an abrupt change of course. Besides a number of bifurcated heads—configurations which dominate the artist's imagery for the next year or so—there are sketches for all manner of subjects: standing figures, anthropomorphic monsters, fantastical still lifes, and a croquis for a decorative project: an interlocking circle of four black-and-white profiles. This was the first idea for a mosaic commissioned by Jean Hugo's hospitable friends, François de Gouy and Russell Greeley, for their *château de poche,* Clavary, near Grasse.[51]

By the end of Picasso's stay at Juan-les-Pins, allegorical magic had given way to cosmological concepts—the elements, no less. The large still lifes he completed before returning to Paris are composed of the same basics—the guitar, mandolin, and fruit dish—that he had repeatedly exploited for their metamorphic possibilities,

but this time their cosmological potential is what he was after. Two of these paintings involved sand, a material Picasso had used in previous summers, but never to such great effect as now. In the more tentative and presumably earlier of these works[52] Picasso has simply incised the outline of a mandolin and dish on a table into sandy pigment, the color of the night sky. Beaubourg's *Still Life* includes the same objects plus an additional instrument on a rather more substantial table.[53] The sound hole in the right-hand instrument doubles as the hole in a palette (palette/guitar: twin begetters of art). This time the paint is much sandier and therefore much more palpable. The tactile subtlety and muted colors of the surface hark back to Braque, who pioneered the use of additives in paint. In view of the impossibility of getting the sandy *matière* to adhere to a canvas on an easel, the artist presumably executed this painting flat on a tabletop or on the floor. This makes us feel we are looking down on a stretch of beach—stained with tar in places—which the surf is about to erase—something that Picasso enjoyed watching happen to the drawings he used to make in the wet sand with a stick. That it was painted soon after *The Kiss* and the *Still Life with Plaster Head* (all the same size) is a measure of how rich and varied this summer had been.

This cosmological still life would be bought from Rosenberg by Charles and Marie-Laure de Noailles and hung high from heavy cords contrived by Jean Michel Frank in a place of honor at the top of their exceedingly grand staircase. By virtue of its elemental simplicity and solemnity, this painting would mock the rococo grandeur of the nearby ballroom, where the Noailles gave dazzling parties for a very mixed bunch: the *gratin,* café society, and assorted painters, poets, and musicians, not to mention the chic gay world of which Marie-Laure was an honorary member.

When the great paintings of this summer were exhibited at Rosenberg's gallery the following summer, in a show devoted to Picasso's work of the previous twenty years, Picasso was seen to have taken still life to previously unclimbed heights and unfathomed profundities. The finest of these works make considerable demands on the viewer. However, there was one remarkable exception, *Still Life with Fishing Net:*[54] a fruit dish brimming over with grapes, a glass tumbler, and a solitary fig on a table beautifully incised with a gauzy veil of fishing net. This work reveals what a seductive painter Picasso could be when he wanted to, without recourse to decorative, Matissean trappings. So gorgeous and, one would imagine, so instantly saleable was *Still Life with Fishing Net* that Rosenberg decided to keep it for himself. It was the quintessence of what the dealer hoped all too vainly that Picasso would produce more of. Although most of Rosenberg's private collection of Picassos has been dispersed, *Still Life with Fishing Net* has remained in his family—and is still in the possession of the dealer's granddaughter.

24

Masterpiece Studio (1925–26)

Picasso returned to Paris at the end of September 1925, the proprietor at last of the fourth and fifth floors of 23, rue la Boétie. He could also have acquired the apartment below—that is to say the third floor—but he was not prepared to pay the extra twenty-five thousand francs a year the landlord asked. Rosenberg told him that he or his brother-in-law, Jacques Helft, might be interested.[1] In the end, a tailor took it.[2] Although Rosenberg had acted on his behalf, Picasso had taken against him and failed to communicate during the summer. "I am beginning to be seriously worried," Rosenberg wrote. "Never have you left me so long without news. Write to reassure me."[3] Picasso does not appear to have done so.

To convert an enfilade of conventional reception rooms into studios, Picasso took off most of the doors, knocked down a few walls, but left the ornate cornices, moldings, and chair rails, also some of the old wallpaper in place. He brought in a few favorite bits of furniture, including the chair embroidered by Olga that he used for portraits, and his vast arsenal of materials. Now that he had a whole floor to himself—with its own front door entrance by invitation only, even to Olga—Picasso was able to return to his promiscuous ways. He could see all he wanted of old Bohemian friends and entertain new girls picked up in his quest for *l'amour fou.* Leiris frequently accompanied him on his nocturnal rambles. Picasso usually made out. Leiris usually failed—ending up at "orgies childishly begged for and always botched."[4] They both loved the black bars, which Josephine Baker's spectacular success in the Revue Nègre had launched in Paris. Their favorite ones were the Bal Nègre on rue Blomet, where Miró and Masson had studios, and Le Grand Duc, where the charismatic Bricktop (Ada Smith), a paleish, heavily freckled black woman with a gravelly voice, would hold sway for half a century. Sometime in the 1950s, Picasso asked if the woman with the freckles was still going. She was.

The artist also put a defiant sign on his studio door, *Je ne suis pas un gentleman,* at least so he told me, but nobody remembered seeing it. He never employed an assistant unless a specific project required one; he also refused to let maids up to the studio floor. Domestic business was handled by Olga, but confidential business was

entrusted to his banker, the discreet and trustworthy Max Pellequer.[5] In keeping with his impersonation of a conventional bourgeois husband, Picasso continued to sleep downstairs in the same bedroom, though not the same bed as his wife. There was also a bed upstairs; as his work would soon confirm, the studio also served as a sexual arena in his work as well as his life.

Brassaï's description of the studios, as they were a few years later, says it all:

I had expected an artist's studio, and this was an apartment converted into a kind of warehouse. Certainly no characteristically middle class dwelling was ever so uncharacteristically furnished. There were four or five rooms—each with a marble fireplace surmounted by a mirror—entirely emptied of customary furniture and littered with stacks of paintings, cartons, wrapped packages, pails of all sizes, many of them containing the molds for [Picasso's] statues, piles of books, reams of paper, odds and ends of everything, placed wherever there was an inch of space, along the walls and even spread across the floors, all covered with a thick layer of dust. The doors between all the rooms were open—they might even have been taken off— transforming this large apartment into a single studio cut up into a multiple series of corners for the multiple activities of its owner. The floors were dull and lusterless, long since deprived of any polish, coated here and there with splotches of paint, and strewn with a carpet of cigarette butts. Picasso had stood his easel in the largest and best-lit room—what once had surely been the living room—and this was the only room that contained any furniture at all. The window faced south, and offered a beautiful view of the rooftops of Paris, bristling with a forest of red and black chimneys, with the slender, far off silhouette of the Eiffel Tower rising between them. Madame Picasso never came up to this apartment. With the exception of a few friends, Picasso admitted no one to it. So the dust would fall where it would and remain there undisturbed, with no fear of the feather dusters of cleaning women.[6]

Brassaï has also described Olga's area:

The extraordinary thing about it was that, except for one mantelpiece on which there was some evidence of [Picasso's] fantasies, nothing whatever bore his stamp. Even his own canvases of the cubist period—classics by this time—carefully framed and hanging on the walls beside Cézanne, Renoir, and Corot, seemed to belong in the apartment of some rich collector, instead of being at home with Picasso himself. The bourgeois apartment was completely alien to his habitual way of life. None of those extraordinary pieces of furniture he is so fond of, none of the totally unexpected objects with which he loves to surround himself, no piles of anything, none of the confused jumble his fantasy usually created. . . . Olga was jealous of the domain she considered hers alone, and she stood careful guard over it, lest Picasso mark it with the powerful imprint of his personality.[7]

Despite the acquisition of the fifth floor, Olga had to fight to keep the entire fourth floor as her realm. Her mother had written in February urging her to insist on

a room of her own and set aside some money.[8] Picasso hated to relinquish rooms where he had lived and worked. He preferred to move on and leave studio after studio stuffed with treasure, bric-à-brac, and dross—time capsules sacred to this or that period of his life. Averse to having his mess in her area, Olga eventually managed to take over the former studio and turn it back into a salon, leaving her husband a smallish room for storage. Twenty years later, Françoise Gilot was amazed at the sight of this accumulation, which Picasso had left behind after moving out of the apartment during the war.[9]

> This was . . . where he kept everything that was to be saved [Gilot wrote]. But since Pablo had never thrown anything away—whether an empty matchbox or a little watercolor by Seurat—the range of its contents was enormous. Old newspapers and magazines, notebooks of drawings he had made, and copies by the dozen of various books he had illustrated formed a wall almost to the ceiling. I picked up a group of letters and saw that they included some from friends like Guillaume Apollinaire and Max Jacob as well as a note from the laundress that he had once found amusing. Suspended on the face of this wall was a charming seventeenth-century Italian puppet, strung together with wires and dressed as Harlequin, about four feet high. Behind it here and there, wedged into a mass, I saw paintings. I looked into a box. It was full of gold pieces.[10]

When, toward the end of October 1925, Clive Bell arrived on his customary fall visit to Paris, Picasso declined to see him. Bell was reduced to hanging around the rue la Boétie, outside number 23, pretending to window-shop. And, sure enough, the artist let him in. Despite breaking with the beau monde, he was still avid for news of it: "I heard my name called [Bell wrote Mary Hutchinson], looked up and there was Picasso in a brown sweater on the balcony. I went upstairs for ten minutes and saw one or two pictures and then Madame in high good looks—but surely her hair was not always a dark brown? Picasso has lost most of his, and is very fat indeed, but as charming as ever."[11]

Bell's cattiness reflects his displeasure at the brevity of the visit. He was not shown the new works in the new studio. Just as well. He would have disliked them. To reingratiate himself, Bell invited the Picassos, a young Englishman, Peter Johnstone, later Lord Derwent, and Robert Le Masle—a former friend of Cocteau's, who was in disgrace for having stolen some letters from him[12]—to dine at the Boeuf sur le Toit.[13] Picasso had not visited the Boeuf in ages and had forgotten about the works he had lent Moysès to jazz up the place when it first opened. He now reclaimed them. Bell joked to Mary, "that the panels left blank by the abstractions of Picasso . . . are to be filled by the twelve apostles painted by" the born-again Cocteau.[14]

The dinner was not a success. Le Masle annoyed Picasso by badgering him to do his portrait.[15] Bell drank too much, as Derwent would later describe in a memoir (under the pseudonym George Vandon) about his life in Paris in the 1920s. "Ortiz [Zárate], the fat grave Spaniard [sic], with his Catalan twinkle of sarcasm (only beaten by that of Picasso), and that evening at the Boeuf when you, my dear Clive, too far advanced in your cups, beflowered [Picasso] with sugary compliments— what a look in that black eye!"[16]

Derwent, who was an old friend of Tony and Juana Gandarillas, Bell's other mistress, and would later marry their daughter, had reason to resent his host. He resented Bell not so much for cuckolding the homosexual Gandarillas, or for sponging off his ravishing, very rich wife—nightly dinners at the Ritz, suppers of plovers' eggs at her house on Cheyne Walk—but for bad-mouthing her to his disapproving Bloomsbury friends.[17] A further irony: while Bell was doing his best to persuade Picasso to do a portrait of Mary Hutchinson, Eugenia Errázuriz was doing her best to have him paint her niece Juana. Neither got a portrait.

To promote his manifesto *Le Surréalisme et la peinture,* which appeared in July 1925, Breton had organized a show of paintings at the Galerie Pierre. The show has become a landmark in the history of the movement; it has also been seen as "a sign of [Picasso's] fascination for the surrealist movement."[18] In fact, Picasso was doing his best to disclaim the surrealist label. To make this clear, he did not attend the opening and lent nothing to Breton's show. Although he had befriended Breton, he was wary of him and fearful of being identified with what was becoming an overtly Marxist movement. Despite the hype of wishful-thinking historians, the Galerie Pierre show was a very modest affair: only nineteen paintings, including Klee and Arp, nothing by Picabia or Duchamp.[19] It was held in a small gallery at 13, rue Bonaparte, newly opened by Pierre Loeb, an enterprising dealer greatly respected by avant-garde artists. It lasted a mere eleven days, from midnight November 14 to November 25.[19] Breton's gimmick of holding the vernissage at midnight attracted more people than the gallery could hold, but the show aroused less attention than Tzara's earlier dadaist manifestations.[20] Nevertheless, it was an auspicious start. In the long run, it would be Breton's artists rather than his poets who established surrealism as a worldwide phenomenon.

Had Picasso "thrown in his lot with the surrealists," as Breton tried to give the impression that he had,[21] he would have advertised the fact by contributing recent works to the show. Instead, he saw to it that the two paintings by him in the show— the quintessentially cubist *Man with a Guitar* (1912–13) and the *Montrouge in the*

Snow (December 1917)[22]—were lent by Jacques Doucet and therefore did not compromise his independent stance. The inclusion of a cubist masterpiece at least enabled Breton to claim Picasso as a respected antecedent. As for the inclusion of the Christmassy *Montrouge in the Snow*—painted to make his Russian fiancée feel at home—he could hardly have chosen anything less surreal. A third painting, the pretty little *Head of a Woman* (1924)—illustrated but not listed in the catalog[23]—likewise made little sense in the context of the show. Unable to discern much common ground in these paintings, Breton and Desnos resorted to whimsy in their preface and imagined themselves snuggling up inside the house at Montrouge. As for the *Man with a Guitar,* they envisaged him as a bogeyman emerging "in his immensity from the fog [to] the groaning [*gémissements*] of the river's embankment."

Picasso had no hesitation about calling on Breton's help: protection from anticubist dadaists, the services of his claque, and the support of his journals. He also helped himself to Breton's concept that beauty should be convulsive. Beyond allowing Breton to reproduce his latest work in surrealist publications, Picasso did little in return. Breton's hosannas were all very well, but Picasso did not altogether appreciate being hailed as the surrealists' progenitor. Besides, Breton was too manipulative, too much of a tyrant for a genius to work with. Picasso made his reservations about Bretonian surrealism very clear twenty years later, when he blamed Dora Maar's collapse on her surrealist past: "One doesn't go to pieces all of a sudden without an underlying cause," Picasso said.

> It's like a fire that smoulders for a long time and then, when the wind picks it up, begins to rage. Don't forget that the leading surrealists, the ones who survived the heyday of the movement—Breton, Eluard, Aragon—have very strong characters. The weaker ones who trailed after them haven't always fared as well: Crevel committed suicide, Artaud went mad, and there are plenty of other cases. As an ideology, it sowed disaster pretty generally. The sources of Surrealism are a rather dubious mixture. It's not strange that with a hodgepodge like that, so many lost their way.[24]

Once settled into his new studio, Picasso continued to work on still lifes with defining contours scratched into the wet paint, but smaller in scale than the Juan-les-Pins ones. His need to come up with new works for the show that Rosenberg had rescheduled for the following June[25] resulted in several fine still lifes, which relate to the two great ones he did at La Vigie in 1925. This time he sets his usual still life objects—mandolin, guitar, fruit dish, plaster cast—against a window with a huge, self-referential knob. He also switched to figures: decorative and emblematic

Far left: Picasso. *The Sculptress,* 1925. Oil on canvas, 130 x 97 cm. Private collection.

Left: Picasso. *Paulo Dressed as a Torero,* 1925. Oil on canvas, 162 x 97 cm. Private collection.

of the arts. Picasso uses a recognizable model for them *(Woman in a Pink Dress, Woman with a Mandolin,* and *The Sculptress).*[26] The model is certainly not Olga; she was a blonde and probably the artist's mistress. We have no way of knowing. Because she is fair-haired, this delicate, wide-eyed woman has repeatedly been confused with Marie-Thérèse, whom Picasso would not meet for another eighteen months. Moreover, Marie-Thérèse was an adolescent bundle of pneumatic bliss with a big nose; the unidentifiable blonde has sharply defined, adult features. As well as the paintings, there are several drawings of her,[27] and she may well have been the inspiration for the girl embedded in the paint of the 1924 Reina Sofía still life.

In November 1925, Picasso took a break from doing paintings for Rosenberg and did a sugary portrait of Paulo dressed as a torero: probably a Christmas present for Olga, who would use any pretext to get her son into fancy dress. A home movie made a few years later shows Paulo in this or another torero outfit being charged by his nanny impersonating a bull. Snapshots taken over the next five years reveal the boy dressed up as a jockey, a harlequin, a Pierrot, and most elaborately as a *maréchal de France* strutting about the Place de la Concorde, while a chauffeur holds the door of the Hispano-Suiza open for him. On Christmas Day, 1925, Picasso embarked on a new sketchbook[28] and proceeded to fill it with some thirty drawings, many of them projects for cubist still lifes. Some have trompe l'oeil frames which make them look as if they are hanging on a wallpapered wall. Surprisingly, none of these beautiful little croquis ended up as a painting. In his zeal to constantly renew cubism, Picasso would periodically come up with a batch of sketches filled with enough ideas for a lifetime. He also needed to keep his cubist hand in, just as he used virtuoso displays of draftsmanship to keep his Ingresque hand in.

Shortly before Paulo's birthday on February 4, 1926, Picasso did a lithograph of his nanny reading to him.[29] Once again Paulo is in fancy dress, this time as a *dix-huitième* gentleman in a lace jabot and powdered wig. Another lithograph depicts the child at play. In drawings done a few days later Paulo presides over his birthday toys: a bicycle and a rocking horse;[30] on the left a shadowy woman is sewing; on the right the boy's mother enters the room. The three characters appear to be entangled, each in his or her own coils. Picasso evidently planned to do a nursery composition. And then, toward the end of February, Olga suffered one of her breakdowns. Whatever the cause, the crisis was severe enough to evoke the exorcist in Picasso. It also prompted him to turn his original project inside out. Instead of evoking domestic life *inside* the apartment, he addresses himself to a very different scene immediately *outside* the apartment. Picasso's voyeuristic eye had been caught by the action across the street from his studio: a roomful of seamstresses treadling away rhythmically, some might say erotically, at their sewing machines.

Mid-March, Picasso embarked on the enormous (172 × 256 cm) canvas known as the *Milliner's Workshop.*[31] Its composition is based on the nursery studies. The model for the two central figures seems to have been the same blond girl who inspired the large paintings he did before Christmas. However, one cannot be entirely sure. Picasso has endowed his seamstress with such an emphatically bifurcated head that he may well have had no particular girl in mind. This point is of interest only insofar as Rosalind Krauss and others have misidentified the girl in the *Milliner's Workshop* as Marie-Thérèse Walter, who did not enter Picasso's life for another year.[32] Krauss's statement that "Picasso dreamed a type and then he found her"[33] has a fairy-story ring to it that comes as a surprise from someone usually averse to this approach. Krauss is not the only victim of Dr. Herbert T. Schwarz, a Canadian doctor, who, as we will see in Chapter 26, made a terrible botch of his foray into Marie-Thérèse's life story.

After originally revolving around his son, Paulo, the *Milliner's Workshop* ended up revolving around Picasso's

Picasso. Pen and India ink study of a framed painting hung on patterned wallpaper, December 1925. Sketchbook page, 11 x 15 cm. Musée Picasso, Paris.

Above: Picasso. *Milliner's Workshop,* 1926. Oil on canvas, 172 x 256 cm. Musée National d'Art Moderne, Centre Georges Pompidou, Paris.

Left: Picasso. *Interior Scene,* 1926. Lithograph, 22.3 x 28 cm. Musée Picasso, Paris.

own childhood. Seen darkly through a window across the street, the shadowy seamstresses have an amorphous look—redolent of his upbringing in a house full of women at work: besides his mother and the maid, two aunts who earned their living sewing gold braid on stationmasters' kepis. Other memories, this time from his eighteenth year, seem to have flashed back into Picasso's mind: the months he had spent in 1899 in a tiny studio lent him by the mother of the Cardona brothers—fellow students at La Llotja, the Barcelona art school. Señora Cardona had a corset factory, and allowed Picasso to hang out in her atelier observing "the gestures of the corsetmakers and the motions of the machines. Then he would return to his room and

Left: Picasso. Costume design for Chinese Conjuror, *Parade,* 1917. Watercolor on paper, 28 x 19 cm. Family Helft, France.

Below: Picasso. Curtain for *Parade,* 1917. 10.5 x 16.4 m. Musée National d'Art Moderne, Centre Georges Pompidou, Paris.

Picasso. *Woman in a Mantilla (La Salchichona),* Barcelona, 1917. Oil on canvas, 116 x 89 cm. Museu Picasso, Barcelona.

Picasso. *Olga Khokhlova in a Mantilla,* Barcelona, 1917. Oil on canvas, 64 x 53 cm.
Collection Christine Ruiz-Picasso, Museo Picasso Málaga.

Picasso. *Blanquita Suárez,* Barcelona, 1917. Oil on canvas, 73.3 x 47 cm.
Museu Picasso, Barcelona.

Picasso. *Olga in an Armchair,* 1918. Oil on canvas, 130 x 88.8 cm. Musée Picasso, Paris.

Picasso. *Harlequin with Violin ("Si tu veux"),* 1918. Oil on canvas, 142 x 100.3 cm.
© The Cleveland Museum of Art. Bequest of Leonard C. Hanna, Jr.

Picasso. *Return from the Baptism* or *The Happy Family (after Le Nain)*, 1917–18. Oil on canvas, 162 x 118 cm. Musée Picasso, Paris.

Picasso. *The Bathers,* Biarritz, 1918. Oil on canvas, 27 x 22 cm. Musée Picasso, Paris.

Picasso. *Still Life,* 1918. Oil on canvas, 97.2 x 130.2 cm. National Gallery of Art, Washington, D.C. Chester Dale Collection.

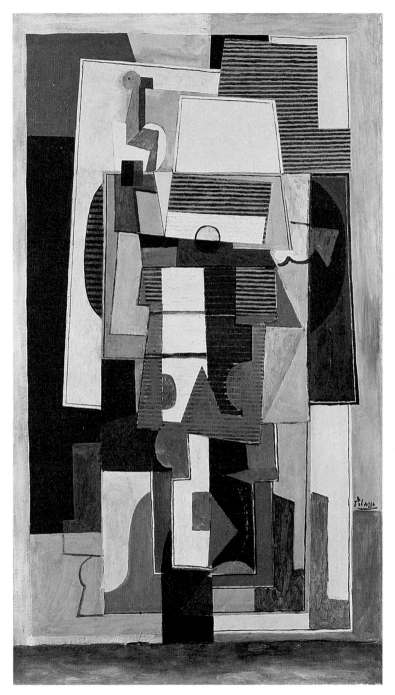

Picasso. *Table, Guitar, and Bottle,* 1918. Oil on canvas, 127 x 74.9 cm.
Smith College Museum of Art, Northampton, Massachusetts.

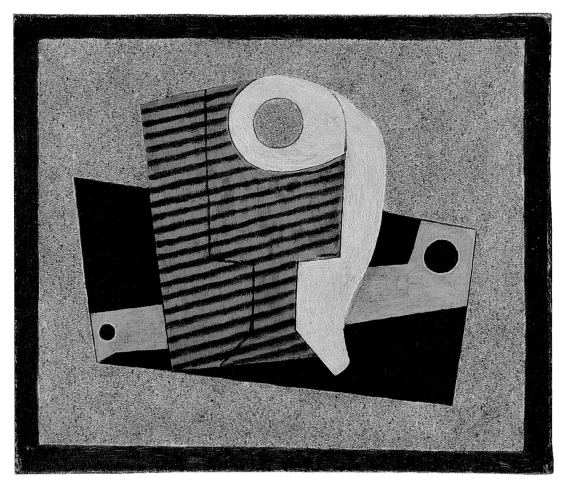

Picasso. *Glass and Pipe,* 1918. Oil on sandpaper, 22 x 27 cm.
Private collection, Dallas.

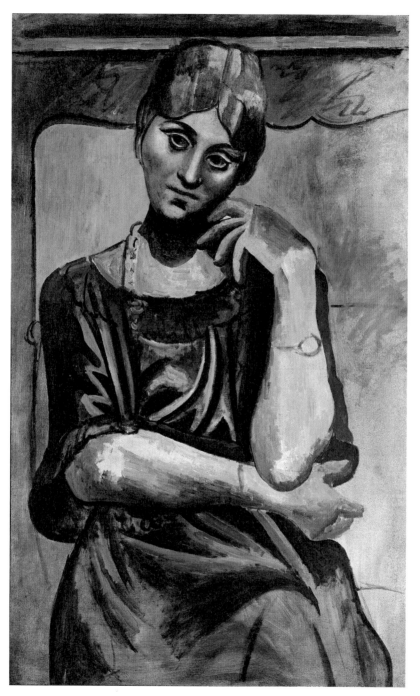

Picasso. *Olga Wearing a Wristwatch,* 1919. Oil on canvas, 120 x 75 cm. Private collection, Galerie Jan Krugier & Cie, Geneva.

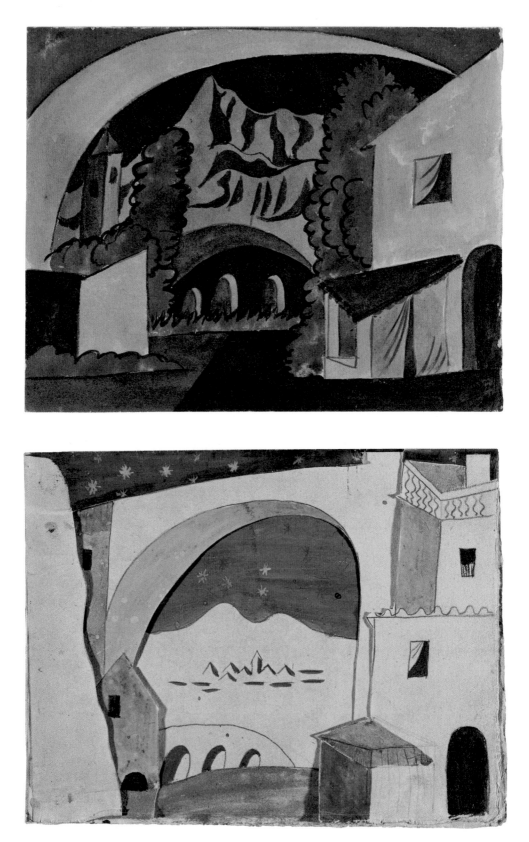

Picasso. Designs for *Tricorne,* 1919.

Opposite top: Study for the curtain. Water-
color and pencil on paper, 17.4 x 22.3 cm.
Musée Picasso, Paris.

Opposite bottom: Study for the curtain.
Gouache and pencil on cut paper, 20.5 x
27 cm. Musée Picasso, Paris.

Above left: Costume design for the Woman
from Seville. Gouache and pencil on paper,
25 x 16 cm. Musée Picasso, Paris.

Above right: Costume design for the Corregi-
dor. Gouache and pencil on paper, 26.5 x
19.5 cm. Musée Picasso, Paris.

Right: Costume design for the Torero.
Gouache on paper, 26 x 20 cm. Musée
Picasso, Paris.

Picasso. *Still Life with Pitcher and Apples,* 1919. Oil on canvas, 65 x 43 cm. Musée Picasso, Paris.

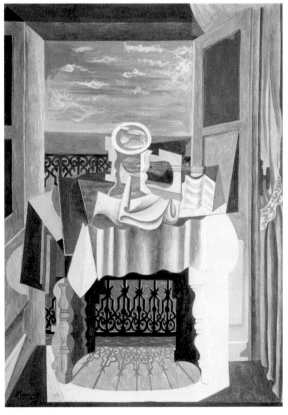

Picasso. *Still Life in Front of a Window,* 1919. Gouache and pencil on paper, 30.5 x 25.5 cm. Museum Berggruen, Staatliche Museen zu Berlin.

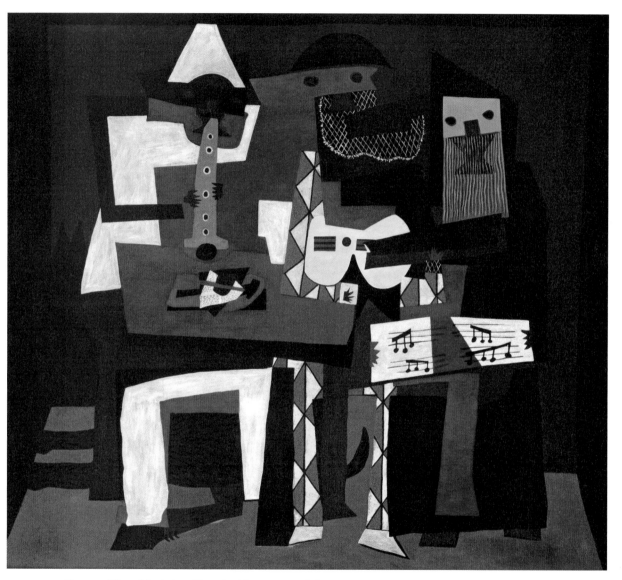

Picasso. *Three Musicians,* Fontainebleau, 1921. Oil on canvas, 200.7 x 222.9 cm.
The Museum of Modern Art, New York.

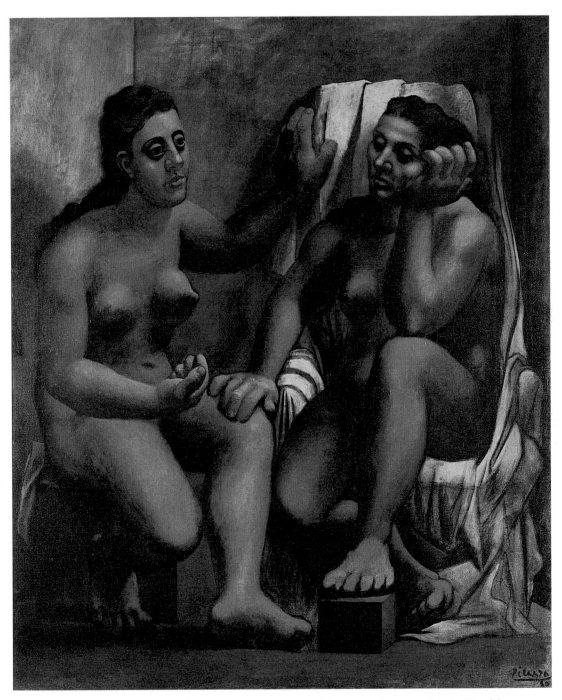

Picasso. *Two Nudes,* 1920. Oil on canvas, 195 x 163 cm. Kunstsammlung Nordrhein-Westfalen, Düsseldorf.

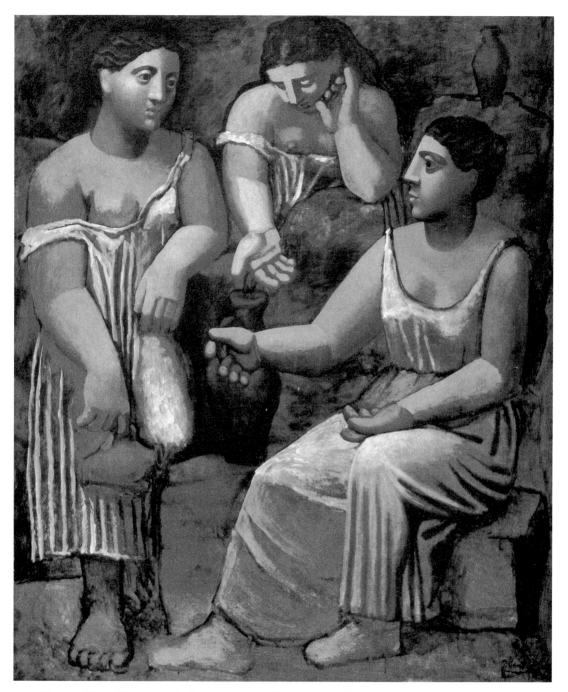

Picasso. *Three Women at the Spring,* Fontainebleau, 1921. Oil on canvas, 203.9 x 174 cm.
The Museum of Modern Art, New York.

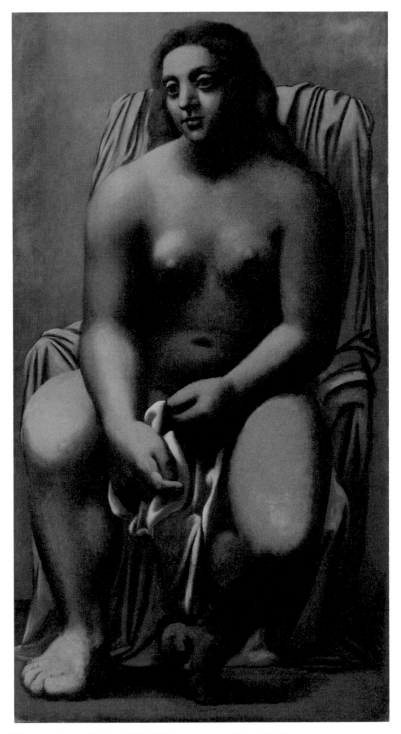

Picasso. *Large Bather,* 1921. Oil on canvas, 182 x 101.5 cm.
Musée de l'Orangerie, Paris.

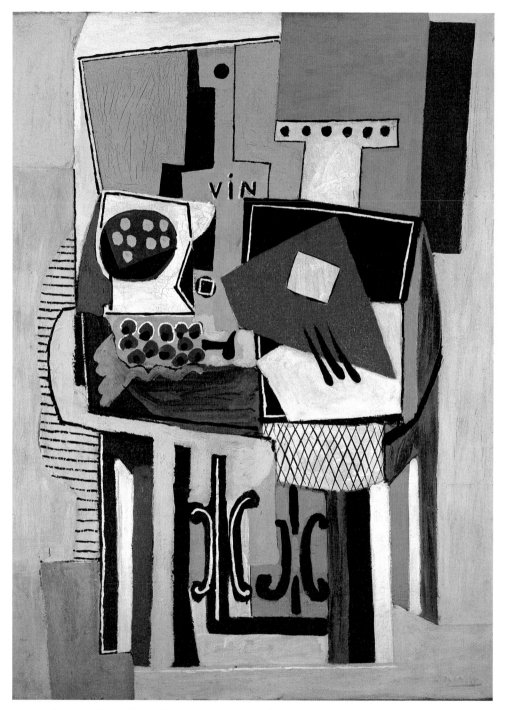

Picasso. *Fruit Dish, Bottle, and Guitar,* 1922–23. Oil on canvas, 130 x 96.5 cm. Private collection.

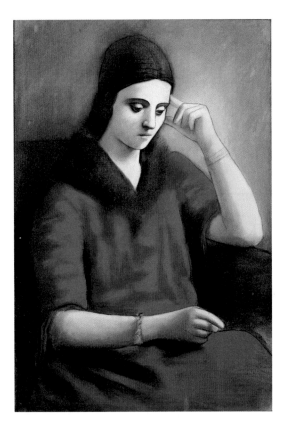

Picasso. *Portrait of Olga,* 1923. Pastel and black pencil on paper, 104 x 71 cm. Musée Picasso, Paris.

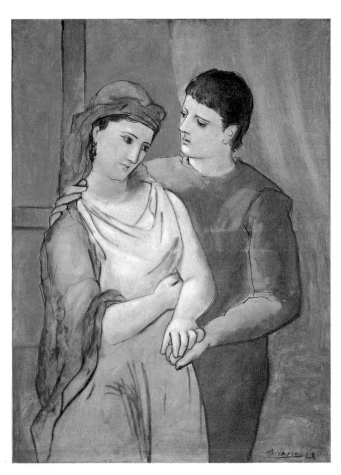

Picasso. *The Lovers,* 1923. Oil on linen, 130.2 x 97.2 cm. National Gallery of Art, Washington, Chester Dale Collection.

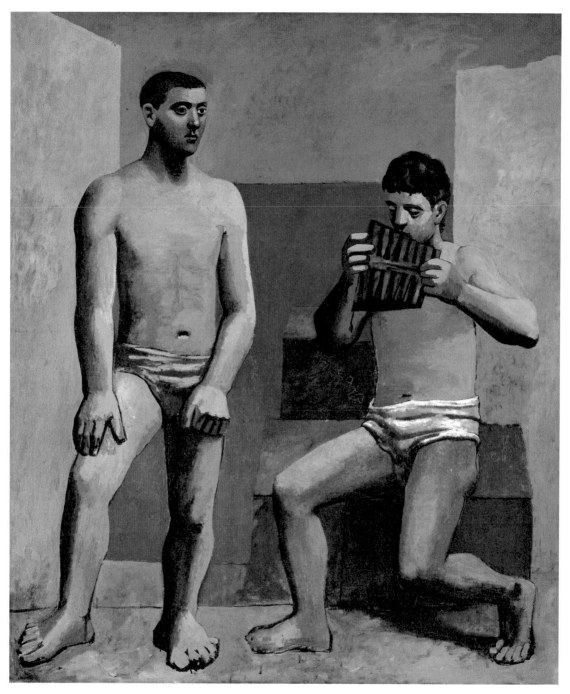

Picasso. *Pipes of Pan,* 1923. Oil on canvas, 205 x 174 cm. Musée Picasso, Paris.

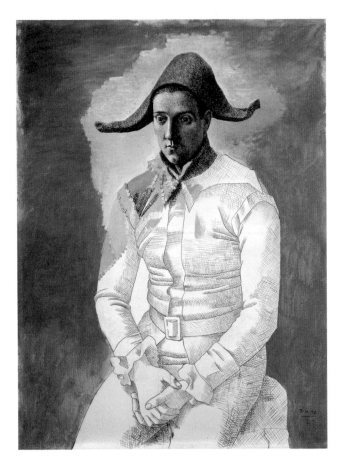

Picasso. *Seated Harlequin (Jacint Salvadó),* 1923. Oil on canvas, 130 x 97 cm. Musée National d'Art Moderne, Centre Georges Pompidou, Paris.

Picasso. *Mandolin and Guitar,* 1924. Oil with sand on canvas, 140.6 x 200.4 cm. Solomon R. Guggenheim Museum, New York.

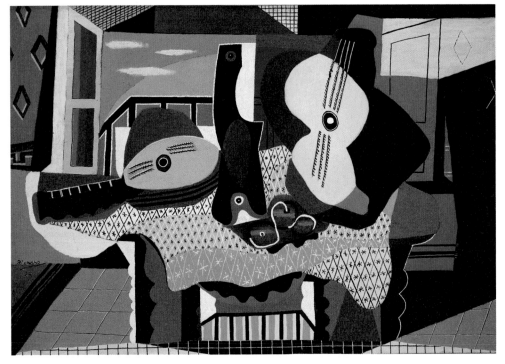

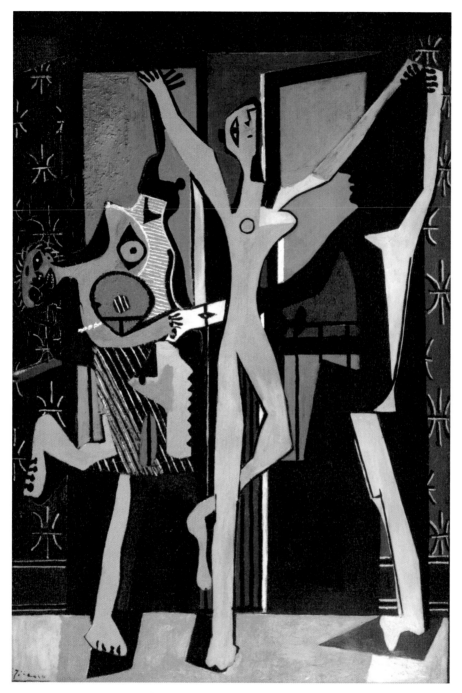

Picasso. *La Danse,* 1925. Oil on canvas, 215.3 x 142.2 cm. Tate, London.

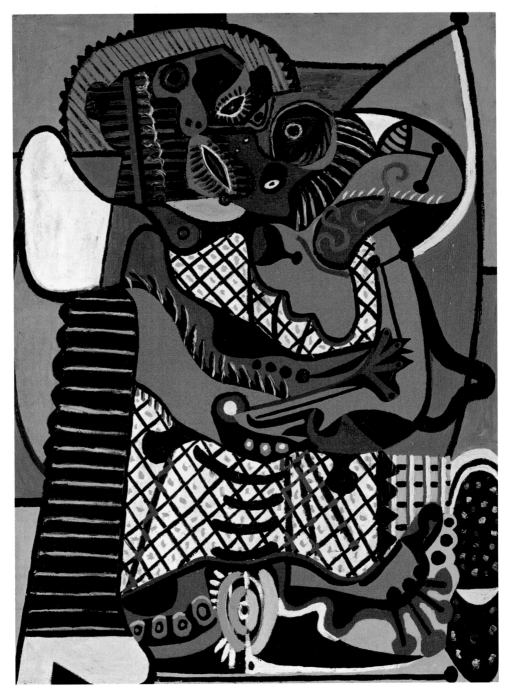

Picasso. *The Kiss,* Juan-les-Pins, 1925. Oil on canvas, 130.5 x 97.7 cm. Musée Picasso, Paris.

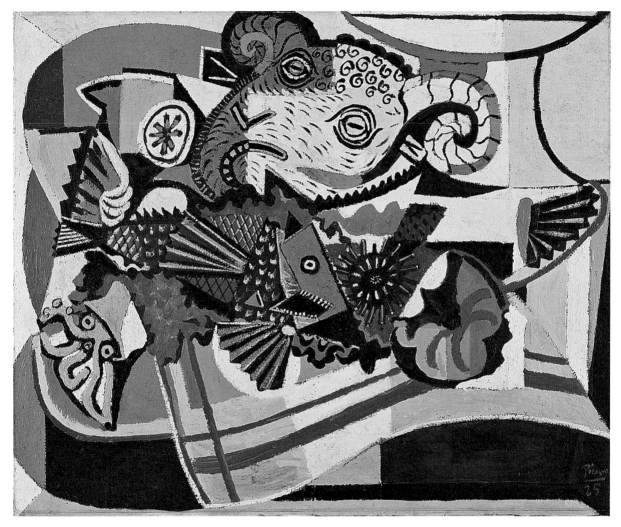

Picasso. *The Ram's Head,* Juan-les-Pins, 1925. Oil on canvas, 77.5 x 99.4 cm.
Norton Simon Museum, Pasadena, California.

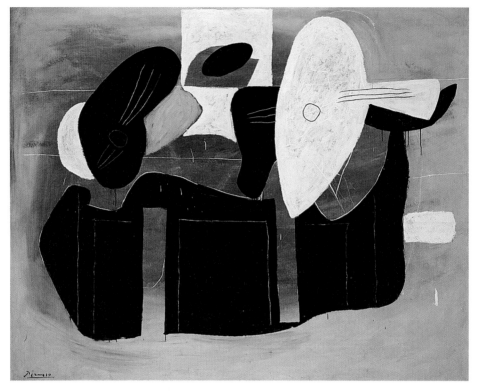

Above: Picasso. *Musical Instruments on a Table,* 1924. Oil on canvas, 162 x 204 cm.
Museo Nacional Centro de Arte Reina Sofía, Madrid.
Below: Picasso. *Still Life,* Juan-les-Pins, 1925. Oil and sand on canvas, 97.8 x 131.2 cm.
Musée National d'Art Moderne, Centre Georges Pompidou, Paris.

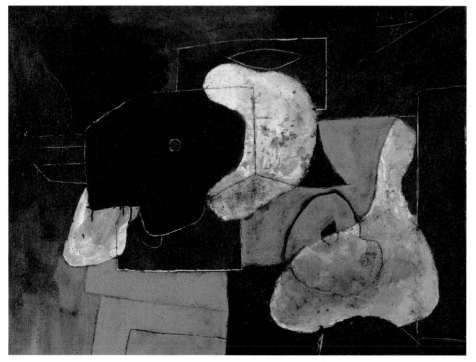

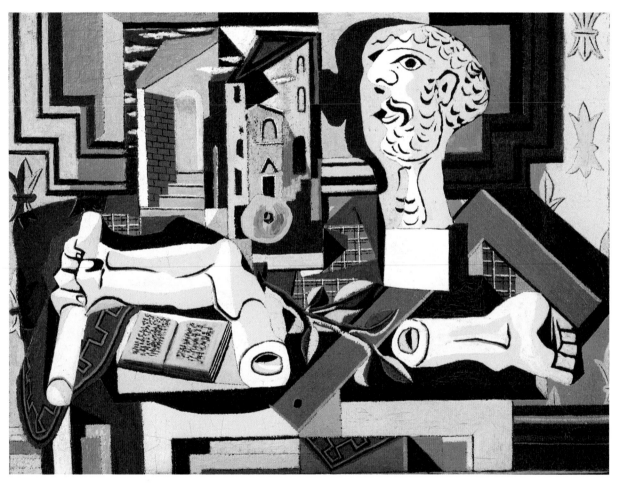

Picasso. *Studio with Plaster Head,* Juan-les-Pins, 1925. Oil on canvas, 98 x 130 cm. The Museum of Modern Art, New York.

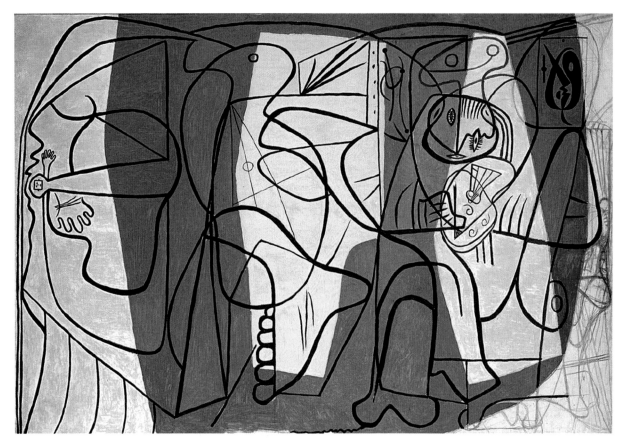

Picasso. *Artist and His Model,* 1926. Oil on canvas, 172 x 256 cm. Musée Picasso, Paris.

Picasso. *Guitar,* 1926. Pencil, paper, string, leaf, and tulle, 42 x 29 cm. Collection Jan Krugier and Marie-Anne Krugier-Poniatowski.

Picasso. *Guitar,* 1926. Canvas, wood, rope, nails, string, newspaper, tacks, and knitting needle on painted panel, 130 x 96.5 cm. Musée Picasso, Paris.

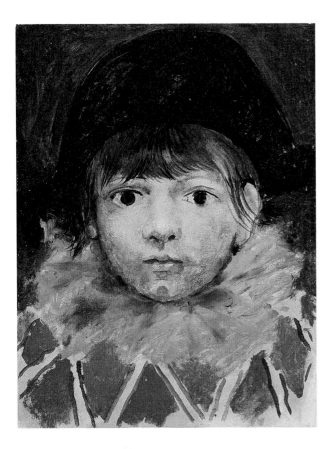

Picasso. *Paulo as Harlequin,* March 4, 1924.
Oil and wash on canvas, 34.9 x 27 cm.
Marlborough Fine Art, London.

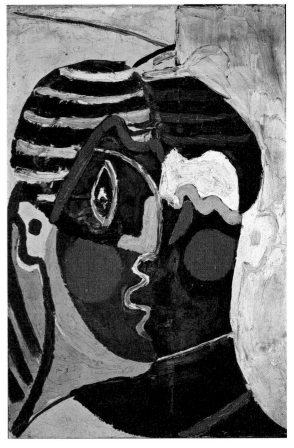

Picasso. *Paulo in a Harlequin Costume,* November 20, 1926. Oil on canvas, 24 x 16 cm. Private collection, Galerie Jan Krugier & Cie, Geneva.

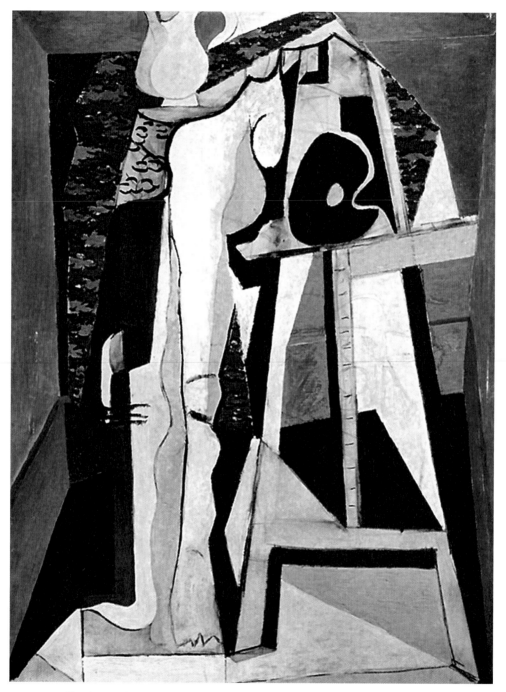

Picasso. *Still Life (Easel and Dancer's Tights),* 1926. Oil on canvas, 130 x 97.5 cm.
Private collection.

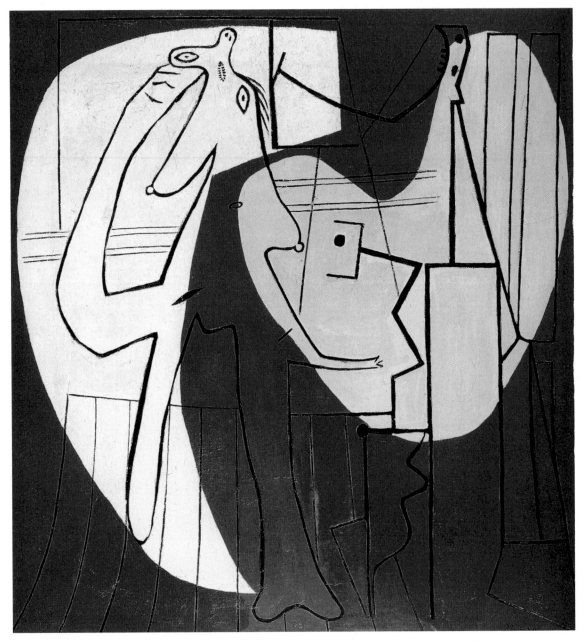

Picasso. *Artist and His Model,* 1927. Oil on canvas, 213 x 196 cm. Tehran Museum of Contemporary Art.

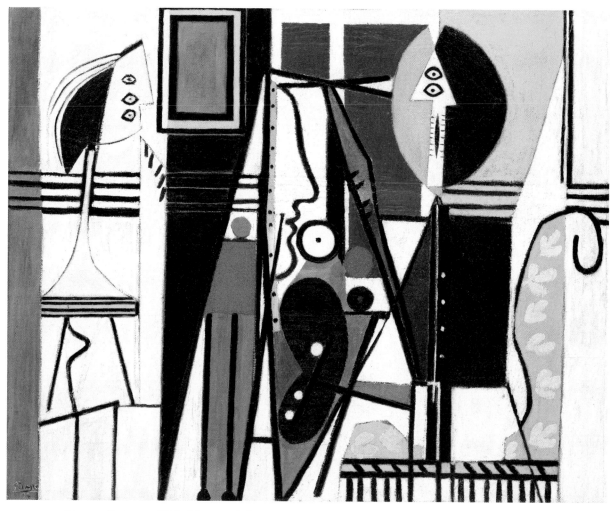

Picasso. *Painter and Model,* 1928. Oil on canvas, 128.8 x 163 cm. The Museum of Modern Art, New York.

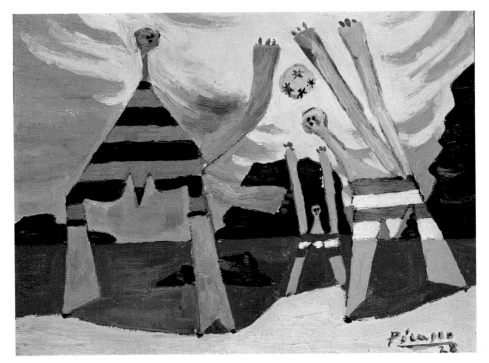

Above: Picasso. *Bathers Playing Ball on the Beach,* August 15, 1928. Oil on canvas, 24 x 34.9 cm. Private collection.
Below: Picasso. *Bather Lying on the Sand,* August 23, 1928. Oil on canvas, 18.8 x 24 cm. Private collection.

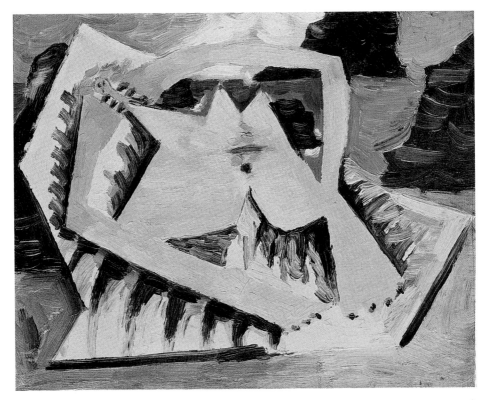

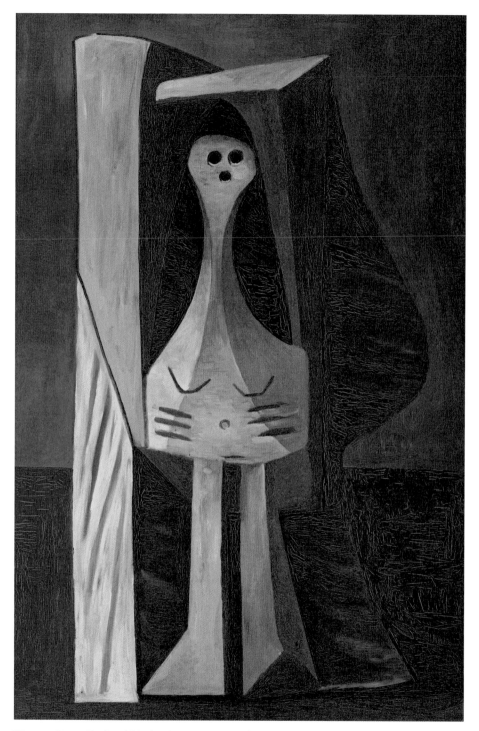

Picasso. *Large Bather (Olga),* May 26, 1929. Oil on canvas, 195 x 130 cm.
Musée Picasso, Paris.

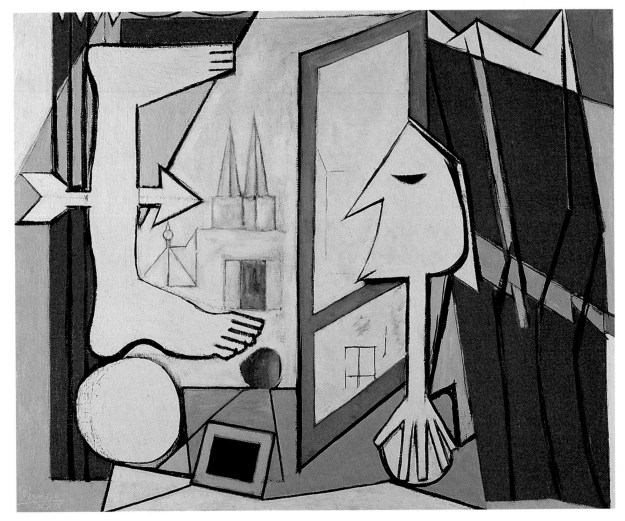

Picasso. *Open Window,* 1929. Oil on canvas, 130 x 162 cm. Staatsgalerie Stuttgart.

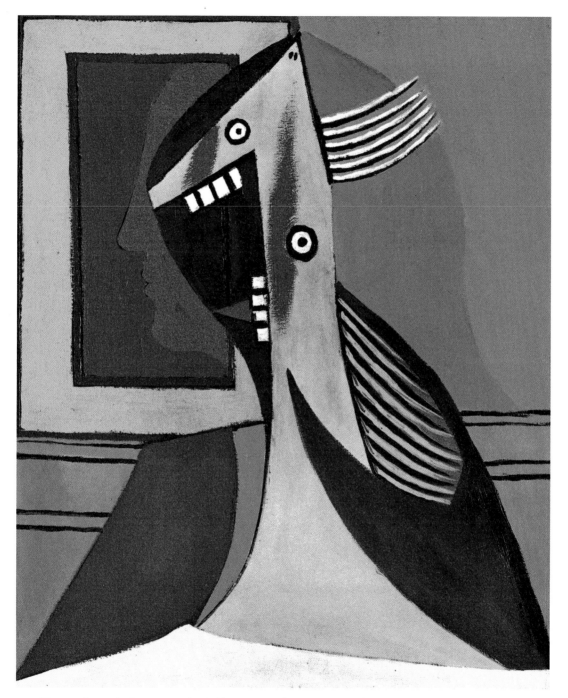

Picasso. *Bust of a Woman with a Self-Portrait,* February 1929. Oil on canvas, 71 x 60 cm. Private collection.

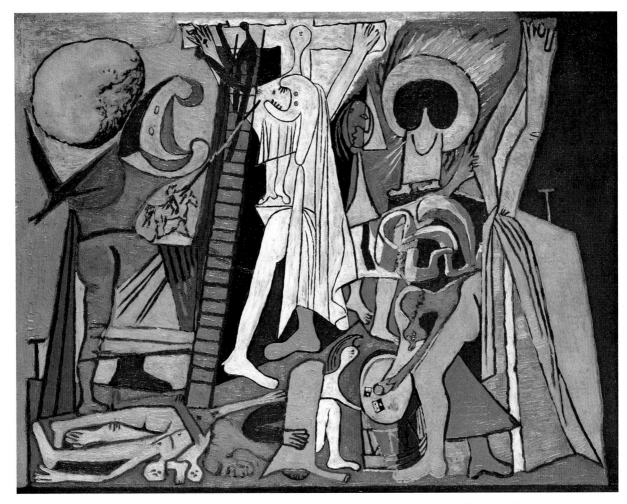

Picasso. *Crucifixion,* February 7, 1930. Oil on plywood, 51.5 x 66.5 cm. Musée Picasso, Paris.

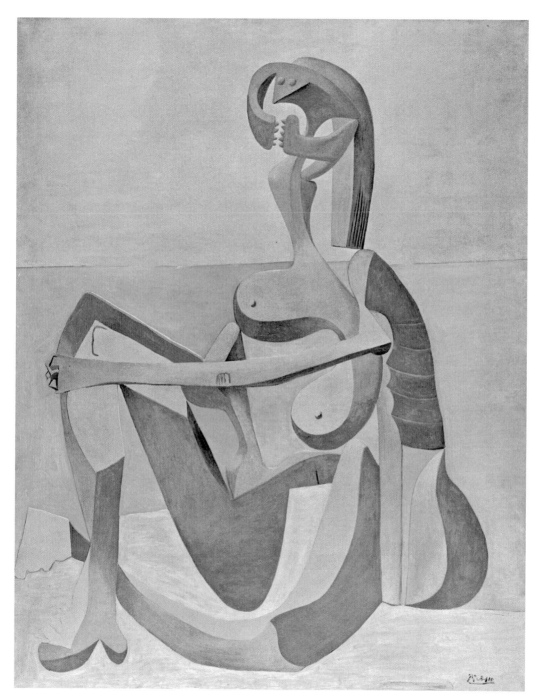

Picasso. *Seated Bather,* Paris, 1930. Oil on canvas, 163.2 x 129.5 cm. The Museum of Modern Art, New York.

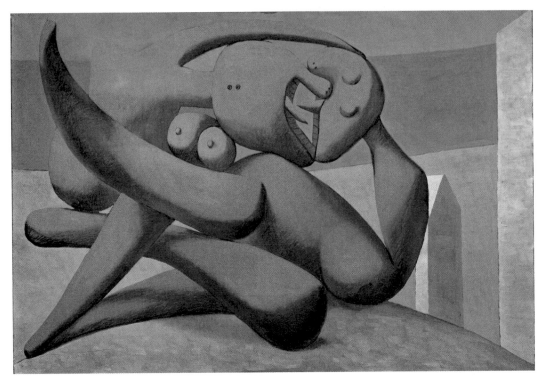

Above: Picasso. *Figures on the Seashore,* January 12, 1931. Oil on canvas, 130 x 195 cm.
Musée Picasso, Paris.
Below: Picasso. *Woman Throwing a Rock,* March 8, 1931. Oil on canvas, 130.5 x 195.5 cm.
Musée Picasso, Paris.

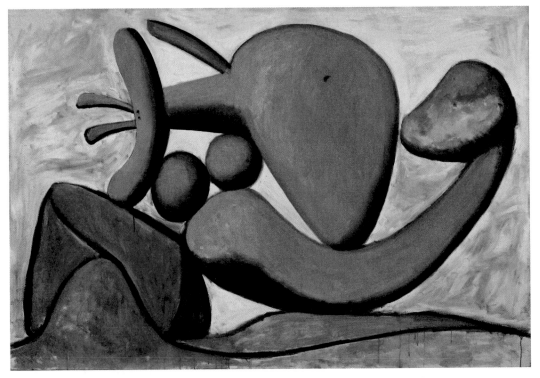

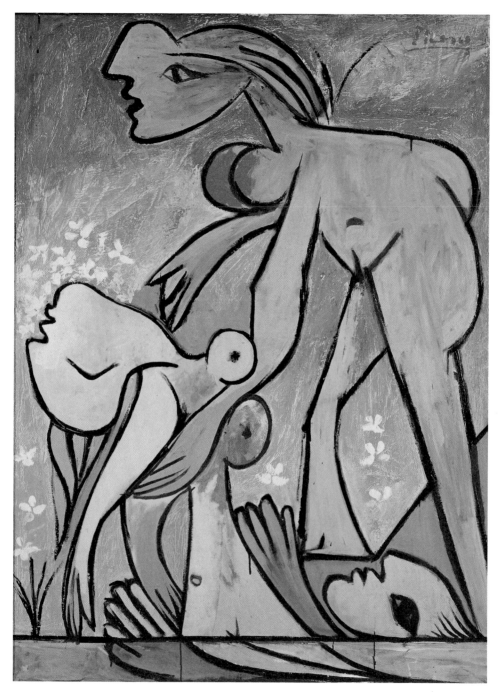

Picasso. *The Rescue (Le Sauvetage),* December 1932. Oil on canvas, 130 x 97.5 x 2.5 cm.
Fondation Beyeler, Riehen/Basel.

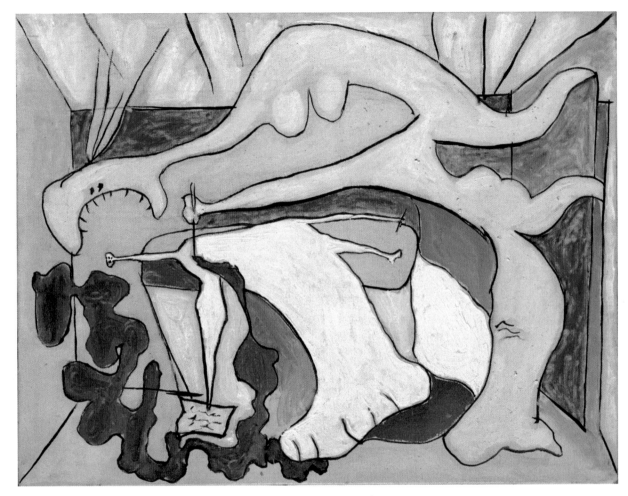

Picasso. *Woman with a Stiletto,* December 19–25, 1931. Oil on canvas, 46.5 x 61.5 cm. Musée Picasso, Paris.

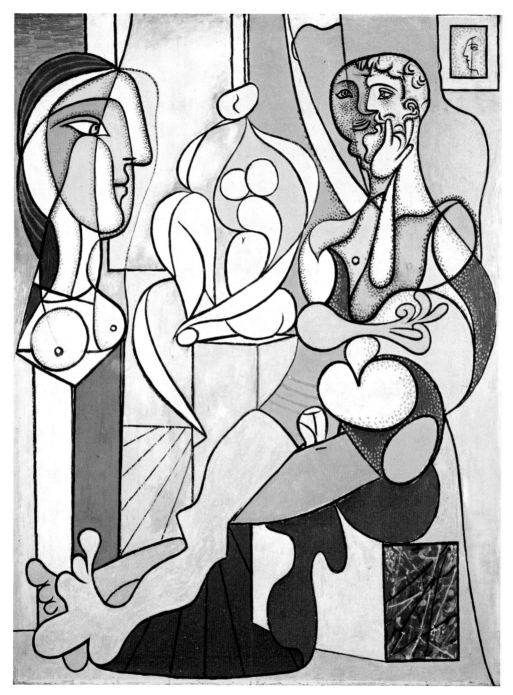

Picasso. *The Sculptor,* December 7, 1931. Oil on plywood, 129 x 96 cm. Musée Picasso, Paris.

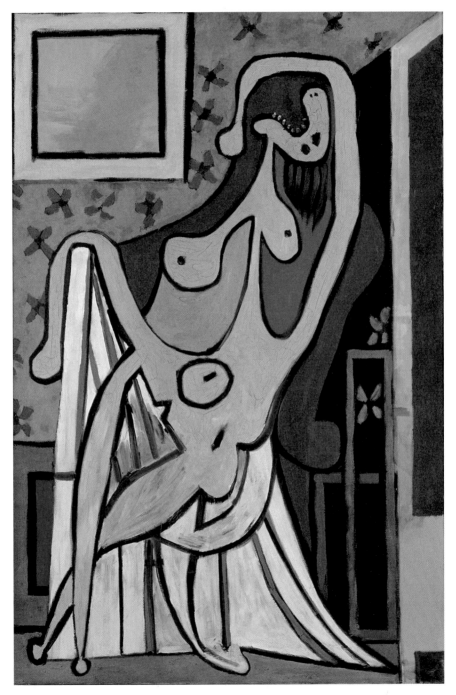

Picasso. *Large Nude in a Red Armchair (Olga),* May 5, 1929. Oil on canvas,
195 x 129 cm. Musée Picasso, Paris.

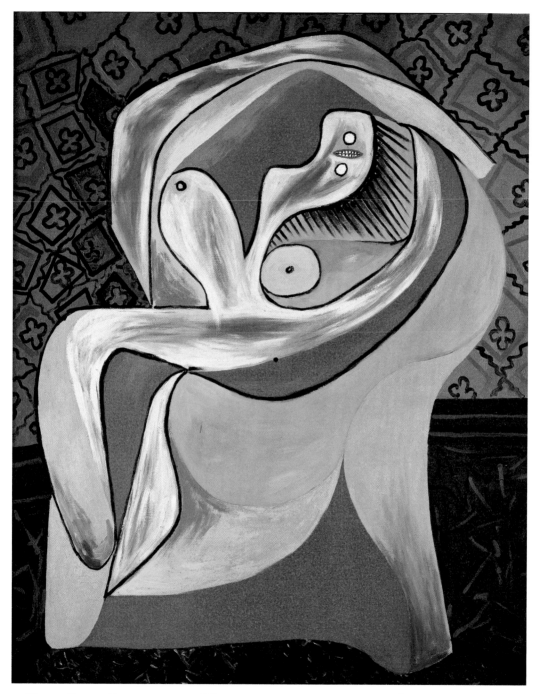

Picasso. *Repose,* January 22, 1932. Oil on canvas, 162 x 130 cm. Private collection, New York.

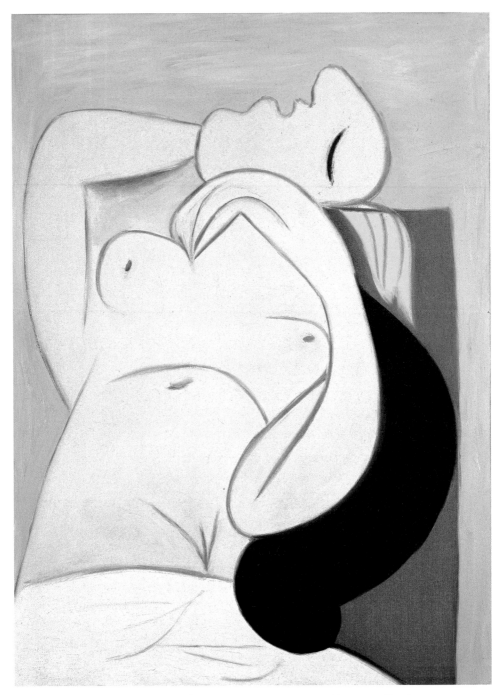

Picasso. *Sleep,* January 23, 1932. Oil on canvas, 130.2 x 97.2 cm. Private collection.

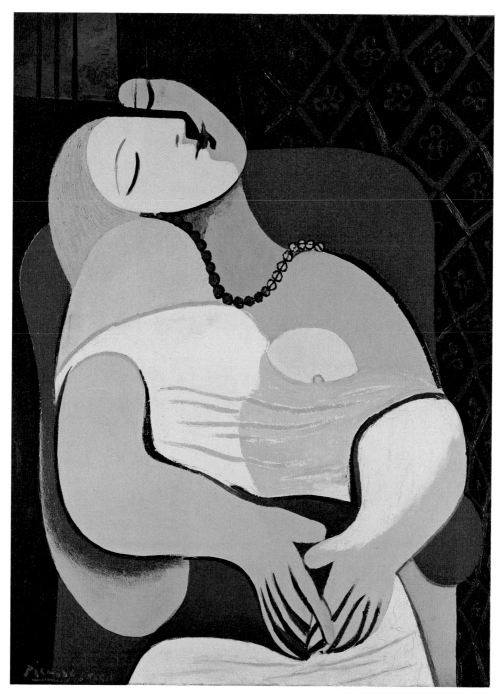

Picasso. *Dream,* January 24, 1932. Oil on canvas, 130 x 97 cm. Steve and Elaine Wynn Collection, Las Vegas, Nevada.

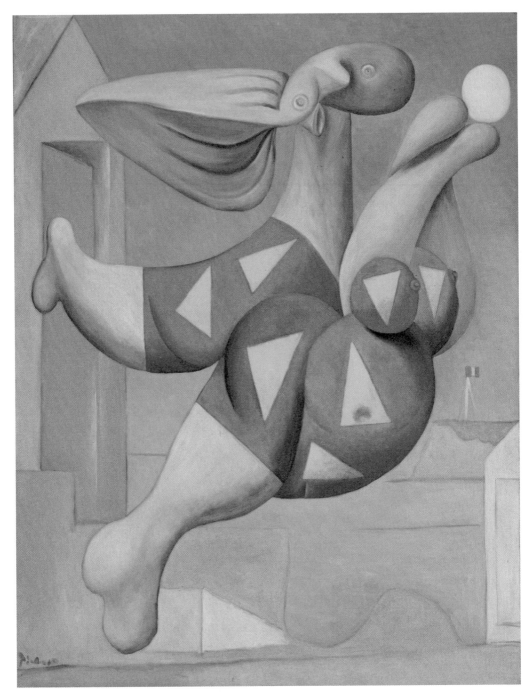

Picasso. *Bather with Beach Ball,* August 1932. Oil on canvas, 147 x 114.6 cm.
The Museum of Modern Art, New York.

paint."[34] The murky windows opposite his studio beamed these memories back at him.

Since the *Milliner's Workshop* is executed in virtual grisaille, Gasman believes that this is the "large black, grey and white painting" in which Picasso claimed to have foreseen the death of Juan Gris a year later. "I didn't know what it represented, but I saw Gris on his deathbed, and it was my picture."[35] Gasman may well be right,[36] but McCully feels that Picasso had the simplified grisaille version of the *Ram's Head* still life in mind.[37] Unlike the *Milliner's Workshop,* it is drenched in death. Picasso's claims to have prophetic powers usually turn out to stem from the grit of guilt, which is at the core of many of his darker paintings.

In his other monumental painting of this spring, Picasso returned to the *Artist and His Model,*[38] a theme that would eventually dominate his imagery. This great work celebrates the acquisition of a new studio, complete with a new model. Its inspiration also derives from Balzac's *Le Chef-d'œuvre inconnu:* the story of a fictional artist, Master Frenhofer, who tantalizes his friends, Poussin and Porbus, by claiming to have worked in secret for ten years on his masterpiece, *La Belle Noiseuse,* a flawlessly beautiful painting of a flawlessly beautiful woman, imbued with "that indescribable something . . . that envelops the body like a haze." When shown the painting, Poussin and Porbus are appalled to see nothing "but . . . a multitude of fantastical lines that go to make a dead wall of paint. . . . In a corner of the canvas . . . a bare foot emerg[es] from the chaos of color, half tints and vague shadows. . . . Its living delicate beauty held them spellbound. . . . 'There,' Porbus continued, as he touched the canvas, 'lies the utmost limit of our art on earth.' "[39]

The *Seated Man* of 1915–16, Picasso's earlier tribute to Balzac's story, had also included the all-important foot, but it is barely discernible. This time, the foot emerging from the "multitude of fantastical lines" is huge,[40] and very recognizable, unlike the phallic foot and leg of the artist figure right next to it. This studio painting is the first of Picasso's portrayals of the creative act and the procreative act as metaphors for each other. To make his point, as he had done the summer before in *The Kiss,* Picasso uses the same vaginal sign for mouths and eyes, his as well as hers. The painter in *Artist and His Model* mixes colors on his palette, while seemingly performing oral sex on her. Note, too, how Picasso has used color independently of line and form by appropriating Léger's *couleurs libres:* abstract planes of color which play no representational role but give an intricate composition such as this a groundswell of support. Over the next two years, Picasso will ring many a change on this device.

Earlier, I mentioned how Picasso had resorted to exorcism in the hope of thwarting Olga's demons. This resumption of interest in shamanistic procedures had been triggered by Leiris, who was becoming more and more involved in ethnography. Early in March, Picasso cobbled together a series of fetishes—two large (130 × 96 cm) and ten smaller ones—out of rags, nails, and other junk. These fetishes are all ostensibly guitars—anthropomorphic ones. The most celebrated consists of a mopping-up cloth that Picasso had spotted on the floor while taking a bath. After cutting a round hole in the cloth, he hammered it onto a canvas from the back so that the points of the nails protrude menacingly from the front. The only other elements are a newspaper cutting, one column wide, some string, and some lengths of cord. The hang of the string is crucial to our perception of the guitar as a horizontal or a vertical. Picasso even managed to disagree with himself on this point.

When this *Guitar*[41] was first exhibited at the 1955 retrospective at the Musée des Arts Décoratifs, the organizer, Maurice Jardot (Kahnweiler's right-hand man), hung it horizontally, but pointed out in the catalog that it might function as a vertical. Summoned a week or two after the opening to tell Picasso about the show, Cooper and I asked him for clarification. To me he gave a huge sigh and said that of course the *Guitar* was horizontal: "Any idiot can see that." And then he turned to Cooper and told him that if he saw it as a vertical it was indeed a vertical. Had it not been published as such? Paradox was not the issue. Picasso subversively wanted to spark a never-ending controversy. The present director of the Musée Picasso reproduces this *Guitar* as a vertical in the Paris edition of her *Papiers Journaux* catalog and as a horizontal in the Dublin edition.[42] The artist would have relished the irony. As Penrose has described when visiting Picasso's apartment, "I happened to notice that a large Renoir hanging over the fireplace was crooked. 'It's better like that,' he said. 'If you want to kill a picture, all you have to do is hang it beautifully on a nail and soon you will see nothing of it but the frame. When it's out of place you see it better.' "[43]

I stand by what Picasso told me. Anyone who sees the *Guitar* as a vertical misses the subtlety of its carefully calibrated balance.[44] A preparatory sketch,[45] signed horizontally, confirms that this is how it was conceived. Seen as a vertical, the strip of newspaper, tinted a reddish brown, fails to register as a shadow and thus fails to generate the crucial illusion of space between the guitar and the wall nails.[46] As for the *Guitar*—cruelest of Picasso's fetishes—it would shred the fingers of conceptual players. The artist told Penrose that he had also considered "embedding razorblades around the edges so that whoever went to lift it would cut their hands."[47] To Dora Maar he was more specific: the razor blades were intended to "discourage col-

Picasso. *Guitar,* 1926. Washcloth, newspaper, string, and nails on painted canvas, 96.5 x 130 cm. Musée Picasso, Paris.

lectors"[48]—not that he had any intention of selling this work. Those nails are Picasso's quills.

The other large rag guitar is unquestionably vertical and less menacing. According to Aragon, this rag was "a dirty shirt" that Picasso had sewn onto the canvas;[49] "and since everything he does turns into guitars, it became a guitar."[50] The rag in question shows no sign of ever being a shirt; presumably it was Picasso who told Aragon that it had been. Shirt or not, what makes this rag truly self-referential is that it was sewn by the artist himself, as crudely as if he had been an Alaskan shaman sewing his powers into a talismanic tunic.

Like the two major *Guitars,* the other smaller fetishes[51] that date from the early spring of 1926 also seem to have been conceived as protection against Olga's demons. In true shamanic fashion Picasso has utilized materials closely associated with his wife—strips of tulle torn from the tutus she always traveled with. Entangled in the tulle are the skeletons of guitars contrived out of sticks and string as well as buttons and, ominously, lead shot.

When Cocteau got wind of Picasso's fetishes, he could not resist coming up with some of his own, and, sorcerer's apprentice that he was, he exhibited them in December.[52] Cocteau's artifacts were merely modish; however, he had a characteristically sharp comment on Picasso's (scribbled in the margin of a letter to Max Jacob): "those canvases [that Picasso] sticks with crucified shirts and bits of string are an attempt to assassinate painting."[53] This anticipates a statement Picasso made to Pen-

rose in 1965 about his late work: "What I am doing now is the destruction of modern painting. We have already destroyed the old masters. We must now destroy the modern ones."[54]

Picasso had not had a show since 1924,[55] so the one that opened at Rosenberg's gallery on June 15, 1926, aroused enormous interest. The show was heralded by a supportive and perceptive article by Christian Zervos, Picasso's intellectual Greek admirer.[56] In 1919 Zervos had published a thesis on an eleventh-century Greek neoplatonist, Michel Psellos, whose ideas are thought by Gasman to have been passed on by the author to Picasso.[57] After a stint as secretary to Anatole France, he decided to become a publisher. Thanks to the damages he had received after being run over by an automobile, he was able in 1926 to found the lavishly illustrated *Cahiers d'Art,* which would keep anyone interested in modern art abreast of the latest developments in the work of the Paris school. Although he had reservations about Picasso as a man, Zervos worshipped him as an artist; and *Cahiers d'Art* would do more to disseminate his reputation than any other publications of the period.[58] Surrealists grumbled about his bias against surrealism, but this would be redressed by his associate editor, Tériade (Efstratios Eleftheriades), who would soon set up on his own and launch the surrealist magazine *Minotaure* (1933) and, later, the luxurious *Verve* (1937).

Picasso wanted his choice of some fifty-eight paintings, mostly large (size 60),[59] for Rosenberg's 1926 exhibition to establish that he had renounced neoclassicism but not surrendered to surrealism. FitzGerald, who has provided the most thorough account of this exhibition, errs only when he sees Picasso embracing "the newest surrealist departures."[60] This was exactly the perception that Picasso had been at pains to discourage, as the surrealists' reaction to the Rosenberg show confirms. Breton's journal, which came out the day the Picasso show opened,[61] pointedly makes no reference to it whatsoever. Breton simply published, almost full-page, a work that was conspicuously absent from Rosenberg's walls, the fetish with the shirt[62]—a sly hint that Picasso was not living up to his subversive image.

Besides catching up on Picasso's new work, Parisian gallerygoers wanted to see what had become of Rosenberg's premises after two years of total reconstruction. The place had been discreetly modernized. Gone was the belle époque panoply—ornate light fittings, alabaster staircases, and walls draped in ruched silk. The new galleries were neither modernist nor art deco; they were architecturally respectable and designed to show off expensive paintings of all styles and periods to their best advantage. The walls were light-colored and the floors were parquet rather than marble. Newly designed frames—the result of discussions with Picasso, Braque, and

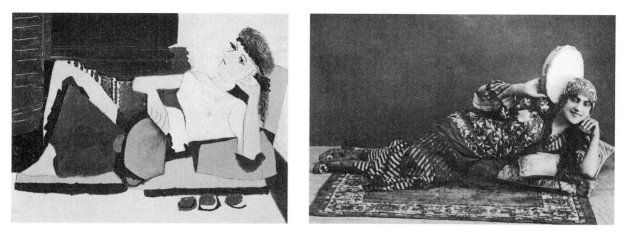

Left: Picasso. *Woman with a Tambourine (Odalisque),* 1925. Oil on canvas, 97 x 130 cm.
Musée de l'Orangerie, Paris.
Right: María d'Albaicín as Scheherazade. Bibliothèque de l'Opera, Paris.

other gallery artists—would make a tremendous difference to this and all Rosenberg's subsequent shows. Even when pickled or otherwise patinated, the rich-looking Régence frames, which Degas and the impressionists had inveighed against forty years earlier, were still being used by dealers to make pictures look expensive. Most modern artists hated them. Rosenberg had set his confreres an excellent example by framing contemporary paintings in a simple, uniform molding that could be adapted to works of all sizes and styles. The surface, too, was uniform—plain, highly burnished gilt. The new frames gave a sense of order to the very disparate works in the Picasso show.

Except for *La Danse,* which Picasso kept back for himself, all the works had been purchased by Rosenberg. In 1925 he had paid Picasso 437,000 francs for twenty-eight paintings, two pastels, and two drawings.[63] To defray the costs of reconstruction, Rosenberg needed to sell as much as he could for as much as he could. He succeeded. The following year, the dealer would mount a retrospective of Picasso's drawings, but he would not put on a major exhibit of his paintings for another ten years.

The give-and-take between Picasso and Matisse has been the subject of so much discussion in recent years that there is little to add. Picasso grabbed whatever he needed from his rival and occasionally communicated with him covertly via his work.[64] Matisse also took whatever he needed from Picasso (notably from cubism) but, unlike his rival, he was embarrassingly petulant about this give and take. Three days before Picasso's show opened, he moaned to his daughter Marguerite that he had "not seen Picasso for years. I don't care to see him again . . . he is a bandit waiting in ambush."[65] The painting of María d'Albaicín mentioned in Chapter 22 is based on the trite publicity photograph of the beautiful flamenco dancer reclining

on an oriental rug and holding a tambourine behind her head like a halo as she smiles roguishly into the camera. In Picasso's painting, the skirt is striped and the left arm rests on a cushion, as in the photograph. A principal difference is the redeployment of the tambourine as the dancer's stomach. It was a message to Matisse, but Picasso did not intend his *Odalisque* as a Matissean parody. Stravinsky, who was very close to Picasso at this period, put the dilemma of a great artist vis-à-vis his peers very succinctly. "When composers show me their music, all I can say is that I would have written it quite differently. Whatever interests me, whatever I love, I wish to make my own."[66] Picasso had far too much respect for Matisse to ridicule him. As Bois puts it, Picasso wanted to administer a rebuke and tease "Matisse out of his self-imposed role as Old Master in Nice and back into the ring of modernity."[67]

Picasso attached enormous importance to this show. He made a point of visiting the gallery every day until it closed. He would always have a curious detachment about his own work, as if it had been executed by someone else. The purpose of his visits was not to glory in his accomplishments but to solve the unsolvable mystery of how he had arrived at this or that particular point. Without a precise idea of his bearings he was unable to go on to make new discoveries. It was time for a pause. Gertrude Stein's book on Picasso—for all its bias, self-promotion, and silliness—can sometimes be surprisingly perceptive. The inaccuracies in the quote below conceal a nugget of truth:

> [F]or the first time in his life [Picasso] did not draw or paint. . . . An enormous production is as necessary as doing nothing in order to find one's self again. . . . During these six months the only thing he did was a picture made of a rag cut by a string, during the great moment of cubism he made such things, at that time it gave him great joy to do it . . . but now it was a tragedy. This picture was beautiful, this picture was sad and it was the only one.[68]

In fact "the rag cut by a string" dates from the time Picasso was working on such major works as the *Milliner's Workshop* and the *Artist and Model.* Elsewhere Stein implies she had 1927 in mind;[69] evidently she has 1926 and 1927 hopelessly muddled. Nevertheless, she makes up for this and other confusions when she characterizes Picasso as "a man who always has need of emptying himself, of completely emptying himself, it is necessary that he should be greatly stimulated so that he could be active enough to empty himself completely."[70] Picasso would "never empty himself completely," but after the mammoth harvest of the previous summer and the following spring, as well as the sense of heroic achievement generated by the Rosenberg show, he felt fully entitled to a few quiet but by no means inactive months.

25

Summer at La Haie Blanche (1926)

On July 10, the Picassos packed up the rue la Boétie apartment and headed south. This time they took their own car and booked into the Hôtel Majestic at Cannes. They had not rented a house ahead of time and had to look around for whatever was available. On July 15, they rented a villa at Juan-les-Pins from Mlle. Blanche Hay—hence the villa's name, La Haie Blanche.[1] It appears to have been a handsome, balustraded house half hidden in a tangle of pine trees and shrubbery. In some of Russell Greeley's snapshots, Picasso—a Peeping Tom like so many Andalusians—peers at the neighborhood through a telescope.[2]

As he had done on previous summers, Picasso recorded his new surroundings. A drawing reveals the salon to have been somewhat oriental: a divan piled with cushions, a Moroccan table, small shaded lamps on the chimneypiece, and Olga standing in the middle of the room in a long dress.[3] Sketchbook drawings[4] suggest that

Picasso. *Olga at La Haie Blanche,* September 1926. India ink on paper, 29.1 x 38.8 cm. Musée Picasso, Paris.

Picasso. *Artist and Model,* 1926. Black pencil on paper,
29 x 38 cm. Whereabouts unknown.

Picasso contemplated doing a painting of a nude—as her body whittled down to five stavelike lines—stretched out on the steps of the house, an overgrown garden to right and left.

It is impossible to be precise about this summer's production because much of it is supposed to have been stolen from the roof of the artist's car during a stop for lunch on the way back to Paris. Asked about this theft sometime in the mid-1950s, Picasso joked that "the thieves must have been disappointed in their loot and probably chucked it into a ditch."[5] The story appears to have been played up—possibly made up—to account for this trip's scant output. In reply to a journalist who asked what he had been doing, Picasso replied, "Heads." "Portraits?" "No, heads, simply what I call heads. Perhaps you might not see them this way, they are . . . what is called cubist."[6]

The "cubist" paintings to which Picasso refers are bifurcated heads—variations on his double-profile images done earlier in the year.[7] At first sight seemingly female, given their vertical vaginalike eyes, at least one of these heads, on closer examination, turns out to be male. In some of them, Paulo appears as bizarrely twisted Harlequins.[8] In another, done later in the year, as Gert Schiff has pointed out, the one with short hair and bib and blobs of red paint on his cheeks is of Paulo or one of the Murphy kids, got up for a costume party as a clown.[9] There are also a couple of drawings of a naked girl with very distinctive features—the unidentifiable blonde?[10] Picasso might well have installed her nearby, as he would his next mistress.

If the theft was indeed apocryphal these powerful tribal faces with their relocated features are virtually all Picasso did this summer and fall, with one notable exception: a largish (130 × 97 cm) anthropomorphic still life, *The Atelier,* which was presumably done at Juan-les-Pins, given the pale blue patches of sea and sky and the unfamiliar bedroom setting.[11] I see this painting as an allegory of painter's block. Picasso pictures himself as an easel with nothing on it but a palette, unsullied by paint, as if to announce that he had stopped painting. And he pictures Olga no less negatively alongside him as a pair of tights. In the preparatory drawing, there is a clumsily darned patch on the tights of the right leg, the one that had been the cause

Left: Picasso. *Head,* 1926. Oil on canvas, 41 x 33 cm. Private collection.
Right: Picasso. *Bust of a Woman,* 1926. Charcoal and oil on canvas, 81 x 64.7 cm.
Musée d'Art Moderne, Strasbourg.

of her giving up dancing. The placement of the palette on the easel in this revelatory painting suggests that Picasso had derived inspiration for the only painting of any importance done this summer from a celebrated simile in Lautréamont's *Les Chants de Maldoror.* Greatly revered by the surrealists, this simile likened the beauty of a young man to "the chance meeting of an umbrella and a sewing machine on an operating table."[12] Picasso has adapted Lautréamont's metaphor to his and Olga's circumstances; however, his confrontation between the easel and the tights on a washstand is too straightforwardly symbolic to be dubbed surrealist.

It took the beau monde a mere three years to follow the footsteps of Picasso and the Murphys and make the Riviera their summer playground. In 1926 there were two hospitable new follies for the Picassos to visit: Russell Greeley and François de Gouy d'Arcy's Château de Clavary, outside Grasse, and the Noailles' Mas Saint-Bernard at Hyères. On May 15, Greeley and Gouy received their first houseguest, Max Jacob. Later in the summer, Picasso would drive up to supervise the installation

Back terrace of Château de Clavary with Germaine Everling, Russell Greeley, Marthe Chenal, Nina Hamnett, Francis Picabia, and François de Gouy d'Arcy, c. 1925–26. Collection of Kimberly Greeley Brown, Courtesy Kenneth Wayne.

of his black-and-white mosaic floor,[13] a circle of interlocking profiles that would be the centerpiece of the *fumoir,* a room for smoking opium rather than tobacco. Ever the perfectionist, Gouy upholstered the smokers' oriental divans in flowered chintz, copied from Liotard's *Countess of Coventry in Turkish Dress.*[14]

By the fashionable standards of the day, Clavary was small—no more than three or four guest rooms—but it was extremely luxurious. Gouy was an obsessive *maître de maison* and a gourmet, whose famously skilled cook kept a supply of caviar ready for Stravinsky's visits. Gouy saw himself not so much as a collector than as a patron of the arts in the eighteenth-century manner. He had Jean Hugo fresco some of the walls and Italian artisans do trompe l'oeil scenes on the staircase. Later he would commission Max Ernst to create a surrealist grotto in the park. The garden was full of surprises: a trellis that concealed a fountain, a marble specimen table, a fig tree made of cement. There was also an artificial lake and an island rimmed with papyrus. Mornings, Greeley and Jean Hugo would swim there while Gouy looked on, glass in hand, laughing at them. Elsewhere in the garden, Nina Hamnett would be teaching Poulenc ribald English sea chanteys, while other guests dressed up the ubiquitous statues of gods and goddesses in hats, coats, umbrellas, and sunglasses. Picasso may have had these scarecrows in mind twenty years later when he set about assembling sculptures of his daughter Paloma and her mother out of old shoes and baskets and lids of things picked up in the street. Views from the property were, indeed still are, superb: the Mediterranean coast to the south, the Alpes-Maritimes to the north, olive groves and fields of jasmine all around. Jean Hugo remembered the songs of the girls picking jasmine and forest fires blazing away in the distance.[15]

That first year at Clavary, the stream of visitors included the Picassos, Picabias, Stravinskys, Murphys, Van Dongens, Marie Laurencin, Man Ray, Rebecca West,

François de Gouy d'Arcy, Jean Hugo, Olga, Russell Greeley, and Picasso in Juan-les-Pins, 1926.

Nina Hamnett, Tony Gandarillas, Christopher Wood, Mary Garden (the Scottish-American Mélisande), René Crevel, Robert Desnos, Honegger, Auric, and Poulenc—everyone except Beaumont, whom Gouy loathed for some arcane genealogical reason. At one of his dinners after a bullfight in the 1950s, Jean Hugo regaled Picasso with stories about Clavary that he was including in his fascinating memoir about high Bohemia in the 1920s and 1930s in the south of France. After World War II, the grounds at Clavary were used as a dump for the mountains of old clothes—rotting shoes, overcoats, and uniforms—which the Abbé Pierre had never got around to distributing to the poor. This discouraged potential buyers of the property, including Douglas Cooper. In the end, Clavary was bought by Peter Wilson, the auctioneer who did his best to lure Picasso back to the house.

Much the same group foregathered at the forty-bedroom Mas Saint-Bernard, which the Noailles had recently built and would go on perfecting and adding to for the next ten years. Marie-Laure could not remember for sure when Picasso first visited them, but thought it was the summer of 1926. Out of curiosity the artist drove over to see this spectacular modernist folly which Robert Mallet-Stevens had designed.[16] Predictably, he disliked the place; the concept of a house as an enormous *machine à habiter* was anathema to him.

Although the Noailles had had the courage to acquire one of the most original and challenging of Picasso's recent paintings—the great sand-encrusted still life of the previous summer—and were in the process of replacing the penny-pinching Doucet as leading backers of modernism, Picasso never warmed to them. He particularly disliked Marie-Laure. Despite her great wit, heart, and acumen, she became too outrageous, too flagrantly "camp" for Picasso's taste. The debutante he had portrayed so blandly in 1921 was turning into an unpredictable exhibitionist who loved to

shock, as in the pass she made at Picasso: "You be Goya and I'll be the Duchess of Alba." Recalling this thirty years later, the artist said that she would have done better to cite Goya's hideous Queen María Luisa of Spain. By that time, however, Marie-Laure, who was half-Jewish, had earned Picasso's undying enmity by having a romance with an Austrian officer during the Occupation, followed by a long affair with Oscar Domínguez, the surrealist Canary Islander who faked Picassos on the side.

When the Picassos arrived at Juan-les-Pins, the Murphys were off in Spain with their new best friends, Ernest and Hadley Hemingway and Pauline Pfeiffer, an attractive *Vogue* editor who would soon replace Hadley as the writer's wife. They had gone to Pamplona for the Fiesta of San Fermín and the running of the bulls. Hemingway was new to bullfighting, but he already behaved, Picasso said, as if his *afición* went deeper than anyone else's. At Pamplona Hemingway had shamed a terrified Gerald into entering a training ring with him and facing up to a young bull.

As an Andalusian, Picasso found Hemingway's appropriation of Andalusian machismo offensive. To make his point, Picasso later described how Hemingway had called on him in Paris soon after the Liberation. Told the artist was out, Hemingway asked the concierge whether he could leave a note for him. Yes, but wouldn't he like to leave some cigarettes? Hemingway went down to his car and returned—to the terror of the concierge—with a box of hand grenades.[17] That's Hemingway for you, Picasso said. On another occasion, summer of 1959, Cooper and I went to a bullfight at Nîmes with Picasso: one of a series of *mano a mano* contests between Luis Miguel Dominguín and his brother-in-law Antonio Ordoñez. Hemingway was covering these historic *corridas* for *Life* magazine and was playing the role of aficionado to the hilt from behind the *barrera*. As the band struck up the "Marseillaise" to open the proceedings, Picasso burst out laughing and pointed down at Hemingway. The author of *Death in the Afternoon* was standing rigidly at attention, his right hand up to his peaked cap in a salute. Noticing that nobody else was saluting, slowly and surreptitiously he lowered his hand and stuffed it in his pocket. *"Quel con,"* Picasso said.

At the beginning of August the Picassos took Man Ray, who was staying at Villefranche with his mistress, the celebrated "Kiki of Montparnasse," to see the Murphys and photograph them and their children. The Murphys, who liked to turn arrivals and departures into special occasions, were all set to welcome the honeymooning Donald Ogden Stewarts at the local railroad station. They had dressed up eight-year-old Honoria in the Harlequin costume that Paulo wore in his father's 1924 portrait and had outgrown. Sara played a drum and Baoth a guitar. The sight of little

Honoria in this familiar costume and Paulo in fancy dress prompted the bizarre stylizations of the Harlequin heads that Picasso worked on this summer. The Murphys had also planned a formal party for the Stewarts and their other houseguests, the Robert Benchleys and Alexander Woollcott; however, letters from Sara to Picasso tell a story of successive postponements due to the bride's exhaustion. "Brides . . . just aren't as sturdy as they used to be," Sara wrote Picasso. "What is it they all seem to have?"[18]

The indisposition of the bride and the news that Hemingway had returned from Spain and was leaving Hadley for Pauline put an end to plans for the party. Sara Murphy's life-enhancing wand no longer seemed to work. All of a sudden *luxe, calme et volupté* gave way to angst. Zelda Fitzgerald's alienation was symptomatic of the malaise at the core of twenties rapture. One evening while dining at the Colombe d'Or—a renowned Saint-Paul-de-Vence restaurant that still caters to Riviera celebrities—the Murphys told Scott that the fat, frowsy woman with purplish hair at a neighboring table was Isadora Duncan. Fitzgerald rushed over to sit at her feet. "My centurion," Duncan said, and ran her hands through his hair, suggesting that he come up and see her later. At this Zelda leapt from her chair, sprang across Gerald, and flung herself off a parapet into the night.[19] Stone steps broke her fall and saved her from death in the valley below. Blood-smeared but relatively unhurt and very, very cool, Zelda miraculously reappeared.

Fear of another "Fitzgerald evening" discouraged friends, the Picassos above all, from frequenting the Villa America. The artist felt more at ease with the *opiomanes* at Clavary than with the Murphys' alcoholic stars. When he failed to find the time to go and see Gerald's recent paintings before he and Sara left for America, their friendship cooled. This might explain why that winter Gerald was observed by Archibald MacLeish to cut Picasso dead at a concert.[20] My own feeling is that Gerald had recognized himself in the *Pipes of Pan*. The two *ménages* would see little of each other the following year. Since there had been no real quarrel, there could be no real reconciliation. They simply drifted apart. After 1930, the Murphys' motto—"Living well is the best revenge"—would cease to have much relevance to their existence. Losses on the stock market curtailed their sybaritic lifestyle. They rented the Villa America and spent more time in the States. Gerald had to take over Mark Cross, the family business, which he did efficiently and profitably. Then tragedy struck. Both their adored sons died in their teens, Baoth in 1935 and Patrick in 1937. In his letter of condolence to the Murphys after Patrick's death, Fitzgerald invoked Henry James: "the golden bowl is broken indeed but it was golden."[21] Fitzgerald of all people should have realized that if the bowl had indeed been golden, it would not have broken.

During the summer of 1926, Picasso resumed going to bullfights—locally at Fréjus and, farther off, at Nîmes, which is where he treated Michel Leiris to his first corrida. For Leiris it was a defining event; it sparked a passion that would bind him to Picasso and at the same time generate some fine taurine writing, which is rather more Mithraic than the sports-reportage style of Hemingway's "how-to" manual, *Death in the Afternoon*. The corrida at Nîmes also reawakened Picasso's *afición*.

At the end of September, when the lease on La Haie Blanche was up, Picasso decided to return to Paris by way of Barcelona and to see more bullfights.[22] En route he stopped at Céret—a bastion in the history of cubism—to visit one of his oldest, dearest, funniest friends, the sculptor Manolo Hugué, and his wife, Totote, who would reemerge in the role of Celestina later in his life. Picasso and family, plus driver and nanny, then drove on to Barcelona, where they put up at the Ritz. The ostensible purpose of this trip was for Paulo to see the country of his forefathers and get to know his Spanish family, whom Olga summoned to tea at the Ritz. Picasso was primarily interested in attending bullfights and catching up with old friends. He unthinkingly allowed himself to be inveigled by one of these cronies—said to have been the editor of the Catalan-language paper *La Publicitat*[23]—into giving an informal press conference in a furniture showroom attached to the Ritz. This was something Picasso had never done before and, given the tragicomic mess he made of it, would never do again.

Angel Ferran, *La Publicitat*'s interviewer and later a sculptor, found Picasso pathologically averse to cooperating.[24] Whenever Ferran questioned him about his work, Picasso would find a pretext for leaving the room: he needed to check on Paulo, who was not feeling well, or fetch him a hat. At these moments Olga took over. She ad-libbed about Satie and how the composer had once thanked Edith de Beaumont for a check: "Your thousand francs have not fallen upon deaf ears." When Picasso returned to the press conference, he behaved even more "like a hedgehog," complaining about previous interviewers who had asked him "terrible things like, 'What do you understand to be art?' " Ferran padded out his article with a story recounted by a former member of the artist's Barcelona *tertulia* about Picasso in Holland in 1905. Needing a painkiller and not speaking Dutch, Picasso had gone to a pharmacy and tried to draw what he required. To his consternation, he found "he did not know how to draw pain." The artist ended up claiming, nonsensically, that this anecdote was at the origin of his "great rapport with Ingres."

To deflect further questions, Picasso embarked on a story about Cocteau and Marshal Foch of no particular interest except that it prompted another journalist— possibly a French one, as Picasso answered in French—to ask a loaded question:

What did he think of Cocteau? Caught off guard, Picasso said in public what he had been saying for years in private, and in doing so dealt his old friend, intentionally or not, a heartbreaking blow:

> Cocteau is a *machine à penser* [a thinking machine]. His drawings are ever so grace-ful, his writings journalistic. If newspapers were written for intellectuals, Cocteau would serve up a fresh dish every day, an elegant trifle. If he could market his tal-ent, we would be able to spend the rest of our lives buying Cocteau potions from a drugstore without ever depleting his stock of talent.[25]

This quote was not included in *La Publicitat;* however, it mysteriously appeared the very same day in the literary gossip column of the Paris newspaper *L'Intran-sigeant.* The piece was headlined "Picasso's Opinion of Jean Cocteau," and subtitled, "Interviewed at Barcelona, where he is attending a bullfight, the father of cubism has declared . . ."; and it was signed, "Les Treize," presumably an editorial pen name. Breton and the surrealists were overjoyed. One of them may well have had a hand in the leak.

Mortified by his hero's denunciation in a leading Paris newspaper, Cocteau cabled Picasso from Villefranche, begging him to put the blame on Picabia:

> *Intransigeant* published views about me which I know to be Picabia's entitled Picasso's opinion of Cocteau stop besides suffering terrible chagrin this will result in universal shame for me stop beg you send one line rectification to Divoire *Intran-sigeant* stop although this is not your habitual line of action do it to preserve our friendship in the eyes of the world beg you in the name of Paulo stop am sending copy of this cable to Barcelona Jean.[26]

Cocteau could not have done more to harden Picasso's heart against him. Drag-ging Picabia into it was bad enough, but invoking Paulo was unpardonable. Receiv-ing no reply from Picasso, Cocteau wrote to *L'Intransigeant* himself:

> [T]hese amusing and offensive comments have already been made by Picabia. Picasso and Picabia have been traveling together in Spain. To me the confusion is self-evident. These words could not be Picasso's. First, because they do not bear the mark of his extreme prudence, also because they would destroy a deep friend-ship. Picabia is at liberty to say whatever he likes about me. Knowing Picasso's dis-taste for clarification and in view of our great friendship, I could not possibly allow this error on the part of a Spanish journalist to go uncorrected.[27]

Two days later, Cocteau followed up his cable with a mawkish letter, which Picasso once again failed to answer:

> After the death of Radiguet, I believed myself incapable of suffering another such blow. I know that people always distort things and reason obliges me to believe that these cruel words are Picabia's, however the deed is done. You, who never talk

about people . . . have talked about whom else but me? About me, who adores you and is ready to die for you and yours. You have repudiated me in the eyes of the young, who listen to you as if to the Gospels. You have handed my enemies a deadly weapon. I suffer so much I want to kill myself. Without Mummy and the Church, I would have thrown myself out of the window.[28]

Cocteau was right, "Mummy" did indeed save the day. As Gertrude Stein relates in the *Autobiography of Alice B. Toklas*:

The Picassos went to the theater and there in front of them seated was Jean Cocteau's mother. At the first intermission they went up to her, and surrounded by all their mutual friends she said, my dear, you cannot imagine the relief to me and to Jean to know that it was not you that gave out that vile interview, do tell me that it was not.

And as Picasso's wife said, I as a mother could not let a mother suffer and I said of course it was not Picasso and Picasso said yes yes of course it was not, and so the public retraction was given.[29]

Since Picabia denied any involvement—had he even been in Spain at the time?—nobody believed this "public retraction." The pretense that Picabia was the culprit may have worked with Madame Cocteau but not with close friends, as a letter from Max Jacob to Cocteau confirms:

Picasso says to himself, "There is no poet. Rimbaud is the only one. Jean is only a journalist—Apollinaire was an idiot and Reverdy has no idea what it is to be a catholic." A newspaper interviewer arrived at just the right moment to record these precious thoughts. You have paid the price. Like Pascal, Picasso is a coiner of phrases: Pascal was careful not to publish any of his for two hundred years.[30]

A week later, Cocteau wrote to reassure Jacob that he was recovering from his suicidal depression:

[Picasso] rattles the buildings in his city. The roof tiles fall. I am proof against this. Picasso hates everything and hates himself. He wants to do the undoable and insists that others do the same. In short, this Spaniard wants to be a saint—and is in a fury because his psyche condemns him to take anything but a saintly path. . . . He is a poor judge of literature. He doesn't understand that his revolt against painting had already been done in our field by Rimbaud, Ducasse [Lautréamont] etc . . . that blood has been shed—and that the present revolt is all about restoring order and love.[31]

Had Picasso enjoyed a productive summer, he is unlikely to have treated Cocteau so shabbily. At fallow periods like this, his mood was apt to turn mean and dark. Cocteau might have seemed a good target for his spite, since this reborn Catholic had publicized his return to the sacraments with a theatrical display of self-

promotional piety. This rebirth seemed all the more insincere given the orgiastic life that he had been enjoying at the Welcome Hotel in Villefranche, smoking opium with a "squadron" of gay fans,[32] headed by his disciple, the creepy, unctuous seminarian Maurice Sachs.

As Picasso knew all too well—he was there at the time—Sachs had recently caused a scandal at Juan-les-Pins by walking up and down the beach hand in hand with an eighteen-year-old American called Tom Pinkerton. Sachs had dressed the boy in his soutane, lined in pink crepe-de-chine, by way of a beach robe. Pinkerton's mother, *"une affreuse Quakeresse,"*[33] reported the matter to the police as well as the ecclesiastical authorities, who talked of charging Sachs with pedophilia. Terrified of being contaminated by the scandal, Cocteau ordered his former favorite to return to his seminary and lie low, but Sachs refused to do so. Before leaving for Spain, Picasso had mischievously urged Sachs to disobey his mentor and stay put.[34] Black humor, by which Breton and the surrealists set such store, was second nature to Picasso. He proceeded to treat Cocteau's misery as a huge, black, enjoyably guilt-inducing joke—"Mummy and the Church," indeed.

On his return to Paris, Picasso found Clive Bell waiting for him. He summoned him to the rue la Boétie on October 25—a week after the paragraph appeared in *L'Intransigeant*—to tell him about "all his pictures [being] stolen from the roof of his car and *l'affaire Cocteau.*"[35] Picasso put himself in a favorable light. He told Bell that on arriving in Barcelona he had been surrounded

> by journalists inquiring what he thought about everything modern—Gide, Anatole France, Proust, MacOrlan, Matisse, Paul Morand—and Cocteau. Of course Picasso couldn't resist being himself. . . . And of course the interview was translated and published. . . . Since then telegrams as long as letters have been flying in every direction from Villefranche . . . and, as telegrams from Spain are forwarded at the recipient's expense, *Picasso commence à trouver la chose moins drôle.*[36]

Cocteau's vengeance was characteristically Delphic. Months before the Barcelona business, he had decided to emulate Picasso and become a *collagiste*—an occupation which did not interfere with the round-the-clock whoopee at the Welcome Hotel. His *objets*—"often very witty," according to Severini[37]—were made of barbed wire, pipe cleaners, matches, candle grease, and bits of ribbon and cloth. Cocteau exhibited them at the Galerie des Quatre Chemins in December.[38] "Picasso was the prime butt of these pranks."[39] However, it was not the exhibits that irritated Picasso; it was an aphorism in Cocteau's catalog preface: "A farmer finds the arms of the Venus de Milo in one of his fields. To whom do they belong? To the farmer or the Venus de Milo?"

This observation infuriated Picasso. Severini provides a Delphic clue as to why: "[because the artist] knew who the owner of the Venus de Milo's arms was."[40] Since

no such owner existed, he presumably meant Picasso. A jokey reference to the plaster casts and broken limbs in his recent still lifes would have bothered Picasso only if he felt it alluded to something discreditable in his past, such as his involvement in the theft of Iberian sculptures from the Louvre. In this context it is important to recall that when Picasso humiliated him publicly, Cocteau had retaliated with a vengeful invention to the effect that a push from Picasso had caused Olga's accident in 1918.[41]

Stories that Picasso refused "to have Cocteau in his house" for the next ten years are untrue.[42] In his infinite masochism where Picasso was concerned, Cocteau immediately set about worming his way back into his favor. He sent Paulo a Christmas present and apologized for his inability—a sudden illness—to hang it on the Christmas tree himself.

In 1926, Cocteau had published a compilation, as *Le Rappel à l'ordre,* of what he considered his most significant texts; it included *Le Coq et l'arlequin, Le Secret Professional,* and his ode to Picasso. For all Cocteau's brilliance and wit, the texts had dated and seemed all too lightweight by comparison with Breton's weighty pronouncements. After his off-the-cuff outburst in Barcelona, Picasso did not want to be perceived as siding with the surrealists, so he stayed above the fray. He did not rate any of the surrealist poets much higher than Cocteau; however, he took a passionate interest in the work of Breton's principal surrealist painters: Masson, Klee—whom "he held in high esteem," he told Daix[43]—and above all Miró, whose work was more of an inspiration to him than he liked to admit. Sometimes in and sometimes out of favor, Masson would have ingratiated himself to Picasso by publishing a letter in the October 1925 issue of *La Révolution Surréaliste:* "We . . . feel that life—whatever Western civilization has made of it—no longer has any right to exist, and that it is time to envelop ourselves in the night; within it we are able to find a new raison d'être. It is also necessary to take part in the class struggle."[44]

Another twenty years would go by before the last phrase would mean much to him. On the other hand, "a new raison d'être" was exactly what he needed: a new love, in the form of a beautiful seventeen-year-old girl who would captivate Picasso and isolate him from both society and his old *tertulia.*

26

Marie-Thérèse Walter (1927)

The year 1927 could not have started more propitiously for Picasso. At six o'clock in the evening of January 8, while cruising the *grands boulevards* in search of *l'amour fou*, the forty-five-year-old artist came upon the *femme-enfant* of his dreams: an adolescent blonde with piercing, cobalt blue eyes and a precociously voluptuous body—big breasts, sturdy thighs, well-cushioned knees, and buttocks like the Callipygian Venus. Physically, the girl was the antithesis of skinny Olga and the boyish, flat-chested flapper look that was de rigueur in the 1920s. Marie-Thérèse Léontine Walter[1] was seventeen and a half years old. For the next nine years or so, she would be Picasso's greatest love. Before her death in 1977 (fifty years after meeting Picasso), Marie-Thérèse, who was unusually truthful, allowed herself to be interviewed by Lydia Gasman in 1972 and Pierre Cabanne in 1977.[2] Gasman was particularly successful in winning her confidence and persuading her to talk without constraint about the first meeting and the nature of her relationship with Picasso.[3]

Marie-Thérèse told Gasman that after shopping at the Galeries Lafayette for a *col Claudine*—a "Peter Pan collar"—and matching cuffs,[4] she had been accosted by Picasso. His broad smile, beautiful red-and-black tie, wide gold ring off an expensive umbrella, and huge mesmeric eyes instantly disarmed her. She remembered him saying, "You have an interesting face. I would like to do a portrait of you. I feel we are going to do great things together." "I am Picasso," he announced.[5] The name meant nothing to Marie-Thérèse, so he took her to a bookstore and showed her a book about him—in Chinese or Japanese, she thought. The fact that he was a painter touched her, "because my mother had had a great romance with a painter. It seemed as if the same story were about to begin all over again."[6] Picasso's comment that she was beautiful gave Marie-Thérèse particular pleasure. Hitherto her family had teased her for having an ugly "Greek" nose instead of a cute little Parisian *retroussé* one.

"I want to see you again," Picasso had said, "Monday at eleven o'clock at the Saint-Lazare Métro station." Marie-Thérèse kept the appointment. *"Il m'a charmé,"* she said[7]—when Picasso set out to charm, he was famously irresistible. In the course of her interviews with Gasman, Marie-Thérèse divulged that she had slept with

Picasso within a week of meeting him. She had previously claimed to have resisted for six months. (She did not turn eighteen—the legal age of consent—until July 13, hence the need for a cover-up.) "It was only after six months that Papa took Mama by the hand" is how, many years later, she coyly put it to her little daughter Maya.[8]

A year after Marie-Thérèse died, her elder sister, Jeanne Volroff,[9] decided to grab a share of the limelight. Events played into her hands. An amateur art enthusiast, Dr. Herbert T. Schwarz, had become fascinated by Marie-Thérèse's story and had started writing a book about her. In the course of his research, this flying doctor, fur trader, and collector of Eskimo artifacts, who lived on the shores of the Arctic Ocean in an Eskimo settlement called Tuktoyaktuk (Northwest Territories), tracked Jeanne down. They played into each other's hands. Schwarz wanted a story for his book; Jeanne wanted to get even for fifty years of sibling rivalry. The book, which raised more questions than it answered, came out in 1988. Scholars, greedy for any information about Marie-Thérèse, were mostly taken in by his fairy tale. When Schwarz's facts were questioned some fifteen years later, Jeanne, who was then in her late nineties, claimed that he had duped her and put words into her mouth. Anyone who bothers to scrutinize Schwarz's wretched book can only conclude that she had also duped him.

The rigmarole that Jeanne told Schwarz has deceived so many writers on Picasso and been the cause of so many misstatements that it is necessary to set things straight. Marie-Thérèse always said that she was alone when Picasso accosted her. Jeanne, who was studying optometry in Paris at the time and in the habit of accompanying her younger sister to the Gare Saint-Lazare to catch a train back home, claimed that she was with her. Home was a riverside house at Maisons-Alfort, a suburb on the city's southeastern periphery, where she and another sister lived with their single mother, Emilie-Marguerite Walter. Jeanne told Schwarz that Picasso had punched a hole in his newspaper so that he could watch, unobserved, as the girls kissed good-bye. Only then did he approach Marie-Thérèse, who supposedly brushed him off. "Flushed and agitated," Picasso grabbed her by the arm and exclaimed, "Mademoiselle, I shall wait for you here every evening at six p.m. I must see you again."[10] Jeanne told Schwarz that it was *her* idea that she and Marie-Thérèse should both go to the Gare Saint-Lazare to check out the "old man," and that they supposedly discovered him sitting on a bench reading a newspaper. It was also *her* idea that they return, day after day, to spy on him, until Jeanne dared Marie-Thérèse to approach him. None of this was true.

Four years after Picasso's death, Marie-Thérèse committed suicide. Not realizing that her sister had told her story to two exceedingly reliable authorities, Jeanne felt free to invent a leading role for herself. Her most dangerous lie was the story that the pickup had taken place in 1925—two years before the correct date of 1927—

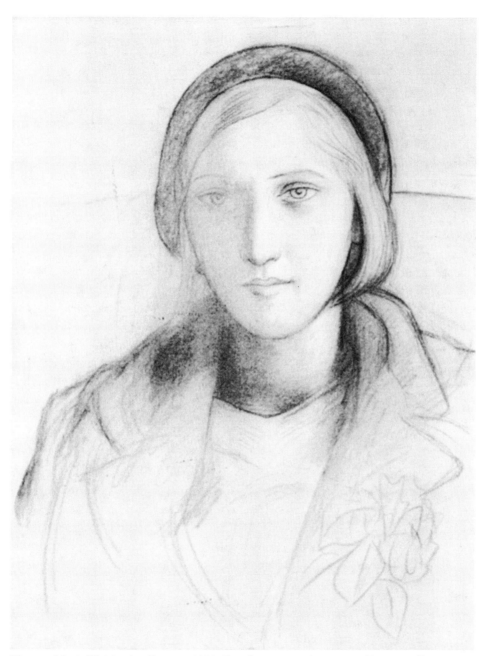

Picasso. *Marie-Thérèse in a Beret,* c. 1930. Pencil on paper, 63 x 48 cm. Private collection.

dangerous because it implied that Picasso had been a pedophile. Jeanne's inventions were also maddening in that they left historians floundering in their efforts to get the artist's life and work to jibe with her invented dates.[11] Another consequence of the doctor from Tuktoyaktuk's misplaced belief in Jeanne has been the misidentification of another fair-haired woman portrayed by Picasso in 1925 and 1926 as an adolescent Marie-Thérèse. These images depict a thinner, less girlish-looking woman whom I have referred to as the unidentified blonde.

According to Schwarz, Jeanne, "a highly regarded specialist in her field,"[12] had the noblest of motives for letting him come out with her story: she wanted to tell the truth; she also wanted to upbraid Marie-Thérèse for her "unwarranted secrecy so long after [her seduction]."[13] In fact, Jeanne's sibling had been truthful—candid rather than reticent. She had said little to Gasman about Jeanne because she "cordially disliked" her.[14] This dislike dated back to the time of Jeanne's marriage and was apparently mutual, which is why Jeanne waited until both Picasso and Marie-Thérèse were dead before coming out with her tall tale. Another conspicuous hole in Schwarz's book is the absence of the girl who *does* appear alongside Marie-Thérèse in many of Picasso's post-1930 paintings: the dark-haired second sister, Geneviève (also called Volroff), whom Marie-Thérèse adored and Picasso fancied and liked to have around.

As for Jeanne's grandiose tales about the Walter girls' paternity, which had impressed Schwarz, let us turn to Marie-Thérèse's art-historian granddaughter, Diana Widmaier Picasso, who has cleared up most of the facts. Although Marie-Thérèse had always wanted to believe she was the daughter of a painter, her father turns out to have been "a rich Parisian industrialist of Swedish origin . . . a married man and father of three children"[15] called Léon Volroff. He had employed Marie-Thérèse's mother as his secretary and, subsequently, made her his mistress. Emilie-Marguerite Walter—known to the family as Mémé—had been the daughter of a prosperous plumber, Burkard Frederic Walter (born at Heidelberg in 1833). After fleeing to France in the 1850s to escape the draft, Walter became a French citizen and settled in Maisons-Alfort. Around 1900, his daughter married a man called Victor Schwarz.[16] He was such an abusive drunkard that Emilie-Marguerite divorced him and took up with Volroff, who fathered her four children—a son as well as three daughters.

Marie-Thérèse was the youngest of the Walter/Volroff children—seemingly a happy enough family. The whiff of permissiveness and the absence of a legitimate father facilitated Picasso's seduction of Marie-Thérèse. At first, Madame Walter made a show of parental propriety, but she was soon welcoming the famous artist as a friend—"Pic," the girls called him. She allowed him to use the potting shed in their garden to paint in and, presumably, carry on with Marie-Thérèse.[17] Picasso would

have known about this reach of the Marne from Radiguet, whose best-known novel, *Le Diable au corps,* has a similar setting.

Besides confirming that Marie-Thérèse was not in Paris but away at school in Germany in January 1925, Diana Widmaier Picasso has published a letter in Picasso's handwriting—dated July 13, 1944, Marie-Thérèse's thirty-fifth birthday—celebrating "the 17th anniversary of your birth in me."[18] In the same article, she reports that the ninety-five-year-old Jeanne had finally come up with the truth. All of a sudden she had recalled that Picasso was forty-six—actually he was forty-five—in January 1927 when he met Marie-Thérèse; so their meeting had to have taken place in 1927. Rather than rely on Jeanne's mendacious memory, let us turn to Marie-Thérèse. Gasman has discovered a note in her writing, added upside down to the manuscript of one of Picasso's poems: "Just to say that I have loved you for nine years. *I love you* and give you everything I have."[19] It is dated January 8, 1936.

The first time Marie-Thérèse came to the rue la Boétie studio (January 11, 1927), Picasso did little more than observe her face and body very closely, so as to fix her image in his mind. As she left, he told her to come back the following day. "From then on it would always be tomorrow; and I had to tell my mother that I had got a job." "I was very shy and never dared look [Picasso] in the eye. I never asked him the slightest question. I posed for him. He worked very hard. . . . He told me that I had saved his life, but I had no idea what he meant."[20] She had indeed saved him: from the psychic stress of his marriage and the bourgeois restraints that it imposed.

Picasso's passion for Marie-Thérèse has inevitably been seen in the context of the surrealists' cult of *l'amour fou:* the theme of Breton's popular book *Nadja.*[21] True, both stories start with a pickup, but Breton's girl was very different from Marie-Thérèse in looks, character, morale, and destiny. *Nadja* reads like one of Freud's case histories. It concerns Breton's relationship with a working-class waif from Lille. Léona-Camille-Ghislaine D., or Nadja, as she preferred to be known, survived by selling her body and, occasionally, drugs to "admirers."[22] Intrigued by Nadja's shabby clothes, "curious make-up . . . faint smile," and strange eyes, which reflected "obscure distress . . . and luminous pride,"[23] Breton had discovered her on the *grands boulevards* in the course of one of his afternoon "cruises." Within a week of their first meeting (October 4, 1926), he was infatuated. In her *jolie-laide* weirdness, mystery, and psychopathic impulses, Nadja reminded some of Breton's associates of their bête noire, Gala Eluard, who had recently seduced Max Ernst and would soon marry Dalí.

As soon as Nadja fell in love with him, Breton's feelings for this schizophrenic victim waned, and he set about exploiting the literary possibilities of this "free

genius . . . one of those spirits of the air,"[24] for the greater glory of surrealism. At the same time that Picasso's passions were being reignited by Marie-Thérèse—January 1927—Breton was doing his best to unload Nadja; the better to write about *l'amour fou* rather than consummate it. To his relief, she broke with him; she was not quite twenty-five. Soon after, Nadja began hallucinating and had to be confined in an asylum. Breton's "subsequent protests of surprise at the news of her breakdown, anger at the psychiatric profession, and refusal to visit her in the hospital all masked a deep guilt over her fate."[25] Guilt too, I would imagine, for misrepresenting Nadja's all too evident schizophrenia and exploiting it in the interest of surrealist poetics not to mention cash.

Although Breton's book was not published until 1928, Picasso would have known all about Nadja. At the time of the affair, the surrealists were obsessed by it. However, it would be a mistake to see Picasso's seduction of Marie-Thérèse in the light of *Nadja*.[26] Let us see it, instead, in the darkness of his lifelong grief at the death of his beloved younger sister, Conchita, all those years before in Corunna, the consequence of breaking his vow to God.[27] Conchita's rebirth as Marie-Thérèse would enable Picasso to see himself as the Minotaur of legend—part bull, part man—to whom one young woman after another would be expected to sacrifice herself. Since Picasso confided the "secret" of his vow to all his mistresses, Marie-Thérèse would have had an inkling of the sacrificial role expected of her. It helped that she had a spiritual side and was sweet-natured—*"il faut savoir être gentille"* ("It is necessary to know how to be kind"), she told Gasman.[28] It helped too that she was also very submissive. Far from questioning her lover's sadistic demands, Marie-Thérèse did her best to comply with them. As for his work, she had little understanding of it beyond the fact that it was by him and about her and commemorated their love, so she revered it.

After their second meeting, Picasso insisted on seeing Marie-Thérèse every day. In the spring he would take her for walks along the banks of the Marne to a secret trysting place. As he would discover, she loved sports, indeed would soon develop into a sturdy athletic woman.[29] Most of all, she enjoyed swimming and boating on the Marne, and even managed to persuade Picasso to go kayaking with her, hence the strange, paddlelike arms in some of his images of her swimming. She was also good at skating. Her lover would suffer pangs of jealousy at the sight of young men admiring her as she circled the rink. In his role of "good daddy," prior to being a bad one, Picasso would take Marie-Thérèse to circuses and amusement parks, sometimes accompanied by the six-year-old Paulo, who seems to have been sufficiently loyal to his father not to betray him to his mother. They would go shopping, especially for toys, which Marie-Thérèse complained she had been deprived of as a child. And, just as he would later do for their daughter, Maya, Picasso amused her by doing drawings and comical cutouts for her.

Picasso wasted no time in training Marie-Thérèse to please him sexually, "initiating the novice . . . into sexual practices freed from all taboos."[30] He started by showing her some of his early erotica, such as a drawing of the Catalan painter Nonell on the receiving end of oral sex.[31] Some of Marie-Thérèse's most vivid memories, she told Gasman, were of Picasso's sadomasochistic preferences: "at the beginning of their liaison, he 'asked' her to comply with his fantasies. . . . she herself was so naïve at the time that his demands made her laugh."[32] However, laughter was frowned upon; Picasso's black humor left little room for girlish giggles. He is said to have enjoyed keeping Marie-Thérèse tearful, yet aroused enough for him to enjoy the perverse pleasure of denying her the release of orgasm.[33] When asked why Picasso liked to make her cry, she admitted that "it was a matter of sadism but also of art which is serious."[34] He had introduced her, as he would most of his women, to the writings of the Marquis de Sade.[35] Picasso never treated Marie-Thérèse as a surrogate wife; he treated her as a kid sister or daughter, with whom he was having a passionate incestuous affair. Indeed, in 1934 he would picture himself as Oedipus (Sophocles' not Freud's): a blinded Minotaur led around by Marie-Thérèse—the ghost of his dead sister—holding a dove.

Picasso's "lovemaking [was] at times intimidating and terrible," Marie-Thérèse told Gasman, "[but] in the end a completely fulfilling experience. . . . [He] was very 'virile.' "[36] Inflicting pain was not his "thing"; what excited him was having total psychological power over her, as his imagery often reveals. As Picasso told Eluard, "You know, in my love affairs there has always been a lot of gnashing and suffering: two bodies entangled in barbed wire, rubbing against each other, tearing themselves to bits."[37] This has the ring of a competitive boast to a fellow disciple of the "divine marquis." The only real problem with Marie-Thérèse was how to conceal her from Olga and the rest of the world. Picasso allegorized her in the form of guitars, jugs, and fruit dishes but he would also do so in the form of his own penis or her vagina. He even envisions her as another woman. Ten years later, Picasso would portray Marie-Thérèse, who was uninterested in fashion, in one of the chic outfits he had bought for Dora Maar. This painting, as we will see in Chapter 39, represents a Japanese model, who has been mistaken for Marie-Thérèse.

Jeanne's blunder as to the date of the Gare Saint-Lazare meeting has blinded historians to the immediacy and intensity of Marie-Thérèse's impact on Picasso's work. Fortunately, a sequence of extraordinarily inventive drawings in a sketchbook[38] covering the first four months of their affair allows us to see how this all-enveloping love for her affected his work. Predictably, one of the first of these drawings—the only one to be dated—was done on January 11, the day of Marie-Thérèse's initial visit to the studio. Not yet sure of what to make of the girl's features, Picasso shuffled them around. A bit later, he portrayed her representationally as two different girls in one

Picasso. *Painter with Two Models Looking at a Canvas*
(Marie-Thérèse on the left), plate II in *Le Chef-d'oeuvre
inconnu d'Honoré de Balzac*, 1927. Engraving,
19.4 x 27.7 cm. Collection Bernard Ruiz-Picasso.

of the finest of his *Chef-d'œuvre inconnu*
engravings:[39] as a boyish page in jerkin
and tights and as a classical maiden with
a wreath in her hair. Both girls are in
attendance on a bearded artist—
Picasso in the role of Balzac's Frenhofer.

A week or two into their affair,
Picasso envisions his new girl as a mon-
ster—a pinheaded, elephant-legged,
buttock-breasted specter of erotic men-
ace in a series of biomorphic draw-
ings.[40] One of these will become the
figure of the model in a key painting,
Artist and His Model,[41] which he would
do in the spring. This huge work (a few
centimeters short of the *Demoiselles d'Avignon*) is something of a *chef-d'œuvre
inconnu* in that it has been hidden away for many years in Tehran's Museum of Con-
temporary Art. At first sight, it looks like a reprise—in its cat's-cradle structure and
black-and-cream tonality—of the great *Artist and His Model* of the year before. But
the Tehran painting surpasses its predecessor in its impact and monumentality. Note
the two shadowy Peter Pan collar shapes; emblems of Marie-Thérèse that hold this
intricate linear maze together. Picasso has encoded his secret love in a masterpiece,
the better to advertise it, secure in the knowledge that only he and possibly Marie-
Thérèse know what the painting is really about. Marie-Thérèse's presence in his life
inspired Picasso to unleash his sexuality and harness it to his imagery. For the rest of
Picasso's life sex would permeate his work almost as cubism did.

Marie-Thérèse loved to sleep and Picasso loved to paint her asleep, as witness two
powerful portrayals of an emphatically outlined Marie-Thérèse sprawled naked in
the embrace of a patterned armchair,[42] her vaginalike mouth agape in what might be
a snore. In one version, Picasso projects a free-form image of Marie-Thérèse's body
onto a shadowy background of two profiles in silhouette, a darker one of him gazing
at a lighter one of her; in the other, smaller version, he has tightened things up and
integrated them. The handling evokes Miró's recent work—no surprise given
Picasso's recognition of Miró's supremacy as an innovator, "You are the one who is
opening a new door."[43] Both these sleepy heads have been visualized from an angle
that allows us to look abruptly up at the girl's knob of a nose, her tiny nostrils form-
ing the painting's pinnacle. By portraying Marie-Thérèse's splayed body from the
viewpoint of a sexual partner, Picasso draws us into his lovemaking. As he once
joked, he had an eye at the end of his penis.

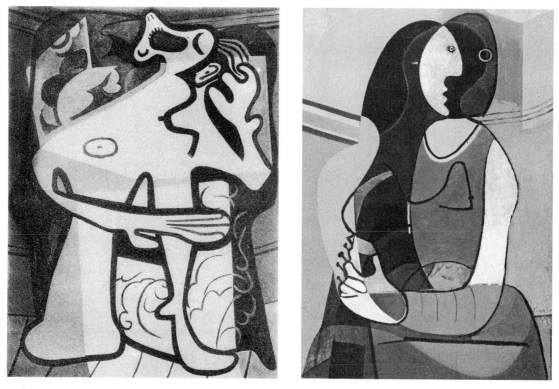

Left: Picasso. *Marie-Thérèse Asleep in a Patterned Armchair,* 1927. Oil on canvas, 130.4 x 97.1 cm. Private collection.
Right: Picasso. *Seated Woman,* 1927. Oil on wood, 130 x 97 cm. The Museum of Modern Art, New York.

At the same time, Picasso was working on a series of smaller Harlequin heads similar to the ones he had done of his son the previous summer. In one of them,[44] Paulo wears Marie-Thérèse's Peter Pan collar in place of his ruff; and sometimes it is in place of the Harlequin's *bicorne.* Later in the series, his father turns Paulo into a biomorphic Marie-Thérèse. He enjoyed playing God, reenacting the creation, and coming up with his own genetic system. All the more reason for students of his work to tread carefully: Picasso loved to tease and perplex. Anyone who believes he has cracked his code and knows for sure who is who in his imagery will sooner or later discover that the artist perversely switches his code and shuffles physiognomies and identities in order to confuse us. Picasso hated to be taken for granted.

The shadow of Olga sometimes falls on Marie-Thérèse. An example is MoMA's imposing *Seated Woman,*[45] which once belonged to Sara Murphy's sister, Hoytie Wiborg. As grave as some of Corot's guitar players, this figure conveys a feeling of melancholy. Picasso has wedged his subject into a wainscoted corner and clenched her hands convulsively together so that her knuckles look hammered onto each other

Picasso. *Guitar with Profile of Marie-Thérèse and Monogram*, 1927. Oil on canvas, 27.1 x 34.9 cm. Alsdorf Collection.

with carpenter's nails. The big-nosed, crescent-moon profile recalls the heads in the *Milliner's Workshop* of the previous year. The black hair and scared eyes recall Olga. A curious feature of this and other works of the same period is a pale but emphatic border, which not only frames the image but suggests that it is the painting of a painting—a picture within a picture.

Secrecy had always been a game Picasso enjoyed playing, but now that it had become obligatory, he took less pleasure in it. He did not dare to be seen with Marie-Thérèse in public—at cafés, restaurants, places of entertainment. Living at home as she did, Marie-Thérèse had similar problems. She had to keep up the pretense of having a job in Paris, but what was she to do with herself—go to skating rinks or swimming pools—when Picasso was busy with his work or his family? At first he rented an apartment around the corner from the Gare Saint-Lazare. A writer called Roy MacGregor-Hastie claims that Tzara offered them his apartment, but it sounds most unlikely.[46] MacGregor-Hastie is extremely unreliable.

To help evoke his mistress in his work, Picasso drew on metamorphosis and poetic rhymes and puns. As he had done with his beloved Eva in certain cubist paintings, he transforms Marie-Thérèse into a stringed instrument: often into the ideogram of a guitar hanging on a wall. This would become her monogram. To demonstrate his power over her, Picasso stabs this monogram through the middle with a hilted sword in the form of his initial *P*. In other paintings, he superimposes this guitarlike configuration over silhouetted profiles of himself and Marie-Thérèse, or uses it to embellish a fruit bowl, which links a pair of shadowy silhouettes—a dove standing for her. "The flight of a bird symbolized . . . the freedom of their relationship," Picasso would tell Françoise Gilot.[47] A bulbous doorknob—an object that implies handling and opening and closing—stands for him.[48] Significantly, Picasso gave Marie-Thérèse what is probably the most blatant of these allegorical works: a painting of a white silhouette of his controlling hand with her monogram on top of it.[49]

So impressive is this avalanche of work—especially by comparison with the rela-

tive dearth of the previous summer and fall—that one can only attribute it to the rapture that Marie-Thérèse released in Picasso. Ruminating in old age about the psychic forces supposedly sparked by the buildup of repressed sexuality in adolescent girls, Picasso associated Marie-Thérèse with this force. She made Picasso feel more fulfilled than he had felt in years. Like the torrents of spring, she cleared away the logjam of rage, resentment, and misogyny that had built up in the course of his marriage.

The romance of Picasso's seduction of Marie-Thérèse Walter has blinded people to the fact that Picasso continued to live and work at the rue la Boétie with a wife who was still totally obsessed by him and who took the role of Madame Picasso—elegant consort, zealous mother, impeccable *maîtresse de maison*—very much to heart. Olga had no intention of relinquishing this role, nor did Picasso, who

Picasso. *Bathers Outside a Beach Cabana* (Marie-Thérèse on the left, Olga on the right), May 19, 1929. Oil on canvas, 33 x 41.5 cm. Musée Picasso, Paris.

still suffered from a residual bourgeois streak, want her to do so. Granted, Olga suffered from gynecological problems that left her prone to mental ones, but much as Picasso would fulminate about her affliction, her attacks would prompt some of his most disturbed and disturbing images of women.

Like many another two-timing husband, Picasso soon found himself leading two separate lives: as an overtly respectable *père de famille*—weekends at smart Normandy resorts[50]—and as a secluded Bohemian with a mistress, whom none of his friends, except possibly for Leiris and Tzara, was allowed to meet. This pattern would be reflected in Picasso's imagery. Marie-Thérèse's images would be suffused with errant sexuality; whereas those of Olga, who appears far more often in his work than people realize, would be suffused with fear, anger, and despair—the consequences of Picasso's shamanic effort to exorcise her psychological as well as physical maladies.

Two years into his affair with Marie-Thérèse, Picasso would make the distinction between her and Olga very clear when he portrays them as naked bathers on a stormy beach: Marie-Thérèse, lithe and trim, emerging from a beach cabana, while Olga—only thirty-seven, although Picasso portrays her as flabby-breasted and boney-ribbed—waits menacingly outside. To make this distinction even clearer, Picasso would usually portray his ballerina wife, who never traveled without her tutu, in a travesty of the dancers' fifth position, hands linked in an arc above her head. Over the next eight years, these two women counterbalance each other in his art as well as in his life. Picasso derived a certain perverse satisfaction from being a paradox. The pervasive sexuality that Marie-Thérèse would provoke in the studio as well as between the sheets couterbalanced the twin-bedded boredom of life with Olga. Desire for Marie-Thérèse would engender some of Picasso's most romantic and erotic works, but by virtue of their Goyesque darkness, the images fueled by Olga's problems would be more disturbingly powerful.

27

Summer of Metamorphosis

For Picasso, the Eros of the joyous spring of 1927 would soon be saddened by the death of Juan Gris. Gris had long been plagued by lung problems. In August 1925 he had told Kahnweiler, his closest friend as well as his dealer, that he was exhausted and going to winter in the south. Toulon, where he and his beautiful wife, Josette, had taken a house, was bad for his lungs, but it turned out to be a good place to work by day and indulge his penchant for the Charleston by night. Depressed and in need of psychic guidance, Gris had joined the Freemasons and was also delving into the study of Paracelsus and palmistry. Far from improving, his health deteriorated. By February 1926, he was running a temperature, "spitting a little blood," and obliged to take long rests.[1] He and Josette rushed back home to Boulogne-sur-Seine. In July, Gris's seventeen-year-old son Georges González, his sister Antonieta, and her son Guillermo arrived from Madrid to keep him company and dissuade him from becoming a French citizen. Georges eventually sided with his father over this matter and decided to stay on with him in France.

Although his doctors had advised him to spend the winter of 1926–27 recuperating in the mountains rather than by the sea, Gris again chose the Mediterranean—a villa at Hyères, near Toulon—and in late November installed his wife and son there. Again, it was a disaster. While nursing his son, who had tonsillitis, Gris caught bronchitis, which developed into emphysema and asthma. Severe asthma attacks in January 1927 necessitated a return to Paris, "in deplorable condition, more dead than alive."[2] And there at Boulogne-sur-Seine, this underestimated master died at the age of forty on May 11, 1927. His neighbors, the Kahnweilers, raced over to help Josette; so did Picasso and Olga, followed by the rest of the artist's tight little group. The funeral took place on May 13. There were no religious observances and no eulogies, despite a cortège of the leading writers, poets, playwrights, and painters of the Parisian avant-garde. Presiding over these bleak proceedings were the artist's wife and son, Picasso, Kahnweiler, Jacques Lipchitz, and Maurice Raynal.

At the graveside, Braque was not happy to find himself next to Gertrude Stein. He would never forgive her for rejecting him in favor of Gris, whom he had come to

respect but still regarded as a usurper of cubism. "As she looked out into the crowd of mourners that had gathered, Gertrude felt that they all looked somehow familiar, though she could not place them. She asked Braque afterwards 'Who are all these people, there are so many and they are so familiar and I do not know who any of them are.' Braque said: 'Oh they are all the people you used to see at the vernissage of the independent and the autumn salon and you saw their faces twice a year, year after year.' "[3]

After paying his last respects to Gris—a painful ordeal for someone terrified of death, especially the death of a fellow Spaniard and painter—Picasso spent the rest of the day with Gertrude at her rue de Fleurus *pavillon.* At one point she rounded on him, saying, "You have no right to mourn." Picasso replied, "You have no right to say that to me." Gertrude banged on angrily, "You never realized his meaning because you do not have it." "You know very well I did," Picasso replied.[4]

Picasso did have every right to mourn. Gris had always considered himself his pupil: he had signed his letters *"ton élève et ami,"* and expressed the hope that his master "was not dissatisfied with his pupil."[5] Their friendship dated back to the Bateau Lavoir, where Gris had lived and barely survived by selling illustrations to satirical magazines like *L'Assiette au Beurre.* Under Picasso's aegis, Gris had transformed himself from a clever cartoonist into a cubist of genius, who managed to harness geometrical and mathematical calculation to modernism without resorting to academic theorizing like the other Salon cubists dismissed by Apollinaire as "jackdaws in peacocks' feathers."[6] In 1912, to show off his newfound cubist mastery and honor his friend and master, Gris had unwisely painted a reverential portrait entitled *Hommage à Picasso.*[7] "Far from being flattered, [Picasso] was extremely irritated and Gris . . . mortified."[8]

Worse was to come. Impressed by Gris's initial paintings, Kahnweiler had put him under contract. Picasso was outraged. How dare Kahnweiler sign up the apprentice without consulting the sorcerer! "Two Spaniards in such a small gallery was a bit much," Kahnweiler's biographer comments.[9] The real reason was Picasso's morbid fear of his genius rubbing off on other people. Gris would also pay dearly for daring to pontificate about cubism—on one occasion in front of Picasso and Braque.[10] When the outbreak of war left Gris destitute, Picasso's innate generosity won out over his competitiveness and he sent him money. With most of his *tertulia* away in the trenches, Picasso had need of old friends, especially Spanish-speaking ones, and he took Gris back into favor. In Madrid in 1917, he had even tried and failed to pay a call on Gris's family. The relationship soured once again when Picasso chucked the Bohemian banquet Gris and Max Jacob had organized in his honor after the first night of *Parade.*[11] And it understandably turned to enmity when Picasso pressured Diaghilev into giving him the job of doing the *Cuadro flamenco* décor after promising it to Gris.

Picasso seldom put lesser artists down. Time and again, he would discreetly give them money, buy their work or get dealers interested, and even marry them off. Gris, however, was *not* a lesser artist. He had absorbed the lessons of cubism at Picasso's elbow and had gone on to take cubism a stage further by dint of calculations, the like of which Picasso and Braque had always distrusted. Ironically, Gris's discoveries were so impressive that Picasso did not hesitate to take advantage of them. After all, Gris had learned virtually everything from him. Gertrude was wrong. Guilt and maybe an occasional twinge of envy had entitled Picasso to grieve for the man he had done so much to form and so much, thoughtlessly, to harm. Thirty years later, at the Château de Castille, Picasso told Cooper that he regretted never having acquired a work by Gris, and asked Cooper to sell him his 1916 *Portrait of Josette*—a masterpiece whose structure is reflected in the rigor of Picasso's later (1917–18) synthetic cubist style. Cooper declined; he would leave the painting to the Prado. I remember watching Picasso's eyes devour Cooper's Gris, while the sitter, of whom Picasso was very fond, looked on. Surrounded by Cooper's incomparable collection of cubist works by Picasso, Braque, Léger, and Gris, I could not help realizing, once and for all, that Gris was cubism's third man.

At the end of April, Clive Bell appeared for his usual spring visit. He had split with Mary Hutchinson (now heavily involved in a three-way affair with Aldous and Maria Huxley), but he still regaled her with accounts of Bohemian high life. Knowing that Bell would spread the word, Picasso invited him to a *déjeuner de reconciliation* with Cocteau. The artist had a further surprise for Bell: "On descending into the rue la Boétie, I found waiting outside a superb black Panhard with the door held open by the most elegant chauffeur imaginable, awaiting the orders of *la belle* Madame Picasso. So Olga has her car and her man."[12] As usual, Bell got it wrong.

On June 15, 1927, Rosenberg opened an exhibition of 106 drawings that Picasso had done over the previous ten years. The show was divided into sections—Dance and Dancers, Harlequins, Pierrots and Saltimbanques, Artist in His Studio, and so forth—in which technical virtuosity and Ingresque finish took precedence over cubist invention, metamorphism, and sex. There were no new paintings: the theft of the previous summer's production and the unseemly, unsaleable nature of so much of Picasso's new work meant that Rosenberg would not have had many current paintings in stock. Picasso would not have shown him any of the Marie-Thérèses. When the Paris show was over, Rosenberg shipped what was left of it to Wildenstein's in New York and, in October, to Flechtheim's in Berlin.

This 1927 show would return to the limelight in 2005, when Anne Baldassari hung photocopies of the works in Rosenberg's drawing show in a separate section of the Bacon-Picasso exhibition that she organized at the Musée Picasso.[13] Baldassari based her claim, that these Picasso drawings had exerted a formative influence on

Bacon's work when he saw them in Paris that spring, on a statement he made to the British critic David Sylvester. However, as Bacon told Lucian Freud, he was not interested in "all that Ingres stuff."[14] To Freud as well as myself Bacon said that it was the *farouche* paintings of 1932–33, exhibited at Rosenberg's in London in April 1937—as well as reproductions in *Minotaure* and *Cahiers d'Art*—that had opened his eyes to the violence and sexuality of Picasso's work and jump-started his own sadomasochistic vision.

The day after Rosenberg's drawing show closed, July 11, 1927, Picasso and his family drove down to the Côte d'Azur. The previous year he had returned to the Antibes area but had avoided the Murphys' exhausting entourage. Indeed, he gave the Villa America and the whole Antibes area a wide berth.[15] Instead, he installed himself and his family in the Hôtel Majestic at Cannes, where the Beaumonts went every summer, and set about looking for a villa in the town. Picasso wanted accommodation for his rambunctious son and Russian nanny, and for himself away from his wife, who was once again *souffrante.* Edith de Beaumont, who was going to do a cure at Salsamaggiore—a spa near Parma specializing in women's problems such as Olga's—proposed that the Picassos join them there.

The Picassos were in luck. They found a "superb villa" with "an atelier to dream about, occupying the whole of the top floor."[16] Known both as the Chalet Madrid and as the Chalet Capron,[17] it nestles in a wooded area on the outskirts of Cannes, just below the belle époque villa La Californie, where he would live in the 1950s. By that time the Chalet Madrid had turned into the Hôtel la Madrilène, where Penrose used to stay while working on his Picasso

Picasso. *Bather,* Cannes, 1927. Pencil on paper, 30.5 x 23.2 cm. Musée Picasso, Paris.

biography. Chalet Madrid would have been as much to Olga's liking as her husband's. It was elegant and secluded and around the corner from the Russian church: a solace when she received news from Russia that the mother she had not seen for ten years had died on September 17. "[Olga] *est dans un grand douleur,*" Picasso wrote Gertrude Stein.[18]

In the end, the Picassos decided against going to Salsamaggiore. Beaumont's rhapsodic report of September 2 confirms how wise they were to have stayed in Cannes. "This is the quintessential Italy—Italy at its purest, its richest, liveliest, most Fascist."[19] In regretting their absence, Beaumont evokes the fun they had—fun that Picasso would in fact have loathed. "The journey would have distracted you after that *mauvais moment;* then the salt waters would have done you a lot of good. Lastly, I would have loved to have seen the prodigious race of women Picasso would have engendered had he spent a few days in this hotel!"[20] The *mauvais moment?* Olga had presumably suffered another of her gynecological crises.

Instead of hiding Marie-Thérèse away in a neighbor's *pension de jeunes filles,* as he would the following summer, Picasso dashed up to Paris to see her.[21] The trip left him more obsessed than ever. Back in Cannes, he filled two *carnets* with one of the most astonishing of all his graphic feats: a series of highly finished biomorphic drawings of Marie-Thérèse's pumped-up body in the guise of his own engorged penis—hybrids composed of erectile tissue.[22] Picasso visualizes the ithyphallic figure of his mistress alone on a sandy beach sunning her rubbery limbs, ballooning breasts, and glans penis of a head. In one of the finest of these drawings, he shrinks her head to the size of a pea set high in the sky to give her height; she trails a beach towel and inserts a tiny key into the door of a beach cabana. *Princess X* (1916)—Brancusi's penile sculpture of his mistress, Princess Marie Bonaparte,

Picasso. *Bather at a Beach Cabana,* Cannes, 1927. Pencil on paper, 30 x 23 cm. Musée Picasso, Paris.

which Picasso would have seen at the Salon d'Automne in 1919—comes to mind as an influence, but we should also take into account Picasso's ribald drawing of a *femme-phallus* with another woman lurking in the figure's scrotum that he had done in 1901.[23] These masturbatory images were deeply rooted in his psyche.

Besides permitting Picasso to indulge in the fantasy that his penis and his girl had become one, these magnificent drawings constitute the first ideas for a monument to Apollinaire. The artist had proposed doing this long before the poet's death. In June 1914, he had sent Apollinaire a postcard from Avignon of the *Apotheosis of Mistral,* a celebrated monument to the celebrated Provençal poet, on the back of which he had written, "I will do an apotheosis of you."[24] After Apollinaire's death, he looked forward to fulfilling his promise. And, indeed, what more appropriate apotheosis of this polymorphous poet than a woman in the form of a penis? Of course, Picasso realized that the widow and the Apollinaire committee might denounce his proposal as a mockery of the poet and a desecration of the Père-Lachaise cemetery, but he was determined to shake them up. He also contemplated shaking up the city fathers of Cannes with the outrageous notion of setting up a row of gigantic *femmes-phallus* on the Croisette overlooking the Mediterranean.[25] That, too, was out of the question. Ultimately, the artist would have to face the fact that the Apollinaire committee would not tolerate anything but the most conventional of monuments. Nevertheless, in the process of fighting with them, he would become one of the greatest modern sculptors.

A monument to Apollinaire had first been mooted back in December 1920, when the magazine *L'Esprit Nouveau* announced the formation of a Comité Apollinaire and launched an appeal for contributions to pay for a memorial to the poet in Père-Lachaise. A pamphlet had also been issued by the journal *L'Action,* listing subscribers and identifying Picasso as the sculptor.[26] Members of the committee assumed he would come up with a nice classical maquette; in fact, he did not give the project another thought for seven years, by which time his classicism had become much less representational, much more blatantly sexual, and no longer compatible with a traditional portrait bust.

Most years, Apollinaire's widow and various friends and supporters, including Picasso, Olga, Serge Férat, and Baroness d'Oettingen, gathered together on November 9 at Père-Lachaise to commemorate the anniversary of the poet's death, as admirers do to this day. In 1924 the group had organized an auction to raise further funds and get the monument going. André Billy—a conservative *homme de lettres* who would exploit his friendship with the poet to his own advantage—had put himself at the head of the Comité Apollinaire. His priority, he said, was to establish

Apollinaire as the modern embodiment of French classicism. To ensure this outcome, Billy packed the committee with likeminded cronies and kept out most of the poet's progressive friends and admirers, notably Tzara and the dadaists, Breton and the surrealists. The young writers to whom Apollinaire was a god were outraged at Billy's exclusionary tactics, his condemnation of Picasso's "shocking" ideas, and his insistence that only a cenotaph or bust could dignify the poet's grave. Picasso made no secret of his contempt for Billy's intransigence; no secret either of his own superstitious fear of the contaminating trappings of death. Nevertheless, at the Comité Apollinaire's 1926 meeting he promised to have a maquette to show them by November 1927.

Billy and Picasso were no less at odds in their views of Apollinaire's place in history. Picasso refused to see him as a traditionally lyric classicist. He saw him as a rebel and iconoclast, much as he saw himself; the only fault he found with Apollinaire was his art criticism. He thought his book on cubism pointless. "I am appalled by all the gossip," he wrote Kahnweiler.[27] Braque confirmed this view: Apollinaire, he said, "was a great poet and a man to whom I was very attached, but . . . the only value of his book on cubism is that, far from enlightening people, it confuses them." Apollinaire knew little about painting, Picasso told Malraux; however, he had an instinct for *la chose vraie* and, like the other Bateau Lavoir poets, he was a seer.[28] As for Apollinaire's supposedly "cubist" *Calligrammes,* Picasso liked them, as did Braque, but they agreed that, despite their format, these poems had little relevance to the cubism that they had created.

What Picasso admired about Apollinaire was the amazing range of his imagination, the perversity of his wit, the darkness and the dazzle of his polymorphous genius, and his miraculous way with words. To *épater* Billy and his ilk, Picasso insisted that the poet's greatest achievement was his outrageous pornographic fantasy *Les Onze Mille Verges.* Apollinaire's subversive Sadeian side is what Picasso hoped to memorialize, but this does not mean we have to take his enthusiasm for his friend's most scabrous book too seriously. The artist also greatly admired that miraculous poem "Zone," which reads like a letter to him. Apropos the monument, we should take note of another poem of Apollinaire's about a man without eyes, nose, or ears, "Le Musicien de Saint-Merry," who anticipates Picasso's *femmes-phallus.* Apollinaire's fascination with androgyny was also a trait that Picasso was out to commemorate. The poet had eulogized his girlfriend Marie Laurencin at the start of their affair as "like a little sun. She is myself as woman."[29] Picasso, too, had an androgynous side. He would tell his mistress, Geneviève Laporte, that "every artist is a woman and ought to be *une gouine* [a dyke]. Pederasts cannot be true artists because they love men. To the extent that they are women, they relapse into normality."[30]

The rubbery extensions of the bionic Marie-Thérèses also had their origins in a ubiquitous new eyesore. "Large red gods, large yellow gods, large green gods," as Louis Aragon had pointed out in his recent novel, *Le Paysan de Paris* (first published in *La Revue Européene* in 1924–25), were replacing roadside shrines.[31] Aragon was referring, of course, to gas pumps: "idols," which he describes as having "a single, long supple arm, a luminous head without a face, a single foot and a circular gauge in place of a belly."[32] Picasso would have been familiar with the contents of this remarkable novel. And just as he had envisaged a woman as a guitar, to be animated by touch, he now saw the interaction of gas pump and automobile— the insertion and pumping that trigger ignition—in a similar sexual light. Picasso's gas pump figures can also be seen in the light of Siegfried Giedion's observation that an artist's duty is to make "new parts of the world . . . accessible to feeling."[33] In citing Giedion Donald Mitchell claims that artists' new realms of feelings bring to light "in their art, not simply by emoting or displaying themselves, but (and this is crucial) by a rigorous application of technique, formal construction, sustained discipline."[34]

Another anthropomorphic link between Aragon's writings and Picasso's paintings is their perception of beach cabanas as sexual symbols. Gasman cites a passage in one of Aragon's stories, *Le Libertinage* (1926), about a married woman's affair with an adolescent boy: "the cabana turns out to be the secret cave-like site of adultery, orgy and incestuous feelings. . . . In Aragon's story, the symbolic interior of the cabana exudes infinite power which enables [the lovers] to reach sexual ecstasy."[35]

Cabanas will recur repeatedly in Picasso's work of the late twenties and early thirties. Gasman relates this cabana obsession to the eleven- or twelve-year-old Picasso's first glimpse of a woman's pubic hair just outside a bathing hut on a Corunna beach (see page 89). This revelation would forever make him associate beach cabanas with the mystery of sex.[36] The nature of this obsession will become ever more evident in next summer's paintings and drawings of Marie-Thérèse at play on the beach at Dinard and a fixation in his later work.

Lastly, in the context of the Apollinaire monument, we should remember that from 1912 to 1916, Picasso had lived opposite the Jewish section of the Montparnasse cemetery, where Brancusi's early masterpiece, euphemistically called *The Kiss,* had been installed over the tomb of Tatiana Rachevsky. *The Kiss* (1910)—two crouching nudes, with their arms wrapped so tightly around each other that they fuse into a single entity—was the first major modernist sculpture to appear in a Paris cemetery. It would have been very familiar to Picasso. The temptation to desecrate an even more celebrated cemetery with an even more profane sculpture would have

been an irresistible challenge. Only a *femme-phallus* could transform the grimy aisles of Père-Lachaise into a priapic grove, where this latter-day Orpheus could live on in death.

Rosenberg's letters to Picasso in Cannes reflect the dealer's fears that his star artist was wasting his time on unprofitable projects. And with the previous year's theft in mind, he begged him to safeguard his "Cannes production." In view of the Chalet Madrid's "splendid studio," Rosenberg further admonished Picasso: "Careful, dear friend, that you don't aspire to doing Bouguereaus,"[37] and in another letter he tells him that his "superb studio" should inspire *de l'excellente peinture artiste français."*[38] Rosenberg's persistent dealerism prompted the artist to do the opposite. The Chalet Madrid did not inspire *de l'excellente peinture artiste français.* Picasso later said that the one time he had a great space at his disposal, he had not painted *chefs-d'oeuvre.* He had evidently forgotten about the life-sized standing nudes he did this summer (mostly 130 × 90 cm), each one seemingly executed in one seismic burst of dripping grayish monochrome paint.[39] Though far less volumetric than the *femme-phallus* drawings from which they derive, these figures hint at the kind of monumental sculptures he had in mind. In their sketchiness they also anticipate the deceptively slapdash juggernauts of Picasso's final decade. For years, these great figures were overlooked. Rosenberg would not have seen their point, which is probably why they were never exhibited or put on the market and never published by Zervos. Their significance was not realized until Carmen Giménez accorded them a place of honor in the shows she organized.[40] These fearsome daughters of the *Demoiselles d'Avignon* anticipate the great sculptures soon to come, and the grim, gray Dora Maars of World War II.

Before leaving Cannes, Picasso did two *Woman in an Armchair* paintings,[41] in which

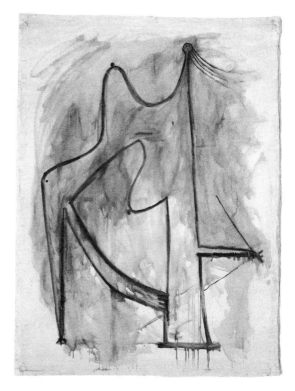

Picasso. *Standing Nude,* Cannes, 1927. Oil on canvas, 136 x 103 cm. Collection Bernard Ruiz-Picasso.

the figure is skinnier, spikier, and sharper-colored than this summer's Marie-Thérèses. The décor is parodically genteel. These are the first of a long series of menacing, ailing Olgas. Missing Marie-Thérèse, he turned on his sickly, mournful wife. Olga's misfortunes came in handy. As he wrote Gertrude Stein,[42] "I have had to get back to Paris earlier than intended"—back to Marie-Thérèse.

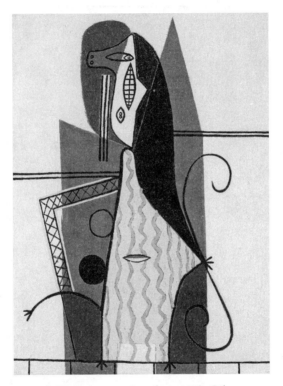

Picasso. *Woman in an Armchair,* 1927. Oil on canvas, 130 x 97 cm. Musée Picasso, Paris.

28

The Apollinaire Monument (1927–28)

The tragicomic saga of Picasso's on-again, off-again memorial to Apollinaire would drag on for thirty more years before being resolved to nobody's satisfaction, least of all Picasso's. After returning to Paris in September 1927 with his *femme-phallus* drawings, he had six weeks in which to prepare the maquette that the committee had requested. They had set their mind on a nice bust. Picasso had no intention of doing anything so banal. As Apollinaire's closest friend, he was convinced that he, and only he, had the right to decide what was appropriate, and it was in this spirit that he set to work on a maquette that had to be ready in time for the reunion around Apollinaire's grave at Père-Lachaise.

The lack of a properly equipped sculpture studio confined the artist to clay—something he had not handled for thirty years or more. As the final version was destined for the open air, it would have to be enlarged and cast in bronze, although Picasso disliked that material—"too rich" and, when patinated, too glossy. Apollinaire had expressed similar reservations. His autobiographical roman à clef, *Le Poète assassiné*—the book that would inspire Picasso's most memorable projects for the monument—reveals that he thought bronze made people look Negroid. In a typically bizarre episode in the novel, the poet-hero, Croniamantal, who loved to wander the streets of Paris, is accosted by the bronze bust of another "wanderer," the poet François Coppé. The bust complains to Croniamantal/Apollinaire: "Wandering past me, the negro, Sam McVea / said I was much the blacker, to his extreme dismay." Sam McVea—known in France as "the Napoleon of the ring"—had been Apollinaire, Picasso, and Braque's favorite boxer in 1908–09. *Le Poète assassiné* abounds in similar jokey references to the life that they had all shared in the days when Apollinaire referred to Picasso's Montmartre neighborhood as "Montmerde."[1]

Instead of a bust, Picasso decided to use the previous summer's drawings of Marie-Thérèse as a point of departure for his maquette. The resultant *Bather* confirms that he still knew how to handle clay.[2] If the play between holes and volumes works so naturally, it is partly because he has taken a look at the copy of the art student's bible, *Gray's Anatomy,* which Duncan Grant and Vanessa Bell had given him

Ant. sacro-iliac ligament

Great sacro-sciatic lig.

Poupart's ligament

Lesser sacro-sciatic lig.

Great sacro-sciatic lig.

Obturator membrane

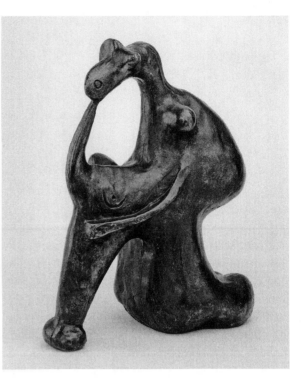

Above: Figure 166 from *Gray's Anatomy* showing side view of the pelvis, by Henry Gray, F.R.S.
Right: Picasso. *Bather (Metamorphosis I),* 1928. Bronze, 22.8 x 18.3 x 11 cm. Musée National d'Art Moderne, Centre Georges Pompidou, Paris.

in 1913. Picasso has used ligaments and membranes to hold his body parts together, as smoothly as they do in Gray's illustration of a side view of the pelvis, showing the great and lesser sacro-sciatic ligaments.[3] As in his neoclassical figures, he has kept the *Bather*'s center of gravity low and played tricks with scale, grotesquely inflating the *Bather*'s left leg and foot and shrinking her right arm so as to endow the little figure with maximum gigantism. Peter Read's description of this maquette says it all:

> The head is pulled into a phallic column and cast back so that the open mouth becomes a vertical orifice. This position and expression combine with the swelling of tumescent tissue at the front of the figure to express the androgynous melding of male and female attributes in orgasmic abandon. Scaled up to monumental size and cast in bronze, the work would have appeared massively anthropomorphic, smooth and bulbous, exuding sensuality, one of those public sculptures which irresistibly attract a caress from the spectator's hand.[4]

After the November 9 gathering around Apollinaire's grave, most of the Comité Apollinaire adjourned to a bar on the Place Gambetta to discuss the memorial. The following day an announcement appeared in *L'Intransigeant:* "Next year on the occasion of the tenth anniversary, a monument designed by Picasso will be inaugurated."[5] A month later, with André Billy presiding, the leading members of the committee foregathered in Picasso's studio to inspect the clay maquette and the previous

year's Cannes drawings, which they were also supposed to consider. The committee members were not just shocked, they were downright horrified—especially Billy.

Evidently, Billy had imposed his views on other committee members, notably Serge Férat and Hélène d'Oettingen. Although Férat had once held Picasso in such high esteem that he forgave him for making off with his mistress, he now declared himself unable to forgive his former hero for what he presumptuously termed his "betrayal of cubism." More to the point, Serge and Hélène could not forgive Picasso for his coolness toward them. Bear in mind, too, that Hélène had kept Apollinaire for several weeks in her luxurious *hôtel particulier;* and had also slept with Picasso. The Russian Revolution had shocked Hélène out of her blind faith in modernism and turned her against all things revolutionary. Far from wanting to commemorate Apollinaire as the avant-garde hero she had admired in life, she now chose to revere him in death as "*the* national poet whose verses should be chanted like those of the ancient Greeks."[6] The poet would have shuddered.

Picasso had drifted apart from another key member of the Comité, André Salmon—one of his earliest Parisian friends and the instigator of his friendship with Apollinaire. Salmon's Montmartre Bohemianism and the opium addiction he shared with his awful wife would have been unacceptable to Olga. But the publication in 1920 of Salmon's sentimental roman à clef, *La Négresse du Sacré Cœur*—about Raymonde, the adolescent orphan girl Picasso and Fernande had adopted in 1907 and returned to the orphanage (he found himself attracted to her)—had annoyed the artist. So had Salmon's fulsome support of Derain[7] and Vlaminck, who were also on the Apollinaire committee and anything but well disposed toward Picasso. An easygoing yes-man by nature, Salmon did nothing to support Picasso's successive maquettes until 1930, when he wrote a gushing article about his welded sculpture in an attempt to reingratiate himself. It was too late. Sadly, Salmon's three volumes of chatty reminiscences, all too appropriately entitled *Souvenirs sans fin,* published after World War II, would show little understanding of the modern movement that he had witnessed up close.

Billy's most fervent ally on the committee was Apollinaire's widow, Jacqueline, "La Jolie Russe," the nice, ordinary girl the poet had married six months before he died. Picasso and Olga had been supportive of Jacqueline, but she had come to see herself as the keeper of her husband's flame—also of his shrinelike apartment at Saint-Germain-des-Prés. Unfortunately, the regilding of the poet's escutcheon in the interest of official recognition—the Légion d'Honneur had been withheld because of his jail record[8]—required that a veil be drawn over the prose that Picasso most enjoyed. What is more, the widow had her reputation to consider. As a former girlfriend of Irène Lagut, she would not have wanted an androgynous *Bather,* pieced together out of buttocks and breasts and genitalia, cavorting on her husband's grave.

To exorcise the past, Jacqueline needed to invoke all the *gloire* she could. Picasso had no time for *gloire.* He wanted to celebrate his friend's far from decorous genius with an effigy the likes of which had never been envisaged.

As was to be expected, the committee members unanimously turned down the Cannes drawings and the clay maquette. Serge and Hélène, who had prided themselves, fifteen years earlier, on riding the crest of every new wave, deluded themselves into believing that Picasso was out to foist a "disgusting" dadaist joke off on them. Billy makes this clear in his memoir, when he dismisses the *femmes-phallus* as "an album of abstract drawings, reminiscent of potatoes and other tubercules, which it would not be incorrect to describe as somewhat obscene. Obviously these drawings had not been done for a tomb. We were dismayed. Picasso was making fools of us. We departed in high dudgeon."[9]

The diarist Paul Léautaud, who was a member of the committee though he had not attended the meeting, reports further fulmination on Billy's part—this time against the clay *Bather:*

> Picasso had come up with something bizarre, monstrous, mad, incomprehensible, somewhat obscene, a sort of lump from which, here and there sexual parts seem to protrude. [Billy] was convinced that in actual fact Picasso had not as yet done any work on the monument and that, faced with the committee meeting, he had dug out any old thing from his portfolios. He told me laughingly that "Apollinaire would have been delighted . . . to have that on his grave. . . . It would have jazzed up Père-Lachaise."[10]

It would indeed. By harnessing his ongoing feeling of *amour fou* for Marie-Thérèse to his feelings of love and grief for Apollinaire, Picasso would have brought a monument to the dead to life. After devoting so much of himself to the project, he was outraged at having his submissions rejected by former associates, whom he now saw as traitors to the cause of modernism. On the other hand, there is no denying that in the years since his marriage, Picasso had rejected most of these former friends. This was not necessarily Olga's fault. He seems sometimes to have used his wife as a pretext for dropping the hacks and hangers-on. This as well as rampant envy on the part of the painters on the committee enabled Billy to turn his followers against Picasso, who believed himself to have been closer in spirit to the poet than any of them, even the widow.

Meanwhile, Breton and his followers had been having the same problems with Billy that Picasso had. Billy's desperate rearguard action against dadaists and surrealists for daring to claim Apollinaire as their founding father dates back to 1917, when he had tried and failed to steer Apollinaire away from young writers he

regarded as dangerously subversive.[11] For the full story of Billy's endeavors to claim Apollinaire for the French literary establishment, while Breton and his followers claimed him as their Messiah, there is no better guide than Read's excellent study, *Picasso et Apollinaire*.[12] To believe Billy, Apollinaire's future glory should depend on the association of his name with canons of classic beauty rather than sexual mayhem and iconoclastic excess. This belief boded ill for the future of the monument.

As well as being the antithesis of Billy's, Picasso's view of surrealism was the antithesis of Breton's. As he told Kahnweiler in 1933, "the surrealists never understood what I intended when I invented this word [this was not entirely true], which Apollinaire later used in print—something more real than reality."[13] "Resemblance is what I am after," Picasso reiterated to André Warnod, "a resemblance deeper and more real than the real, that is what constitutes the sur-real."[14] In 1951, when discussing his great sculpture of a goat (a pregnant goat, whose anus he planned to plug with a squeaker), the artist claimed, "She's more like a goat than a goat!"[15]

Leiris, who was closer intellectually to Picasso than anyone else, vaunted the artist's sur-realism as opposed to surrealism in an article—all too clearly authorized by the artist—in *Documents* in February 1929. Now that he had been expelled—along with Bataille, Desnos, and Artaud—from the surrealist movement, Leiris was free to declare that Picasso did not belong with the surrealists. His painting was too "down to earth [*terre à terre*]: [it] never emanates from the foggy world of dreams, nor does it lend itself to symbolic exploitation—in other words, it is in no sense surrealist."[16]

As for the surrealist poets—novelists, journalists, ghostwriters, who were in thrall to Breton—Picasso confided "on several occasions" to Leiris that he rated Aragon, Soupault, and the surrealists in general as "the equivalent of André Salmon"—that is to say, second-rate.[17] To Kahnweiler, Picasso claimed that surrealist poetry was the sort that "appeals to pale young girls rather than girls in good health on the grounds that moonlight is more poetic than sunlight etc. . . . Dada followed a better route."[18]

Picasso particularly derided the surrealists for their faith in automatic writing as a shortcut to the subconscious. "Just look at this automatic poetry," he told Otero years later, as he brandished the original manuscript of Breton and Eluard's *L'Immaculée Conception,* its pages covered with authors' corrections. "This poetry is as automatic as I am an Egyptian-style painter, as [the Douanier] Rousseau used to say."[19] It was not that Picasso thought automatic writing intrinsically silly, though that too, so much as intrinsically factitious—at least in surrealist hands. Picasso felt even more strongly about automatic drawing. "Some friends and I," he told Tériade,

decided to draw in the dark in a manner completely automatic. The first time, I exclaimed . . . "I know what I'm making—the head of a woman." When we turned on the lights, we saw that it was in fact the head of a woman which I might have drawn in full daylight. We turned off the lights again and began again, and this

time . . . I was absolutely unaware of what I was making. When the lights were on again, I saw that it was exactly the same head of a woman as before, but in reverse.[20]

Picasso's disdain did not deter him from appropriating whatever surrealist effects—eerie lighting, blasphemous references, sexual fetishism—he felt he could improve upon, that is to say Picassify. Twenty-five years later, Picasso put it even more clearly. Angered at being so often characterized as a surrealist, he used the occasion of his Paris retrospective in 1955 to authorize Kahnweiler to clarify his position vis-à-vis the movement. He had never been influenced, he said, by the surrealists, except during a "brief period of darkness and despair (in 1933) before his final break with Olga."[21] Averse to appearing indebted to anyone except the long-dead Apollinaire, Picasso would always be at pains to reiterate that he had refrained from joining Breton's movement; and that its emphasis on the subconscious and dreams and its dogmatic canonization of Freud and Marx, not to mention the sectarian squabbles and arbitrary expulsions, had little to do with Apollinare's, or more importantly, his perception of sur-realism. Although he admitted to having been on friendly enough terms with Breton until 1939, Picasso said he regarded his almightiness as a joke. He was also a weirdo, he told Roberto Otero, in the course of showing him a collection of erotic letters he had purchased from an ex-mistress of Breton's—probably Valentine Hugo, who had left her husband for him. Pointing to some messy stains on one of the letters, Picasso asked Otero, "What do you think this is?" "Hydrochloric acid?" he suggested. "No, it's sperm . . . That's how Breton was. I told you before. A weird type."[22]

Out of loyalty to his and Apollinaire's vision, Picasso managed to elude Breton's surrealist embrace in the 1920s and early 1930s. However, for all his disclaimers, he did not entirely elude his shadow. Picasso would not have made such an issue of this if he did not also have doubts. According to Gasman, their concepts were not all that far apart, especially in their contradictions, their antithetical polarity. "The psychological-Freudian and the metaphysical-mystical in Breton's contradictory interpretations of 'surreality' were unmistakably echoed by Picasso in his crucial 1937 statement to Malraux that 'they're all the same thing.' "[23] Gasman also quotes a statement Picasso made to Penrose, around the time of his denial to Kahnweiler, that "the Surrealists . . . were right. Reality is more than the thing itself. I always look for its super-reality."[24] However, this surely does not entitle us to apply the word "surrealist" indiscriminately to Picasso's work of the 1920s and early 1930s.

The disastrous meeting with Billy and his confreres ruled out a large-scale bronze version of the *Bather*. However, Picasso had a couple of casts made

from the clay maquette, one of which shows traces of gilding.[25] Given the use of burnished gilt surfaces by modernist sculptors—Brancusi, for one—he may have contemplated burnishing the never-to-be-executed bronze version of the *Bather.* The maquette was put aside, but the committee's rejection had strengthened Picasso's determination to come up with a revolutionary new sculpture—one that would interact with space instead of merely occupying it.

The starting point for this new venture is to be found in a *carnet* that Picasso had used earlier in the year after attending a corrida at Fréjus.[26] These croquis defy interpretation. They can be read as a horse (with or without a picador), or a bull, or a cross between the two, or, maybe, a posse of pinheaded toreros distracting a bull by twirling their capes. Little by little, Picasso eliminates the tauromachic references and comes up instead with cagelike configurations of stick figures playing ball, distilled from the following summer's paintings of Marie-Thérèse and her girlfriends playing on the beach at Dinard. The airiness of the concept derives from a passage in Apollinaire's *Le Poète assassiné,* when the Benin Bird—Picasso hated the name that Apollinaire had invented for him[27]—made a suggestion. The memorial to the poet Croniamantal should take the form of a statue made of nothing but poetry and glory. Tristouse (Marie Laurencin) had another suggestion: the memorial should suggest a void—a hole in the ground tailored to Croniamantal's measurements. In his new sculpture, Picasso would opt for a hole in space rather than the ground—a void that would be filled up, he hoped, "with Apollinaire's spirit."

A new sculpture, Picasso realized, would require a new technique; and for help with this he turned to an old friend from Barcelona days, Julio González. The most gifted member of a family of Catalan metalworkers, González had moved to Paris around 1900 and renounced sculpture for painting. During World War I he had worked in the Renault factory. While there, he was awarded a diploma in oxyacetylene welding. Given his skills and technical expertise, González was much in demand by Brancusi and other sculptors to do polishing and make armatures and plinths. He also helped his sisters produce fashion accessories—buttons, buckles, costume jewelry—in his workshop. Picasso and González had had a long-standing disagreement dating back to the death of González's adored brother in 1908, but in coming face to face on the boulevard Raspail in 1921, they had had a dramatic reconciliation.[28] After this, they saw a lot of each other. When Picasso cracked open the traditional carapace of sculpture and let the air blow through it, he and González set about welding whatever bits and pieces the nature of the piece demanded.

Actually, González had sent Picasso an urgent message as early as January 1928, announcing that he needed to discuss "something very important concerning the matter from the other day," and that Picasso should drop by his studio at 11, rue de Médéah any afternoon from three to six.[29] Nothing had transpired. A black-

Above: Marcel Duchamp. *Rotary Demisphere (Precision Optics),* Paris, 1924. Motor-driven, mixed-media construction, 148.6 x 60.9 cm. The Museum of Modern Art, New York.

Right: Picasso. *Head,* 1928. Painted brass and iron, 18 x 11 x 7.5 cm. Musée Picasso, Paris.

bordered letter from González, dated May 13, announcing that his mother had died, confirms that they had not yet got down to work. "If, as I assume, you intend to have me work with you," González continued, "please be kind enough to let me have an advance."[30] Picasso mailed González a check, and they forthwith embarked on the most fruitful collaboration in twentieth-century art since cubism. It would be an exceedingly friendly one—no recriminations, as there had been with Gris. Picasso would always prefer working with craftsmen—scene painters, weavers, printers, potters, metalworkers—rather than with fellow artists, especially now that he was coming to see his work as shamanic. Leiris's preoccupation with tribal fetishes had rubbed off on Picasso; from now on his concept of sculpture increasingly resembled a witch doctor's.

Dated sketches in the *carnets* confirm that the first piece Picasso and González worked on was the small, metal *Head*—a bit like a miniature archery target mounted on a tripod. This piece has been compared to Duchamp's *Rotary Demisphere* (1924), painted with concentric spirals, which pulsated with "copulatory motions" when its electric motor was switched on; however, it is anything but kinetic. (Duchamp's piece had been commissioned by Doucet and photographed by Man Ray for *391* in 1924.) Like Duchamp's target heads as well as Picabia's, Picasso's represent a woman. In all, he made three little targets in iron and brass, each riveted and soldered, each painted differently.[31] Appropriately, he gave one of them to Gertrude Stein, who had often been the target for his potshots. If Picasso never got around to doing a large-scale sculptural target, it is doubtless because people might have been reminded of Duchamp's *Demisphère.* I do not think Picasso's target was intended for the Apollinaire memorial. It appears to have been a tryout of a new technique as well as a new technician.

Target heads had in fact started life in paint rather than metal, as a representation of himself in the vast *Painter and His Model* that Picasso had been working on since February. This complex painting,[32] for which there are numerous studies, has been said to reveal that he had resumed his dialogue with Matisse, but there is a great deal more to *Painter and His Model* than that. I see it as a brilliant modernist synthesis of Léger, Gris, and even Mondrian, and also of his own synthetic cubist past and his metal-rod sculptures. Besides summarizing and improving upon specific avant-garde trends, *Painter and His Model* is about Picasso's concept of representationalism and the actual act of painting. Once again the artist leaves us guessing as to the nature as well as the identity of the model. Is she a bust on a plinth or a live woman? If a woman, is she blond-haired Marie-Thérèse whose profile is materializing on the canvas, a skinny, dark-haired Olga, or a blend of both? And why is the artist seated on the chair usually reserved for models? There are of course no answers to these questions; there would be no magic if there were.

29

The Beach at Dinard (1928)

At the beginning of 1928, Picasso embarked on what at first appears to have been an unimportant sideline: tapestries. In fact, his earliest exercise in this field, a powerful collage of a Minotaur,[1] is exceedingly relevant to the artist's development, above all to his reuse of papier collé, which had triggered synthetic cubism.

The impetus for this new venture came from Marie Cuttoli—the entrepreneurial, art patron wife of a powerful senator from Algiers—who had started, as early as 1910, to cajole Algerian weavers into improving the quality and design of their carpets. She marketed them under the name of Myrbor, the name of the Algerian village where the weavers worked. Madame Cuttoli's carpets were so well received at the Exposition des Arts Décoratifs in 1925 that she opened a Galerie Myrbor in Paris. She hoped to do for the French what she had done for the Algerians: rescue the tapestry industry, first the state-owned Gobelin factory in Paris, later Aubusson and Beauvais. Cheap machine-made ripoffs had ruined the market for fine tapestries; so had a steady deterioration into fustian, not to mention improvements in the heating of large houses. Miraculously, the quality of the workmanship had held up.

In 1927, Madame Cuttoli commissioned tapestry cartoons from Picasso, Braque, Léger, Miró, and other major artists. Delighted to follow in the steps of Goya, Picasso went ahead and by January 1, 1928, had executed his *Minotaur*. Cuttoli's letter of January 29 reveals that although he had not as yet shown her the maquette, Picasso was anxious to get it woven.[2] For reasons that are unclear, the weaving would not begin until 1934. Meanwhile, Madame Cuttoli set about becoming an active collector; her acquisition of Braque's *Grand nu* (1908) from Aragon strengthened her hand with artists as well as poets.[3]

Picasso would also have welcomed the prospect of having a new backer, who was adept at pulling political strings. In this respect Madame Cuttoli would prove very useful. The agents of the Préfecture de Police, who had kept an eye on Picasso ever since he had first settled in Paris, had recently stepped up their surveillance. For consorting with the increasingly politicized surrealists, Picasso was suspected—on no evidence whatsoever—of being an anarchist or a Marxist, even though he was deter-

mined at all costs to stay above the fray and avoid any political affiliation.[4] Until civil war broke out in Spain, pacifism was his only cause.

Expertise in theatrical design—above all, at judging the effects of line and color seen at a distance—had made for an instinctive understanding of tapestry design. Unfortunately, whereas Diaghilev's scene painters could execute a décor in a matter of days, Madame Cuttoli's weavers needed months, even years, to execute a tapestry: this first commission required six years, before the looms were ready for weaving. So relieved was Picasso to see his *Minotaur* tapestry finally being woven in 1934–35 that he immediately embarked on an even more elaborate papier collé design: Marie-Thérèse in conversation with one of her sisters, entitled *Confidences*[5] (though not by Picasso). The degree of imagination and inventiveness that he lavished on this side-line demonstrates how seriously he felt about it. That Madame Cuttoli had commissioned Matisse to do a Tahitian tapestry, *Papeete,* in 1935, would also have put Picasso on his mettle. Matisse surprisingly conceded that his rival had bettered him. As he told Father Rayssiguier, Picasso had far more success with Madame Cuttoli than he had. *Papeete* "was very badly made."[6]

Picasso. *Minotaur* (collage for tapestry), 1928. Charcoal and pasted cut papers, 139 x 230 cm. Musée National d'Art Moderne, Centre Georges Pompidou, Paris.

Picasso's seemingly simple design, a stylized bull's head rearing upward and a long bull's penis—blue, tipped with tan—emerging from a pair of splayed human legs, was a problem.[7] Comparison of the original tapestry (Musé Picasso, Antibes) with the cartoon, which is in Beaubourg, reveals that the latter has faded disastrously. The "ribbon" no longer registers as bright-blue moiré. Unless you see the original, you miss the point that the Minotaur's blue moiré penis is a pun on the ribbon of the Saint-Esprit: the ancien régime's highest order of chivalry that figures in so many eighteenth-century state portraits. By conferring the sacred cordon bleu on the Minotaur's self-referential genitalia, Picasso explicitly mocks the genre of armorial tapestry.

Three months after the first, Picasso did a second, squarer version of the *Minotaur* cartoon, probably at Madame Cuttoli's request. This second *Minotaur*[8] was never woven. Tapestry-related sketches[9] reveal that he tried out some less self-referential hybrids: a man with the head of a horse, an eagle with a woman's breasts and bull's legs, and a bird with the head of a girl—emblematic of Marie-Thérèse and later of

Dora Maar. Picasso would envisage himself as a skyscraper, a jug, a heraldic arrow, a cabana, and much else, but above all he identifies with the Minotaur, as the Cuttoli tapestry announces—a Minotaur to whom in his fantasy his mistresses would sacrifice themselves.

The maquette for the last and by far the most important of Picasso's tapestry designs is the vast (some ten by fifteen feet) *Femmes à leur toilette,*[10] which he would execute in 1938 to take the place, as Brassaï said, of *Guernica* on the wall of his rue des Grands Augustins studio.[11] Although poorly displayed in the bowels of the Musée Picasso, this great set piece—an amazing assemblage of multipatterned, multicolored wallpapers—confirms that Picasso's interest in tapestry had less to do with rescuing an obsolescent craft than in exploiting the technique of papier collé on an enormous scale in a spectacular new way. Because of the war, Madame Cuttoli never succeeded in having the maquette woven. It was only after its belated first appearance in the Picasso retrospective at the Grand Palais (1966–67) that André Malraux was so astounded by it that he arranged for two tapestries to be made.[12] When shown one of them in 1970, Picasso was delighted but disinclined to sign a document making it over to the Musées nationaux. He was nudging ninety and unwilling to sign anything that pertained to the settlement of his estate.

In April 1928, Olga fell ill again. On the fifteenth they stopped at Lisieux so that she could offer up a prayer to the miracle-working Sainte Thérèse. Her condition only worsened. In May and June, she repeatedly visited Dr. Petit's clinic for treatment. On July 12, when the Picassos, accompanied by Paulo and his English governess, set off for Dinard, Olga was apparently suffering from hemorrhages. On the following day they were even worse. A month later, the same thing would happen. As in 1929, the Picassos stayed in the Hôtel des Terrasses, next to the High-Life Casino, while looking for a villa. The house they found, the Villa des Roches on the passage du Tertre Mignon, was big and a bit bleak—nothing like as attractive as their 1922 rental, the Villa Beauregard. However, it was in a residential area to the north of the town and gave directly onto the Saint-Enogat beach.

Picasso. *Bathers*. Project for a monument, 1928. Pen and India ink and tinted wash on sketchbook page, 30.2 x 22 cm. Musée Picasso, Paris.

For the first ten days or so in Dinard, Picasso lay low and seemingly did no work. And then, on July 27, he resumed drawing where he had left off in Paris. Spies believes that he had torn the last page, dated July 8, out of the Carnet Paris which he had been using and taken it to Dinard as a starting point for the dramatically contorted bathers he now began to paint.[13] Unlike the *femmes-phallus* in the Cannes drawings which appear to be made of "erectile tissue," the *matière* of the Dinard ones is less highly charged: driftwood, pebbles, and bones that have been smoothed by the sea. "Pebbles are so beautiful," Picasso told Brassaï, apropos the pebbles he liked to engrave, "that one is tempted to work on all of them. The sea has already done it so well, giving them forms so pure, so complete that all that is needed is a flick of the finger to make them into works of art. . . . One I don't dare touch: the nose and sockets hollowed out by the sea [have] formed a skull."[14]

After the sad end to his sojourn at Dinard six years earlier, Picasso's decision to return there might seem puzzling, were it not for Olga's health. Dinard was salubrious: a nice family place, where the artist's overprotected, soon to be recalcitrant son, could take part in organized sports with other suitable boys and girls, while his mother convalesced. Picasso had a more devious motive for spending the summer in the breezy north rather than the sunny south. It was easier to bring Marie-Thérèse secretly to Dinard than to the Riviera, where an unsupervised eighteen-year-old blonde would have been an easy target for predators. Dinard was so suited to Picasso's needs that he would return the following summer to stash Marie-Thérèse away, yet again, and contemplate buying rather than renting a house. Like Proust's narrator, he derived a perverse pleasure from controlling and concealing his *prisonnière* and subjecting her to the torture of his jealousy. Although Marie-Thérèse was innately faithful, she admitted to Gasman that he was innately unfaithful, even to her.[15]

The highlight of Dinard's 1928 season was the annual *weekend de la mode,* culminating in a "fabulous *thé dansant*" and a beauty pageant of girls in bathing suits vying to be "Miss France." As someone—albeit aged twelve—who stayed at the Hôtel des Terrasses a few years later, I can vouch for the deadly decorum of the place—not least the *soirées musicales* with "Depuis le jour" sung by an elderly Opéra Comique star—and can readily understand Picasso's compulsion to perform lubricious acts of exorcism in a beach cabana. What ironical amusement he would have derived from appearing at the High-Life Casino gala, ever so slightly overplaying the fashionable, blazered air of a Parisian celebrity on holiday, arm in arm with his tranquilized wife doing her best to fill the role of the elegant Madame Picasso. The parodic little politesses, which Picasso sometimes affected in the face of people he did not know or was unable to communicate with were reminiscent of the movie star he most admired, Charlie Chaplin. Like Chaplin, Picasso knew how to signal exasperation or

Left: Olga and Paulo in costume, Dinard, 1929.
Right: Picasso. *Olga in a Breton Costume,* 1928. India ink on sketchbook page, 38 x 31 cm. Marina Picasso Collection, Galerie Jan Krugler & Cie, Geneva.

delight with a quizzical furrowing of his brows, a flash of his *mirada fuerte* eyes, or, on later occasions, a flick of a long-nailed little finger. We Spaniards let it grow, he said, to show we are not laborers. Picasso knew Chaplin and liked him well enough; however, as he complained to Penrose, he talked too much, which was a bore, as everything had to be translated. And how baffled he once was when the Chaplins, "all dressed up in furs in spite of the weather," arrived in their car for an appointment, only to deliver "a letter saying that they couldn't come in person and left."[16]

For the sake of local piety, the catalog of the 1999 *Picasso à Dinard* exhibition would have us believe that the town enabled the artist to "rub shoulders with some of the most illustrious names in politics, the aristocracy, arts and letters [and that] they formed a faithful group."[17] This is the one thing Picasso would not have wanted. His privacy was precious to him. The only celebrities he would have tolerated were Olga's friends Anton Dolin and Vera Nemchinova, who were on tour with their ballet company.[18] However, Picasso did make one new friend this summer: Georges Hugnet, a young protégé of Max Jacob's, who was vacationing in a family house across the estuary at Saint-Malo. Picasso took a liking to the twenty-two-year-

old poet and saw him almost every day. He would watch out for Hugnet from his window and whisk him off. *"Je m'en vais avec Georges,"*[19] he would tell Olga, as they went in search of the girl who was kept hidden from most of his friends. On returning to Paris, Hugnet would join the surrealists, only to be expelled by Breton. Later, Gertrude Stein took him up; then she, too, dropped him and wrote a smug piece about their bust-up entitled "When the Flowers of Friendship Faded, Friendship Faded." Hugnet would remain a friend and eloquent supporter of Picasso.

Another of Picasso's regular guests was Christian Zervos. They had much to discuss: articles in *Cahiers d'Art,* but above all the catalogue raisonné of his work that the artist had set his heart on. On one of these visits, Zervos, whose current mistress was in a sanatorium, picked up a local girl (her grandmother lived at Dinard), Yvonne Marion, at the railway station. Picasso enjoyed playing Cupid, and he encouraged the affair, which would soon blossom into a highly successful business relationship and later (1932) into marriage. In 1929 Yvonne would open a gallery, the Galerie du Dragon, in the *Cahiers d'Art* office on the rue du Dragon; and there she would organize exhibitions of Picasso's work, including the first show of his Dinard *Bathers.*[20]

Marie-Thérèse arrived in Dinard around August 5. Picasso had arranged for her to stay in a *pension de jeunes filles,* where she would be well supervised and well out of his wife's sight. Olga, Paulo, and his governess kept to the Plage de Saint-Enogat,

Beach cabanas at Dinard, c. 1928.

immediately below the villa. Picasso and Marie-Thérèse kept to the Plage de l'Ecluse, with its rows of concupiscent cabanas. Picasso probably rented a room for work and his trysts with Marie-Thérèse. It would have been more comfortable than the cabana and justified his daily absences to Olga.

With Marie-Thérèse by his side, Picasso no longer needed to conceptualize her. Each day, he would do several small paintings of her. At first, he depicted her as an assemblage of sticks, beach balls, and boomerangs, trying to enter his beach cabana, and then he gradually transformed her into a cutout, playing ball with other identical cutouts of herself.[21] In one of the paintings,[22] he portrays himself inside the cabana, crouching down, waiting to catch the ball she is about to throw him. And whereas the previous summer he envisions her as a bionic gas pump, extending a hose-pipe arm to unlock her cabana, this summer he portrays her two-dimensionally with a key in *her* hand—to *his* cabana. As Penrose points out in his notes,[23] Picasso had a fetish about keys; they enabled him conceptually to lock Marie-Thérèse up and have his way with her. Hoping to film Marie-Thérèse at play, he had brought his movie camera with him, but no footage of Dinard has survived. There is, however, a cut of Olga lying in the sand in a very becoming bathing suit, while Paulo and his friends play leapfrog in the foreground.

The twenty or more paintings of Marie-Thérèse tossing a ball around with her playmates, which Picasso executed over the next two or three weeks, may be small, but they are crammed with action, imbued with the cult of sun, sea, and sand, and they crackle with sexual energy. Sometimes he adopts the viewpoint of someone lying on the beach. As they burst out of their tiny formats these figures appear all the taller[24] and turn into flat, pinheaded cutouts in striped bathing suits[25] like the Douanier Rousseau's *Football Players*.[26] The girls' sticklike limbs rhyme with the rickety wooden frames of the deck chairs on the beach. Picasso was intrigued by the way deck chairs can switch from two-dimensional inertness

Picasso. *Bathers,* August 28, 1928. Oil on canvas, 35.8 x 19.6 cm. Whereabouts unknown.

to three-dimensional functionalism. In a painting of Marie-Thérèse naked on a beach towel,[27] her lover has added a glint of golden pubic hair to confirm that this is indeed her and she is indeed his. Although absent from most of these paintings, the artist makes his Peeping Tom presence felt just outside the picture, devouring his gorgeous prey with his eyes. By contrast, drawings of a skinny bather with a tight, reproachful mouth[28]—Olga of course—are bereft of desire.

Note how Picasso sets up pictorial rhymes between the jagged silhouettes of the offshore rocks and the jagged cutouts of the girls' breasts and buttocks and straddled limbs. Note, too, how alert he is to changes in the weather and light; how sensitive he is to the way the wind picks up around the middle of August; and the pennants rustle and the towels and bathing suits flap on clotheslines. This wind threatens to waft the girls aloft, as if kites or birds, as in this summer's crisp little painting of a bird (Marie-Thérèse, of course) caught in the branches of a tree.[29] The artist had evidently been watching someone—Paulo or Marie-Thérèse—fly a kite on the beach. Picasso was justifiably proud of having caught the light of Dinard in these paintings—so subtly different from the light he would catch in beach paintings done in the Dieppe area.

In mid-August, Olga's hemorrhages started up again more seriously than ever. By the fifteenth, they had become a daily occurrence and eventually so serious that the family returned to Paris on September 5. The following day, Olga entered Dr. Petit's clinic. Friends and associates kept quiet, as they had in 1922, when Olga was rushed to a clinic after suffering what were probably the earliest symptoms of her malady. One of the few to have been informed about her condition was Eugenia Errázuriz,[30] who had hoped to see the Picasso family at the end of the summer when they stopped off at Biarritz en route to Spain.[31] But the trip had had to be canceled. Back in Paris, with Olga out of the way, Picasso was able to paint some of his most joyous images of Marie-Thérèse.

Olga remained in Dr. Petit's clinic for nearly a month after her operation on September 12. Picasso was attentive, to judge by a letter from González[32] two days later: González had gone around to the rue la Boétie to see Picasso, only to be told that he was spending the day with his wife at the clinic. On September 17, Picasso wrote to thank Gertrude Stein, who had also been notified about Olga's illness, for her letter: "Olga is getting better, but she must remain in the clinic for some time. I'll keep you informed about her health, but what a summer we have had! In spite of everything, I've worked and I will show you what I've done when you return."[33] This letter was also signed by Olga, who had left the clinic on October 10, only to return a month later for a second operation on November 2. On December 8, she was well enough to dine with the Rosenbergs, but was back in the clinic on December 10. A letter from Beaumont, December 20, confirms that she was still in the clinic at Christmas.[34]

Picasso, with or without Olga, may well have visited the Beaumonts over Christmas, judging by a fine, unpublished portrait, gouache and papier collé, of a stylish looking young woman—signed and inscribed "Picasso Noel 1928"—that he gave Beaumont. The subject is not Edith but one of their fashionable friends: possibly the beautiful, blonde Russian princess Natalie Paley, granddaughter of Tsar Alexander II, who had recently married the couturier Lucien Lelong. Cocteau was about to fall in love with her, introduce her to opium, and make her pregnant. This famously beguiling woman failed to live up to her reputation for converting homosexuals to heterosexuality. Her "little Tsarevich" did not survive. As for Diaghilev, according to Lifar, he "could see his old friend [Picasso] only occasionally, because [Olga] was dangerously ill."[35] There is no record of the Picassos attending the last Ballets Russes season in Paris, spring 1929, Misia's lunch before the opening, or Chanel's soirée after the last night, June 12—events they usually attended.

Olga's absence in a clinic cast no shadow on Picasso's life and work. For the first time in their relationship, he and Marie-Thérèse could see each other as often as they liked without marital constraints. Buoyed by love and sex and freedom from stress, Picasso would turn back to sculpture. With González's help, he would whittle the girls on the beach down to a cat's cradle of metal rods, thereby advancing triumphantly into the new age of iron.

30

The Sculptor (1928–1929)

Picasso began working with González in September 1928 on yet another project for the Apollinaire memorial—three-dimensional constructions made of welded metal rods. The maquettes had to be ready in time for the tenth-anniversary reunion around the poet's grave in November. They were not. Later that month, there was a further get-together at which Picasso submitted drawings[1] and also at least one of the constructions that he and González had prepared.[2] To reassure the poet's admirers, the committee informed the *Mercure de France* (December 1) that the maquette was *"entièrement terminée."* The maquette was not rustproof: were it to be accepted, it would have to be replicated in bronze for its inauguration the following April.

There was no follow-up. André Billy and his committee members did not exactly turn Picasso's maquettes down, nor did they denounce them, as they had the previous year; they just never formally accepted them. After the date of the inauguration came and went the project lapsed. Some years later, Serge Férat gave a specious explanation to Maurice Noël of the *Figaro Littéraire.* Pointing to the illustration of a drawing for the project, Férat said that the motif may have been "very beautiful in itself, but for our purposes it had a serious shortcoming: it was a daytime monument. . . . Through it one would have been able to see the cenotaphs and vaults of Père-Lachaise, which are of utmost hideosity."[3] Férat took his interviewer to the window of his studio, which overlooked the Montparnasse cemetery. Disregarding Brancusi's *Kiss,* he said, "Look at that. Picasso's monument must make us forget these horrors." The dreary menhir that Férat would design for the tomb some thirty years later exemplifies these "horrors," and makes his successive vetoes of Picasso's maquettes the more reprehensible.

With González's help, Picasso executed four maquettes,[4] which vary in height from 38 cm to 60.5 cm. All of them are very precisely constructed out of thin iron rods soldered together. Tériade, who interviewed Picasso for *L'Intransigeant,* describes them:

Picasso. *Head of a Man (Tête d'homme)*, winter 1928–29. Mixed media including brass and bronze, 83.5 x 40.5 x 36 cm. Musée Picasso, Paris.

I found Picasso doing sculpture, which is what is closest to his heart at the moment. One feels he is obsessed by these experiments, which allow us to hope that, even if they have not yet been resolved, they will lead the painter Picasso to a new destiny—something that one has sensed in his work for a long time. . . .

[He showed me] small constructions of iron rods topped with minuscule heads that are flat and round. They correspond to the linear figures in his recent drawings [and] demonstrate Picasso's desire to make sculptures that partake of space and air. Space will no longer define mass. . . . Picasso hopes to execute these sculptures, airy as rigging or [radio] antennae, in the form of large-scale metal pylons. . . . "I would like to do something of the kind for the Apollinaire monument." . . .

There were other experiments in heavy-gauge wire, twisted round and round into a tangle and mounted on bobbins instead of pedestals.[5]

These bobbins had started life as the reels around which the wire had wound.[6] Typically, Picasso could not resist using the reel as well as the wire as sculptural elements. At the end of this interview, the artist answered Tériade's question as to whether he had ever worked in an abstract mode: "I have a horror of so-called abstract painting. What an error abstraction is. What a spurious idea! When one sticks colors next to each other and traces lines in space that don't correspond to anything, the result is decoration."[7]

Picasso went on to claim that he was a stickler for exactitude, that he worked like a pharmacist, getting his weights and measures precisely right; and that he wanted every painting and drawing to correspond to his vision of the world. "Try setting synthetic cubist drawings alongside [my] representational ones [Picasso said]; only then will it be possible to understand [my] obsession with exactitude. People might even be able to see that the former are more exact than the latter."[8]

This insistence on the representational nature of the constructions stemmed from Picasso's anxiety to distance himself from constructivists like Gabo and Pevsner, whose abstract sculptures had caused a stir at Level's Galerie Percier in 1924. Apart from a few experimental diagrams, the drawings for Picasso's constructions are mostly distillations of the previous summer's images of Marie-Thérèse and her girlfriends playing ball. As FitzGerald points out, Picasso has captured "the [girls'] running and reaching posture . . . within his linear network."[9] He also draws our

attention to the flattening of the ends of the rods into fingertips and suggests that these see-through constructions are skeletal cabanas, and the needle-thin, pinheaded girls are the "formal inverse of Picasso's massive figures."[10]

The first major welded, as opposed to soldered, sculpture that Picasso worked on with González was yet another project for the Apollinaire monument. This was the menacing iron, brass, and bronze *Head of a Man*— often dated 1930, but more likely to have been done during the winter of 1928–29.[11] This piece consists of a rectangular face—a mustachioed mouth, a flat wedge of a nose, and two eye-holes, faintly reminiscent of Apollinaire— which is almost entirely concealed behind a large bronze vagina-shaped extension.[12] Like virtually all the pieces Picasso welded and forged with González, *Head of a Man* would never

Picasso. *Figure (Proposed Monument to Guillaume Apollinaire)*, 1928. Iron and sheet metal construction, 60.5 x 15 x 34 cm. Musée Picasso, Paris.

leave his possession. It was a fetish, a shamanic defense against evil and death—all the more so for the androgyny, which belies its title.

Shamans, as Picasso knew well, can change sex "without losing face. . . . Neither man nor woman, [the shaman] becomes something else, something superhuman, something beyond the culturally-induced distinctions between good and evil, master and slave, mother and father, boy and girl."[13] In standing guard over Apollinaire's grave, the shamanic *Head* would stave off oblivion and confer immortality on the live sculptor as well as the dead poet. Once again, Picasso would have González replicate the piece in bronze; once again the committee would take no action. The vaginal mask was too flagrantly "in your face" for them.

After concentrating on sculpture through the fall of 1928, Picasso turned back to painting. As he would tell Kahnweiler, he had fantasized about turning his heads of Marie-Thérèse into houses, which he envisioned overlooking the Mediterranean, much as he had dreamt of setting up ithyphallic sculptures on the Croisette

Picasso. *Standing Nude,* December 7, 1928. Oil on canvas, 162 x 130 cm. Private collection.

at Cannes the year before. "But I have to paint them," Picasso told the dealer, "because nobody is ready to commission one from me."[14] In the first of these conceptual "building," *Standing Nude* (December 7, 1928),[15] Picasso transforms Marie-Thérèse into an Arc de Triomphe. Set theatrically against a bright blue Mediterranean sky, far from being anchored in the sand this behemoth is on the move and threatens to trample the viewer under her stumpy, cabana-shaped legs. To emphasize the gigantism, Picasso has topped her off with a pinnacle so small and high in the sky that all we see is a tiny tip-tilted nose with dots for nostrils. The downward convergence of the figure's gas-pump arms confirms that Marie-Thérèse is headed for the magic door of the cabana. The sliver of white down the left side of the painting. The only trouble, the cabana's keyhole is at ground level; to enter, the giantess will have to shrink or crawl.

In April, Picasso did another monumental beach sculpture, *Nude Standing by the Sea.*[16] The uplifted arms in this great painting do not stand for Olga; they stand for Marie-Thérèse. Picasso evidently wanted to see how his beautiful, trim young mistress would be enhanced by the position that he usually used to travesty his former ballerina wife. See how Picasso has based her torso and tiny head on the decorative obelisk with the ball on top that was part of the furniture of their Left Bank hideaway (see page 372). It enables Marie-Thérèse to tower up into the sky.

As for the figure's amazing legs: the secret of their monumentality had escaped me until Courbet's great view of Etretat in the Musée d'Orsay provide a sudden subliminal flash. Picasso has used the rock arches of Eretat—the Porte d'Aral and the Porte d'Amont—to magnify the scale of the bather's legs and breasts, indeed of her entire figure. The legs are easy to spot, but don't miss the tiny cone-shaped projections—rocky outcroppings—on the topmost edge of the cliff, which correspond to the figure's disembodied, cone-shaped breasts. Guy de Maupassant, who had lived at Etretat, described his vision of the Porte d'Aral as the "leg of a colossus [with] the separate 'Needle' . . . pointing its sharp head at the sky" and of the Porte d'Amont as "an enormous elephant [with] its trunk in the waves."[17] Snapshots of Picasso with the Braques in front of the cliffs leave us little room for doubt.

Picasso, it turns out, spent far more time on the Normandy coast in the late 1920s and early 1930s than has yet been recorded. Until he bought Boisgeloup in 1930, he had no place of his own to go for weekends. And so, like many another well-off Parisian, he took his family off for weekends by the sea, usually in the Trouville Hon-

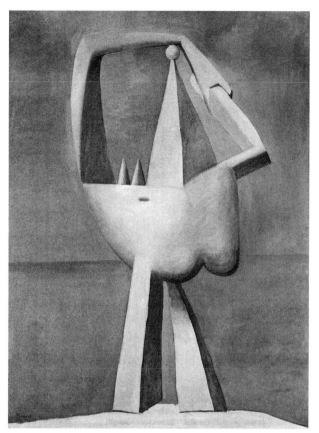

Top, left: Picasso with Marcelle and Georges Braque at Etretat, 1931.
Above, right: Picasso. *Nude Standing by the Sea,* 1929. Oil on canvas, 129.9 x 96.8 cm. The Metropolitan Museum of Art, New York. Bequest of Florene M. Schoenborn.
Above: Gustave Courbet. *The Cliff of Etretat After the Storm* (detail), 1870. Oil on canvas, Musée d'Orsay, Paris.

fleur area. A favorite destination was La Ferme Saint-Siméon, an *auberge de luxe* outside Honfleur frequented by the rich in quest of privacy. Picasso also spent some time in the Dieppe area farther to the east, as he told Zervos in 1935, when he compared the different light of his Pourville paintings with that of his Dinard ones. "I didn't copy the light of the Dieppe cliffs, nor did I pay it any special attention. I was simply soaked in it."[18]

Pourville? This attractive place is usually associated with Monet's duller cliff-and-seascapes rather than with Picasso. And yet, if we study the 1928–29 *Bather* paintings in the light of Picasso's statement, we realize that the setting is not the Mediterranean, as is usually assumed; it is Normandy. The cliffs of Pourville are not as spectacular as the Etretat ones, but the light is much the same. Picasso had a good reason for going there. The Braques were staying nearby. They had commissioned a

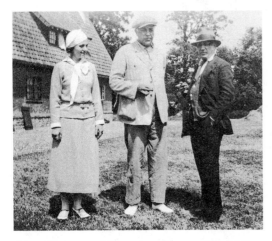

Olga, Braque, and Picasso at Varengeville, 1931.

house at Varengeville, which was next door to Pourville, from their friend, the American architect Paul Nelson.[19] It would be finished in 1931.

By the mid-1920s, Braque realized that he was no longer perceived as an avant-garde painter. Paul Rosenberg was partly to blame: he had marketed him as a latter-day Chardin, accomplished purveyor of *belle peinture.* As Picasso once mercilessly said, *"Avec Braque, toujours la crème— moi, jamais!"*[20] In his bid to regain avant-garde credibility, Braque had turned to Picasso for inspiration and painted a series of Picasso-like beach scenes—boats, bathers, and cabanas at the foot of the Pourville cliffs. Given certain similarities, it would seem that at times the two artists may have worked in tandem as they had before. As always, they had much to give and much to take from each other. Picasso would always miss their former togetherness and would nurse a fantasy that the two of them could resume their old association. Braque was right to be less sanguine. Their rapport could never be as close as it had been in the years of cubism.

Braque never succeeded in adapting Picasso's iconic bathers—the angular Dinard ones or the boomerang-shaped ones conceived in the studio—to his painterly vision. However, he showed Picasso how to paint the light of the north— the pale, veiled sunlight as well as the thunderous grays and foggy browns, which are the glory of his seascapes. Braque's use of the local chalk for his sculptures may also have inspired Picasso to draw upon the scale and light-refracting whiteness of the cliffs to monumentalize his bathers.

In years to come, Picasso would use landscapes to give even greater scale and an element of mother-earthiness to his women. In 1938, he took Dora Maar to stay with the Zervoses at Vézelay, and painted a large, sprawling nude *(Nu couché),* in which the contours of Dora's body follow the hills and dales and highways of the locality.[21] In 1959, after acquiring the Château de Vauvenargues, which included several hundred acres of the Montagne Sainte-Victoire, he told friends that he did not know how he would go about painting Cézanne's favorite motif. In the end, he transformed its lengthy backbone and abrupt western face into a reclining figure of the woman he was about to marry *(Nude under a Pine Tree,* 1959, Art Institute of Chicago).[22] Just as Cézanne often did, Picasso uses a pine tree in the foreground as a *repoussoir.* He tries to make the mountain very much his own. Had he, one wonders, already decided to be buried at its foot?

Early in 1929, Olga emerged from the clinic, where she had intermittently spent the previous four or five months. Cured or not, she would now be the victim of some of Picasso's most harrowing images. For the previous two years, his passion for Marie-Thérèse had been the main source of the psychic energy that fueled his work. But now, resentment and superstitious fear of sickness in women—Olga, above all—proved to be a source of demonic energy. Paintings triggered by her depressive state suggest that she was far from cured. Accounts of hysterical scenes and threats to kill her husband[23] might suggest that the distraught wife had discovered that "the other woman" had become a fixture while she was in the clinic. She had only to look in his wallet to see that he always carried Marie-Thérèse's photograph with him; or check his work to be confronted by image after image of her. ("How awful," Picasso once said, "for a woman to realize from my work that she is being supplanted.")[23] Not that there was much question of Olga being supplanted as the wife. Marie-Thérèse would have been miscast as Madame Picasso. The status quo suited Picasso. Olga seems to have sensed that Marie-Thérèse had no desire to take her place, which is why she came to accept her existence. Acceptance did not preclude resentment; but it would have been easier for Olga to bear than the promiscuity of the past. Interestingly, Dora Maar reported that Olga never harassed or attacked Marie-Thérèse,[24] as she would Dora and Françoise Gilot.

Women's tears evoked a predatory tenderness in Picasso—indeed, that is what gives his images of Dora Maar such intensity, but the tears of Olga evoked only guilt and rage—rage, above all, to paint. Take *Bust of a Woman with Self-Portrait* (February 1929).[25] This depicts Olga as a scrawny succubus; eyes sewn onto her cheeks like buttons and a dagger-sharp tongue protruding from her gaping mouth. Perversely, Picasso has given his wife, who had begun to dye her hair, a chignon dyed the color of Marie-Thérèse's. Most hurtful of all, he has set this travesty of Olga off against a fine, cool profile of himself incised into a rectangle of paint redder than her blood. As before, the manic conviction of these images has been attributed to the influence of Dr. Charcot's clinical photographs of women in the throes of hysteria, which Breton and Eluard had recently published in *La Révolution Surréaliste*.[26] These attempts to "surrealize" Picasso by association do not, to my mind, work. Why would he bother with Charcot's old photographs, when he had a prime example of something like hysteria on his arm?

In another bifurcated head of Olga,[27] done around this time—goggle-eyed and manic on the left, depressed and tranquilized on the right—Picasso diagnoses Olga's perturbed state, the better, perhaps, to exorcise it. In yet another bifurcated head (August 25, 1929),[28] entitled *The Kiss,* he contrasts a demonic dark-haired Olga on

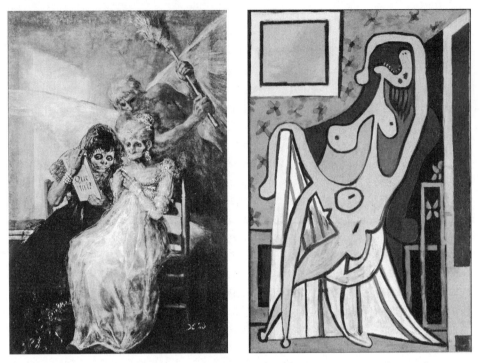

Left: Goya. *Time* or *The Old Ones,* 1808–12. Oil on canvas, 180 x 120 cm. Musée des Beaux-Arts, Lille.
Right: Picasso. *Large Nude in a Red Armchair* (Olga), May 5, 1929. Oil on canvas, 195 x 129 cm. Musée Picasso, Paris.

the left with a serene blond-haired Marie-Thérèse on the right. The anger in these images suggests that Picasso suffered from the atavistic misogyny toward women that supposedly lurks in the psyche of every full-blooded Andalusian male.

It is above all in the two masterpieces of this spring—*Large Nude in a Red Armchair* (May 5) and the *Large Bather* (May 26),[29] that Picasso pits his demons against Olga's. The shadows of two very different artists fall across the *Large Nude:* Matisse and Goya. Bois has pointed out that this painting is another of Picasso's responses to Matisse's *Odalisque with a Tambourine,*[30] which had been reproduced full-page in the September 1926 issue of *Cahiers d'Art.*[31] He may indeed have mocked the Matissean pose, but by positioning her right arm flopping bonelessly over the arm of the chair to look like a broken leg he has endowed it with a hideous new meaning. However, it is the darkness of Goya—a shadow Picasso usually avoided—that falls across this stridently colored work. The *Large Nude* bears an uncanny resemblance to his predecessor's misogynistic masterpiece, *Time* or *The Old Ones:* a bedizened hag gazing into a mirror, its back emblazoned with the words *¿Qué tal?* (What's

up?), which a no less hideous attendant holds up to her. The similarities—malevolent distortions, the ominousness, the droopy flesh—are self-evident. Primed with Goya's merciless Spanish irony, Picasso gets back at his wife of a little more than ten years by picturing her as *une vieille*.

The red armchair is intentionally menacing. He had no intention, Picasso said, of painting bored-looking *Seated Women* ensconced in comfortable *fauteuils*. He preferred to envisage his subjects "caught in the trap of these armchairs like birds caught in a cage. I want to chart the trail of flesh and blood through time."[32] To Malraux, Picasso elaborated on this theme. The armchair in which he sat his women "implies old age or death, right? So too bad for her. Or else the armchair is there to protect her . . . like Negro sculpture."[33] Olga's *fauteuil* looks about as protective as an electric chair. Its redness might refer to her hemorrhages, and the contorted right arm to the damaged right leg that put an end to her career as a dancer.

After joining the Communist Party at the end of World War II, Picasso would come to see armchairs in a very different light. Françoise Gilot describes him launching into an attack on Matisse for his famous 1908 statement that he aspired to an art of purity and serenity "that might be for every mental worker, be he businessman or writer . . . something like a good armchair in which to rest from physical fatigue." Why on earth does Matisse want to provide a businessman with an armchair? Picasso asked. "Why wouldn't his art appeal to a simple workman who is certainly more in need of a good armchair at the end of the day than his boss?"[34] The views of the nouveau Communist do not ring as true as those of the old misogynist. Picasso would soon revert to using armchairs in his later paintings to enhance or entrap the women in his life. Apropos armchairs, Dora Maar told me that ten years or so after she had broken with Picasso, she received a large crate from him. She was puzzled to discover that it contained a chair made of wooden balls and a web of string, designed by the boyfriend of one of his models.[35] Once assembled, it looked like a cage, she said.

Unlike the *Large Nude in a Red Armchair,* which is very much a painting, the next tragic portrayal of Olga, the *Large Bather* (May 26, 1929), is a conceptual sculpture—a monument that Picasso treats with the dignity and solemnity due to a sacrificial victim. It is dusk. A naked Olga stands, like a pillar of chalk carved from the cliffs of Pourville, staring numbly out to sea, her angular arms clasped in the fifth position above her head. Her skinny body—note the protruding ribs—is cloaked in a dark shroud, whose *craquelure* is certainly intentional. The light is northern, the sky a thunderous gray, the beach is the color and texture of coffee grounds. And yet, despite the gloom, this portrayal of Olga is one of the few of the great late denunciations in which Picasso shows a glimmer of mercy.[36] He has captured Olga's solitude—"I have never seen a more solitary person," Gilot said of her;[37] and, for once, her *âme russe,* her Russian soul, receives its due; too much of Russia, Picasso com-

plained, had rubbed off on him, especially the Russian superstitions which, Gilot claimed, enabled him to demonstrate his power over his family:

> Every time we left on a trip, however short it might be, we had to carry out the Russian custom of having all members of the family sit down in the room from which we were going to leave, without speaking a word for at least two minutes. After that we were allowed to start out on our trip, with complete assurance that nothing bad would befall us. We did that in the most serious fashion and if one of the children laughed or spoke before the time was up, we had to begin all over again; otherwise Pablo would refuse to leave.[38]

Dora Maar, who had suffered more from Picasso's cruelty than his other mistresses, told Penrose that "in some ways Picasso enjoyed [Olga's] violence."[39] It certainly inspired some of his most powerful images. By sticking her tongue out at him, cursing him in Russian, and telling him that he was not Paulo's father, which he so obviously was, Olga generated the rage, misogyny, and guilt that fueled his shamanic powers. However, for all the violence of his imagery and his cult of Sade, Picasso deplored physical violence. To fight back at Olga, he used his paintbrush, and only resorted to force to protect himself. These cruel paintings acted as lightning conductors, and they apparently worked. Home movies Picasso made two years later, around the time he was working on the convulsively cruel *Repose,* reveal a seemingly united family at play in the garden at Boisgeloup. A bit on the plump side and formally dressed, Picasso behaves like a quintessential bourgeois husband and father—the antithesis of the priapic polymorph he would turn back into, after his wife and child returned to Paris.

Earlier images of Marie-Thérèse are set on the beach or in the studio. However, in the early spring of 1929, Picasso took to painting her in a very different indoor setting.[40] This setting is certainly not the apartment Picasso rented for Marie-Thérèse in 1928–29 on the rue de Liège[41] nor is it the rue Boétie apartment. The view through the back window includes the twin steeples of Sainte-Clotilde, which is on the Left Bank. It has not been possible to locate the apartment, but McCully thinks the building was near or on the corner of the rue de l'Université and the rue Courty.[42] So much for the view. The décor of this rented hideaway apartment would provide Picasso with an uncharacteristically fancy setting for his paintings of Marie-Thérèse.[43] Decorative features include an arched doorway, a screen, windows opening onto a balcony, patterned wallpaper, a little table with a lamp, a fringed shade protruding from it, and a fashionable art deco accessory in the form of an obelisk, conceivably mirrored, topped with a ball that appears alongside a bust of Marie-Thérèse in a large interior scene, dated April 24.[44]

Another feature of the apartment—one that Picasso will come to identify with Marie-Thérèse—is a philodendron plant. The plant would make its first appearance in the *Woman in the Garden* sculpture (see Chapter 31) and later play a decorative role in *The Dream* and other Marie-Thérèse paintings of 1931–32. The dried-up remains of this or another philodendron would end up at the rue la Boétie as an assemblage, hung with such oddities as "a brightly colored feather duster, the horny beak of a bird, and a number of . . . empty cigarette packs. The chance accumulation of so many unrelated objects . . . was more Picasso than anything one could have put together consciously."[45] A small painting[46] of the love nest depicts the colorful wallpaper, a *treillage* pattern usually but not always on a reddish ground. This wallpaper would provide figure paintings and still lifes of 1931–32 with a variety of ornate settings, regardless of where they were executed.[47]

While working on his exorcisms of Olga, Picasso did the first drawings (June 17–18, 1929) for the *Crucifixion*,[48] which he would begin painting in December. And then, all of a sudden, he reverted—mercifully for no more than a day or two—to his commedia dell'arte penchant. Perhaps to placate Olga on their eleventh wedding anniversary (July 12, 1929), he painted two mawkish portraits of Paulo, one as Harlequin, one as Pierrot.[49] These images are at such odds with his recent work that they were presumably done as a tongue-in-cheek mea culpa and possibly a sop to his dealer. Rosenberg had been out of favor with Picasso for having declared that he did not want any more *culs* (assholes) in the paintings he showed and may have needed placating.[50] Delighted that his artist had reverted to the Harlequins he favored, Rosenberg persuaded him to sell the version that Olga liked less. Picasso's failure to hand over the painting before leaving for the summer elicited a further reprimand: "You departed without handing over my Harlequin—you are terrible." The dealer went on to "hope that Madame Picasso is in excellent health and that the bad memories of last summer have been washed away. Lucky man, in going to Dinard you have blotted Foujita out of the picture."[51]

In another letter, Rosenberg, who was spending the summer in his villa at Deauville, announced that he had taken up racing. He had bought ten racehorses, which he proposed to name after his artists—"excellent publicity for your products," he was stupid enough to tell Picasso.[52] This new venture, doubtless inspired by his partner, Georges Wildenstein—owner of a famously profitable racing stable—would not survive the Wall Street crash in October, or Rosenberg's discovery that Wildenstein had been having a long affair with his wife, Margot. That this conventional *mère de famille* preferred the loathsome Wildenstein to her far more scrupulous husband is not altogether surprising: Rosenberg was a workaholic, who lived

above the shop and often liked to return to his office after dinner; whereas Wildenstein took Margot racing and nightclubbing and gave her expensive presents. After the dust settled, the wives dutifully resumed marital life with their respective husbands. Recently a Cartier *minaudière* surfaced among the late Madame Rosenberg's effects with a wafer-thin ivory dance card in a secret compartment. On it was a caricature of Wildenstein—not by Picasso, as the heirs had hoped—but by Wildenstein himself. After the affair came to light in 1932, Rosenberg and Wildenstein ended their partnership[53] and divided up the Picassos and other works they co-owned. Rosenberg absorbed his share into stock. Wildenstein stashed his away; decades would go by before any of them came on the market.

Sometime in June 1929, just before *le tout Paris* departed for the summer, Charles and Marie-Laure de Noailles, who had decided to back avant-garde movies, attended a preview of the Buñuel-Dalí film *Un Chien andalou* at the Ursuline studios. The program also included *Les Mystères du Château du Dé,* a film that the Noailles had paid Man Ray to make in their new villa at Hyères. Man Ray's lackluster film was a flop—he would henceforth abandon movies—but Buñuel's was an instant success. Buñuel had been a nervous wreck at the preview. "I sat behind the screen with a gramophone and during the projection alternated Argentine tangos with *Tristan and Isolde.* I had filled my pockets with stones to throw at the public [presumably the surrealists] if they caused a disturbance."[54] Far from remonstrating, the surrealists hailed the film as a masterpiece. The Noailles were thrilled and arranged a preview of their own. They commissioned a second movie from Buñuel, the sacrilegious *L'Age d'or.* When shown in 1931, it would result in Charles de Noailles having to resign from the Jockey Club amid threats of his excommunication from the Church and the Beaumonts' guest list. They also backed their great friend Cocteau's masterpiece, *Le Sang d'un poète.*

The Noailles' party for *Un Chien andalou* took place on July 3, in what the press described as their "private cinema": actually, their mirrored ballroom with its great frescoed ceiling. An up-to-date projection room equipped for sound had been concealed behind the rococo paneling from a palazzo in Palermo. Guests included Cocteau, Poulenc, the Beaumonts, the Jean Hugos—who were about to separate because of Valentine's affair with Breton—and assorted members of the *gratin.* Marxist surrealists railed against the splendor; nevertheless, they continued to avail themselves of the Noailles' patronage.[55]

Since *un chien andalou* is derogatory French slang for Andalusians such as himself, Picasso, who had not attended the Ursuline preview, would have been anxious to see it. He was not the target of Buñuel and Dalí's disturbing film, whose opening

shot of a razor slicing into an eyeball has become one of the most memorable in cinematic history. The target was the already celebrated Spanish poet Federico García Lorca, who had been Dalí's boyfriend. Now that Dalí was living with Gala, he needed to distance himself from his ex-lover; and Buñuel was not averse to stirring up homophobic mischief.[56] Picasso liked the Spanishness of the film but he and Buñuel would never derive much pleasure from each other's company.

The Noailles' party spelled the end of Picasso's *époque des duchesses.* Out of habit and *bella figura,* he and Olga would continue to appear in a box at opening nights, but ever less frequently. Picasso even managed to keep Cocteau at a distance. Friends, among them the Beaumonts, complained that the artist had gone into hiding. Picasso's disappearance from the social scene is recorded by Count Harry Kessler, who was told over tea by the Beaumonts that

> they have not seen him for a year, although they are his closest friends. Whenever they invite him, he accepts, but ten minutes before they are to sit down for the meal a message arrives that his children [*sic*] have scarlet fever, his wife is indisposed, or something of the sort. He does not answer letters on principle, and telephone callers are informed that he is not at home. All his friends have had the same experience. Nobody knows what he is up to.[57]

Marie-Thérèse is what he was up to. Picasso had no intention of bringing her into the Beaumonts' lives. Anyway, he had no time to spare from his experimental new sculptures. In search of further guidance, he had recently arranged—presumably through their mutual friend González—to visit Brancusi's studio, a privilege the sculptor had been unwilling to extend. Brancusi's fear proved to be justified. Picasso, who had already derived some of the inspiration for his *femmes-phallus* from *Princess X,* would exploit even more of Brancusi's ideas for his 1931 sculptures.

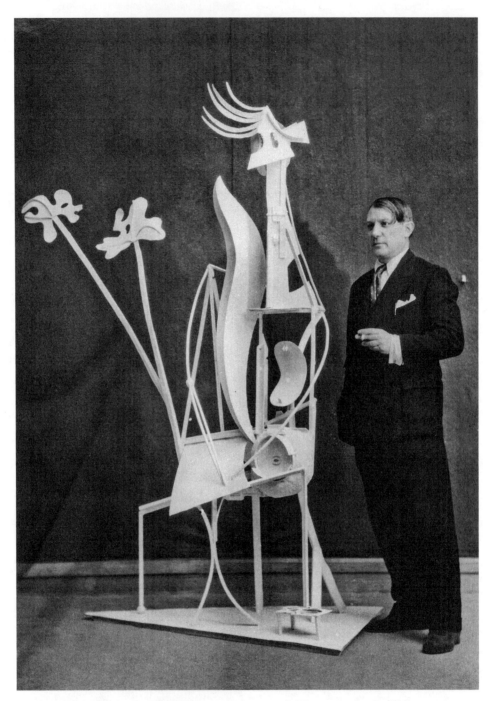

Picasso at the Galeries Georges Petit retrospective with *Woman in the Garden,* 1932.
Painted, welded metal. Musée Picasso, Paris.

31

Woman in the Garden (1929)

O n August 2, 1929, *Le Journal de Dinard et de la Côte Eméraude* announced
that the Picassos had returned to Dinard and installed themselves at the
Hôtel Le Gallic. They stayed there a couple of weeks while looking for a villa; they
finally settled for the Villa Bel-Event, a biggish gabled house on a hill facing the
sea. Rosenberg's brother-in-law, the silver dealer Yvon Helft, had also taken a house
at Dinard for his wife and two sons, one of them the same age as Paulo. Picasso
would leave the two families at play and join up with Marie-Thérèse, who was once
again lodged in the neighborhood. This year, both her sisters joined her for part of
the time.[1] Helft sent news of the Picassos to Rosenberg, who reported back to
Picasso:

> I have heard that [Olga] is younger and prettier than ever, that she is fit as a fiddle
> and that she has taken part in all kinds of sporting activities even *boule*. I am so
> happy for her and that her troubles must now seem so far away. . . . It appears that
> you take such pleasure in fishing that you are going to appear before the Eternal
> Father as a *pêcheur* [the word means "sinner" as well as "fisherman"]. But watch
> out. He may not take a good view of your massacre of the human race.[2]

Around August 15, Picasso took his family on a trip to Quimper on the south
coast of Brittany. Max Jacob was there for the summer, staying with his family in the
house they ran as an antiques shop.[3] Olga, who had been responsible for cutting
Max out of Picasso's life, was obliged to be friendly. Max had suffered horribly from
this rejection. Now he was proud to show off his celebrated friend, not to mention
the elegant wife and child and the white-gloved chauffeur at the wheel of the Pan-
hard, to his mother, brother Gaston, and sister Delphine.[4] Picasso duly pho-
tographed them. They spent at least one night in a local hotel. Max complained to
André Level that Picasso had liked only his *"vieille mère"* and the *"vieilles pierres"*—
the menhirs and dolmens which had attracted Picasso to this area of prehistoric
megaliths in the first place.[5]

An hour's drive southeast from Quimper, Carnac is famous for its astonishing

Iron Age crop of some five thousand menhirs ("long stones" in Breton), numerous dolmens (primitive altars of large flat stones supported on granite blocks), and burial mounds. The most spectacular site consists of rows of megaliths, known as the Soldiers of Saint-Cornély. According to legend, an army of pagan invaders had been stopped in their tracks by a miracle-working saint, who turned them to stone. According to archaeologists, the megaliths were Druidic or Mithraic tombstones. Jacob, who was versed in myth and mysticism, had urged Picasso to see these *vieilles pierres*. In ancient times, bonfires had been lit around them on Midsummer's Eve and large copper bowls struck with rattan canes until they resonated with *"une curieuse et fort pénétrante sonorité"*—the voices of the dead.[6] It would be a year or two before these stones manifested themselves in Picasso's imagery,[7] but "the voices of the dead" would do so all too soon.

Back in Dinard, Picasso received the news that shortly after he had left him Max Jacob had fractured his left leg and dislocated his shoulder in a motor accident. Pierre Colle, the young dealer who showed the drawings that kept Max solvent, had had a blowout while driving him home after a visit to Saint-Malo and crashed into a tree. The injuries would keep the poet in a cast for two and a half months. Two days later (August 21), Picasso received far graver news: a telegram from Misia stating that Diaghilev had died in Venice.[8]

Exhausted and discouraged after his company's disappointing London season, Diaghilev had undertaken a strenuous musical tour of Germany with his new Russian protégé, a very handsome, very costly seventeen-year-old musician called Igor Markevich. Igor's next protector, Marie-Laure de Noailles, spent so much money on him that her trustees took over control of her fortune. The trip had left the diabetic Diaghilev exhausted. To recover, he had retired to Venice, to the Grand Hôtel des Bains de Mer on the Lido, where his lover, Lifar, and secretary, Kochno, who loathed each other, could take care of him. It was too late. A lifetime of overindulgence in very rich food and sugary desserts had done him in and within days he was on the brink of death. On receiving a telegram, "Am sick, come quickly," Misia Sert and Chanel, who were cruising the Adriatic on the Duke of Westminster's yacht, raced back to Venice. Misia sent for doctors—bungling German ones she said—as well as an English nurse and, just in time, a priest to give the dying man the last rites.

As the nurse closed Diaghilev's eyes in death, Kochno, who had been kneeling on one side of the bed, hurled himself in a rage on Lifar, who had been kneeling on the other side—"like two mad dogs fighting over the body of their master."[9] Misia and the nurse had trouble separating the biting, snarling rivals so that the body could be laid out. Besides Misia, who made all the arrangements, and Chanel, who paid for them, only Lifar and Kochno attended the funeral on the Isola de San Michele. Once again, the Russian rivals gave way to exhibitionistic excess, crawling on their knees to

the gravesite. "Stop that clowning," Chanel snapped, as Lifar tried to throw himself into the muddy hole.

For the ailing Olga, who had come to regard Diaghilev in loco parentis, his death was a devastating blow. It was also a great blow for Picasso, who had enjoyed making fun of the impresario's absurdly grand manner, but admired him for his courageous support of modernist artists and composers. Diaghilev's fellow White Russians would mostly deplore his use of Soviet designers and theater directors. Years later, when helping Cooper with his *Picasso Theatre* book, I was surprised at the relish Picasso took in reliving backstage dramas and farces—Diaghilev's jealous rages, Misia's betrayals, Cocteau's prima donna tantrums—not to mention the décors that Picasso characterized sardonically as "my *divertissements*." Picasso readily admitted that his décors for Diaghilev had done more to disseminate his fame internationally than Rosenberg's Paris shows.

Despite their bitter bust-up, Massine claimed to "have felt [Diaghilev's] loss more than anybody."[10] Henceforth the choreographer would have a total change of heart about their past. As his biographer points out, Massine's "recollections of Diaghilev would gradually shift from memory to myth."[11] From being an antagonist, Massine "eventually became his most fervent apostle." Shortly after Diaghilev's death, Massine tried to persuade Beaumont to step into the dead man's boots: "we would create masterpieces—Picasso will help us. . . . I am full of enthusiasm. . . . We will take another direction—there are so many beautiful things to be done—discuss all of this with Picasso."[12] Beaumont was not interested. His one attempt at being an impresario—the *Soirées de Paris,* which gave birth to *Mercure* in 1924—had proved far too costly. Nor was Picasso tempted; he wanted no further truck with Olga's Russian associates. Lifar also approached him. Would he execute a monument to Diaghilev? Picasso promised to do so but, as Lifar put it, he "never found the inspiration."[13] A chic Greek architect, Rodocanachi, took over the job.

This summer's harvest of work would be less abundant than that of previous Dinard summers, but the one sketchbook Picasso filled—inscribed on the cover: Villa Bel-Event, August 16, 1929[14]—includes a number of ingenious variations on the theme of bifurcated heads: a genre which Carla Gottlieb compares to an eighteenth-century painting, *The Living and Dead Lady,* which belonged to Picasso's friend Ramón Gómez de la Serna.[15] The rooms of Villa Bel-Event seem to have been unsuited to work on a large scale. Canvases—mostly heads of Marie-Thérèse but sometimes of Olga—are small. Although entitled *The Kiss,*[16] they portray a single face in double profile, as if to incorporate his wife and mistress into a single physiognomy. Before leaving Dinard, Picasso did a very small painting of a very large,

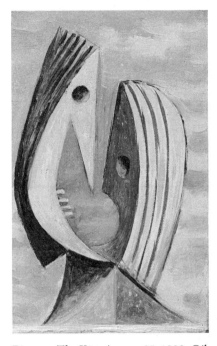

Picasso. *The Kiss,* August 25, 1929. Oil on canvas, 22 x 14 cm. Musée Picasso, Paris.

recumbent Marie-Thérèse—visualized, as it were, from the viewpoint of a beach towel. He also took a sexy photograph of her holding a large rubber ball, which inspired a little painting of her as stiff and long-armed as a gasoline pump.

Shortly before returning to Paris at the end of September, Olga received a letter addressed to her from Jacqueline Apollinaire but intended for her husband—not the most tactful way of nudging him into modifying his stance on the Apollinaire monument.

Someone with whom you recently discussed the monument to Guillaume asserts that you said that your project was finished and ready to be executed, but that I had begged you to abandon this idea for a monument.

I can only imagine there has been a misunderstanding, for you are surely aware of my feeling that a monument, whose excessive modernity might cause a scandal, would never be acceptable. If it is true that you have come up with a project that is easy-on-the-eye and ready to be executed, be so good as to write me about it and I will see that it is brought to the attention of Billy or Salmon to the satisfaction of all the friends.[17]

The letter suggests that Picasso had had little contact with the committee for a year or so, and that the *malentendu* of which she speaks may have reflected differences between traditionalists like Billy and herself and the pseudo-modernist, Salmon, who wanted to worm his way back into Picasso's favor. At all events, Jacqueline's letter had little effect. Picasso simply went ahead with a private plan to honor the poet *his* way with yet another monument, once again inspired by Marie-Thérèse.

By now the Apollinaire commission had ceased to be a primary factor in Picasso's sculptural development, other than constituting a pretext for experimenting with new techniques and new metamorphic concepts. As usual, the artist did countless preparatory drawings, but, as González says:

[He could] never find the time to realize any of his projects. On the rare occasions when he does decide to, he always chooses to work on the most recent one. This is because he is such an anxious man, always wanting to surpass himself, that he ends up just filling more folios in his sketchbooks. . . . despite his thousands of sketches, he didn't take a single one on the morning he set to work at the forge. His hammer was all he needed to try and build his monument to Apollinaire. He worked at it over a period of several long months, and he completed it. Often he would say, "I feel as happy again now as I did in 1912."[18]

Left: Marie-Thérèse Walter at Dinard, 1929. Photograph taken by Picasso. Musée Picasso, Paris.
Right: Picasso. *Bather with Beach Ball,* 1929. Oil on canvas, 21.9 x 14 cm. Musée Picasso, Paris.

Like the wire constructions, the new welded piece, *Woman in the Garden,*[19] derives from the 1928 images of Marie-Thérèse, hair flying in the breeze, playing ball on the Dinard beach. Cowling has interpreted this figure as a "screaming woman . . . a desperately grieving Magdalen."[20] I agree with González that it is a joyous and celebratory piece—one made with "much love and tenderness."[21] Far from commemorating Christianity's saintly sinner, *Woman in the Garden* is intrinsically pagan. To understand what it stands for, we need to realize that the Latin poet Ovid had begun to exert a far more radical influence on Picasso's choice of theme and imagery than any contemporary poet.

> My soul would sing of metamorphoses.
> But since, o gods, you were the source of these
> bodies becoming other bodies, breathe
> your breath into my book of changes.[22]

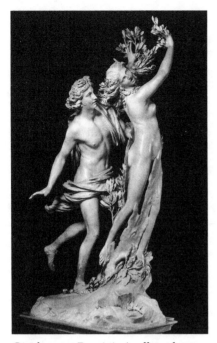

Gianlorenzo Bernini. *Apollo and Daphne,* 1625. Marble, ht. 243 cm. Galleria Borghese, Rome.

This is how Ovid begins the eternally radiant fifteen-book sequence of his *Metamorphoses.* Picasso was especially drawn to the second poem of the first book, the story of Apollo's first love, the mountain nymph Daphne, who was a priestess of Mother Earth. This provided him with the subject for the most complex of his welded sculptures, the *Woman in the Garden.*[23] The desire to do a sculpture of Daphne in the throes of metamorphosis dated back to Picasso's visit to Rome in 1917. Picasso had been fascinated by Bernini's Ovid-inspired sculpture of Daphne turning into a tree, when he saw it in the Villa Borghese.[24] And, indeed, so striking are the parallels with Bernini, one is tempted to see Picasso's sculpture as a reprise of the baroque as well as a radical rethinking of classicism.

Ovid's poem recounts how Cupid, to prove his power, shot one of his love-kindling arrows at Apollo and a leaden, love-defying one at Daphne—an act that was bound to end in rape. The passage describing the love-struck god chasing the terrified nymph through the woods was made for Picasso. "The wind laid bare [Daphne's] limbs/against the nymph it blew/her dress was fluttering/her hair streamed in the breeze/in flight she was more fair."[25] "Exhausted, wayworn, pale and terrified,"/she appealed to her father, Peneus, a river god, to save her from Apollo. Peneus metamorphosed Daphne into a laurel bush. "A heavy numbness grips her limbs; thin bark/begins to gird her tender frame, her hair/is changed to leaves, her arms to boughs; her feet—/ . . . are now held fast by sluggish roots; the girl's head vanishes,/becoming a treetop. All that is left/of Daphne is her radiance."[26] For want of a laurel bush, Picasso used the philodendron plant that we know from the drawing of the Left Bank apartment. He has played off the upper part of Daphne's body—the feeling of flight, of wind in the treetops—against the feeling of earthbound stasis below. To establish the figure unequivocally as Daphne, he has welded a small trivet to the figure's foot: a neat device to demonstrate that her feet have taken root.

I believe that there is also a comical, personal side to Picasso's predilection for this particular metamorphosis. As the reader of Volume II may remember, Apollinaire had been Picasso's accomplice in a quasi-Apollonian *enlèvement* of Irène Lagut, the mistress that Picasso was trying to lure away from Serge Férat.[27] Inevitably the *enlèvement*—more of a game than a rape—had ended in drunken farce. Irène had no difficulty escaping from Picasso's suburban villa, to which she returned of her own free will the following day. Just as Apollinaire drew on this comical episode for

his roman à clef *La Femme assise,* Picasso drew on it for this *sculpture à clef, Woman in the Garden.* The evocation of Ovid is particularly appropriate to the commemoration of a poet, who likewise saw sexual passion, violence, and metamorphosis as the raw material of art.

Once again, the Apollinaire committee showed no enthusiasm. Picasso was not offended; he was on the contrary delighted to keep this monument, that allegorized both the living and the dead, for himself. For her part, the widow was pleased that he had stopped forcing his unacceptable maquettes on them. She remained on sufficiently good terms with Picasso to bring an entrepreneurial twenty-six-year-old from Geneva called Albert Skira to meet him. Skira's looks—tall, slender, fair-haired and blue-eyed as any *jeune premier*—were a useful adjunct to his infinite ambition. Skira had set his mind on becoming the new Ambroise Vollard and had a proposal to make. The son of a janitor and a notorious battle-ax—said by Cooper to have run a brothel—he had started his career selling paintings out of the back of a truck to rich tourists in Saint-Moritz.[28] In the evenings, Skira is also said by Cooper to have worked as a professional dancing partner at the Palace Hotel; and it was there in 1928 that he met a well-heeled, well-born American beauty, who had recently left her playboy husband, Sonny Whitney, to marry a more enterprising playboy, Averell Harriman.

Harriman was about to open his own ski resort in Sun Valley, Idaho, and had come to Saint-Moritz to check out Swiss skiing facilities. This left his wife, Marie, in need of distraction. She liked to dance and drink, so did Skira. Another link: although far from knowledgeable, Marie loved modern art and was in the process of launching her own gallery in New York. Skira promised to help her get things going. Without his advice, she would never have been able to acquire such masterpieces as Picasso's 1905 *Woman with a Fan* for her husband (who left it to the National Gallery, Washington), and the even more magnificent 1906 *Boy Leading a Horse* for their friend William Paley (who left it to MoMA).[29]

His dream, Skira told Marie Harriman, was to be a publisher of *éditions de luxe* like Vollard, above all of books illustrated by his hero, Picasso. Such were his powers of persuasion, Marie agreed to back him. Next, Skira had to face up to the more daunting task of persuading Picasso to overlook his total lack of experience and accept a major commission from him. Knowing nothing about him, Picasso had refused to take Skira's telephone calls, but that did not deter the caller. Somehow or other he persuaded Jacqueline Apollinaire to take him to the rue la Boétie. When Skira explained what he wanted, Picasso was dismissive. "Young man, I am very expensive."

How expensive? Skira asked, although his pockets were virtually empty. Twenty thousand francs an engraving, Picasso said, hoping to get rid of him. Unfazed, Skira

promptly commissioned fifteen plates, without having any idea of what book he wanted Picasso to illustrate. "The difficulty was to find a text suitable to the style of Picasso," Skira later admitted.[30] Picasso told Françoise Gilot that the publisher wanted him to do a book about Napoleon.[31] This was surely a joke at Skira's expense. Let us turn instead to François Chapon—the illustrious former librarian of the Bibliothèque Doucet—who had the true story from Brassaï. In the course of discussing possible books, Picasso recounted a dream he had had about women turning into fish. Pierre Matisse, who was present in the studio, picked up on this. "Why don't you illustrate the *Metamorphoses* of Ovid?" he said.[32] The suggestion was instantly agreed upon. Picasso was already at work on Daphne; and in 1920, he had done drawings of Nessus and Dejanira.

To raise the requisite money, Skira had to have written proof of Picasso's collaboration, so he asked the artist to sign a contract. "A contract?" Picasso was appalled. "Young man, do you realize that never in my life have I signed a contract? Neither with Kahnweiler nor Vollard nor anyone else."[33] Skira's blandishments prevailed. By the end of April, the arrangements had gone far enough for Picasso to order copper plates from his printer, Louis Fort. By early May, the Harrimans came up with the cash. In the hope that the project would never materialize, Picasso refused to take an advance. So persistent was Skira that the artist finished his work in record time.

The Wall Street crash of October 25, 1929, left the modern art market in shambles. Paul Rosenberg, who had just spent a fortune refurbishing his gallery and establishing a racing stable, lapsed back into innate cautiousness. The dealer had planned a major Picasso show for March–April 1930; with this in mind, he had acquired sixteen paintings in the spring of 1929 and a further twelve later in the year. The crash put a stop to this project: Rosenberg substituted a group show for an exclusively Picasso one. Apart from a few piecemeal acquisitions to keep his principal artist happy, he would not make another major purchase of Picasso's work until 1934.[34] Instead, he shifted his focus back to impressionists and post-impressionists.

Kahnweiler, who had reestablished his rapports with Picasso and bought the occasional work from him—in January 1929 he had acquired a large painting for 125,000 francs[35]—would have gone out of business had he not been financially astute and well connected. One of Kahnweiler's rich Anglicized uncles, Sir Ludwig Neumann, came to the rescue, his elder brother, Sir Sigmund, the gallery's original backer, having recently died. In his memoirs Kahnweiler complains of making virtually no sales.[36] Day after day, he and his stepdaughter, Zette Leiris, were alone in the gallery; they had fired the office boy. "We saw nobody," Kahnweiler wrote. "It would have been relatively supportable, had I not had the responsibility of my painters. I

did not want to abandon them. Not so much the big ones. Picasso had no need of me. Nobody bought Picasso any more; but Picasso could wait. Braque, too, could wait."[37] Four years later, Kahnweiler would write to his Swiss friend Hermann Rupf that "a Picasso worth 100,000 francs today fetches 20,000–25,000"; also that Rosenberg should henceforth concentrate on nineteenth-century art and "leave living painters completely in peace."[38]

Collectors anxious to turn art back into cash would further depress the market. Chief among them was the mysterious German industrialist, Masonic bigwig and art investor G. F. Reber, who had seventy mostly major Picassos—including MoMA's version of the *Three Musicians*—and countless works on paper in his château at Lausanne. Among other treasures Reber would liquidate at bargain prices were some thirty Cézannes, sixteen Braques, and eighty works by Juan Gris.[39] Many of these were snapped up by Douglas Cooper, who would put together the world's finest private collection of cubist masters.[40] Like Reber, who was in some respects his mentor, Cooper—a die-hard elitist—confined his acquisitions to the four masters, Picasso, Braque, Gris, and Léger, who had constituted Kahnweiler's pre-1914 stable.

Despite the devaluation of his work, Picasso suffered little from the crash. Thanks to Rosenberg's successive hikes in his prices over the previous decade, and his banker Max Pellequer's management of his funds, the artist had amassed a considerable fortune, which enabled him to continue as before. Picasso was about to buy one of the most expensive cars at the Salon de l'Automobile,[41] a large, luxurious Hispano-Suiza coupe de ville—"its elegant interior adorned with mirrors and little crystal vases for flowers"[42]—which, twenty years later, his son Paulo would end up chauffeuring. Picasso, who had experienced greater poverty than most of his painter friends, enjoyed driving around, to Olga's dismay, in this ostentatious chauffeured car wearing an old suit the worse for paint stains, cigarette burns, and plaster dust. As he said more than once, "I would like to live like a pauper with lots of money."[43]

Picasso's generosity to friends and fellow artists did not preclude a superstitious respect for the thrifty precepts of his Andalusian forebears. Hidden away in the rue la Boétie was a hoard of gold coins, and in the vaults of the Banque de France, a vast stash of cash. In 1934 or 1935, Picasso would take Zervos to one of these strong rooms to look at some paintings. Zervos told Otero that after the guard left them,

> "Picasso said to me, winking his eye like a mischievous schoolboy: 'I have two more rooms. Do you want to see them?' I said that I did . . . and he had another armored room opened for us. . . .
>
> "The second room was even bigger than the first. . . . To my amazement, there were no paintings in it, but only packages, piled one atop the other to the height,

Picasso in the front passenger seat of his Hispano-Suiza with Marcel Boudin, his chauffeur, Juan-les-Pins, c. 1930.

say, of Picasso. Between [them] there was a kind of labyrinthine trench that enabled one to reach the packages piled against the walls. I thought they were drawings, or engravings, or letters. . . .

"... And do you know what there was inside? Bank notes! Yes, sir, bank notes, the largest denomination that existed in France then, which was enormous. . . . Instead of depositing his money in a bank account earning interest . . . he preferred having it in bundles wrapped in newspaper . . . no different from the country bumpkin who keeps his savings sewn into his mattress."[44]

Picasso was an obsessive hoarder, but the reverse of a miser. By far the most generous of the major School of Paris artists, he kept a number of his poorer friends, poets especially, in funds with gifts of his work. After 1936, he would secretly provide more support—including a hospital at Toulouse—for Spanish refugees than any other private person. However, Picasso was as paradoxical about money as he was about everything else; his largesse did not always extend to family members and dependents. Control necessitated a tight monetary rein. When one of his Vilató nephews, of whom he was fond, asked him for money, Picasso suggested he become a hustler.

Despite the crash, there was heartening news from New York's cultural front. In November 1929, a group of rich New York philanthropists—Abby Aldrich Rockefeller, Lillie P. Bliss, and Conger Goodyear—opened the world's first museum of modern art. In their wisdom, they appointed Alfred Barr, a young modernist art historian with an eye as sharp as his mind, to be its director. Barr was convinced that

Picasso and Matisse were the two greatest artists of their time and did everything he could to propagate this view. Over the years he managed to make the Museum of Modern Art (MoMA) the world's richest repository of their work. In his pioneer exhibitions and writings and the guidance he gave to a new generation of collectors, Barr would do more than anyone on either side of the Atlantic to promote the public's understanding of Picasso. Picasso thought very highly of Barr but never really warmed to him. He found Barr dry and academic, but the problem may have been Barr's clever, caustic, outspoken, Irish-Italian wife, Marga.

Barr's first major project, a Picasso retrospective exhibition in 1931, would come to nothing: the artist and his dealer decided that this should take place in Paris. However, the acquisitions Barr made—sometimes in the teeth of opposition from some of the crustier trustees—and the magnificent exhibitions that he organized and cataloged in 1939, 1946, and 1957 would convert successive generations of the public to Picasso's work. The blockbuster Matisse-Picasso show at MoMA (2002–2003), which had originated at the Tate Modern in London in 2002 and came to MoMA via the Grand Palais in Paris was in a sense the apotheosis of Alfred Barr, who had died twenty-two years earlier. Sadly, the museum that Barr created, and which owes so much to him, failed to honor him on the occasion of this exhibition. Those of us who have benefited from his wisdom found the galleries redolent with his presence and austere modernist spirit. Without realizing it, everyone who visited this show, whether in London, Paris, or New York, was in Barr's debt.

Left: Picasso. *The Swimmer,* 1929. Oil on canvas, 130 x 162 cm. Musée Picasso, Paris.

Below, left: Picasso. *Female Acrobat,* January 19, 1930. Oil on canvas, 69 x 59 cm. Collection Bernard Ruiz-Picasso.

Below, right: *The Deluge,* page from the *Apocalypse of Saint-Sever* by Stephanus Garsia, eleventh century. Bibliothèque nationale de France, Paris.

32

The Bones of Vesalius (1929–30)

Just as it had in the spring, the Left Bank apartment Picasso had taken for Marie-Thérèse continued to provide the setting for paintings that were probably not done there. Some of the larger canvases, which include a view of Sainte-Clotilde, are likely to have been executed back at rue la Boétie. A case in point is *La Fenêtre ouverte,* dated November 1929.[1] This puzzling allegory becomes less puzzling once we realize that it dates from the time of Picasso's close collaboration with González and that the Left Bank apartment was halfway between the rue la Boétie and the sculptor's rue Médéah workshop.

In *La Fenêtre ouverte,* Picasso reverses the Pygmalion process and metamorphoses himself and Marie-Thérèse into conceptual sculptures. The artist likens himself to the semblance of the letter *E:* two huge feet connected by a single vertical leg,[2] pierced by a mammoth arrow. The arrow forms the middle bar of the *E* and is aimed directly at the humanoid facing him: Marie-Thérèse, who has been no less drastically reduced to a sharp-featured head on a tall armlike neck, clutched by a hand as if it were a beach ball. ("It's me all right," Marie-Thérèse told Gasman, when shown an illustration of this painting.)[3]

Three days after finishing *La Fenêtre ouverte,* Picasso reverted to using a sketchbook,[4] which he had not touched since mid-June. New drawings include a group of *têtes à jambes:* monstrous heads with radiating limbs like the ones in medieval illuminations. The manuscript that would leave the most decisive mark on Picasso's work—on the primitive spirit as well as the color and the drawing of the *Crucifixion* he already had in mind—was the *Apocalypse de Saint-Sever,* by the eleventh-century Spanish master Stephanus Garsia. Picasso is likely to have seen this *Apocalypse* in the famed 1926 exhibition of medieval manuscripts at the Bibliothèque Nationale, but its manifestation in his work was prompted by Georges Bataille's article in the April 1929 issue of *Documents.* The hold that this manuscript had on Picasso's vision is confirmed in numerous drawings,[5] as well as two large (160 × 130 cm) *Swimmer* paintings—one vertical, one horizontal[6]—which are as minimalist as some of Miró's recent work. Stephanus Garsia, the *Saint-Sever* illuminator, turns out to have exerted

as much influence on Picasso—above all, in years to come on his *Guernica*—as any Spanish master, except perhaps El Greco.

The vertical *Swimmer* stems from images of agonized flood victims on the *Deluge* page of the *Saint-Sever Apocalypse*.[7] Picasso's pale blue figure looks as if it might melt into the pale green water, were it not for the contour—taken from Garsia—that defines and articulates it. Picasso has simply added a long thin neck ending in a head shaped like a hand. The horizontal *Swimmer* belongs in a different, airier element. The scumbled blue ground—similar to the blue heavens in which Miró turns scraps of words into kites—suggests that this reddish figure is going for a swim in the sky. These swimmers are neither male nor female. The pale blue one has faint, breastlike bumps, while the reddish one clutches a dagger. Other oddities: the *Swimmer*'s upward-pointing nose (bottom right) mutates into an admonitory forefinger, while the hand makes a covert sign against the evil eye. These paintings do not refer to Olga or Marie-Thérèse. They are shamanic and can best be compared in shape,[8] size, and flatness to the shamanic robes that the Sioux and Crow Indians made from the hides of buffalo or deer for their medicine rituals—hence their rudimentary quadrupal look.[9] Picasso had lengthy discussions about such things with Leiris.

After Christmas 1929, these airborne swimmers gave way to contortionists[10]—perhaps the consequence of visits to the Cirque Medrano, which were usually reflected in his work. The first (January 18) and most striking of these contortionists is the *Acrobat* in the Musée Picasso.[11] For better or worse, this dramatic white silhouette, the same size and style as the *Swimmers,* draws so much attention to itself that it reads as a magnificent poster rather than a shamanic exercise. Less imposing are two smaller but livelier contortionists, done the following day.[12] Like the *Swimmers,* these paintings fulfill an ambition that had long been on Picasso's mind: to do a painting that would make sense whichever way it was hung, that would say yes as well as no, and be male as well as female. So successful was he that the vicious, reactionary anti-Semitic critic Camille Mauclair would maintain that Picasso's only claim to fame was the invention of "the picture without up side or down." Mauclair's statement was published in *Le Figaro* and *L'Ami du Peuple* as well as in the Hearst papers in the United States. As Cabanne observes, "Mauclair actually was voicing what many felt, and what good students at the Beaux-Arts were being taught daily: Picasso was a hoaxer, his fake reputation, artificially built up by international Jewry, would not last; and the 'modern' art dealers were impostors or crooks (mostly Jews, anyway)."[13]

One of the January 19 *Acrobat* paintings—of a contortionist poking his nose up his own bottom—typifies this upside-down, downside-up look. In this book the painting is a vertical, whereas in Zervos it is a horizontal. When it was first published

by Leiris straight off the easel in 1929,[14] it appeared as a horizontal, and for a seemingly good reason: the wet paint in one corner of the canvas drips downward, not sideways. Far from indicating which way the painting should be hung, Picasso uses this dribble to belie its most obvious orientation. The viewer "must learn to see the familiar from an unfamiliar point of view," as the artist later told Françoise Gilot.[15] He also liked the idea of manipulating viewers into twisting their heads this way and that, and wondering whether they are dealing with a lie that tells the truth or a truth that appears to lie. Even when there is no doubt as to which way up a painting should be hung, Picasso took pleasure in giving different answers to anyone rash enough to question him.

The day after finishing this reversible painting, Picasso set his contortionists in motion,[16] where they form a filmic backdrop—not unlike the group of writhing, resurrected nudes at the back of El Greco's *Apocalyptic Vision,* which had played a part in the *Demoiselles d'Avignon.*[17] The artist, a minimal, easel-like presence on the right, and Marie-Thérèse, an attenuated figure with a colossal hand on the left—are in static contrast to the contortionists looping the loop in the background.[18] Turn this painting upside down, as brushstrokes indicate Picasso did when working on it, and your perception of the subject will change. Instead of flying, the contortionists appear grounded. Fifty years later, Georg Baselitz would do something of the sort in his upside-down paintings, but to a very different end. Baselitz wants to focus our attention on the eloquence of his paint.

While working on the *Swimmers* and the contortionist paintings, Picasso embarked on the "bone" head series, from which this period derives its catchy name. Apart from the two great *Bather* paintings in MoMA,[19] Bone-period paintings are mostly done on smallish wooden panels.[20] Wood would be in keeping with the retablelike *Crucifixion,* for which these panels are studies; canvas could not provide the unyielding hardness that Picasso hoped to attain.[21] To explain this obsession with bones to Brassaï, the artist would later (1943) show him a prized object from his collection of curiosities, the skeleton of a bat:

> I have an absolute passion for bones. I have a lot of others at Boisgeloup: skeletons of birds, heads of dogs and sheep. . . . I even have a skull of a rhinoceros. Did you see them, out in the barn? Have you ever noticed that bones are always modeled, not just chipped out? One always has the impression that they have just been taken from a mold, after having been modeled originally in clay. No matter what kind of bone you look at, you will always discover the trace of fingers . . . sometimes enormous fingers, sometimes Lilliputian ones, like the ones that must have modeled the fragile little bones of this bat. On any piece of bone at all, I always find the fingerprints of the god who amused himself with shaping it. And have you noticed how the convex and concave forms of bones fit into each other—how artfully the vertebrae are "adjusted" to each other?[22]

Left: Andreas Vesalius. Plate 59: Kidneys, Bladder, and Seminal Organs, *De humani corporis fabrica,* 1543. Courtesy of New York Academy of Medicine Library.
Right: Picasso. *Study for a Sculpture,* 1928. India ink on sketchbook page, 38 x 31 cm.
Collection Marina Picasso. Galerie Jan Krugier & Cie, Geneva.

On a later occasion, Picasso would draw Malraux's attention to the wingspread of this same bat's skeleton: "It's very pretty, very delicate," the artist said, but "I didn't realize it was a crucifixion, a fantastic crucifixion."[23]

This fascination with bones led Picasso back once again to the work of Andreas Vesalius, the sixteenth-century pioneer anatomical artist who pried open the human envelope and made the first accurate record of its contents.[24] Picasso had first used one of Vesalius's woodcuts in 1908 for his great *Dryad* in the Hermitage. As Picasso told Aragon at this time, anatomical plates constituted his "blueprints" *(maquettes de tableaux).*[25] Vesalius's *De humani corporis fabrica* (1543) is the source he had in mind. It is one of the most scientifically revelatory books of the sixteenth century, also one of the most beautiful. Vesalius's gorgeous, grisly woodcuts enable us to follow the successive stages of his dissections: the removal of the skin and the flesh to show us the musculature, the flaying of the muscles to reveal the bones, and finally the dismantling of the skeleton to demonstrate the intricacy of its construction.

Vesalius does the same with the brain, blood vessels, nervous system, digestive tract, and reproductive organs. In opening up his cadavers for artists as well as scientists, this pioneer of genius opened up—above all to Picasso, four centuries later—a new range of imagery and, as we shall see, a new set of blueprints.

Picasso was haunted by a traumatic experience he had had when he was seventeen, while recuperating from an illness in the remote *alta terra* on the borders of Aragón. As recounted in Volume I,[26] he had been taken to watch the autopsy of a young girl and her grandmother, who had been struck by lightning. The sight of the local sheriff, puffing on a blood-spattered cigar while he sawed the girl's head in half, so nauseated Picasso that he left before the old woman was chopped up. Memories of this experience seem to have reinforced the impact of Vesalius's plates, particularly the sixth plate of the section on muscles, in which Vesalius has cracked the cadaver's lower jawbone in two and wrenched the separate sections backward and outward to form protruding mandibles. This radical reordering of the face is a key source of the physiognomical distortions of Picasso's "bone" period heads, also the source of even more radical ones to come. Picasso's obsession with bones will live on

Above: Andreas Vesalius. Plate 29 detail: The Sixth Plate of the Muscles, *De humani corporis fabrica,* 1543. Courtesy of New York Academy of Medicine Library.

Right: Picasso. *Seated Bather,* Paris, 1930. Oil on canvas, 163.2 x 129.5 cm. The Museum of Modern Art, New York.

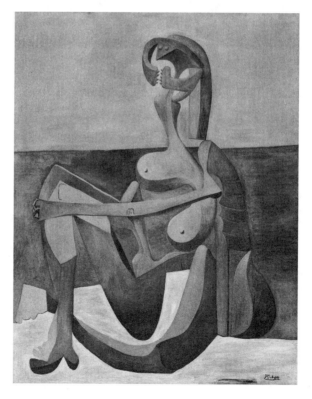

in his imagery and reassert itself in 1931 in such paintings as *Woman Throwing a Rock,* and, above all, in his sculpture.

The masterpiece of the Bone period is the MoMA's monumental *Seated Bather* of January 1930—a portrayal of Olga, as Picasso made a point of confirming.[27] With its porcelain finish, sharp focus, eerie serenity, and cracked-open Vesalian head, this painting has come to be seen as a surrealist icon, despite Picasso's denial of any surrealist involvement at this time. We should, however, remember that work on the *Seated Bather* followed closely on the succès de scandale of Salvador Dalí's first one-man exhibition in Paris (November 20–December 5, 1929). The surrealist wonder works in this show—among them the *Lugubrious Game,* acquired by the Noailles, and the *Great Masturbator*[28]—apparently left Picasso feeling challenged to go one better than Dalí, and also demonstrate the difference between Apollinairean sur-realism and Breton's surrealism: the difference between Picasso's radical imagery and the glossy effluvium from Dalí's subconscious.

Dalí revered Picasso; Picasso did not revere Dalí, but he was much amused by him and impressed by the technical virtuosity of this Catalan clown. He also praised him for painting the smell of shit better than anyone else. He meant this as a compliment. He saw Dalí's set pieces of the 1930s as *fata morganas*—meticulously painted mirages. For all their "convulsive" qualities, Dalí's visions deceive, much as the mirage of an oasis deceives someone dying of thirst in the desert. Up close, there is nothing palpable to grasp. Picasso was not interested in painting dreams; he wanted to paint smoke, he once said, as if you could drive a nail through it. There is nothing oneiric about his *Seated Bather;* it has the heft of the real thing. Thanks partly to Vesalius, Picasso has turned Olga's body inside out and submitted it to a radical, sculptural deconstruction. Look, for instance, how the spinal column buttresses the back from the outside rather than the inside.

The head of this *Seated Bather* has often been likened to a praying mantis.[29] Surrealist painters and poets had a collective male fantasy about these insects. Some even collected them in the hope of seeing the female bite the head off the male at the climax of their mating. As a result, this insect had become a surrealist cliché, not least in the work of Masson and Ernst. Picasso would have been at pains to avoid it. No, it was Vesalius who put him on the road to Golgotha, the place of bones where Christ is said to have been crucified. Golgotha would be the setting for his next great work.

33

Golgotha (1930)

Central to Picasso's "bone" period is his 1930 *Crucifixion*.[1] The idea of addressing what he admitted to be "the greatest subject in art"[2] goes back to his student days, but his first attempt at deconstructing the subject dates from 1917, when he did some worked-up cubist drawings of a picador as a centurion as if for a Crucifixion, but failed to follow them up. In 1926 and 1927, Picasso did some ironical drawings of this hallowed subject, but the arrival of Marie-Thérèse in his life put all such thoughts out of his mind. It was not until May–June 1929 that he came up with four more detailed studies for a Crucifixion composition cut off at the level of Christ's loincloth.[3] These include a detail missing from the final painting—an overscaled hand, seemingly the artist's and conceptually the viewer's, gripping the rungs of a ladder overlooking the action on Golgotha, thus bringing it within reach.

Picasso, it is important to remember, had been trained as a religious artist. His father had apprenticed him to an Andalusian painter of sacred subjects, José Garnelo Alda, in the belief that the boy would make a fortune doing devotional genre scenes. Garnelo's studio resembled a film set; props included a baroque altar for ceremonial subjects and a grotto where Bernadette's vision of the Virgin could be reenacted. However, it was Garnelo's knowledge of Catholic iconography, rather than his flashy academicism, that inspired his fifteen-year-old apprentice to fill sketchbooks with martyrdoms, mostly of female saints.[4] Pablo Ruiz—he had yet to adopt his mother's name—also specialized in scenes from the life of Christ: several Annunciations, the Education of Christ, the Supper at Emmaus, the Last Supper, the Taking of Christ, the Crucifixion, the Entombment, the Resurrection, and Veronica's Veil. Iconographical knowledge of these images would enable Picasso, later in life, to blaspheme all he wanted and, on occasion, to give a faint hint of sanctity to a secular image, and also depict the ecstasies, torments, and martyrdoms of his women in the divine light of sainthood. When civil war broke out in Spain, Picasso would be uniquely equipped to use the black Catholicism of his forebears against Franco's fascistic faith.

Despite insisting that he was an atheist, Picasso would never be able to disown his faith. It was too atavistic, too deeply ingrained. The prelates in his family included

Left: Picasso. Study for *Crucifixion,* May–June 1929. Pencil on sketchbook page, 23 x 30.5 cm. Musée Picasso, Paris.
Right: Picasso. Detail of *Crucifixion* with soldiers throwing dice, February 7, 1930. Oil on plywood. Musée Picasso, Paris.

his paternal uncle, Canon Pablo, after whom he had been named: "almost a saint" (according to his nephew). "When he died, we found him wearing a hair shirt that caused him some very nasty wounds."[5] The "hair shirt" turned out to be a fakirish chain belt, which Picasso hung on a wall of his living room at La Californie.[6] His great uncle Perico (Brother Pedro de Cristo) had done much to reform the Church, and then retired to live on alms as a hermit in the mountains of Córdoba. Centuries earlier, a forebear, the venerable Juan de Almoguera y Ramírez, had risen to the apex of spiritual and secular power as both archbishop of Lima and viceroy and captain-general of Peru.

Such was young Pablo's proficiency at religious painting that a Barcelona convent had commissioned a pair of altarpieces from him. The nuns wanted him to copy Murillo, but, as Picasso told Apollinaire, "the idea bored me so I copied them up to a point, then rearranged things according to my own ideas."[7] These altarpieces, which were destroyed during the Setmana Tràgica, the anticlerical riots in 1909, were never photographed. However, drawings and an oil study suggest that one depicted the Annunciation, the other Marguerite Marie Alacoque's Vision of Christ, which launched the cult of the Sacred Heart. Picasso would later use the emblem of the Sacred Heart as a blasphemous metaphor for Marie-Thérèse's sexual parts.

Picasso's residual faith proved an inexhaustible source of inspiration for the saint-like whores and beggars of the Blue period—quintessentially Spanish images that recall the morbid piety of the sixteenth-century Luis de Morales's lachrymose Pietà and the theatrical exaltation of El Greco. Later borrowings from *ars sacra* were more

covert. Much as Picasso dismissed the idea of a fourth dimension, his addition of a subliminal flicker of spirituality—heavenly or hellish, as the case may be—to a still life would serve a similar purpose in that it would leave the viewer wondering how a seemingly matter-of-fact subject could suggest such heights and depths and such mystifying echoes.

As Picasso doubtless intended, his *Crucifixion* is an iconographical conundrum. Nobody in the field of Picasso studies agrees as to who is who. Is it even a Crucifixion?[8] Some forty years ago, Anthony Blunt pronounced the painting a Deposition.[9] And indeed, the death agony appears to be over; Christ's body is about to be taken down off the cross, as have the bodies of the two thieves—the good Dismas and the bad Gestas—whose broken remains we see bottom left.[10] To support his theory, Blunt claims that the little soldier on the ladder is pulling the nails out of the cross. He is not; he is hammering them in. Like medieval artists and modern cartoonists, Picasso chose to portray ongoing events simultaneously rather than sequentially.

Let us start with the lesser figures. In the drawings, Longinus, the Roman lancer who stabbed Christ's side and was later canonized for catching the sacred blood, is seen as a major protagonist, on horseback, with helmet and sword; in the painting he has been downgraded into a minuscule, Mithraic picador. This time, Picasso pays no heed to the medieval artists who used variations in scale to denote degrees of sanctity and secular importance. Picasso manipulates scale solely in the interests of gigantism—an all-important element given the smallness of the *Crucifixion* panel and the amount of characters and action to be packed into it.

Towering over little Longinus is the huge, hollowed-out "bone" head of another of the bit players, Stephaton, the sponge bearer, who offered the dying Christ a vinegar-soaked sponge on the end of a stick. If this minor figure plays a major pictorial role, it is because Picasso has used a large green sponge as a symbol of the moon on Christ's right side, a pendant to the sun on the left.[11] Traditionally, the moon belongs on Christ's left, his "bad" side, and the sun on his right, his "good" side. Perversely, Picasso has switched the sun and moon around so that the sponge bearer's head doubles as a crescent moon, an emblem of the Virgin Mary.[12] Immediately below the sponge is a V-shaped bird—possibly the pelican that symbolizes the shedding of Christ's blood to redeem the world or, no less likely, the Raven (the messenger of Apollo in classical literature) who, according to Mithraic myth, transmits the sun's order to Mithra to slaughter the sacrificial bull so that the faithful can drink its Eucharistic blood.

In front on the right, two small soldiers, each with a very large leg, are rolling dice for Christ's seamless tunic. "Art dealers," Picasso said. The drum they use as a table previously served a similar purpose in the *Parade* curtain, which is also the source of the horse in the preparatory drawings and the ladder in the *Crucifixion* painting. The

Colosseum-like arches in the drawings give Golgotha a whiff of the blood and sand of the bullring in that they evoke the Roman arenas at Fréjus, Nîmes, and Arles, where Picasso regularly attended corridas.

So much for the lesser figures; now for the hierarchy. In giving Christ a pinhead with two dots and a dash by way of features, Picasso implies that the image on the cross is as much of a blank as the tomb of the unknown soldier, and that it is up to us to identify this blank as Christ or Anti-Christ, Mithra or Dionysus, the artist, or even the viewer. Picasso's close friend the Spanish sculptor Fenosa maintained that Picasso was obsessed by God. "God to him meant what accounted for Creation, what made man. . . . He was always talking about God."[13] As for the tunic, Saint John of the Cross—a poet Picasso revered— described Christ wearing a white tunic that "dazzles the eyes of all human understanding. When the soul travels in [this] vestment, the devil can neither see it nor harm it."[14] The Virgin Mary is similarly robed in white, which pentiments reveal to have started as black. Years later, when shown the photograph that Inge Morath had taken of the Vilató family's apartment in Barcelona,[15] Picasso was fascinated to see a figure of the Virgin, which his father had contrived,

Sculpture of the Virgin contrived by Picasso's father in the Vilatós' Barcelona apartment, 1954. Inge Morath Foundation / Magnum.

> on a small eighteenth-century table, which had been painted black in Ripolin by his father and later white all over, both of which attempts to improve it were "bien laid," and the Virgin herself had been made from a plaster cast of the head of a Greek goddess that his father had painted over with utmost realism, giving it eyelashes and a look of sorrow with golden tears stuck to her cheeks. The conventional scarf draping the Virgin's head was made of cloth dipped in plaster and painted over so as to harmonise with the painted bust. The whole effect was convincing and troubling, the Greek features adapted to the Spanish drama of sorrow, the cloth and paint made a form of "collage" of borrowed elements. P[icasso] was delighted at this forerunner of "collage" and admired the way two round lamps had been placed where breasts might be, giving the Virgin a new form of illumination.[16]

Picasso's portrayal of the Virgin Mary as all of a piece with her son on the cross is one of the most perplexing elements in his *Crucifixion*. That she is depicted as a

virago with the vagina-dentata mouth, which we will come to associate with Olga—mother of Christ poised to bite the end off Longinus's spear—has opened the painting up to many varied interpretations. Thanks perhaps to his Quaker origins, Penrose, the artist's biographer, is eager to put Picasso in the most positive light. Penrose interprets the Virgin's snarl as an image of "ungovernable suffering and rage at [the] picador for plunging his lance into the defenseless body of Christ.[17] I see it otherwise. Insofar as Picasso identified with Christ, he identified his mother with his vindictive concept of the Virgin. She was, after all, called María; she had belonged to a sisterhood devoted to the cult of the Virgin; and, although incapable of understanding her son's work, she had always had implicit faith in his messianic aspirations. For his part, Picasso's feelings for the tough, dumpy, down-to-earth woman who was the source of so much of his strength, have always been ambiguous—and they would soon worsen, as we are about to see. A further clue to his maternal resentments is a ribald drawing based on this 1930 *Crucifixion* done in 1938:[18] a malign Madonna all set to bite the umbilical cord that attaches her to her crucified son. Coincidence or not, this most blasphemous of all his drawings dates from the time when Picasso was in the throes of a lawsuit to reclaim some four hundred of his early drawings, which his mother had entrusted to a crook.[19]

While readying himself for his *Crucifixion,* Picasso had evidently taken account of a large, provocative drawing (India ink on fine linen pasted on cardboard) by Salvador Dalí, entitled *The Sacred Heart.*[20] This had caused a scandal at Dalí's November–December 1929 show. Unlike Dalí's usually meticulous paintings, this drawing is crass and crude: a rough outline of the Virgin Mary with the emblem of the Sacred Heart on her breast, over which Dalí had scrawled "I spit for pleasure on the portrait of my mother." For this desecration the artist's father disowned and disinherited him. Dalí, who in fact had adored his mother, whose death, when he was sixteen, had been the greatest blow of his life, blamed his blasphemous attack on "the dictates of his subconscious."[21] This cop-out did not delude anyone. The drawing was a shock tactic, designed to enhance his notoriety and curry favor with the surrealists in their excoriation of Church, fatherland, and family. Dalí played to the public; Picasso to the demons within him.

Picasso's treatment of the Magdalen raises problems that are totally different from his treatment of the Virgin—problems that the viewer is left to ponder rather than solve. Most writers agree that the disembodied arms on the right, stretched up in a general gesture of grief, are the Magdalen's, but no one is sure which head and torso they belong to. A series of extraordinary drawings reveal that Picasso originally envisaged the Magdalen as a contortionist—one who could bend

her head so far backward that her face appears to the viewer upside down; as a result her inverted nose and eyes appear to hang down her back like a disembodied penis and testicles. Surprisingly, this unforgettable image is missing from the painting.

Of the many who have struggled to identify and interpret Picasso's Magdalen, only Ruth Kaufmann, author of a pioneer study of the *Crucifixion,* and Lydia Gasman have cast much light on it.[22] Both of them agree that the bony Versalian head, right center, belongs to her. She inclines her head penitently downward—the reverse of the shameless backward flip she makes in some of the drawings—the better to kiss Christ's robe as she had once kissed his feet. Appropriately, her head resembles a skull, the Magdalen's traditional emblem. As for the small, bifurcated head on a yellow neck squashed between the heads of the Virgin and the Magdalen, this corresponds to an earlier painting of Marie-Thérèse.[23] Since three Marys were traditionally in attendance at the Crucifixion, Picasso might well have wanted to include Marie-Thérèse as the third one.

The possibility of Marie-Thérèse's presence in this *Crucifixion* raises a question as to whether this panel was intended as a Christmas present for her, as Tzara (courtesy of the unreliable MacGregor-Hastie) is said to have suggested. MacGregor-Hastie goes on to claim that Marie-Thérèse had been raised a Catholic and, far from allowing her faith to lapse, had remained, privately, a fervent believer.

> [This] showed itself in an insistence on going to Mass on all holy days of obligation, and during Lent, 1930, in a spasm of sexual self-denial. Her lover was furious, but unable to change her mind, and painted a startling and angry *Crucifixion* during his enforced abstinence. . . . Marie-Thérèse was always very pleased with and proud of this painting, not only because a work of religious inspiration seldom got beyond the drawing stage with Picasso, but also because she said it showed his soul could be reached. She did not, however, try to reach it in that way again.[24]

As usual with MacGregor-Hastie, the dates do not work—Lent started late that year: March 5, a month after the *Crucifixion* was finished—but it is conceivable that Picasso would have wanted to put Marie-Thérèse's faith, or the lack of it, to the test in his work. It could have given a sacrilegious charge to their lovemaking.

The inclusion of Mithra—god of light and wisdom—in his *Crucifixion* suggests that Picasso probably had Mithra as much as Christ in mind when he identified with God. Fundamental to Mithraism was the dualistic struggle between good and evil, in which the sun god vanquishes the powers of darkness, just as day vanquishes night. But Mithra's identification with the bull, which his followers worshipped as the source of all that is good on earth, is primarily what attracted Picasso to this cult.[25] Years later, when the artist's mistress Geneviève Laporte reproached him for enjoying bullfights, he invoked Mithraism as a rationale. Bullfighting, he said, was the last manifestation of this great faith and he had a duty to maintain it. Shy at first, Picasso

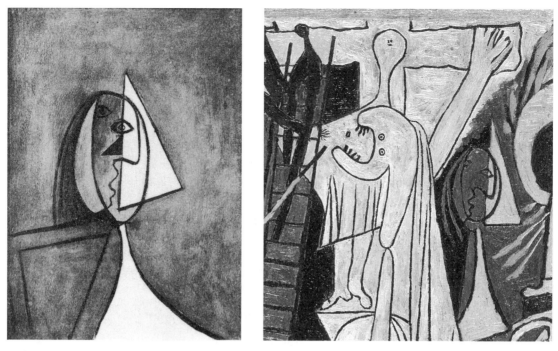

Left: Picasso. *Head of Marie-Thérèse,* 1929. Oil on panel, 64 x 47 cm. Private collection.
Right: Picasso. Detail of *Crucifixion* with Christ and the Virgin, 1930. Oil on plywood.
Musée Picasso, Paris.

warmed to his subject and let Geneviève in on the secret of his Mithraism and other *croyances mystérieuses.* She was "astounded."[26]

Always avid for knowledge of such things, Picasso knew about the Mithraic cult of the sun and the moon, that it had been a principal religion of the Roman Empire, and had resisted the rise of Christianity until the third century. He also knew something about the survival of many of its tenets in medieval iconography, also that Christ's birthday fell on more or less the same day as Mithra's (December 21)—the rebirth of the sun. That Picasso was preparing to execute his *Crucifixion*—maybe had even started work on it—over Christmas is no coincidence.

Picasso's Mithraism of the 1930s[27] was supposedly sparked by Bataille's brief, sensational essay, "Le Soleil pourri." This first appeared in a special Picasso issue of *Documents.* Although this journal did not come out until April 1930, two months *after* Picasso's Mithraic *Crucifixion* was finished, Leiris was Bataille's coeditor and would certainly have gone over the contents of this issue with the artist it honored. Since Mithraism was much discussed in the artist's prewar circle, it may well have been Picasso's work that triggered Bataille's interest in it, to judge by Bataille's invocation in his final sentence of Picasso as the only artist capable of facing up to the blinding flash of the Mithraic sun.[28]

Rather more basic to our understanding of the *Crucifixion* is the transformation from a predominantly Christian icon into a partly Mithraic one. Pentiments suggest that this happened in the course of execution, when Picasso changed the centurion's golden shield (top right in the drawing) into Mithra the sun god. To distinguish the sun god from an otherwise incoherent jumble of limbs and heads, Picasso has given him two little feet. However, he remains an anomaly with his scrotum-shaped visage, which may or may not refer to the testicles of the Mithraic bull.[29]

Bataille was one of the most fascinating and alarming writers of his time—vastly superior to most of the surrealists, which may explain why Breton threw him out. Bataille was also a great admirer of Picasso. They shared many obsessions, not least for the works of the Marquis de Sade; they also shared a great friend in Leiris. And yet the phenomenal artist did not take to the phenomenal writer. Nothing seems to have come between them, but I can only imagine that Picasso had a superstitious fear of Bataille. Despite his priestly appearance and style, Bataille was committed—supposedly in intellectual rather than physical ways—to extreme forms of sadism, Satanism, coprophilia, and bestiality. I believe that he had positioned himself too close for comfort to Picasso's archenemy, Death. Picasso's superstitious nature and fear of the power of evil should never be underestimated.

Dora Maar, who had been Bataille's mistress before she became Picasso's, was inclined to think along these lines. Apropos the story Bataille liked to tell about himself, how after his mother's death he went at night in his pajamas to the bedroom where she had been laid out and, racked with sobs and trembling with fear and sexual excitement, had masturbated.[30] Dora thought it greatly exaggerated and proceeded to recount how, at the height of World War II, the curfew marooned Picasso and her in the apartment that the Leirises shared with the Kahnweilers. Since the Kahnweilers spent the war in hiding in the Midi, Picasso rightly assumed that he and Dora would be invited to sleep in their room. Picasso could not wait, Dora said, to set about desecrating his dealer's marriage bed.[31]

A drawing for the figures of Christ, the Virgin, and the Magdalen, dated the following December,[32] suggests that Picasso thought of doing a second, more expanded *Crucifixion,* incorporating the backward-bending Magdalen in it. Nothing came of this. Two years later, however, after stopping at Colmar to see Mathias Grünewald's Isenheim altarpiece for the first time, he would return to the theme.

34

L'Affaire Picasso

Early in May 1930, Picasso was horrified to discover that a number of early works he had left in the family's Barcelona apartment for safekeeping had been stolen and were being offered for sale on the Paris market.[1] After realizing the extent of the theft—391 drawings and 10 paintings—he brought a lawsuit against the perpetrators. In the fight to have this stash of juvenilia returned to him, Picasso behaved with the same outraged tenacity he had manifested when he had tried desperately to repossess the cubist works confiscated by the Custodian of Enemy Property. This time, the fight to get his early work back would last eight years. It would stir up a storm of animosity and set Picasso against his mother and his sister's family in Barcelona.

In a letter to the State Prosecutor (dated May 9, 1930) stating his case, Picasso described how on March 20, his elderly mother had been alone in the family apartment at no. 7, Paseo de Colón,[2] when she received a visit from two men—a Catalan rogue called Miguel Calvet and a nameless "American." They were great friends of her son's, they said, and were writing a study on his early work and needed material for illustrations. Doña María told them that none of the important early paintings on the walls or the hundreds of early drawings tucked away in closets were available. However, there was an old basket full of stuff in the attic, which she could let them have. "Taking advantage of my mother's great age and credulity,"[3] Picasso's letter continues, "they persuaded her to entrust them with all my work . . . and handed over 1,500 pesetas by way of a receipt."[4]

Calvet was a small-time "runner," who claimed to be an art dealer, but "had no apparent resources." The "American" turned out to be Joan Merli: a Catalan art critic and publisher of a minor avant-garde magazine, who had become acquainted with Picasso in Paris and would later write the first book to chart his early years in Barcelona.[5] Merli was supposedly honest; he claimed to have been helping out a friend rather than aiding and abetting a thief and was never accused of any wrongdoing. Nevertheless, Picasso would always regard Merli as a scoundrel. Sabartés told Penrose that Merli was very *mal vu* by Picasso, and that his account of the artist's early years was exceedingly inaccurate.[6]

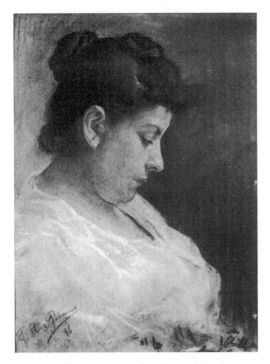

Picasso. *The Artist's Mother* (Doña María),
Barcelona, 1896. Pastel on paper, 49.8 x 39 cm.
Museu Picasso, Barcelona.

After handing Doña María 1,500 pesetas and persuading her to sign a document that she failed to realize was a bill of sale, Calvet took the drawings to Paris and showed them to a dealer called Alice Manteau, who was initially tempted to buy them. This unscrupulous woman, who would be indicted after World War II for dealing in looted paintings,[7] lost interest after Picasso refused to see her, let alone sign the drawings. Signatures were, of course, crucial. Unsigned, these untypical, unpublished drawings were virtually unsaleable. Next, Calvet turned to another expatriate Catalan friend of Picasso's, Josep Llorens Artigas: a potter (known in France as Artigas) who would subsequently make a name for himself as Miró's ceramist. Calvet promised Artigas 20,000 francs and two of the drawings if he persuaded Picasso to sign the rest. Artigas's courage apparently failed him. Instead of showing Picasso the drawings, he took Calvet to see a dealer, the widow of the Polish painter Eugene Zak, whose work had once been mentioned unfavorably by Apollinaire.[8] The Zaks had met Picasso at Avignon in 1914, presumably through his lover, Eva Gouel, who had formerly been the mistress of their Polish friend Louis Marcoussis. After her husband's death, Edwige Zak had opened a small Left Bank gallery on the rue de l'Abbaye that dealt in minor works by major School of Paris artists. She needed stock and was delighted to handle this huge, potentially valuable consignment.

After twenty-seven years "in a filthy old basket," which Calvet said was verminous, the drawings needed to be cleaned up before being signed and framed and offered for sale. To help with this, Madame Zak consulted a friend: a former rope dancer turned painter called Dietz Edzard. Edzard's Laurencinesque soubrettes, adorned in "laces, feather boas, ruffles, shimmering silks,"[9] sold well enough for him to start "collecting"—some might say dealing. Edzard proceeded to acquire the entire collection of Picassos for 220,000 francs. Madame Zak agreed to sell them off for a 10 percent commission. Meanwhile, Edzard set about "restoring" the drawings. This procedure, unmentioned in legal reports, involved cutting up the sheets with multiple studies into more saleable units.[10]

Madame Zak wasted no time making sales. Georges Bernheim, a serious dealer in

modern art, not to be confused with the prestigious Bernheim-Jeune brothers, paid her 220,000 francs for a group including a Blue period view of Barcelona at night,[11] two more paintings or gouaches, and seventeen drawings. When Bernheim sent his son round to the rue la Boétie to have these works signed, Picasso duly did so, not realizing that they came from the cache in his mother's apartment. So many early works from Barcelona had been surfacing in Paris that he was having difficulty keeping track of their origins. Once the works were signed, they could be marketed. Bernheim asked René Gimpel for 200,000 francs for the Blue-period painting. Madame Zak offered items to other Paris dealers: to Ernest Brummer and, supposedly, Pierre Loeb,[12] as well as the German Georg Caspari of Munich, a violinist turned art dealer, who specialized in Blue period Picassos. Caspari was not interested—much too expensive, too early, and too disparate to be of more than iconographical appeal: "they would harm [Picasso's] reputation; one cannot foresee the talent to come."[13] Caspari should have kept to his fiddle. Besides being a phenomenal achievement for an adult, let alone an adolescent, these drawings are of absorbing interest to any student of Picasso's graphic virtuosity.

Encouraged by Picasso's readiness to sign the works Bernheim had purchased, Madame Zak decided to exhibit 191 of them in her gallery. She invited Picasso to take a look before her show opened in the hope that he would sign them.[14] According to Madame Zak, Picasso said he was too *ému*—upset—at seeing his earliest drawings again after so many years to sign them that very day, but he promised to return the following day with his wife to do so. He was indeed *ému,* not by sentiment, but by sheer rage that his mother, supposedly the keeper of his flame, should have handed so much of his early work over to a con man. Her folly had robbed him of control over his work—what should or should not be preserved. There was also the possibility that some of the drawings might be partly or wholly the work of his father or sister[15] or of fellow students at La Llotja.

On realizing the magnitude of the theft, Picasso cabled his mother in Barcelona for an explanation. Had she gone mad? he asked Zervos. Doña María replied with an abject apology and a story that raised a lot more questions. Picasso instructed his lawyers—Maîtres Henry-Robert and Bacqué de Sariac—to bring a suit against Calvet, Madame Zak, and others as yet unnamed.[16] He was damned if he was going to be done out of an intrinsic part of his cherished oeuvre—his buttress against oblivion and death.

On May 10, accompanied by his lawyers and plainclothes detectives from the Sûreté as well as police, Picasso went from dealer to dealer to supervise the seizure of his drawings. Gimpel—brother-in-law of Lord Duveen, the world's most celebrated dealer of the day—noted in his diary, "The dealers who have helped build [Picasso's] reputation and fortune are furious."[17] When one of them said so to his

Les négociations des œuvres
de jeunesse du peintre Picasso

PICASSO Vu par Ex

L'artiste espagnol bien connu a déposé
une plainte contre l'abus fait de sa si-
gnature pour certaines œuvres qui ne
sont pas de lui.

Ex. Caricature of Picasso from *L'Algérienne,*
May 21, 1930. Musée Picasso, Paris.

face, Picasso left the man's gallery speechless with rage.[18] What about the far greater fortunes that he had made for them? What about the poverty, hunger, and hardship he had endured during his early years in Paris at the hands of swindling dealers, who had left him with a chronic loathing of the art trade (Kahnweiler, Vollard, Flechtheim, and Level excepted).[19] And now these predators were at it again: using his mother to defraud him of the precious early works he had kept back out of sentiment and pride for himself.

Predictably, that perennial failure, Léonce Rosenberg, who had briefly (1915–16) been his dealer, came out against Picasso. Unlike his brother Paul, Léonce was supposedly more interested in modernism than money, but this did not stop him imputing his dealerish values to Picasso's conduct. In reply to a question about the case from Picabia, Léonce claimed that Picasso had brought a lawsuit out of fear that the emergence of so much early work would flood the market and endanger the very high prices that his current work was fetching.[20] Sour grapes. Léonce resented Picasso for defecting to his brother Paul, but Picasso resented Léonce for his inept handling of the Kahnweiler sales. Since they had formerly been on friendly terms, as numerous letters in the Picasso archives attest, Léonce should have known that all Picasso wanted was his work back. Their financial worth was not an issue. Picabia's reply to Léonce's letter—"Like his work, Picasso lacks sincerity"[21]—suggests there had been a falling-out. Had Picabia discovered that Picasso gave his name as Picabia when discreditable adventures necessitated a pseudonym?

Picasso's raid on the galleries resulted in the recovery of three-quarters of the works Calvet had extorted from his mother. Madame Zak had to forfeit the 191 items she was about to exhibit; Edzard had to hand over 150 more, which he had stashed in his apartment, and Georges Bernheim relinquished most, but not all, of the works he had purchased, as did Brummer.[22] Successive countersuits on the part of Calvet, Madame Zak, and Edzard would keep the case going. In 1938, some 350 drawings would be returned to him.[23]

Another fifty or so works apparently stuck to the hands of Calvet and his associates; and these would all too soon trickle into the market.[24] Rafael Padilla, the painter who had allowed Picasso to use his Barcelona studio in 1917, informed him (July 12, 1930) that he had recently been offered a group of juvenilia: a Blue period seated nude; a gouache of a man on a bench with a mother and child; a tiny pastel of a bullfight, and two other little paintings. The asking price was 80,000 francs—"not pesetas," Padilla added.[25] They were presumably part of the hoard that the French police had been unable to lay their hands on.

News of the raids on the galleries triggered headlines on both sides of the Atlantic. Since the persons involved were a polyglot bunch, Spanish, Polish, and German newspapers were just as interested in the affair as French ones. The scandal soon came to be known as *l'affaire Picasso*. Philistine journalists sided against Picasso and attacked him for going to law to retrieve his own work. The Hamburg *Fremdenblatt* stated that the affair was nothing but a "publicity stunt by Picasso."[26] *L'Oeil de Paris* took a different line: it accused Picasso of being "a strategist," of wanting to withdraw his early works from circulation because they revealed how indebted he was to French artists—Steinlen, Toulouse-Lautrec, and Forain. "When I embarked on my career," Picasso retorted, "I was not influenced by this or that master, but by all of them."[27] Picasso supposedly gave a very different reply to a similar accusation: "When I did those drawings, I did not yet know about [these artists]."[28] True, he enjoyed giving contradictory answers to the same question; however, the only source for this quote is Madame Zak.

Picasso overcame his dread of the press sufficiently to give a number of interviews, notably to Merry Bromberger of *Le Matin,* an editor he had reason to trust. "These drawings," Picasso told Bromberger, "are for me of unestimable value. They are childhood souvenirs . . . and I suffer when I see them up for sale. I don't know if they have great artistic value, but they constitute the origins of my work and I want to have them back in my possession." And he went on to specify the drawings that meant most to him: one of his "father's hand, which I made [him] hold still for an hour so that I could draw it; [another of] my little sister at her dressing table; and of my mother's face bent over her needlework. . . . These are my family's bottom drawer." "How well I understand," Picasso concluded, "why papas and mamas tell their children to stop scribbling on bits of paper. The brats don't realize the difficulties this will create in the future."[29]

Eager as ever to believe the worst about Picasso, the gutter press excoriated him for failing to give his old mother enough money to live on. Replying to this accusation, he told *L'Intransigeant* that "she has need of nothing . . . every month I give her enough to live comfortably on."[30] *Le Matin* even published a letter from Doña María: "how could I possibly have wanted to harm the person I love the most and to whom I owe

the most: above all to have harmed a son, who is so different from other sons, who is my support and to whom I owe everything."[31] The wording of Picasso's authorized statement to *Le Petit Parisien* is inadvertently revealing: "Picasso is not at all cross with his mother, to whom he gives all possible support. The sale—or more accurately, the loan—does not constitute a betrayal but rather an imprudence."[32] A betrayal? Only Picasso used this word. For all his disavowals to the press, this is evidently what he thought of his mother's behavior. According to family members, he would never really forgive her,[33] nor would he forgive his sister or her neurologist husband, Dr. Juan Bautista Vilató Gómez, fond as he would become of their two painter sons.

Another innocent victim of *l'affaire* would be Artigas. He was the only person involved in the case to have been a friend of Picasso's, and he was heartbroken at having unwittingly incurred his wrath. He scrupulously returned the two drawings Calvet had given him for being a go-between, but this did not repair their friendship; regrettably, because Artigas was an immensely gifted technical innovator, and he might have ended up working wonders for Picasso instead of for Miró. Artigas would never have exploited Picasso's name as his Vallauris potters, the Ramiés family, did by swamping the market with mass-produced multiples.

Before retreating to Barcelona, Calvet defended himself against Picasso's charges in yet more interviews and a public letter.[34] He reiterated that his acquisition of "the filthy old basket" had been an act of mercy—a friend had asked him to rescue Picasso's mother from the *misère* into which her son had let her sink—and that his altruism, far from being profitable, was going to lose him a lot of money. To believe Calvet, as many journalists did, most of the stuff was worthless; Picasso's early drawings were supposedly so unappreciated that they sold for no more than twenty-five to fifty francs, even when framed as well as signed. Calvet did not let on that many of the "early Picassos" that surfaced in Barcelona—and continue to do so to this day— were fakes, often the handiwork of fellow students, who had added a signature to one of their own drawings in the hope of cashing in on the master's prices. To look less like a villain who preyed on elderly widows, Calvet embroiled the widow's daughter and son-in-law in the transaction by stating that Dr. Vilató had carried the basket of drawings to the closing. This would have further irritated Picasso, as would Calvet's blatant lie that the artist "had been kept informed about all the negotiations." Calvet's admission that Doña María repeatedly said, "He will find out about it and he won't be happy," disproves his own story.

Meanwhile, Madame Zak had taken care to protect her interests. No fool, she had chosen one of the younger stars in the French legal firmament, Maître Maurice

Garçon, to represent her. Garçon photographed Doña María's "receipt" and immediately distributed copies to the press—"Received from Sr. Calvet fifteen hundred pesetas for diverse drawings." This document, the lawyer argued, proved that the transaction was an outright sale and therefore legal. Let us take a look at the dollar value of the peseta and the franc in 1930. The 1,500 pesetas that Calvet "paid" Doña María for the four hundred works was the equivalent of $175 in 1930 (around $2,150 in 2007); the 200,000 francs that Calvet received for them from Dietz Edzard was the equivalent of $7,850 in 1930 (around $96,500 in 2007); and the 210,000 francs Bernheim asked for a single painting—*View of Barcelona by Night*—was worth $8,250 in 1930 ($101,500 in 2007).

At the end of May 1930, de Gentile, the examining magistrate, embarked on a task that would last two years—interviewing everybody involved in the affair, some more than once. Doña María and Dr. Vilató were obliged to make trips to Paris in June 1930 and again in 1932. Doña María and, in all likelihood, Dr. Vilató stayed at the rue la Boétie when they came to Paris in 1930.[35] Their lack of French may have been a problem; at all events, the judge would dismiss the mother's and brother-in-law's testimony as *"pas recevable"* (not acceptable). Since the Vilató papers are not available, it has not been possible to ascertain what the reason was. In January 1931, Picasso's lawyer announced that the case was finally under way and that Calvet was going to make a counterclaim. This involved round after round of negotiations. With Garçon leading the attack, Picasso's lawyers had an uphill fight. He was adamant about recovering his property; Edzard was no less adamant about recovering the stolen goods that he regarded as his property.

There were no further developments in the case until 1932, when Maître Garçon's argument prevailed and the case against Calvet and Madame Zak was dismissed. Picasso appealed. In October 1933, there would be another hearing. Calvet was summoned but failed to appear

Dr. Juan Bautista Vilató, Doña María, Picasso, and Olga at the Clos Normand, c. 1930.

in court—the summons had never reached him, he claimed—and was sentenced, in absentia, to two years in jail. Whereupon *he* appealed. At a hearing on March 17, 1934, Calvet was convicted—not, however, for disobeying a court order, but for profiteering. Once again, he appealed. Picasso was present at the hearing but lost his temper and threatened to stalk out when the judge told the noisy Catalan contingent—Calvet, Artigas, and Vilató—"Shut up, Spaniards."[36] Palau believes that this outburst may have prompted Picasso to consider dropping the case,[37] but adduces no evidence. *L'affaire Picasso* had developed a life of its own and would go grinding on.

The case was not resolved until July 28, 1938, when the judge decided that the drawings did indeed belong to Picasso and not Edzard. When contacted some seventy years later about the missing drawings, Edzard's daughter Christine—a documentary filmmaker based in London—was not much help. She vaguely remembered her parents talking about the Picasso affair. Her father had apparently expressed some bitterness at having been "taken for a ride,"[38] which is just how Picasso and his mother felt.

By the time Picasso regained possession of his drawings, he could not have returned them to his mother, even if he had wanted to: Franco had laid siege to Barcelona. Doña María would die the following year. And so he locked the drawings away in Paris, and they became part of his estate. In due course, Picasso allowed Zervos to include them in his catalogue raisonné. Zervos had tried to have these unknown drawings photographed, when they surfaced in 1930, but they had been impounded by the court. By the time they were back in Picasso's hands, Zervos was deep into publishing later volumes. It was only after Volume V came out in 1952 that he decided to devote a supplementary Volume VI to the early works that had not been discovered in time for Volume I.[39]

So much for the fate of the four hundred items that Calvet had made off with. How about the much larger and more important stash of his oeuvre that Picasso had left in his mother's care—a stash whose existence was apparently not divulged in the course of *l'affaire*? Its safety must have been on Picasso's mind when, unbeknownst to Olga, he took Marie-Thérèse on a trip to Barcelona in August 1930. Picasso apparently agreed to leave this vast collection—681 drawings, 200 paintings, and 17 sketchbooks—in the care of his mother and the Vilatós, so long as they *never* let any outsiders take a look.[40] If the Vilatós were lulled into thinking of the collection as their *fond de tiroir,* their nest egg, they were in for a disappointment. To their dismay, Uncle Pablo would make the entire collection over to the Museu Picasso in Barcelona—a sensible decision. When Alfred Barr visited Picasso's sister,

Lola Vilató, in the summer of 1955 in quest of loans for his seventy-fifth anniversary show of Picasso's work at MoMA (1957), he was appalled at what he found. As he wrote Peggy Guggenheim, "the apartment with the paintings [was] in a most extraordinary state of neglect and dirt . . . a strange Bohemian and rather disquieting atmosphere."[41]

Lola and her children in Barcelona. Photograph by Inge Morath, 1954. Inge Morath Foundation / Magnum Photos.

Château de Boisgeloup, 1931. Musée Picasso, Paris.

35

Château de Boisgeloup

To Picasso's irritation, the surrealists intensified their persecution of Cocteau. On February 15, 1930, he and Olga attended the first night of the poet's new play at the Comédie Française, *La Voix humaine*—Cocteau's apogee as a playwright. This instant and lasting success consisted of a forty-five-minute monologue by a brokenhearted woman, alone onstage—with a telephone as her only prop—trying to win back her lover. Berthe Bovy triumphed as the protagonist; so did the young designer, Christian Bérard, with his décor. Ten minutes into the first performance, a voice was heard from a balcony box, repeatedly yelling, "It's obscene . . . Enough! It's obscene . . . It's Desbordes [Cocteau's lover] she is telephoning." Someone in the audience identified the culprit as Breton. It was not. When the man was ejected for rhythmically chanting, "Shit, shit, shit!" he was recognized as who else but Eluard. Outraged members of the audience called for his arrest. In the darkness of the theater, women shrieked. Someone ripped Eluard's jacket; another stubbed out a cigarette on his neck. Cocteau rescued him from what threatened to become a lynching. "I will end up killing you, you disgust me," was all the thanks he received from his surrealist foe.[1]

That same night, Cocteau's mother, who had been plagued by malicious telephone calls about her son's homosexual affairs, received yet another call—Jean had been badly injured in a motor accident. The anonymous caller also used the telephone (*La Voix humaine*'s central prop) to inform Picasso, André Gide, and Anna de Noailles that Cocteau had committed suicide in a bar.[2] As a precaution, the poet had Eluard barred from the Boeuf sur le Toit. Madame de Chevigné, who lived in the same building as Madame Cocteau, rushed to comfort her. So did Picasso, who was appalled by the surrealists' telephone calls and later lashed out at them. "If it wasn't you who did it, it was you all the same."[3] To save face, Cocteau pretended that "minor journalists claiming to be surrealists" were responsible. In fact, it was Robert Desnos, whose wife Youki would subsequently fall in love with Picasso.

Picasso's solicitude was typical of him. Mean as he often was to Cocteau as, at one time or another, he would be to many of his old friends, he had a very loyal, if some-

times paradoxical, heart. Moreover, as Dora Maar maintained, in his sadistic way Picasso loved Cocteau. The great artist and the mercurial jack-of-all-trades needed each other. Unwittingly, Cocteau was always doing or saying something for which Picasso would make him suffer. The whipping boy would rail against his master, but always come back for more. They could not in the end do without each other. For Christmas 1930, Picasso sent Cocteau some drawings, but they turned out to be by his son Paulo. He also sent him a more symbolic, more touching present—a pot of four-leaf clovers. In his thank-you letter,[4] Cocteau said he was watering them with *eau de Vittel.*

If Picasso was upset by the ruckus at the first night of *La Voix humaine,* it is because there was a menacing political edge to the surrealists' persecution of Cocteau. In the early 1930s Picasso was adamantly apolitical: determined to remain neutral and out of the crossfire, as explained in the Epilogue. By now active communists, Eluard and Desnos were not so much attacking Cocteau for his very public *pédérastie*—though that, too—as for his closeness to important right-wingers like Philippe Berthelot and above all the egregious Préfet of Paris, Jean Chiappe. Cocteau's politics were too opportunistic to be taken seriously. He deserves credit for using his right-wing contacts to protect his left-wing friends, not least Sergey Eisenstein, the great Soviet filmmaker, who was sitting next to Eluard when he caused the uproar at *La Voix humaine.* "Maybe [Cocteau] even had cause to thank me," Eisenstein wrote in his memoirs,[5] as if Eluard's intervention contributed to its success.

Of late Picasso had been inundated with offers of properties from all over France, but he had never been interested. However, after spending weekends at one or another of the *hostelleries* on or near the Normandy coast, he felt the need for a country house not too far from Paris, where he could shut himself away from the prying public and have a sculpture studio of his own, rather than have to work in González's cramped workshop. As Picasso told Brassaï, he was weary of lugging back to Paris "every year, from Dinard, from Cannes, from Juan-les-Pins, the cumbersome harvest of his summer; of packing and unpacking canvases, paints, brushes, sketchbooks, all the paraphernalia of his traveling studio."[6]

Kahnweiler's brother-in-law, Elie Lascaux, supposedly told Picasso about the secluded Château de Boisgeloup, some forty-five miles northwest of Paris, near Gisors. Gisors was on the road—a little less than halfway—from Paris to Pourville, where, as recounted in Chapter 30, Picasso wanted to resume the habit of painting alongside Braque, who was already at work on his country house. Picasso pur-

chased the Château de Boisgeloup on June 10, 1930, from Monsieur Léon Louis Joseph Renard and Madame Jeanne Marie Georgette Weibel.[7] He moved in almost immediately. Boisgeloup was a perfect solution to Picasso's requirements: a handsome house, more *manoir* than château, in a beautiful, secluded setting with a wall around it. For a château, it was modest in scale, yet imposing, and totally free of *conforts modernes:* no electricity, central heating, or proper bathrooms. The lack of heating would prove a mixed blessing in winter, when Boisgeloup, as Picasso recalled to Brassaï, became an "unheatable barn, riddled with drafts. . . . That's where I got my sciatica. . . . But I can tell you one thing—cold stimulates you; it keeps the mind alert. . . . You work to keep warm, and you keep warm by working. But a comfortable warmth makes you sleepy."[8] And so no *chauffage.* "Just because I bought [Boisgeloup], that's no reason to modernize it," Picasso told Françoise Gilot one freezing day many years later, when he took her to see what she dubbed "Bluebeard's Castle."[9]

The name Boisgeloup derives from *bois-jaloux*; *jaloux,* in this context, implies a wood that is hidden away—screened as if by a jalousie. The property nestles in a declivity in an otherwise extensive plain—the site of many a skirmish in the Hundred Years' War. The River Epte, which formerly bordered the estate, served as a kind of frontier between the French and English armies. In the fourteenth century Boisgeloup had been a *château fort,* linked by secret tunnels to the fortress of the Knights Templar at Gisors. In times of siege, these underground passageways kept the garrison supplied with food and arms and even horses. Although proud that so much history had rubbed off on his property, Picasso did not hesitate to brick up the entrances to the tunnels to keep out trespassers and people in search of the Templars' nonexistent treasure. Sometime in the seventeenth century, the fortress was transformed into a château, which had burned down in the eighteenth century. The present building is thought to have been added onto an earlier gatehouse at the beginning of the nineteenth century. Stones for its construction came from the previous château.

Notwithstanding its piecemeal past, the house is traditionally classical in style, the more elegant for being only one room wide, and *entre cour et jardin.* Light floods through the lofty, white-shuttered windows into an enfilade of simple, handsome rooms on the ground floor and into the bedrooms on the floors above. For a painting studio, Picasso used a large room on the second floor immediately above the entrance to the older part of the house, and to this day the floor is speckled with paint. Books still lie about the room: devotional works mostly in Spanish, an illustrated edition of *Don Quijote,* and one volume of a set of *Antiquités étrusques* (1786), engraved by F. A. David. On the main staircase is the life-size carving of Christ in

agony on the cross—sixteenth- or seventeenth-century Spanish—which Eugenia Errázuriz had given Picasso in 1916. It had inspired a dazzling drawing.[10]

Across from the château is a long, low range of stable buildings. One of these became Picasso's sculpture studio; it is not nearly as large as it looks in Brassaï's photographs.[11] Other stables served as garages and storage rooms. Behind the stable block are the *communs*—farm buildings; at the center of the yard a typical Norman dovecote with roses climbing over it. The domed roof of the dovecote is a large wheel-like structure for the doves to perch on. In Picasso's time, the *communs* belonged to a neighboring farmer; these now belong to his grandson Bernard, who has inherited the property and is transforming them into galleries for his collection of contemporary art. Back of the château is a twenty-acre park surrounded by stone walls. A rivulet used to meander through it, but Picasso had it filled to discourage mosquitoes. The once neglected park is now impeccably maintained. A vast lawn stretches away from the house to a great screen of trees.

Inside the gates of Boisgeloup is a lofty, fourteenth-century chapel dedicated to the Virgin—virtually all that remains of the ancient Boisgeloup complex—where Mass was celebrated until the 1950s. Although the interior was re-Gothicized in 1886, it retains the original corbels—*têtes de fou* and dragons, which were much to Picasso's taste. So was the nineteenth-century stained glass, insofar as it left its stamp on the *cloisonnisme* of some of his 1931 still lifes. Picasso took superstitious pleasure in having his own chapel and, although there is no record of his actually attending Mass there, he relished the protection that the sacraments provided. It is no coincidence that, thirty years later, Picasso acquired a property named Notre-Dame-de-Vie, which is sanctified by having a pilgrimage church on it.

The summer after Picasso's purchase of Boisgeloup, Clive Bell visited Paris and found that the artist no longer had any desire to see his former fan. Picasso had finally seen through Bell's obsequiousness.[12] A readiness to believe anything bad about the artist emerges in a letter to Mary Hutchinson, in which Bell regales her with gossip about the couple he had formerly courted and the château he had not been asked to visit:

> Did I tell you that Picasso had bought a country-house near Montargis and that poor Olga at last saw her vœux couronnés—to be chatelaine—the curé had called—and a local landowner, a "de" she said? And then Picasso set up on the lawn—where she dreamed of un peu de thé et tennis—a lamp-post, une colonne Morris with the theatre advertisements still on it, and an iron urinal. He is becoming sinister, that Spaniard; and if money gives out, as it may, I shouldn't be in the least surprised if he were to disappear.[13]

Bell's malicious, snobbish, and totally inaccurate gossip is all too redolent of Alice Derain and Marie Laurencin, who had also been dropped. The gossip was the more

Picasso, Elie Lascaux, Marcelle Braque, Bero Lascaux, Lucie Kahnweiler, Daniel-Henri Kahnweiler, and Michel Leiris at Boisgeloup, 1933. Musée Picasso, Paris.

reprehensible in that Picasso's acceptance of Bell as a courtier had had little to do with the man's meager understanding of his work, rather more to do with his abject toadying and courting of Olga. Picasso had indeed suggested setting up a *pissotière* in the garden, but that was nine years earlier at Fontainebleau, and even then it had been a joke. Photographs of Olga with her husband looking somewhat portly entertaining friends in the garden in the early 1930s confirm that she had indeed found her rightful niche as chatelaine. Most weekends in the warmer months, when friends rallied round and her demons were dozing, Olga would play this part to perfection. The moment she left, Marie-Thérèse was apt to materialize. Although the sculptures she inspired allegorized the numinous spirit of Boisgeloup, she remained the mistress of the artist and never aspired to become the mistress of the house.

Besides enabling Picasso to work in unwonted privacy, the château enabled him to indulge two antithetical sides of his character. During the week he played Mars to Marie-Thérèse's Venus. Weekends he played the role of an affable *père de famille* in a three-piece suit and spats, having fun with a much fussed over child and a very large dog. Home movies confirm that when they were alone, and Olga was in good spirits, the family was united in an atmosphere of affectionate relaxation. Especially revealing are sequences in which Paulo is dressed up as a Napoleonic marshal in a bicorne, or as a torero, parrying the charge of a bull in the form of Mimi, his plump old nanny, index fingers extended to mimic horns. Most touching of all is a glimpse

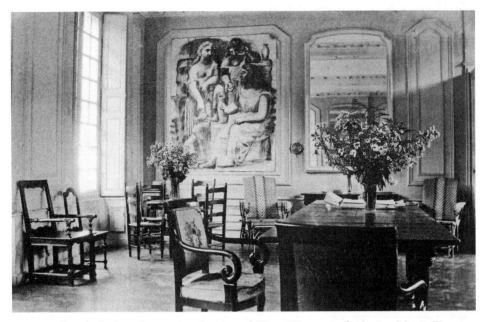

Interior of Boisgeloup with sanguine drawing of *Three Women at the Spring*. Musée Picasso, Paris.

of the elegant chatelaine emerging from the house, a wistful smile on her face as she pulls the petals off a daisy—he loves me, he loves me not: an image that is painful to equate with the *Large Nude in a Red Armchair* of 1929.

Olga did her best to make Boisgeloup habitable; she was especially grateful when Eugenia Errázuriz sent them a set of chairs.[14] The most dramatic addition to the salon was Picasso's monumental sanguine version of his 1921 *Three Women at the Spring.* This gave the room a touch of appropriate grandeur. Despite her bouts of illness, Olga managed to impose her sense of order and tidiness on things and keep her husband's love of accumulation under control. Should Marie-Thérèse show up when Olga was around, she would clear off on her bicycle to an inn at Gisors. Too bad Boisgeloup's subterranean tunnels had been blocked up.[15]

According to legend, the scales did not fall from Olga's eyes until the Galeries Georges Petit retrospective in 1932, when painting after painting is said to have left her in no doubt as to the appearance if not the identity of her rival. However, Bernard Picasso questions this assumption. He believes that his grandmother realized what was going on. Olga was jealous and suspicious by nature, but she was no fool and is likely to have made inquiries of the concierge or people in the village. Maybe Picasso had even told her. How else explain the rows? Posterity has come to associate Boisgeloup with Marie-Thérèse's imagery, but it was never her turf; it was

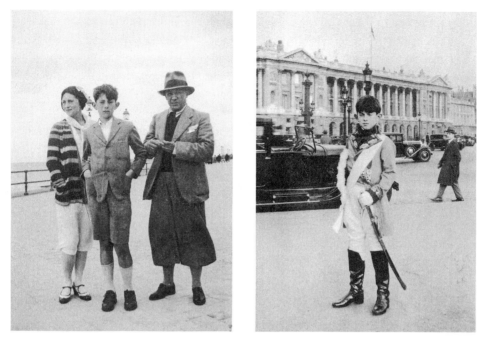

Left: Olga, Paulo, and Picasso, c. 1932.
Right: Paulo dressed as a marshal of France at place de la Concorde, Paris, c. 1930.

very much Olga's domain. Insofar as Picasso and Marie-Thérèse had a place of their own, it was the hideaway on the Left Bank; and later, a separate apartment on the rue la Boétie.[16] It was not Boisgeloup. Ironically, when the Picassos separated in 1935, Olga would get the château. After no more than five years the artist would lose possession of the property. Instead, he accepted Vollard's offer of an idyllic country house at Le Tremblay-sur-Mauldre near Rambouillet.

Like many another married man passionately in love with a mistress, Picasso repeatedly promised to marry Marie-Thérèse. These promises would not be kept. As he told Dora Maar and his second wife, Jacqueline Roque, he would never remarry until Olga was dead. Spaniards are averse to divorce, and although Picasso certainly contemplated it, he surely realized that, without Olga, he would have been the target of every woman he slept with. And for her part, unambitious, unassuming albeit adoring Marie-Thérèse had no desire to be a chatelaine.[17]

Now that Picasso's focus had switched to sculpture, he had González help him install a sculpture studio in the stables. There would be no welding equipment: ironically, the inventor of welded sculpture did not ever weld. Too protective of his

precious hands to drive a car, Picasso was averse to handling an oxyacetylene torch. That was González's responsibility. Since the Galerie de France was giving him a show in February, the welder had less time for Picasso. However, the country house where he spent his summers was not too far from Boisgeloup,[18] and he continued to be of help whenever he could. When he was not available, Picasso summoned the village blacksmith to do the welding.

The year before, Picasso had set aside the two welded heads he had worked on with González: the immensely powerful *Head of a Man*[19] and the unresolved iron mask of Marie-Thérèse. Now he proposed to turn them into full-length figures. Dated sketchbook drawings[20] reveal the artist trying to match the *Head of a Man* to body after body—a squatting one (one knee up, one knee down), a standing one, as well as a conglomeration of penises and testicles. Wisely, he concluded that the *Head of a Man* had no need of extensions, so he left it as it was. Nevertheless, as the sketchbooks confirm, he continued to redistribute body parts with ingenuity and abandon. Three lusty drawings suggest that Picasso saw himself as Jupiter Tonans in pursuit of a nymph, with a clutch of thunderbolts in his right hand and an erect penis in the other. He was having conceptual fun; few of these sketches lent themselves to three-dimensional realization. Only Jupiter's great bloated bladder of a belly would resurface the following year in Picasso's volumetric sculptures.

The other welded head[21]—it can be seen propped up on a chair in a 1928 photograph of Picasso in his studio—needed a lot more additional work, above all a cranium. Picasso fixed this by having González buy a pair of colanders. After tearing off their little feet with pliers, he had the two hemispheres welded together into a head. The result is a Picassian paradox, seemingly solid yet open to the space around it; the holes in the colanders establish the scalp to be follicular. Locks of hair fashioned out of old bedsprings and metal flanges further fetishize the head and extend it into space. These embellishments also give the piece a ramshackle primitivism that is up-to-date and industrial-looking, and quite unlike the timeless, tribal look of his earlier sculptures.

Once he had solved the problem of the cranium, Picasso turned his attention to the rest of the figure. He had originally envisaged a somewhat cumbersome base: a rectangular stack of shelves topped with twin cones by way of breasts.[22] In the end, he found inspiration for the torso and

Picasso. *Jupiter Tonans,* July 1930. Pencil on sketchbook page, 17 x 10.5 cm. Musée Picasso, Paris.

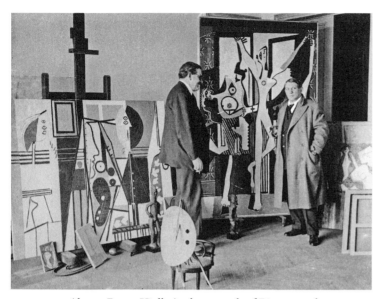

Above: Roger Viollet's photograph of Picasso and an unidentified man in his studio with the colander head, *Artist and His Model,* and *La Danse,* 1928. Getty Images.
Right: Picasso. *Head of a Woman,* 1928–30. Painted iron, sheet metal, colander, and springs, 100 x 37 x 59 cm. Musée Picasso, Paris.

legs in a Kota figure in his own collection.[23] A perfect solution. The top-heavy colander head looks all the more gigantic for the rickety minimalism of the diamond-shaped legs.

Among the astonishingly varied ideas for sculpture in the Boisgeloup sketchbook are several drawings of a head of Mithra, the sun god. Nothing came of this project at the time; twenty years later, however, this image of a disk-like face superimposed onto a flat, square head, edged with zigzag sun rays, would materialize as the sunflower face of the life-size, freestanding assemblage, *Girl Jumping Rope* (1950).[24] The Mithraic aura endows this lighthearted piece with a cosmic radiance. The old basket that stands for the belly of the *Girl Jumping Rope* derives from the Jupiter Tonans drawing in the same *carnet.* "I use my old sketchbooks the same way a chef uses his cookbooks," Braque once said.[25] So did Picasso.

Besides working on welded pieces, Picasso had taken to whittling away at bits of wood—sixteen of them—all Marie-Thérèse–inspired figures,[26] which predict Giacometti. He had used wood, Picasso told Spies, that was lying around the studio—mostly "fragments of canvas stretchers."[27] To Daix he said he had used branches he

Picasso. Sculptures of Marie-Thérèse,
1930. Carved wood, ht. 48 cm, 51 cm,
and 55.7 cm. Musée Picasso, Paris.

had found in the park, pine for preference, which were easy to carve with a penknife.[28] These figures are closely related to the Etruscan sculptures from the Villa Julia, which had been illustrated in the May 1930 issue of *Documents,* though not nearly as closely related as the famously attenuated figure in the archaeological museum at Volterra is to Giacometti's later work. Like the figures of Fernande Olivier he had whittled at Gósol in 1906,[29] the Boisgeloup carvings have taken their shape from the sticks and slats that engendered them. Their similarity to the hugely tall sculpture of Daphne that Picasso would execute in November suggests that these little figures can be seen as a three-dimensional sketchbook.[30]

The acquisition of Boisgeloup did not release Picasso from the obligatory "summer exodus," as he had hoped. At what was probably Olga's behest, they arranged to leave for Juan-les-Pins on July 26; but Paulo caught cold, so they postponed their departure until the thirtieth. En route, they stayed overnight at Bourg-en-Bresse,[31] doubtless to see the magnificent Eglise de Bresse before spending a day at Bilignin, near Aix-les-Bains in the Haute-Savoie. This is where Gertrude Stein and Alice Toklas had found their "dream house," a seventeenth-century *manoir*[32] that had even fewer amenities than Boisgeloup. Picasso's visit may have been prompted by the recent publication of Gertrude's *Dix portraits,* in which her "portrait" of Picasso, entitled "If I Told Him: A Complete Portrait of Picasso" appeared.[33] Georges Hugnet and Virgil Thomson had translated Gertrude's idiosyncratic "portraits" into French, and Picasso had contributed drawings of Satie, Apollinaire, and himself.

Here is Alice's recollection of this visit:

One day at Bilignin Picasso and his wife, with Elf their Airedale dog, came up in their big car—they had a big limousine with a chauffeur. They had come to spend the day with us. They got out of the car and we thought they were a circus. They were wearing the . . . sports clothes of southern France, which had not gotten to America yet and were a novelty to us—bare legs, bare arms, bright clothes. Pablo said, explaining himself, that is all right, it is done down on the Mediterranean. Elf ran over the box hedges of the terrace flower beds. Basket [Gertrude and Alice's

poodle] looked at the dog with the same scandal with which we had looked at her masters. Basket was outraged, he had never been allowed to do that.[34]

After a lunch cooked by Alice, Picasso took a number of photographs and drove on to Juan-les-Pins, where he had rented the Villa Bachelyk, around the corner from the Villa Belle Rose, which they had taken in 1925. Once again, Picasso arranged for Marie-Thérèse to have a room nearby. During this visit, he stayed away from most of his old Riviera friends. The Murphys had gone to live in Switzerland, to be with their tubercular son. As for the Beaumonts, whether or not they were at Cannes, he preferred to be alone with Marie-Thérèse.

Before he left for the south, Picasso had been bombarded with telephone calls from Skira as to whether he had started work on the Ovid engravings. Exasperated, he told Skira to come by the following Friday, "and I'll show you the first plate for the *Metamorphoses.*" Skira duly appeared, only to be told that Picasso had left for Juan-les-Pins the day before. "Strike while the iron is hot," the indomitable Madame Skira declared, *"prends ta Bugatti!"*[35] And off they sped to the Riviera. The following morning, Picasso was astonished to find the mother and son on his doorstep at Juan-les-Pins. Skira knew instinctively how to charm Picasso. So sure of himself was he that when Picasso showed him the first trial plate[36]—a somewhat incoherent engraving of the death of Orpheus—Skira rejected it as "too abstract," the word "abstract" apparently a euphemism for "violent." An instinctive editor, Skira felt that the plate did not correspond to his concept of the book. It included too much of the action, not only the killing of Orpheus by the Thracian maenads, but also the maenads' slaughter of the local bulls. The appearance of bulls in Picasso's work usually implies that he had attended a corrida. Indeed, he had—in Spain. Early in his stay at Juan-les-Pins, he took Marie-Thérèse off to Barcelona for a few days. As well as checking that his mother was taking good care of the rest of his early works, Picasso wanted to show Marie-Thérèse *his* Spain, not so much his old friends as the bullfights, which were about to become a dominant theme in his imagery. According to the artist's grandson, Olivier Widmaier Picasso, the Spanish journalists who usually trailed him "failed to notice Marie-Thérèse."[37]

Back in Juan-les-Pins, sculpture was still uppermost in Picasso's mind. Far from allowing a lack of materials to hamper him, he improvised with whatever was at hand: flotsam and jetsam from the beach as well as sand, the additive he had used on previous visits to enrich his paint surfaces. This summer, Picasso would use sand as the subject as well as the *matière* for a series of little reliefs.[38] These were ingeniously contrived from bits of driftwood and metal, toy boats, palm fronds, rope, rags, roots, and seaweed. There was also a glove, which he stuffed with bran to give it the look of a washed-up hand.[39] He would glue, sew, or otherwise fasten these bits and pieces as

Picasso. *Bather and Profile,* August 14, 1930. Sand, cardboard, and plants on canvas, 27 x 35 x 3 cm. Musée Picasso, Paris.

well as additional cardboard cutouts onto the backs of small canvases placed face downward so as to form shallow boxes.[40] And Picasso would then sprinkle the contents of these boxes with a unifying layer of sand, perhaps to evoke the sand-encrusted embraces endemic to beach cabanas.

Since her first summer with Picasso in 1928, Marie-Thérèse had developed from an adolescent playing ball with her playmates—simulacra of herself—into a langurous sun worshipper in thrall to her sun god of a lover. And it is this sexy, sandy sleeper that Picasso encapsulates in one after another of his little boxes. The one exception is a comical clutter of toy boats, which he presumably did to amuse his son.

That these reliefs represent yet another advance in Picasso's blurring of the gap between the second and third dimensions[41] should not blind us to the joy with which he distills the delights of his favorite arena, the beach. Nor should we overlook the little jokes: for instance, the cardboard fingers affixed to the right-hand stretcher of one of these reliefs,[42] which suggests that Marie-Thérèse is trying to clamber out of the space she shares with a cutout of the artist's profile; or the identical tassels of frayed rope standing for the sandy hair between her legs as well as on her head.[43] The box evokes all too memorably the awful invasiveness of sand. Forty-one summers later Picasso will summon us back to this beach on the occasion of what is probably

his last apotheosis: a sequence of five paintings of the *Three Ages of Man* set on a Riviera beach.[44] In four out of these five paintings, a surrogate of the artist holds a stick with which to draw in the sand, just as he used to do as a child in Málaga.

On September 5 and 6, just before leaving Juan-les-Pins, Picasso devised a more impromptu tribute to Marie-Thérèse. By superimposing her image onto magazine illustrations of successive lunar phases, he visualizes her as a Mithraic moon-woman. As Picasso told Penrose, he associated Marie-Thérèse with the moon. "The sleeping blonde paintings [of her are] lunar," he said. "She has always done just what she wanted—strayed, wandered, changed her way of living. . . . [Her] long neck carries [her head] like the moon racing through the clouds . . . like a ball, a satellite."[45]

36

The Shadow of Ovid

Besides the ongoing scandal of the theft of his early drawings from his mother, Picasso had to face an even greater public embarrassment on his return to Paris around September 7, 1930: successive installments (September 10, 11, 12, 13) of his former mistress Fernande Olivier's memoirs in the popular evening newspaper *Le Soir.* Instead of using Fernande's original title, *Neuf ans chez Picasso,* the editors used the offensive rubric *Quand Picasso était pompier* (When Picasso Painted Kitsch). That Fernande's disclosures—opium, mistresses, involvement in thefts from the Louvre—were mostly true made this exposé the more distressing for Olga. She resented her husband's past affairs almost as much as she resented his present ones, and was even more determined than he was to have the series legally stopped.[1] Six installments would appear before the lawyers prevailed. Years later, Picasso would express a very different view of Fernande's memoir: the only account to capture the ambiance of the Bateau Lavoir, he said in the 1950s.

Readers of Volume II may recall how Fernande's foolish affair with the Italian painter Ubaldo Oppi in 1912 had enabled Picasso to leave her for her treacherous confidante, Eva Gouel[2]—leave her, what is more, without a penny and only a single drawing to show for an eight-year relationship. Except for the saintly Max Jacob, most of her friends had melted away. After telling Serge Férat that "*la basse prostitution*"[3] was the only solution to her problems, this most voluptuous of all Picasso's women tried out a succession of jobs: movie extra, *antiquaire's* assistant, children's nanny, cashier in a *boucherie,* cabaret manager, reciter of poems (at the Lapin Agile), and astrologer—a skill she had learned from Max Jacob—but she usually ended up giving French or drawing lessons and using her beautiful voice to teach diction. During World War I, Fernande took up with a raffishly handsome movie star, Roger Karl, whom she and Picasso had known in Lapin Agile days. Karl had originally wanted to be a painter, then a writer: his aspiration to be "the French Dostoyevsky" prompted a sharp *"Tu parles, Karl"* from Max Jacob. Instead, he became a successful actor on stage and screen and a golden-voiced reader of poetry on French radio.

The great actor Louis Jouvet thought that Karl could have been the greatest tragedian of his generation had he worked harder and been less of a drunkard, philanderer, and spendthrift. Fernande, who had refused out of sentiment to move in with Karl until Picasso got married, would always have to provide for herself.[4]

In 1927, hoping to cash in on her glamorous Bohemian past, Fernande had embarked on an account of her life with Picasso. She had girlish diaries to draw on as well as a sharp sense of character and humor. An ability to write meant that Fernande could dispense with help from her literary friends. Just as well; except for Max Jacob, they would have been too fearful to do so. Gertrude Stein and Alice Toklas, who had disregarded her pleas for help, were the ones Fernande most regretted. And then all of a sudden, in May 1928, she heard through Marcoussis that these women, formerly her closest confidantes, wanted to see her again. She was thrilled and went to visit them and told them about her book. An excellent idea, Gertrude said, as she took Fernande's manuscript and promised to find her a

Fernande Olivier, c. 1925.
Collection Gilbert Krill.

translator and an American publisher. This offer was a poisoned chalice. Gertrude wanted access to Fernande's material for a book of her own—her self-hagiographic *Autobiography of Alice B. Toklas,* about the so-called banquet years. She was anything but eager for Fernande's book to be published before hers. Fortunately for Fernande, the excerpts in *Le Soir* had so impressed the eminent diarist Paul Léautaud that he arranged for the *Mercure de France,* the prestigious magazine he edited, to publish more of it. Besides the author's ability to tell a tale, her alluring looks had set Léautaud wondering to his diary whether he might hire Fernande to strip and "sit" for him, the better to feast his eyes on her.

Back at Boisgeloup, Picasso settled down to work on his Ovid engravings. Louis Fort, the printer, had delivered twenty-one varnished copper plates in the spring,[5] but so far he had used only one of them: the tryout for the *Death of Orpheus* that Skira had criticized." Whether or not Skira's criticism was responsible, Picasso refined his concept. For inspiration, he turned to a source that was quintessentially classical: Etruscan mirror backs chased with mythological scenes, which, as he knew from his visits to the Louvre, are among the finest examples of engraving in antiquity.

The British neoclassicist John Flaxman's illustrations for Homer's *Iliad* are sometimes said to have left their mark on engravings for the *Metamorphoses*. However, when Picasso was asked by Cooper about Flaxman, he was dismissive. And, indeed, these insipid pastiches are bereft of the energy and concision of Etruscan mirror backs.

In a recent book, Lisa Florman has proposed a new interpretation of Picasso's *Metamorphoses* and other classical engravings.[6] Her observations are original and illuminating, but she goes too far in claiming that two of the paintings on Ovidian themes that Rubens and his assistants executed for Philip IV's hunting lodge at Torre de la Parada may have "provided the models for Picasso's own illustration of the myth."[7] The evidence? As Florman concedes, there is none. Picasso never clapped eyes on them. But even if he had, he is unlikely to have been interested. For Picasso *loathed* Rubens. The great Rubens exhibition in Paris in 1936 was the occasion for a spirited attack, as Kahnweiler has recorded:

> *Kahnweiler:* ". . . I was wrong when I said, after seeing the photographs, that I thought I would like it. You were right. I disliked it a lot."
> *Picasso:* ". . . I told you so. [Rubens] is gifted, but his gifts engender bad art. . . . it's journalism, epic film stuff. Take Poussin, when he paints Orpheus, he tells the story. The least leaf tells the story. Whereas with Rubens, it's not even painted. Everything is identical. He thinks he is painting a big breast [he makes a large circular gesture with his arm], but it is not a breast. His drapery looks like breasts. Everything looks the same as everything else."[8]

Picasso is more likely to have found the poetic reassurance that Apollinaire and Max Jacob had formerly provided in a recently reissued book by Mallarmé. First published in 1880, *Les Dieux antiques* is a lively compendium, which includes sections on Asiatic, African, and Norse mythology, but is principally focused on the Greek and Latin gods and their mythic deeds.[9] Mallarmé's comments on metamorphic legends, their connection with the workings of the sun, and the pagan ethos, would have appealed to Picasso. Originally conceived as a *"mythologie à l'usage des classes"*—a schoolbook—*Les Dieux antiques* was based on a popular work by an English classicist, George W. Cox, entitled *Tales of Gods and Heroes* (1862). Mallarmé's almost total reworking of Cox's text is so lucid, so effortlessly informative and devoid of Victorian cant that Gallimard brought out a new edition in 1925. The full contents of Picasso's library have yet to be established, but he must have owned a copy of this book. It would have enabled him to glimpse Ovid's metamorphic myths through Mallarmé's prismatic mind. *Les Dieux antiques* is also likely to have been known to Matisse, who revered Mallarmé and was about to illustrate his *Poésies,* which Skira would publish a year after Picasso's Ovid.

Since Picasso had spent much of the previous year on a sculpture of Daphne in

Picasso. Etchings for Ovid's *Metamorphoses,* 1930. Left: *The Daughters of Minyas,* 31.2 x 22.4. cm. Right: *Cephalus and Procris,* 31.2 x 22.4 cm. Musée Picasso, Paris.

flight from Apollo and was about to start on yet another hugely tall plaster of her, this was one metamorphosis that he did not need to illustrate. The choice of subjects is said to have been Skira's, who supposedly gave Picasso a copy of Georges Lafaye's prose translation marked with his preferences. However, the artist would certainly have had the final say in the selection. As an opener,[10] Picasso chose to illustrate the first legend in Ovid's Book I: the story of Deucalion and Pyrrha, sole survivors, like the Noahs, of a great flood ordained by Jupiter to cleanse blood-soaked Earth of chaos and corruption. After the flood subsides, Deucalion and Pyrrha ask an oracle how they can perpetuate the human race. "Throw behind you the bones of the Great Mother [i.e. the stones of Mother Earth]," they are told. This they do, and as the stones soften, vestiges of human form emerge, much as a likeness does "when one has just begun to block the marble."[11] Deucalion's stones become men; Pyrrha's, women.

The parallels between Ovid's metamorphic poem and Picasso's figures of the "bone" period are self-evident. Although there are no references to the re-creation

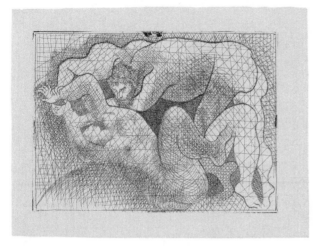

Picasso. *The Rape (Philomena and Tereus)*, July 9, 1931.
Etching, 21.6 x 30.7 cm. Musée Picasso, Paris.

of the human race in his illustrations, there is such an abundance of them in his paintings of 1929–31 that it is tempting to call this Picasso's "Deucalion" period. Picasso also treats the story of Semele self-referentially. There was even a role for Olga: Juno. On discovering that Semele was carrying her husband's child (Dionysos), Jupiter's jealous wife arranged for her rival to be atomized by Jupiter's thunderbolts, much as Marie-Thérèse would allow herself to be consumed in the furnace of Picasso's love. This incineration is not even hinted at in Picasso's engravings,[12] which are amorous but most un-Picassian in their decorum. This is likely to have been imposed by Skira. Half the edition of this book was destined for the American market—conservative bibliophiles and clients of Marie Harriman's new gallery. Decorum would have been obligatory.

For an artist so often identified with metamorphism, Picasso paid surprisingly little attention to Ovid's metamorphic denouements. For instance, the daughters of Minyas are depicted spinning yarn,[13] but we have no inkling that they are about to be turned into bats. Likewise, without knowledge of the poem, nobody would realize from Picasso's engraving[14] that the story of Cephalus and Procris is a horrendous drama of jealousy and treachery. The same with Philomela:[15] Philomela was the beautiful sister of Procne, whose husband, Tereus, king of Thrace, raped her, then cut off her tongue and hid her away in a forest fortress. Unable to speak, Philomela wove her story onto a Thracian loom and had her handiwork smuggled out to her sister. In revenge, Procne killed her adored son and had his flesh served up to his rapist father. The story ends in successive metamorphoses: Procne becomes a nightingale, Philomela a swallow, and Tereus a hoopoe. Once again, all that Picasso distills from this shocking story is a mildly erotic scene in which an ardent young Tereus mounts Philomela, who offers herself up to him, much as Marie-Thérèse did to the artist. A year later (July 9, 1931), Picasso returns to the subject and comes up with a far more telling image: Philomela desperately struggling with the brutal king.[16] To hint at the denouement, he covers the entire surface with crisscross lines—the warp and weft of Philomela's loom.

In playing down the pervasive violence of these myths, Picasso approached them

in the spirit of Olga's husband rather than the Sadeian guise of Marie-Thérèse's lover. At the same time, he wanted his images to evoke the metamorphic spirit of the classical world—much as Shakespeare did in his Ovidian *Midsummer Night's Dream.* For Picasso, the rape and slaughter endemic to Olympus was not to be taken literally. Instead of burning in hell, victims would be resurrected as trees or birds or stags or constellations—made one again with nature or the cosmos—thanks to the power of metamorphosis. Zervos spoke for the artist in an article celebrating the publication of the Ovid book: "these are not properly speaking illustrations . . . they are personal interpretations of the world that Ovid had envisaged"[17]—a pagan Mount Olympus, very different from the guilt-ridden darkness of Golgotha, where the artist had lingered earlier that year.

Between September 18 and his forty-ninth birthday on October 25, 1930, Picasso produced fifteen full-page engravings, as well as fourteen alternate plates which do not appear in the Skira book. The engravings were printed at Louis Fort's Paris workshop, not at Boisgeloup as is often said. It would be another four years before Picasso acquired Fort's printing press.[18] The following spring, Picasso would engrave a second batch of half-page illustrations to break up the extensive blocks of text.[19] Concerned that the artist might drag his feet, Skira had taken a small office at 25, rue la Boétie, next door to Picasso's apartment, to urge him on. "As soon as I had finished with one of the plates," the artist told Brassaï, "instead of reaching for the telephone, I reached for my bugle, went to the window, and sounded the notes [*Ta-ta-ti, ta-ta-ti, ti-ta-tati-ta-ta*], and presto! In no time at all, there was Skira!"[20]

The *Metamorphoses* would be published on Picasso's fiftieth birthday, October 25, 1931. The book did not at first have as much success with bibliophiles as had been hoped. Nevertheless, it made Skira's name as a publisher, a name that would be further enhanced, a year later, when he brought out Matisse's no less beautiful engravings for Mallarmé's *Poésies* (October 25, 1932).[21] This was followed by Dalí's sensational *Les Chants de Maldoror* in 1934. Henceforth, Picasso's enjoyment of printmaking would become ever more consuming—thanks largely to the encouragement of Vollard, who had been his first Paris dealer. Vollard had made so much money out of impressionist and post-impressionist paintings that he preferred publishing *éditions de luxe* to depleting his stock of ever more valuable Renoirs, Cézannes, and Gauguins. The venerable dealer was furious with the young interloper Skira for encroaching on what he had come to regard as his territory. From a hospital bed, where he was recovering from a gallstone operation, Vollard wrote Picasso that he could not wait to leave his bed and challenge Skira to "a race, which he [Vollard] was sure to win."[22] The publication a month later of Vollard's magnificent edition of Balzac's *Chef-d'œuvre inconnu,* with the thirteen engravings that Picasso had done in 1927, would settle that point—some felt in Vollard's favor.

Meanwhile, the Apollinaire memorial committee had held its annual meeting on November 9, to commemorate the poet's death. As usual, Picasso attended. He informed the group that after a year's work, his promised sculpture was ready; and he asked André Salmon to take a look at the piece in González's workshop. Salmon was amazed at the cigar-box size of the space, the ferocity of the furnace, and above all the welded *Woman in the Garden.* "Nothing is more beautiful," Salmon gushed nostalgically to Picasso. "For a moment I felt the same as I did on certain occasions [at the Bateau Lavoir] in 1906. You know what I mean."[23] González had also shown Salmon one of the sheets of bronze for the outdoor Père-Lachaise version. "Seductive, but iron is more pure":[24] Salmon's comments were designed to please the artist. So was a fable about a blacksmith, in the manner of La Fontaine, that he dedicated to Picasso and included in his letter.

In a two-part article inspired by this visit, Salmon provides a picturesque glimpse of Picasso as Vulcan at his forge, "roaring with laughter" as "the gas cylinders spewed out their fire."[25] If Salmon did indeed see Picasso playing with fire, it would have been an act contrived for his benefit. Salmon's change of tune—he had deified Derain and sided against Picasso at the Apollinaire committee meetings—does not ring true. He regretted being dropped from Picasso's circle, but no amount of sucking-up would get him readmitted any more than his boring stanzas would win him the avant-garde acceptance he craved. His work for a collaborationist newspaper during World War II would finally do him in with Picasso. At the memorial mass for Max Jacob (March 28, 1944), Picasso was chatting to friends on the street outside the church when Salmon advised him to move along, as the police might come. "Since you are present," Picasso replied, "the police are already here."[26]

Picasso, too, was playing games—pretending to go along with the Apollinaire project because it provided cover for a secret volte-face. He no longer wanted to have his Daphne replicated in bronze for Père-Lachaise; he now planned to set her up in his park—*Le Nymphe de Boisgeloup.* That he did not reveal his intention even to González emerges from the latter's notes on their collaboration: "[Picasso did not] want to be separated from [the sculpture] or think of its being at Père-Lachaise in that collection of monuments where people seldom go. He wanted this monument to become the reliquary for the lamented poet's ashes, and to be placed in his [Picasso's] garden, where his friends could gather around him who is no longer."[27]

González was either very credulous or very discreet. Picasso would never have allowed Apollinaire's friends to gather at Boisgeloup. Besides infringing on his sacrosanct privacy, a throng of mourners would have evoked his fear of the shadow of death. As he had told the Apollinaire committee, he was "superstitious and

feared cemeteries."[28] A monument to the dead on his property would have been abhorrent. A monument to the living Marie-Thérèse would be a very different matter.

The replica of the *Woman in the Garden* would necessitate almost a year of finicky work on the part of González. Each separate element of the original had to be re-created exactly before being welded into place. González's assistant, Augusto Torres (son of the painter Torres García), confirmed that Picasso took no part in the replication, but visited the workshop regularly to urge them on. Your "casserole" (slang for "wench"), González told Picasso, has "turned into [such] a titanic undertaking" that "I have had to go and buy the heaviest hammers in the scrap-iron market."[29] The bronze replica brought their historic collaboration to an amicable end.

Though seemingly modest, González was ambitious and intent on making a reputation for himself; and, to his credit,

Brassaï. Photograph of Picasso's *Woman in the Garden* in the park at Boisgeloup, December 1932. Musée Picasso, Paris. © Estate Brassaï-RMN.

Picasso helped him to do so. He continued to supply Picasso with pedestals,[30] just as he did Brancusi. In 1937 González would do a *Daphne* of his own—composed of elements not unlike the ones Picasso used for *his* Daphne. This would lead, in 1939, to a formidable pair of welded figures entitled *Monsieur Cactus* and *Madame Cactus*—handsome allegories of the toughness of the Catalan people in the face of the civil war—but they lack the magic fire of the pieces he did with Picasso.

The notes González kept of his collaboration with Picasso make no mention of the woman who had inspired the piece he had been working on for the previous year or so. Picasso had presumably sworn his closest and most trustworthy associates—González, Leiris, Pellequer, Kahnweiler—to secrecy about Marie-Thérèse. Kahnweiler would still be in denial about her after Picasso had embarked on his affair with Dora Maar. The secrecy about Marie-Thérèse likewise explains why, after the bronze version of *Woman in the Garden* was installed at Boisgeloup, Picasso and his

friends referred to it as *Le Cerf* (The Stag). This code name corresponded to the sculpture's four-legged support and antlerlike hair—features that looked all the more striking when the bronze was set up in the long grass. To have an effigy of his mistress mistaken for a startled stag would have amused Picasso, so would the idea of turning Marie-Thérèse into the same animal that, as Ovid relates, Diana metamorphosed Actaeon into.

Eager to show off his new château to old friends, Picasso had Gertrude Stein and Alice down to Boisgeloup for the day. The visit sometime in November was a success, as Gertrude confirmed in a characteristically misspelled postcard. (*"Nous sommes rentrait toute doucement, et tellement contente de votre* home . . . *et maintenant nous mangeons un bon poire de Boisgeloup."*)[31] The visit also inspired her to write a very short five-act "play," called *Say It with Flowers* (1931). The main characters are called George Henry, Henry Henry, Elisabeth Henry, Elizabeth Long, and William Long, but she muddles up their names. As far as one can tell, Elizabeth and William Long correspond to the Picassos. The play is set nearby at Gisors at the time of Louis XI, in a cake shop as well as at "the seashore where they are near Gisors." Here is a typical passage from this tedious, self-indulgent text:

> The cake shop in Gisors.
> They did not open the door before.
> Elizabeth Ernest and William Long.
> Who makes threads pay.
> Butter is used as much as hay.
> So they will shoulder it in every way
> To ask did they expect to come in the month of May.
> Ernest and William Long and Elizabeth Long were not happy.[32]

Gertrude found it impossible to get this stuff published, so Alice proposed to become a publisher. To finance the publishing house, which they called "Plain Edition," Gertrude decided to sell Picasso's 1905 masterpiece, *Woman with a Fan* (National Gallery, Washington). Did Gertrude, one wonders, consult the artist, as she had done in 1923 when she had contemplated swapping his celebrated portrait of her with Rosenberg for another more recent Picasso? On that occasion, he had laughed off the suggestion.[33] Picasso was still fond of Gertrude but dubious about her claims to genius. Had he understood English, he might have found the *Woman with a Fan* was a ridiculously high price to pay for publishing *Say It with Flowers.*

A little later, another very close friend from the past came back into Picasso's life. Max Jacob reappeared in Paris for a small exhibition of his dim little drawings and watercolors—twenty-seven of them—at the Galeries Georges Petit, where Picasso

would have his retrospective in 1932. Olga had always disliked Jacob, and she disliked him even more after Fernande Olivier's recent revelations about him in *Le Soir*. And so, instead of inviting him to the rue la Boétie, Picasso visited him at his hotel. The composer Henri Sauguet, who was present, has described this fraught encounter: "The two friends had not seen one another for a long time. Pablo arrived, amiable and affectionate. Max remained circumspect. All of a sudden he gave the artist a meaningful look and said, 'Eh, it seems that you have just bought a château.' And he burst out laughing."[34]

Max did not receive an invitation to Boisgeloup. Nevertheless, Picasso attended his vernissage, where he found himself surrounded by the chic people he mostly avoided, headed by Cocteau, who had written the catalog preface. Charles de Noailles had returned to Paris specially for the occasion; and among the others were "Flames" d'Erlanger, Winnie de Polignac, Johnny and Baba Faucigny-Lucinge, Arturo López, as well as a smattering of collectors, critics (Salmon), and dealers (Kahnweiler). Since the Fernande Olivier articles, Picasso had laid very low; and now, at this of all moments, he found himself confronted by his past in the form of Max Jacob, who personified the Bateau Lavoir, and Cocteau, who personified *l'époque des duchesses*. Both these laureates had been in love with Picasso and, deny it though they might, still resentfully were.

Olga in front of the sculpture studio at Boisgeloup, c. 1932.

37

Annus Mirabilis I—The Sculpture (1931)

La sculpture est le meilleur commentaire qu'un peintre puisse addresser à la peinture. —Picasso to Renato Guttuso[1]

Picasso's switch to volumetric sculpture in March 1931 comes as no surprise. Intimations of an imminent change had appeared in two very large, very sculptural paintings that he had done shortly before he reopened his Boisgeloup studio. In these monumental works—*Figures on the Seashore* (January 12, 1931) and *Woman Throwing a Rock* (March 8, 1931)[2]—Picasso carries the deconstruction of his figures into separate biomorphic elements further than ever before. In the first of these paintings, Picasso takes the bodies of two naked bathers—as it might be himself and Marie-Thérèse—and reassembles them into a baroque heap of inflated body parts; at the center dagger tongues jab at each other in a cannibal kiss. In the background, an erect cabana testifies once again to the artist's virility. It is a sunny day; the sea is a wall of blue, but not quite as intense a blue as the Mediterranean. We are evidently in Normandy. Working in Paris in the depth of winter, the artist wants to evoke the pleasures of the beach in summer. So sculptural is the handling, we are able to envision how the figures would look from the other side.

Woman Throwing a Rock is grimmer.[3] It is not as self-referential as *Figures on the Seashore;* it is mythic. The woman has little to do with Olga or Marie-Thérèse. She is all alone on her bleak eminence, a monumental sculpture set on a cliff against a cold, cloudy sky, as if she were Ovid's Pyrrha, at the dawn of creation, caught in the act of ridding herself of one of her life-engendering stones. Or is she about to insert it—the stone looks suspiciously like a glans penis—into her blimp of a body? The rock also serves as a counterweight to keep the seesawing figure in balance. Breasts in the form of two balls prop up her belly and make for an androgynous pun. *Woman Throwing a Rock* is the harbinger of Picasso's reemergence as a volumetric sculptor later in the spring.

Another possible source for these genitalian deconstructions is an amateurish

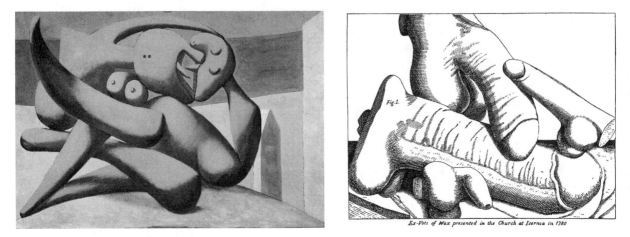

Ex-Voti of Wax presented in the Church at Isernia in 1780

Left: Picasso. *Figures on the Seashore,* January 12, 1931. Oil on canvas, 130 x 195 cm. Musée Picasso, Paris.

Right: Engraving of phallic ex-votos from Isernia, in *A Discourse on the Worship of Priapus: Theology of the Ancients* by Richard Payne Knight, 1786.

engraving in an obscure work of salacious eighteenth-century scholarship, *A Discourse on the Worship of Priapus: Theology of the Ancients,* by Richard Payne Knight (1786).[4] The artifacts illustrated in Payne Knight's volume would have been familiar to Picasso from his visits to Naples. However, the book contained an additional preface by another classicist, Sir William Hamilton—British envoy to the court of Naples and the Two Sicilies, and husband of Nelson's Emma—which would have been of the greatest interest to him. An engraving of a pile of disembodied phalluses illustrates an astonishing discovery that Sir William had recently made. Far from dying out in the Dark Ages, as was generally thought, the cult of Priapus still flourished in the Neapolitan countryside at a place called Isernia. To share this news with his fellow cognoscenti, Sir William had dispatched a Neapolitan friend to attend the festivities, write an account, and obtain samples of the phallic ex-votos that were distributed at the cult's priapic ceremonies. He commissioned the engraving and presented a selection of the wax ex-votos to the British Museum, where they remain to this day. Those ex-votos would inspire Picasso to make some votive pieces of his own—mostly of eyes.[5]

According to Sir William's informant, the three-day festival took place every February outside Isernia in an ancient church dedicated to Saints Cosmo and Damian—martyred Syrian doctors whose only conceivable link with Priapus was their mythic power as healers of venereal diseases. The waxen votive phalluses came in all sizes. Parishioners would kiss them fervently in the hope that Priapus would make their women and their beasts fertile and their harvests bountiful. The priests also sold a miraculous oil of "invigorating quality" for the faithful to smear on themselves. Sadly, the festival did not survive Sir William's account for long. In 1805 Isernia was

destroyed like Pompeii, though in an earthquake rather than an eruption.[6] Picasso's two great paintings perpetuate the survival of priapism and its rituals into the twentieth century. The engraving served as a time warp that would bring antiquity closer than Pompeian relics could. Another consideration: although well aware that in antiquity sexual imagery was not considered pornographic, the artist would have been delighted to find a way of sexualizing his imagery, the better to dismay, offend, shock, and, who knows, excite the puritans of his day.

Payne Knight's volume does not figure in the incomplete lists of books in Picasso's various houses; or in the well-cataloged library of Apollinaire, that formidable expert on erotica once described by Picasso as "my discoverer of rare manuscripts." However, the parallels in style, composition, and implications of the two paintings discussed above are so striking that Picasso must surely have known the engraving. The sexually charged image would certainly have been to Picasso's taste, but the naive gigantism of the engraving and the no less naive disproportion of image to format left an even greater mark on these works. To my mind, this engraving constitutes as useful a source of monumentality as the rock arch at Etretat.

Since the Wall Street crash, Rosenberg had cut back on purchases and done little to promote his most important artist. Unaffected by the crash, Picasso—who kept much of his money in a bank vault—had taken against his dealer and saw as little as possible of him. In a New Year's letter, facetiously addressed to the *Noble Seigneur de Bois-Jeloux et de la Boétie Hispano (Six Cylindres) Parigot,* Rosenberg set about reestablishing a more personal rapport with Picasso. He regretted that they had drifted apart: "the distance between 23 and 21 rue la Boétie has become too great."[7] Picasso responded positively with a promise to deliver some large, yet-to-be-executed paintings for an exhibition to be held July 1–21. Rosenberg wanted this show to coincide with the large Matisse retrospective at the Galeries Georges Petit scheduled for the summer (June 16–July 25, 1931). So did Picasso, who encouraged André Level to organize yet another exhibit of his work.[8]

To satisfy his obligation to Rosenberg, Picasso took a rest from the Isernian figures and embarked on four large still lifes (dated February 11, 14, 22, and March 11).[9] All four of them conform to the familiar allegorical formula: a pitcher (the artist) on the left and a bowl piled with fruit (Marie-Thérèse) on the right. In the first three paintings Picasso reduces these objects to essentials and sets them out on a cloth-covered, rectangular table. In the second one he adds Marie-Thérèse's emblematic philodendron leaves: a tangle of tendrils that evokes the curves of the loved one's buttocks and breasts and suggests her Ovidian oneness with nature.[10]

The third of these still lifes (Solomon R. Guggenheim Museum) is more intricate

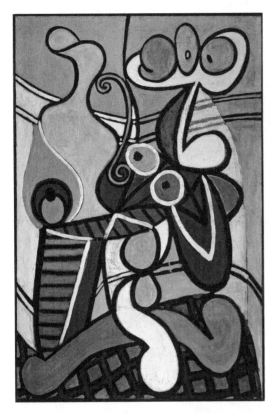

Picasso. *Large Still Life on a Gueridon (Marie-Thérèse),* March 11, 1931. Oil on canvas, 195 x 130.5 cm. Musée Picasso, Paris.

and richer in color. Its luminosity stems from the nineteenth-century stained glass in the Boisgeloup chapel; a small, teardrop-shaped fragment of the glass is still to be seen in a vitrine in the house. Thick leaded outlines had appeared in earlier works, but the incandescence testifies to Picasso's ownership of a chapel where Mass was celebrated—yet another example of his surreptitious use of sacred magic to enhance anything but sacred work. He may also have drawn on memories of the *cloisonniste* set piece, *Virgin with Golden Hair,* that he had exhibited in 1902 and subsequently painted out.[11]

Picasso would keep the fourth and last of these paintings for himself. It is one of his most memorable still lifes, also one of his most memorable Marie-Thérèses. The objects in *Large Still Life on a Gueridon* are the same as in the previous ones; only the table has been replaced by that other standby, a gueridon.[12] Picasso took particular pride in this metamorphic tour de force. When showing it to Alfred Barr,[13] he jokingly remarked with a smile, *"Et voilà une nature morte,"* emphasizing the word *morte.* Years later, when Daix said that it reminded him of Marie-Thérèse, Picasso recalled his conversation with Barr, and indicated with his finger the profile and curves that pertain to Marie-Thérèse.[14]

Daix does not say which curves Picasso delineated, but the girl's head corresponds to the fruit dish, her neck to its stem, her eyes to the dots on the peaches, her breasts to the green apples and her buttocks to yet more peaches. As for the golden pitcher that rears up like a crowing cock, this stands for the triumphant artist. Once again, Picasso adjusts the perspective of the dado rail and skirting board so that they can be read as both convex and concave, simultaneously thrusting the gueridon out at us while also holding it back. The black (sometimes white) leading enclosing the orbs and arabesques is another reference to the stained glass. To accusations that his depiction of women as objects degraded them, Picasso said that he liked to take inanimate objects and turn them into people and vice versa. He failed to add that his metamorphoses were not as mechanical as those of the dadaists and surrealists, who tended to see women as metronomes or coffee grinders.

Shortly before Picasso's show—the four still lifes plus major works from the gallery's stock[15]—opened at Rosenberg's (July 1, 1931), Matisse's large retrospective of 141 paintings, 100 drawings, and a sculpture opened at the Galeries Georges Petit. The selection was disappointing: too tainted with dealerism. An American critic, Helen Appleton Read, reported that "Matisse refused to be lionized and slipped away early in the evening, preferring that his pictures speak for him. . . . But Picasso, who shares with Matisse the distinction of being leader of twentieth-century painting, was much in evidence."[16] Picasso would return more than once to study his rival's work and gauge the gallery's suitability for his own show there the following year.

The nature of Picasso and Matisse's rivalry has recently come under a great deal of scrutiny as a result of two remarkable exhibitions. The first, at Fort Worth, Texas, in 1999, was organized by Yve-Alain Bois, whose sagacious catalog preface, slyly subtitled "A Gentle Rivalry," tends to see things from Matisse's viewpoint. Bois took the line that "behind the erotic flourish of [Picasso's] rhetoric, no one can miss the hint of Matisse," and that Picasso chose "to signify sensuality via a detour through Matisse's language."[17] These and other of his views strike me as a touch chauvinistic, but Bois is so astute that one learns from him even when not agreeing with him.

The other, a blockbuster show that opened at the Tate Modern in London and traveled to the Grand Palais in Paris and MoMA in New York in 2002–03,[18] provided members of the public with a once-in-a-lifetime spectacle, but resulted in distorted perceptions of the artists' relationship. On both sides of the Atlantic, crowds flocked to see the show under the misapprehension that it was a wrestling match with a winner and a loser. This is not at all what the organizers had in mind. On a more positive side, these exhibits stimulated controversy and sharpened people's perceptions—made them *look.* In contrast to Bois's preface to the Fort Worth show, a book, *Matisse and Picasso,* by Jack Flam, Matisse's most insightful biographer, favored Picasso. Flam sees Picasso as a master who felt compelled to correct or improve his fellow painters' performances. He imagines Picasso saying to Matisse, "Look, here is how it should be done!" As an example, he cites the defiantly straight back of Matisse's celebrated *Decorative Figure on an Ornamental Ground* (1925–26):[19] a would-be modernist touch that fails to counteract Matisse's riot of orientalist patterning. According to Flam, Picasso pointed out Matisse's misunderstanding of this particular distortion by using it for the back of his 1930 *Seated Bather.*[20] There it works perfectly, and by further stripping the *Decorative Figure* of its ingratiating ornamental ground—the carpet, the potted plant, etc. Picasso translated it into something much more meaningful.[21]

In fact, Picasso's and Matisse's mutual appropriations and put-downs were coming to an end. The give-and-take would continue, but there would be a truce and a renewal of their friendship. And it would be very moving to watch the two greatest artists of their time communicating in a language only they could understand; moving, too, to realize how much they needed each other and how little they were ever able totally to trust each other. Braque's heartfelt comparison of Picasso and himself at the time of cubism as two mountaineers roped together could never be applied to Picasso and Matisse. They were ascending different mountains.

After signing *Woman Throwing a Rock* on March 8, Picasso moved back to Boisgeloup to switch from doing paintings of sculptures to doing sculptures in the round: solid, volumetric pieces that would not be soldered or welded but built up out of plaster. He gave Penrose one of many reasons for his change of course: "Pictures are never finished in the sense that they suddenly become ready to be signed and framed. They usually come to a halt when the time is ripe, because something happens which breaks the continuity of their development. When this happens it is often a good plan to return to sculpture."[22]

This might imply that for Picasso sculpture was merely an alternative to painting. It was not. Just as much of his sculpture would be about painting, or about blurring the distinctions between the two, sculpture was a lifelong obsession that went back to Picasso's early days in Paris, when Gauguin's friend and collaborator Paco Durrio, the Spanish ceramist, had taken him under his wing. Durrio had helped Gauguin create his *Oviri*[23]—the gruesome phallic figure of the Tahitian goddess of life and death that was intended for Gauguin's grave. Hoping that Picasso would don Gauguin's mantle, Durrio had urged him to use the same kiln for his early stoneware sculptures. He also told him of Gauguin's age-old belief that if certain secrets were correctly observed, a lump of clay could be transformed into a golem.[24] Through Durrio, Gauguin's shamanic spirit had rubbed off on Picasso. Indeed, the great heads he was about to execute could be seen as Picasso's *Oviris*.[25]

Perhaps to endear herself after landing him with endless litigation, Doña María sent her son a letter (June 7, 1931), thanking him for keeping her abreast of his work in progress:

> I needn't tell you how happy I was to receive your letter, even if it took three months and the main reason for that was work. In Boisgeloup you will work at your ease because you have plenty of space and no one to bother you. I am enthusiastic to learn that you are working on sculptures, but since you are too lazy to write, I will never know what you are really doing. But in any case I already know that it will be good and different from everything else.[26]

On the last day of March, Picasso commemorated his switch from two dimensions to three in a portrait of himself[27] looking unusually tentative and modest and utterly devoid of charisma: evidently a craftsman. Two months later, he did one more painting. Entitled *The Lamp*,[28] it depicts the doorway of the sculpture studio—a massive stone arch framing a plaster head of Marie-Thérèse. The head in the painting predates the ones Picasso was already working on. It goes back to a grisaille painting (dated April 1929),[29] where it is contrasted with a sad and shadowy Olga: one of her earliest appearances in the fifth position. *The Lamp* implies that although Olga was the chatelaine of Boisgeloup, Marie-Thérèse, wreathed in tendrils of philodendron, was queen of the sculpture studio. His predilection for this plant, Picasso told Penrose, had to do with its "overwhelming vitality": "He once left one that had been given him in Paris in the bathroom, where it would be sure to have plenty of water while he was away in the south. On his return he found that it had completely filled the little room with luxuriant growth and also completely blocked the drain with its roots."[30]

The hanging kerosene lamp in the painting of the studio where Picasso worked much of the night as well as most of the day was the only source of light in this as yet unelectrified area. When more illumination was called for, he left the double doors open so that the headlights of the Hispano-Suiza could flood the studio with light so bright that Picasso wore a peaked cap to protect his eyes. Until recently nobody realized that, as well as Brassaï's celebrated photographs,[31] there existed numerous snapshots taken by Picasso himself—recently discovered by his grandson, Bernard, in a family archive—which teach us a great deal more about these sculptures than Brassaï's do. Picasso took them while he was actually on the job.

These revelatory photographs were taken between early March and early July 1931. We can date the earlier out-of-doors ones by the foliage on the trees—bare, in bud, or in leaf—in the background. In the earliest, the studio is empty except for a large stove, which later vanishes—too big for this former stable?—and a single plaster figure some three meters tall. Preparatory drawings for this figure date back to the previous November,[32] that is to say shortly before Picasso closed the icy studio down for the winter. He is unlikely to have

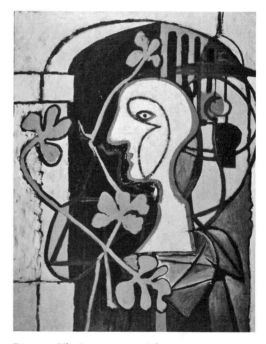

Picasso. *The Lamp,* 1931. Oil on canvas, 162 x 130 cm. Private collection.

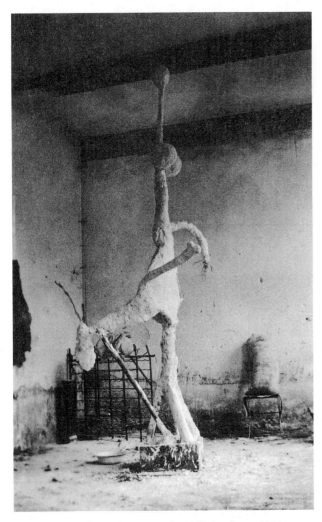

Tall Figure in the sculpture studio at Boisgeloup, 1931.

embarked on this technically daunting *Tall Figure*—Spies's title *Large Sculpture*[33] is insufficiently specific—so late in the year.

Once again, the subject is Daphne; once again, she is in flight, an ungainly right leg extended so far behind her that it needed propping up with a forked stick. This time, however, the nymph is turning into a tree rather than a shrub. Arms sprout from this toplofty Daphne, like branches from a tree trunk. Halfway up this treelike neck two small balls are squeezed together—breasts— and then it goes on and on, up and up, almost as high as Brancusi's skyscraping *Colonnes sans fin,* which Picasso is likely to have wanted to challenge. The height of the piece necessitated a special ladder: a huge librarylike affair with a platform on top and massive legs, which appears in the background of some of the photographs.

Whatever Picasso used as an armature for the *Tall Figure,* it failed to hold up. The piece fell apart. Unfortunately, González was no longer around to repair it. Picasso never found a replacement for him. In 1937 he failed to steal Jean van Dongen—the painter's brother—away from Maillol. González would be his only sculptural collaborator until he embarked on his metal cutouts in the early 1960s. It would always be a matter of pride for Picasso to do the heaving and hoisting himself. He was extremely strong and regarded these chores as an integral part of the creative process. For heavier work he could count on his concierge, or chauffeur, or the farm workers.

Whether the *Tall Figure* was ever actually finished is unclear. It was too fragile to cast and never properly photographed. This is the more regrettable since it would be further damaged in World War II, possibly by French soldiers retreating from the advancing Germans. As Picasso told Penrose, the French did a lot of damage during

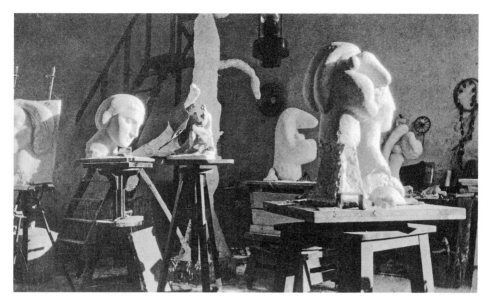

The sculpture studio at Boisgeloup, 1931.

their brief occupation of Boisgeloup.[34] And so, sadly, this arboreal Daphne never joined the shrublike Marie-Thérèse in Picasso's park.

After World War II, Picasso told Spies "over a tray of tea" that he intended to restore this second Daphne:

> "When I am gone, no one will be able to put it back together again." Pointing to the tray in front of him, he added: "As if one were to give tea, butter and jam to someone who had come into the world without knowing what they were for. What would he do with them? Maybe he would wash his feet in the tea, spread the jam on his head, and want red or blue butter instead of yellow."[35]

Nothing came of the restoration project and in due course the fragments disappeared. At least so it was thought. On a visit to the artist's widow at Notre-Dame-de-Vie in the late 1970s, I wandered into a gatehouse used for storage and came upon a large crate filled with plaster fragments, which looked as if they might once have added up to Picasso's tallest sculpture. But who knows? When I went to tell Jacqueline, she had been taken ill and was in no condition to deal with the problem.[36]

After the *Tall Figure,* Picasso devoted the next three months to a group of plasters, all but one of which were inspired by Marie-Thérèse. He was out to prove to the world that he was as great a sculptor as he was a painter. Matisse was very

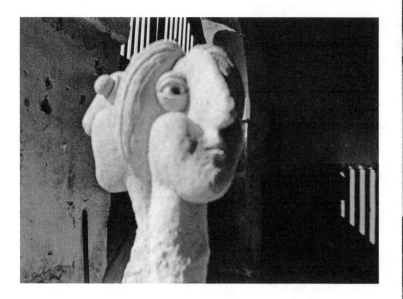

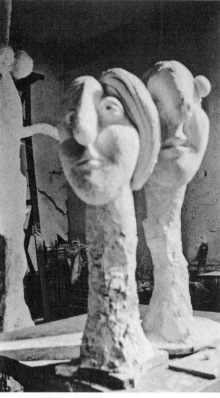

Above and right: Picasso's attempts to combine his plasters of Marie-Thérèse, *Head of a Woman* and *Bust of a Woman,* while working on them in his sculpture studio at Boisgeloup, 1931.

much in his sights; so was Brancusi. The earliest of the Boisgeloup photographs—the bare trees of March can be seen in the background—reveal that Picasso had completed the basic modeling of the two large heads within a few weeks of starting work. Initially, both of them had strikingly long necks—the only feature they share with the *Tall Figure*—but these would be modified. To differentiate between the two heads, Spies calls one of them *Bust of a Woman* and the slightly larger one *Head of a Woman.*[37] The studio photographs reveal that Picasso had progressively shortened the *Bust of a Woman*'s originally giraffe-like neck, and had also added breasts to the figure's armless chest. These give it the look of a crouching sphinx. Its phallic nose is a reference to Marie-Thérèse's most prominent feature—a feature she disliked and Picasso admired. The artist evidently had trouble articulating the head and neck until he had added breasts to the base.

The companion piece—which Spies calls *Head of a Woman*—is almost as much a portrayal of Picasso's genitals as it is of Marie-Thérèse. The nose is an extension of the flange of Marie-Thérèse's hair, which in turn is an extension of the buttocky back of her head. By once again substituting his penis for her nose, but adding testicular eyeballs on either side of its base, Picasso endows this sculpture with primeval mystery and power—characteristics that the submissive Marie-Thérèse lacked.

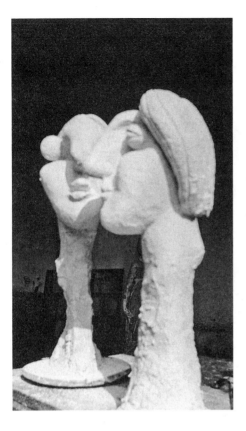

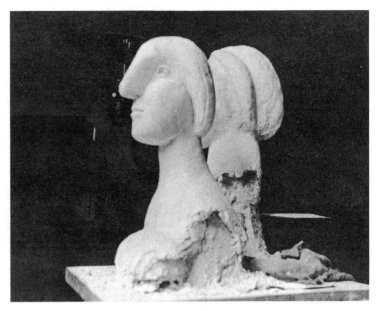

Left and above: Two more examples of Picasso's
experimental arrangements of his two plasters.

One of the most surprising things about these photographs is Picasso's attempt to
merge the two heads into one. He tries this out by setting them out in the courtyard
on a sculptor's turntable in a variety of bizarre combinations. Back to back, they look
as if he had a two-headed Janus figure in mind; and indeed dualities—sun and
moon, sea and sky, night and day—are a theme of much of this period's work. How-
ever, nothing would come of this idea. Face to face, the heads look slightly comical—
Eskimos rubbing noses—but as he pushes them closer and closer, the purpose of
these juxtapositions becomes clear. Picasso is out to maneuver them into a *Kiss*—
one that would outdo Brancusi's famously fused kissing couple of 1909. Shortly
before turning to sculpture, he had done this with horrifying success in a painting of
the two faces inexorably clamped together in a brutally toothy kiss.[38] This proved to
be impossible to duplicate in plaster. The huge noses got in the way. All that remains
of these experiments are these extraordinary photographs. Another revelation: they
bear out an illuminating statement Picasso made to Brassaï: "For a sculpture to
attain maximum rotundity, the bright parts must be much brighter than the rest of
the surface, the dark parts much darker. It's that simple."[39] Photographs enabled
Picasso to see how his sculptures took the light and how they would appear from dif-
ferent viewpoints—factors he never had to consider in his paintings.

Left: Picasso. *Bust of a Woman,* 1931. Bronze, 78 x 44.5 x 54 cm. Musée Picasso, Paris. Right: Brassaï. Photograph of Picasso's *Head of a Woman* (1931, bronze, 86 x 32 x 48.5 cm). Musée Picasso, Paris. © Estate Brassaï-RMN.

Some of Brassaï's most arresting photographs of the sculptures were taken at night. As Penrose reports:

> Working at night in the studio at Boisgeloup [Picasso] had first built up a very complicated construction of wire, which looked quite incomprehensible except when a light [presumably from the headlights of the Hispano-Suiza] projected its shadow on the wall. At that moment the shadow became a lifelike profile of Marie-Thérèse. He was delighted at this projection from an otherwise undecipherable mass. But he said, "I went on, added plaster and gave it its present form." The secret image was lost.[40]

Since the third and largest of Picasso's heads does not appear in Picasso's photographs, it must have been done later—possibly when he returned to Boisgeloup at the end of the summer or even the following year. However, since this head is so similar to its predecessors, it needs to be seen in their light. Arguably the artist's greatest sculpture, the third *Head of a Woman,*[41] is larger and nobler than the two others. Picasso was evidently determined that this was going to be a masterpiece—an advertisement for himself as a supreme modern sculptor. Although conceivably intended to be the cynosure of the upcoming Georges Petit show, the culminant head would not be ready in time. Brassaï's December 1932 photographs confirm that there was still work to be done on the neck.

Less overtly phallic than its predecessors, this phenomenal *Head* is indebted to two remarkable objects that Picasso had moved to Boisgeloup: a rhinoceros skull with two large horns, which, as he certainly knew, were prized as aphrodisiacs; and a massive Nimba fertility mask[42] that he had owned since before 1918.[43] He had installed it just inside the front door to the château as if on guard. Besides its awe-inspiring profile, the four-foot-high mask boasts a pair of pendulous breasts, flat as tongues. The shamanic power with which Picasso endowed his Nimba-inspired mask may have proved effective, to judge by Marie-Thérèse's pregnant belly in MoMA's all too famil-

Right: Picasso. *Head of a Woman,* 1932. Plaster and wood, 128.5 x 54.5 x 62.5 cm. Musée Picasso, Paris.

Below: Picasso's Nimba fertility mask, Baga culture of Guinea. Wood and iron, 126 x 59 x 64 cm. Musée Picasso, Paris.

Brassaï. Photograph of Picasso's *Head of a Woman* (1931, bronze, 50 x 31 x 27 cm). Private collection. © Estate Brassaï-RMN.

iar *Girl before a Mirror*.[44] Marie-Thérèse would not give birth until 1935, but Picasso's desire for a child might well be reflected in the fullness and repleteness of his Boisgeloup heads—the feeling that they are imbued with inner life.

Golding's apt comparison of the largest head's beak of a nose to "a crowing cock symbol from time immemorial of rampant male sexuality"[45] helps to explain a seemingly pointless snapshot of chickens pecking in the dirt. Picasso executed these sculptures to the accompaniment of squawks from the *basse-cour* and *roucoulements* from the doves in the dovecote behind the studio. Back in Boisgeloup earlier this fall or the following year, he would model a quintessential hen and a heraldic rooster.[46] The lowing of cattle in the fields—rented like the *basse-cour* to a local farmer—might account for the large bull's head[47] that Picasso would do around this time. These farmyard noises would have been new to the artist, who was city born and bred. Rural life was a total change from the city or the beach. Painting the countryside would never be his thing, but he relished the sounds and the smells and the earthiness.

Watch how a number of these photographs depict the creation of the great bas-relief of Marie-Thérèse in profile.[48] Picasso sets out to evoke the monumentality he was achieving volumetrically in a shallow space that limited him to a single viewpoint. To gauge how the light heightened chiaroscuro, he had the relief positioned outdoors at different angles. Plaster crumbs on the cobblestones confirm that adjustments were made on the spot. It is fascinating to watch Picasso reworking and darkening the area between eye and nostril, gouging out the cleft delineating the cheek and adding light-catching bulges to forehead and hair. Though small, these changes transformed an initially bland Maillolesque relief into a radical rethinking of a traditional form of classical sculpture. Besides checking the changes against photographs, Picasso evidently checked Marie-Thérèse's nose against his own—and decided she should have his. Two years later, he would do a smaller, more spontaneous version of this relief;[49] coils of wet plaster seemingly squeezed out of a tube give this profile the look of a large ear.

At the same time Picasso was working on yet another neoclassical portrait head of Marie-Thérèse.[50] He wanted to outdo Maillol—ironically, the first person to spot

that the Gertrude Stein portrait was derived from Ingres's *Monsieur Bertin*[51]—and he succeeded. The delicacy and precision with which the girl's head is tilted makes for a tenderness that is missing from the other sculptures. Picasso took the pose from a neoclassical plaster cast, still to be found, although pretty much wrecked, in the Boisgeloup studio. He has harkened back to the Mediterranean classicism of his youth, as exemplified by his sculptor friends Manolo, Pablo Gargallo, and Enric Casanovas. Indeed this head is remarkably close to the sharply chiseled heads of Casanovas.[52]

Another consideration: although Picasso had long ago internalized Marie-Thérèse's features, he had not yet done a representational sculpture of her and needed to reexplore the head of this straightforward girl in a straightforward, classical way. Allowances must also be made for the pleasure Picasso took in showing off his sculptural virtuosity, just as he showed off his graphic mastery in order to validate his more difficult modernist work and demonstrate his infinite technical superiority to academic detractors.

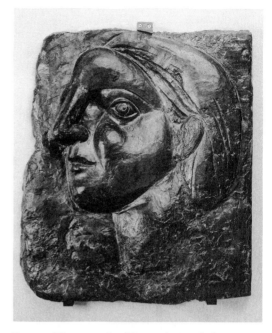

Brassaï. Photograph of Picasso's *Head of a Woman* (1931, plaster, 69 x 60 x 10 cm). Private collection. © Estate Brassaï-RMN.

Picasso also worked on four other plasters. One of them is a smallish, tentative head that appears for the one and only time in the background of some of the photographs. Dakin Hart discerns a distinct resemblance to Brancusi's *La Baronne* (1920),[53] which is perhaps why it did not survive. Another perplexing piece is a *modello:* a smallish seated figure in a traditionally masculine pose[54]—strong arms planted on strong thighs. Were it not for flattish breasts and a tiny head taken from the neolithic Venus de Lespugue, this figure could be taken for a man. This hybrid has nothing to do with Marie-Thérèse or Olga. The androgynous pose recalls Picasso's Gertrude Stein portrait, but she was short and sturdy and this figure has very long legs. Although it is the only failure of this triumphant summer, there is a particularly aggrandizing photograph of it. Hart has an explanation. He suggests that just as Picasso derived some of the distortions for the smaller of his two great heads, *Bust of a Woman,* from Matisse's radically pared-down *Jeanette V* (1916), he may also have wanted to go one better than another Matisse: the magnificent *Large Seated Nude* of 1917.[55] But this time he did not succeed. Usually a synthesizer of genius, Picasso was unable to get neolithic primitivism, Hellenic classicism, neoclassical mannerism, and Matisse to meld.

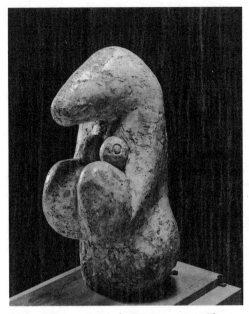

Right: Picasso. *Bust of a Woman,* 1931. Plaster, 62.5 x 28 x 41.5 cm. Musée Picasso, Paris.

Lastly, two other more abstract plasters both of which refer to Marie-Thérèse: the earlier one[56] confusingly entitled *Bust of a Woman* is yet another bid on Picasso's part to envision his mistress in the guise of his and her genitalia. Its brash, priapic look is reminiscent of the Isernian ex-votos, also of Brancusi's ithyphallic *Princess X* (1916).[57] The photographer Xavier Lucchesi has used an X-ray scanner to make a number of fascinating discoveries inside Picasso's sculptures.[58] Inside the *Bust of a Woman* he has found an armature consisting of a tangle of thick wire that has been fashioned into a stick figure. This find reminds me of the secret that MoMA's researchers discovered when they shined an infrared light onto Miró's early masterpiece *The Hunter (Catalan Landscape)* and found a print of Ferdinand and Isabella welcoming Columbus back from the New World carefully buried under the paint. The gauzelike stuff that Picasso has wrapped around the stick figure's waist gives it the look of a dancer in a tutu. Like Miró, Picasso was evidently having his own secret joke—Olga inside Marie-Thérèse. Though less spectacular, Lucchesi's other finds are nonetheless interesting in their revelation of Picasso's rough-and-ready methods. Some of the armatures consist of very large nails and screws bound together with wire in such a way that they resemble figures. As a result, three sculptures made of twisted wire illustrated in Spies's catalog can now be seen to have started life as armatures and were either not used or elaborated upon.[59]

The other at first sight nonfigurative piece—yet another *Head of a Woman*[60]—appears to have been prompted by the sight of Marie-Thérèse reading, as she liked to for hours on end, her head cradled in her hand, while Picasso worked. There are countless *carnet* studies for this piece,[61] where it is whittled down to four separate elements: a potato head with a penile excrescence of a nose, a bone-shaped forearm, a banana-shaped hank of hair and a small orb at the center—eyeball?—which holds everything together in precarious equilibrium. The only trouble with this piece is that over the last two decades Brancusi had been doing numerous variations on a very similar configuration. Brancusi did not keep his resentment to himself. He asked his friend the Romanian sculptor Jacques Hérold, "What's with this painter who is now making sculpture? He steals from me, he came [to my studio] to steal from me."[62]

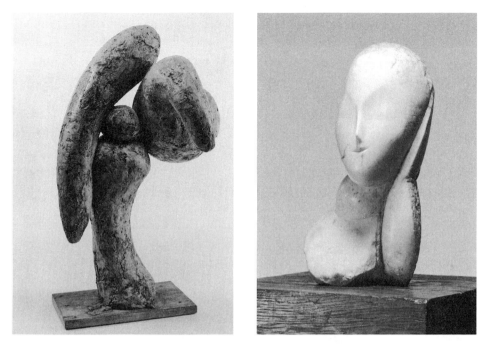

Left: Picasso. *Head of a Woman,* 1931. Plaster, 71.5 x 41 x 33 cm. Musée Picasso, Paris.
Right: Constantin Brancusi. *Muse,* 1912. Marble, 45 x 23 x 17 cm. Solomon R. Guggenheim
Museum, New York.

Difficult and mistrustful to a paranoiac degree, Brancusi had never liked Picasso.
For invading the sacrosanct field of sculpture, he disliked him even more. Their rela-
tionship had got off to a bad start. Circa 1908, Picasso had invited Brancusi to visit
his studio at a certain time on a certain day. The sculptor had showed up, but finding
nobody at home, left a note. The next day, an embarrassed Picasso knocked on Bran-
cusi's door. Asked to identify himself, he did. "I don't know you, sir," Brancusi said,
and slammed the door in his visitor's face.[63] After that, they barely spoke, except
behind each other's backs. Their mutual friend, Jean Cassou, remembered Picasso
comparing Brancusi, who was forever polishing his surfaces, to "a cleaning-woman
who spends all day polishing her pots."[64]

Sometime in 1929, Brancusi was prevailed upon—seemingly by González, in the
hope that the two sculptors he worked with would bond—to overcome his resent-
ment and allow Picasso to visit his studio. Picasso had recently (1928) done a draw-
ing of a plaster version of the ovoid *Beginning of the World,* which Brancusi had
given González.[65] He would certainly have seen Brancusi's photographs of his own
work—works of art in their own right—that had appeared in two recent issues of
Cahiers d'Art.[66] Nevertheless, Picasso was very eager to see the rival shaman's lair

and study the infinite variations that Brancusi had played on the egg and other basic forms. To judge by the studio photographs, Picasso still had difficulty grounding his pieces. Brancusi paid particular attention to this, setting his sculptures on the simplest and subtlest of plinths as well as on carefully contrived *socles* that became part of them.

It was rash of Picasso to help himself to Brancusi's *Muse* (1912)—a long-necked girl sometimes described as goiterous, with a hand up to her face—and use an almost identical pose for his *Head of a Woman.* He may have kidded himself that he was taking the idea a stage further, but in Brancusi's case that was virtually impossible. Brancusi was a perfectionist who took every work as far as it could be taken—technically, stylistically, and philosophically. No one ever succeeded in beating him at his own game. Picasso has given his *Head of a Woman* a brilliant parodic twist, but it lacks the integrity and the conviction of Brancusi's original.

Given his belief that art should be profoundly serene and joyful, Brancusi was anything but an admirer of Picasso or his work. He inveighed against his indulgence in the "tragic and dramatic,"[67] as the Swiss psychiatrist Carl Gustav Jung would a year later. Brancusi also disapproved of another of Picasso's fundamental characteristics—one that was all too familiar to the latter's fellow artists and friends—his habit of making off not so much with their ideas as with their energy. "Picasso is a cannibal," Brancusi said.[68] He had a point. After a pleasurable day in Picasso's company, those present were apt to end up suffering from collective nervous exhaustion. Picasso had made off with their energy and would go off to his studio and spend all night living off it. Brancusi hailed from vampire country and knew about such things, and he was not going to have his energy or the fruits of his energy appropriated by Picasso. Some of us—myself, for one—prided ourselves on having made a contribution, however paltry, to his work.

By the end of June, Picasso, who had taken his big heads as far as he could, was ready for a break. He had chores to do and people to see in Paris before leaving for the south in mid-July. There was also the sale of Breton's and Eluard's collections of tribal art at the Hôtel Drouôt, July 2–3, which he is likely to have attended. On July 3, Picasso had arranged to visit González, but took Olga to collect their new identity cards instead. On the fourth, Picasso was back at Boisgeloup doing engravings: rapes inspired by Ovid and self-referential scenes of a classical sculptor—as noble and meditative as the the Farnese Hercules—sitting with a model in his studio.[69] This series, which would ultimately include one hundred plates and occupy him for the next three years,[70] had been commissioned by Vollard, who had vowed to stop Picasso from defecting to Skira.[71] On July 11, Picasso attended the vernissage of

Paul Jamot's revelatory exhibition, *Degas, Portraitiste, Sculpteur* at the Orangerie: it was the first definitive show of this artist's work since his death, and it included a set of Degas's virtually unknown sculptures, which Hébrard had recently cast and sold to the Louvre. Among them was the little bust of Rose Caron with her hand up to her face—which would have reminded Picasso as well as Brancusi of their own renderings of a similar subject.[72]

Picasso never took much interest in Degas's paintings. He preferred the sculptures and above all the monotypes, some of which Vollard had used to illustrate *La Maison Tellier,* Maupassant's novel about a brothel's holiday outing. Twenty-five years later, Picasso coveted a small, sexually explicit monotype, from Maurice Exsteens's famed collection, which I had acquired. He was so captivated by it that I gave it to him; he went on to acquire several more monotypes from Exsteen's collection. Much later, they would inspire a series of brilliant brothel scenes. Many of these engravings feature an elderly artist who is drawing the girls at their work. Lines connect his eyes to his subject.[73] This voyeur is a curious hybrid: Picasso's painter father, who was addicted to whores, in the guise of Degas. "I like to improve people's circumstances for them,"[74] as the artist used to say of his earliest portraits of family and friends back in Barcelona. Over the next few years, Picasso would do exactly that for Marie-Thérèse and the reverse for his wife. Portrayals of the latter are often the more powerful.

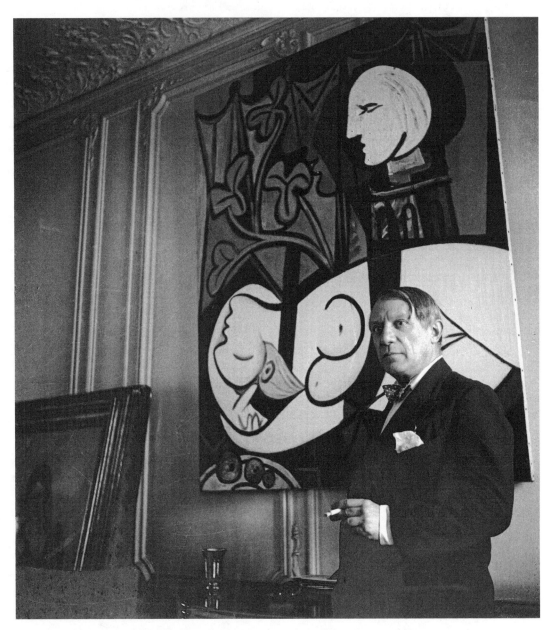

Picasso standing in front of his *Nude, Green Leaves, and Bust* (1932, oil on canvas, 164.4 x 132 cm. Private collection), rue la Boétie, 1932. Photograph by Cecil Beaton. Courtesy Sotheby's.

38

Annus Mirabilis II—The Paintings (1931–32)

On July 16, 1931, the Picasso family set off in the Hispano-Suiza for the Riviera. Since they intended to visit Gertrude Stein and Alice Toklas at Bilignin, as they had done the previous year, they took a roundabout route. A bill from the Hôtel Pernollet nearby at Belley confirms that they spent the night of July 16 there.[1] It was apparently on this occasion that

> Gertrude brought up the subject of Alice's needlework. "Alice wants to make a tapestry of that little picture," she said, pointing to one of his paintings, "and I said I would trace it for her." Picasso, of course, would have no one tamper with his work. ". . . If it is done by anybody . . . it will be done by me," he replied. Quickly, Gertrude places a piece of tapestry in front of him. "Well, go to it."[2]

Picasso was particularly fond of Alice and enjoyed teasing her. He designed two seat covers and chair backs for her to stitch.[3] One has a large, white, disembodied hand woven into the pattern so that anyone using the chair would, as it were, feel the artist fondling them. The other includes trompe l'oeil patterned wallpaper, a chair rail, and the corner of a frame, suggesting that the chair back is transparent. During the war, the Germans looted the footstool that completed the ensemble.

On this visit, Picasso had good reason to keep his hostesses happy. He wanted Gertrude to lend the finest of her paintings to his retrospective at the Galeries Georges Petit the following year. Gertrude was already at work on her *Autobiography of Alice B. Toklas;* and she welcomed the chance to mull over the past. The immensely readable, infuriatingly self-promotional account of their early years in Paris that Gertrude put into Alice's mouth would include embarrassing stories about Picasso's personal relationships and imply that he owed his fame to Gertrude rather than to her far more artistically perceptive brother Leo. When the book came out in 1933 it would be a best seller, despite a pamphlet included in an issue of the avant-garde magazine *transition,* in which Matisse, Braque, and other former friends accused Gertrude of flagrant inaccuracies.[4]

After leaving Bilignin, Picasso made a further detour, this time into Switzerland.

Above: Villa Chêne-Roc as it was when Picasso rented it, Juan-les-Pins, Antibes.
Monuments Historiques.
Right: Picasso. *Villa Chêne Roc at Juan-les-Pins,* 1931. Oil on canvas, 33 x 55 cm.
Musée Picasso, Antibes.

He was anxious to visit Dr. G. F. Reber at his Château de Béthusy in Lausanne. Reber had liquidated his magnificent post-impressionist collection—among much else it had included twenty-eight paintings by Cézanne—in order to assemble the world's most comprehensive collection of cubism and also the world's largest collection of Picasso.[5] The artist hoped to persuade Reber to lend major works to next year's retrospective. Since the collector's speculations on the Paris Bourse were souring, he agreed. Most of his loans to the show would be discreetly for sale.

After a couple of days including a luncheon in their honor at the Château de Béthusy, the Picassos made their way slowly to the Riviera, where they rented a villa at Juan-les-Pins for the month of August. It was across the road overlooking La Vigie, the castellated house they had rented in 1924. Picasso's paintings of the Villa Chêne-Roc depict a wedding-cake baroque mansion, with a grandiose flight of balustraded steps leading up to it. As a contemporary photograph reveals, it is in fact a charming, smallish house with a high raked roof like a chapel, balustraded balconies, and a skimpy flight of steps. To upgrade its appearance, Picasso aggrandized the steps with dramatic volutes; these features appear not only in paintings of the house but in paintings of Marie-Thérèse. Her massive volute-like arms reach out to gather the viewer into her architectural embrace.

For the first week or so at Juan-les-Pins, Picasso relaxed, mostly with Marie-Thérèse, who was installed in the neighborhood, with one of her sisters to keep her company.[6] They spent much of their time on the beach. The Murphys were no longer around—they had rented the Villa America and taken their sick son to the United States—so Picasso could take the girls to the beach at La Garoupe without fear of detection or distraction.

On August 2, Picasso resumed drawing the same classical sculptor-and-model

subjects he had been doing at Boisgeloup.[7] Two days later, he executed a heavily worked variation on this theme.[8] The balustrade and palm fronds outside the window are true to Chêne Roc. Inside the villa, a bearded, bare-chested sculptor is working on a reduced version of a life-size statue conceivably of Galatea in a state of metamorphosis. Picasso teasingly leaves us in two minds as to whether his Galatea is flesh or plaster. Partially hidden, crouching at his knee, Marie-Therese is rendered in chiaroscuro hatching of utmost delicacy. Later in the month he did a couple of oil sketches,[9] similar in subject, but nothing like as evocative as the drawing in which he transports himself back to Antipolis.

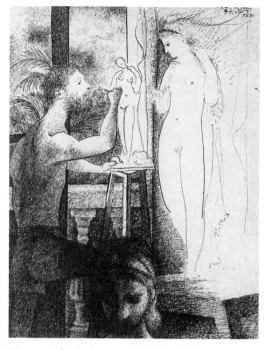

Picasso. *The Sculptor and His Model,* August 4, 1931. Pen and India ink on paper, 32.4 x 25.5 cm. Musée Picasso, Paris.

After a few more drawings in this vein,[10] Picasso did a number of sketches for the sculpture of a reclining figure,[11] which he had been planning for months and would finally realize on his return to Boisgeloup. And then, on Sunday, August 16, he turned his attention to a subject entirely new to him. A forest fire had broken out in the hills back of Mougins and Vallauris[12]—an area where Picasso would spend his last twenty-five years of life. The spectacle of the façade of the Villa Chêne-Roc against a starlit night sky obscured by flames and smoke excited him. Between August 15 and 23 he did five colorful paintings—only one a daylight view—of the fiery scene.[13]

At the end of August, Picasso and his family returned to Paris via Bilignin, once again to see Gertrude and Alice, who enjoyed fussing over Olga. Their stay was brief and wet—so much rain that a swan had ended up in Gertrude's garden. The day after they left, Gertrude wrote Picasso that she was worried about his leg—probably sciatica—and suggested he visit a Dr. Crosset, who would see there would be no recurrence.[14] Their on-again, off-again friendship appeared to be as close as ever; in fact, the dynamics of it had totally changed.

In earlier days, Gertrude's understanding of Picasso's work, such as it was, had depended on her involvement in his life as well as with the women in his life. Picasso had never told Gertrude about Marie-Thérèse, let alone introduced them. In revenge, Gertrude, who certainly realized what was going on, wrote off the entire period with which this girl is identified.

From 1927 to 1935 [Gertrude wrote in her 1938 book on Picasso] the souls of people commenced to dominate him and his vision . . . lost itself in interpretation. . . . in these years . . . for the first time, the interpretations destroyed his own vision so that he made forms not seen but conceived. All this is difficult to put into words but the distinction is plain and clear, it is why he stopped working. The only way to purge himself of a vision which was not his was to cease to express it, so that as it was impossible for him to do nothing he made poetry.[15]

Gertrude's emphasis on the dates of Marie-Thérèse's reign are a giveaway. With no link to Picasso's mistress, she decided she had no obligation to like his work. And so in her ruthless self-centrism, Gertrude denounced his most innovative period since cubism, and in doing so disqualified herself as a champion of his art. The reason for her negativism—lèse-majesté—would indeed have been "difficult to put into words." By the mid-1920s, Gertrude's inner bell, which had once upon a time rung only for genius, now rang only for duds like Sir Francis Rose.

On his return to Boisgeloup, Picasso set about realizing his long mulled-over plan to extend the plaster of Marie-Thérèse with the hand up to her head into a full-length, reclining figure consisting of separate elements. Drawings in a sketchbook confirm that as early as May 26–27,[16] he had contemplated adding a boomeranglike torso, which would have transformed the pose into a curvaceous crouch—a pose he conceptualized from different angles. Later in the same sketchbook, Picasso elongates the body to its fullest extent by adding legs as well as arms and testicular looking buttocks. This would be the prototype of the piecemeal reclining nude sculpture that he now began to work on. A photograph of Olga in a bathing costume on the beach clutching an inner tube—very like a figure in one of the drawings—confirms that Picasso had no compunction about mixing up his women's attributes.

Picasso's penchant for dismemberment and reattachment had manifested itself the previous December in drawings in which he redistributes body parts as if he were redesigning humanity. Hands emerge from necks, heads from ankles, a conjoined pair of amputated legs clutch a disembodied arm. Just as he had jolted us into seeing eyes and noses anew by repositioning them in his paintings, Picasso was now ready to go even further and do sculptures that could be dismantled and reassembled in different ways. As he said, he loved displacing things: "To put eyes between the legs, or sex organs on the face. To contradict. To show one eye full face and one in profile. Nature does many things the way I do, but she hides them."[17]

Another possible reason for Picasso's interest in dismemberment: from earliest childhood, he had been aware that disembodied limbs had played a memorable role

in one of the most celebrated events in Málaga's history. This had taken place in 1487, during the reconquest of Spain by the Catholic kings, in the Moorish castle of the Gibralfaro and the Alcazaba, whose ruins had served as Picasso's playground. In the rubble of what had once been hanging gardens, Gypsy kids had taught him how to smoke a cigarette up his nostril, as well as the rudiments of flamenco. Sabartès remembered Picasso describing how beggars and Gypsies used to sit "delousing one another in the sun among the whiffs of orange flower and drying excrement and children up to the age of twelve ran naked."[18]

In his book *Islamic Spain,* Professor L. P. Harvey recounts what had transpired at the Gibralfaro:[19] a venerable hermit called Ibrahim al-Jarbi had had a vision in which Allah instructed him to proclaim a jihad. Putting himself at the head of four hundred adherents, he advanced on Málaga's Gibralfaro, where the King and Queen were encamped with a retinue that included Don Alvaro of Portugal and his wife, Doña Felipa. After contriving to be captured in the course of the attack, Ibrahim asked to be taken to the King and Queen; he had a secret that he would divulge only to them.

The King was having a siesta, so the venerable hermit was taken instead to Don Alvaro, who was playing chess with his wife. Ibrahim did not understand Castilian. Mistaking the richly arrayed Don Alvaro for the King, the holy man lunged at him with a sword hidden in his garments, wounding him severely. Doña Felipa's screams for help alerted a treasury official who subdued the holy man. Ibrahim was subsequently cut up by the King's retainers. The Spaniards catapulted bits of Ibrahim's dismembered body back at the Moors occupying the city, with the message, "There you have him—he came on land and we are sending him back by air." The Moors "collected the remains of Ibrahim, sewing him together with silk thread, washing them with scented water, and they made a shroud for the body. With weeping and sadness, they buried him."[20]

Gijs van Hensbergen—author of an excellent book on the Spanish roots of *Guernica*—believes that the dismemberment of Ibrahim al-Jarbi's body inspired some of *Guernica*'s imagery.[21] A fascinating insight, but Ibrahim's story is also relevant to Picasso's *Reclining Figure:* a sculpture "originally made in separate pieces." Picasso told Penrose "that he had wanted to move the pieces around—arms and breasts, head and body, leg-leg—But when cast in bronze, they were fixed together."[22] Brassaï's photograph of the *plâtre originale,* taken a year later, reveals that there were indeed two separate sections divided at the waist. These are what the caster "fixed together." Ironically, it would be Henry Moore, a sculptor Picasso never much liked, who took over the idea and, a few years later, started chopping up his reclining figures.

In the wake of the Matisse-Picasso show, discussed in the previous chapter, this

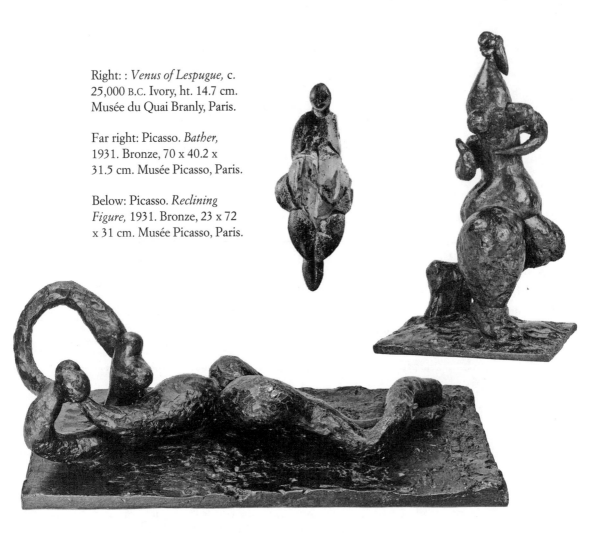

Right: : *Venus of Lespugue,* c. 25,000 B.C. Ivory, ht. 14.7 cm. Musée du Quai Branly, Paris.

Far right: Picasso. *Bather,* 1931. Bronze, 70 x 40.2 x 31.5 cm. Musée Picasso, Paris.

Below: Picasso. *Reclining Figure,* 1931. Bronze, 23 x 72 x 31 cm. Musée Picasso, Paris.

Reclining Figure has inevitably been seen, with some justice, as a response to Matisse's *Blue Nude (Souvenir of Biskra)* (1907)[23] and the succession of bronzes of reclining figures in a similar pose that he did over the next two decades. No doubt about it, Picasso "rummaged through Matisse's catalogue of sculptural forms— seated nudes, reclining nudes and heads—in a bid to go one better,"[24] but Matisse is only part of the story. In his *Reclining Figure,* Picasso pits himself against all the reclining nudes in history from antiquity onward, not just the Ariadnes and Artemises of the Hellenistic tradition, but their progeny in works by Titian and Rubens, Ingres, Courbet, and Renoir, as well as Matisse. Picasso's astonishing visual memory and digestive powers enabled him to assimilate all the above and "create and populate an alternative Picassian antiquity."[25] *Reclining Figure* thus constitutes a supremely important Picassian synthesis, which would help to shunt the classical rendition of figural sculpture onto a new modernist track.

Back at Boisgeloup, summer memories of Marie-Thérèse and her sister frolicking on the beach prompted four playful, plaster figures,[26] which appear to be moving—a total change from the earthbound stasis of his Boisgeloup sculptures. To simulate the effortless friskiness of his Dinard pictures, Picasso has simply given these little plasters a rhythmic twist so that Marie-Thérèse and her playmates can cavort three-dimensionally, just as they did two-dimensionally at Dinard. The larger of these *Bathers* reveals how, in quest of movement and getting, as Leo Steinberg puts it, "recto and verso to cohabit,"[27] Picasso has resorted to classical contrapposto, as exemplified by the Callipygian Venus he had admired in the Naples Museum. Contrapposto gives his figure a spiral twist that is almost futurist. Protuberances below the neck can be interpreted as either breasts or rudimentary arms. As well as exploring contrapposto in plaster, Picasso would explore it in the elegiac engravings of the *Vollard Suite*—meditations on a sculptor's complex feelings for his model and his work in the light and shadow of Galatean ambiguity—which would preoccupy him over the next two years.

The light-footed dancer serves as a tryout for a culminant *Bather* sculpture. Notwithstanding its bottom-heaviness—her huge feet stuck in the wet sand as she struggles out of the sea—this sculpture has the same callipygian twist as the *modello.* Back and front twirl into one. Its eerie little head, which derives from the Venus de Lespugue, suggests that this piece is a fertility symbol. Compact as a *netsuke,* the head makes the body look larger than it is, and endows it with a mythic presence. Despite its bulk, this figure—like one of those fat girls who turn out to be nimble dancers—indubitably has rhythm.

Picasso then sets sculpture aside for a year or so and returns to his easel. The first manifestation of this is a large still life done on September 22, of a square-handled jug alongside a corny arrangement of flowers in a vase that looks like an inverted straw hat;[28] however, for once the irony, which usually redeems Picasso's kitschy flower arrangement, is missing. In this work Picasso returns to the charcoal-on-canvas technique, which he would use to great effect over the next few years. The rough nub of canvas proved an ideal surface for black chalk, charcoal, and on occasion sanguine.[29] This technique allows the artist to do monumental drawings in which graphic precision is played off against a web of misty, out-of-focus contours.

On October 25, 1931, Picasso had to face the fact of his fiftieth birthday. For someone so fearful of mortality and so conscious of all he had to achieve, this anniversary must have been an enormous challenge. Skira celebrated the occasion with a party, ostensibly in honor of the new edition of Ovid's *Metamorphoses,* which the artist had finished engraving (all but the half-page illustrations) exactly one year

earlier. Picasso was delighted with the book as well as with the hyperactive Skira, who would remain a friend for life. Ovidian allusions would surface in many of the paintings he was about to start on for next year's retrospective. Picasso hoped that besides establishing his supremacy as a modern master, the Herculean bouts of painting and sculpture engendered by his fiftieth birthday would somehow keep age and death at bay.

The initial work in what would turn out to be one of the most sustained creative feats of his career is an allegorical self-portrait dated December 7.[30] Picasso portrays himself in his new role as a Hellenistic sculptor taking his ease in his studio, wiggling his toes, twiddling his fingers as he contemplates his recent work: a crouching nude and a large head of Marie-Thérèse. She is also the subject of a tiny framed painting hanging behind his head. Note how the superstitious artist holds his fingers up to his face "horned" against the evil eye; and how he bisects his head—half shadowy painter, half classical sculptor. Even his legs and arms are different colors. As Picasso would explain to Françoise Gilot some fifteen years later, when showing her a similar subject in the *Vollard Suite:*

> "[The artist is] a little mixed up. . . . He's not sure of which way he wants to work. Of course if you note all the different shapes, sizes, and colors of models he works from, you can understand his confusion. He doesn't know what he wants. No wonder his style is so ambiguous. It's like God's. God is really only another artist. He invented the giraffe, the elephant, and the cat. He has no real style. He just keeps on trying other things. The same with this sculptor. First he works from nature; then he tries abstraction. Finally he winds up lying around caressing his models."[31]

Picasso had continued to conceal Marie-Thérèse from the world in his paintings as well as in his life, but that was about to change. That Olga was almost certainly aware of her existence made concealment less necessary; however, she still made terrible scenes and occasionally had to be sedated. Picasso's thoughts began to turn to divorce,[32] with a view not so much to marrying Marie-Thérèse, Picasso told his wife Jacqueline, as to ridding himself of Olga.

The first of the new portrayals of Marie-Thérèse—identifiable though not always recognizable—that Picasso painted for his retrospective the following June was *The Red Armchair* (Art Institute of Chicago).[33] Dated December 16, it is executed on a panel in oil paint and Ripolin, and is as far removed from sculpture as possible. The image is flat and stylized as a playing card, the face as lunar as the man in the moon's. To temper the hieratic look of this very unhieratic girl, Picasso wraps her in a fur tippet that doubles as her arms and ends comically in twin white tails sug-

gestive of fingers. This time the red armchair that had rat-trapped Olga looks positively benevolent.

For Picasso, as for most Spaniards, Christmas was not a major festival (the January 6 feast of Three Kings takes precedence), but as a dutiful father, he was obliged to celebrate it. He was in a far from festive mood. One of Olga's hemorrhage-related crises was about to trigger what is perhaps his cruelest exorcism of her: *Woman with a Stiletto*.[34] On December 19 Picasso had begun his blood-soaked reenactment of Charlotte Corday's assassination of Jean-Paul Marat, while the revolutionary demagogue revered as *l'ami du peuple*[35] was soaking in his bath. The subject derives from Jacques-Louis David's iconic portrayal of the event: a painting that Picasso greatly admired.[36]

To distance himself as far as possible from David's secular Crucifixion, Picasso came up with an image that is all the more harrowing for being crass and caricatural. At first sight, *Woman with a Stiletto* looks like a large rough sketch. Marat has the same minute head and body as the self-referential Christ in his *Crucifixion*, painted almost exactly a year before. Besides being stabbed in the heart, the Marat/Picasso figure is about to be snapped up in Corday/Olga's toothy maw. Picasso takes the same preposterous liberties with scale that he took in the *Crucifixion*. The disproportionately large leg and foot (bottom center) belong to the otherwise minuscule Marat. Their odd shape may stem from the weird-looking bath in which Marat was actually murdered. This was no Davidian sarcophagus: it was a therapeutic contrivance shaped like a huge boot that alleviated the appalling skin disease—incessant itching and peeling—that Marat had contracted while a fugitive hiding in the sewers. Anecdotal details are all Picasso took from David: the letter from Corday that Marat holds in his hand and the governmental report that he had been reading.

The bloodstains in the David are very discreet; Picasso serves up oozing gobs of vermilion gore which end up as the red in a tricolor flag. This grotesquely farcical approach suggests that for Picasso demonic mockery was the most effective way to exorcise Olga's murderous threats.[37] Better that he should purge himself of his wrath on canvas rather than on her. Meanwhile, he had to celebrate Christmas *en famille*. When they split up in 1934, Picasso would do an even more fiendish drawing of the murder of Marat.[38] This time round, a maniacal Olga is cutting Marie-Thérèse's throat with a gigantic knife.

Picasso finished this *Woman with a Stiletto* on Christmas Day. While he was working on it, Olga had been busy arranging an elaborate tea party for Paulo and his friends as well as the Picassos' inner circle—in an effort, perhaps, to demonstrate what a united family they were. The party would take place on December 30 and, surprisingly, at Boisgeloup. Olga's memo has survived.[39] Presents included sixteen

dolls, seventeen toy cars, eight ducks, ten fountain pens, fourteen necklaces, cotillion favors, and candy. Her guest list was equally meticulous: four boys, four girls, eighteen adults, among them the André Levels, the Kahnweilers, the Lascauxs (Bero Lascaux had become and would remain very close to Olga), Zette Leiris (Michel was in Africa on the Dakar-Djibouti Ethnographic Expedition), the Ortizes, the Pellequers, Gertrude Stein, Alice Toklas, Vollard, and Lifar. How the unheatable château was heated for the occasion, we do not know.

The catharsis of portraying Olga as Charlotte Corday left Picasso all the readier to adulate Marie-Thérèse. Three days later, he did a languorous, loving painting of lilac-skinned Marie-Thérèse asleep, her head cradled in flipperlike arms.[40] On December 30, the day of the Christmas party, Picasso found time to turn her into a swirl of arabesques:[41] a lunar octopus, which reminds us that he had associated her with the phases of the moon the previous summer. By January 2, Marie-Thérèse's moon face is full, her eyes stare us down.[42] The fuzzy print in the open book that this moon goddess clutches in her anaconda arms signifies pubic hair. Over the next three weeks, Picasso produced a succession of large (size 100) Marie-Thérèses, dozing in a chair with a red leather back, studded with brass nails.[43] Some of these paintings flew off the artist's easel rather too easily.

In the course of this series, Picasso comes up with some bizarre substitutes for Marie-Thérèse's arms. Flippers, tentacles, and snakelike coils eventually give way to the baroque balustrades he had dreamed up for the Villa Chêne-Roc. Volutes swell out at us, as they did in paintings of the villa, except that they end in large bearlike paws. They generate monumentality and volume. In another mid-January painting, *The Sleeper and the Mirror,* Picasso borrows a mirror from a 1916 Matisse[44] and contrasts Marie-Thérèse with her own reflection. The right breast mimics an erect penis; the left one droops postcoitally. Picasso has likened her face to a palette daubed with black, as if to embed her in his paint.

If we obey the artist and interpret his work as a diary, it would appear that Olga suffered a further attack in mid-January. Once again, catharsis was called for. On January 22, Picasso executed the first of three sizable paintings—one a day for three days—to which, exceptionally, he gave thematically linked titles. *Repose (Le Repos),*[45] the title of the first and most violent of the paintings, is ironical; it depicts Olga in the throes of hysteria. The pose—hands linked over her head in the fifth position—mocks Olga's balletic past as well as her psychological and physical state, just as the *Large Nude in a Red Armchair* had done so memorably in 1929.[46] Once again, the armchair, which Picasso portrays as friendly or inimical, depending on the occupant, wraps itself around her like a shroud. Olga's hair, which she now dyed black, is rendered as if it were as short, straight, and stiff as the teeth of a comb; Marie-Thérèse's chignon in the next two paintings is floppy and yellow.

Emptied of rage, Picasso is at his most loving in the second of these three allegories, *Sleep (Le Sommeil),*[47] which depicts Marie-Thérèse naked and asleep in a friendly armchair. A self-congratulatory inscription on the stretcher—"executed between three and six o'clock on January 23, 1932"—suggests the time frame of one of Marie-Thérèse's naps. Picasso has wickedly used the circular swoop of the arms and the positioning of his hysterical wife's head and breasts in *Repos* to evoke the true repose in this portrayal of his mistress. The next day, Picasso executed the third painting, the celebrated *Dream.*[48] The wallpaper pattern, which staggered off the wall in *Repose,* keeps its place in the *Dream,* and its darker, denser colors evoke the workings of the subconscious every bit as effectively and much more economically than Dalí. Picasso's transformation of the dreamer's thumbs and forefingers into a vaginal image, and her forehead into a penile one, confirms that sex is on her mind as well as between her legs. The *Dream* has become one of Picasso's most popular images; sadly, the record prices it fetched in 1997 and 2006[49] and its renown as a tourist attraction at a Las Vegas casino have left this painting so sullied that it is difficult to judge it on its merits.

The wallpaper, which sets the mood of these paintings, is evidently one that Picasso knew well. A small oil sketch of the bedroom in the fancifully decorated love nest he had rented was papered with it.[50] Apart from its first feverish appearance in *Repose,* where it mirrors Olga's manic state, the wallpaper mirrors Marie-Thérèse's passive tranquility. If Picasso sometimes uses the mistress's sign for the wife and the wife's sign for the mistress, it is because he preferred confusing the viewer to spelling things out for him. Whereas Matisse, from whom Picasso supposedly borrowed his patterned backgrounds, uses patterns decoratively, Picasso uses them dramatically to establish a mood and characterize the woman in the picture. Whereas Matisse's models have the air of still-life objects, Picasso's still-life objects have the air of women.

That Picasso's thoughts reverted briefly to sculpture—conceptual sculpture—at the end of January emerges in two paintings of a naked Marie-Thérèse, seated in a red armchair, composed of separate biomorphic elements, stone colored and stone shaped.[51] Ovid was still on his mind, specifically the legend of Pyrrha and Deucalion, whose stones turned into men and women. The black backgrounds, against which Picasso sets his Pyrrha figures, evoke primeval darkness. The head of the first of them derives from one of his drawings after Grünewald, the head of the other from Brancusi. Although they correspond to the artist's pictorial concept of Marie-Thérèse, these formidably mythic paintings cannot be said to reflect Picasso's love or desire for her as much as an urge to deconstruct her and re-create her merging with the fateful armchair.

Exhausted from doing monumental paintings at the rate of almost one a day for the previous six weeks, Picasso lay fallow for most of February. The one major work

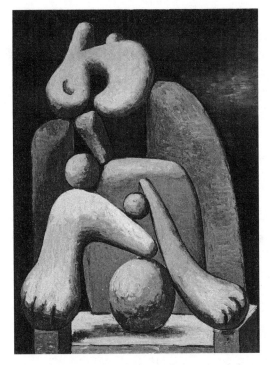

Picasso. *Woman in a Red Armchair,* 1932. Oil on canvas, 130 x 97 cm. Musée Picasso, Paris.

of this month is a no less passionate evocation of his love for Marie-Thérèse in the form of a voluptuous guitar and fruit dish set against the usual wallpaper, this time painted a vivid red in contrast to the yellow of the guitar.[52] On a visit to Cooper, who used to own the painting, Picasso observed that red and yellow were the colors of the Spanish flag. Might Alfonso XIII's exile the previous year have boosted his patriotism? (His mother's first cousin, General Picasso, had helped lay the groundwork for the King's removal, as explained in the Epilogue.)

The next group of Marie-Thérèses takes an allegorical form: a plaster head of her set on a plinth paired with flowers and fruit that likewise stand for her. In the first of this fresh batch, dated March 2,[53] the plaster head confronts the kitschy basket of flowers left over from the charcoal-on-canvas still life of the previous September. By contrast, the following day's painting is a triumph:[54] Marie-Thérèse's plaster head gazes at a bowl of peaches as intently as if it were her face in a mirror. A palette hanging from a nail establishes that the setting is the studio and not the Left Bank love nest. Picasso liked to signal a locality, he also liked to make his presence or his absence felt.[55]

Two of the most memorable paintings of this memorable series date from March 8 and 9. In the first, *Nude, Green Leaves, and Bust,*[56] the plaster head looks down on the live Marie-Thérèse, sleepily proffering her naked body to another image of herself. The philodendron plant and decorative hanging—into which a shadowy profile has been worked—identify the setting as the Left Bank apartment, though it was not necessarily painted there. In a second, even more remarkable version, *Nude in Black Armchair,*[57] painted the following day, the plaster head has gone, so has the decorative hanging. The philodendron plant now issues from a cleft in Marie-Thérèse's body. No less metamorphically, one of her hands is turning into a lily—a Daphne no longer in flight. *Nude in Black Armchair* is the most consummately romantic image of the series.

The lily owes its appearance to the magnified photographs of natural phenomena by the German art teacher Karl Blossfeldt.[58] Some of these had appeared in the third issue of *Documents* (1929), with a commentary, "The Language of Flowers," by Bataille. The

writer had no time for "art photographers"; he admired Blossfeldt's plates for reminding us, as Picasso sometimes does, that "even the most beautiful flowers are spoiled at the center by hairy sexual organs."[59] Sketches done later in the year suggest that the artist contemplated further use of Blossfeldt's photographs to give Marie-Thérèse an even more organic look.[60]

In the next two paintings, the trellis-patterned wallpaper dominates the composition. Marie-Thérèse's pose in *The Mirror*[61] (March 12) enables Picasso to play off the swirl of her breasts against her gorgeous buttocks in a mirror—one of those old-fashioned looking glasses, known in France as a *psyché*. This time, the blue and green of the wallpaper gives the bedroom an ethereal look. The following day, he took a rest from color and did two sublime charcoal-on-canvas drawings of a sleeping Marie-Thérèse, in which Picasso combines the back and front of his nude to callipygian perfection.[62]

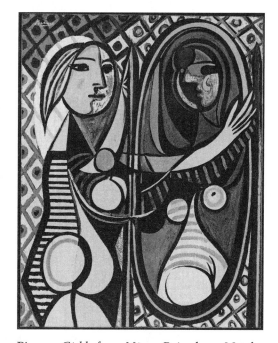

Picasso. *Girl before a Mirror,* Boisgeloup, March 14, 1932. Oil on canvas, 162.3 x 130.2 cm. The Museum of Modern Art, New York. Gift of Mrs. Simon Guggenheim.

Two days later (March 14), Picasso further explored the dramatic possibilities of the *psyché* in MoMA's celebrated *Girl before a Mirror,*[63] a standing Marie-Thérèse, reaching out as if to embrace her mirror image. The lower half of this painting is taken up with side and frontal views of her bulging, conspicuously empty uterus. This suggests that Marie-Thérèse was or had been pregnant, and may have had a miscarriage.[64] It might also signify that the painting is a fertility symbol: Picasso wanted her uterus filled. Not that there is any evidence for these suppositions. When Marie-Thérèse did become pregnant in 1935, Picasso was not altogether pleased. He relished the idea rather than the fact of having children. Also, by that time his feelings for Marie-Thérèse were beginning to wane; he was about to leave her for someone else.

The inordinately exalted place that *Girl before a Mirror* has come to occupy in the eyes of scholars as well as the general public has always mystified me. This set piece is not in the first ten or even twenty of MoMA's Picassos. And yet Rubin claims in his catalog of the museum's collection that this work is this great museum's "emblem": "the balance and reciprocity of the expressive and the decorative here set a standard for all Picasso's subsequent painting—indeed, for twentieth-century art as a whole."[65]

This overweening claim belittles many of MoMA's far greater works. As Picasso

observed on more than one occasion, the culminant painting in a series, as *Girl before a Mirror* is usually thought to be, is seldom the best. "The penultimate one is almost always the strongest."[66] Once all the problems are solved, a painting ceases to live. None of Cézanne's finest paintings is "finished." *Girl before a Mirror* is a case in point. Compared to most of its predecessors, it is overworked and academic, which is perhaps why academics including Barr have thought so highly of it. The *cloisonnisme* is too constricting; the trellis wallpaper is too tight and busy to work its magic; hence there is no trace of what Braque called *poésie*. If any of this sequence of paintings sets a "standard for all Picasso's subsequent painting," it is *Repose*—the artist's rage at his wife's hysterics and maybe at women in general electrifies every brushstroke.

On March 17 (1932), three days after signing *Girl before a Mirror*, Picasso invited Kahnweiler to come to the rue la Boétie and see what he was working on. As Kahnweiler wrote Leiris, who was still driving across Africa:

> Yes; as you say, painting is really sustained by Picasso: and so wonderfully. We saw two paintings at his place which he had just finished. Two nudes, perhaps the most moving things he's done. "A satyr who had just killed a woman might have painted this picture," I told him. It's neither cubist nor naturalist. And it's without painterly artifice: very alive, very erotic, but the eroticism of a giant. For years Picasso hasn't done anything like it. He had told me a few days before, "I want to paint like a blind man, who does a buttock by feel." It really is that. We came away, overwhelmed.[67]

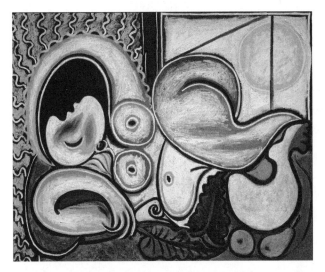

Picasso. *Reclining Nude* (day), April 4, 1932. Oil on panel, 130 x 161.7 cm. Musée Picasso, Paris.

Toward the end of March, Picasso drove to the Normandy coast—to Pourville, whose light he claimed to have caught.[68] He wanted to see Braque, who was about to celebrate his fiftieth birthday and had finished building his house at Varengeville. On his return to Paris, Picasso executed several paintings (dated March 25–26) of a woman in a deck chair on the beach.[69] A large pale sun in a wan greenish sky confirms the locale as Normandy. The Varengeville *plage* was difficult to access, so Pourville is more likely to have been the setting for Picasso's *Bathers*. Braque's *Bathers*—boomerang-

shaped shadows overpainted with the free-form outline of a body—were not force-ful enough to propel the artist back to the forefront of the avant-garde. He needed his old friend's help. For his part, Picasso still fantasized—and would continue to do so until the 1950s—that he and Braque could reestablish their former partnership. There was also something that Picasso needed from Braque, something that nobody else could provide—his light. When Picasso told Zervos that the light in his Pourville paintings differed from the light in his Dinard paintings, it was Braque's light that he had in mind: the charcoal-colored skies, the coffee-colored beaches, and the eerie-colored sea—so unlike the light of the Mediterranean—of his recent sea-side paintings.

Partly, I suspect, to rekindle the flame that had died out twenty years earlier, Picasso proceeded to deconstruct one of the beach compositions that Braque had been working on for the previous year or so and demonstrate how *he* would have done it. Between March 26 and 29 he painted six variations on this theme. To give his bather a touch of surreal eroticism, Picasso has helped himself to an airborne pair of conjoined legs from Max Ernst's *Les Hommes n'en sauront rien*[70](1923), stuffed them into black tights and shoes with Cuban heels, and set their malign silhouette hovering over or under the deckchair—Olga! (That deckchairs have a two-dimensional as well as a three-dimensional function fascinated Picasso.) The second of these *Bathers* paintings was instru-mental in transforming a budding surrealist, Roland Penrose, into an obsessive admirer of his work. Hence his acquisition of this painting.[71]

Now that spring had returned to Boisgeloup, Picasso finally got around to painting the place, not the château itself, but the courtyard with its chapel, gateway, and stables, as well as the village houses beyond the walls.[72] Easter was very wet that year; most of these views are striated with driving rain—an effect that van Gogh had borrowed from Hiroshige—otherwise they are surprisingly pro-saic. Gone is the pride in ownership to be found in Picasso's first images of the rue la Boétie apart-ment, or of the Riviera villas he had rented.

Inscriptions on the stretchers of his April and May canvases confirm that Picasso spent most of this spring at Boisgeloup. While the wife stayed in Paris during the week looking after Paulo, the mis-

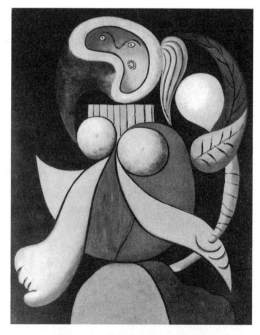

Picasso. Woman with a Flower (night), April 10, 1932. Oil on canvas, 162 x 130 cm. Private col-lection. Courtesy Galerie Beyeler, Basel.

tress would move into the château. Weekends, she would go home to Maisons-Alfort, and Olga would take over again. She would come down with Paulo and his English governess and, possibly, additional help. Domestic chores were not Olga's province. Picasso's impersonation of a country gentleman was mitigated by self-mockery. He enjoyed playing the role, impeccably disguised in tweed suits, some-times going as far as wearing spats and plus-fours and a waistcoat complete with watch chain. Out of doors, he would sport one of the hats he had bought in London. In public, Picasso would match his behavior to his costume. Snapshots taken over these weekends make it clear that when a nanny or governess was around, or friends came to visit, family life at Boisgeloup could not have been more conventional. Paintings tell a very different story.

Meanwhile, Marie-Thérèse, in one emblematic form or another and the lilac color Picasso associated with her, continued to be the principal subject of his work. Two of the last of this spring's paintings take the form of contrasting allegories—day and night. The allegory of day (April 4) portrays a roly-poly sexpot[73]—volumetric but-tocks aloft, curlicue arms and flipper legs awrithe. The source of light is a large, pal-lid northern sun outside the window. Indoors, it is hot. The sizzle of the girl's body is spelled out in cartoonists' shorthand: frizzy lines of heat radiating from her arms and breasts. The leaf in her hand serves as an organic fan, while another larger one shades her right thigh and doubles as a vagina. Besides allegorizing day, this painting pokes fun at Matisse. Picasso wants to show him how he would have done it.

In the allegory of night (April 10),[74] Picasso floats the girl's disconnected body parts—the lilac volute of her arms and her pneumatic breasts—as well as a large, white balloon, the moon of course, in a sky of intense darkness. Once again Marie-Thérèse holds a leaf, a crescent-shaped one, rising heavenward like everything else in this painting. The lusty daytime girl has turned into a fearsome queen of the night. Dotted eyes and a toothy little mouth suggest Olga, but the quiff of blond hair and the striped blouse tag her as Marie-Thérèse. Jung would pick up on Picasso's binary approach to night and day when he saw these paintings on exhibit in Zurich: "As the day is woman to [Picasso], so is the night; psychologically speaking, they are the light and the dark soul (anima)."[75] This pair of allegories and two equally large, rather more decorative paintings of Marie-Thérèse in profile bring this phenomenal succes-sion of some thirty major works to a close. Now Picasso had to decide how best to show them at his upcoming retrospective.

39

Paris and Zurich Retrospective (1932)

At the end of April 1932, Picasso's mother and brother-in-law, Dr. Vilató, arrived in Paris to give depositions in preparation for the upcoming case against Calvet and Madame Zak.[1] Although the artist was still sore at his mother for her abysmal guardianship of his work, he was happy to show Boisgeloup off to her. Doña María's visit turned out to be opportune: it coincided with her eleven-year-old grandson Paulo's First Communion at the Eglise Saint-Augustin on April 28. Photographs taken later outside Sacré Coeur show the boy with his tiny grandmother. Paulo looks embarrassed: an unwitting victim of parental animosity, this unfortunate boy would all too soon change from being Olga's pride and joy to being a rebellious adolescent, violently resentful of his overprotective mother. Paulo's godfather, Georges Bemberg, did not attend; he was locked away in a Swiss *maison de repos,* ironically where Paulo would go for rehabilitation a few years later.[2] As for the boy's fashionable godmother, Misia Sert was still sporadically kind to Olga, and although she exemplified a world Picasso had come to despise, she would certainly have been invited, as were Stein and Toklas, who appear in some of the snapshots. In snapshots of the three generations of the Ruiz-Picasso family taken in the garden at Boisgeloup, they are all doing their best to look happy. Official photographs taken for the actual Communion tell a different story. Olga appears to be in a state of nervous distress. She was still a beautiful woman, but the tranquilized eyes had become infinitely, Slavically, sad. These were the traits Picasso would mercilessly seize upon in his portrayals of her.

His wife's physical and psychological problems, as well as the pending lawsuit and worry about the upcoming retrospective, had also left Picasso understandably stressed.

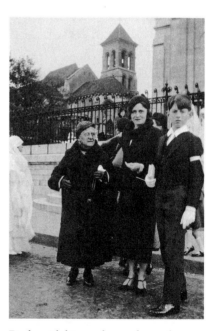

Paulo with his mother and grandmother in front of Sacré Coeur after his First Communion at the Eglise Saint-Augustin, Paris, April 28, 1932.

Picasso. *Woman in an Armchair (The Japanese Model)*,
August 8, 1932. Oil on canvas, 92.1 x 73 cm. Private
collection.

As a distraction, he had reverted to promiscuity, a habit he had never entirely abandoned. The writer Raymond Queneau noted in his diary (October 19, 1931) that Picasso had "resumed chasing girls."[3] These affairs were usually casual. Sometime in 1932, however, Picasso took a liking to a Japanese model and did at least two remarkable portrayals of her.[4] All we know about this woman is what Picasso told Otero:[5] Olga found out about the affair and insisted she be thrown out—something she never attempted to do to Marie-Thérèse.

As a suitable setting for Picasso's first full-scale retrospective—225 paintings, 7 sculptures, 6 illustrated books—the Galeries Georges Petit was an odd choice. At the turn of the century, the place had been a flashy alternative—Zola described it as "the apotheosis of dealers"[6]—to the venerable impressionist emporium, Galerie Durand-Ruel. Petit's success had been short-lived. In failing to plow his profits back into stock, he lost out to his rivals. By the time of his death in 1921, the gallery was best known for auctions.[7] After the 1929 crash, the Bernheim brothers and the dealer Etienne Bignou joined forces with their principal rival, Paul Rosenberg, and took the place over for contemporary shows. Additional backing came from the canny American financier Chester Dale, who had recently bought the Rose period *Saltimbanques*[8] and other major Picassos and was eager to invest in art, so long as dealers granted him "dealers' prices." As Michael FitzGerald points out,[9] "While the lesser figures went broke, the Bernheims, Rosenbergs and Wildensteins worked in greater concert than they ever had before. With the disappearance of most clients, their fierce competitiveness subsided into cooperation."[10] The Matisse and Picasso retrospectives at the Galeries Georges Petit in 1931 and 1932 would result from this newly awakened and all too brief camaraderie.

This new alliance of Parisian dealers would put paid to the dream of Alfred Barr to hold a major Picasso retrospective at the Museum of Modern Art in New York.

Barr had been hard at work persuading European collectors and dealers to lend to such a show, but he found himself stymied by Picasso's objections and his own scruples about dealer sponsorship. As FitzGerald relates:

> Without the cooperation of Rosenberg and the dealers who controlled the Galeries Georges Petit . . . [Barr's] desire to maintain his independence from the trade ultimately gave the dealers even greater control. Picasso, meanwhile, was no mere pawn in the machinations. On June 21, 1931 . . . Barr sent [his assistant at the Museum of Modern Art] a wire. Instead of confirming plans for the fall exhibition, the message recorded the collapse of [his] plans: "PICASSO ABSOLUTELY POSTPONES TEMPERAMENTAL REASONS REBER REFUSES WITHOUT PICASSO'S APPROVAL." . . . Picasso's reasons for refusing to cooperate were not merely temperamental. They included both his desire not to be distracted from his work and his Parisian dealer's advice that he resist being rushed by this relative newcomer.[11]

Beaten to the post by Chick Austin's beautiful 137-work retrospective at Wadsworth Atheneum in Hartford (in 1934), New York would have to wait until 1939 for MoMA's first Picasso retrospective—far and away the most comprehensive show of the artist's work ever held. Barr's obsession with the artist, and the acuity of his perceptions, would set a new standard for Picasso scholarship, also a new standard for catalogs. The outbreak of modern art collecting that the show engendered would establish New York, as opposed to Paris, as the center for Picasso studies.

Forty years after its heyday, the décor of the Galeries Georges Petit looked as overblown as Paul Rosenberg's premises had before he redid them. Although an architect[12] had supposedly modernized the gallery's "gilded salons"[13] for the occasion, installation shots show that some walls were still ornately patterned. ("Royal purple," Cabanne says.)[14] Jacques-Emile Blanche took exception to the garish hangings and the ubiquitous gilt frames.[15] Others disapproved of the gallery's corny grandeur. Picasso relished it. The Beaux-Arts look made the shock of the new all the more shocking.

In successive visits to the Galeries Georges Petit's Matisse exhibit the year before, Picasso had checked out the place's possibilities. Critics of the Matisse show had deplored the shortage of important early works and the surfeit of minor, "Nice period" paintings from his dealer's stock. Profiting from these failings, Picasso was determined that his show should not suffer a similar fate. He insisted on a full-scale retrospective that would chart his development from 1900 onward and draw on private as well as dealers' holdings. He also insisted on control over the selection and a well-illustrated catalog. Among others, Gertrude Stein, Eugenia Errázuriz, and Reber

would lend masterpieces. Besides twenty of the paintings he had done during the previous winter and spring, Picasso lent a great many works from his own vast collection, which had never previously been exhibited. Officially nothing would be for sale, but in reality at least a third of the loans could be had for a price.[16]

By far the most important absentee from the show was *Les Demoiselles d'Avignon*. Although Doucet, to whom Picasso had sold it, had died, the painting still hung on the walls of his Neuilly mansion. If pressed, the widow, who contributed a 1905 *Head of an Acrobat*[17] to the show, would surely have lent it. Why the exclusion? Daix believes that Picasso wished to avoid discussion of the *Demoiselles* and the so-called Negro period (1907–08).[18] I suspect that he may not have wanted this shocking, still little-known work to overshadow his more recent achievements. His anger at Doucet for promising and failing to donate the *Demoiselles* to the Louvre so as to get it cheaply[19] may also have influenced the artist's decision. Actually, this period was well represented by Reber's magnificent *Nudes in the Forest* (1907–08),[20] soon to become the jewel of Cooper's cubist collection. The only other major gap: no loans from the Shchukin or Morosov collections, which the Soviets had nationalized and hidden away. There was nothing from French museums; but then, apart from the Musée de Grenoble, none of them had anything much to lend.

Opposite and right: Picasso's installation of works at the Galeries Georges Petit, Paris, 1932. Photograph with annotations by Alfred Barr. The Museum of Modern Art, New York.

Hanging the show obsessed Picasso. "I've been hooking these things on the wall for six days now and I've had enough of them," he claimed to Guy Hickok,[21] an American journalist who interviewed him. Even well-disposed viewers found the artist's hang peculiar. Installation photographs demonstrate that his disregard for chronology, subject, style, and coherence, was, to say the least, idiosyncratic. On one wall Blue and Rose period paintings hung next to works from the classical and "bone" periods. The mismatching was strategic: Picasso wanted his disparate oeuvre to be seen as an organic whole and not chopped up into arbitrary "periods" by critics and academics, without his authorization. He saw his work as an ongoing family, but "members of the same family don't always look identical," he told Tériade in a frank interview shortly before the show opened.[22] Picasso regarded his assembled works as "prodigal children returning home clothed in gold." Apropos the show, he went on to say:

> Someone asked me how I was going to hang [it]. "Badly," I told him, for an exhibition is like a picture, whether it is well or badly "arranged," all comes down to the same thing. What counts is the element of continuity in [an artist's] ideas. When that element is seen to exist, everything ends up falling into place, just as it does in the worst of households.[23]

Did Picasso have his own household in mind? In yet another cri de coeur, he told Tériade that nothing could be achieved "without solitude."

> [E]verything depends on oneself—on the fire in one's belly [*un soleil dans le ventre*]. The rest does not matter. It is only because of this that, for example, Matisse is Matisse. It is thanks to the fire in his belly. . . . One's work is a way of keeping a diary. . . . Nobody has any suspicion of the solitude I have created around myself. It is so difficult these days to be alone, since we all have watches. Have you ever seen a saint with a watch?[24]

Hanging the show permitted Picasso to investigate the workings of his creative process, which, as he frequently complained, were a total mystery to him. Having his hands once again on some of his finest paintings enabled him to *feel* his way back into them and measure his most recent works—some not yet dry—against them, the better to establish where he might be headed. We should not forget that besides such masters as El Greco, Ingres, Gauguin, and Cézanne, the principal influence on Picasso would be his own earlier paintings.

Picasso's disregard of chronology may have been intended to deprive the surrealists of a handle on his more recent work, and at the same time to demonstrate that he had never been indebted to their movement. Finally, as discussed in Chapter 28, Breton seems to have accepted the fact that Picasso had eluded him. In the masterfully argued tribute to Picasso he would contribute to the opening number of *Minotaure* in 1933, Breton barely mentions the Galeries Georges Petit retrospective,[25] except to comment on the effect made by the positioning of the two versions of the welded *Woman in the Garden*—"one of which was covered with rust . . . the other freshly painted with white enamel"—at opposite ends of one of the galleries.[26]

A day or two before the retrospective opened on June 16, 1932, Picasso gave an old, though never particularly close friend, the society painter Jacques-Emile Blanche,[27] a guided tour. Intelligent, articulate, and worldly, Blanche had prevailed upon Proust to write a preface for one of his memoirs. His comments typify the views of the cultivated *gens bien* Picasso had met through Cocteau and Diaghilev—people intent on appearing more *à la page* than they really were. Blanche was not alone in seeing the artist as a rebel and innovator like Manet—an artist Picasso particularly admired—whose centenary would be celebrated by a retrospective later in the summer. After granting that Picasso had "a Paganini-like virtuosity" and could succeed at anything he undertakes,[28] Blanche took to grumbling. He rightly recognized Picasso and Stravinsky as "brothers in arms" at the head of the modern movement, but criticized them both for being "too *engagé* to take a step backwards, they were always obliged to forge ahead."[29] That they both lost the capacity to shock has the ring of insincerity: Blanche evidently *had* been shocked but could not admit it.

Far from demonstrating that the exhibits were all of a piece, Picasso's hanging, according to Blanche, demonstrated the contrary. "What would be right for one of these pictures would be wrong for another. . . . Each manner, each stage of the Picassian journey requires the critic to change his position."[30] The only unifying element that Blanche detected in Picasso's work was "taste, taste, always taste." So long as this implied bad taste, the artist might have agreed, but good taste was abhorrent to him. In addition, the Anglophile Blanche's comment that the Rose-period Harlequins "derived from the English post pre-Raphaelite Augustus John"[31] would hardly have pleased him. In his youth Picasso had admired Edward Burne-Jones, but never the artist he had memorably described as "the best bad painter in Britain."[32]

Among the adverse reviews, one particularly crass example is worth quoting, since the ambitious young journalist who wrote it, Germain Bazin, was destined to end up as one of the Louvre's least distinguished directors. In *L'Amour de l'Art,* the magazine he edited, Bazin decreed that "Picasso belongs to the past. . . . His downfall is one of the most upsetting problems of our era."[33] Much the same could be said of Bazin's rise to the top. The one critic who was unstinting in his praise was Charensol, who hailed the retrospective as "the most important aesthetic event of these past thirty years."[34]

The Georges Petit vernissage turned out to be stiflingly *mondain,* to believe Hickok:

[C]elebs wander in with a bored air around midnight. Duchesses, diplomats, monocles, tail-coats, nude spines, such diamonds and pearls as are not in pawn, bottled tan on the women, larded hair on the men, a few paunchy politicians who like to be "among those present," champagne, microscopic sandwiches and sharp-eyed dealers trying to read the thermometer of Picasso's value five years from now.[35]

Picasso stayed away. He "planned to skip the opening and go to a movie," he told Hickok.[36] Had he attended, he would have been obliged to take Olga.[37] The shock of seeing so many loving images of her rival and so many hurtful ones of herself—*Large Nude in a Red Armchair* and *Repose* were both on exhibit—might have precipitated an ugly scene. The pleasure of mixing with the beau monde, which her husband was intent on avoiding, was not worth the shame of scandal.

The day after the opening, Picasso was back working at Boisgeloup. He had the place to himself—and Marie-Thérèse. Olga and Paulo had been packed off to Juan-les-Pins;[38] whether he ever intended to join them, he never did. The small reclining nudes of Marie-Thérèse asleep exude a tenderness and intimacy that was missing from most of the larger, more stylized portrayals that Picasso had done of her for his

retrospective. Indeed, a profile of Marie-Thérèse cradling her head in her hands,[39] silkily painted onto a small square canvas, is as loving as any of his images of her. With their flipper limbs and gorgeous buttocks, and free-and-easy *facture,* these little paintings—mostly done while the show was still on—constitute a touching epilogue to the daunting set pieces of the winter and early spring.

On July 30, the day the show closed, Picasso celebrated by doing a virtuoso pen-and-ink drawing in the same fine but fuzzy graphic technique he had used a year earlier, for his dazzling *Sculptor and His Model.*[40] Zervos entitles this drawing *Nu couché;*[41] it actually represents three Marie-Thérèses, squashed together under a beach umbrella with a cabana on the left. In another similar worked-up drawing,[42] three identical Marie-Thérèses disport themselves on one of the Normandy beaches. At the top, she is vigorously paddling her dart-shaped kayak; below, she sits astride her bicycle; lower left, she sprawls on the sand. In other, idyllic drawings done this August,[43] the artist sees himself as a Pan-like piper serenading a nymph.

These small formats soon gave way to much larger ones. Picasso had regained his momentum and was back to painting Marie-Thérèse as intensively as he had earlier in the year. These new paintings are even more stylistically disparate than their predecessors. In *Woman Holding a Book,*[44] Marie-Thérèse is seated, wearing a black lace slip, with her right hand held daintily up to her chin, as in Ingres's *Madame Moitessier.* In the more curvaceous *Nude in a Red Chair,*[45] Marie-Thérèse coyly frames her face in her curly-fingered hands. In yet another painting,[46] Picasso takes the girl out-of-doors and envisions her as a mountain of lilac flesh, sunning herself on the bright green grass of Boisgeloup.

Marie-Thérèse was not always uppermost in Picasso's thoughts. For business or family reasons he had to drive into Paris; also to pick up girls. On August 14, he did a painting of his Japanese model.[47] The pose, the chair, and the swirling rhythms are much the same as in recent Marie-Thérèses, but the woman's hair is greenish black and the eyes are unmistakably oriental. Another painting, done a few months later, of a black-haired woman, *en profil perdu,*[48] which bears no resemblance whatsoever to Marie-Thérèse or Olga, portrays the same Japanese model. By the time Picasso painted this portrait, Olga was back in Paris. It was probably then that she had the Japanese thrown out.

The culminant painting of this summer, dated August 30, on the eve of Olga's reappearance, is MoMA's awe-inspiring *Bather with a Beach Ball.*[49] In this glorious work Picasso has pumped Marie-Thérèse so full of pneumatic bliss that she looks ready to burst her yellow-and-mauve bathing suit. Her hair—all too soon to fall out—streams out behind her like a wing. Her blunt snout looks ahead to next spring's great sculpture of the *Woman with a Vase.*[50] In his eternal quest for gigantism, the artist has not only filled the vast canvas to the edges with his volumetric

bather, he has her reaching up to pluck the moon from the sky as if it were a beach ball—an image that is both proto-pop and cosmological. Note, too, the flagpole on the distant cliff; it might refer to Seurat's views of the same stretch of the Normandy coast.

To commemorate his fiftieth birthday Picasso did not limit himself to a huge retrospective. He had also set his heart on a catalogue raisonné, and for the previous three years he and Christian Zervos had been working together on an exceedingly ambitious publication. In the summer of 1932, the first volume of this project made its appearance; and it would do a great deal more to familiarize people with his beginnings in Spain as well as the Blue and Rose periods. It was handsomely produced on good thick paper with illustrations that are far larger and provide a far more palpable feel of the artist's work than those in any comparable catalogues raisonnés. Given Picasso's innate caginess and the dearth of information available at the time, the entries are scanty and often unreliable. However, the thirty-three volumes that Zervos would ultimately publish have proved a godsend to scholars, collectors, curators, dealers, students, not to mention fakers. Alexandra Parigoris has pointed out[51] a shortcoming which is probably Picasso's fault: related drawings and pages from sketchbooks are seldom placed where they logically belong. She believes that Picasso did this in collusion with Zervos to prevent nosy scholars or other artists from tracking his sources or his codes.

Artist and publisher worked closely together, but a letter that Zervos wrote in 1932 to the eminent Swiss modernist Siegfried Giedion, *Cahiers d'Art*'s architectural adviser, suggests that the publisher's feelings for the artist were sometimes far from friendly. One of his wife Yvonne's deals had evidently gone awry.

> Yvonne got nothing out of Picasso. He did to her what he did to me, he said that he was not around. What disgusts me is that he doesn't even have the courage to refuse. I told Yvonne about this new development in order to convince you that in asking for the painting I was not acting in bad faith, but I did not want to approach [Picasso] again, because I know the pleasure he gets from seeing someone suffer physically or mentally. For instance, when he is at his château, he takes great pleasure in having his Saint Bernard dog attack the cats and watching them agonize as their backbones crack.[52]

Zervos goes on to cite Picasso's denial of Apollinaire at the time of *l'affaire des statuettes:* "this proves that the work and the man are never one and the same. The artist is great, the man very small. But that does not settle my affairs. I am at a loss and need to hear what you decide."[53]

This shocking letter should perhaps be seen in the light of Zervos's marital and financial problems. For some years, he had had a relationship with an assistant, called Suzanne. When she had to enter a sanatorium in 1928, he switched to the

woman he had picked up in the Dinand station, Yvonne Marion.[54] Rather than rejoin Zervos when she left the sanatorium a year later, Suzanne had married a young Spanish painter, Ismael González de la Serna. Ismael was a friend of Lorca's and a cousin of Ramón Gómez de la Serna, who had organized the banquet in Picasso's honor in Madrid in 1917. He had been written up in *Cahiers d'Art,* which had sponsored an edition of Gongora's sonnets illustrated by him. After Ismael's marriage to Suzanne, Zervos dropped him and saw to it that he was not received into Picasso's Parisian group of Spanish painters.

Zervos married Yvonne in May 1932. According to Christian Derouet, director of the Musée Zervos at Vézelay, his marriage was a response "to the necessity of introducing new capital into a business that was prestigious but lost money."[55] To raise funds for his ambitious publishing ventures—the first volume of the catalogue raisonné was selling badly—Zervos was reduced to desperate measures: selling his cars and also his apartment, borrowing money from his brother who worked on cruise ships, and soliciting contributions from the artists he published.[56] Picasso's affection for Yvonne enabled her to make some very profitable sales, notably to the Italian tycoon Frua di Angeli and his consort, the American sculptor Meric Callery. This couple were about to supplant Reber as Picasso's biggest collectors, and they relied on the Zervoses to keep them supplied. However, fond as he was of Yvonne, the artist was often recalcitrant with dealers who pressured him—hence Zervos's whining letter.

As for the cat story, it is completely out of character. True, Picasso was fascinated by nature in the raw, as Françoise Gilot observed at Menerbes some years later:[57] On his evening walks, he liked to watch barn owls swoop down on the local cats and carry them off in their claws—a spectacle he would later draw; and he probably watched similar encounters at Boisgeloup. However, his instinctive rapport with animals, he is unlikely to have done anything as callous and utterly pointless as hunting cats with a Saint Bernard—one of the gentlest and slowest of large dogs. That "nocturnal cat hunter" used to be a pejorative phrase used to stigmatize someone as a brute.

The outbreak of civil war in Spain brought Picasso and the Zervoses back together. As Communists, the Zervoses were indefatigable in their work for the Republican cause. Zervos's adulation of *Guernica* in *Cahiers d'Art* reveals that he had come to see Picasso—the man as well as the artist—in a heroic light. He would frequently act as Picasso's spokesman: as, for instance, when the fascists insinuated that Picasso was a Marrano—descended from one of the Jewish families forced to practice their faith in secret or be persecuted by the Inquisition or expelled by Ferdinand and Isabella. There had been no Jewish blood, Zervos stated, on either side of his family for four or five generations[58]—an assertion that did not exactly settle the mat-

ter. For his part, Picasso would do everything he could to help Zervos in his clandestine printing for the Resistance.

On September 11, Picasso's Parisian retrospective resurfaced in Zurich in a very different form. Wilhelm Wartmann, director of Zurich's Kunsthaus, had originally intended to include Braque and Léger, but after visiting the Georges Petit show, he allowed himself to be persuaded by Picasso to limit the show to *his* work. Braque, who had already agreed to lend Wartmann forty paintings, was furious, so was Léger. Wartmann placated them with promises of one-man shows later in the year.[59] Meanwhile, he had written to his colleague, Carl Montag—later a notorious trafficker in art looted during World War II[60]—that "the Zurich exhibition must be . . . more beautiful and more serious, as far as structure and general impression, than the Paris exhibition. This will be its only justification."[61] Wartmann was as good as his word; nobody found fault with the chronological hanging.

To give the Zurich exhibit an extra dimension, Wartmann included two hundred works on paper: 90 watercolors and drawings, many of them for sale, as well as 110 prints. These had been assembled by Bernhard Geiser[62]—a Swiss protégé of Kahnweiler and Rupf—who had recently completed the first volume of his catalogue raisonné of the prints, which he had been working on since 1928. To compensate for the cancellation of several American loans—Zurich, not Paris, would have had to

The installation of works at the 1932 Picasso retrospective at the Kunsthaus Zürich.

pay the shipping costs back to the States—Picasso lent ten more paintings to Zurich than he had to Paris.[63] There were also several extra works from Swiss sources, even some from Basel; the rivalry between the two cities was such that the director of the Basel Kunsthaus—cross at not getting the Picasso show—had tried unsuccessfully to organize a rival attraction, *Modern Art from Private Basel Collections.* To defray the considerable costs at a time of financial crisis for Zürich, Wartmann had arranged for the Kunsthaus to pocket the commissions on any sales the show generated. Several major works from private collections were indeed for sale—among them some from the artist's own holdings, *Pipes of Pan* (500,000 French francs) and *La Danse* (400,000 francs), as well as Madame Errázuriz's 1914 *Portrait of a Young Girl* (150,000 francs) and the 1915–16 *Seated Man* (200,000 francs).[64] Gertrude Stein offered the Kunsthaus Zürich her *Girl with Basket of Flowers,*[65] to no avail. The city decided instead to buy the relatively unimportant *Writing Desk*[66] (75,000 francs) from the artist himself.

Accompanied by Olga and Paulo, Picasso left Paris on September 7 in the Hispano-Suiza, stopping en route at the Hôtel des Trois Rois in Basel.[67] They arrived in Zurich on September 8, where they stayed at the Bauer au Lac Hotel, and left on the morning of the eleventh. Wartmann had arranged for Hanns Welti—a lawyer who dabbled in painting and journalism—and his wife to look after the Picassos. The Weltis took them sightseeing and for a boat ride on the Zuricher See. It was a beautiful day, and Picasso declared that he could live and work in Zurich, "not too southern, not too hard and northern."[68] His politesses were characteristically double-edged. He liked the way the city's ugly buildings disappeared in the haze, and went on to say how much he enjoyed looking at particularly hideous ones, pointing at what turned out to be the concert hall. "Never allow that building to be pulled down . . . no architect could have built something like that—it is a contribution to Surrealism."[69] Welti took lots of snapshots. These reveal the artist, who had depicted his wife as a lethal monster six months earlier, as a quintessential *père de famille bourgeoise* on holiday. On September 10 there was a luncheon and reception for Picasso at the Bellevue Park, and the following morning they left before the show's official opening. When asked why he did not stay for the occasion, Picasso said he wanted to spend a few days in the Engadine; besides, he preferred not to remain in a city where *"je suis collé sur tous murs"* (I'm plastered all over the walls).[70] And off the family drove to Tiefencastel, near Saint-Moritz, and then to Interlaken, where they stayed at the Beau Rivage & Grand Hotel, and on September 13 they left for Paris.

The Zurich show was such a success—a record 2,362 people visited it on Sunday, September 25—that it had to be extended another two weeks until November 13. Cooper, who visited both shows, thought the Paris version eye-opening, but "a bit of a mess"[71] and the Zurich exhibit more comprehensive. It was the prototype of all the

great Picasso retrospectives to come, particularly those organized by Barr. And yet, despite plaudits from the modernist theoretician Siegfried Giedion, the Bauhaus's Oskar Schlemmer, as well as promotional lectures from Max Raphael, Hans Hildebrandt, and Gotthard Jedlicka, the show came under attack—less from the right than from the left. Especially virulent was the Social Democratic newspaper, *Volksrecht*. It parroted the Soviet writer Anatoly Lunacharsky's dismissal of Picasso as "typically bourgeois-decadent" and accused his work of being "painted psychoanalysis," and thus "a sign of the decadence of our times."[72] Giedion protested that if Picasso's work was "bourgeois-decadent," what about the fountains and monuments of Zurich?

These attacks stirred up a lot of latent philistinism. According to Christian Geelhaar,[73] Klee blamed negative articles spawned by the Picasso show (one of them entitled "Paul Klee's Schizophrenic Garden") for the difficulties that he, as the son of a German father and Swiss mother, would have obtaining Swiss citizenship. Nevertheless, the controversy had a positive side: it set other institutions—among them Stuttgart's Würtembergische Kunstverein and the Bern and Basel Kunsthalles—vying for the exhibition. Too late, lenders wanted their pictures back.

The day after the Zurich show closed, a lengthy critique appeared in the *Neue Züricher Zeitung,* signed by the eminent Swiss psychiatrist Carl Gustav Jung. Picasso's followers were dismayed by the author's censorious tone as well as by his summary diagnosis of Picasso as a schizophrenic. Seventy-five years later, this diagnosis does not seem all that egregious. For all his moralizing, Jung was the first non-poet to shine fresh light onto Picasso's dark side. When, for instance, he compares the artist to "the underworld form of the tragic Harlequin," an ambiguous figure who "already bears on his costume the symbols of the next stage of development . . . the hero who must pass through the perils of Hades,"[74] Jung echoes Apollinaire and Max Jacob. When he invokes the *Nekyia*—"a meaningful descent into the cave of initiation and secret knowledge . . . [a] journey through the psychic history of mankind,"[75] he sounds a bit like Bataille. Jung is at his blindest when he indicts Picasso for being "demoniacally attracted to ugliness and evil."[76] Of all people, Jung should have sensed the exorcistic nature of Picasso's work and that, far from delighting in the "demoniacal," Picasso felt it was his shamanistic duty to exorcise evil by fighting it with evil. Regrettably, the psychiatrist had no inkling of Picasso's shamanic nature or his conviction that art had a magic function.

Zervos rashly chose himself to refute Jung's critique in the pages of *Cahiers d'Art.* In a tedious, self-important piece, he impugns Jung for applying his psychological theories to Picasso's work. "If Dr. Jung had taken account of historical facts," Zervos writes, "he would have realized that Picasso's predilection for blue was due to the influence of Cézanne . . . that when Picasso painted prostitutes, he was only follow-

ing a fashion common to Barcelona painters at the time"; and that his predilection for Harlequin, "too, was due to Cézanne's influence."[77] Zervos's "historical facts" were half-baked half-truths.

Picasso did not resent Jung's diagnosis as much as his supporters did. Years later, I asked Jacqueline Picasso what her husband thought of Freud. *"Il préférait beaucoup l'autre,"* she said. I was not surprised. The surrealists had put him off Freud. Picasso's persona was too much of a paradox and too deeply involved in myth for Freudian analysis to grapple with. Freudian interpretations of Picasso's work tend to fall short. Jung's ideas are much better suited to the intricacies and ambiguities and cosmological dimensions of the artist's psyche.

For Picasso, the main reason for his trip to Zurich was the opportunity to stop on the way at Colmar and visit the Mathias Grünewald altarpiece. He told Kahnweiler he proposed to do so on his return from Zurich.[78] Picasso was bowled over by the Grünewald. Back at Boisgeloup, he set about reinterpreting Grünewald's altarpiece in a fresh series of Crucifixion drawings, "but as soon as I had begun to draw it, it became something else entirely."[79] Years later, Kahnweiler would persuade Picasso that Cranach was a greater painter and that Grünewald's expressionistic side was inferior to Cranach's "purity and firmness." "People are always citing Raphael's drawings," the dealer said. "Cranach is better."[80] Be that as it may, Picasso's later drawings after Cranach lack the dark power of his Grünewald ones.

Mathias Grünewald. *Crucifixion* (from Isenheim Altar), c. 1475. Musée d'Unterlinden, Colmar.

The dramatic ink-wash drawings in which Picasso transforms Grünewald's tortured figures into a frieze of Vesalian bones had a great impact when they were published in *Minotaure*.[81] Their solemnity should not blind us to the flashes of black Picassian humor. Christ's loincloth is held together by a safety pin and the figure on the cross has been given a pair of freakish hands, based on a photograph found in Picasso's papers of a man with hands malformed like lobster claws.[82]

Unlike the 1930 Crucifixion drawings, Picasso's Grünewald drawings focus on Christ and the two Marys. He has also

Left: Photograph of a handicapped man using a plane, c. 1920–25, Musée Picasso, Paris.
Right: Picasso. *Crucifixion,* September 19, 1932. Pen and India ink wash on paper, 34 x 51 cm.
Musée Picasso, Paris.

followed Grünewald in choosing to depict Christ's passion at the time—from midday until three in the afternoon—when darkness fell over the land, "a sign that the heavens went into mourning at the death of the Savior."[83] To simulate this eclipse, Picasso has drenched these drawings in great washes of India ink. Against this enveloping darkness—Saint John of the Cross's dark night of the soul—a frieze of whitened bones performs a ghostly *Totentanz,* as if in some cavernous Mithraic ossuary. There is nothing insubstantial about the figures. They are conceptual sculptures rather than sacred phantoms. Picasso would never again do a major painting of the Crucifixion. Henceforth, horrors of war would supplant the horrors of his private life as the inspiration for a tragic masterpiece. The next Golgotha would be *Guernica.*

Toward the end of 1932, Marie-Thérèse fell seriously ill. While swimming or more likely kayaking in the Marne, she contracted a spirochetal disease from the rats in the river.[84] She was hospitalized with a high fever for several weeks, and most of her hair fell out. Picasso commemorated the incident in a number of dramatic paintings—variations on the Eros and Thanatos theme. He transposes the accident from the icy, rat-infested river to a sunny beach, where he envisions Marie-Thérèse being saved from drowning by her sisters or alternate versions of herself. She looks inert—maybe alive, maybe dead.[85] The pathos of these images is tinged with eroticism. The drowned girl—eyes closed, head thrown back, breasts thrust

up—swoons erotically in the arms of one of her alter egos, while others dive, swim, and play ball, just as they did at Dinard in 1928.

No one seems to have noticed that the drowning woman in these paintings is usually bald, as is the culminant Marie-Thérèse plaster—the full-length *Woman with a Vase*—which Picasso would execute at Boisgeloup, shortly after the girl's recovery. Gone are the flanges of hair that are the crowning glory of the previous plasters. Cowling describes this great sculpture as "the surviving masterpiece" of Picasso's "prehistoric mode,"[86] that is to say inspired by the Venus de Lespugue. I would also like to evoke the great primeval sculpture *Oviri,* which Gauguin designed for his grave (as discussed in Chapter 37). Like Gauguin, Picasso chose his most exorcistic sculpture, *Woman with a Vase,* for his grave on the terrace of the Château de Vauvenargues. The significance of the vase she holds has always been a mystery. I believe that the vase signifies the alabaster box of ointment that Mary Magdalen—the saint who had always obsessed the artist—proffered to Christ. The sculpture commemorates both Picasso's shamanism and his paradoxical Spanish faith. This might well explain why, after his death and burial in 1973, his second wife had the original plaster of *Woman with a Vase* smashed—whether at his or her behest, we do not know.

By April 1933, Marie-Thérèse had fully recovered, to judge by her lover's magnificent down-to-earth drawings in which Picasso portrays himself as a Minotaur, plunging his monstrous, taurine penis into Marie-Thérèse's tumescent folds. These are surely the most ecstatic and celebratory images of sex by a great artist.[87]

Since 1933 was the only year in which Picasso confessed to being a surrealist, let us see how next year's work differs from previous years'. It is no coincidence that his brief capitulation coincides with the first appearance (June 1933) of *Minotaure.* Originally intended as an organ for surrealist dissidents (like *Documents*), *Minotaure* turned out to be refreshingly nonpartisan and eclectic, thanks to Tériade's deft handling of Breton and other surrealist contributors. Since the first issue was primarily devoted to his work, Picasso had designed a sensational, self-referential cover: a collage of a Minotaur set off against corrugated paper and some faded trimming from one of Olga's hats.

Picasso's contributions to the all-important first number of *Minotaure* dazzled more than they shocked, and did much to enhance the artist's fame. *Minotaure*'s most revelatory feature was Brassaï's series of dramatic photographs of the hitherto unknown Boisgeloup sculptures.[88] Over the years these photographs would do much to establish Picasso as a great sculptor as well as a great painter. No less revelatory were the Crucifixion drawings and the astonishing sequence of his twenty-eight *Anatomies* (February 25–March 1, 1933). These conceptual sculptures of Marie-Thérèse are all the same size, set out in rows like samples in a pattern book, as if viewers were expected to take their pick. Although Picasso had given up on the

Apollinaire memorial, this group might be said to constitute his last thoughts on that ill-fated project. The *Anatomies* are composed of a variety of disparate elements: legs in the shape of the Etretat cliffs; and torsos in the shape of potatoes and gourds, which sprout cogwheels, bananas, and other exotic extensions. Although many of these combines had figured in recent works, the figures take on a surrealist air en masse. Picasso doubtless wanted to show Breton and his followers how *he* would go about being a surrealist.

Far more intrinsically surrealist than the *Anatomies* are the whimsical yet disquieting drawings and watercolors that Picasso would do at Cannes in July 1933.[89] Like the 1929 beach scenes, which pit Olga and Marie-Thérèse against each other, these works portray the sun shining down on a breezy beach where Picasso has set up confrontations between his two women: each one an assemblage of bric-a-brac, bits of sculpture, gloves, stockings, picture frames, children's balloons, forks, and so forth. These works are all too evidently inspired by Lautréamont's celebrated metaphor for a boy's beauty. Picasso's exploitation of this surrealist mantra must have delighted Breton. After eluding him for all these years, the artist had come over to his side without, of course, joining his movement.

The shadow of surrealism did not rest on Picasso's paintings and drawings for long, but it would leave a permanent mark on the still too little appreciated poetry, which was about to become his principal form of expression. After the breakup with Olga, Picasso's campaign to bridge the gap between painting and sculpture seemingly prompted him to bridge the gap between word and image. After briefly ceasing to paint, in 1935, the blinded Minotaur—a surrogate for Picasso in some of his finest engravings—would devote himself to writing poems of such vividness and color that a blind man would be able to see them. This was how the surrealists should write poetry. Breton's poetasters disagreed.

Olga, Doña María, and Picasso at Boisgeloup, c. 1932.

Epilogue

Treacherous generals, see my dead house, look at broken Spain.[1]
—Pablo Neruda

If readers wonder why politics play such a small role in this volume, it is because the artist was determined not to get involved in them. As Kahnweiler said, Picasso was "the most apolitical man I have ever met."[2] Insofar as he was Spanish and Spain was a kingdom, Picasso claimed to be a monarchist. He was not being ironical. As a pacifist, he had approved of the King for keeping Spain out of World War I; but his monarchism had more to do with his view of himself as *"yo el rey"*—the inscription on an early self-portrait—than fealty to Alfonso XIII. Until the outbreak of civil war forced his hand, a royalist stance enabled him to withstand pressure from both right and left, refrain from any ideological commitment, and yet keep faith with his inherent humanism.

Virtually all his biographers[3] have overlooked the fact that Picasso had a very distinguished "uncle"—in fact, his mother's first cousin. General Juan Picasso would unwittingly play a behind-the-scenes role in events leading up to the removal of the King and the outbreak of civil war. In 1922, Uncle Juan had been responsible for a report on the military disaster at Annual that had taken place the year before. Known as the "terrible papers of General Picasso," the report would put the King in an embarrassing light and have far-reaching political consequences.

Although the cousins may never have met—the artist thought they had, the general's family think they hadn't—Pablo Picasso took pride in his uncle's courage on the battlefield as well as in the role of investigator. The two Picasso cousins had inherited many of the same genes: both were small, tough, charismatic, and driven—albeit by compulsions of a very different stripe. The general's forte was military reform and the honor and destiny of the cavalry; he was also an accomplished topographical draftsman and a lucid writer of reports. Xavier Vilató, the artist's nephew, remembered him as lively and witty—not the least highfalutin.[4] The general had the

General Juan Picasso González. Collection Heirs
of Juan Picasso González, Madrid. Courtesy of
Rafael Inglada.

unusual virtue, at least in fin de siècle Spain, of
being fearless and loyal to the ethos of the military
rather than king and country.

Juan Ricardo Ramón Fabriciano de la Santísima Trinidad Picasso was born in Málaga in
1857.[5] He owed his promotion to an act of suicidal heroism in the course of one of the earlier
Moroccan wars, when he galloped through a line
of Rifeño riflemen and relieved a beleaguered
garrison. After becoming a general, and later
under-secretary of war, Juan Picasso declined the
Prime Minister's offer of the ministry. "Thank
you very much," he said, "but I prefer to continue being who I am, an honorable soldier."[6]
And he went off to Geneva to represent Spain on
the League of Nations Military Committee, only
to be summoned back to Madrid to head the inquiry into the Army's infamous defeat by Moroccan rebels at Annual in 1921. His report would
be far harsher in apportioning blame than anyone had expected.

The Annual disaster was the last dismal act in
the decline and fall of the Spanish Empire. In a
vainglorious pretense that he still wielded imperial power, Alfonso XIII had secretly encouraged
a gung-ho favorite of his, General Manuel Fernández Silvestre, to bring the fractious
Moroccan Rif under military control so that greedy settlers could exploit the country
and found a new capital to be called Ciudad Alfonsina. When the Moroccan leader,
Abd-el-Krim, rebelled, Silvestre rushed in to crush him, although he had no mandate
beyond secret telegrams from the King and the pusillanimous support of another
royal favorite, General Dámaso Berenguer, the high commissioner of Morocco and
chief of the Army in Africa. At the first sign of attack, more than 4,500 of Silvestre's
Moroccan troops promptly deserted, most of them to Abd-el-Krim, leaving his
Spanish troops—poorly trained, poorly supplied, underpaid, and utterly demoralized—to be routed and massacred.

General Picasso's blistering report established that most of those in command
were either cowardly, corrupt, or inept, interested only in saving their own skin—in
some cases their baggage—at the expense of their men. Abd-el-Krim's victory was
total. Silvestre committed suicide. The High Command had expected General

Picasso to exempt his fellow generals from his strictures, to whitewash the meddlesome King, and limit the investigation "to obvious cases of dishonorable conduct during the panicky retreat."[7] Besides rocklike integrity, General Picasso had the all-important backing of the minister of war, Juan de la Cierva, who was able to deflect the old guard's attempts to derail the inquiry. *"Los terribles papeles,"* which the general submitted on April 18, 1922, confirmed the High Command's worst fears. It compromised the King and many of the King's men, including General Berenguer and other military and civilian authorities. General Picasso denounced "the procedures followed in the Spanish zone of Morocco [as] misguided in every respect."[8] His report was further vindicated when Abd-el-Krim's prisoners of war were repatriated in 1923 with yet more stories of their superiors' cowardice and betrayals.

To save himself and his minions, the King managed to have the report suppressed and, to General Picasso's fury, granted pardons to the inept Berenguer and the cowardly Colonel Jiménez Arroyo, whose surrender had left the Spanish line of defense untenable. Alfonso suffered no harm; in return for surrendering his royal prerogatives, he was allowed to go on playing at being king. Henceforth, absolute power would be vested in the military dictator, General Miguel Primo de Rivera, who took over the country in 1923. Rather than act on the report, he kept it up his sleeve.

For France, which shared Morocco with Spain, the Annual disaster would have very different but no less far-reaching consequences. The left—socialists, Communists, and the increasingly politicized surrealists—vociferously supported Abd-el-Krim and his Rifeños. The right was terrified that the rebellion would spread to their protectorate and that France would suffer the same fate as Spain unless the Rifeños were put down. When, on May 15, 1925, President Poincaré decided to send French troops to help Spain regain control of Morocco, there were massive demonstrations, including some sixty thousand protesters at Père-Lachaise on May 24. For the surrealists, opposition to the war in Morocco became a defining political cause. Despite his attachment to the beau monde, the young surrealist poet René Crevel became one of the most fervent activists. "The more brutal the better," he said of the protests he helped to organize.[9] Neither Crevel nor his surrealist or leftist associates were aware that the artist had a cousin who had played a heroic role in Moroccan affairs. In 1926 the French enabled the Spanish to crush the insurrection and force Abd-el-Krim to surrender to Marshal Pétain. Thirty years later, history would repeat itself, when outrage on the left put a stop to de Gaulle's brutal policies in Algeria.

Perceived as a whistle-blower, General Picasso was reviled for his courage and honesty and shunted off to the Reserva with the rank of lieutenant general. However, his courage did not go unperceived. A cartoon by Bagaría in *El Sol* portrays Pablo Picasso, palette in hand, glowering at a large cubist painting on his easel. The caption reads, "I'm angry with my uncle, the general. Previously only my art was dismissed as

too dark. Now they complain of his clarity. Whatever catches the public eye!"[10] General Picasso came from the same Andalusian background as Miguel Primo de Rivera and had worked with him, which might explain the artist's surprisingly uncritical attitude toward the dictator as well as his son, José Antonio.

As military dictators go, Miguel Primo de Rivera was relatively humane—at least at first. Although born to a family of reactionary landowners, he differed from his neighbors, as Gerald Brenan writes, in his

> desire to remedy the condition of the poor within the rather narrow framework of what was possible to him. As a general too he was something of a pacifist. He stood out against the strong feeling in the Army for a *revanche* in Morocco and began a withdrawal of the troops to the fortresses on the coast. And he was humane: although his six years of rule had their share of plots and risings, on only one occasion were there executions.[11]

However, power did not take long to corrupt the dictator. Forced to resign in 1930, he retired to Paris, where he soon gorged his life away in bars and brothels.[12] Berenguer replaced him, but not for long. The Picasso report was dusted off and used to help remove him from power, and also to taint the monarchy. Alfonso XIII's reign had started with the blast of an anarchist's bomb decimating his wedding cortege; his exile was greeted with a national sigh of relief: no bloodshed and few tears. Municipal elections in March 1931 brought the Republicans to power. It was hoped that "the Golden Age of a Socialist-led Second Republic" would bring peace, prosperity, and democracy to Spain.[13] Republicans went boldly ahead with their liberal agenda. They wrenched control of education away from the church, built thousands of new schools, and instituted agrarian reforms and cultural initiatives, including an exhibition of Picasso's work in Spain. Plans for this fell through when it turned out that a squad of the Guardia Civil (National Guard) on the train bringing the paintings to Madrid was all the insurance the Republican government could afford.

In August 1933, Picasso, accompanied by Olga and Paulo,[14] paid a state visit to Barcelona to celebrate the acquisition by the Palau de Belles Artes of Lluis Plandiura's collection of his early works. Besides being reunited with some of his oldest friends—the de Sotos, Manolos, Reventoses, Junyer-Vidals—he traveled around attending bullfights and encouraging his son's *afición*. The delight the Catalans took in their "Golden Age" was turning to foreboding at rebellious rumblings from the right. In the face of fascism the parties of the left coalesced into the Popular Front, whose members organized strikes, demonstrations, and such subversive acts as derailing trains. When coal miners in Asturias came out on strike, they were brutally put down by General Franco and his troops. Chaos ensued. To stave off revolution, a general election was called for in February 1936, and the Popular Front won, but it

did not hold together. After the murder of Calvo Sotelo, a leading right-wing politician, in July 1936, civil war was inevitable. A mismatched coalition of liberal idealists, socialists, anarchists, and Communists stood no chance against unified totalitarian might. By the elections of November 1933, the church, the military, and the landowners had joined forces. After two and a half years of rickety utopian democracy, the Republicans were ousted and the Right regained power—power that was vested in a fascist party named the Falange, under the leadership of Primo de Rivera's son, José Antonio.

Just as he had liked Miguel Primo de Rivera for not disliking his work, Picasso warmed to the son. "El Jefe," as he was known, was notoriously charming. Far more sophisticated than his "glorified café politician"[15] of a father, he realized the public relations advantage that Mussolini had derived from harnessing Marinetti and the futurists to his "new order," so he promptly set about attracting avant-garde painters, poets, and intellectuals to promote his endeavor. José Antonio took on the dynamic Ernesto Giménez Caballero, owner-editor of the prestigious *Gaceta Literaria,* which had employed Buñuel as a film critic, published Federico García Lorca, and even a work by Picasso. Formerly one of the most progressive intellectuals in Spain, Giménez Caballero had experienced a radical epiphany and reinvented himself as a fascist ideologue who would forsake avant-garde involvement to write proselytizing Catholic tracts, including *La nueva catolicidad* (1933) and *Roma madre* (1939), as well as Franco's speeches. After recruiting Dalí—he filmed the artist and his "arachnid" wife on the rooftop of his Madrid office[16]—Giménez Caballero set about winning over Picasso and Lorca to the fascist side. In this endeavor he had the support of an ambitious young modernist architect, José Manuel Aizpurua, whom José Antonio named as delegate for press and propaganda to the Junta Nacional de Falange Español.[17] Aizpurua would be one of the first important Falangists to be shot in the civil war.

For all his liberal beliefs, Lorca had been almost as careful as Picasso to avoid overt political commitment. As the poet told Rafael Martínez Nadal, he was "an anarchist—communist—libertarian, a pagan catholic, a traditionalist and monarchist who supports don Duarte of Portugal."[18] To another friend Lorca said "I greet some people like this"—he raised his hand in a fascist salute—"and others like that"—he raised a clenched Communist fist. "But to my friends, this"—he cried and held out his hand.[19] Nervous of being cornered by José Antonio's advances, Lorca left for South America. Back in Spain, he was warned by friends to stay in Madrid, but he could not keep away from his beloved hometown of Granada, where "a small but determined Falangist party"[20] was in power. Lorca was soon obliged to go into hiding, but the Falangists found him and executed him. The assassin did the rounds of the Granada cafés boasting of having shot the poet "up the ass." A month before

his death, Lorca had told a friend, "As for me, I'll never be political. I'm a revolutionary, because all true poets are revolutionaries . . . but political, never."[21]

Picasso felt much the same way. In 1932 he had been asked by Eluard to sign a petition in support of Aragon, who had been charged with inciting violence in his poem *Front rouge*. Fearful that the secret police might use his signature on a petition as an excuse for expelling him from France, he insisted on consulting his lawyer before signing. If he failed to do so, Eluard threatened, in a shockingly revealing letter to his former wife, Gala Dalí, "to denounce him, attack him violently."[22] No wonder Picasso mistrusted the surrealists. So did the Communists. An article in their newspaper *L'Humanité* accused the surrealists of being "pretentious intellectuals" out to exploit Aragon's plight to their advantage.[23] As for Picasso, the Soviet embassy in Paris had discouraged Moscow from taking any interest in this artist who was "little more than a leftist bourgeois."[24] Had he known this, Picasso would have been greatly relieved.

Picasso's lack of political involvement gave José Antonio cause for hope. Hearing that the artist was returning to Spain, at the end of August 1934, for another tauromachic tour, El Jefe invited him and his wife and son to San Sebastián—Spain's smartest resort—to be guest of honor at the inaugural dinner of a "cultural and gastronomic club" called the GU. Twenty years later, Picasso told his Argentine friend, Otero, that he found José Antonio *"muy simpático."*[25] He had not, however, realized that GU was the propagandist arm of the Falange. The dinner was held on the premises of the Club Náutico (the Royal Yacht Club), a stylish Corbusierish pavilion, "hanging over San Sebastián's La Concha beach,"[26] which had been designed by Aizpurua. Giménez Caballero was in charge of the arrangements. This should have put Picasso on his guard. He must surely have recalled that in 1931 Giménez Caballero had attacked the eminent philosopher Dr. Gregorio Marañón for calling on Picasso to consider returning to Spain or, at least, to consent to be buried there when his brilliant career ended.[27] Among those who lent their names to this petition were Eugenio d'Ors, Gómez de la Serna, the Duke of Alba, Pedro Sainz Rodríguez (assistant editor of *La Gaceta*), José Ortega y Gasset, and Gregorio Marañón.

Giménez Caballero assailed the petition in a front-page editorial in *La Gaceta* attacking Picasso's artistry. Picasso had achieved fame "thanks only to the bourgeois class, the capitalists and their army of critics and merchants, the agents of the stock exchange of paintings. . . . Promoters of the petition were representatives of Spanish 'snobbism,' who simply could not comprehend the direction of Vanguardist art."[28] In his differing accounts of his meetings with Picasso, there seems to have been no mention of past history. Giménez Caballero first encountered the artist lunching at the Club Náutico with Olga and Paulo and someone he identifies as either Aizpurua or a lawyer.[29] Although Olga spoke good Spanish, they were talking French out of

courtesy to her. "I have been here for several days," Picasso reportedly said, "more than I thought. I came for twenty-four hours, but I have stayed much longer so that I can get back to the heart of Spain."[30] He had been amused to discover that "the nuns take their girls to the bullfights. Since the Republic, they have free passes as if it were a feast day and they were going to be blessed."[31] Picasso had also been struck, he said, by all the "lost children on the beach and by the voice from a loudspeaker telling them what to do." "Perhaps Picasso was no more than a lost child on a Spanish beach," Giménez Caballero fantasized[32]—as if he were the official with the loudspeaker.

Three days of Giménez Caballero's attempts at indoctrination confirmed Picasso in his distaste for fascism. The man's questions were surprisingly dim: "Which book do you prefer of all those written about you?" "One in Japanese that I couldn't read." "Do you believe that art should be abstract?" "No, simple and direct, like a bridge connecting two different points."[33] Someone else asked why he lived in Paris and not in Spain. "One carries one's passport on one's face."[34] Picasso's habit of combing his graying forelock over his forehead reminded Giménez Caballero of a picador. The gold watch chain on his lapel, the handkerchief in his breast pocket, and "the waist-coated belly exploding from his jacket" were more reminiscent of "a priest in a casino."[35]

José Antonio was more suave than his henchman. "What would you say if in the distant future an encyclopedia defined you as a great Andalusian poet—better known in his lifetime as a painter?" he asked. Picasso would recall this incident in the 1950s, when Otero asked the very same question that José Antonio had put to him at "the banquet in my honor at the San Sebastián Yacht Club. Strange, isn't it?"[36] Strange, indeed, in that Picasso *did* abandon painting for poetry a year later. The artist never explained why he had accepted the Falangist invitation, but the reason can only have been that he wanted a retrospective of his work to be held in Spain—something the Falange was very keen to promote. When Picasso complained about the Republican government's failure to come up with enough money, only guards, to insure such a show, José Antonio promised a detachment of the Guardia Civil as an escort, "but only after we have insured your work."[37]

To further the prospects of a show, Picasso told José Antonio that "the only Spanish politician who spoke well of me as a national glory was your father."[38] Miguel Primo de Rivera had supposedly made this statement in an article in "a North American newspaper," no trace of which has been found. Besides arranging for an exhibition in the land of his birth, Picasso wanted to show his wife and son how highly regarded he was in his own country. The excuse he gave Otero for accepting José Antonio's compromising invitation was political naïveté. He claimed that he had been "set up" by Giménez Caballero:

Just listen to what [Giménez Caballero] said about my eyes . . . that I had the same expression as Mussolini. Of course, that was a compliment of sorts, coming from him. However, for me it was anything but. I knew the people wining and dining me that night were very dangerous and as I remember I boarded the train for France that same evening. And that was my last day in Spain.[39]

This was not true. Far from returning to Paris, Picasso stayed on to be feted by these "very dangerous" people. When he left, it was not to return to Paris but to go on to Burgos—and not by train but in his Hispano-Suiza. To Picasso's fury, Giménez Caballero announced to the press that "the Picasso meeting . . . [was] a resounding propaganda coup. . . . the artist had been finally won over to the right by Primo de Rivera's unctuous charm."[40] This outright lie convinced Picasso that he could no longer stay above the fray. It was time to commit himself: when he emerged from the political closet, he became a passionate supporter of the Republican cause in Spain and, thanks to the strategic blandishments of the opportunistic Eluard, a vocal supporter of the left in France. The comparison of Picasso's eyes to Mussolini's had settled that. In due course, an exhibition—by no means a retrospective—would take place shortly before civil war broke out in 1936,[41] under Republican as opposed to Falangist auspices as a result of Eluard's intervention.

Within two years of the San Sebastián dinner, José Antonio would be dead— arrested and executed by the Republican militia, a victim of the civil war that his Falange had provoked. In commemoration of El Jefe's "martyrdom," Franco would rename many of the main streets in large cities of Spain Avenida José Antonio Primo de Rivera. Meanwhile (April 1935), Picasso's cousin, the gallant general, had died of throat cancer. As Pando Despierto, who finally published "the terrible papers of General Picasso," observed, "there were no speeches nor a state funeral . . . nor is there a street named after the general who saved the moral integrity of the military at the cost of suffering a personal Calvary."[42] No matter, his cousin Pablo would immortalize the name.

The outbreak of civil war in Spain would politicize Picasso and re-Hispanicize his art, as witness his antifascist icon *Guernica,* which is thought by many, though not the artist—he attached more importance to *Les Demoiselles d'Avignon* and *La Danse*— to be his finest work. To Picasso's delight, refugee painters, poets, and architects, not to mention two of his Vilató nephews, settled in Paris and enabled him finally to establish a Spanish *tertulia.* Despite pressure from Eluard among others, Picasso did not join the Communists, just as he had resisted joining the surrealists. He would not do so until the end of World War II. According to Dora Maar,[43] who was living with Picasso at the time, his ultimate conversion to communism was partly the consequence of his short-lived admiration of de Gaulle for liberating Paris. An invitation to dine with a group of leading Gaullists put paid to that. Their right-wing agenda

put such a scare into Picasso that, without informing Dora, he joined the Communists a few days later. With Aragon and Joliot-Curie, the artist would become one of the party's "Three Musketeers,"[44] who were trotted out on appropriate cultural occasions to help rally the masses. He was also under pressure to come up with agitprop: the less said about the mercifully few examples, the better. At heart, Picasso never forsook his old gods. As he told a Spanish friend in the 1930s, "God is really another artist . . . like me. . . . I am God, I am God, I am God . . ."[45]

SHORT TITLES

Abbreviations of archives and libraries where original documents are located:

Archives Picasso	Picasso Archives at the Musée National Picasso, Paris
Beinecke Library	Gertrude Stein Archives, Beinecke Library, Yale University, New Haven, Conn.
Pierpont Morgan Library	Archives (Diaghilev/De Falla, Rosenberg), Pierpont Morgan Library, New York
Ransom Center	Harry Ransom Humanities Research Center, University of Texas at Austin

Short titles of catalogs used to identify works by Picasso:

Baer	Brigitte Baer. *Picasso: Peintre-Graveur.* 7 vols. (Original editions of vols. I–II by Bernhard Geiser.) Bern: Kornfeld, 1933–96.
JSLC	Arnold Glimcher and Marc Glimcher, eds. *Je suis le cahier: The Sketchbooks of Picasso.* New York: Pace Gallery, 1986.
MP	*Musée Picasso: Catalogue sommaire des collections.* 2 vols. Paris: Réunion des musées nationaux, 1985, 1987.
MP Carnets	*Musée Picasso: Carnets: Catalogue des dessins.* 2 vols. Paris: Réunion des musées nationaux, 1996.
P.F.III	Josep Palau i Fabre. *Picasso: From the Ballets to Drama (1917–1926).* Trans. by Richard-Lewis Rees. Hagen, Germany: Könemann, 1999.
S.	Werner Spies. *Picasso: The Sculptures.* Trans. by Melissa Thorson House and Margie Mounier. Ostfildern/Stuttgart: Hatje Canz, 2000.
Z.	Christian Zervos. *Pablo Picasso.* 33 vols. Paris: Cahiers d'Art, 1932–78.

Short titles of principal sources cited in the notes:

Adéma	Pierre Marcel Adéma. *Guillaume Apollinaire.* Paris: La Table Ronde, 1968.
Aragon	Louis Aragon. *Ecrits sur l'art moderne.* Paris: Flammarion, 1981.
Armel	Aliette Armel. *Michel Leiris.* Paris: Fayard, 1997.
Arnaud	Claude Arnaud. *Jean Cocteau.* Paris: Gallimard, 2003.
Assouline	Pierre Assouline. *An Artful Life: A Biography of D. H. Kahnweiler, 1884–1979.* Trans. Charles Ruas. New York: Grove Weidenfeld, 1990. Originally published 1988.
Axsom	Richard Hayden Axsom. *Parade: Cubism as Theater.* Ann Arbor: University of Michigan Press, 1994.
Bach	Friedrich Teja Bach. *Constantin Brancusi: Metamorphosen Plastischer Form.* Cologne: Dumont, 1987.

Baer 1997	Brigitte Baer. *Picasso the Engraver.* Trans. Iain Watson and Judith Schub. London: Thames and Hudson, 1997.
Baldassari 1997	Anne Baldassari. *Picasso and Photography: The Dark Mirror.* Trans. Deke Dusinberre. Houston: Museum of Fine Arts, 1997.
Baldassari 1998a	Anne Baldassari. "Olga Koklova and Dance." In *Picasso 1917–1924.* Venice: Palazzo Grassi, 1998, 87–92.
Baldassari 1998b	Anne Baldassari. "1917–21: Tracing Picasso's Iconography from *L'Italienne* (*The Italian Woman*) to *Trois femmes à la fontaine* (*Three Women at the Spring*)." In *Picasso 1917–1924.* Venice: Palazzo Grassi, 1998, 100–5.
Baldassari 2002	Anne Baldassari. "Exposition 'Matisse-Picasso,' galerie Paul Guillaume, Paris, 1918." In *Matisse Picasso.* Paris: Réunion des musées nationaux, 2002, 361–4.
Baldassari 2005	Anne Baldassari. *Bacon/Picasso: La Vie des images.* Paris: Flammarion, 2005.
Barr	Alfred H. Barr Jr. *Picasso: Fifty Years of His Art.* New York: Museum of Modern Art, 1980. Originally published 1946.
Beaumont	Cyril W. Beaumont. *The Diaghilev Ballet in London: A Personal Record.* London: Putnam, 1945.
Bell	Clive Bell. *Old Friends: Personal Recollections.* London: Chatto and Windus, 1956.
Bernadac and Michaël	Marie-Laure Bernadac and Androula Michaël. *Picasso: Propos sur l'art.* Paris: Gallimard, 1998.
Bernadac and Piot	Marie-Laure Bernadac and Christine Piot, eds. *Picasso: Collected Writings.* Trans. Carol Volk and Albert Bensoussan. London: Aurum Press, 1989.
Bernier	Rosamond Bernier. "48, Paseo de Gracia." *L'Œil,* no. 4 (April 15, 1955), 4–13.
Billot	Marcel Billot. *Journal de L'Abbé Mugnier (1879–1939).* Paris: Mercure de France, 1935.
Blanche	Jacques-Emile Blanche. "Retrospective Picasso." *L'Art Vivant* 3 (July 1932), 333–41.
Boehm, Mosch, and Schmidt	Gottfried Boehm, Ulrich Mosch, and Katharina Schmidt. *Canto d'Amore: Classicism in Modern Art and Music 1914–1935.* Basel: Kunstmuseum, 1996.
Boggs	Jean Sutherland Boggs. *Picasso & Things.* Cleveland: Cleveland Museum of Art, 1992.
Bois	Yve-Alain Bois. *Matisse and Picasso.* Paris: Flammarion, 2001.
Boyd	Carolyn P. Boyd. *Praetorian Politics in Liberal Spain.* Chapel Hill: University of North Carolina Press, 1979.
Brassaï	Brassaï. *Picasso and Company.* Trans. Francis Price. Garden City, N.Y.: Doubleday, 1966. Originally published 1964.
Brenan	Gerald Brenan. *The Spanish Labyrinth: An Account of the Social and Political Background of the Civil War.* Cambridge, U.K.: Cambridge University Press, 1964.
Buckle 1971	Richard Buckle. *Nijinsky.* London: Weidenfeld and Nicolson, 1971. Reprinted by Penguin Books, 1980.
Buckle 1979	Richard Buckle. *Diaghilev.* London: Weidenfeld and Nicolson, 1979. Reprinted by Hamish Hamilton, 1984.

Buffet-Picabia	Gabrielle Buffet-Picabia. *Rencontres avec Picabia, Apollinaire, Cravan, Duchamp, Arp, Calder.* Paris: Belfond, 1977.
Buñuel	Luis Buñuel. *Mi ultimo suspiro (Memorias).* Barcelona: Plaza & Janes, 1982.
Cabanne 1977	Pierre Cabanne. *Pablo Picasso: His Life and Times.* Trans. Harold J. Salemson. New York: William Morrow, 1977.
Cabanne 1984	Pierre Cabanne. "Picasso et les joies de la paternité." *L'Œil,* no. 226 (1974), 1–10.
Cabanne 1992	Pierre Cabanne. *Le Siècle de Picasso.* Vol. 2, *L'Epoque des métamorphoses.* Paris: Denoël, 1992.
Caizergues and Seckel	Pierre Caizergues and Hélène Seckel. *Picasso/Apollinaire: Correspondance.* Paris: Gallimard, 1992.
Canseco-Jerez	Alejandro Canseco-Jerez. *Le Mecenat de Madame Errazuriz.* Paris: L'Harmattan, 2000.
Carandente	Giovanni Carandente. "Picasso and the Italian Scene." In *Picasso 1917–1924.* Venice: Palazzo Grassi, 1998, 31–48.
Chapon 1984	François Chapon. *Jacques Doucet ou l'art du mécénat.* Paris: Perrin, 1996. Originally published 1984.
Chapon 1987	François Chapon. *Le Peintre et le livre: L'Age d'or du livre illustré en France 1870–1970.* Paris: Flammarion, 1987.
Charles-Roux	Edmonde Charles-Roux. *Chanel: Her Life, Her World—and the Woman behind the Legend She Herself Created.* Trans. Nancy Amphoux. London: Jonathan Cape, 1975. Originally published 1974.
Cline	Sally Cline. *Zelda Fitzgerald: Her Voice in Paradise.* New York: Arcade, 2002.
Cocteau 1989	Jean Cocteau. *Lettres à sa mère.* Paris: Gallimard, 1989.
Combalía	Victoria Combalía. *Picasso-Miró: Miradas cruzadas.* Madrid: Electa, 1998.
Cooper	Douglas Cooper. *Picasso Theatre.* London: Weidenfeld and Nicolson, 1968.
Cousins and Seckel	Judith Cousins and Hélène Seckel. "Chronology of *Les Demoiselles d'Avignon,* 1907 to 1939." In *Les Demoiselles d'Avignon: Studies in Modern Art 3.* New York: Museum of Modern Art, 1994, 145–205.
Cowling 2002	Elizabeth Cowling. *Picasso: Style and Meaning.* London: Phaidon, 2002.
Cowling 2006	Elizabeth Cowling. *Visiting Picasso: The Notebooks and Letters of Roland Penrose.* London: Thames and Hudson, 2006.
Daix 1977	Pierre Daix. *La Vie de peintre de Pablo Picasso.* Paris: Seuil, 1977.
Daix 1993	Pierre Daix. *Picasso: Life and Art.* Trans. Olivia Emmet. New York: HarperCollins, Icon Editions, 1993. Originally published 1987.
Daix 1995	Pierre Daix. *Dictionnaire Picasso.* Paris: Robert Laffont, 1995.
Danchev	Alex Danchev. *Georges Braque: A Life.* London: Hamish Hamilton, 2005.
Derouet 1999	Christian Derouet. "Juan Gris: Correspondances avec Léonce Rosenberg 1915–1927." *Les Cahiers du Musée national d'art moderne.* Paris: Centre Pompidou, 1999.
Derouet 2000	Christian Derouet. "Francis Picabia: Lettres à Léonce Rosenberg 1929–1940." *Les Cahiers du Musée national d'art moderne.* Paris: Centre Pompidou, 2000.

Derouet 2006	Christian Derouet. *Cahiers d'Art: musée Zervos à Vézelay.* Paris: Hazan, 2006.
Dolin	Anton Dolin. *Divertissement.* London: Sampson Low, Marston, 1931.
Donnelly	Honoria Murphy Donnelly with Richard N. Billings. *Sara & Gerald: Villa America and After.* New York: Times Books, 1982.
Duke	Vernon Duke. *Passport to Paris.* Boston: Little, Brown, 1955.
Everling	Germaine Everling. *L'Anneau de Saturne.* Paris: Fayard, 1970.
Ferran	A[ngel] F[erran]. "Interviu amb Picasso." *La Publicitat,* October 19, 1926.
FitzGerald 1988	Michael C. FitzGerald. *Pablo Picasso's Monument to Guillaume Apollinaire: Surrealism and Monumental Sculpture in France 1918–1959.* Ann Arbor, Mich.: Garland Press, 1988.
FitzGerald 1995	Michael C. FitzGerald. *Making Modernism: Picasso and the Creation of the Market for Twentieth-Century Art.* New York: Farrar, Straus and Giroux, 1995.
FitzGerald 1996	Michael C. FitzGerald. "The Modernists' Dilemma: Neoclassicism and the Portrayal of Olga Khokhlova." In *Picasso and Portraiture: Representation and Transformation.* New York: Museum of Modern Art (1996), 296–335.
Flam	Jack Flam. *Matisse Picasso: The Story of Their Rivalry and Friendship.* Cambridge, Mass.: Westview Press, 2003.
Florman	Lisa Florman. *Myth and Metamorphosis: Picasso's Classical Prints of the 1930s.* Cambridge, Mass.: MIT Press, 2002.
García-Márquez	Vicente García-Márquez. *Massine: A Biography.* New York: Knopf, 1995.
Gasman	Lydia Gasman. *Mystery, Magic and Love in Picasso, 1925–1938: Picasso and the Surrealist Poets.* Ann Arbor, Mich.: University Microfilms, 1981.
Gee	Malcolm Gee. *Dealers, Critics, and Collectors of Modern Painting: Aspects of the Parisian Art Market Between 1910 and 1930.* New York: Garland Publishing, 1981.
Geelhaar	Christian Geelhaar. *Picasso: Wegbererter und Förderer seines Aufstiegs 1899–1939.* Zurich: Palladion, 1993.
Georges-Michel 1923	Michel Georges-Michel. *Ballets Russes.* Paris: Editions du monde nouveau, 1923.
Georges-Michel 1957	Michel Georges-Michel. *From Renoir to Picasso: Artists I Have Known.* London: Gollancz, 1957.
Gibson 1989	Ian Gibson. *Federico García Lorca: A Life.* London: Faber and Faber, 1989.
Gibson 1997	Ian Gibson. *The Shameful Life of Salvador Dalí.* London: Faber and Faber, 1997.
Gillmor	Alan M. Gillmor. *Erik Satie.* Basingstoke, U.K.: Macmillan, 1988.
Gilmore 1998	David D. Gilmore. *Carnival Culture: Sex, Symbol and Status in Spain.* New Haven, Conn.: Yale University Press, 1998.
Gilot 1964	Françoise Gilot with Carlton Lake. *Life with Picasso.* New York: McGraw-Hill, 1964.
Gilot 1990	Françoise Gilot. *Matisse and Picasso: A Friendship in Art.* London: Bloomsbury, 1990.
Giménez	Carmen Giménez. *Picasso and the Age of Iron.* New York: Guggenheim Museum, 1993.

Giménez Caballero	Ernesto Giménez Caballero. *Memorias de un dictador.* Madrid: Planeta, 1979.
Gimpel	René Gimpel. *Diary of an Art Dealer.* New York: Farrar, Straus and Giroux, 1966.
Goeppert	Sebastian Goeppert and Herma C. Goeppert-Frank. *Minotauromachy by Pablo Picasso.* Zurich: Patrick Cramer, 1987.
Gold and Fizdale	Arthur Gold and Robert Fizdale. *Misia: The Life of Misia Sert.* New York: Morrow Quill, 1981.
Gombrich	E. H. Gombrich. *Art and Illusion.* London: Phaidon, 1960.
Grigoriev	S. L. Grigoriev. *The Diaghilev Ballet 1909–1929.* Trans. Vera Bowen. Harmondsworth, U.K.: Penguin, 1960. Originally published 1953.
Guillen Robles	F. Guillen Robles. *Málaga Musulmana.* Málaga, 1957.
Häger	Bengt Häger. *Ballets Suédois.* Trans. Ruth Sharman. London: Thames and Hudson, 1990. Originally published 1989.
Holroyd 1968	Michael Holroyd. *Lytton Strachey: A Critical Biography.* Vol. II, *The Years of Achievement (1910–1932).* New York: Holt, Rinehart and Winston, 1968.
Holroyd 1996	Michael Holroyd. *Augustus John.* London: Chatto and Windus, 1996.
Hubert	Etienne-Alain Hubert. "Was *Les Demoiselles d'Avignon* exhibited in 1918?" In *Les Demoiselles d'Avignon: Studies in Modern Art 3.* New York: Museum of Modern Art, 1994, 206–10.
Hugo 1953	Valentine Hugo. "Il y a trente ans." *La Parisienne,* December 1953. Reprinted in *De Valentine Gross à Valentine Hugo.* Boulogne-sur-Mer: Bibliothèque Municipale, 2000, 19–28.
Hugo 1983	Jean Hugo. *Le Regard de la mémoire.* Arles: Actes Sud, 1983.
Johns	Catherine Johns. *Sex or Symbol: Erotic Images of Greece and Rome.* Austin: University of Texas Press, 1982.
Kahnweiler 1949	Daniel-Henry Kahnweiler. *The Sculptures of Picasso.* Trans. A. D. B. Sylvester. London: Rodney Phillips, 1949.
Kahnweiler 1956	Daniel-Henry Kahnweiler. "Entretiens avec Picasso." *Quadrum,* no. 2 (November 1956), 73–6.
Kahnweiler 1971	Daniel-Henry Kahnweiler with Francis Crémieux. *My Galleries and Painters.* Trans. Helen Weaver. New York: Viking, 1971. Originally published 1961.
Kahnweiler-Gris 1956	Daniel-Henry Kahnweiler. *Letters of Juan Gris.* Trans. Douglas Cooper. London: Privately printed, 1956.
Kammen	Michael Kammen. *The Lively Arts: Gilbert Seldes and the Transformation of Cultural Criticism in the United States.* New York: Oxford University Press, 1996.
Karsavina	Tamara Karsavina. *Theatre Street.* London: Readers Union, 1950. Originally published 1948.
Kaufmann	Ruth Kaufmann. "Picasso's *Crucifixion* of 1930." In *The Body on the Cross.* Paris: Musée Picasso, 1993, 74–83.
Kean	Beverly Whitney Kean. *All the Empty Palaces: The Merchant Patrons of Modern Art in Pre-Revolutionary Russia.* New York: Universe Books, 1983.
Kimball	Anne Kimball. *Max Jacob/Jean Cocteau Correspondance 1917–1944.* Paris: Editions Paris-Méditerranée, 2002.

Klein	Hélène Klein. "Présentation." In Fernande Olivier, *Picasso et ses amis.* Paris: Pygmalion, 2001.
Kochno	Boris Kochno. *Le Ballet.* Paris: Hachette, 1954.
Kosinski	Dorothy Kosinski. "G. F. Reber: Collector of Cubism." *Burlington Magazine,* August 1991, 519–32.
Kostenevich	Albert Kostenevich. "Russian Collectors of French Art: The Shchukin and Morozov Families." In *Morozov and Shchukin—The Russian Collectors: Monet to Picasso.* Essen: Museum Folkwang, 1993.
Krauss 1986	Rosalind E. Krauss. "Life with Picasso: Sketchbook No. 92, 1926." In *Je suis le cahier: The Sketchbooks of Picasso.* New York, Pace Gallery, 1986, 113–23.
Krauss 1998	Rosalind E. Krauss. *The Picasso Papers.* New York: Farrar, Straus and Giroux, 1998.
Lagut	Unpublished interview with Irène Lagut by Jean-José Marchand and Philippe Colin. "Archives du XXème siècle." Radiodiffusion Télévision Française, 1973.
Lake and Ashton	Carlton Lake and Linda Ashton. *Henri-Pierre Roché: An Introduction.* Austin: Harry Ransom Humanities Research Center, 1991.
Laporte	Geneviève Laporte. *Sunshine at Midnight: Memories of Picasso and Cocteau.* Trans. Douglas Cooper. London: Weidenfeld and Nicolson, 1973.
Larralde and Casenave	Jean-François Larralde and Jean Casenave. *Picasso à Biarritz été 1918.* Biarritz: Lavielle, 1995.
Léal	Brigitte Léal. *Picasso: Papiers collés.* Paris: Musée Picasso, 1998.
Leiris 1930	Michel Leiris. "Toiles récentes de Picasso." *Documents* 2, no. 2 (February 1930), 57–70.
Leiris 1946	Michel Leiris. *Manhood: A Journey from Childhood into the Fierce Order of Virility.* Trans. Richard Howard. San Francisco: North Point Press, 1984. Originally published 1946.
Leiris 1992	Michel Leiris. *Journal: 1922–1989.* Ed. Jean Jamin. Paris: Gallimard, 1992.
Levinson	*André Levinson on Dance: Writings from Paris in the Twenties.* Ed. Joan Acocella and Lynn Garafola. Hanover, N.H.: Wesleyan University Press, 1991.
Loeb	*L'Aventure de Pierre Loeb: La Galerie Pierre Paris 1924–1965.* Paris: Musée d'art moderne de la Ville, 1979.
MacGregor-Hastie	Roy MacGregor-Hastie. *Picasso's Women.* Luton, U.K.: Lennard Books, 1988.
Madeline 2005a	Laurence Madeline. "Picasso and the Calvet Affair of 1930." *Burlington Magazine* 147, no. 1226 (May 2005), 316–23.
Madeline 2005b	Laurence Madeline. *Gertrude Stein Pablo Picasso: Correspondance.* Paris: Gallimard, 2005.
Malraux	André Malraux. *Picasso's Mask.* Trans. June Guicharnaud with Jacques Guicharnaud. New York: Da Capo, 1994. Originally published 1974.
Marler	Regina Marler, ed. *Selected Letters of Vanessa Bell.* London: Bloomsbury, 1993.
Martin	Georges Martin. "Dans l'air de Paris: Picasso." *L'Intransigeant,* October 27, 1919.

Massine	Léonide Massine. *My Life in Ballet.* London: Macmillan, 1968.
McCully	Marilyn McCully, ed. *A Picasso Anthology.* London: Arts Council of Great Britain, 1981.
Menaker-Rothschild	Deborah Menaker-Rothschild. *Picasso's "Parade" from Street to Stage.* New York: Drawing Center, 1991.
Miller	Charles Miller. "The Ambivalent Eye: Picasso 1925–1933." Ph.D. dissertation. London: Courtauld Institute, 2006.
Mitchell	Donald Mitchell. *The Language of Modern Music.* Philadelphia: University of Pennsylvania Press, 1994. Originally published 1963; revised 1993.
Monod-Fontaine	Isabelle Monod-Fontaine. *Donation Louise et Michel Leiris.* Paris: Centre Georges Pompidou, Musée national d'art moderne, 1984.
Morand 1976	Paul Morand. *L'Allure de Chanel.* Paris: Hermann, 1976.
Morand 1996	Paul Morand. *Journal d'un attaché d'ambassade: 1916–1917.* Paris: Gallimard, 1996.
Morand 2001	Paul Morand. *Journal inutile 1968–1972.* Paris: Gallimard, 2001.
Morris	Margaret Morris. *The Art of J. D. Fergusson.* Glasgow: Blackie, 1974.
Mosch	Ulrich Mosch. "On Relations between Music and Art in the Classicist Ballets *Pulcinella* and *La Giara*." In *Canto d'Amore: Classicism in Modern Art and Music 1914–1935.* Basel, Kunstmuseum, 1996, 222–406.
Nemer	Monique Nemer. *Raymond Radiguet.* Paris: Fayard, 2002.
Noël	Maurice Noël. "Le Monument de Guillaume Apollinaire, ou dix années de gestation de M. Pablo Picasso." *Le Figaro Littéraire,* October 20, 1934.
Otero	Roberto Otero. *Forever Picasso: An Intimate Look at His Last Years.* Trans. Elaine Kerrigan. New York: Abrams, 1974.
Ovid	*The Metamorphoses of Ovid.* Trans. Allen Mandelbaum. San Diego: Harcourt Brace, 1993.
Painter	George D. Painter. *Marcel Proust.* Vol. II. London: Chatto and Windus, 1965.
Palau 1971	Josep Palau i Fabre. *Picasso i els seus amics catalans.* Barcelona: Aedos, 1971.
Palau 1999	Josep Palau i Fabre. *Picasso: From the Ballets to Drama (1917–1926).* Trans. Richard-Lewis Rees. Hagen, Germany: Könemann, 1999.
Pando Despierto	Juan Pando Despierto. "Los terribles papeles del general Picasso." *La Aventura de la Historia,* no. 4 (January 1999), 30–7.
Penrose	Roland Penrose. *Picasso: His Life and Work.* London: Granada, 1981. Originally published 1958.
Polizzotti	Mark Polizzotti. *Revolution of the Mind: The Life of André Breton.* New York: Farrar, Straus and Giroux, 1995.
Polunin	Vladimir Polunin. *The Continental Method of Scene Painting: Seven Years with the Diaghileff Company.* New York: Da Capo, 1979. Originally published 1927.
Poulenc	Francis Poulenc. *My Friends and Myself.* Ed. Stéphane Audel. Trans. James Harding. London: Dennis Dobson, 1978.
Prampolini	Enrico Prampolini. "Incontro con Picasso." In *Cinquanta disigeni di Pablo Picasso.* Novara, 1943.
Proust 1993	Marcel Proust. *Correspondance.* Vol. XXI. Ed. Philip Kolb. Paris: Plon, 1993.

Proust 2000	Marcel Proust. *Selected Letters: 1918–1922*. Vol. 4. Ed. Philip Kolb. Trans. Joanna Kilmartin. New York: HarperCollins, 2000.
Raczymow	Henri Raczymow. *Maurice Sachs*. Paris: Gallimard, 1988.
Read 1994	Peter Read. "From Sketchbook to Sculpture in the Work of Picasso, 1924–32." In *Picasso: Sculptor/Painter*. London: Tate Gallery, 1994, 199–209.
Read 1995	Peter Read. *Picasso et Apollinaire: Les Métamorphoses de la mémoire 1905/1973*. Paris: Jean-Michel Place, 1995.
Read 2002	Peter Read. *Apollinaire and Cubism*. With Guillaume Apollinaire, *The Cubist Painters*, trans. Peter Read. Omnibus vol. Forest Row, England: Bookworks, 2002.
Reff	Theodore Reff. "Picasso's *Three Musicians*: Maskers, Artists and Friends." *Art in America*, December 1980, 124–42.
Régnier 1993	Gérard Régnier. *The Body of the Cross*. Paris: Musée Picasso, 1993.
Régnier 2002	Jean Clair (Gérard Régnier). *Picasso: Sous le soleil de Mithra*. Paris: Musée Picasso, 2002.
Reid	Benjamin L. Reid. *That Man from New York: John Quinn and His Friends*. New York: Oxford University Press, 1968.
Reverdy	Pierre Reverdy. *Pablo Picasso*. Paris: Nouvelle Revue Française, 1924.
Richardson 1999	John Richardson. *The Sorcerer's Apprentice: Picasso, Provence, and Douglas Cooper*. New York: Knopf, 1999.
Rosenthal	Mark Rosenthal. "Night Fishing at Antibes: A Meditation on Death." *Art Bulletin* 65, no. 4 (December 1983), 649–58.
Rowell	Margit Rowell. *Joan Miró: Selected Writings and Interviews*. Trans. from French by Paul Auster; trans. from Spanish and Catalan by Patricia Mathews. Boston: Hall, 1986.
Rubin 1972	William Rubin. *Picasso in the Collection of the Museum of Modern Art*. New York: Museum of Modern Art, 1972.
Rubin 1984	William Rubin. "Picasso." In *"Primitivism" in Twentieth-Century Art*, 1. New York: The Museum of Modern Art, 1984, 241–343.
Rubin 1994	William Rubin. "The Pipes of Pan: Picasso's Aborted Love Song to Sara Murphy." *Artnews* 93, no. 5 (May 1994), 138–47.
Rubin 1996	William Rubin. *Picasso and Portraiture: Representation and Transformation*. New York: The Museum of Modern Art, 1996.
Rubinstein 1980	Arthur Rubinstein. *My Many Years*. London: Jonathan Cape, 1980.
Sachs	Maurice Sachs. *The Decade of Illusion: Paris 1918–1928*. Trans. Gwladys Matthews Sachs. New York: Knopf, 1933.
Salvadó 1924	Jacint Salvadó. "Chez Picasso." *Paris-Journal*, March 14, 1924.
Salvadó 1995	Jacint Salvadó, interviewed by González Fortea. In *Jacint Salvadó 1892–1983*. Barcelona: Generalitat de Catalunya, 1999. Originally published 1995.
Sanouillet	Michel Sanouillet. *Dada à Paris*. Paris: Flammarion, 1993.
Schneider	Pierre Schneider. *Matisse*. Trans. Michael Taylor and Bridget Stevens Romer. New York: Rizzoli, 2002. Originally published 1984.
Schwarz	Herbert T. Schwarz. *Picasso and Marie-Thérèse Walter, 1925–1977*. Inuvik, N.W.T., Canada: Editions Isabeau, 1988.
Seckel	Hélène Seckel. *Max Jacob et Picasso*. Quimper: Musée des Beaux-Arts, 1994.

Seckel-Klein	Hélène Seckel-Klein. *Picasso collectionneur.* Paris: Réunion des musées nationaux, 1998.
Severini	Gino Severini. *The Life of a Painter.* Trans. Jennifer Franchina. Princeton, N.J.: Princeton University Press, 1995. Originally published 1946.
Shattuck	Roger Shattuck. *The Banquet Years: The Origins of the Avant-Garde in France—1885 to World War I.* New York: Vintage, 1968. Originally published 1955.
Shone	Richard Shone. *The Art of Bloomsbury.* London: Tate Gallery, 1999.
Silver	Kenneth Silver. *Esprit de Corps: The Art of the Parisian Avant-Garde and the First World War, 1914–1925.* London: Thames and Hudson, 1989.
Sokolova 1950	Lydia Sokolova. "A Pair of Castanets." *Ballet* 9, no. 6 (June 1950), 23–30.
Sokolova 1960	Lydia Sokolova. *Dancing for Diaghilev: The Memoirs of Lydia Sokolova.* London: John Murray, 1960.
Spalding	Frances Spalding. *Roger Fry: Art and Life.* London: Black Dog Books, 1999. Originally published 1980.
Spies	Werner Spies. *Picasso: The Sculptures.* Trans. by Melissa Thorson House and Margie Mounier. Ostfildern/Stuttgart: Hatje Canz, 2000.
Stainton	Leslie Stainton. *Lorca: A Dream of Life.* New York: Farrar, Straus and Giroux, 1999.
Steegmuller 1963	Francis Steegmuller. *Apollinaire: Poet among the Painters.* New York: Penguin, 1986. Originally published 1963.
Steegmuller 1970	Francis Steegmuller. *Cocteau: A Biography.* Boston: Nonpareil, 1986. Originally published 1970.
Stein 1933	Gertrude Stein. *The Autobiography of Alice B. Toklas.* New York: Vintage, 1961. Originally published 1933.
Stein 1938	Gertrude Stein. *Picasso.* Boston: Beacon, 1959. Originally published 1938.
Stravinsky 1959	Igor Stravinsky and Robert Craft. *Conversations with Igor Stravinsky.* London: Faber and Faber, 1959.
Stravinsky 1982	Igor S. Stravinsky. *Selected Correspondence.* Vol. I. Ed. Robert Craft. London: Faber and Faber, 1982.
Stravinsky 1984	Igor S. Stravinsky. *Selected Correspondence.* Vol. II. Ed. Robert Craft. London: Faber and Faber, 1984.
Surya	Michel Surya. *Georges Bataille: La Mort à l'œuvre.* Paris: Séguier, 1987.
Sutton	Denys Sutton. *Roger Fry: Letters.* London: Chatto and Windus, 1972.
Tériade	Tériade. *Ecrits sur l'art.* Paris: Adam Biro, 1996.
Terrasse	Antoine Terrasse. "Picasso in Fontainebleau: The Setting of *Trois femmes à la fontaine*." In *Picasso 1917–1924.* Venice: Palazzo Grassi, 1998, 93–4.
Tomkins	Calvin Tomkins. *Living Well Is the Best Revenge.* New York: Signet, 1971. Originally published 1962.
Vaill	Amanda Vaill. *Everybody Was Young: Gerald and Sara Murphy: A Lost Generation Love Story.* Boston: Houghton Mifflin, 1998.
Vallentin	Antonina Vallentin. *Picasso.* Ed. and trans. Katherine Woods. Garden City, N.Y.: Doubleday, 1963. Originally published as *Pablo Picasso.* Paris: Albin Michel, 1957.
Van Hensbergen	Gijs van Hensbergen. *Guernica: The Biography of a Twentieth-Century Icon.* London: Bloomsbury, 2004.

Vol. I	John Richardson. *A Life of Picasso.* Vol. I, 1881–1906. New York: Random House, 1991.
Vol. II	John Richardson. *A Life of Picasso.* Vol. II, 1907–1917. New York: Random House, 1996.
Volta 1989	Ornella Volta. *Satie Seen through His Letters.* Trans. Marion Boyars publishers. London: Marion Boyars, 1989.
Volta 2000	Ornella Volta. *Erik Satie: Correspondance presque complète.* Paris: Fayard/Imec, 2000.
Walsh	Stephen Walsh. *Stravinsky: A Creative Spring: Russia and France 1882–1934.* New York: Knopf, 1999.
Whiting	Steven Moore Whiting. *Satie the Bohemian: From Cabaret to Concert Hall.* Oxford: Clarendon, 1999.
Widmaier Picasso 2002	Olivier Widmaier Picasso. *Picasso: Portraits de famille.* Paris: Ramsay, 2002.
Widmaier Picasso 2004	Diana Widmaier Picasso. "Marie-Thérèse Walter and Pablo Picasso: New Insights into a Secret Love." In *Pablo Picasso and Marie-Thérèse Walter: Between Classicism and Surrealism.* Münster: Kerber Verlag (2004), 27–36.
Withers	Josephine Withers. *Sculpture in Iron.* New York: New York University Press, 1978.

NOTES

Any statements or observations by Picasso not credited in the text or the notes have been made in the presence of, or in conversation with, the author, and, on occasion, Douglas Cooper.

CHAPTER 1
Rome and the Ballets Russes

1. Jean Cocteau, *Œuvres complètes,* vol. IX (Lausanne: Marguerat, 1946–51), 246.

2. Letter from Cocteau to his mother, February 22, 1917, Cocteau 1989, 297.

3. Picasso sent one of these Villa Medici drawings to the dealer André Level, who wrote him on March 10, 1917 (Archives Picasso): *"Merci du croquis de la villa Médicis, dont vous serez peut être un jour le Directeur."* Level goes on to say *"Revenez-nous avec un tableau de Romaines, frère de celui des Hollandaises, ou, simplement avec des souvenirs agréables."*

4. Letter from Cocteau to his mother, February 20, 1917, Cocteau 1989, 296.

5. Letter from Cocteau to his mother, February 22, 1917, ibid., 297. After living with Sert since 1908, Misia was known as Madame Sert, although she was not married to him until 1920.

6. Cocteau refers to Olga in a letter to Picasso, April 13, 1917 (Archives Picasso) as *"La fille du Général Koklov."*

7. The school was run by Yevgenia Pavlovna Sokolova.

8. Carandente 1998, 37.

9. Penrose presumably believed that Olga was a general's rather than a colonel's daughter; otherwise he would not have described her as such (Penrose, 201). In her typescript, "A tale of brief love and enternal hatred," Natalia Semenyova, the only Russian art historian to write about Olga, likewise mistakenly claimed she was a noblewoman.

10. Rubinstein 1980, 150.

11. Menaker-Rothschild, 49 n. 8.

12. Genya Smakov in conversation with the author.

13. Baldassari 1998, 96.

14. Letter from Cocteau to "Mademoiselle Olga Koclowa"[*sic*], April 21, 1917, Archives Picasso.

15. Ernest Ansermet, *Ecrits sur la musique* (Neuchatel: Langages, 1971), 26.

16. MP Carnets I, cat. 19 (MP 1867).

17. Postcard from Picasso to Guillaume Apollinaire, February 1917, Caizergues and Seckel, 144.

18. Postcard from Picasso to Apollinaire, March 10, 1917, ibid., 145.

19. According to Laurence Madeline, former Conservateur, Archives Picasso.

20. Buckle 1971, 56–7.

21. Recounted to the author by Tatiana Lieberman.

22. Sokolova 1960, 170.

23. García-Márquez, 87.

24. Picasso is quoted in Cocteau's letter to his mother, April 6, 1917, Cocteau 1989, 315.

25. Letter from Juan Gris to Picasso, March 27, 1917 (Archives Picasso), in which Gris says to tell Diaghilev that *"Rosenberg a du partir l'expédier les tableaux comme c'était convenu."*

26. Georges-Michel 1957, 80.

27. Massine quoted in Buckle 1979, 323.

28. Mark Amory, *Lord Berners: The Last Eccentric* (London: Chatto and Windus, 1998), 59.

29. *Le Carosse du Saint-Sacrement* (opera, 1924) and *The Triumph of Neptune* (ballet, 1925).

30. Z.III.24.

31. Stravinsky 1984, 141.

32. Levinson, 63.

33. Postcard from Picasso to Apollinaire, February 1917, Caizerges and Seckel, 140, reproduced 143.

34. Postcard from Gris to Picasso, March 12, 1917, Archives Picasso.

35. Cocteau 1989, 311.

36. Postcard from Cocteau to his mother, March 7, 1917, ibid., 304.

37. See Vol. I, 132.

38. García-Márquez, 44.

39. Gilot 1964, 147–8.

40. Boris Taslitsky in conversation with the author and McCully.

41. García-Márquez, 87.

42. This drawing is mistakenly included in the Zervos catalog as Z.XXIX.280.

43. Prampolini, 13.

44. These postcards were found in the artist's archive (see Baldassari 1988).

45. Z.III.18.

46. Z.III.23.

47. In a sketchbook drawing made of the composition, Cocteau described the painting as Picasso's *"chez d-oeuvre: L'arlequin et la femme nue,"* repr. in *Picasso 1917–1924* (Venice: Palazzo Grassi, 1998), 154.

48. Severini, 183.

49. Z.XXIX.224.

50. See Vol. II, 407–17.

51. Letter from Gris to Picasso, April 13, 1917, Archives Picasso.

52. See Scot D. Ryerson and Michael Orlando Vaccarino, *Infinite Variety: The Life and Legend of the Marchesa Casati* (New York: Viridian, 1999); also Brigitte Leal, MP Carnets I, 254 n. 11.

53. Letter from Cocteau to Igor Stravinsky, March 1917, Stravinsky 1982, 89.

54. Letter from Cocteau to his mother, March 16, 1917, Cocteau 1989, 309.

55. Otero, 159.

56. Steegmuller 1970, 175.

57. Ibid., 176.

58. Arnaud, 780 n. 29.

59. Serge Lifar, *Serge Diaghilev: His Life, His Work, His Legend* (London: Putnam, 1940), 299.

60. Letter from Cocteau to his mother, March 1917, Cocteau 1989, 312.

61. Letter from Cocteau to his mother, March 7, 1917, ibid., 304.

62. García-Márquez, 126.

63. Antonello Trombadori, "1949: Il secondo viaggio italiano di Picasso," *Picasso in Italia* (Verona: Galleria d'Arte Moderna e Contemporanea Palazzo Forti, 1990). Picasso told Otero, 189–90, that Trombadori had accompanied him to the Sistine Chapel.

64. Prampolini, 13, also claimed to have accompanied Picasso to the Sistine Chapel, but his assertions are not always reliable.

65. Georges-Michel 1923, 64.

66. D.-H. Kahnweiler, November 17, 1949, in Bernadac and Michaël, 85.

67. Letter from Cocteau to his mother, March 22, 1917, Cocteau 1989, 310.

68. Ansermet, quoted by Cooper, 32. When asked by Cooper whether he had seen the Sistine ceiling in 1917, Picasso said yes. (Cooper's papers, The Getty Research Institute, L.A.)

69. Pitti Palace, Florence. Carandente, 37, suggests that Picasso derived inspiration from Guido Reni's portrait of Beatrice Cenci in the Palazzo Barberini.

CHAPTER 2
Naples

1. Arnaud, 778.

2. Ibid.

3. Postcard from Cocteau to his mother, March 13, 1917, Cocteau 1989, 306.

4. Steegmuller 1986, 181.

5. Caizergues and Seckel, 147.

6. Postcard from Cocteau to his mother, March 12, 1917, Cocteau 1989, 306.

7. Massine, 108.

8. Ibid.

9. Sokolova 1960, 98.

10. Walsh, 614 n. 31, thinks that the provisional government in Petrograd's choice of "The Volga Boat Song" most unlikely.

11. Craft, 104.

12. Letter from Ernest Ansermet to Stravinsky (February 21, 1917), quoted in Walsh, 41.

13. Ibid., 266.

14. Letter from Picasso to Gertrude Stein, April 1917, Beinecke Library.

15. Menaker-Rothschild, 189.

16. Léger's lecture at the Académie Wassilieff in 1913, was mentioned by Apollinaire in *The Cubist Painters.* Read 2002, 91.

17. Vol. II, 406 (Z.II.881).

18. Z.VI.1431.

19. Buckle 1979, 328. Walsh, 278, confirms that the company played only twice at the

Teatro San Carlo. Carandente, 42, claims that there were four performances and that *Les Femmes de bonne humeur* received a long ovation.

20. MP Carnets I, cat. 19 (MP 1867).

21. Arnaud, 174.

22. Walsh, 277.

23. Ibid.

24. See Johns, 89–90.

25. Stravinsky 1959, 105.

26. Carandente, 41. According to *Baedecker's Southern Italy and Sicily* (1930), 37, these Pulcinella shows harked back to the *fibula Atellana,* the early Roman farces that originated a few miles outside Naples in the town of Atella.

27. See MP Carnets I, 265. The figures on the postcard are from a play, *Tre Amante de Lauretta.* The original setting included a backdrop of Vesuvius and a prompter's box with a hand sticking out of it.

28. See MP Carnets I, 266.

29. Letter from Picasso to Stein, April 1917, Beinecke Library.

30. See Cocteau's Italian notebook, 1917, reproduced in Menaker-Rothschild, 62.

31. Photographs of the Gabinetto Segreto as it was in Picasso's time reveal a setting rather more redolent of antiquity: terracotta phalluses the size of chimney pots piled up in great heaps. Information supplied by John Clarke.

32. Originally a central feature of the Baths of Caracalla, the monumental Hercules had been acquired by Michelangelo's patron, Alessandro Farnese.

33. Z.IV.380.

34. See, for example, Z.IV.346–7.

35. Letter from Cocteau to Picasso, April 15, 1917, Archives Picasso.

36. Letter from Cocteau to Picasso, April 13, 1917, ibid.

37. Morand 1996, 237.

38. Cabanne 1992. 480.

CHAPTER 3
Parade

1. Letter from Apollinaire to Picasso [December 15, 1916], Caizergues and Seckel, 139.

2. Letter from Apollinaire to Picasso, [March 22, 1917], ibid., 149–50.

3. See Vol. II, 153–4.

4. A projected "profile" of Diaghilev by Apollinaire never materialized.

5. Letter from Apollinaire to Paul Dermée, [March 1917], published in *Surréalisme* (October 1924).

6. Letter from Gris to Léonce Rosenberg, May 15, 1917, Derouet 1999, 54.

7. Proust also referred to Misia as "a monument"; see Morand 1996, 209.

8. Ibid.

9. From the unpublished memoir of Boulos Ristenhueber, courtesy of Bernard Minoret.

10. These previously unidentified photographs are in the Archives Picasso.

11. PF.III.214.

12. For further biographical information about Férat and Oettingen, see Vol. II, Chapter 25, 395–406.

13. Ibid.

14. Grigoriev, 131.

15. See Z.XXIX.290.

16. See Vol. II, 199.

17. MP 1613; see Menaker-Rothschild, 157.

18. Z.II.2.

19. Shattuck, 121.

20. Ibid.

21. Axsom 1975, 90.

22. Satie in a letter to Valentine Gross (December 12, 1916); see Lake and Ashton, 58.

23. Arnaud, 179.

24. Vol. I, 384 (Z.I.285).

25. See Vol. II, 422.

26. Massine, 106.

27. Polunin, 59.

28. Barr, 98.

29. Picasso, Braque, Gris, and Léger.

30. Gleizes, Metzinger, etc.; see Vol. II, Chapter 14, 207–19.

31. See, for example, B. M. A. Danilowitz, "The Iconography of Picasso's Ballet Designs 1917–1924," master's thesis (Johannesburg, 1985), 120; also García Márquez, 98; and Cowling 2002, 300.

32. Palau 1999, 48.

33. See Picasso's drawing of himself as a monkey; Vol. I, 259.

34. Axsom, 124, was the first writer to see the monkey's significance.

35. Gasman to the author.

36. See Vol. I, 68–9, for more information about Picasso's first mistress, Rosita del Oro, including her 1897 poster.

37. The gala also benefited front-line canteens, Polish prisoners of war, refugees from the Ardennes, and other charities.

38. According to Domingo Carles, Renoir attended the premiere of *Parade;* in *Memorias de un pintor* (Barcelona: Editorial Barna, 1944), 76.

39. Francis Poulenc, *My Friends and Myself,* trans. James Harding (London: Dobson, 1978), 68.

40. Arnaud, 180.

41. *Cahiers Jean Cocteau I* (Paris : Gallimard, 1969), 71–2.

42. Paul Morand quoted in Buckle 1979, 332.

43. Arnaud, 180; see also Vol. II, 390.

44. Stravinsky 1959, 104.

45. Fine Arts Museums, San Francisco.

46. Cooper, 26.

47. Barbara Bagenal to the author.

48. Schneider, 735.

49. Apollinaire describes "the realistic steps of the horse . . . formed by two dancers." See LeRoy C. Breunig, *Apollinaire on Art: Essays and Reviews 1902–1918* (New York: Viking, 1972), 452.

50. Ibid., 453.

51. Arnaud, 179.

52. Steegmuller 1970, 186.

53. Jean Cocteau, "Parade Réaliste: In which Four Modernist Artists have a Hand," *Vanity Fair,* September 1917, 90.

54. Buckle 1979, 331.

55. Letter from Gris to Maurice Raynal, May 23, 1917, Kahnweiler-Gris 1956, 18.

56. Morand 1996 (May 19, 1917), 143–4.

57. Letter from Jean Metzinger to Léonce Rosenberg, May 25, 1917, quoted in Cowling 2002, 303–4.

58. Valentine Gross quoted in Buckle 1979, 253.

59. According to Stravinsky in ibid., 254.

60. Morand 1996, 307.

61. Steegmuller 1970, 225.

62. Ibid., 232.

63. Jean Cocteau, *Les Foyers* (1947), cited by Axsom, 65.

64. Massine supervised both of these revivals of *Parade.* Cooper was instrumental in getting Picasso's permission to make certain changes.

65. Buckle's 1955 exhibition, *In Search of Diaghilev,* was shown first in Edinburgh and then in London.

66. Whiting, 474.

67. James Harding, *The Ox on the Roof* (London: Macdonald, 1972), 37.

68. See *Le Carnet de la Semaine,* June 7, 1917.

69. Volta 1989, 131–40.

70. Volta 2000, 179.

71. Seckel, 145.

72. Kikimora was also the name of the witch in *Comtes russes,* a ballet based on Russian fairy tales.

73. Baer, 54.

74. Sachs, 216–17.

75. A postcard from Olga to Picasso, May 29, 1917, Archives Picasso, indicates that she had already left for Madrid with the company. The card was forwarded from Montrouge to the Teatro Real, Madrid, suggesting that Picasso was on his way to Spain when the card arrived.

CHAPTER 4
The Ballet in Spain

1. Room 188.

2. Buckle 1979, 332.

3. According to Romola Nijinsky in Buckle 1971, 460.

4. Ibid.

5. García-Márquez, 111.

6. Buckle 1979, 336.

7. Lydia Sokolova was an English dancer, originally called Hilda Munnings. Diaghilev had Russified her name to Munningsova before changing it to Sokolova. See Sokolova 1960, 34, 69.

8. Buckle 1979, 334.

9. Buckle 1971, 463.

10. The portrait of Fatma (Z.III.45) was referred to as "jewel-like" in *La Veu de Catalunya,* June 18, 1917.

11. According to Juan Ainaud de Lasarte, Padilla's girlfriend mispronounced the Spanish word for sausage: *salchichón.* Hence she was known as "La Salchichona." *Picasso i Barcelona* (Barcelona: Saló del Tinell 1981), 244.

12. *La Publicidad,* June 13, 1917, gives an account of the dinner, which was held at the Lyon d'Or restaurant.

13. Picasso's portrait of Maetzu appeared on the cover of *Vell i Nou,* July 1, 1917; it also published Josep Junoy's article about Picasso.

14. Telegram from Serge Diaghilev and Olga to Picasso, June 13, 1917, Archives Picasso.

15. Grigoriev, 132.

16. See Vol. I, 157.

17. Gregoriev, 132.

18. *La Epoca,* June 20, 1917.

19. Ramón Gómez de la Serna, *Completa y verídica historia de Picasso y el cubismo* (Milan: Chiantore, 1945), 43–4.

20. Gilot 1964, 148.

21. Undated [1917] letter from Marie Laurencin to Henri-Pierre Roché, Ransom Center.

22. Flora Groult, *Marie Laurencin* (Paris: Mercure de France, 1987), 168.

23. Morand 1996, 436–7. Delaunay's Russian wife Sonia was also arrested as a spy.

24. Picabia's grandfather had emigrated from Corunna to Cuba, made a fortune as a coffee planter, returned to Spain, and made another fortune in railroad construction. Picabia's family was exceedingly rich; his father had been born in Havana and later settled in Paris, where he married the daughter of a wealthy French businessman.

25. For a description of *391* see Gabrielle Buffet-Picabia, "Some Memories of Pre-Dada: Picabia and Duchamp," *The Dada Painters and Poets* (New York: Wittenborn, Schulz, 1981), 262.

26. *391,* no. 1 (January 25, 1917), 4.

27. See Krauss 1998, 113–14. By taking Picabia's squib too seriously, Krauss arrives at some questionable conclusions.

28. Picasso is reported by Pharamousse (*391,* no. 4 [March 25, 1917], 8) to have said: "I want to give public proof of my right to the crown I have placed on my head. Spanish on my father's side, Italian on my mother's, and French by education, [I see] the purity of my origins as the sign of my innate royalty. Some people aspire to be sacred supermen, because they have read Nietzsche; others see themselves elevated to the rank of emperor. . . . Apostle of every liberty, I have however recognized the authority of the masters. And I owe everything to Leonardo da Vinci, Greco, Goya, sculpture both Greek and tribal, Apollinaire, André Salmon, Max Jacob, my paint supplier, and Monsieur Kahnweiler."

29. Letter from Francis Picabia to Picasso, January 14, 1922, Archives Picasso.

30. According to Romola Nijinsky in Buckle 1971, 465.

31. Grigoriev, 134.

32. Buckle 1971, 470.

33. Olga loathed ocean voyages. On the trip to South America in 1912, she was supposedly seasick every single day. Ibid., 381.

34. Charles Deering was restoring a former hospital on a beautiful outcrop of land next to Santiago Rusiñol's Cau Ferrat. He was also making a collection of Spanish masterpieces (now in the Art Institute of Chicago) and rare books.

35. Nijinsky had been disgusted by the ugly stains on the pillows left by Diaghilev's dyed hair.

36. Buckle 1979, 335.

37. Ibid., 336.

38. Ibid.

39. Letter from Max Jacob to Jacques Doucet, August 4, 1917. Chapon 1984, 243.

CHAPTER 5
With Olga in Barcelona

1. See, for example, Z.III.41 and Z.XXIX.300.

2. This dress was given by Olga's granddaughter, Marina, to the Musée Picasso.

3. Z.III.83.

4. Conde de Sert to the author.

5. Z.III.40.

6. According to Dora Maar in conversation with the author. She was mistaken. This had happened at the Ritz in Madrid, not the Hotel National.

7. Bernier, 8; Combalía, 35.

8. MP Carnets I, cats. 20–1 (MP 1866, MP 1990-103).

9. Marina Picasso Collection, 2192.

10. P.F.III.130.

11. FitzGerald's claim that Picasso gave the painting to his mother, "who kept it throughout the remainder of her life," is incorrect. See "Neoclassicism and Olga Khokhlova," *Picasso and Portraiture* (New York: Museum of Modern Art, 1996), 306.

12. P.F.III.165.

13. Z.VIII.21.

14. Z.III.19.

15. See Vol. I, 195.

16. Vol. II, 340.

17. Vol. I, 195; Vol. II, 340.

18. Vollard did not give a lecture on Picasso as rumored. His lecture, "Ingres according to Renoir," was published in the June number of *La Revista.*

19. See Vol. I, 170–1.

20. Marilyn McCully, *Els Quatre Gats: Art in Barcelona around 1900* (Princeton: Art Gallery, 1978), 134.

21. Letter from Joan Miró to Enric Ricart, July 18, 1920, quoted by Robert Lubar, "El Mediterráneo de Miró: Concepciones de una identidad cultural," in *Joan Miró* (Barcelona: Fundacó Joan Miró, 1993), 43.

22. Z.III.28. Picasso told Palau that the *Harlequin* was definitely not a portrait of Massine, as is often said. Palau 1999, 71.

23. Pallarès had replaced Picasso's father as a teacher at La Llotja.

24. *Troços,* no. 1 (September 1917).

25. See Joan-Josep Tharrats, *Picasso i els artistes catalans en el ballet* (Barcelona: Edicions del Cotal, 1982), 75.

26. Letter from Doucet to Roché, 1917, Ransom Center.

27. Letter from Max Jacob to Doucet, August 4, 1917, Chapon 1984, 243.

28. JSLC 62 (Museu Picasso, Barcelona, MPB 110-012).

29. Ernest Ansermet, "Ma Rencontre avec Picasso," in Boehm, Mosch, and Schmidt, 190.

30. Z.III.70.

31. MP Carnets I, cat. 20 (MP 1866).

32. Gross's card was enclosed in a note from Cocteau to Picasso, Archives Picasso.

33. Letter from Picasso to Apollinaire, October 18, 1917, Caizergues and Seckel, 162.

34. Palau 1999, 486.

35. Z.III.47. According to Miró this view was painted from Doña María's apartment. See Combalía, 35.

36. Palau 1999, 486. Palau identifies the anonymous critic as Eugeni d'Ors.

37. *La Revista,* December 1, 1917.

38. Letter from Robert Delaunay to Albert Gleizes, 1917, quoted in Silver, 148.

39. Letter from Cocteau to Picasso, September 30, 1918, Archives Picasso.

40. Axel Madsen, *Sonia Delaunay: Artist of the Lost Generation* (New York: McGraw-Hill, 1989), 227.

41. Picasso wrote Stein that he had had to leave his Barcelona paintings behind for the unlikely reason that they were "*objets de luxe,*" January 8, 1918, Beinecke Library.

CHAPTER 6
Return to Montrouge

1. Severini, 182.

2. Z.III.106.

3. For Picasso's collection of primitive sculptures, see Seckel-Klein, 236–53. Also see Rubin 1984, 247, about the influence of this mask on Picasso's 1912 constructions.

4. The bills include one for a lunch, dated March 20, 1918, Archives Picasso.

5. Letter from Erik Satie to Roland-Manuel, March 14, 1918, Volta 1989, 129.

6. FitzGerald 1995, 82. The receipt, dated January 12, 1918, is in the Pierpont Morgan Library.

7. Letter from Paul Guillaume to Picasso, January 18, 1918, Archives Picasso.

8. Letter from Guillaume to Picasso, December 15, 1917, Archives Picasso.

9. Hubert, 206–7.

10. Quoted in Flam, 115.

11. Quoted in *Henri Hayden* (Dublin: Hugh Lane Municipal Gallery, 1994), 22.

12. Z.II.18. The *Demoiselles* was exhibited in Paris at the Salon d'Antin in 1916. See Vol. II, 19.

13. "Pinturrichio," *Carnet de la semaine,* February 3, 1917. The nineteen-second film featured Matisse's 1916 *Interior of the Studio,* Picasso's 1915 *Guitar* (mistakenly identified as *Femme à la mandoline*), and a 1907 *Tête d'homme.* See Baldassari 2002.

14. Hubert, 208.

15. Billot, 362.

16. See Chapter 3.

17. Letter from Satie to Picasso, October 10, 1918, Archives Picasso.

18. Cabanne 1992, 513.

19. Seckel, 155.

20. Steegmuller 1970, 206, suggests that the title is a pun on Cocteau's name; also, "Cocteau is a diminutive, a contraction of *coqueteau,* meaning "little cock."

21. Morand 1996, 337. Allais was a whimsical humorist who had been associated, like Satie, with the Chat Noir cabaret.

22. According to Francis Hugo 1983, 124, Cocteau told Les Six to derive ideas from popular culture, for example "*le French can-can.*"

23. Cocteau quoted in Walsh, 380.

24. According to Francis Poulenc, a leading light of Cocteau's *Rappel à l'ordre.* Poulenc, 43.

25. Axsom, 58.

26. Silver, 131.

27. Ibid.

28. Daix 1993, 230.

29. See Louis Aragon, "Calligrammes," *L'Esprit nouveau,* October 1920, in Sanouillet, 67.

30. Z.III.102.

31. See Vol. II, 167–72.

32. See, for example, Z.II.944.

33. Z.III.142. When ignorant of a work's provenance, Palau demeans his useful corpus of plates by wrongly attributing works to "the artist's heirs," such as PF.III, 245 (Z.III.142). This painting was for many years in Cooper's collection.

34. Letter from Henri Danet to Picasso, December 9, 1917, Archives Picasso.

35. FitzGerald 1995, 79, reproduced 19.

36. Z.III.98–100 and PF.III.205.

37. Cabanne 1977, 194.

38. Z.III.83.

39. See letter from Eugenia Errázuriz to Picasso, January 31, 1918, Archives Picasso, suggesting that the chair be covered in tapestry.

40. Daix 1993, 167–8.

41. Quentin Laurens told McCully that Emile Délétang took several more photographs of her on the same day. Galerie Louise Leiris archives.

42. Letter from Olga to Picasso, March 14, 1918 (private archive), informing him that she will arrive by train from Madrid the following day.

43. PF.III. 1976.

44. Clive Bell commented in a letter to Mary Hutchinson, November 2, 1919, Ransom Center, that Olga loved furs and took "advantage of the cold to run hither and thither in her fine new furs."

45. Although entitled *Olga in an Armchair,* she is seated on the armless slipper chair on which Picasso will often pose his models.

46. Letter from Picasso to Stein, April 26, 1918, Beinecke Library.

47. Letter from Stein to Picasso, May 9–10, 1918, Beinecke Library.

48. Z.III.160. See E. B. Henning, "Picasso: Harlequin with Violin (*Si tu veux*)," *Bulletin of the Cleveland Museum of Art* 63 (January 1976), 6–7.

49. See Vol. I, 274, 334.

50. The French Pierrot derives from the Italian Pulcinella, but is a more romantic, more moonstruck character, whose attributes are not at all Picasso-like.

51. Z.III.137.

52. See, for example, Z.III.128 and Z.III.134.

53. Letter from Cocteau to Picasso, March 18, 1918, Archives Picasso.

54. Marina Picasso Collection, 02287.

55. The glass is vertical in Zervos (Z.III.148); horizontal in Palau (PF.III.234).

56. Daix 1995, 779.

57. Z.III.96.

58. Galassi has pointed out that Le Nain's *Happy Family* did not enter the Louvre's collections until 1923. Picasso probably saw this work at one of the Paris dealers; see Susan Grace Galassi, *Picasso's Variations on the Masters: Confrontations with the Past* (New York: Harry N. Abrams, 1996).

59. Z.I.285.

60. See Seckel-Klein, 152–5, 158–9.

61. D.-H. Kahnweiler, "Huit entretiens avec Picasso (16 Février 1935)," *Le Point,* October 1952, 26.

62. See Chapter 24, 534 (see Vol. II, 416).

63. Letter from Apollinaire to Picasso, March 30, 1918, Caizergues and Seckel, 164.

64. Letter from Apollinaire to Picasso, [August 22, 1918], ibid., 179–80.

65. Z.IV.322.

66. See Valentina Kachouba's photograph album, reproduced in Yvan Nommick and Antonio Alvarez Cañibano, *Los Ballets Russes de Diaghilev y España* (Granada: Centro Cultural Manuel de Falla, 1989), 284.

67. James Lord, *Some Remarkable Men* (New York: Farrar, Straus and Giroux, 1996), 110. Lord attributes this accusation to Cocteau's spite.

68. Z.III.153 and P.F.III.244.

69. Letter from Cocteau to his mother, June 1918, Cocteau 1989, 380.

70. Letter from Cocteau to his mother, June 1918, Cocteau 1989, 380–1.

71. According to Michel Décaudin, the Opéra Comique proposed a posthumous production of this operetta. See *Apollinaire 18: le "Casanova" d'Apollinaire "comédie parodique"* (Paris: Lettres Modernes Minard, 1991), 130.

72. Steegmuller 1963, 267.

73. See Vol. II, 199–206.

74. Claude Debon, "Apollinaire in 1918," in *Apollinaire en 1918* (Paris: Méridiens Klincksieck, 1988), 21.

75. See Vol. II, 396. The photograph of Irène Lagut and Ruby Kolb should be redated 1916.

76. Ibid.

77. Letter from Apollinaire and Ruby (Jacqueline) to Picasso, March 22, 1917, Caizergues and Seckel, 150, 152 n. 18.

78. Pierre Marcel Adéma, *Guillaume Apollinaire* (Paris: La Table Ronde, 1968), 322.

79. Z.III.164. Letter from Apollinaire to Picasso, August 13, 1918, Caizergues and Seckel, 174.

80. Letter from Errázuriz to Picasso, June 18, 1918, Archives Picasso.

CHAPTER 7
Marriage

1. Caizergues and Seckel, 165 n. 1.

2. Seckel, 165, 43.

3. The clinic which Olga gave as her address on the marriage register was located in the seventh arrondisement, where the ceremony took place.

4. The marriage certificate is reproduced in Seckel, 159.

5. Gold and Fizdale, 195.

6. Letter from Cocteau to his mother, July 12, 1918, Cocteau 1989, 397–8.

7. Stassinopoulos-Huffington's wedding-guest list—Matisse, Braque, Stein, Toklas—is guesswork. They were out of Paris or out of the country, as were Diaghilev and his company. Huffington, *Picasso: Creator and Destroyer* (New York: Simon and Schuster, 1988), 157.

8. Letter from Level to Picasso, June 13, 1918, Archives Picasso.

9. The poem appears in Caizergues and Seckel, 172.

10. Letter from Jacqueline Apollinaire to Olga, July 16, 1918, ibid., 204.

11. The draft of Picasso's letter to Doctor Pascalis, 3, rue de Dôme, appears in JSLC 64.

12. Steegmuller 1970, 200.

13. Z.III.228–30.

14. Letter from Picasso to Apollinaire, August 16, 1918, Caizergues and Seckel, 176.

15. Guillaume Apollinaire, *Œuvres poétiques,* ed. Marcel Adéma and Michel Décaudin (Paris: Les Pléiades, 1965), 240.

16. Larralde and Casenave, 83.

17. Arthur Rubinstein, *My Young Years* (London: Jonathan Cape, 1973), 474.

18. Letter from Picasso to Apollinaire, August 16, 1918, Caizergues and Seckel, 176.

19. In his letter of August 30, 1918, Archives Picasso, Paul Guillaume explained to Picasso that "*pour des raisons d'ordre militaire,*" he was unable to go to Biarritz.

20. Z.III.242.

21. Picasso would do another portrait of Micheline in fall 1919 (Z.III.381).

22. FitzGerald 1995, 27.

23. Z.III.255.

24. Daix 1977, 162.

25. JSLC 66.

26. Ibid.

27. Postcard from Picasso to Apollinaire, August 3, 1918, Caizergues and Seckel, 173.

28. See, for example, PF.III.295.

29. Z.III.247–9.

30. Z.III.197.

31. PF.III.278.

32. Morand 1996, 236.

33. Letter from Cocteau to his mother, August 13, 1918, Cocteau 1989, 410.

34. Z.III.237.

35. Private collection, France.

36. Vol. II, 109 (Z.II.111).

37. Vol. II, 433 (Z.III.233).

38. Vol. II, 421.

39. Philadelphia Museum of Fine Art.

40. Z.XXIX.336.

41. Z.III.214.

42. Michael de Cossart, *The Food of Love: Princesse Edmond de Polignac (1865–1943)* (London: Hamish Hamilton, 1978), 132.

43. Letter from Diaghilev to Picasso, October 18, 1918, Archives Picasso.

44. Z.III.137 and Z.III.130.

45. Z.III.297.

46. See letter from Diaghilev to Picasso, October 18, 1918, Archives Picasso.

47. See letter from Jacqueline Apollinaire to Olga, August 22, 1918, Caizergues and Seckel, 205.

48. Letter from Olga to Jacqueline Apollinaire, September 2, 1918, ibid., 208.

49. See letter from Jacqueline Apollinaire to Olga, September 22, 1918, ibid., 210.

50. Telegram from Picasso to Apollinaire, September 28, 1918, Caizergues and Seckel, 184.

51. Undated letter from Picasso to Apollinaire, [1918], ibid., 192.

52. Z.III.550, Z.III.137, Z.III.257, ZIII.237, and Z.III.242.

CHAPTER 8
Death of Apollinaire

1. Stein 1938, 29.

2. Gimpel, 71 (November 14, 1918).

3. See last entry, October 16, 1918, in Apollinaire's *Journal intime* (Paris: Editions du limon, 1991), 161.

4. This painting did not come to light until Palau published it (PF.III.335) and baptized it, *Flour-covered Harlequin.*

5. The painting is not dated or otherwise recorded, so this interpretation is hypothetical.

6. Z.III.437.

7. Cowling's dating of these two paintings around the same time is based on her discovery (Cowling 2002, 377), in one of the preparatory photographs for the Olga portrait, of a corner of the Smith College painting upside down on the easel.

8. Ibid., 378.

9. Ambroise Vollard, *Recollections of a Picture Dealer,* trans. Violet M. Macdonald (London: Constable, 1936), 100.

10. Steegmuller 1968, 218.

11. See Pierre Caizergues and Michel Décaudin, *Correspondance: Jean Cocteau Guillaume Apollinaire* (Paris: Jean-Michel Place, 1991), 44.

12. Otero, 82.

13. Penrose, 221.

14. Z.III.76. Jacqueline Picasso assured the author that this was the self-portrait done on the day of Apollinaire's death.

15. Michel Décaudin, "Apollinaire et Picasso," *Esprit,* January 1982, 82.

16. Vallentin, 146.

17. Arnaud, 199.

18. Ibid.

19. Letter from Cocteau to André Salmon, November 9 [midnight], 1918, Adéma, 342.

20. Letter from Jacob to René Fauchois, November 12, 1918, ibid., 343.

21. Recounted in Lagut.

22. Paul Léautaud, quoted in Steegmuller 1963, 275.

23. Adéma, 344, gives a partial list of those who attended.

24. See Vol. II, 199–205.

25. Ibid., 205.

26. Morand 1996, 266.

27. *Lettriste;* wordless letters.

28. Steegmuller 1963, 234.

29. Hugo 1983, 125.

30. Richard McDougall, *The Very Rich Hours of Adrienne Monnier* (New York: Scribner, 1976), 456.

31. Ibid.

32. Letter from Cocteau to Picasso, June 10, 1919, Archives Picasso.

CHAPTER 9
Rue la Boétie

1. FitzGerald 1995, 78.

2. Martin, 94.

3. Z.VI.1331.

4. See, for example, Z.III.380.

5. Brassaï, 7.

6. Hugo 1983, 126.

7. Z.III.380. The self-portrait with a birdcage in front of a lace-curtained window, was incorrectly captioned in Vol. II, 399, "Montrouge, 1917." It was executed at the rue la Boétie in 1919.

8. Z.III.289.

9. Z.III.438.

10. Otero, 77.

11. Z.IV.1335.

12. Gasman, 1192.

13. This partnership would end abruptly in 1932, when Rosenberg found out about his wife's affair with Wildenstein. There would be no public scandal or divorce, only a division of the spoils and a subsequent lifelong mutual loathing. Although Rosenberg's cousin, Jos Hessel, was originally a partner in this consortium, he soon ceased to play an active role in it.

14. FitzGerald 1995, 82–5.

15. Daniel Wildenstein and Yves Stavridès, *Marchands d'art* (Paris: Plon, 1999), 50.

16. The widow of Rosenberg's son, Alexandre, Elaine Rosenberg to the author.

17. Dealers frequently offered artists contracts for their entire production over a given period, paying according to the point size of the canvases; see Vol II, 457 n.7 for details of standard canvas formats.

18. FitzGerald 1995, 64, 66.

19. Ibid., 282 n. 27.

20. In reply Cocteau said that he would "arrive in beautiful solitude, not in the slippers of a Rothschild, but in shoes that pinch—to escape . . . to other Ballets Russes." FitzGerald 1995, 73.

21. See Vol. II, 359.

22. Gimpel, 107.

23. Concerning Guillaume's wife, see Florence Trystram, *La Dame au grand chapeau: L'Histoire vraie de Domenica Walter-Guillaume* (Paris: Flammarion, 1966).

24. Colette Giraudon, *Paul Guillaume et les peintres du XXe siècle de l'art nègre à l'avant-garde* (Paris: Bibliothèque des Arts, 1993), 75.

25. Paul Rosenberg interviewed by Tériade (1927), Tériade, 106.

26. Grigoriev, 137.

27. Ibid., 139.

28. Ibid.

29. *Pneumatique* from Diaghilev to Picasso, April 15, 1919, Archives Picasso.

30. Letter from Diaghilev to Picasso, April 15, 1919, Archives Picasso.

31. Letter from Diaghilev to Falla, May 10, 1919, Pierpont Morgan Library, New York.

32. Cowling 2002, 360.

33. On a visit to Picasso's widow, Jacqueline, at Notre-Dame-de-Vie, the author discovered several sketches annotated in Max Jacob's handwriting on the studio floor. Surprised that these items had not been shipped to the Musée Picasso with the rest of the artist's papers. After one look it became clear what they were. Picasso had hired the impecunious Jacob to do the costume research for *Tricorne*—probably in the Bibliothèque Nationale. Jacob's drawings, which had evidently been copied from an encyclopedia of costume, specified such Andalusian types as a *corregidor,* a beggar, a watchman, a grandee, etc. The present whereabouts of these drawings is unknown.

34. Letter from Diaghilev to Picasso, May 12, 1919, Archives Picasso.

35. Telegram from Diaghilev to Picasso, May 15, 1919, Archives Picasso.

CHAPTER 10
London and Tricorne

1. See Arnold Haskell and Walter Nouvel, *Diaghileff: His Artistic and Private Life* (New York: Da Capo, 1978; originally published 1935), 282–3.

2. Ulrich Mosch, "Manuel de Falla: The Three-Cornered Hat, 1917–19," in Boehm, Mosch, and Schmidt, 218.

3. García-Márquez, 112.

4. "Talk between Massine and Haskell," *Royal Academy of Dancing Gazette,* 1947, 6.

5. Sokolova 1960, 140.

6. For a more technical discussion of these points, See André Levinson's magesterial essay, "The Spirit of the Spanish Dance," in Levinson, 49–55.

7. Sokolova 1960, 122.

8. Sokolova 1950, 25–6.

9. A dancer named Fernández is listed on the roster throughout the season. The company may have wanted to hush up the scandal.

10. Sokolova 1950, 27.

11. Karsavina, 190–1.

12. Sokolova 1960, 137.

13. Sokolova 1950, 29.

14. Sokolova 1960, 137.

15. García-Márquez, 145.

16. Z.XXIX.375.

17. Sokolova 1950, 30.

18. The County Archivist, Surrey County Council, confirmed to McCully that the "Long Grove Hospital, Epsom, lists Felix García and confirms his date of death as 18 March 1941, aged 44."

19. García-Márquez, 321.

20. Ibid., 313.

21. Joan Acocella in conversation with the author.

22. On December 20, 1919 (Archives Picasso), Bell wrote to to Olga Picasso that he had sent her the scores of *Boutique fantasque* and *Les Femmes de bonne humeur.* Enrico Cecchetti still hoped that Olga would dance again, but in a letter to her six months later (June 24, 1920, Archives Picasso), he expressed regret that she had "given up again."

23. Susan Scott has kindly checked the Savoy Hotel archives and confirmed that Diaghilev took two other rooms (old numbers 487–492/new numbers 430–431).

24. Letter from Paul Rosenberg to Picasso, June 10, 1919, Archives Picasso.

25. Monet had repeatedly stayed (1899–1905), sometimes as long as three months at a time, in one of the Savoy Hotel's rooms (old room number 504) overlooking the river. From the vantage point of his balcony, Monet would paint views of Waterloo Bridge to the left and Charing Cross Bridge to the right. See Robert Gordon and Andrew Forge, *Monet* (New York: Abrams, 1983), 186.

26. Z.III.300.

27. Z.III.298–9, Z.III.414.

28. Vol. I, 402 (Z.I.352).

29. André Lhote, quoted in *Nouvelle Revue Française,* January 1920, reprinted in *André Derain : Le Peintre du "trouble moderne"* (Paris : Musée d'art moderne de la Ville de Paris, 1994), 236.

30. Letter from Roger Fry to Vanessa Bell, March 15, 1921, Sutton, 504.

31. Letter from Bell to Mary Hutchinson, July 11, 1919, Ransom Center.

32. They married in 1926.

33. Z.III.297.

34. Z.III.301.

35. Z.III.352–354.

36. Vladimir Polunin had met the English painter Violet Elizabeth Hart in St. Petersburg, where she was studying with Bakst. They married in 1908 and settled in London in 1914. Polunin worked as a scene painter for Sir Thomas Beecham. Chaliapin, for whom they painted sets, and who introduced them to Diaghilev.

37. Polunin, 53–4.

38. Under Picasso's supervision, Polunin also repainted the set for *Parade,* which (according to Picasso) had been "hurriedly painted by someone in Paris [and] was so unsatisfactory that it required to be repainted before almost every performance." Polunin, 59. The priming had been applied carelessly so that the colors peeled off. Polunin restored everything so satisfactorily that it never needed retouching. *Parade* was not

39. Private collection.

40. Sacheverell Sitwell, *Massine: Camera Studies by Gordon Anthony* (London: Routledge, 1939), 20.

41. Musée Picasso, Paris.

42. The finest of these drawings (Z.III.308) is inscribed "London." Apparently the central motif was not decided upon until Picasso was able to consult with Polunin, Diaghilev, and Massine.

43. P.F.III.399.

44. P.F.III.405.

45. P.F.III.401.

46. See Rubin 1972, 104.

47. Palau 1999, 148.

48. See Nesta MacDonald's text, "Picasso's Curtain for *Le Tricorne,*" which originally appeared in the London *Observer Colour Supplement* (November 2, 1986). I am unable to agree with her identification of the figures in the curtain.

49. Polunin, 55.

50. Both Cooper, 51–2, and Grigoriev, 224, incorrectly date the sale of the *Tricorne* curtain as 1926.

51. Grigoriev, 224.

52. For further information on G. F. Reber, see Richardson 1999, 26–9.

53. What happened to the decorative borders after Diaghilev chopped them off is unknown.

54. Polunin, 53.

55. Horta is on the border of Catalonia and Aragon, hence Picasso's comments on the margins of his designs for the villagers' costumes that they were specifically Aragonese. Palau 1999, 150, chooses to see these costumes as a tribute to Goya, who was Aragonese.

56. See, for example, Sacheverell Sitwell in *The Hunters and the Hunted* (London: Macmillan, 1947), 108.

57. W. A. Propert, *The Russian Ballet in Western Europe* (London: John Lane, 1921), 55.

58. Levinson, 65.

59. Letter from Diaghilev to Picasso, [June 1919], Archives Picasso.

60. Polunin, 58.

61. Letter from Diaghilev to Picasso, [June 1919], Archives Picasso.

62. Ibid.

63. Reported by Massine in Buckle 1979, 354.

64. See, for example, Z.III.298–9 and Z.XXIX.414.

65. My thanks to Richard Shone, who remembers seeing the photograph on the mantelpiece at Lopokova's home in 1965.

66. Spalding, 210. Duncan Grant told Richard Shone that Picasso asked technical questions about Omega pottery.

67. Ibid.

68. Z.II.431.

69. The Morrells' house inspired Aldous Huxley's *Chrome Yellow.* Lady Ottoline was also pilloried by D. H. Lawrence in *Women in Love,* as well as by Osbert Sitwell.

70. H. T. J. (Harry) Norton was a Cambridge mathematician who had bought a cubist Picasso (Z.II.241) on Bell's advice in 1912.

71. Letter from Bell to Mary Hutchinson, May 28, 1919, Ransom Center.

72. See a letter from Lady Ottoline Morrell, published by James Beechey, "Letter to the Editor, 'Picasso in London,' " *Burlington Magazine* 149 (January 2007), 42.

73. Shone, 40.

74. Letter from Vanessa Bell to Virginia Woolf, February 6, 1913, Marler, 137.

75. Shone, 155.

76. Angelica would later marry David Garnett, one of her father Duncan Grant's lovers.

77. Picasso quoted by Ben Nicholson, in Jeffrey Meyers, *The Enemy: A Biography of Wyndham Lewis* (London: Routledge/Kegan Paul, 1980), 162.

78. Desmond MacCarthy, *Memories* (1953), in *Bloomsbury: The Artists, Authors and Designers by Themselves,* ed. Gillian Naylor (London: Mitchell Beazley, 1993; originally published 1990), 37.

79. Letter from Bell to Mary Hutchinson, June 2, 1919, Ransom Center.

80. Holroyd 1968, 486.

81. Vanessa Bell's portrait of *Mrs. St. John Hutchinson* (1915) appears as cat. 35 in Shone, 103.

82. Lord Rothschild to the author.

83. See Vol. II, 234 (Z.II.351).

84. Holroyd 1996, 257.

85. Letter from Bell to Mary Hutchinson, June 2, 1919, Ransom Center; Holroyd 1996, 344.

86. Bell, 171.

87. This farrago Picasso supposedly told the British artist Eileen Agar (*A Look at My Life* [London: Methuen, 1988], 138) about a dinner given by a grand lady in a black nightgown, who blew out the candles one by one, does not ring true.

88. Beaumont, 132.

89. Ibid., 143–4.

90. Ibid., 144.

91. Letter from Margot Asquith to Diaghilev, July 12, 1919, in Buckle 1979, 358.

92. Cooper, 42.

93. Grigoriev, 148.

94. Buckle 1979, 357.

95. See Larralde and Casenave, 67.

96. Adrian Goodman confirmed to Richard Shone that the woman friend was Molly Hamilton, according to the visitors' book at Garsington on July 28, 1919.

97. Holroyd 1968, 5.

98. Bell, 172. In a letter to his mother, Maynard Keynes says (July 29, 1919), "we sat down twenty-three to supper and did not rise from the table until half past one." Robert Skidelsky, *John Maynard Keynes, Vol. I, Hopes Betrayed 1883–1920* (London: Macmillan, 1983), 350.

99. Holyrod 1968, 69.

100. Duncan Grant to Vanessa Bell, July 30, 1919, Tate archives, London.

101. Letter from Bell to Mary Hutchinson, August 4, 1919, Ransom Center.

102. The modern French art exhibition consisted of minor works by Matisse, Derain, Modigliani, Soutine, Léger, Utrillo, Dufy, as well as one or two early Picassos. See Osbert Sitwell, *Laughter in the Next Room* (London: Macmillan, 1949), 154. Sitwell bought a Modigliani painting for four pounds.

103. Letter from Bell to Mary Hutchinson, August 4, 1919, Ransom Center.

104. Ibid.

105. Ibid.

106. Letter from Paul Rosenberg to Picasso, July 29, 1919, Archives Picasso.

107. Z.III.413.

108. Letter from Paul Rosenberg to Picasso, confirming his lunch with Renoir, August 20, 1919, Archives Picasso.

109. Cowling 2006, 147.

110. Gilot 1964, 149.

CHAPTER 11
Summer at San Raphaël

1. Most of the Picassos' business and domestic accounts from 1918 onward are in Olga's hand.

2. See Level correspondence with Picasso, Archives Picasso.

3. See Vol. II, Chapter 27.

4. Hugo 1983, 134.

5. Picasso would not start on *Three Musicians* for another two years. Hugo's visual memory had for once failed him.

6. Hugo 1983, 135.

7. There were no bullfights in the Fréjus arena between 1914 and 1926. Tickets in the Musée Picasso confirm that Picasso did not attend a bullfight there until 1927. The last *corrida* he attended (October 25, 1970) took place in the Fréjus arena. It engendered the finest of his late bullfight subjects.

8. Letter from Errázuriz to Picasso, August 20, 1919, Archives Picasso.

9. See Gasman, 1135ff, for further discussion of Picasso's portrayls of Olga in the late 1920s.

10. Room number 55.

11. Letter from Level to Picasso, August 28, 1919, Archives Picasso.

12. Z.III.387 and P.F.III.498.

13. Z.III.385 and Z.III.379.

14. See Z.III.386, Z.III.389, Z.III.397–9, and Z.III.401–3.

15. Postcard from Paul Rosenberg to Picasso, January 21, 1920, Archives Picasso.

16. Z.III.370–1.

17. Z.III.372.

18. Z.III.364.

19. Letter from Paul Rosenberg to Picasso, July 6, 1920, Archives Picasso. The Armenian

dealer Dikran Kelekian bought the *"rousseauiste"* landscape, and sold it to Quinn in 1922 (see Reid, 548).

20. Olga wrote Jacqueline Apollinaire (September 15, 1919, Archives Picasso), "We will arrive in Paris on Thursday the 17th.

21. Letter from Diaghilev to Picasso, August 24, 1919, Archives Picasso.

22. Walsh, 622 n. 55.

23. Ibid., 306. Stravinsky had originally claimed that he and Diaghilev had done the research; no less ironically most of the pieces turned out *not* to be by Pergolesi.

24. Z.XXIX.427. Ibid.

25. Editions de la Sirène: publishing house run by Cocteau and Cendrars and backed by Paul Rosenberg. Picasso designed its logo.

26. Z.VI.1334.

27. Hugo 1983, 137.

28. Rubinstein 1980, 149.

29. Ibid., 150.

30. On July 19, 1958, Picasso would do twenty-four drawings of Rubinstein (Z.XVIII.270–96).

31. See Vol. II, 374.

32. Letter from Georges Bemberg to Picasso, February 13, 1914, Archives Picasso.

33. Z.III.373; the full-length portrait is reproduced in *Picasso Ingres* (Paris : Musée Picasso, 2004), 106.

34. Z.XXIX.315 and Z.III.256.

35. Letter from Bemberg to Picasso, May 15, 1919, Archives Picasso.

36. Ibid.

CHAPTER 12
Pulcinella

1. The catalog of the show lists 167 drawings and watercolors by subject: Harlequins and Pierrots (1–23), Horses, Circuses, and Bullfights (24–30), Dancers (31–46), Open Windows at Saint-Raphaël (i.e., Gueridons) (47–71), Figures (72–95), Still lifes (96–121), Nudes (122–9), Landscapes (130–6), Portraits (137–53), Subjects (154–64), and After Ingres and Renoir (165–7).

2. In *Valori Plastici* 1, nos. 11–12 (November–December 1919), Armando Ferri described the show as a retrospective, including drawings from the Blue as well as the Rose and cubist periods. The only items the article identifies are twenty-five gueridon watercolors Picasso did at Saint-Raphaël: "The farthest point attained by the artist," in the opinion of Ferri, who went on to claim that these works—displayed two to a frame by Rosenberg—demonstrated that Picasso had "overcome cubism without having renounced it."

3. See Martin.

4. J. G. Lemoine, "Picasso Chez Paul Rosenberg 21 rue la Boétie," *L'Intransigeant,* October 29, 1919.

5. Roger Allard, *Le Nouvel spectateur* 1, no. 21-22 (October 25–November 10, 1919).

6. Letter from Gris to Kahnweiler, November 27, 1921, in Kahnweiler-Gris 1956, 128.

7. Salvador Dalí would quote this and other sayings of Ingres in the catalog to his first exhibition at the Galeries Dalmau in 1925.

8. FitzGerald 1995, 96.

9. Gee, 59.

10. Letter from Bell to Mary Hutchinson, November 2, 1919, Ransom Center.

11. Letters from Bell to Mary Hutchinson, November 4, 8, 9, and 11, 1919, Ransom Center.

12. Letter from Bell to Mary Hutchinson, November 12, 1919, Ransom Center.

13. Letter from Bell to Mary Hutchinson, November 16, 1919, Ransom Center.

14. Bell incorrectly claims in his memoir (Bell, 182) that Derain was present and that the drawing dated from 1920. During the lunch, Bell read out his wife's enthusiastic account of *Parade*'s premiere in London.

15. Letter from Bell to Mary Hutchinson, November 22, 1919, Ransom Center.

16. Ibid.

17. Z.III.427.

18. Letter from Bell to Mary Hutchinson, November 22, 1919, Ransom Center.

19. Bell, 187.

20. See Vol. 1, 101.

21. Letter from Bell to Mary Hutchinson, November 30, 1919, Ransom Center.

22. Ibid.

23. Ibid.

24. Letter from Bell to Mary Hutchinson, December 7, 1919, Ransom Center.

25. Letter from Bell to Mary Hutchinson, December 4, 1919, Ransom Center.

26. Fauconnet would soon be dead. Raoul Dufy would do Cocteau's décor instead.

27. Letter from Bell to Mary Hutchinson, December 3, 1919, Ransom Center.

28. Ibid.

29. Letter from Bell to Mary Hutchinson, December 7, 1919, Ransom Center.

30. Ibid.

31. See letter from Jacques-Emile Blanche to Cocteau, September 11, 1919, in *Jean Cocteau–Jacques-Emile Blanche Correspondance* (Paris: La Table Ronde, 1993), 148.

32. Silver, 148.

33. For a definition of "crystal" cubism see Chapter 6.

34. Z.III.363.

35. Corot's *Mademoiselle de Foudras* reportedly belonged to the Galerie Bernheim-Jeune. However, Cowling 2002, 665 n. 40, believes that Picasso made his drawing, which is dated January 8, 1920, after a photograph.

36. André Derain, "Idées d'un peintre," *Littérature,* May 1921.

37. Walker Art Gallery, Liverpool.

38. Musée Picasso, Paris (MP 64).

39. Letter from Gris to Kahnweiler, August 25, 1919, Kahnweiler-Gris 1956, 65.

40. Pierre Rosenberg, *Chardin* (Paris: Flammarion, 1999), no. 76B, 220.

41. Robert Rosenblum, acoustiguide tour C, "Picasso" (New York: MoMA, 1980), in Boggs, 190.

42. In a letter, July 4, 1919, Archives Picasso, Paul Rosenberg tells Picasso he has bought *"un beau Puvis Chavanne. Vous n'aimez pas cet artiste, mais il se vend bien. . . ."* In fact Puvis had exerted a considerable influence on the Blue period.

43. Mitchell, 98.

44. Musée Picasso, Paris (MP 1990–6).

45. Vol. I, 70 (Z.XXI.49).

46. Vol. I, 377 (Z.XXIX.186). One of these idiosyncratic First Communion paintings would be acquired by Doucet.

47. Cooper, 46.

48. Z.XXX.50–1, 54; Z.IV.24.

49. Massine, 145.

50. Cooper, 47.

51. Recounted in Cooper, 46–7.

52. Mosch, 232.

53. Cooper, 45–6.

54. Ibid.

55. Z.III.193–4, 196.

56. On receipt of Diaghilev's telegram, the Polunins contacted Picasso (April 19, 1920, Archives Picasso), to give him the gist of Diaghilev's telegram and to ask if he needed them to work on his curtain, as their contract ended with the completion of the décor.

57. Z.IV.28.

58. Sokolova 1960, 151.

59. Cooper, 48.

60. Musée Picasso, Paris.

61. Walsh, 313.

62. Stravinsky quoted in Mitchell, 98.

63. See Christian Martin Schmidt, "The Viennese School and Classicism," in Boehm, Mosch, and Schmidt, 358.

64. Ibid.

65. Ibid.

66. Ibid.

67. Buckle 1979, 363.

CHAPTER 13
Summer at Juan-les-Pins

1. Letter from Vanessa Bell to Fry, May 17, 1920, Marler, 244. The pastel mentioned by Vanessa, *Family of Napoleon III* (illustrated in Baldassari 1997, 157, but dated 1919), was based on a Levitsky photograph of Napoleon III, Empress Eugénie, and the Crown Prince (Archives Picasso), and dates from spring 1920.

2. Vol. I, 381.

3. Vol. I, 408, 515 n.25.

4. Musée du Petit Palais, Paris.

5. Reid, 501.

6. Z.VI.1396, 1398, and PF.III.885.

7. Satie (Z.IV.59), Falla (Z.IV.62), Stravinsky (Z.IV.60), Helft (Z.IV.77), and Berthe Weill (Z.IV.76). To promote her gallery Weill had recently published a bulletin and approached artists she had exhibited for contributions; see Seckel, 187 n. 10.

8. The frequently misdated portrait drawing of Etienne de Beaumont (reproduced in Cooper, no. 327) can be seen on an easel in a drawing of Picasso's studio (PF.III.747) dated June 12, 1920. Picasso's portrait drawing of Edith de Beaumont dates from the following year (Z.IV.274).

9. *Madame Wildenstein* (private collection) and *Portrait of Lopokova* (Z.XXIX.414).

10. Z.XXX.76–8 and Z.IV.3.

11. Palau 1999, 209.

12. Letter from Level to Picasso, June 23, 1920, Archives Picasso (discussing the Kahnweiler sales), in which he tells the artist, "you can therefore leave in peace, but give me your address as soon as you arrive, in the event that I need to write to you."

13. Vallentin, 246.

14. Z.XXX.60, 65.

15. Letter from Bell to Mary Hutchinson, October 23, 1920, Ransom Center.

16. PF.III.794–5; Z.IV.89, 96; Z.XXX.88, 92.

17. Kostenevich, 119.

18. Ibid.

19. Kean, 269. This drawing has not been traced.

20. Ibid., 267.

21. Ibid., 268.

22. Milhaud took the name *Le Bœuf sur le toit* from a samba, "O boi no telhado," that he had heard during the Rio de Janeiro Carnival.

23. Steegmuller 1970, Appendix IX.

24. See, for example, Z.IV.203–4 and Z.XXX.85.

25. PF.III.803–6.

26. Z.IV.107

27. Elizabeth Cowling, "Introduction," *On Classic Ground: Picasso, Léger, de Chirico and the New Classicism 1910–1930* (London: Tate Gallery, 1990), 26.

28. Z.IV.123–4, PF.III.783, and Z.XXX.89, 91.

29. Z.IV.127, 99, 97, 180, 183.

30. See p. 28.

31. In 1920 Matisse had given the Museum in Grenoble his 1917 painting *L'Allé d'arbres dans le bois de Clamart.* possibly in gratitude for Farcy's son-in-law Marcel Sembat's monograph on the artist.

32. Kenneth Clark, *The Nude* (London: Penguin, 1960; originally published 1956), 2.

33. See the exhibition catalog of *Picasso Badende,* StaatsGalerie Stuttgart (2005), for many of these bather compositions.

34. Z.IV.169.

35. Gilot 1964, 119.

36. Letter from Paul Rosenberg to Picasso, July 27, 1920, Archives Picasso. The *contre-plaqué* panels apparently ended up as the three-panel screen Picasso executed for Olga's sitting room.

37. Gris's letter to Picasso of October 24, 1919, Archives Picasso, provides the address, 5, rue de la Main d'or, for the supplier of *contre-plaqué.*

38. PF.III.790.

39. PF.III.779, for instance.

40. For example, Z.IV.211–4.

41. Palau 1999, 246.

42. See letter from Paul Rosenberg to Picasso, July 13, 1920, Archives Picasso.

43. See FitzGerald 1995, 120: the first museum exhibition of Picasso's work in America was held in the spring of 1923 at the Chicago Arts Club. It had been organized by Prince Wladimir Argotinsky-Dolgoroukoff (diplomat, collector, and sometime dealer), who selected fifty-three drawings, covering the period 1907–22.

44. Z.IV.184–5, 187, 1394–5, 1402; Z.XXX.104; PF.III.843.

45. For further discussion regarding the subject of these drawings, see Cowling 2002, 405, and Carandente, 32.

46. Baer 160.

47. See Gary Tinterow, *Master Drawings by Picasso* (Cambridge, Mass.: Fogg Art Museum, 1981), 162, and Cowling 2002, 407.

48. Letter from Bell to Mary Hutchinson, October 30, 1920, Ransom Center. Lady Colefax was the London hostess lampooned by Aldous Huxley, Osbert Sitwell, and Evelyn Waugh, and

described by Virginia Woolf as "glittering as a cheap cherry."

49. Letter from Bell to Mary Hutchinson, October 29, 1920, Ransom Center.

50. Letter from Bell to Mary Hutchinson, November 2, 1920, Ransom Center.

51. Letter from Fry to Vanessa Bell, March 15, 1921, Sutton, 504.

52. Letter from Bell to Mary Hutchinson, May 5, 1921, Ransom Center.

53. Letter from Bell to Mary Hutchinson, October 29, 1920, Ransom Center.

54. Letter from Satie to Valentine Hugo, December 13, 1920, Volta 2000, 430.

55. Steegmuller 1970, 261.

56. Ibid.

57. Ibid., 261–2.

58. Hugo 1983, 195.

59. Steegmuller 1970, 273.

60. For a typical though much later example, see Richardson 1999, 241.

CHAPTER 14
L'Epoque des Duchesses

1. Z.IV.268.

2. The Paroïsse Saint-Augustin baptismal certificate lists the child as Paul Joseph Riuz [*sic*] y Picasso. In a letter of the following year (April 8, 1922, Archives Picasso), Level sends a "*bonne caresse à Paul-Joseph.*" Picasso's son was known to family and friends as Paulo or simply Paul.

3. Stein 1933, 190.

4. Ibid., 211.

5. Ibid., 190.

6. Seckel, 178.

7. Louis Aragon, *Anicet ou le Panorama, roman* (Paris: Gallimard, 1949; originally published 1921), 69–70.

8. Letter from Jacob to Picasso, June 4, 1921, Seckel, 180.

9. Baer, 62.

10. Seckel, 180.

11. Stein 1933, 194.

12. Palau 1999, 371.

13. Cabanne 1977, 203.

14. Gilot 1964, 149.

15. Gold and Fizdale, 198–9.

16. See Vol. II, 391.

17. Steegmuller 1970, 227 note.

18. See Chapter 30.

19. A silversmith, François Hugo, executed Picasso's designs for silver plates and fruit dishes in the 1950s and 1960s.

20. Buckle 1979, 366.

21. Sokolova 1960, 163.

22. Buckle, 370.

23. Grigoriev, 169.

24. According to the late Genya Smakov, the Russian ballet historian, in conversation with the author.

25. See Cooper, no. 284; and Kochno, 283.

26. Picasso to the author.

27. Buckle 1979, 378.

28. According to Claustre Rafart, "Cuadro Flamenco," *Picasso y el teatro* (Barcelona: Museu Picasso, 1966), 120, d'Albaicín's real name was María García Escudero. Buckle 1979, 378, claims that Diaghilev made her follow her bullfighter brother's example and change her name to d'Albaicín (after the caves outside Granada where the Gypsies lived).

29. Buckle 1979, 380–1.

30. Letter from Gris to Kahnweiler, April 21, 1921, Kahnweiler-Gris 1956, 110.

31. Telegram from Diaghilev to Picasso, April 20, 1921, Archives Picasso.

32. Letter from Gris to Kahnweiler, April 29, 1921, in Kahnweiler-Gris 1956, 112.

33. See MP 1824.

34. Buckle 1979, 381.

35. Ibid.,

36. Beaumont, 186.

37. Charles-Roux, 211.

38. Beaumont, 186–7.

39. See Cooper, 52, on the fate of the curtain.

40. Cooper, 53. Cowling 2002, 667 n. 95, reveals that Picasso also envisaged a ballet to be called *La Petite Fille écrasée* with "scenario, choreography, mise-en-scène and music" by himself.

41. Cooper, 52.

42. Letter from Georges Auric to Picasso, September 17, 1962, Archives Picasso.

43. Cooper, 71.

44. Z.I.308, Z.II.550, Z.II.529, Z.I.300, and Z.II.555.

45. Z.IV.331–332.

46. Reverdy, 9. A related pastel (Z.IV.202) was also reproduced in *La Révolution surréaliste* with the caption "Adam et Eve."

47. See Vol. II, 29.

48. See *L'Amour de l'art,* 1921: Maurice Raynal, "Picasso et l'Impressionisme," 213–16; and Roger Bissière, "L'Exposition Picasso," 209–12.

49. Braque to the author.

50. Although written in 1921, Reverdy's text did not appear in book form until 1924.

51. Danchev, 136.

52. Reverdy, 8.

53. Ibid., 13.

54. Braque in conversation with the author.

55. Centre Georges Pompidou, Paris.

56. Letter from Pierre Reverdy to Picasso, July 1, 1922, Archives Picasso.

57. Musée Picasso, Paris (MP 72).

58. The one and only time Picasso reprimanded me was for mentioning in an article that Braque had turned down Picasso's offer of a studio space in La Californie so that they could work together as they had in the distant past. He felt I had put him at a disadvantage, Jacqueline told me.

59. Stein 1933, 194.

CHAPTER 15
Summer at Fontainebleau

1. For detailed accounts of the Kahnweiler sales see Assouline, FitzGerald 1995, and Gee.

2. Although Goetz had been a friend of Picasso's there were no works by the artist in his sale, which took place in February 1922.

3. According to Cooper, who took advantage of the fall in cubist prices to form an exceptionally rich cubist collection.

4. Z.II.217, Z.II.235.

5. Kunsthaus, Zurich.

6. Danchev, 212.

7. Assouline, 168.

8. Ibid., 169.

9. See Vol. II, 35–6.

10. Adolphe Basler, "Über Kunst und Künstler in Frankreich," *Der Cicerone,* July 6, 1922, 547–52.

11. Assouline, 173.

12. Ibid.

13. Ibid., 174.

14. Ibid., 174–5.

15. See Vol. II, 352.

16. Jean Cocteau, *Journal: 1942–1945* (Paris: Gallimard, 1989), 70.

17. Assouline, 175.

18. See Piet de Jonge, "Helene Kröller-Müller e il cubismo," *Il Cubismo: Rivoluzione e tradizione* (Ferrara: Palazzo Diamanti, 2004), 79–86.

19. Assouline, 176.

20. Ibid., 175.

21. Now 33, avenue Leclerc.

22. Z.IV.294.

23. Z.IV.295–8.

24. See Z.IV.282. The coach house (seven by nine meters) has been remodeled.

25. Penrose, 239.

26. Ibid., 240.

27. Charles-Roux, 211–12.

28. Morand 1976, 121.

29. Ibid., 124.

30. Ibid., 93.

31. Ibid.

32. Ibid., 63.

33. Baer, 63.

34. Whereabouts unknown.

35. Charles-Roux, 220.

36. Rosenberg paid 18,000 francs for *Two Nudes* on June 22, 1921, and sold them two months later to Quinn for 27,000 francs. The following year Quinn would buy *Three Women at the Spring* directly from Picasso. FitzGerald 1995, 119.

37. Letter from Roché to John Quinn, June 12, 1922, Reid, 551.

38. Although the "Small Giants" has not been identified, the work that fits Quinn's description most closely is Z.IV.278.

39. Letter from Roché to Quinn, July 11, 1922, Reid, 551.

40. Bemberg's second wife was the widow of Count Alexander Vrubov, the young naval lieutenant who had been obliged by the Tsarina to marry her manipulative lady-in-waiting, Anya Taneeva, who had served as her go-between with Rasputin. Eighteen months later, after discover-

ing the extent of the intrigues between his wife and the Tsarina, Vrubov asked the Tsar for an annulment. It was instantly granted, so long as he retired to his country estate. Vrubov remarried. After his death his wife would marry Bemberg.

41. Napoleon III had renovated the springs; see Terrasse, 94.

42. PF.III.1082 and Z.IV.322.

43. Harold Osborne, ed., *The Oxford Companion to Art* (Oxford University Press, 1971), 687–8.

44. See Geneviève Brese-Bautier, "La Sculpture de l'attique du Louvre par l'atelier de Jean Goujon," *Revue de Louvre* 2 (1989), 1997. Also, Alexandra Parigoris, "Pastiche and the Use of Tradition, 1917–1922," in *On Classic Ground* (London: Tate Gallery, 1990), 301–4.

45. Gilot 1964, 20.

46. Terrasse, 93.

47. Z.IV.301–3 and PF.III.1045. The spring at Fontainebleau was supposedly discovered by a hound named Bliaud; see Katharina Schmidt, "Pablo Picasso: *Three Women at the Spring*," in Boehm, Mosch, and Schmidt, 247.

48. PF.III.1046 and Z.IV.304.

49. Picasso sent one of these sketches to Rosenberg, who commented in his thank you letter, July 7, 1921, Archives Picasso, "*vous êtes tout à fait Ecole de Fontainebleau!*"

50. Z.II.108.

51. Z.XXX.257. One of many drinking fountains set up in Paris by Sir Richard Wallace (illegitimate son of the Marquess of Hertford) after whom the Wallace collection is named.

52. See Z.IV.358, Z.IV.365, and Z.XXX.259–61.

53. Letter from Fry to Vanessa Bell, March 15, 1921, Sutton, 505.

54. John Pearson, *Façades* (London: Macmillan, 1978), 143.

55. See Vol. II, 167–72.

56. Z.IV.331–2.

57. Reff, 124–42.

58. Z.II.555.

59. On October 29, 1920 Bell informs Mary Hutchinson that "Picasso . . . is strangely isolated and solitary" (Ransom Center).

60. Cowling (Cowling 2002, 367) identifies the *Three Musicians* as Satie, Stravinsky, and Falla.

61. Vol. II, 280.

62. See Picasso's drawing of a *cobla:* Vol. II, 186.

63. The difference between a *tenora* and a clarinet has to do with the shape of the reed and the scale of the instrument. Since the *tenora* is emblematic of French Catalonia and Picasso had a special affection for the cobla and the sardana dances that it accompanied, we can assume that the wind instruments in *Three Musicians* include a *tenora.*

64. Z.IV.1344.

65. See Lewis Kachur, "Picasso, Popular Music and Collage Cubism (1911–12)," *Burlington Magazine,* April 1993, 252–60.

66. See Vol. II, 163–4.

67. Ibid., 186.

68. Seckel, 179.

69. Z.IV.310.

70. See Vol. II, 278.

71. Reff, 135, sees the dog as a manifestation of Anubis, the Egyptian god of death.

72. Gilmore 1998, 20, 71.

73. Ibid., 23.

74. Letter from Roché to Quinn, February 19, 1922, Reid, 552.

75. Robert Schmutzler, *Art Nouveau* (New York : Harry N. Abrams, 1962), 137.

76. Bemberg's few surviving works belong to the family.

77. Princess Gortchakow in conversation with the author.

78. For example, Z.IV.273.

79. Letter from Bemberg to Picasso, April 14, 1922, Archives Picasso.

80. Letter from Bemberg to Picasso, September 16, 1922, Archives Picasso.

81. Princess Gortchakow to the author.

82. An older family member informed the author that no such person existed. However, a younger member, Peter Bemberg, acknowledged that there had been such a person. He also made it possible to consult the cache of his letters in the Archives Picasso. Coincidentally, a chance remark to Mrs. Katusha Davison elicited the fact that her cousin, Princess Marie Gortchakow, was a stepdaughter of Georges Bemberg. Princess Gortchakow provided most of the information included in these pages.

83. *C'était Picasso,* produced by Leo Scheer and Nathalie Rheims for Antenne 2 (French television), 1991.

CHAPTER 16
Beau Monde

1. In her younger days, when Misia was married to Thadée Natanson, editor of the *Revue Blanche,* she posed for Toulouse-Lautrec's poster for the inks of Ault & Wiborg. Misia's friends, Hoytie Wiborg and her sister Sara Murphy were née Wyborg. See Loys Delteil, *Toulouse-Lautrec: Le Peintre Graveur Illustré,* vols. X–XI (Paris, 1920), D.365.

2. According to an Ogden Stewart family member.

3. Vaill, 272.

4. Volta 2000, 907.

5. Tomkins, 27.

6. Vaill, 104.

7. Ibid., 105.

8. Tomkins, 38. Also see Kammen, 133.

9. Hoytie Wiborg was also the model for Baby Warren in Scott Fitzgerald's Murphy-inspired *Tender Is the Night.*

10. Gold and Fizdale, 233–4.

11. Tomkins, 151.

12. Vaill, 166.

13. Tomkins, 158–9.

14. Letter from Bell to Mary Hutchinson, May 14, 1923, Ransom Center.

15. Z.IV.363.

16. Everling thinks that Picasso also attended *"un Réveillon cacodylate,"* given by Picabia, to which many of the same guests, including Picasso, were invited. See Everling, 138–9.

17. Hugo 1983, 201. "Caryathis" (Elisabeth Toulemon) was the stage name of a statuesque dancer who married Marcel Jouhandeau and became a writer.

18. Letter from Marcel Proust to Beaumont, December 31, 1921, Proust 2000, 283.

19. Hugo 1983, 201.

20. Letter from Proust to Princess Soutzo, February 28, 1922, Proust 2000, 304.

21. See Céleste Albaret, *Monsieur Proust,* trans. Barbara Bray (New York: McGraw Hill, 1997), 233.

22. See letter from Sydney Schiff to Proust (May 15, 1922, Proust 1993, 195): since the Ritz did not allow music after 12:30, Schiff was obliged to give his famous party at the Majestic.

23. Princess Edmond de Polignac had commissioned *Renard* and financed its production, which would open Diaghilev's spring season at the Paris Opéra on May 18.

24. Letter from Bell to Mary Hutchinson, May 6, 1922, Ransom Center.

25. Letter from Schiff to Proust, June 21, 1922, Proust 1993, 295.

26. Letter from Bell to Mary Hutchinson, May 6, 1922, Ransom Center.

27. Letter from Cocteau to Picasso, May 24, 1922, Archives Picasso.

28. Painter, 341.

29. Ibid.

30. Stein 1933, 212.

31. Letter from Bell to Mary Hutchinson, May 6, 1922, Ransom Center.

32. Letter from Cocteau to his mother, March 30, 1921, Steegmuller 1970, 271.

33. Ibid., 260.

34. "Cacodylic" literally means "shitty." It may also refer to a lotion that Picabia used for shingles that afflicted his eye. See Raczymow, 89.

35. William A. Camfield, *Francis Picabia: His Art, Life and Times* (Princeton, N.J.: Princeton University Press, 1979), 170.

36. Hugo 1983, 204.

37. Painter, 345.

38. Hugo 1983, 203. In her lively memoir, *Laughing Torso* (London: Constable, 1932) Nina Hamnett claims that this occured "some days before the official opening." Hugo is more dependable.

39. Radiguet sent the artist a postcard of a Corsican shepherdess, inscribed "Bonjour Monsieur Picasso" and dated January 16, 1922. Archives Picasso.

40. Baer, 223.

41. Volta 2000, 797.

42. The playwright Edouard Bourdet would also satirize his friend Beaumont as Duc "Toto"

d'Anche in his beau monde comedy, *La Fleur des pois.*

43. Häger, 29.

44. Ibid., 163.

45. Assouline, 179.

46. Ibid., 180. This gave great offense to the purists Ozenfant and Jeanneret, who lashed out at Vauxcelles, accusing him of "playing a double game of hypocrisy."

47. JSLC 77 (Z.XXX.332–48).

48. See Chapter 24.

49. Penrose, 243–4. See, for example, Z.XXX.412.

50. March 29, 1922, Hôtel Drouôt, Paris.

51. Z.IV.330.

52. See Seckel-Klein, 202.

53. Z.IV.380.

54. Z.IV.175–8.

55. Penrose, 244.

56. PF.III.1261.

57. Cabanne 1977, 224, claims that Picasso returned to pick up Paulo, as well as his work. Penrose's story is more convincing.

CHAPTER 17
Paris

1. Gilot 1990, 223.

2. Palau 1999, 370.

3. Gilot 1990, 187.

4. Z.V.30.

5. Z.V.38.

6. Jacques Baron, *L'An I du surréalisme* (Paris : Denoël, 1969), 59–60.

7. The horse in Z.V.52 had been carved by Polunin, the scene painter, as a birthday present for Paulo. On March 10, 1923, Picasso wrote to thank him: *"mon fils est dans la joie."* Polunin family archives.

8. See, for, example, Z.IV.1429, Z.V.177, Z.VII.267, and Z.VI.1452.

9. Penrose, 330.

10. Steegmuller 1970, 292–3.

11. Cooper, 54.

12. MP Carnets II, cat. 25 (MP 1990-101); and Z.XXX.178, 180, 182–6.

13. *The Journals of Jean Cocteau,* trans. Wallace Fowlie (London: Museum Press, 1956), 102.

14. See, for example, Z.IV.11 and Z.V.13.

15. Z.V.12.

16. Sokolova 1960, 30.

17. Z.V.15.

18. Z.V.14.

19. Lagut.

20. Ibid.

21. A year or two later, *The Lovers* would be acquired by Sara Murphy's sister, Hoytie Wiborg.

22. Z.V.122.

23. *Pan and Daphnis,* Roman copy of Hellenistic original, Museo Archeologic Nazionale, Naples.

24. See Danièle Giraudy, "Pablo Picasso: *The Pipes of Pan,*" in Bohem, Mosch, and Schmidt, 268–78.

25. Rubin 1994, 140.

26. Z.V.141.

27. Rubin 1994, 144.

28. Wearing her pearls down her back was a habit Sara copied from Violet, Duchess of Rutland (mother of her friend, Lady Diana Cooper), with whom she had stayed as a debutante. See, for example, Z.V.42.

29. PF.III.1399.

30. Salvadó 1924.

31. Robert Desnos, "La Dernière Vente Kahnweiler," *Paris-Journal,* May 1923.

32. Ibid.

33. Assouline, 178.

34. Jacques Helft, *Vive la Chine! Mémoirs d'un antiquaire* (Monaco: du Rocher, 1955), 44.

35. Volta 2000, 515.

36. Letter from Beaumont to Picasso, May 26, 1923, Archives Picasso. Written a week before the ball, this letter confirms that these entrées were improvised at the last moment.

37. The poster for the *Bal Olympique,* held at the Olympia Taverne in Paris (July 11, 1924), lists among the performers "Mme. Koklova (Danse)"; however, her name may have been used for publicity purposes only along with the fifty artists (Picasso, Braque, Brancusi, Matisse, Man Ray, Satie, Stravinsky, Sara. Murphy, etc.)

who supposedly participated in a competition for the decoration of the ball.

38. Letter from Satie to Edith de Beaumont, May [23], 1923, Volta 2000, 538.

39. Letter from Satie to Princesse Edmond de Polignac, May 24, 1923, ibid.

40. Hugo 1983, 216.

41. Letter from Beaumont to Picasso, February or March 15, 1923, Archives Picasso.

42. Z.V.250.

43. Z.V.249.

44. Beaumont claimed to have "come into an unexpected windfall," but "the budget was limited." See letter of February or March 15, 1923, Archives Picasso.

45. Letter from Paul Rosenberg to Picasso, November 3, 1923, Archives Picasso.

46. Sokolova 1960, 203.

47. Walsh, 366.

48. Vaill, 118.

49. André Warnod, "Le Clown et ses peintres," *Comoedia,* June 6, 1923.

50. Vaill, 118.

51. Tomkins, 35.

52. Ibid.

53. Marcel Raval was a rich poet whose magazine, *Feuilles Libres,* published articles by Satie.

54. Letter from Satie to Marcel Raval, July 6, 1923, Volta 2000, 546.

55. Despite, or maybe because he had referred to Tzara (real name, Sami Rosenstock) as "a little Romanian Jew," Massot had been allowed to add an iconoclastic note to the evening; see Sanouillet, 395 n. 47.

56. Salvadó 1924.

57. Sanouillet, 396.

58. Polizzotti, 181.

59. Letter from Satie to Jean Guérin, July 9, 1923, Volta 2000, 547.

Kodak business in London and then joined the Communist Party.

3. Besides the summer school at Antibes, Davidson had established a winter school back in Wales.

4. Morris, 152.

5. Letter from Bell to Picasso, October 16, 1923, Ransom Center.

6. Morris, 152–3.

7. Two years earlier, Miró had offered to see her safely to Paris, as he wrote Picasso from Barcelona on July 25, 1921, Archives Picasso: "I . . . told her about your plans to bring her to Paris and my offer to accompany her myself on the next trip. The idea of seeing her son, naturally, made her very happy." Nothing came of this plan.

8. Baer 1997, 48.

9. Gilot 1990, 291.

10. Xavier Vilató to the author.

11. Tomkins, 37.

12. Palau 1999, 379.

13. Letter from Bell to Picasso, October 15, 1923, Archives Picasso.

14. Z.VI.1435.

15. Z.V.30, for example, and Z.VI.1429.

16. Tomkins, 39.

17. Stein 1933, 221.

18. Tomkins, 41.

19. Christian Zervos, "Conversation avec Picasso," *Cahiers d'Art,* 1935; see Bernadac and Michaël, 35.

20. Z.V.141.

21. See Vol. I, 443 (Z.I.305/Z.VI.715). For another possible source for this painting of *The Pipes of Pan:* photographs of Sicilian boys by Baron Wilhelm von Gloeden; See Robert Judson Clark and Marian Burleigh-Motley, "New Sources for Picasso's 'Pipes of Pan,' " *Arts Magazine,* October 1980, 92–3.

CHAPTER 18
Summer at Cap d'Antibes

1. Postcard postmarked Royan from Picasso to Stein, July 10, [1923], Beinecke Library.

2. George Davidson was an eccentric philanthropist who had made a fortune launching the

CHAPTER 19
Cocteau and Radiguet

1. Salvadó's address appears at the back of MP Carnets I, cat. 25 (MP 1990-101).

2. Palau i Fabre to McCully.

3. Salvadó 1995, 18.

4. The date for Derain's *Harlequin and Pierrot* was 1923 and not 1924–25, as the artist claimed. The misdating seems to have been intentional. Derain's contract with Kahnweiler ended in February 1924, when he signed up with Paul Guillaume, who had commissioned this work and modeled for it as Pierrot. Had Kahnweiler discovered that the painting dated from 1923, he might have had a a legal claim to it.

5. Salvadó 1995, 18.

6. Ibid., 18–19.

7. Z.V.17, Z.V.23, Z.V.37, and Z.V.135.

8. Salvadó 1995, 19; he mistakenly identifies the dealer as Kahnweiler.

9. Ibid.

10. Letter from André Breton to Picasso, September 18, 1923, Archives Picasso.

11. Letter from Breton to Picasso, October 9, 1923, Archives Picasso.

12. Baer 111.

13. Baer 110. Letter from Breton to Picasso, October 29, 1923, Archives Picasso.

14. Polizzotti, 194.

15. Ibid.

16. Cousins and Seckel, 175.

17. Ibid., 231.

18. Letter from Breton to Doucet; November 6, 1923, in ibid., 177.

19. Ibid.

20. Ibid, 178.

21. Ibid., 177.

22. Both Musée d'Orsay, Paris.

23. Chapon, 298–9. Before hanging the *Demoiselles* in his staircase, Doucet contemplated displaying it in his fanciful art deco bathroom.

24. Ibid., 305.

25. Letter from Roché to Picasso, January 24, 1924, Archives Picasso.

26. Roché journals, January 31 and February 10, 1924, Ransom Center.

27. Letter from Edith de Beaumont to Picasso, [June] 20, 1923, and undated note from Sert, both Archives Picasso.

28. Stein 1938, 31.

29. FitzGerald 1995, 127.

30. Letter from Quinn to Roché, June 9, 1922, Ransom Center.

31. Letter from Quinn to Roché, March 14, 1924, Ransom Center.

32. Letter from Paul Rosenberg to Picasso, November 21, 1923, Archives Picasso.

33. Letter from Paul Rosenberg to Picasso, November 26, 1923, Archives Picasso.

34. Letter from Paul Rosenberg to Picasso, December 11, 1923, Archives Picasso.

35. FitzGerald 1995, 128.

36. Letter from Quinn to Roché, December 6, 1923, Ransom Center.

37. Ibid.

38. Letter from Quinn to Roché, June 25, 1924, Ransom Center.

39. FitzGerald 1995, 126.

40. Ibid., 151.

41. Hugo 1983, 212–14. For Valentine's account of the same evening, see Hugo 1953, 22–3.

42. Steegmuller 1970, 308.

43. Nemer, 476, 478. Though still alive, Bronia Clair refuses to discuss this period of her life.

44. Russell Greeley was a descendant of Horace Greeley, founder of the *New York Tribune*, whose "Greeleyisms," such as "Go west, young man, go west," are still quoted today.

45. Hugo 1953, 24.

46. According to Nemer, 491, "Food poisoning is unlikely to have been the cause, three months later, of both [Radiguet's] typhoid and [Valentine's] peritonitis."

47. Ibid., 484.

48. Léon Daudet never accepted the death of his son as a suicide and accused the anarchists among others of shooting him. For wrongly accusing a taxi driver he was fined and sentenced to some months in prison.

49. Billot, 426.

50. Recounted in letter from Radiguet's father Maurice to Poulenc, December 15, 1923, Poulenc, 216.

51. Hugo 1983, 227.

52. Steegmuller 1970, 317.

53. Cocteau wrote on January 2, 1924, from Monte Carlo to a Paris editor. Steegmuller 1970, 321.

54. Erik Satie, "Les Ballets Russes à Monte Carlo," *Paris-Journal,* February 15, 1924, reprinted in Erik Satie, *Ecrits* (Paris: Champ Libre, 1977), 70.

55. Ibid.

56. Laloy's book was published in 1913. Steegmuller 1970, 323.

57. Ibid., 324.

58. Ten years old at the time his father shot himself, Cocteau would be haunted by dreams that his father had turned into a parrot.

59. Morand 2001, 81.

60. Arnaud, 326. Thirty years later, the artist made the same remark to Cooper and the author, substituting soap for sugar.

61. Ibid.

62. Jean Cocteau, *Oeuvres poétiques complètes* (Paris: Gallimard, 1999), 509.

63. A draft of stanza 13 was found on the last page of Cocteau's copy of Mallarmé's *Un Coup de dés n'abolira le hazard.*

64. Steegmuller 1970, 336.

65. Ibid., 346.

CHAPTER 20
Mercure

1. The Théâtre de la Cigale was nicknamed the Beaumont Palace (a play on "Gaumont Palace") for the duration of this season.

2. Letter from Beaumont to Satie, February 20, 1924, Volta 2000, 591–2.

3. Letter from Beaumont to Picasso, February 21, 1924, Archives Picasso.

4. Volta 1989, 160.

5. Gillmor, 245.

6. Whiting, 524.

7. Letter from Elizabeth Polunin to Picasso, May 20, 1924, Archives Picasso, about the signs of the zodiac they had in the studio, which were subsequently used in the ballet. (See Whiting, 535.)

8. Whiting, 523. When performed in London, *Mercure*'s Graces reminded Horace Horsnell, the (London) *Observer* critic, of "life on a submerged houseboat as lived by three Edwardian barmaids with hypertrophied period busts." Gillmor, 246.

9. Whiting, 527.

10. Cooper, 58.

11. The *Soirées de Paris* spectacles benefited two charities—war widows and Russian refugees—hence the presence of high-ranking officials.

12. Serge Lifar quoted in Buckle 1979, 434.

13. Ornella Volta, *Satie et la danse* (Paris: Editions Plume, 1992), 75.

14. Later productions had different choreography and different décor.

15. The *Mercure* drop curtain is in the Centre Georges Pompidou, Paris; documentary photographs are in the Fondation Erik Satie, Paris. Some of the pastel studies are in the Cramer collection, Geneva, in addition to studies and a sketchbook in the Musée Picasso, Paris.

16. Aragon quoted in *Picasso and Theater* (Frankfurt: Schirn Kunsthalle, 2006), 212.

17. "Hommage à Pablo Picasso" was published in *Paris-Journal,* June 21, 1924; *Le Journal Littéraire,* June 21, 1924; and *391,* no. 18 (July 1924).

18. Z.IV.380.

19. The 1922 panel of two bathers was first used as a *rideau de scène* for Nijinska's ballet *Les Biches,* before becoming identified with *Le Train bleu.* See Buckle 1979, 576 n. 147.

20. Dolin, 80.

21. Buckle 1979, 428.

22. One of these *Soirées de Paris* ballets, *Trois pages dansées,* was choreographed by Etienne de Beaumont, who had once trained as a dancer.

23. Letter from Stravinsky to C. F. Ramuz, June 26, 1924, Walsh, 392.

CHAPTER 21
Still Lifes at La Vigie

1. Donnelly, 29.

2. See, for example, Z.V.262–5.

3. The garage that Picasso used as a studio at La Vigie was demolished in 1956; it was later reconstructed after the road had been widened.

4. According to Tomkins, 39, the scrubbing of the "oil cartoon" off the garage walls cost Picasso 800 francs. Also see Bell's letter to Mary Hutchinson, October 26, 1924, Ransom Center.

5. Gilot 1964, 150.

6. Vaill, 148, suggests that the Beaumonts stayed in Juan-les-Pins during the summer of 1924.

7. Z.V.254-5.

8. Letter from Olga to Stein, October 23, 1924, and postcard from Picasso to Stein, July 29, 1924, Beinecke Library.

9. This drawing was presented to Alice and Gilbert Seldes on the occasion of their wedding, which the Picassos attended, in the Bois de Boulogne, in June 1924. Kammen, 107.

10. Gilot 1964, 149.

11. Cline, 245.

12. Vaill, 147.

13. Charles Scribner III, "Introduction," *Tender Is the Night* (New York: Scribner, 1982), 13.

14. Musée Picasso, Paris (MP 999). Evidently baffled, Palau 1999, 414, entitles this drawing *Arabesque.*

15. Cowling 2002, 460.

16. A rough sketch of a reclining nude with a vagina dentata of a mouth (PF.III.1478), done around the same time, confirms this reading of the beach towel drawing.

17. PF.III.1474.

18. See MP Carnets II, cat. 30 (MP 1869).

19. Z.V.224.

20. Z.V.228.

21. Letter from Sara Murphy to the Picassos, undated [September 1924], Archives Picasso.

22. Z.V.220.

23. Elizabeth Cowling, *Matisse Picasso* (London: Tate Gallery, 2002), 151–4.

24. Museum of Modern Art, New York.

25. Cowling 2002, 461.

26. Gilot 1964, 74.

27. The wormlike thread that unites the three oranges is more baffling. Might it refer to the thread that unites the three Norns representing past, present, and future in Wagner's *Götterdämmerung*?

28. F. Scott Fitzgerald, *Tender Is the Night* (London: Penguin, 1975; first published 1934), 199.

29. Apollinaire took Meyerhold on a visit to various artists' studios, including Boccioni's— and most likely Picasso's. According to Ilya Ehrenburg, "Apollinaire understood that in the theater the point was neither D'Annunzio nor Ida Rubenstein nor the décor of Bakst, but the moral concerns of a young theater director from Saint Petersburg." Ilya Ehrenburg, *Un Ecrivain dans la révolution* (Paris: Gallimard, 1963), 172. See also Peter Read, "Guillaume Apollinaire et Vsevolod Meyerhold," *La Revue des lettres modernes, Guillaume Apollinaire,* 15 (1980), 159–64.

30. Hilary Spurling, *Matisse the Master: A Life of Henri Matisse,* Vol. 2, 1909–1954 (London: Penguin, 2006), 244.

31. On eye-teasing devices such as these, see Adelbert Ames Jr. in Gombrich, 209–10.

32. Guillaume Apollinaire, "L'Esprit nouveau et les poètes" (November 1917), *Œuvres en prose complètes,* III (Paris: Gallimard, 1993), 906.

33. Z.VII.3.

34. Z.V.416.

35. Pierre Daix, "On a hidden portrait of Marie-Thérèse," *Art in America,* September 1983, 127.

36. PF.III.1512, 1514, and 1547. Palau has invented strange titles for the first two: *Face of Irritated Woman* and *Face of Perplexed Woman.* He thinks the last one was done later in Paris.

37. Z.V.285.

38. PF.III.1503 and PF.III.1507. A vaginalike sun makes its first appearance in a similar view painted on Picasso's 1920 visit to Juan-les-Pins (see PF.III.777).

39. MP Carnets II, cat. 30 (MP 1869).

40. Braque in conversation with the author.

41. It is surely no coincidence that certain experimental musical scores resemble Picasso's "constellations."

42. In confirmation of this, Gombrich, cites the ethnologist Koch-Grunberg's study of the different ways different Indian tribes interpret the same constellation (the lion constellation, for instance, as a crawfish or lobster). Gombrich, 91.

CHAPTER 22
La Danse

1. Letter from Bell to Mary Hutchinson, October 26, 1924, Ransom Center.

2. Ibid.

3. Vladimir Mayakovski had first met Picasso

in 1922, when he visited the artist's studio. See McCully, 154.

4. Letter from Bell to Mary Hutchinson, November 9, 1924, Ransom Center.

5. Picasso was mentioned in *Paris-Journal* (December 5, 1924) as being among the reportedly three thousand people who had turned up for the "opening night" of *Relâche* on November 27. In fact the opening was postponed until December 4.

6. Gillmor, 256.

7. Ibid., 258.

8. Volta 1989, 205.

9. Ibid.

10. Gasman, 762.

11. Shattuck, 183.

12. Z.V.426.

13. Letter from Eduardo Marquina to his wife (Pichot's sister), December 26, 1924 (Pixot family archives, Cadaqués): "Picasso will return next Monday or Tuesday if the slight improvement continues."

14. See Vol. I, 211.

15. See Chapter 18.

16. According to Penrose, 250, who persuaded Picasso to sell the painting to the Tate Gallery.

17. Ibid.

18. Cowling 2006, 276. Picasso always referred to the painting as *La Danse,* Penrose as *Les Trois Danseuses.* Given Penrose's role in its acquisition, the Tate continues to call it *The Three Dancers;* elsewhere it is known as *La Danse.*

19. Z.V.367. Cecchetti wrote Olga the following year (March 15, 1926), thanking her for photographs of the drawing: "*c'est un très agréable souvenir de notre cher Picasso très joli, très ressemblant et je l'aime beaucoup.*" Archives Picasso.

20. Kochno, cited by Gasman, 799–800.

21. P.F.III.1541.

22. Buckle 1979, 451.

23. For drawings of Lifar, see "Dessins de Pablo Picasso: Serge Lifar et la danse," Double carnet critique no. 280–1, *La Revue Musicale* (1971).

24. Cooper, 62.

25. In 1960, Picasso finally did a portrait of Lifar. see Cooper, 420.

26. Z.V.415.

27. The opening had been postponed. See pages 178 and 309.

28. Sokolova 1960, 192.

29. Bois, 33.

30. Buckle 1979, 211.

31. Paul Morand, *Lettres de Paris* (July 1924) (Paris: Salvy, 1996), 77.

32. Buckle 1979, 450.

33. Dukelsky's score was criticized by Prokofiev as too amateurish, "Too much Glazunov," Buckle 1979, 452.

34. Danchev, 161.

35. Letter from Poulenc to Picasso [July 19, 1925], Poulenc, 258.

36. Danchev, 162.

37. According to Poulenc, quoted in Danchev, 161.

38. Dolin, 106.

39. Letter from Paul Rosenberg to Picasso, April 30, 1925, Archives Picasso.

40. See Ferran.

41. Duke, 146.

42. Cowling 2002, 465.

43. Kochno, quoted in Gasman, 637.

44. Stein 1933, 107.

45. Letter from Breton to Picasso, June 9, 1925, Archives Picasso.

CHAPTER 23
The Villa Belle Rose

1. Cowling 2006, 146.

2. See the July 15, 1925, issue of *La Révolution Surréaliste.*

3. See cat. 249 in *André Breton: La Beauté convulsive* (Paris: Centre Georges Pompidou, 1991).

4. A[gnès Angliviel de] L[a] B[aumelle], "André Masson," in Monod-Fontaine, 134.

5. See Vol. II, 35.

6. Zette Leiris kept the gallery functioning throughout the Occupation, while the Kahnweilers hid in a farm in the Southern Zone.

7. Leiris 1946, 127.

8. Ibid., 128.

9. Armel, 571–2.

10. Donnelly, 19. The gardens had been planted by the former owner, a colonial official

who had brought back exotic trees and plants from his travels.

11. Tomkins, 117.

12. John Dos Passos, *The Best Times: An Informal Memoir* (New York: New American Library, 1966), 150.

13. See Vaill, 162, "After one such exhibition Honoria sent Picasso a note in . . . phonetic French : 'Chere mecie picaso,' she wrote, 'vous vous le que je vous decine une animal' with a drawing of a hippopotamus-like horse and rider which. . . . Picasso reportedly admired."

14. Ibid., 184.

15. Palau 1999, 448.

16. Stainton, 93–5.

17. Juan Antonio Gaya Nuño, *La pintura española del siglo XX* (Madrid: Ibérico Europea, 1972), 55–6.

18. Cabanne 1977, 269, based on Peinado's account in Brassaï, 175.

19. Francis Picabia, "Le Cubisme est une cathédrale de merde," *La Pomme de Pins* (Saint-Raphaël), February 25, 1922.

20. Ibid.

21. Francis Picabia, "Le Salon des Indépendants," *La Vie Moderne,* February 11, 1923.

22. Buffet-Picabia, 53.

23. Picabia never married Lorenzo's mother. See Everling for an account of the years they spent together.

24. Ibid., 165–6.

25. Z.V.460.

26. Cowling 2002, 476–80. Cowling invokes Freud and interprets *The Kiss* as an oedipal image: "The mother is rousing her child's sexual instinct and preparing for its later intensity. Her maternal caresses . . . are sexual in character and transform the child into a lover." Picasso had no time for Freud or Freudian interpretations of his work. The cramming together of these two kissing figures into a single erotic entity will become more and more of an obsession.

27. Cowling 2006, 246.

28. Musée de la Ville de Paris.

29. Letter from Picabia to Pierre de Massot (reprinted in *Francis Picabia: Singulier idéal* [Paris: Musée d'art moderne de la Ville de Paris, 2003], 298). Ripolin is the shiny house paint that

Picasso was the first to use as an alternative to, or in conjunction with, traditional oil paint. It allowed the artist to apply local color to a specific object instead of representing it tonally. Picabia had copied Picasso and used Ripolin in some of his recent compositions. See also Vol. II, 225.

30. Picabia's letter to Massot (see above) was written around the time of the Mi-Carême—that is to say in March 1925. Picabia thus embarked on the series in Cannes shortly before Picasso's Easter trip to Monte Carlo, during which they may have met.

31. Buffet-Picabia, 52.

32. Picasso did not allow Zervos to publish it until 1952 (as *Femme assise*), by which time Picabia was dying.

33. MP Carnets II, cat. 31 (MP 1870).

34. Z.V.445.

35. Picasso told Rubin (Rubin 1972, 221) that "the toy theater in this picture is an absolute accurate representation of the one he had made for Paulo, except for the omission of a human figure originally placed at stage right." When Cooper questioned Picasso about the similarity between the toy theater and the various designs for the ballet *Pulcinella,* the artist allowed that Paulo's toy theater might have started life as a maquette. That the artist should have gone to the trouble of reconstructing a scale model with a new set of steps for a set he had done four years earlier is hard to believe. That he played around conceptually with an existing model for the purposes of this painting as opposed to his son's amusement is more likely.

36. According to Paloma Picasso in conversation with the author.

37. Rubin 1972, 120.

38. Gasman, 836.

39. Ibid.

40. Z.V.443. Meyer Schapiro coined the term "still lifes of cruelty." Rubin 1972, 121.

41. Gasman, 761 n 1.

42. Gasman, who devotes seventy-five pages of her thesis to the severed ram's head, sees it in the context of classical myth, Christian and pagan religions, as well as Masonic symbolism (Ram-Hiram was the Masons' name for their "Divine

Architect of the Universe"). She also suggests that the ram's head stands for Picasso and also for Satie, whose death a few weeks earlier had been a terrible blow.

43. Z.II.134.

44. Cabanne 1977, 244,

45. The late Gustav Zumsteg collection, Zurich.

46. Rowell, 92.

47. Ibid., 102.

48. Z.V.461.

49. Also see Chapter 24, with reference to the death of Gris.

50. JSLC 88.

51. See Chapter 26.

52. Z.V.188; this painting is usually dated 1924, but it was more likely done at the same time (summer 1925) as Z.V.262.

53. Z.V.262.

54. Z.V.459.

CHAPTER 24
Masterpiece Studio

1. Letter from Paul Rosenberg to Picasso, September 16, 1925, Archives Picasso.

2. Ibid.

3. Ibid.

4. Leiris 1946, 116.

5. Pellequer's correspondence is not available to scholars, so very little is known about Picasso's finances.

6. Brassaï, 5.

7. Ibid., 7.

8. Letter from Olga's mother, February 1925, private archive.

9. Although he had long since ceased to reside there, Picasso would be outraged in 1951, when the government took over a great many apartments in Paris, including his own, because they were no longer lived in.

10. Gilot 1964, 150–1.

11. Letter from Bell to Mary Hutchinson, October 21, 1925, Ransom Center.

12. See Raczymov, 147.

13. Bell sent Picasso a postcard (October 18, 1925, Archives Picasso) inviting him to dine at the Boeuf on Friday, October 23: "*vous trouverez un homme charmant—qui ressemble un peu à Lord Byron—qui veut bien faire votre connaissance.*"

14. Letter from Bell to Mary Hutchinson, October 29, 1925, Ransom Center.

15. Letter from Bell to Mary Hutchinson, October 25, 1925, Ransom Center.

16. George Vandon (pseudonym for George [known as Peter] Harcourt Johnstone III, later Baron Derwent); see *Return Ticket: Reminiscences* (London: William Heinemann, 1940), 110–11, where the author describes the dinner. Bell, 183, wrote a huffy rebuttal.

17. Virginia Woolf described Juana as "very stupid, but so incredibly beautiful that one forgives all" (*The Letters of Virginia Woolf,* vol. 2, 1912–22, ed. Nigel Nicolson and Joanne Trautmann, 467); and Lytton Strachey as having "the finest underclothes in Europe" (*The Letters of Lytton Strachey,* ed. Paul Levy [London: Viking, 2005], 479).

18. Krauss 1986, 116.

19. The exhibition included Man Ray, Picasso, Arp, Klee, Masson, Ernst, Miró, Pierre Roy, and Chirico; see Loeb, 115–16.

20. An exception is Maurice Raynal's mean-spirited review, quoted in Loeb, 116.

21. André Breton, *Surrealism and Painting,* trans. Simon Watson Taylor (New York: Icon Editions, 1972), 70.

22. Z.III.354 and Z.III.98.

23. Z.V.357.

24. Gilot 1964, 89.

25. Originally scheduled for fall 1925, the show was postponed until June 1926 as the renovations to Rosenberg's premises were not ready.

26. PF.III.1557, PF.III.1559, and PF.III.1583.

27. See, for example, Musée Picasso, Paris (MP 1990-12).

28. MP Carnets II, cat. 32 (MP 1871).

29. Baer 242.

30. See, for example, Z.VII.16, PF.III.1623–1624, and PF.III.1672. Baer thinks the bicycle is more likely to be a kiddy-car. Schwarz, 126, mistakes the rocking horse for Marie-Thérèse: "a high spirited white pony with a fringed mane and quizzical facial expression."

31. Zervos first published the painting in 1952 as *Les Modistes* (Z.VII.2); Maurice Jardot gave the work its present title, *L'Atelier de la modiste,* at the time of the retrospective exhibition in 1955 and added a note in the catalog concerning the subject matter: *"Cet atelier se trouvait effectivement de l'autre côté de la rue, en face des fenêtres de l'appartement que Picasso occupait rue de la Boétie."* It was in fact a dressmaker's rather than a milliner's atelier. See Vallentin, 168. "Picasso could gaze directly into a workshop across the way and see customers and *modistes* moving to and fro behind the windows."

32. Schwarz, 101, is the source of the misidentification.

33. Krauss, 118.

34. Vol. I, 110.

35. Cabanne 1992, 657.

36. To emphasize this painting's association with death, Gasman, 739, relates the figure at the right in the *Milliner's Workshop* to the Pichot figure in *La Danse.*

37. Musée Picasso, Paris (MP 1990-11).

38. Z.VII.30.

39. See Vol. II, 416.

40. Marie-Laure Bernadac, in "Picasso 1954–1972: Painting as Model," *Late Picasso: Paintings, Sculpture, Drawings, Prints 1953–1972* (London: Tate Gallery, 1988), 74, also associates the enormous foot emerging from the tangle of lines with the Balzac story.

41. Z.VII.9.

42. Anne Baldassari, *Picasso: Papiers journaux* (Paris: Musée Picasso, 2003), 141; and *Picasso: Working on Paper* (Dublin: Irish Museum of Modern Art, 2002), 121.

43. Penrose, 66–7.

44. The nail in the wall in the *Guitar* serves as a fulcrum for the cord; the two horizontal bars on the right have been lengthened to compensate for the off-center placement of the sound hole.

45. Z.VII.10.

46. Boggs, 223, who sees the piece vertically, cites a vertical croquis (Z.VII.14) executed later as "evidence" of how the *Guitar* should be hung. The author sees this croquis as a red herring intended to cause further confusion.

47. Cowling 2006, 360 n. 123.

48. Ibid.

49. Louis Aragon, "La Peinture au défi" (1930), Aragon, 27.

50. Carlton Lake, "Picasso Speaking," *Atlantic Monthly,* July 1957, 39.

51. Z.VII.19; Musée Picasso, Paris (MP 86, 88–95).

52. See Chapter 25.

53. Letter from Cocteau to Jacob, November 20, 1926, Kimball, 453.

54. Cowling 2006, 277.

55. Many of the paintings in Rosenberg's 1924 exhibition (March 28–April 17) had been shown the previous winter in New York and Chicago.

56. Zervos had met Picasso as early as 1924 and first championed his work in the journal *L'Art d'aujourd'hui.* See Rubin 1996, 98 n. 2.

57. Gasman to the author.

58. See Chapter 39.

59. For standard canvas formats, see Vol. II, 457 n 7.

60. FitzGerald 1995, 158.

61. *La Révolution surréaliste,* no. 7 (June 15, 1926).

62. Ibid., 21.

63. FitzGerald 1995, 160.

64. See Volume II, 387.

65. Letter from Matisse to his daughter, June 13, 1926, quoted in Bois, 33.

66. Igor Stravinsky and Robert Craft, *Memories and Commentaries* (London: Faber and Faber, 1960), 122.

67. Bois, 36.

68. Stein 1938, 42–3.

69. Ibid., 38.

70. Ibid., 5.

CHAPTER 25
Summer at La Haie Blanche

1. Sachs, 152.

2. See Kenneth Wayne, *Impressions of the Riviera* (Portland, Ore.: Museum of Art, 1998), 62.

3. Z.VII.34.

4. MP Carnets II, cat. 33 (MP 1872).

5. Picasso in conversation with the author.

6. See Ferran.

7. See, for example, Z.VII.11, Z.VII.23, and Z.VII.31, among many others.

8. PF.III.1715–16.

9. PF.III.1707, dated November 20, 1926; Zervos mistakenly dated this work 1934 (Z.VIII.242).

10. PF.III.1671–2.

11. Unknown until included in the 1985 Montreal show as *Interior with Easel* (PF.III.1705). Rubin misreads a drawing for it (Z.VII.32) in Rubin 1996, 68, for a dressmaker's dummy—although such things lack legs—and relates it to Chirico's metaphysical work.

12. The simile appears in the sixth canto of *Les Chants de Maldoror.*

13. This mosaic floor prompted Rosenberg to request a similar mosaic for the entrance to his refurbished gallery in 1928. Picasso did nothing about it. See letter from Rosenberg to Picasso, August 5, 1928, Archives Picasso.

14. Hugo 1983, 253. The Liotard is in the Musée d'art et histoire, Geneva.

15. Ibid.

16. The Noailles signed up Mallet-Stevens after failing to interest Le Corbusier and Mies van der Rohe in the project.

17. Gilot 1964, 61.

18. Undated letter [August 1926] from Sara Murphy to Picasso, Archives Picasso.

19. Cline, 183.

20. Interview with Archibald MacLeish, *Paris Review* 14, no. 57 (spring 1974), 69.

21. Letter from F. Scott Fitzgerald to the Murphys, January 30, 1937, *The Letters of F. Scott Fitzgerald,* ed. Andrew Turnbull (New York: Scribner, 1963), 447.

22. In a letter to Picasso (July 24, 1926, Archives Picasso) Rosenberg warned of an absurd rumor that said he was going to Russia to paint the Soviet leaders. Any attempt to associate him with communism terrified Picasso.

23. In 1926 *La Publicitat* was owned by Acció Catalana; the editor was Martí Esteve i Gual.

24. See Ferran.

25. Picasso's comments appeared in *L'Intransigeant,* October 19, 1926, reproduced in Kimball, 452 n. 2.

26. Telegram from Cocteau to Picasso, October 24, 1926, Archives Picasso.

27. *L'Intransigeant,* October 27, 1926, reproduced in Kimball, 452 n.2.

28. Letter from Cocteau to Picasso, October 29, 1926, Archives Picasso.

29. Stein 1933, 222.

30. Letter from Jacob to Cocteau, November 14, 1926, Kimball, 50.

31. Letter from Cocteau to Jacob, November 20, 1926, Kimball, 453.

32. The publication of Cocteau's *Lettre à Maritain* and Maritain's reply had caused a stir earlier in the year.

33. Arnaud, 375.

34. Ibid.

35. Letter from Bell to Mary Hutchinson, October 26, 1926, Ransom Center.

36. Ibid.

37. Severini, 284.

38. Cocteau called his collages *têtes aux punaises* (*punaises* can mean thumbtacks or fleas).

39. Severini, 284.

40. Ibid.

41. History would repeat itself in 1950. James Lord recalls an incident chez Picasso after the inauguration of the *Man with the Lamb* at Vallauris. The artist had pointedly wounded Cocteau by presenting him with a phallic knob of a ceramic pot, decorated with a face, after presenting an unknown photographer in quest of a souvenir with a fine drawing. This slight had launched Cocteau into a litany of Picasso's misdeeds, including the broken limb story. James Lord, *Some Remarkable Men* (New York: Farrar, Straus and Giroux, 1996), 110.

42. Severini, 385.

43. Daix 1977, 208 and 214 n. 6.

44. André Masson, "Correspondance," *La Révolution Surréaliste,* no. 5 (October 15, 1925), 30.

CHAPTER 26
Marie-Thérèse Walter

1. Marie-Thérèse Léontine Deslierres is the name given on her birth certificate. According to

Widmaier Picasso 2004, 28, the name Deslierres was taken from the Villa Deslierres at Perreux, where Marie-Thérèse was born out of wedlock in 1909. Legally recognized two years later, she took her mother's surname, Walter.

2. In a previous interview with a *Life* magazine reporter, Marie-Thérèse had been much more guarded. See Barry Farrell, "His Women: The wonder is that he found time to paint," *Life* 65, no. 26 (December 27, 1968), 74.

3. See Gasman, 39, 58, etc.

4. Collars used by girls in the 1920s and 1930s to enliven a plain dress.

5. Gasman, 954.

6. Cabanne 1974, 954.

7. Ibid.

8. Schwarz, 133.

9. Jeanne, unlike Marie-Thérèse, took the name of her father.

10. Schwarz, 119.

11. See, for example, the essays by Rubin, Rosenblum, and FitzGerald in *Picasso and Portraiture* (New York: Museum of Modern Art, 1996).

12. Schwarz, 113.

13. Ibid., 120.

14. Baer 1997, 34.

15. Widmaier Picasso 2004, 27. Rightly or wrongly, Jeanne believed her father to have been Léon's brother, Eugène Volroff. Jeanne's boast to Schwarz that the Volroffs were a distinguished Franco-Swedish family, whose ancestry went back to the reign of Louis XIII, was somewhat exaggerated.

16. Victor Schwarz's sister subsequently became Burkard Walter's fourth wife.

17. Schwarz, 120.

18. Widmaier Picasso 2004, 33.

19. Pointed out by Gasman; see "Silence ivre mort" in Bernadac and Piot, 393.

20. Cabanne 1974, 7.

21. Not least by the author of these pages in "Picasso and *L'Amour fou*," *New York Review of Books* 32, no. 20 (December 19, 1985), 59–69.

22. Her family name is unknown, hence rumors, now disproved, that she never existed. Polizzotti, 265, 283–5.

23. Ibid., 264.

24. Ibid., 269.

25. Ibid., 285.

26. Daix 1993, 418 n. 2, maintains that Breton's *Nadja* had no influence on Picasso.

27. See Vol. I, 49–50.

28. Marie-Thérèse also told Cabanne 1974, 7, "*J'étais gentille.*"

29. Widmaier Picasso 2004, 28, reports that Marie-Thérèse's taste for sports was the result of attending a German boarding school.

30. Gasman, 64.

31. Museu Picasso, Barcelona (MPB 50.493).

32. Gasman, 64.

33. Alice Paalen, who was Picasso's mistress for a time in the 1930s, reported that "one of [the artist's] joys was to deny women their climaxes"; Cabanne 1977, 254.

34. Gasman, 1444.

35. Another mistress, Geneviève Laporte, told Schwarz, 57, that "when introducing his partners to sex," he gave them books by the Marquis de Sade.

36. Gasman, 1442.

37. Laporte, 76.

38. MP Carnets II, cat. 34 (MP 1873), is dated on the cover "December 1926–May 8, 1927."

39. Baer 124.

40. MP Carnets II, cat. 34 (MP 1873).

41. Z.VII.59.

42. Z.VII.78–9.

43. Rowell, 102.

44. Z.VII.40.

45. MoMA deaccessioned another more schematic, less poignant *Seated Woman*—same date, same size, same pose—to the Toronto Art Gallery. Dated on the back 1926–27, this painting (Z.VII.77) started as a portrayal of the unidentifiable blond model and ended up as a transitional Marie-Thérèse.

46. MacGregor-Hastie, 118.

47. Gilot 1964, 235.

48. See Gasman, 729–48, for the significance of doorknobs for Picasso.

49. Reproduced in Markus Müller, *Pablo Picasso and Marie-Thérése Walter* (Bielefeld, Germany: Kerber Verlag, 2004), 71.

50. The Picassos' favorite weekend destination was the Ferme Saint-Siméon outside Honfleur.

CHAPTER 27
Summer at Metamorphosis

1. Letter from Gris to Kahnweiler, February 6, 1926, Kahnweiler-Gris 1956, 180.

2. Letter from Gris to W. Walter, February 1927, ibid., 211.

3. *Selected Writings of Gertrude Stein,* ed. Carl Van Vechten (New York: Random House, 1946), 17.

4. Stein 1933, 211–12.

5. Letter from Gris to Picasso, August 18, 1918, Archives Picasso.

6. Vol. II, 207–19.

7. Art Institute of Chicago.

8. Severini, 101.

9. Assouline, 99.

10. See Vol. II, 282.

11. See Chapter 3.

12. Letter from Bell to Mary Hutchinson, April 30, 1927, Ransom Center. In January, Picasso had told Jean Crotti (Duchamp's brother-in-law) that he had been looking for a new car for Olga. "Did you buy the Panhard at Neuilly," Crotti wrote, "or has the Hispano or Citroën won out?" Letter from Crotti to Picasso, January 10, 1927, Archives Picasso.

13. *Bacon Picasso: La Vie des images* (Paris: Musée Picasso, 2005).

14. Lucian Freud to the author.

15. See Gerald Murphy's letter to Picasso, September 19, 1927, Archives Picasso, regretting they had not seen him in Cannes.

16. Letter from Paul Rosenberg to Picasso, August 5, 1927, Archives Picasso.

17. The Chalet Madrid is located on the boulevard Alexandre III.

18. Letter from Picasso to Stein, September 17, 1927, Beinecke Library.

19. Letter from Beaumont to Picasso, September 2, 1927, Archives Picasso.

20. Ibid.

21. Confirmation of this visit to Paris is a letter dated September 6 from Rosenberg to Picasso in Cannes. It had been forwarded to Paris and then sent back to the Chalet Madrid. (Archives Picasso.)

22. Musée Picasso, Paris (MP 1874 and MP 1990-1907). See Robert Rosenblum, "Picasso and the anatomy of eroticism," *Studies in Erotic Art* (New York: Basic Books, 1970), 144.

23. Vol. I, 280.

24. Postcard from Picasso to Apollinaire [June 1914], Caizergues and Seckel, 112–13.

25. Christian Zervos, "Projets de Picasso pour un monument," *Cahiers d'Art,* 1930, 342.

26. See Read 1995, 148, for a complete list of subscribers.

27. Letter from Picasso to Kahnweiler, April 11, 1913, Monod-Fontaine, 170.

28. Malraux, 122.

29. Vol. II, 64.

30. Geneviève Laporte, *Un Amour secret de Picasso: Si tard le soir* (Monaco: Editions du Rocher, 1989), 66.

31. Louis Aragon, *Paris Peasant,* trans. Simon Watson Taylor (Boston : Exact Change, 1994), 117.

32. In his study of the Apollinaire monument, FitzGerald 1988, 184, quotes the same passage from *Paris Peasant* to make a different point.

33. Mitchell, 101 n. 2.

34. Ibid., 6.

35. Gasman, 189. See Gasman for her pioneer study of the cabana's significance in Picasso's work, as well as writings of Breton, Vitrac, and the other surrealist writers.

36. Vol. I, 42.

37. Letter from Paul Rosenberg to Picasso, August 5, 1927, Archives Picasso.

38. Letter from Paul Rosenberg to Picasso, September 6, 1927, Archives Picasso.

39. Musée Picasso, Paris (MP 101–2); Marina Picasso collection (12471); and *Figure,* reproduced in *El Picasso de los Picasso* (Museo Picasso Málaga, 2004), cat. II.

40. See Carmen Giménez, *Age of Iron* (New York: Guggenheim Museum, 1993), nos. 14–15.

41. Musée Picasso, Paris (MP 99), and Z.VII.67.

42. Letter from Picasso to Stein, September 17, 1927, Beinecke Library.

CHAPTER 28
The Apollinaire Monument

1. Klein, 13.

2. Sometimes entitled *Metamorphosis,* Picasso's maquette is now generally known as *Bather.*

3. See Chapter 32 for a further discussion of the influence of anatomical drawings on Picasso's work.

4. Read 1994, 200.

5. *L'Intransigeant,* November 10, 1927.

6. FitzGerald 1988, 357.

7. André Salmon, *A. Derain* (Paris: Nouvelle Revue Française, 1923).

8. See Vol. II, 199–205.

9. André Billy, *Avec Apollinaire : Souvenirs inédit* (Paris: La Palatine, 1966), 142.

10. Paul Léautaud, December 14, 1927, *Journal littéraire* 4 (Paris: Mercure de France, 1956–63), 164.

11. In 1951, long after losing his battle with the surrealists, Billy continued to maintain "that Dadaism and Surrealism derived from Apollinaire's influence is true only to a certain point; between [Apollinaire] and the generation that followed an abyss opened up" (*Le Figaro,* November 9, 1951), an abyss of Billy's making. In a desperate attempt to find a dignified niche for the poet, Billy's preface to the Pléiades edition of Apollinaire's *Œuvres poétiques* (1965) categorizes his writing as neither classical nor romantic nor symbolist; it is "baroque." Billy applies this term to more or less anything—bizarre, primitive, newfangled, tragicomic, seductive, prophetic, operatic, barbarous, etc. Billy's "baroquism" might also be said to apply to Picasso's clay maquette for Apollinaire's grave, which Billy's committee had so disdainfully rejected.

12. Read 1995, 169–77. See also FitzGerald's equally well-researched doctoral thesis (FitzGerald 1988).

13. D.-H. Kahnweiler, "Conversations avec Picasso," February 5, 1933, in Bernadac and Michael, 91. After using the term *sur-réalisme* in the *Parade* program, Apollinaire used it (without the hyphen) in his preface to *Les Mamelles de Tirésias.*

14. André Warnod, " 'En peinture tout n'est que signe,' nous dit Picasso," *Arts* (Paris, June 29, 1945), in Bernadac and Michaël, 53.

15. See Robert Picault, quoted by Cowling in "Objects into Sculpture," *Picasso Sculptor/ Painter* (London: Tate Gallery, 1994), 236.

16. Leiris 1930, 64.

17. Leiris 1992, journal entry for May 21, 1929, 176.

18. D.-H. Kahnweiler, "Conversations avec Picasso," February 5, 1933, in Bernadac and Michael, 90–1.

19. Otero, 172–3.

20. E. Tériade, "Emancipation de la peinture," *Minotaure,* nos. 3–4 (December 1933), 13.

21. *Picasso Peintures 1900–1955* (Paris: Musée des arts décoratifs, 1955); [n.p.] following no. 40.

22. Otero, 88.

23. Gasman, 1326.

24. Ibid., 1325.

25. *Picasso. Anthology: 1895–1971* (Málaga: Museo Picasso Málaga, 2004), cat. 64.

26. MP Carnets II, cat. 35 (MP 1874).

27. Cowling 2006, 131.

28. According to Roberta González; see Marilyn McCully, "Julio González and Pablo Picasso: A Documentary Chronology of a Working Relationship," *Picasso: Sculptor/Painter* (London: Tate Gallery, 1994), 215.

29. Letter from González to Picasso, January 2, 1928, Archives Picasso.

30. Letter from González to Picasso, May 13, 1928, Archives Picasso.

31. S.66, 66A, 66B.

32. Z.VII.143.

CHAPTER 29
The Beach at Dinard

1. Z.VII.135.

2. Letter from Marie Cuttoli to Picasso, January 29, 1928, Archives Picasso: *"Vous avez promis de faire quelques maquettes de tapis [. . .] peut-être parmi des gouaches et vos dessins serait-il possible d'en utiliser à cet effet."*

3. The Cuttoli-Laugier donation (1969) of

Picassos to the Musée National d'Art Moderne, Paris, included among many other works ten papiers collés.

4. His police dossier confirms that, despite having anarchist friends, Picasso was not one. See Daix and Armand Israël, *Pablo Picasso: Dossiers de la Préfecture de Police 1901–1940* (Paris: Editions des Catalogues Raisonnés, 2003).

5. Z.VIII.268. Another tapestry, *Femme aux pigeons* (*La Fermière*), was woven in the 1950s (not in 1935–36, as Léal 1998, 76 n. 2, claims) after a magnificent pastel of a Marie-Thérèse–like figure in a dovecote, which was a centerpiece of Madame Cuttoli's collections. This work may or may not have been a maquette for a tapestry.

6. Letter from Henri Matisse to Brother Rayssiguier, September 28, 1949, in Schneider 1984, 657 n. 144. Matisse's tapestry was woven at the Gobelin factory.

7. Catherine Prudhom, the paper specialist at Beaubourg, confirms that brown wrapping paper, white paper, and blue wallpaper were used; communication from Léal.

8. Musée Picasso, Paris (MP 105).

9. *Carnet Paris,* June 18–July 8, 1928; Marina Picasso Collection, 09273-09325.

10. Z.IX.103.

11. Brassaï, 45.

12. *Femmes à leur toilette* would finally be woven in 1967, thanks to Malraux's enthusiasm for the project. See Léal 1998, 75 n. 4; and Marilyn McCully, "Women at Their Toilette," *Picasso in Istanbul* (Istanbul: Sabanci Museum, 2005), 216–18.

13. Werner Spies, "Pablo Picasso: Les Chemins qui mènent à la sculpture," *Picasso à Dinard* (Dinard: Palais des Arts, 1999), 55.

14. Brassaï, 194.

15. Marie-Thérèse Walter to Gasman.

16. Cowling 2006, 140.

17. See *Picasso à Dinard* (Dinard: Palais des Arts, 1999), 19.

18. The Nemchinova-Dolin Ballet company toured Holland, Germany, France, and Spain (1927–29). It was disbanded early in 1929, when Dolin rejoined the Ballets Russes.

19. Picasso quoted in Cowling 2006, 198.

20. Daix 1995, 915.

21. See, for example, Z.VII.213–14, Z.VII.233, and Z.VII.235.

22. Z.VII.223.

23. Cowling 2006, 172.

24. See, for example, Z.VII.222.

25. See, for example, Z.VII.226.

26. The Solomon R. Guggenheim Museum, New York.

27. Z.VII.221.

28. JSLC 96.

29. Z.VII.217.

30. Letter from Errazuriz to Olga Picasso, August 20, 1928, Archives Picasso.

31. Letter from Madeline Helft to Picasso, August 16, 1928, Archives Picasso.

32. Letter from Julio González to Picasso, September 14, 1928, Archives Picasso.

33. Letter from Picasso to Stein, September 17, 1928, Beinecke Library.

34. Letter from Beaumont to Picasso, December 20, 1928, Archives Picasso.

35. See Serge Lifar, *Ma Vie* (London: Hutchinson, 1970), 59.

CHAPTER 30
The Sculptor

1. See Noël.

2. See a photograph of Picasso standing alongside the largest of these constructions, which was probably the one Picasso submitted to the Apollinaire committee. Reproduced in FitzGerald 1995, 183.

3. Noël. Read 1994, 210, n. 5, believes the drawing is Z.VII.424, dated November 11, 1928.

4. S.68–71.

5. Tériade, 160.

6. See, for example, S.83.

7. Tériade, 162.

8. Ibid.

9. FitzGerald 1988, 215.

10. Ibid., 216.

11. S.80; see drawings for a similar head in MP Carnets II, cat. 38 (MP 1875), begun February 25, 1929.

12. Rubin 1984, 321, convincingly relates *Head of a Man* to a Junkan mask, but states that

Picasso "could not have seen even a photograph of such a Junkan mask before making this sculpture," but surely, as a curator of the Musée de l'Homme, Leiris might well have been familiar with just such a photograph and brought it to Picasso's attention. Rubin interprets the projecting mandala in the *Head of a Man* as a mouth.

13. Catherine Clément, *The Lives and Legends of Jacques Lacan,* trans. Arthur Goldhammer (New York: Columbia University Press, 1983), 202.

14. Kahnweiler 1949, [7].

15. Z.VII.138.

16. Z.VII.252.

17. Guy de Maupassant, *Contes et nouvelles* (1883), quoted in *Hommage à Claude Monet* (Paris: Grand Palais, 1980), 237.

18. Bernadac and Michaël, 33.

19. Nelson remembered sharing the sights of Varengeville "with lots of artist friends, including Braque . . . and most of the celebrated painters of the day with the exception of Picasso. The mention of famous names was supposed to demonstrate . . . the pricelessness of this place and how precious it is in the eyes of creators." His own studio, Nelson said, had been "rented by Claude Monet, Corot and Isabey before he bought it." Quoted in Danchev, 184.

20. Cowling 2006, 144.

21. In his catalog entry Zervos confirms that the right foot depicts the road to Avallon; the left one to Clamecy. The two arms follow the roads to the famous Basilica, and the stomach is the town's Place de la Foire.

22. Z.XVIII.323.

23. See Rubin 1984, 340 n. 196. According to Cabanne 1977, 264, Picasso responded by dragging her around by the hair.

24. Olga quoted in Cowling 2006, 131.

25. Z.VII.248.

26. The article commemorated the fiftieth anniversary of the discovery of hysteria: *La Révolution Surréaliste,* no. 11 (1928); see Cowling 2002, 465.

27. Z.VII.245.

28. Musée Picasso, Paris (MP 117).

29. Z.VII.263 and Z.VII.262. Picasso's dates record the day on which he finished a painting. It does not necessarily follow that the *Large Nude* was started *before* the *Large Bather.* He worked on both of them at around the same time.

30. See Chapter 22.

31. Bois, 18.

32. Bernadac and Michaël, 120.

33. Malraux, 138.

34. Gilot 1990, 150.

35. The designer was Toby Jellinek, the boyfriend of Sylvette David, Picasso's model in 1953–54.

36. An earlier (May 5) version (Z.VII.256) has the telltale ribs of Olga, but little of the pathos of the final version.

37. Gilot 1964, 208.

38. Ibid., 231.

39. Cowling 2006, 108.

40. Z.VII.260.

41. The rue de Liège apartment had been conveniently close to the Gare Saint-Lazare, where Marie-Thérèse caught the train back home.

42. A very literal painting (Z.VII.266) dated May 2, 1929, of the view from Picasso and Marie-Thérèse's new hideaway, clearly shows the steeples of Sainte-Clotilde on the right and a handsome building with a garden in the foreground. This building appears to have been incorporated into the war ministry on the rue de l'Université.

43. The only writer to hint at the existence of this Left Bank hideaway is the unreliable Mac-Gregor-Hastie, 124. He refers to an apartment "near the Seine [and] the Gare d'Orsay." The information tallies with the author and McCully's supposition. Confidential arrangements such as this were usually taken care of by Pellequer, hence no record in the archives. Nor is there any mention of the apartment in the accounts of Marie-Thérèse's living arrangements by her Widmaier grandchildren.

44. Z.VII.259.

45. Gilot 1964, 152.

46. Z.VII.270.

47. Away from his principal studio, Picasso was apt to indicate where a work had been executed. The sudden addition of "Paris" to drawings of 1929–30 implies that they were not done in the rue la Boétie studio, but elsewhere in Paris.

48. Z.VII.279–83.

49. Z.VII.267 and Z.VII.278.

50. Daix 1993, 236.

51. The publicity seeking Japanese painter Foujita was also in Dinard. Letter from Paul Rosenberg to Picasso, August 9, 1929, Archives Picasso.

52. Letter from Paul Rosenberg to Picasso, September 10, 1929, Archives Picasso.

53. Daix 1995, 910.

54. Buñuel, 104.

55. Besides major works by Picasso, Braque, Gris, Mondrian, Klee, Balthus, and Dalí, the Noailles' collection included masterpieces by Rembrandt, Rubens, Goya, Delacroix, Géricault, Constable, and much more, including the famous manuscript of Marie-Laure's ancestor, the Marquis de Sade's *Les Cent Vingt Journées de Sodome,* later stolen from the Noailles' daughter, Natalie, and sold to a Swiss collector. Attempts to repossess it have failed.

56. Gibson 1997, 195.

57. Harry Kessler, *Berlin in Lights: The Diaries of Count Harry Kessler (1918–1937)*, trans. and ed. Charles Kessler (New York: Grove Press, 1999; originally published 1961), 382.

CHAPTER 31
Woman in the Garden

1. According to Widmaier Picasso 2004, 30, Marie-Thérèse and her sisters Jeanne and Geneviève stayed at the Pension Albion, 37, rue de la Malouine, Dinard.

2. Letter from Paul Rosenberg to Picasso, September 10, 1929, Archives Picasso.

3. The Jacobs' shop is currently the Georges Rech boutique. Georges Rech's daughter Almine is the wife of the artist's only surviving legitimate grandson, Bernard Picasso.

4. Jacob's other sister, Myrté-Léa, who would be deported and killed by the Germans in 1944, seems to have been absent.

5. Letter from Jacob to Level, August 28, 1929, in Seckel, 218.

6. *Guide de la Bretagne mystérieuse* (Paris: Tchou, 1966), 63.

7. See also, for example, Spies, 164, who relates some of Picasso's Carnac-inspired drawings to plans for the Apollinaire monument.

8. Telegram from Misia Sert to Picasso, August 21, 1929, Archives Picasso.

9. Gold and Fizdale, 261.

10. García-Márquez, 208.

11. Ibid., 209.

12. Ibid.

13. Serge Lifar, *Les Memoires d'Icare* (Monaco: Edicions Sauret, 1993), 229.

14. JSLC 99.

15. Gottlieb is quoted in Rubin 1972, 227.

16. See, for example, Musée Picasso, Paris (MP 117).

17. Letter from Jacqueline Apollinaire to Olga, September 16, 1929, Archives Picasso.

18. Withers, 135; also Read 1994, 205.

19. S. 72.

20. Cowling 2002, 513.

21. Julio González, *Cahiers d'Art* (1936), trans. in Giménez, 286.

22. Ovid, 3.

23. FitzGerald 1988, 264, observes that "the woman does not merely sit among the vegetation, she metamorphoses—Daphne-like."

24. Cooper, 31.

25. Ovid, 23.

26. Ibid., 24.

27. Vol. II, 400.

28. According to Alex Gregory, to the author.

29. Z.I.308 and Z.I.264.

30. Interview with Skira, *Chicago Tribune,* October 4, 1931.

31. Gilot 1964, 191.

32. Chapon 1987, 145–6.

33. Ibid., 146. Picasso had in fact signed a contract letter with Kahnweiler in 1912. See Vol. II, 268–9.

34. FitzGerald 1995, 188.

35. Z.VII.136.

36. Kahnweiler 1971, 103.

37. Ibid.

38. Letter from Kahnweiler to Hermann Rupf, October 29, 1931, Kunstmuseum Bern.

39. See Kosinski, 519–32.

40. Cooper told the author that he acquired Picasso's early masterpiece, the 1907 *Nudes in*

the Forest (Z.II.53, now in the Musée Picasso, Paris), from Reber for ten thousand Swiss francs paid to the Municipal pawn shop in Geneva.

41. Widmaier Picasso 2002, 55, says the car was bought in 1927; the current owner, Bernard Picasso, has confirmed that it is a 1930 model.

42. Brassaï, 17. Traditionally, the owner's chauffeur and manservant sat outside on the open front seat of the car, which is where Picasso liked to sit.

43. Kahnweiler 1971, 91.

44. Zervos's account is given in Otero, 186–7.

CHAPTER 32
The Bones of Vesalius

1. Z.VII.288.

2. *La Fenêtre ouverte* (*The Open Window*) is said to have been prompted by Bataille's article "Le Gros Orteil" (The Big Toe). Fingers as well as toes play a space-enhancing role in many of Picasso's figure paintings. Picasso would have been amused to discover that foot fetishism was evidently a Spanish phenomenon; see Georges Bataille, "Le Gros Orteil," *Documents* 1, no. 6 (November 1929), 289–302.

3. Gasman, 1043. In 1951 Picasso would replicate this as a sculpture of Françoise Gilot (S. 411).

4. MP Carnets II, cat. 38 (MP 1875).

5. Ibid.

6. The vertical *Swimmer* (not in Zervos) is reproduced in the catalog of Picasso's 1985 show at the Museum of Fine Arts in Montreal. The horizontal *Swimmer* is Z.VII.419.

7. This page turns out to derive in turn from an even earlier manuscript, the ninth-century *Pentateuque de Tours* (according to Georges Bataille, "Apocalypse de Saint-Sever," *Documents* 2 [May 1929] 79, citing Philippe Lauer). Among others Kaufmann, 80, points out that the *Deluge* page is similar to the eighth-century Spanish *Beatus Liebana.*

8. The scale, style, and simplification of these *Swimmer*s harks back to Picasso's *Minotaur* tapestry maquettes of the previous year. They look as if they may have been conceived as tapestries.

9. See, for example, Ted Coe, *Sacred Circles* (London: Arts Council, 1976), no. 669, 226.

10. Though usually entitled *Acrobats,* these paintings represent contortionists.

11. Z.VII.310.

12. Z.VII.307–8.

13. Cabanne 1977, 256.

14. Leiris 1930, 67.

15. Gilot 1990, 151.

16. Z.VII.309.

17. See Vol. II, 15; and John Richardson, "Picasso's Apocalyptic Whorehouse," *New York Review of Books,* April 23, 1987, 40–7.

18. The self-referential scaffolding is taken from a similarly self-referential feature in Matisse's 1914 *Goldfish and Palette.* See Vol. II, 386–7, for an account of how Picasso used this source for his great 1915 *Harlequin.*

19. Z.VII.252; Z.VII.306.

20. See Z.VII.298–305 and Z.VII.311–14.

21. These panels are virtually all the same size (64 × 47 cm), except the *Crucifixion* one, which is marginally larger, but still smaller than reproductions suggest.

22. Brassaï, 74.

23. Malraux, 42–3.

24. Picasso had based his great 1908 *Dryad* on Vesalius's seventh plate of the muscles from the second book of *De humani corporis fabrica*. See Vol. II, pp. 88–9.

25. Aragon, 33 n 1.

26. Vol. I, 105–6.

27. Z.VII.206. Picasso told Rubin that this *Seated Bather* is a portrayal of Olga. FitzGerald 1996, 324.

28. Museo Centro de Arte Reina Sofía, Madrid.

29. The catalog of *Picassos in the Collection of the Museum of Modern Art* makes the same claim. Rubin 1972, 132.

CHAPTER 33
Golgotha

1. Although this painting (Z.VII.287) is dated February 7, 1930, layers of paint indicate that it

was certainly not done in a day, as Gasman thinks, 1064.

2. Bernadac and Michaël, 128.

3. Z.VII.279–82.

4. See Vol. I, 71–88.

5. Kahnweiler 1956, 73.

6. Cowling 2006, 126.

7. Vol. I, 73.

8. Based on some of the June 1929 drawings, which show only Christ's legs, Gasman, 1049, argues that the scene anticipates the Resurrection.

9. Anthony Blunt, *Picasso's 'Guernica'* (New York: Oxford University Press, 1969), 26.

10. Thanks to his knowledge of iconography Picasso has portrayed the tiny crosses of the two thieves to right and left as T-shaped ones, to which miscreants were bound by the armpits, and not nailed like Christ to a Roman cross.

11. Some commentators see this green mass as a rock. Picasso liked his images to mean different things to different people. I see it as a sponge. It has also been seen as a reference to Bataille's *Anus solaire.*

12. Picasso was doubtless aware of a book by Francisco Pacheco (the father-in-law of Velázquez) called the *Arte de la pintura* (1649), which details iconographical usage.

13. Cabanne 1977, 255.

14. St. John of the Cross, *The Dark Night of the Soul,* trans. Kurt F. Reinhardt (New York: Frederick Unger, 1957), 218.

15. The photograph was published in Bernier.

16. See Penrose's account of a day with Picasso (February 24, 1955). Cowling 2006, 106–7.

17. Penrose, 259.

18. Z.IX.193.

19. See Chapter 34.

20. See Gibson 1997, pl. 62.

21. Ibid., 236.

22. See Kaufmann; Gasman, 958ff.

23. Z.VII.311.

24. MacGregor-Hastie, 125.

25. For further discussion, see Régnier 1993 and Régnier 2002.

26. Laporte, 2.

27. Régnier 2002, 19, points out that Picasso

moves from Catholic to Mithraic to shamanic iconography, often blending one with another.

28. In his recent dissertation, Charles Miller has argued that the reference to Mithra in Picasso's *Crucifixion* is a red herring, since Bataille's article had appeared after the painting. He prefers to see the "reference-point" as the devotional *image d'Epinal* and the controversial and much discussed writings of Jacques Maritain; see Miller, 201–2 and 189.

29. Other interpretations include Rosenthal, 651, who envisions this configuration as "sunglasses" on the face of a woman with "an expansive smile"; and MacGregor-Hastie, 125, who sees it as "a grinning, Spanish, straw-hatted aficionado."

30. Notably in *Le Bleu du ciel;* see Surya, 187–8.

31. Dora Maar to the author.

32. JSLC, 102.

CHAPTER 34
L'Affaire Picasso

1. Over the years, *l'affaire Picasso*—the theft of several hundred early drawings from his mother's Barcelona apartment—had been virtually forgotten. Cooper had told the author what he had heard about the case at the time; this triggered his interest. After this chapter was under way, it transpired that Laurence Madeline, archivist at the Musée Picasso, was embarking on a similar project. Madeline generously made a draft of her *Burlington Magazine* article (May 2005) available. This has been of great help. Francesc Parcerisas has also provided information about the Catalan involvement.

2. In 1927 Doña María had moved to the apartment of her daughter, Lola, and son-in-law Dr. Vilató, at no. 7, Paseo de Colón, around the corner from the Carrer de Mercè home where Picasso had lived as a youth. Doña María and the Vilatós moved to 48, paseo de Gracia in 1938.

3. She was seventy-five, not eighty as Picasso claimed.

4. Letter from Picasso to the "Procureur de la République," May 9, 1930, Archives Picasso.

5. Apropos the involvement of the Paris-based Catalan potter Josep Llorens Artigas in the theft, his son, Joanet Artigas Gardy, said that the best account of the affair was in Buñuel's memoir, perhaps not realizing that Buñuel wrongfully believed that the "American companion" of the thief was his father. The first that Artigas knew of the drawings was when Calvet showed them to him in Paris. Communication from Elisenda Sala to McCully.

6. Cowling 2006, 107.

7. Hector Feliciano, *The Lost Museum* (New York: Basic Books, 1997), 131.

8. Guillaume Apollinaire, "Le Salon des Artistes Indépendants (1910)," *Œuvres en prose complètes,* ed. Pierre Caizergues and Michel Décaudin, vol. 2 (Paris: Gallimard, 1991), 152.

9. Gerd Muehsam, *D. Edzard* (New York: H. Bittner, 1948), 5.

10. Edzard's dismemberment of the drawings appears only to have been reported in the German press, *Germania,* May 21, 1930, thanks probably to the Munich dealer, Georg Caspari.

11. Z.XXII.43.

12. Madeline 2005a, 318, claims that Brummer authenticated the drawings. Although the Galerie Pierre is mistakenly mentioned in Picasso's letter to the public prosecutor, Madeline has found no evidence of this gallery's involvement. Pierre Loeb was a modernist dealer exceedingly loyal to Picasso and would never have involved himself in this sleazy affair, as the artist wrongly assumed that he had. Their friendship would survive this *malentendu.*

13. Madeline 2005a, 323.

14. According to some reports, Picasso attended the vernissage.

15. The Vilató family's drawings by Lola have been published in the exhibition catalog *Lola Ruiz Picasso* (Málaga: Fundación Pablo Ruiz Picasso, 2003).

16. Over fifty years later, unscrupulous art dealers tried to swindle the aged Maître Bacqué de Sariac out of a major Blue period Picasso, *Les Noces de Pierette* (Z.I.212). Sariac's heirs got it back.

17. Gimpel's account is dated May 12, 1930; Gimpel, 101.

18. Cabanne 1977, 160.

19. See Vol. I, 351.

20. Letter from Léonce Rosenberg to Picabia, May 19, 1930, Derouet, 49.

21. Letter from Picabia to Léonce Rosenberg, May 23, 1930, ibid.

22. Madeline 2005a, 316 n. 5.

23. The discrepancy in the numbers is probably due to Edzard's cutting up of study sheets.

24. Madeline 2005a, 319 n. 19; the Blue period "Study of a Naked Man with His Arms Raised" was acquired from the Galerie Zak by the Musée de Grenoble in 1934.

25. Padilla's letter (July 12, 1930, Archives Picasso) mentions that someone else had offered him a Blue period painting of a life-size mother and child, which "belonged to a certain Ugarte, to whom Picasso had given it after hearing him play the guitar."

26. *Hamburger Fremdenblatt,* May 12, 1930.

27. Madeline 2005a, 323 n. 60.

28. Ibid.

29. Two of the drawings Picasso mentioned were probably Z.VI.157 and Z.VII.156. *Le Matin,* May 13, 1980.

30. *L'Intransigeant,* May 12, 1930.

31. Madeline 2005a, 323, Appendix 2.

32. *Le Petit Parisien,* May 14, 1930.

33. Madeline 2005a, 322 n. 52.

34. The letter was published (May 12, 1930) in *Le Petit Parisien* and also in the Turin paper *Stampa.*

35. In a letter to Stein, July 1, 1930, Kahnweiler reports that Picasso's "mother has come from Barcelona (partly for that affair of stolen drawings) and is with him just Know [*sic*]"; reprinted in Madeline 2005a, 320 n. 33.

36. Palau 1971, 179.

37. Ibid.

38. Letter from Christine Edzard to McCully, November 26, 2004.

39. Before Vol. VI of the catalogue raisonné appeared, Zervos published a selection of "Œuvres et images inédites de la jeunesse de Picasso," in *Cahiers d'art* 2 (1950), 277–331.

40. An exception was made for Alfred and Marga Barr. In 1955 the young German photographer Inge Morath managed to charm her way

into the Vilatós' apartment and do a reportage for *L'Oeil* magazine.

41. Quoted by Alice Goldfarb Marquis, *Alfred H. Barr Jr., Missionary for the Modern* (Chicago: Contemporary Books, 1989), 3.

CHAPTER 35
Château de Boisgeloup

1. Arnaud, 441.

2. Since Cocteau's father had committed suicide, this would have been very painful for his mother.

3. Arnaud, 442.

4. Letter from Cocteau to Picasso, December 12 [1930], Archives Picasso.

5. Quoted in Arnaud, 442.

6. Brassaï, 17.

7. The histoy of Boisgeloup dates back to the fourteenth century, when Philippe de Gamaches was Seigneur de Boisgeloup.

8. Brassaï, 109.

9. Gilot 1964, 153.

10. Z.VI.1331.

11. See Chapter 37, n. 31.

12. Another twenty years would go by before Bell would be received as before, and then largely because Jacqueline Picasso took a shine to Bell's last love, Bloomsbury's handmaiden, Barbara Bagenal.

13. Letter from Bell to Mary Hutchinson, August 2, 1931, Ransom Center.

14. "How does the furniture look and is it comfortable?" Errázuriz asks in a letter to Olga and Picasso, December 7, 1931, Archives Picasso.

15. Musée Picasso, Paris (MP 74). During World War II, the salon would be used to store logs. Paulo, who inherited it from his mother, did nothing to modernize it. Growing up at Boisgeloup in the 1960s, Bernard was scared of going into his grandmother's old bedroom, which had cobweb-covered stacks of her suitcases.

16. Widmaier Picasso 2004, 42–3, confirms that Picasso took the apartment at 45, rue la Boétie, for Marie-Thérèse in 1935 (not 1930, as often stated).

17. Marie-Thérèse to Gasman.

18. González had a house at Monthyon on the Marne, east of Paris.

19. S.80.

20. MP Carnets II, cat. 39 (MP 1990-109). This *carnet* also includes drawings by González.

21. S.81.

22. See MP Carnets II, cat. 38 (MP 1875).

23. Rubin 1984, 322–3, 340, concludes that Picasso owned three Kota figures. He sees the colander head as representing Olga. Apart from two small plasters executed in Paris in the spring of 1929 (S.104 and 106), none of Picasso's sculptures appear to stand for Olga, except insofar that some of them might be said to constitute fetishes designed to protect him from her.

24. S.408.

25. Braque to the author.

26. S.86–101; these wood carvings include a small bust of Marie-Thérèse and an embracing couple (S.102, 103).

27. Spies, 157.

28. Daix 1993, 217.

29. See Vol. I, 444.

30. See Chapter 37.

31. Madeline 2005b, 331.

32. Stein and Toklas had leased this house the year before and would continue to live there until it was requisitioned in 1943.

33. Besides Picasso, *Dix portraits* evoked Apollinaire, Satie, Virgil Thomson, Hugnet, Tchelitchev, Bérard, Kristians Tonny, Bernard Faÿ and Eugène Berman. In a postcard on July 16, 1930 (Archives Picasso), Georges Hugnet inquired whether or not Picasso had received his copy.

34. See Alice B. Toklas, *What Is Remembered* (New York: Holt, Rinehart and Winston, 1963), 125. Photographs taken on the day of the Picassos' visit do not confirm Toklas's description of their clothes. See ed. Edward Burns, *Gertrude Stein on Picasso* (New York: Liveright, 1970), 52. Other photographs taken the following summer are reproduced in Burns, 50, 53, and Madeline 2005b, 340.

35. Chapon 1987, 146.

36. Baer 173.

37. Widmaier Picasso 2002, 55.

38. S.76–8, 117, 118, 118A, and 119.

39. Vallentin, 174, mentions the glove stuffed with bran. Brassaï, 109, notes that the glove was Olga's.

40. S.119 is the only one done on the front of the canvas.

41. Kahnweiler describes these reliefs—"all done in the second half of August"—as "tableaux-sculptures," in a letter to Max Jacob, September 24, 1930, Seckel, 220 n. 5.

42. S.76.

43. S.118.

44. Z.XXXIII.144–8.

45. See Cowling 2006, 119. Hence the great lunar sculptures of Marie-Thérèse that Picasso would execute the following year.

CHAPTER 36
The Shadow of Ovid

1. Klein, 10.

2. See Vol. II, 221.

3. Letter from Serge Férat to Ardengo Soffici, October 21, 1912, Soffici Archives, Florence.

4. For the full story of Fernande's later life, see John Richardson's Epilogue in Marilyn McCully, *Loving Picasso: The Private Journal of Fernande Olivier* (New York: Harry N. Abrams, 2001).

5. See bill for delivery of copper plates, April 30, 1930, Archives Picasso.

6. See Florman.

7. The inclusion of one of the Torre de la Parada paintings in an obscure article, "Peter Symons, a Rubens Collaborator," in the September 1930 issue of an obscure academic journal, *Archivo español del arte,* is most unlikely to have been seen by Picasso.

8. D.-H. Kahnweiler, "Huit entretiens avec Picasso" (December 10, 1936), *Le Point,* October 1952, 26.

9. Stéphane Mallarmé, *Oeuvres complètes,* ed. Henri Mondor and G. Jean-Aubry (Paris: Gallimard, 1945), 1168.

10. Baer 144.

11. Ovid, 18.

12. Baer 148.

13. Ibid., 150.

14. Ibid., 156.

15. Ibid., 154.

16. Ibid., 209.

17. Christian Zervos, "Les Métamorphoses d'Ovide illustré par Picasso," *Cahiers d'Art* 6, nos. 7–8 (1931), 369.

18. Baer 1997, 55.

19. Sketches of heads for the half-page illustrations fill many pages (all done in early April 1931) of JSLC 101. Skira claimed to have chosen the chapters for the half-page titles; see Albert Skira, "Souvenirs sur des Métamorphoses," *Picasso: Etampes 1904–1972* (Martigny: Fondation Pierre Gianadda, 1981), 29.

20. Brassaï, 105–6.

21. Tériade, whom Skira had lured away from Zervos, was responsible for the Matisse commission. Skira chose to publish Matisse's Mallarmé exactly a year after he had celebrated the publication of Picasso's *Ovid* on the latter's fiftieth birthday.

22. Letter from Ambrose Vollard to Picasso, May 1931, Archives Picasso.

23. Letter from Salmon to Picasso, November 15, 1930, Archives Picasso.

24. Ibid.

25. See André Salmon, "Vint-cinq ans d'Art vivant," *La Revue de France* (February–March 1931).

26. Lise de Harme, *Les Années perdues* (Paris: Plon, 1961), 92.

27. González quoted in Giménez, 286–7.

28. FitzGerald 1988, 274.

29. Letter from González to Picasso, April 2, 1931, Archives Picasso.

30. Concerning pedestals, see notes from González to Picasso, December 19, 20, 1929, January 5 and February 16, 1930, Archives Picasso.

31. Postcard from Stein to Picasso, November 10, 1930, Beinecke Library.

32. See *Gertrude Stein: Writings and Lectures,* ed. Patricia Meyerowitz (London: Penguin, 1967), 257.

33. Tomkins, 39.

34. Seckel, 219.

CHAPTER 37
Annus Mirabilis I

1. Bernadac and Michaël, 129.

2. Z.VII.328–9.

3. This is one of the paintings that Claude Picasso allowed Citroën to use in the promotion of their Picasso automobile.

4. A rich landowner and member of Parliament, Payne Knight was an avid collector of Etruscan vases, sculptures, and bronzes, which he would study exhaustively and donate to the British Museum. First published in 1786 for the edification of cognoscenti like himself (prurient details are in Latin), the *Discourse* was almost immediately suppressed by the author, who found that, like their counterparts today, conservative bigots were using his writings to demonize him in Parliament. Reprinted in 1865, the book came under even fiercer fire from Victorian prudes, who refused to believe that in antiquity phallic amulets were no more pornographic than a charm bracelet. A militant fanatic named Thomas Mathias denounced Payne Knight's book as "one of the most unbecoming and indecent treatises which ever disgraced the pen of a man who would be considered a scholar and philosopher." See Johns, 25.

5. See, for example, S.122, 122A, 123, and 124.

6. Johns, 24.

7. Letter from Paul Rosenberg to Picasso, January 6, 1931, Archives Picasso.

8. *Exposition d'œuvres de Picasso: peintures, gouaches, pastels, dessins, d'époques diverses,* Galerie Percier, June 23–July 11, 1931.

9. Z.VII.327, Z.VII.326, Z.VII.322, and Z.VII.317.

10. For Picasso's statement about his philodendron plant, see page 443.

11. See Vol. I, 502 n. 31.

12. See Chapter 11.

13. Barr was selecting works for MoMA's 1939 Picasso retrospective.

14. Boggs, 234.

15. Rosenberg also included four earlier paintings, including *Three Musicians* and several plates from Skira's Ovid.

16. Flam, 152.

17. Bois, 64.

18. *Matisse and Picasso:* Kimbell Art Museum, Fort Worth, Texas, 1999. *Matisse Picasso:* Tate Modern, London, May 11–August 18, 2002; Grand Palais, Paris, September 25–January 6, 2003; MoMA, New York, February 13–May 19, 2003.

19. Centre Georges Pompidou, Paris.

20. Z.VII.306.

21. Flam, 146–7.

22. Penrose, 397.

23. Vol. I, 458.

24. Ibid., 456–60.

25. Although he had intended *Oviri* to preside over his tomb, Gauguin left it on deposit with his patron, Gustave Fayet, before returning to Tahiti. In 1925 Vollard acquired *Oviri* from Fayet. After Vollard's death, it came into the possession of Edouard Jonas, who had purchased interest in the dealer's estate from his sisters in Réunion, the family's birthplace.

26. Widmaier Picasso 2004, 30.

27. JSLC 101.

28. Z.VII.347.

29. Z.VII.259.

30. Penrose, 242.

31. Brassaï's photographs were commissioned for the first number of Skira's magazine, *Minotaure.* "My photos were to occupy thirty or so pages," Brassaï, 7.

32. The earliest drawings for the *Tall Figure* appear in JSLC 101, which was begun on November 8, 1930.

33. S.107.

34. Cowling 2006, 302.

35. Spies, 167–8.

36. Subsequent inquiries failed to confirm whether this supposition had been correct.

37. S.131 and S.132.

38. See, for example, Z.VII.323 and Z.VII.325.

39. Brassaï, *Conversations avec Picasso* (Paris: Gallimard, 1964), 65, 69; translation by the author.

40. Penrose, 244.

41. S.133.

42. From the Baga tribe in French Guinea— one that the wearer carried on his shoulders.

43. The Nimba mask appears in the 1918 pho-

tograph of Olga in the Montrouge studio; see page 79.

44. Z.VII.379.

45. Golding, 26.

46. See the *Hen* (S.155), identified as a *Cock* by Spies, and S.154.

47. S.127.

48. S.130.

49. S.198.

50. S.128.

51. See Vol. I, 403.

52. Ibid., 434. Casanovas also did neoclassical bas-reliefs in plaster.

53. Suggested by Dakin Hart, whose knowledge of Picasso's sculpture has been of great help.

54. S.105.

55. Picasso would have seen *Jeanette V* and the *Large Seated Nude* at the Galerie Pierre's 1930 show of Matisse sculpture.

56. This piece (S.111) figures in the earlier photographs of the 1931 sculptures. The companion piece (S.110) does not appear until much later.

57. *Princess X* was supposedly inspired by Princess Marie Bonaparte, Freud's favorite disciple and a mistress of Brancusi's.

58. See *Picasso x-rays: Photographies de Xavier Lucchesi* (Paris: Musée National Picasso, *Beaux-Arts Magazine,* 2006).

59. S.83, 84, and 85.

60. S.110.

61. JSLC 101.

62. Bach, 259.

63. Ibid., 378 n. 605.

64. Ibid., 253. Cassou was director of the Musée d'Art Moderne, Paris, 1946–65.

65. Picasso's drawing (July 7, 1928) appeared in his so-called Carnet Paris. Parigoris pointed out the existence of the plaster cast in González's studio to the author.

66. Albert Dreyfus, "Constantin Brancusi," *Cahiers d'art,* no. 2 (1927), 69–74; Roger Vitrac, "Constantin Brancusi," *Cahiers d'art,* nos. 8–9 (1929), 383–96.

67. According to Etienne Hajdu, Bach, 264.

68. According to François-Xavier Lalanne, ibid.

69. Baer, 204–5, 207–9.

70. Picasso engraved most of the Vollard suite

plates in 1933 and 1934; three more were executed in 1939.

71. See Chapter 36 n. 24.

72. Charles W. Millard, *The Sculptures of Edgar Degas* (Princeton, N.J.: Princeton University Press, 1976), compares Degas's *Rose Caron* (plate 121) to Brancusi's *Muse* (plate 122).

73. Picasso's engravings of brothel scenes were executed between March and June 1971; see Baer 1942–2001, 2009–10.

74. See Vol. 1, 82.

CHAPTER 38
Annus Mirabilis II

1. Archives Picasso.

2. Linda Simon. *The Biography of Alice B. Toklas* (Garden City, N.Y.: Doubleday, 1977), 144.

3. Now in the collection of Beinecke Library.

4. See Vol. II, 131–2.

5. See Kosinski, 521.

6. Marie-Thérèse told Gasman that she was accompanied this summer by her sister Geneviève.

7. Two drypoints of the sculptor's studio (see Baer, 205, 207).

8. MP 1052.

9. E.g., *Sculptor and Model* in the Fondation Beyeler, Basel.

10. See MP 1053–5.

11. MP 1058–61.

12. *L'Eclaireur de Nice* (August 17 and 18, 1931) reported that forest fires had begun on August 16 and had spread to Mougins, Vallauris, and Le Cannet.

13. See Hélène [S.] Klein's note on the series in *Picasso: Une Nouvelle Dation* (Paris: Musée Picasso, 1990), 48.

14. Letter from Stein to Picasso, September 1931, Beinecke Library.

15. Stein 1938, 47.

16. JSLC 101.

17. Cabanne 1977, 268.

18. See Vol. I, 27.

19. L. P. Harvey, *Islamic Spain: 1250–1500* (Chicago: University of Chicago Press, 1990), 298–9.

20. Guillen Robles, 186.

21. Gijs van Hensbergen, *Guernica: The Biography of a Twentieth-Century Icon* (London: Bloomsbury, 2004) made this point in his lecture on the occasion of the 2006 *Guernica* exhibit at the Museo Nacional Centro de Arte, Reina Sofía, Madrid.

22. Cowling 2006, 261.

23. See Vol. II, 37.

24. Pointed out by Dakin Hart.

25. Ibid.

26. S.112–15.

27. Leo Steinberg, "The Algerian Women and Picasso at Large," *Other Criteria* (London: Oxford University Press, 1972), 167.

28. Marina Picasso Collection, 12578.

29. MP 74.

30. Z.VII.346.

31. Gilot 1964, 50.

32. According to Widmaier Picasso, Picasso first consulted a lawyer about divorce in the autumn of 1933 but when he discovered that Olga would have a claim on half of everything he owned, there was no further question of it. When Marie-Thérèse became pregnant, a legal separation was arranged, July 29, 1935 (Widmaier Picasso 2002, 86–9).

33. Z.VII.334.

34. MP 136.

35. Piot suggests that Abel Gance's 1929 film *Napoléon* (in which Antonin Artaud played Marat) might have played a role in Picasso's choice of subject. See Léal, Piot, and Bernadac, *The Ultimate Picasso,* trans. Molly Stevens and Marjolin de Jager (Barcelona: Ediciones Polígrafa, 2000), 262.

36. Picasso seemingly knew the David painting only from reproductions; the original is in the Musées Royaux des Beaux-Arts, Brussels.

37. See chapter 30, n. 23.

38. Z.VIII.216.

39. Archives Picasso.

40. Bois sees Matisse drawing on this painting for his no less dazzling painting of a woman in a peasant blouse, entitled *The Dream.* For Matisse's comments, see Bois, 137 and n. 265.

41. Marina Picasso Collection, 12584.

42. Z.VII.358.

43. See, for example, Z.VII.357, Z.VII.359.

44. *Still Life with a Plaster Bust* (Barnes Foundation, Merion, Pa.).

45. Z.VII.361.

46. Z.VII.263.

47. Z.VII.362.

48. Z.VII.364.

49. Steve Cohen had agreed to pay $139 million, but the deal was annulled after Steve Wynn, the owner of the painting, put his elbow through it before it could be shipped.

50. Z.VII.269.

51. Drawings done on January 31 (e.g. Z.VII.330) (dated January 27, 1932) and MP 139 reveal that Picasso contemplated doing a full-length, seated version of what had started as a half-length painting. It was just as well he failed to do so; the addition of legs, as in the drawing, would not have improved it.

52. Z.VII.375.

53. Z.VII.376.

54. MP 140.

55. Bois, 15, believes this still life derives from Matisse's 1916 *Still Life with a Plaster Bust* (Barnes Foundation).

56. Private collection, California.

57. Z.VII.377.

58. See K. Blossfeldt, *Urformen der Kunst* (Berlin, 1928), trans. as *Art Forms in Nature* (London: Dover, 1986).

59. Georges Bataille, "Le Langage des fleurs," *Documents,* no. 3 (June 1929), 162.

60. See, for example, Z.VIII.1–9.

61. Z.VII.378.

62. *Sleeping Nude,* reproduced in *Matisse Picasso* (London: Tate Modern, 2002), 217; and the smaller *Reclining Nude,* reproduced in *Pablo Picasso Meeting in Montreal* (Montreal: Museum of Fine Arts, 1985), 167.

63. Z.VII.379.

64. See also Cowling 2002, 496.

65. Rubin 1972, 138.

66. In 1955–56 Picasso told the author, apropos his 1954 variations on Delacroix's *Femmes d'Alger,* that the penultimate painting of a series was "*le plus fort,*" the strongest one.

67. Daix 1993, 221–2; Cowling 2002, 492.

68. See chapter 30, note 18.

69. Z.VII.355–6 and no. 68 in *Picasso: Anthology* (Málaga: Museo Picasso Málaga, 2004).

70. Elizabeth Cowling, *The "Reclining Woman on the Beach" Series* (Málaga: Museo Picasso Málaga), 38.

71. Roland Penrose, *Scrap Book* (London: Thames and Hudson, 1981), 68–9.

72. Z.VII.339–40, 344.

73. Z.VII.332.

74. Z.VII.381.

75. *The Collected Works of C. G. Jung,* vol. 15 (New York: Bollingen Foundation, 1966), 138.

CHAPTER 39
Paris and Zurich Retrospective

1. See Chapter 34.

2. Paulo was admitted to Prangins in the 1940s.

3. Raymond Queneau, *Journaux 1914–1965* (Paris: Gallimard, 1996), 275.

4. These portrayals are so close in pose, color, and treatment to ones of Marie-Thérèse that her daughter Maya mistook one of them for a portrait of her mother. See the commemorative photograph of her and her family, see Widmaier Picasso 2002, plate XVI.

5. Otero, 192.

6. Quoted in FitzGerald 1995, 193.

7. The contents of Degas's studio and his great collection were auctioned at the Galeries Georges Petit in four sales in May and December 1918 and April and July 1919.

8. Z.I.285; Chester Dale bequeathed his collection to the National Gallery, Washington.

9. See FitzGerald's book *Making Modernism* (FitzGerald 1995) for the most comprehensive account of Picasso's relationship with Rosenberg and other dealers.

10. Ibid., 194.

11. Ibid., 206.

12. According to Alejo Carpentier, *Crónicas* (Havana, 1975), 265, the architect was André Lurçat.

13. Brassaï, 4.

14. Cabanne 1977, 270.

15. Blanche, 334.

16. FitzGerald 1995, 214.

17. Z.VI.686.

18. Daix 1993, 222.

19. See Chapter 19.

20. See Vol. II, 57.

21. Quoted in FitzGerald 1995, 193.

22. Tériade's interview appeared in *L'Intransigeant,* June 15, 1932.

23. Ibid., 28.

24. Ibid., 27–8.

25. Breton loaned his iconic papier collé of a triangular head (1913). Tzara, who had bought a number of important papiers collés at the Kahnweiler sales, lent nothing.

26. André Breton, "Picasso in His Element," *Surrealism and Painting,* trans. Simon Watson Taylor (New York: Icon, 1972), 110.

27. Picasso told Zervos (*Cahiers d'Art,* 1935) that Cézanne would never have interested him "if he had lived and thought like Jacques Emile Blanche, even if the apple he had painted had been ten times as beautiful"; see Bernadac and Michaël, 36.

28. Jacques-Emile Blanche, "Rétrospective Picasso," *L'Art Vivant* 8 (July 1932), 334.

29. Ibid., 333.

30. Ibid., 334.

31. Ibid.

32. See Chapter 10, 129.

33. Quoted in Cabanne 1977, 271.

34. Charensol, quoted in ibid.

35. Quoted in FitzGerald 1995, 190.

36. Ibid., 192.

37. Daix 1977, 236, gives no evidence for his statement that Olga did in fact attend the vernissage.

38. Madeline has confirmed that Olga and Paulo were there during the summer of 1932; see Madeline 2005b, 344.

39. Z.VII.387.

40. Z.VII.351.

41. Z.VII.398.

42. Z.VIII.12.

43. See, for example, Z.VIII.26–33.

44. Z.VIII.70.

45. Z.VII.395.

46. Known as *Siesta,* this painting (reproduced

in *Picasso: Figur und Porträt* [Kunstforum Wien, 2000], 141) is inscribed on reverse: *Boisgeloup, 18 août XXXII.*

47. Z.VIII.154.

48. Z.VIII.133.

49. Z.VIII.147.

50. S.135.

51. Alexandra Parigoris to the author.

52. Derouet 2006, 154.

53. Ibid.

54. See Chapter 29.

55. Derouet 2006, 11.

56. In November 1930, Picasso gave the maquette and proofs of the full-page illustrations for Ovid's *Metamorphoses* to Zervos, who sold them to Chester Dale. He also gave Zervos fifty copies of the book. See Derouet 2004, 153. Other artists, including Paul Klee, gave Zervos editions of prints that could be sold.

57. Gilot 1964, 128.

58. Derouet 2006, 154.

59. The Braque show was eventually held in April 1933, followed in May by a Léger retrospective.

60. One of the most zealous investigators of works of art looted during WWII, Cooper had Montag arrested and rearrested—to little avail. Each time, Montag appealed to Winston Churchill, whom he had taught to paint. Churchill could not believe that Montag could have done anything so reprehensible and had him set free.

61. Quoted in Geelhaar, 184.

62. Geiser briefly assumed the role of Paulo's tutor after he came out of the Lindenhofspital in Zurich in 1937; see Therese Bhattacharya-Stettler, "Picasso un Bern," *Picasso und die Schweiz* (Kunstmuseum Bern, 2001), 81–2, n. 36.

63. Apart from the works on paper, the Zurich show included 224 paintings, 43 of them new additions.

64. Z.V.141, Z.V.426, Z.II.528, and Z.II.550.

65. Z.I.256.

66. Z.II.536.

67. Rafael Inglada provided details of the hotels where the Picassos stayed on their trip to Switzerland.

68. Hans Welti, "Picasso auf dem Zürichsee," *Neue Zürcherzeitung,* September 14, 1932.

69. Ibid.

70. Ibid.

71. Douglas Cooper to the author.

72. Geelhaar, 196. Geelhaar's essay on the Picasso retrospective in Zurich (Kunstmuseum Bern, 2001), 65–73, is the principal source of information concerning this show and its reception.

73. Geelhaar, 200.

74. *The Collected Works of C. G. Jung,* vol. 15 (New York: Bollingen Foundation), 138.

75. Ibid., 139–40.

76. Ibid., 140.

77. Christian Zervos, "Picasso étudié par le Dr. Jung," *Cahiers d'art,* 1932, 352.

78. In a letter dated September 8, 1932 (Kunstmuseum Bern), Kahnweiler asks Rupf if he has seen Picasso, since he was under the impression that Picasso only wanted to stay in Zurich one or two days and then drive home through Colmar. Since Picasso had left Paris on the seventh, arriving in Basel that day, it is conceivable he visited Colmar en route to Zurich, rather than on his way back to Paris.

79. Quoted in Bernadac and Michaël, 84.

80. Ibid., 108.

81. *Minotaure* no. 1 (June 1933), 31–3.

82. Reproduced in Baldassari 1997, 196.

83. *Hall's Dictionary of Subjects and Symbols in Art* (London: John Murray, 1989 reprint), 85.

84. Baer 1997, 33.

85. Gasman cites a poem, August 2, 1940, in which Picasso fantasizes about saving her life; see Bernadac and Piot, 228.

86. Cowling 2002, 535.

87. See, for example, Z.VIII.100–3.

88. See Chapter 37, n. 31.

89. See, for example, Z.VIII.124–6, 128.

EPILOGUE

1. Pablo Neruda, "Explico algunas cosas," *Pablo Neruda: Selected Poems,* ed. and trans. Nathaniel Tarn (London: Penguin, 1975), 102.

2. Kahnweiler 1971, 108. Gasman cites a refer-

ence in one of Picasso's poems, dated December 21, 1935, in which he invents a Spanish word, *realeales,* in order to make a pun on "royal" and "loyal."

3. See Rafael Inglada, *Picasso antes del azul (1881–1901)* (Málaga: Ayuntamiento, 1995), 180–5.

4. Xavier Vilató to the author.

5. Originally from Genoa, branches of the Picassi family had settled in the Sori on the Adriatic coast as well as in Argentina and Spain. Tomasso Picassi (1787–1851), who changed his name to Picasso, was married to a *malagueña* called Doña María Guardeño. One of Tomasso's sons, Francisco, married Inez López Robles, whose daughter, María, was Pablo Picasso's mother. Tomasso's other son, Juan Bautista, married Dolores González Soto. They had six children: Adela, Amelia, Dolores, Eulalia, Trinidad, and one son, Juan, the future general, who was born in Málaga on August 22, 1857. In 1876, when he was eighteen, Juan enrolled in the Cuerpo de Estado Mayor. He was a good student and an excellent horseman. This information from Pando Despierto about the Picasso family was not available at the time of the publication of Vol. I; see the family tree reproduced in Vol. I, 476.

6. Pando Despierto, 31.

7. Carolyn P. Boyd, *Praetorian Politics in Liberal Spain* (Chapel Hill: University of North Carolina Press, 1979), 188.

8. Pando Despierto, 36.

9. François Buot, *Crevel* (Paris: Grasset, 1991), 124.

10. Pando Despierto, 31.

11. Brenan, 78–9.

12. Ibid., 80.

13. Van Hensbergen, 12.

14. Olivier Widmaier Picasso claims that Picasso had Marie-Thérèse stashed away "in a neighboring hotel" on this visit to Spain, as well as the one he would make the following year; see Widmaier Picasso 2002, 86.

15. According to Salvador Madariaga, in Brenan, 79.

16. Gibson 1997, 263.

17. Van Hensbergen, 10. Aizpurua was a founder with Josep Lluis Sert of GATEPAC (Grupo de arquitectos y técnicos españoles para el arte contemporania).

18. Stainton, 425–6.

19. Ibid., 426.

20. Gibson 1989, 446.

21. Lorca, quoted in ibid., 443.

22. Paul Eluard, *Lettres à Gala* (Paris: Gallimard, 1984), 158.

23. "We resolutely denounce the use of this affair to generate publicity for themselves. . . . we do not accept the line taken by those pretentious intellectuals. . . . The surrealists' position is bullshit . . . their revolutionary zeal merely verbal." *L'Humanité,* February 9, 1932.

24. Gertje R. Utley, *Picasso: The Communist Years* (New Haven: Yale University Press, 2000), 14–15.

25. Otero, 183.

26. Van Hensbergen, 10.

27. "Ante el traslado a Madrid de los restos de Pablo Picasso," *La Gaceta Literaria,* March 1, 1931.

28. Douglas W. Foard, *The Revolt of the Aesthetes (Ernesto Giménez Caballero and the Origins of Spanish Fascism)* (New York: Peter Lang Publishing, 1989), 228.

29. See Ernesto Giménez Caballero's accounts of the meeting with Picasso in *El Arte y el Estado* (Madrid: Gráficas Universal, 1935), 43–9; Giménez Caballero; and *Retratos españoles (Bastante parecidos)* (Barcelona: Planeta, 1985), 139–42.

30. Giménez Caballero, 140.

31. Ibid.

32. Ibid., 142.

33. Ibid., 140.

34. Ibid., 142.

35. Ibid.

36. Otero, 181.

37. Giménez Caballero, 140.

38. Ibid.

39. Otero, 181–2.

40. Van Hensbergen, 11. See also Alexandre Cirici-Pellicer's account of "Arte y Estado" in *La Estética del Franquismo* (Barcelona: Gustavo Gili, 1977), 56–68.

41. Under the sponsorship of ADLAN (Amics

de l'art nou), the Picasso exhibition, which included twenty-five paintings, drawings, and papiers collés, opened first in Barcelona in January 1936. The exhibition traveled to Bilbao, where it was sponsored by GATEPAC, and Madrid. A planned showing in Málaga failed to take place because of the war.

42. Pando Despierto, 37.

43. Dora Maar to the author.

44. According to Boris Taslitsky in conversation with the author and McCully.

45. See Vol. I, 463, 580 n. 1.

INDEX

Page numbers in *italics* refer to illustrations.

ILLUSTRATION CREDITS

ARS: Artists Rights Society, New York
BnF: Bibliothèque nationale de France
CNAC/MNAM: Centre national d'art et de culture/Musée national d'art moderne
RMN: Agence photographique de la Réunion des Musées Nationaux

All images by Pablo Picasso are © 2007 Estate of Pablo Picasso/Artists Rights Society (ARS), New York

All the images in these pages credited to the Archives Olga Ruiz-Picasso have been made available courtesy of the Fundación Almine y Bernard Ruiz-Picasso para el Arte. Please note that these photographs are mostly unposed snapshots that can in most cases be attributed to Olga Picasso or Pablo Picasso. However, unless the identity of the photographer is self-evident, the credit should read, "photographer unknown."

Frontispiece: Photographer unknown. Photograph © RMN/Thierry Le Mage/Art Resource, NY.

page
2 Archives Olga Ruiz-Picasso, Courtesy Fundación Almine y Bernard Ruiz-Picasso para el Arte. Photographer unknown, All Rights Reserved.
4 Photograph © BnF.
10 Photograph © RMN/Jean-Gilles Berizzi.
13 © Foundation E.G. Bührle, Zurich (photograph SIAR).
15 Image © Ryersson & Yaccarino/The Casati Archives.
17 Photograph © RMN/Madeleine Coursaget/Art Resource, NY.
20 Photograph © Alinari/Art Resource, NY.
22 Archives Olga Ruiz-Picasso, Courtesy Fundación Almine y Bernard Ruiz-Picasso para el Arte. Photographer unknown, All Rights Reserved.
24 Photograph © RMN/Art Resource, NY.
25 Photograph © CNAC/MNAM/Dist. RMN/Jacques Fajour/Art Resource, NY.
27 Photograph © The Art Institute of Chicago.
28 (both) Photograph © Alinari/Art Resource, NY.
29 Archives Olga Ruiz-Picasso, Courtesy Fundación Almine y Bernard Ruiz-Picasso para el Arte. All Rights Reserved.
32 Private collection.
33 Private collection.
35 Photograph © BnF.
41 Left: Photograph © RMN/René-Gabriel Ojéda/Art Resource, NY. Right: Photographer unknown, All Rights Reserved. Photograph © RMN/Hervé Lewandowski/Art Resource, NY.
42 Photograph © RMN/Madeleine Coursaget/Art Resource, NY.
45 Photograph © RMN/Thierry Le Mage/Art Resource, NY.
50 Photographer unknown, All Rights Reserved.
55 Spencer Collection, The New York Public Library, Astor, Lenox and Tilden Foundations.
58 Photograph © Galerie Jan Krugier & Cie, Geneva.
61, 63, 64 Photographs © Museu Picasso, Barcelona/Ramon Muro.
69 Archives Olga Ruiz-Picasso, Courtesy Fundación Almine y Bernard Ruiz-Picasso para el Arte. All Rights Reserved.
73 Photograph © Boris Lipnitzki/Roger Viollet/Getty Images.
75 Private collection. © *Cahiers d'Art*, Paris.
77 Private collection. © *Cahiers d'Art*, Paris.
79 Photograph © RMN/Madeleine Coursaget/Art Resource, NY.
80 Photograph © RMN/Thierry Le Mage/Art Resource, NY.
84, 87 (both) Archives Olga Ruiz-Picasso, Courtesy Fundación Almine y Bernard Ruiz-Picasso para el Arte. Photographer unknown, All Rights Reserved.
88 Private collection.
89 Private collection. © *Cahiers d'Art*, Paris.
90 Private collection.
91 Private collection. © *Cahiers d'Art*, Paris.
94, 95 Archives Olga Ruiz-Picasso, Courtesy Fundación Almine y Bernard Ruiz-Picasso para el Arte. Photographer unknown, All Rights Reserved.

96 Private collection. © *Cahiers d'Art*, Paris.
98 Private collection. Courtesy Succession Picasso Paris.
100 Photograph © BnF.
105 Photograph © RMN/Thierry Le Mage/Art Resource, NY.
106 Photograph © CNAC/MNAM/Dist. RMN/Philippe Migeat/Art Resource, NY.
107 Archives Olga Ruiz-Picasso, Courtesy Fundación Almine y Bernard Ruiz-Picasso para el Arte. Photographer unknown, All Rights Reserved.
109 Private collection.
112 Photograph © Popperfoto/Classicstock.com.
116 Private collection. © *Cahiers d'Art*, Paris.
118 Photograph © RMN/Michèle Bellot/Art Resource, NY.
119 Photograph © RMN/Béatrice Hatala/Art Resource, NY.
121 Photographer unknown. Photograph © RMN/Art Resource, NY.
125 Photograph © BnF.
133 Photograph © Tate, London 2007.
137 Left: Private collection. Right: Private collection. © *Cahiers d'Art*, Paris.
138 The Museum of Modern Art, New York. Abby Aldrich Rockefeller Fund, 148.1951. Photograph © The Museum of Modern Art/Licensed by SCALA/Art Resource, NY.
139 Photograph Bridgestone Museum of Art, Ishibashi Foundation, Tokyo.
142 Private collection. Courtesy Succession Picasso Paris.
143 Private collection. © *Cahiers d'Art*, Paris.
146 Photograph © RMN/Béatrice Hatala/Art Resource, NY.
149 Private collection. © *Cahiers d'Art*, Paris.
150 Photograph © RMN/Gérard Blot/Art Resource, NY.
152 Photograph © RMN/Thierry Le Mage/Art Resource, NY.
153 Photograph © RMN/Christian Jean/Art Resource, NY.
156 Archives Olga Ruiz-Picasso, Courtesy Fundación Almine y Bernard Ruiz-Picasso para el Arte. Photographer unknown, All Rights Reserved.
159 Photograph © RMN/Jean-Gilles Berizzi/Art Resource, NY.
160 Igor Stravinsky Collection, Paul Sacher Foundation, Basel. Photographer unknown, All Rights Reserved.
162 Private collection. Photograph © Christie's Images, Ltd. [1985].
163 Left: Photograph © The National Gallery, London. Right: Photograph © Musée de Grenoble.
164 Private collection. © *Cahiers d'Art*, Paris.
165 Photograph © RMN/Art Resource, NY.
167 The Art Institute of Chicago, Clarence Buckingham Collection, 1965.783. Photograph © The Art Institute of Chicago.
170 Archives Olga Ruiz-Picasso, Courtesy Fundación Almine y Bernard Ruiz-Picasso para el Arte. Photographer unknown, All Rights Reserved.
173 Photograph by Bert Sabourin. © RMN/Michèle Bellot.
174 Left: Photograph by Man Ray. Photograph © Man Ray Trust/ADAGP-ARS/Telimage 2007. Right: © Collection PFB/Rue des Archives.
176 Left: Private collection. © *Cahiers d'Art*, Paris. Right: Photograph © akg–images/CDA/Guillemot.
182 Photograph © RMN/Thierry Le Mage/Art Resource, NY.
184 © The Pushkin State Museum of Fine Arts, Moscow.
189 Archives Olga Ruiz-Picasso, Courtesy Fundación Almine y Bernard Ruiz-Picasso para el Arte. Photographer unknown, All Rights Reserved.
190 Photograph © *Evening Standard*/Hulton Archive/Getty Images.
193 Photograph © RMN/Daniel Arnaudet/Art Resource, NY.
194 The Museum of Modern Art, New York. John S. Newberry Collection. Digital image © The Museum of Modern Art/Licensed by SCALA/Art Resource, NY.
195 The Metropolitan Museum of Art, Gift of Junius S. Morgan, 1932 (32.105). Image © The Metropolitan Museum of Art.
196 The Metropolitan Museum of Art, Bequest of Scofield Thayer, 1982 (1984.433.270). Image © The Metropolitan Museum of Art.
197 Photograph © Alinari/Art Resource, NY.
202 Photograph © Lebrecht Music and Arts/The Image Works.
205 Museum of Art, Rhode Island School of Design. Gift of Mrs. Gustav Radeke and Mr. William T. Aldrich. All Rights Reserved. Photography by Erik Gould. *Every effort has been made to determine the copyright holder of this work.*

209 Photograph from catalog, courtesy Artcurial, Paris. Photographer unknown, All Rights Reserved.

211 Private collection.

213 Private collection. © *Cahiers d'Art*, Paris.

214 The Baltimore Museum of Art: The Cone Collection, formed by Dr. Claribel Cone and Miss Etta Cone of Baltimore, Maryland BMA 1950.279. Photograph The Baltimore Museum of Art.

215 Left: Photograph © RMN/René-Gabriel Ojéda/Art Resource, NY. Right: Photograph © Bildarchiv Preussischer Kulturbesita/ Jens Ziehe/Art Resource, NY.

216 Photograph © RMN/Jean-Gilles Berizzi/Art Resource, NY.

217 © Fundación Almine y Bernard Ruiz-Picasso para el Arte.

219 Collection Bernard Ruiz-Picasso, Courtesy Fundación Almine y Bernard Ruiz-Picasso para el Arte. © Fundación Almine y Bernard Ruiz-Picasso para el Arte. Photograph Marc Domage, All Rights Reserved.

222 The Museum of Modern Art, New York, James Thrall Soby Bequest. Digital image © The Museum of Modern Art/Licensed by SCALA/Art Resource, NY.

223 Left: Photograph © Galerie Jan Krugier & Cie, Geneva. Right: Photograph © Alinari/Art Resource, NY.

224 Private collection. © *Cahiers d'Art*, Paris.

229 Photograph by Man Ray. © Man Ray Trust/ ADAGP-ARS/Telimage 2007.

232 Collection Bernard Ruiz-Picasso, Courtesy Fundación Almine y Bernard Ruiz-Picasso para el Arte. © Fundación Almine y Bernard Ruiz-Picasso para el Arte. Photograph Marc Domage, All Rights Reserved.

234 Collection Pierre Joannon. Photographer unknown, All Rights Reserved.

235 Private collection.

237 Left: Archives Picasso, Musée Picasso, Paris. Photographer unknown, All Rights Reserved. Photograph © RMN/Thierry Le Mage. Right and at bottom: Archives Olga Ruiz-Picasso, Courtesy Fundación Almine y Bernard Ruiz-Picasso para el Arte. Photographers unknown, All Rights Reserved.

239 Photograph © Bildarchiv Preussischer Kulturbesitz/Jens Ziehe/Art Resource, NY.

241 Left: Collection Bernard Ruiz-Picasso, Courtesy Fundación Almine y Bernard Ruiz-Picasso para el Arte. © Fundación Almine y

Bernard Ruiz-Picasso para el Arte. Photograph Eric Baudouin, All Rights Reserved. Right: Private collection. Copyright Christie's Images, Ltd., [2001].

244 Photograph © RMN/Thierry Le Mage/Art Resource, NY.

245 Image courtesy Daniel Wolf, Inc., NY.

249 Photograph © Marcel Ravel, All Rights Reserved.

250 Frontispiece from *Le Diable au Corps,* by Raymond Radiguet.

256 Photograph © RMN/Franck Raux/Art Resource, NY.

258 Photograph © RMN/Jean-Gilles Berizzi/Art Resource, NY.

259 Photograph © RMN/Michèle Bellot/Art Resource, NY.

260 Photograph © RMN/Daniel Arnaudet/Art Resource, NY.

261 Photograph © RMN/Philippe Bernard.

262 Photograph © Sasha/Hulton Archive/Getty Images.

264 Archives Olga Ruiz-Picasso, Courtesy Fundación Almine y Bernard Ruiz-Picasso para el Arte. All Rights Reserved.

266 Archives Olga Ruiz-Picasso, Courtesy Fundación Almine y Bernard Ruiz-Picasso para el Arte. Photographer unknown, All Rights Reserved.

267 Private collection. © *Cahiers d'Art*, Paris.

268 Photograph © RMN Art Resource, NY.

269 Photograph © Stedelijk Museum Amsterdam

271 Archives Olga Ruiz-Picasso, Courtesy Fundación Almine y Bernard Ruiz-Picasso para el Arte. Photographer unknown, All Rights Reserved.

273 Photograph © RMN/Béatrice Hatala/Art Resource, NY.

276 © Lee Miller Archives, England 2006. All Rights Reserved. www.leemiller.co.uk.

277 Photograph © Galerie Jan Krugier & Cie, Geneva.

279 Photograph © BnF.

281 Top and left: Archives Olga Ruiz-Picasso, Courtesy Fundación Almine y Bernard Ruiz-Picasso para el Arte. Photographers unknown, All Rights Reserved. Bottom right: Photograph © BnF.

284 Archives Olga Ruiz-Picasso, Courtesy Fundación Almine y Bernard Ruiz-Picasso para el Arte. All Rights Reserved.

286 Archives Olga Ruiz-Picasso, Courtesy Fundación Almine y Bernard Ruiz-Picasso para el

dación Almine y Bernard Ruiz-Picasso para el Arte. Photographer unknown, All Rights Reserved.

370 Left: Photograph © RMN/P. Bernard/Art Resource, NY. Right: Photograph © RMN/Jean-Gilles Berizzi/Art Resource, NY.

376 Photographer unknown. Photograph © RMN.

380 Photograph © RMN/René-Gabriel Ojéda/Art Resource, NY.

381 Left: Photograph taken by Picasso. Archives Picasso, Musée Picasso, Paris. Photograph © RMN/Gérard Blot. Right: Photograph © RMN/Réne-Gabriel Ojéda/Art Resource, NY.

382 Photograph © Alinari/Art Resource, NY.

386 Archives Olga Ruiz-Picasso, Courtesy Fundación Almine y Bernard Ruiz-Picasso para el Arte. Photographer unknown, All Rights Reserved.

388 Top: Photograph © RMN/Réne-Gabriel Ojéda/Art Resource, NY. Below, left: Collection Bernard Ruiz-Picasso, Courtesy Fundación Almine y Bernard Ruiz-Picasso para el Arte. © Fundación Almine y Bernard Ruiz-Picasso para el Arte. Photograph Marc Domage, All Rights Reserved. Below, right: Photograph © BnF.

392 Left: Courtesy New York Academy of Medicine Library. Right: Photograph © Galerie Jan Krugier & Cie, Geneva.

393 Left: Courtesy New York Academy of Medicine Library. Right: The Museum of Modern Art, New York, Mrs. Simon Guggenheim Fund. Digital image © The Museum of Modern Art/Licensed by SCALA/Art Resource, NY.

396 Left: Photograph © RMN/Michèle Bellot/Art Resource, NY. Right: Photograph © RMN/René-Gabriel Ojéda/Art Resource, NY.

398 Photograph by Inge Morath, 1954. © Inge Morath Foundation/Magnum Photos.

401 Left: Private collection. © *Cahiers d'Art*, Paris. Right: Photograph © RMN/René-Gabriel Ojéda/Art Resource, NY.

404 Photograph © Museu Picasso, Barcelona/Ramon Muro.

406 Photograph © RMN.

409 Archives Olga Ruiz-Picasso, Courtesy Fundación Almine y Bernard Ruiz-Picasso para el Arte. Photographer unknown, All Rights Reserved.

411 Photograph by Inge Morath, 1954. © Inge Morath Foundation/Magnum Photos.

412 Photograph © RMN/Michele Bellot/Art Resource, NY.

417 Photographer unknown. Photograph © RMN/Michèle Bellot/Art Resource, NY.

418 Archives Olga Ruiz-Picasso, Courtesy Fundación Almine y Bernard Ruiz-Picasso para el Arte. Photographer unknown, All Rights Reserved.

419 (both) Archives Olga Ruiz-Picasso, Courtesy Fundación Almine y Bernard Ruiz-Picasso para el Arte. Photographers unknown, All Rights Reserved.

420 Photograph © RMN/Béatrice Hatala/Art Resource, NY.

421 Left: Photograph © Roger Viollet/Getty Images. Right: Photograph © RMN/Béatrice Hatala/Art Resource, NY.

422 Photograph © John Hedgecoe.

424 Photograph © RMN/Béatrice Hatala/Art Resource, NY.

427 Photographer unknown, All Rights Reserved.

429 (both) Photographs © RMN/Thierry Le Mage/Art Resource, NY.

430 Photograph © RMN/Béatrice Hatala/Art Resource, NY.

433 © Estate Brassaï/RMN, Photograph © RMN/Franck Raux/Art Resource, NY.

436 Archives Olga Ruiz-Picasso, Courtesy Fundación Almine y Bernard Ruiz-Picasso para el Arte. Photographer unknown, All Rights Reserved.

438 Left: Photograph © RMN/Réne-Gabriel Ojéda/Art Resource, NY. Right: From *A Discourse on the Worship of Priapus: Theology of the Ancients* by Richard Payne Knight, 1786.

440 Photograph © RMN/René-Gabriel Ojéda/Art Resource, NY.

443 Private collection. Courtesy Succession Picasso Paris.

444 Archives Olga Ruiz-Picasso, Courtesy Fundación Almine y Bernard Ruiz-Picasso para el Arte. Photographer unknown, All Rights Reserved.

445 Archives Olga Ruiz-Picasso, Courtesy Fundación Almine y Bernard Ruiz-Picasso para el Arte. Photographer unknown, All Rights Reserved.

446–447 (all four) Archives Olga Ruiz-Picasso, Courtesy Fundación Almine y Bernard Ruiz-Picasso para el Arte. Photographer(s) unknown, All Rights Reserved.

448 Left: Photograph © RMN/Béatrice Hatala/Art Resource, NY. Right: © Estate Brassaï/RMN, Photograph © RMN/Daniel Arnaudet/Art Resource, NY.

449 (both) Photographs © RMN/Béatrice Hatala/Art Resource, NY.

450 Private collection. © Estate Brassa_/RMN, Photograph © RMN/Daniel Arnaudet/Art Resource, NY.

451 Private collection. © Estate Brassaï/RMN, Photograph © RMN/Franck Raux/Art Resource, NY.

452 Photograph © RMN/Béatrice Hatala/Art Resource, NY.

453 Left: Photograph © RMN/Béatrice Hatala/Art Resource, NY. Right: Solomon R. Guggenheim Museum, New York (85.3317). Photograph by David Heald © The Solomon R. Guggenheim Foundation, New York.

456 Photograph by Cecil Beaton. Photograph courtesy of the Cecil Beaton Studio Archive at Sotheby's.

458 Left: Photograph © Gérard Roucaute-Inventaire général-ADAGP. Right: Photograph © RMN/Gérard Blot/Art Resource, NY.

459 Photograph © RMN/Jean-Gilles Berizzi/Art Resource, NY.

462 Right: Photograph © Scala/Art Resource, NY. Far right and bottom: Photographs © RMN/Béatrice Hatala/Art Resource, NY.

468 Photograph © RMN/René-Gabriel Ojéda/Art Resource, NY.

469 Digital image © The Museum of Modern Art/Licensed by SCALA/Art Resource, NY.

470 Photograph © RMN/René-Gabriel Ojéda/Art Resource, NY.

471 Private collection. Photograph courtesy Galerie Beyeler, Basel.

473 Archives Olga Ruiz-Picasso, Courtesy Fundación Almine y Bernard Ruiz-Picasso para el Arte. Photographer unknown, All Rights Reserved.

474 Private collection. Photograph © Christie's Images, Ltd. [2003].

476–477 Photographs with annotations by Alfred H. Barr, Jr. Alfred H. Barr, Jr. Papers, 12a8. The Museum of Modern Art Archives, New York. © Bernheim-Jeune Galerie (MA682) Digital image © The Museum of Modern Art/Licensed by SCALA/Art Resource, NY.

483 Photograph courtesy Kunsthaus Zurich.

486 Photograph © Musée d'Unterlinden, Colmar/O. Zimmermann.

487 Left: Photographer unknown. Photograph © RMN/Jean-Gilles Berizzi/ Art Resource, NY.

Right: Photograph © RMN/Béatrice Hatala/Art Resource, NY.

490 Archives Olga Ruiz-Picasso, Courtesy Fundación Almine y Bernard Ruiz-Picasso, para el Arte. Photographer unknown, All Rights Reserved.

492 Collection Heirs of Juan Picasso González, Madrid, Courtesy Rafael Inglada.

COLOR INSERTS

Costume design for Chinese Conjuror, *Parade*. Photograph courtesy Alain Helft.

Curtain for *Parade*. Photograph © CNAC/MNAM/Dist. RMN/Christian Bahier/Art Resource, NY.

Woman in a Mantilla. Photograph © Museu Picasso, Barcelona/Ramon Muro.

Olga Khokhlova in a Mantilla. Photograph © Museo Picasso Málaga/Rafael Lobato.

Blanquita Suárez. Photograph © Museu Picasso, Barcelona/Ramon Muro.

Olga in an Armchair. Photograph © RMN/René-Gabriel Ojéda/Art Resource, NY.

Harlequin with Violin ("Si tu veux"). © The Cleveland Museum of Art, Leonard C. Hanna, Jr. 1975.2.

Return from the Baptism or *The Happy Family* (after *Le Nain*). Photograph © RMN/René-Gabriel Ojéda/Art Resource, NY.

The Bathers. Photograph © RMN/Béatrice Hatala/Art Resource, NY.

Still Life. Image © 2007 Board of Trustees, National Gallery of Art, Washington, Chester Dale Collection (1963.10.195).

Table, Guitar, and Bottle. Smith College Museum of Art, Northampton, Massachusetts. Purchased with the Sarah J. Mather Fund SC 1932:15. Photograph by Stephen Petegorsky and Jim Gipe.

Glass and Pipe. Private collection, Dallas. Photograph courtesy of Sotheby's.

Olga Wearing a Wristwatch. Photograph © Galerie Jan Krugier & Cie, Geneva.

Designs for *Tricorne*. All five photographs © RMN/Hervé Lewandowski/Art Resource, NY.

Still Life with Pitcher and Apples. Photograph © RMN/C. Jean/Art Resource, NY.

Still Life in Front of a Window. Photograph © Bildarchiv Preussischer Kulturbesitz/Jens Ziehe/Art Resource, NY.

Three Musicians. The Museum of Modern Art, New York, Mrs. Simon Guggenheim Fund (55.1949). Digital image © The Museum of Modern Art/Licensed by SCALA/Art Resource, NY.

Two Nudes. Photograph © Walter Klein, Düsseldorf.

Three Women at the Spring. The Museum of Modern Art, New York, Gift of Mr. and Mrs. Allan D. Emil (332.1952). Digital image © The Museum of Modern Art/ Licensed by SCALA/Art Resource, NY.

Large Bather. Photograph © RMN/Franck Raux/Art Resource, NY.

Fruit Dish, Bottle, and Guitar. Private collection.

Portrait of Olga. Photograph © RMN/Art Resource, NY.

The Lovers. Image © 2007 Board of Trustees, National Gallery of Art, Washington, Chester Dale Collection (1963.10.195).

Pipes of Pan. Photograph © RMN/Jean-Gilles Berizzi/Art Resource, NY.

Seated Harlequin (Jacint Salvadó). Photograph © CNAC/MNAM/Dist. RMN/Art Resource, NY.

Mandolin and Guitar. Solomon R. Guggenheim Museum, New York (53.1358) Photograph © The Solomon R. Guggenheim Foundation, New York.

La Danse. Photograph © Tate, London/Art Resource, NY.

The Kiss. Photograph © RMN/Jean-Gilles Berizzi/Art Resource, NY.

The Ram's Head. Norton Simon Museum, Pasadena, California, Gift of Mr. Alexandre P. Rosenberg.

Musical Instruments on a Table. Archivo Fotográfico Museo Nacional Centro de Reina Sofía, Madrid.

Still Life. Photograph © CNAC/MNAM/Dist. RMN/Art Resource, NY.

Studio with Plaster Head. Digital image © The Museum of Modern Art/Licensed by SCALA/Art Resource, NY.

Artist and His Model. Photograph © RMN/Jean-Gilles Berizzi/Art Resource, NY.

Guitar (top left). Photograph © Galerie Jan Krugier & Cie, Geneva.

Guitar (bottom right). Photograph © RMN/ Jean-Gilles Berizzi/Art Resource, NY.

Paulo as Harlequin. Photograph courtesy of Sotheby's.

Paulo in a Harlequin Costume. Private collection. Photograph © Galerie Jan Krugier & Cie, Geneva.

Still Life (Easel and Dancer's Tights). Private collection. Courtesy Succession Picasso Paris.

Artist and His Model. Photograph courtesy Galerie Beyeler, Basel.

Painter and Model. The Museum of Modern Art, New York, The Sidney and Harriet Janis Collection. Digital image © The Museum of Modern Art/Licensed by SCALA/Art Resource, NY.

Bathers Playing Ball on the Beach. Private collection. Photograph courtesy Acquavella Galleries.

Bather Lying on the Sand. Private collection. Photograph courtesy of Sotheby's.

Large Bather (Olga). Photograph © RMN/Réne-Gabriel Ojéda/Art Resource, NY.

Open Window. Staatsgalerie Stuttgart, Stuttgart (Inv. L1346). Photograph Staatsgalerie Stuttgart.

Bust of a Woman with a Self-Portrait. Private collection. Photograph courtesy of Sotheby's.

Crucifixion. Photograph © RMN/Réne-Gabriel Ojéda/Art Resource, NY.

Seated Bather. The Museum of Modern Art, New York, Mrs. Simon Guggenheim Fund. Digital image © The Museum of Modern Art/ Licensed by SCALA/Art Resource, NY.

Figures on the Seashore. Photograph © RMN/ Réne-Gabriel Ojéda/Art Resource, NY.

Woman Throwing a Rock. Photograph © RMN/ Réne-Gabriel Ojéda/Art Resource, NY.

The Rescue (Le Sauvetage). Photograph Robert Bayer, Basel.

Woman with a Stiletto. Photograph © RMN/ Réne-Gabriel Ojéda/Art Resource, NY.

The Sculptor. Paris. Photograph © RMN/Béatrice Hatala/Art Resource, NY.

Large Nude in a Red Armchair (Olga). Photograph © RMN/Jean-Gilles Berizzi/Art Resource, NY.

Repose. Private collection. Photograph courtesy of Christie's.

Sleep. Private collection. Photograph by Ellen Page Wilson, courtesy PaceWildenstein, New York.

Dream. Steve and Elaine Wynn Collection, Las Vegas, Nevada.

Bather with Beach Ball. The Museum of Modern Art, New York, Partial gift of an anonymous donor and promised gift of Jo Carole and Ronald S. Lauder (689.1980). Digital image © The Museum of Modern Art/ Licensed by SCALA/Art Resource, NY.

PERMISSIONS ACKNOWLEDGMENTS

Grateful acknowledgment is made to the following for permission to reprint previously published material:

The Estate of Richard Buckle: Excerpts from *Dancing for Diaghilev: The Memoirs of Lydia Sokolova* by Lydia Sokolova, edited by Richard Buckle (John Murray Publishers Ltd., London, 1960). Reprinted by permission of The Estate of Richard Buckle.

Doubleday: Excerpt from *Picasso and Company* by Brassaï, translated by Francis Price, copyright © 1966 by Doubleday, a division of Random House, Inc. Reprinted by permission of Doubleday, a division of Random House, Inc.

Liveright Publishing Corporation: Excerpt from *Picasso* by Gertrude Stein, published by Liveright Publishing Corporation, a division of W. W. Norton & Company, Inc.

The McGraw-Hill Companies: Excerpts from *Life with Picasso* by Françoise Gilot and Carlton Lake, copyright © 1964 by Françoise Gilot and Carlton Lake. Reprinted by permission of The McGraw-Hill Companies.

Tate Trustees: Excerpt from "From Sketchbook to Sculpture in the Work of Picasso, 1924–32" by Peter Read, originally published in *Picasso: Sculptor/Painter,* edited by Elizabeth Cowling and John Golding, copyright © 1994 by Tate. Reprinted by permission of Tate Trustees.